AMERICAN PHOTOGRAPHERS

AN ILLUSTRATED WHO'S WHO AMONG LEADING CONTEMPORARY AMERICANS

LES KRANTZ

EDITOR

FOREWORD BY
CORNELL CAPA

COVER PHOTOGRAPH BY
ART KANE

Facts On File
New York • Oxford

Editor & Publisher: **Les Krantz**

Managing Editor: **Jean Lyons**
Manuscript Editor: **Mark Mravic**
Production Director: **Suzanne E. Hampson**
Art Director: **Ron Richter**
Production Manager: **Carol J. Bast**

Associate Editors: **Penny Berkman, Mark Harris, Joe Hines, Lisa Leavitt, Jeryl Levin, Eric Wadell**
Staff Manager: **Debra Swank**

Contributing Editors: **Barb Koenan, Janis Hunt-Haney, Gordon Mayer, Martha Schoolman, Sheila Ralston, Melissa Ulloa**
Writers: **Peter Kime, Jordan Wankoff, Garrison Beik, Barbara Bowen, Debra Latourette**
Production Assistants: **Tina MacDonald, Elizabeth Trask, Oliver Steck**

Buisiness Manager: **Carol Green**
Public Relations: **Mary Jo Drungil**
Administration: **Lyn Pusztai**
Administrative Assistants: **Linda Leifer, Brett Paesel, Hilary Hammond-Merritt, David Novac**

Facts on File, Inc.
460 Park Avenue South
New York, NY 10016
Library of Congress Cataloging-in-Publication Data

Krantz, Les.
 American photographers

 1. Photographers – United States – Biography.
I. Title.
TR139.K73 1989 770'.92'273 [B] 89-1435
ISBN: 0-8160-1419-1

Facts On File books are available at special discounts when purchased in bulk quantities for businesses, associations, institutions or sales promotion. Please contact the Special Sales Department of our New York office at 212/683-2244 (dial 800/322-8755 except in NY, AK or HI).

10 9 8 7 6 5 4 3 2 1

To my respected colleagues in publishing for their support and confidence in this project: Ed Knappman, Martin Greenwald and Phil Saltz — Thank you.

Photography records the gamut of feelings written on the human face; the beauty of the earth and skies that man has inherited; and the wealth and confusion man has created. It is a major force in explaining man to man.

Edward Steichen
1879–1973

Contents

Johann Gutenberg is famed for his invention of the printing press and the creation of the first printed book, the Mazarine Bible. But history texts often ignore the whole story. During the printing job, it seems that Gutenberg ran out of money and had to borrow from the goldsmith Johann Fust. He could not repay the loan and lost his press and types, leaving Fust to complete the world's first printed book. Notwithstanding the Germans' joint labor, a museum has been devoted to Gutenberg and a statue erected, although his appearance was unknown at the time the statue was made. Fust is virtually forgotten.

A similar saga of publicity and printing occurred in the 1820s. In France in 1826, the chemist Joseph Nicéphore Niépce produced the world's first permanent photograph by coating a pewter plate with bitumen, placing it in a camera obscura and exposing it to light for a day. In 1829, Niépce was sixty-four, ailing and in need of money. He met Louis Jacques Mandé Daguerre, a theatrical scene painter who was twenty years younger, prosperous and interested in fixing and reproducing images projected by the camera obscura. The two formed a partnership, and in 1839 the invention of photography was announced. But Niépce had died six years before, and his family received only token compensation. In France the first photographs were called "Daguerreotypes."

Today our lives are unimaginable without printed words and images. The printing press and the photograph have opened limitless possibilities for writers and photographers who have expanded our knowledge and means of communication beyond all previous boundaries. From the family snapshot and office memo to the masterpieces of world culture, Gutenberg (and Fust) and Daguerre (and Niépce) are very much alive.

This book lists some of the living American beneficiaries of the invention of photography. And it also seeks to tell who is *really* who — distinguishing the inventors from the promoters, the explorers from those who have colonized territories already discovered, the Gutenbergs from the Fusts. Such a job is never easy, for the honor roll of American contributors to world photography is long.

In the 20th century, such a list would have to begin with Alfred Stieglitz, the tireless impresario of photography as an art form, the founder-editor of *Camera Work* magazine and the founder of the Photo-Secessionist group. Group members included Edward Steichen, Clarence White, Gertrude Käsebier, Alvin Langdon Coburn and F. Holland Day, as well as distinguished English camera artists.

The drive to win fine-art status for photography continued with the f/64 group, founded in 1932 by Edward Weston, Imogen Cunningham and Ansel Adams, among others. Later, Adams was instrumental in founding the Friends of Photography.

These photographers sought to change art-world attitudes to their print medium; at the same time, embattled photojournalists sought to change world attitudes to their subjects. In 1908, while Stieglitz photographed *The Steerage* from his ship's first-class deck, Lewis Hine photographed poverty-stricken immigrants on the dock at Ellis Island. Hine was extending the tradition of "straight," socially concerned documentary photography pioneered in America by Jacob Riis, whose book *How the Other Half Lives* inspired laws to correct slum conditions on New York's Lower East Side.

This tradition continued in America during the 1930s, when the Federal Government's Farm Security Administration (FSA) sent photographers such as Walker Evans, Dorothea Lange, Russell Lee, Marion Post Wolcott and Arthur Rothstein into the country's Dustbowl, migrant labor camps, as well as urban settings, to document conditions that deserved federal relief. In the same years, unemployment and social inequities roused the concern of the Photo League, a New York-based organization of photographers and filmmakers who considered the camera a tool for social change. Active members included Sid Grossman and Sol Libsohn, as well as Eliot Elisofon, Aaron Siskind, Dan Weiner, Lou Stoumen, Paul Strand, W. Eugene Smith and many others.

Thanks to the pioneering historians of photography, Beaumont and Nancy Newhall and Helmut Gernsheim, and more recent scholars such as Peter Pollack and Naomi Rosenblum, these Americans — and many more — have been recovered from obscurity. Today, in fact, research in photography and public appreciation of it has never been so vigorous and extensive. In 1989-90, three major, diverse exhibitions in the United States celebrated the 150th birthday of the invention of photography. One was mounted by a collector/connoisseur and former dealer who celebrated the sheer beauty and novelty of the single photograph. Another was organized by four scholars representing two of the country's foremost art museums; it charted the generations of master camera artists. The third show traced changes in the medium fostered by changes in technology — from Daguerre to Polaroid and beyond. That such different approaches could produce equally valid and fascinating surveys of photography proves the richness of the medium — as well as the energy and diversity of its experts and and admirers.

The years covered by this volume, *American Photographers*, and the many photographers cited in it are very familiar to me. I have been a photographer for over forty years and the director of the International Center of Photography since its founding in 1974. In 1984, ICP published a single-volume encyclopedia on photography to make the latest information about the medium and its practitioners more readily accessible. In adding these few words to *American Photographers*, I am delighted to contribute again to the ever-growing body of documentation of our century's preeminent medium, the photograph, and again to salute my fellow photographers.

Cornell Capa
Founder/Director, International Center of Photography
New York, 1989

Photographers deal in things which are continually vanishing and when they have vanished there is no contrivance on earth which can make them come back again.

Henri Cartier-Bresson
1908–

ABBOTT, BERENICE (Portraiture, Fine Art)
R.D. 1, Abbot Village, ME 04406

Born: 1898 *Subject Matter:* Portraits, Architecture, Landscape *Situations:* Studio, U.S. Locations *Awards:* Honorary Doctorate, U. of Maine, Orono *Education:* Smith College; New School for Social Research

Working exclusively in large-format black and white, Abbott is celebrated for her documentary and architectural photographs of New York City in the 1930s. This work appeared in her book, *Changing New York*, published in 1939. She studied with sculptors Brancusi and Bourdelle and was an assistant to Man Ray in Paris. While in Paris in the 1920s Abbott opened a portrait studio and photographed famous artists, writers and expatriates, including Peggy Guggenheim, Max Ernst, Andre Gide, Marcel Duchamp, Leo Stein, James Joyce, Sylvia Beach, Edna St. Vincent Millay and others. In the 1940s Abbott involved herself in photographing scientific work. She is also credited with preserving and subsequently publishing the work of the French photographer Eugene Atget. Most recently Abbott traveled along Route 1 from Maine to Florida, taking photographs to document this experience.

ABOLAFIA, OSCAR (Entertainment, Photojournalism)
215 West 98 St., New York, NY 10025
(212) 662-8472

Born: 1937 *Subject Matter:* Fashion, People *Situations:* U.S. & Foreign Locations *Education:* School of Visual Arts, NYC

He began his career as an industrial photographer, later opening a fashion studio in New York City. For the past eighteen years he has concentrated on photo reportages of famous people around the world. He has also worked as a special still photographer on movie sets. His photographs have appeared in many magazines, including *Time, People, Bunte, MacLean's, Redbook* and *Celebrity Focus.*

ABRAMS, LARRY (Advertising, Corporate/Industrial)
30 Thompson Hill Rd., Milford, CT (203) 877-9291

Subject Matter: Fashion, Food, People, Travel *Situations:* Studio, U.S. & Foreign Locations *Awards:* Connecticut Art Directors; Andy *Education:* SUNY; New School for Social Research

Abrams' diverse portfolio includes product shots for Pepperidge Farm, Kraft, Exxon and Pepsi, as well as corporate portraiture. With an increasing interest in people-oriented photography, his assignments have included photographing the Channel Eight News Team. He prefers to capture real-life situations, looking for the unexpected and non-traditional. Product shots often involve difficult situations and intricate lighting; an assignment for Timex required construction of a special piece of equipment that enabled every facet of the watch to be properly lit. Experienced in production techniques, he has on occasion produced advertising campaigns and collateral materials for national publication. He recently supervised the art and lighting direction for a heart attack education film designed as a public service.

ADAMS, GEORGE (Portraiture, Editorial)
15 W. 38th St., New York, NY 10018 (212) 391-1245

Born: 1936 *Subject Matter:* Food, People, Nudes *Situations:* Studio, U.S. Locations *Education:* Boston College

After a brief stint as a print designer and art director, which has given his work strong graphic design, he opened a photography studio in New York City. He quickly established himself with a series of satirical posters, the most memorable of which was *The Nun Adjusting Her Stocking.* He is experienced in all camera formats, and his work has appeared in all media, including television. Avon Books published *How To Photograph a Woman*, a book he both wrote and illustrated. His nudes have also been featured in critic Arthur Goldsmith's book *The Nude in Photography.* He has taught photography at The School of Visual Arts.

ADAMS, JANET L. (Advertising, Editorial)
1199 Franklin Ave., Columbus, OH 43205
(614) 252-7922

Born: 1957 *Subject Matter:* Travel, Fashion *Situations:* U.S. & Foreign Locations, Studio, Underwater *Education:* Ohio State U.

After working for three years as an industrial photographer at the Battelle Memorial Institute, she had the opportunity to work on a number of challenging assignments including photographing the containment barrels of water from Three Mile Island. There she learned underwater photography, a skill she put to use for the cover of *Apartment Tour*, which featured a man relaxing in a lounge chair, fruit and drink on a nearby table, all at the bottom of a pool, complete with fake tropical fish. In 1982 she began freelancing while based in the Midwest. In 1987 she opened her own 6,000-square-foot studio equipped with a lift for large product shots including automobiles. A versatile photographer, she works on architectural, advertising, multi-media and editorial accounts. In addition to her studio work, she has traveled throughout the U.S., Europe and South America to shoot stock. Most recently she has become very interested in fashion, producing covers and fashion portraits for a number of local magazines.

ADAMS, ROBERT (Fine Art, Nature)
326 Lincoln St., Longmont, CO 80501 (303) 776-7733

Born: 1937 *Subject Matter:* Landscape, People *Situations:* U.S. Locations *Awards:* NEA Fellowship; Guggenheim Fellowship; Award of Merit, American Association of State and Local History; Colorado Governor's Award for the Arts *Education:* U. of Redlands; UCLA

Adams is best known for his landscapes of the American West. He works mainly in black and white. His landscapes capture the beauty of the American West while recording man's presence and the urbanization of this region. In one of his more recent books of photographs, *From the Missouri West*, Adams presents panoramic views of the land and nature, yet he has selected views that remind us of the presence of man, such as the inclusion of structures in the distance, roads, litter, etc. Some of his prints incorporate the actual inhabitants of these urban areas.

AHRENHOLZ, DAVID H., MD (Scientific)
c/o St. Paul/Ramsey Medical Center, 640 Jackson St., St. Paul, MN 55101 (612) 221-2881

Born: 1948 *Subject Matter:* Nature, Wildlife *Situations:* U.S. & Foreign Locations *Education:* Luther College; U. of Iowa

His interests center around interpretive natural history. Not interested in frozen or drugged animal subjects or studio settings, he travels throughout the United States and South America in search of unusual and obscure subjects. His extensive background in the biological sciences helps him to identify these subjects, such as insects, plants, spiders and vertebrates. He also offers his special skills in the monophotography of living subjects in the field.

AIELLO, FRANK (Advertising)
35 S. Van Brunt St., Englewood, NJ 07631
(201) 894-5120

Born: 1957 *Subject Matter:* People *Situations:* Studio *Education:* St. John's U.

Trained in fine art photography, he brings a range of techniques to his advertising images. In these photos, he captures people in real-life situations and alters the background to create images dreamlike and fantastic. The quality is often playful and "escapist." Using incandescent gels, he creates his own filters to manipulate the light such that the inanimate appears animate. Although his clients appreciate the overall special effects he achieves, he is most interested in what can be accomplished with light alone.

AIGNER, LUCIEN (Photojournalism, Portraiture)
15 Dresser Ave., Great Barrington, MA 01230
(413) 528-3610

Born: 1901 *Subject Matter:* People, Events *Situations:* U.S. & Foreign Locations, Studio *Awards:* Leica Award; Art Directors Award, NY

Aigner is best known for his contribution to photojournalism, namely in Europe between the World Wars. He covered events such as the 1932 Geneva Conference on Disarmament and the 1936 Olympic Games in Berlin and photographed Hitler, Roosevelt, Churchill, Mussolini and Anthony Eden, among others. Unable to continue covering the war upon emigrating to the U.S., he photographed such people as Einstein and Paderewski and documented daily life in America. Aigner was employed by the *London General Press, L'Illustration, Miroir du Monde, The Picture Post* and *Muenchner Illustrierte.* Images appeared in *Look, Time, Newsweek* and the *New York Times,* among other U.S. publications. He also served as director of foreign languages for *Voice of America,* and is credited with two films: "Paintings for Halloween," and "Hong Kong Breakthrough."

AKIS, EMANUEL (Advertising, Corporate/ Industrial)
6 West 18 St., New York, NY 10011 (212) 620-0299

Born: 1954 *Subject Matter:* Food *Situations:* Studio *Education:* Germaine School of Photography

Fascinated with the intricacies involved in still-life photography, he has devoted his career to photographing products. In 12 years, he has built his business into a large operation, including a 5,000-square-foot studio, a staff and a lab on the premises. A master of lighting, multiple exposures and multiple masking, he specializes in experimental shots and special effects. Clients from advertising and corporate/industrial fields use his talents most frequently. A partial list of his clients includes John Henry, Yves St. Laurent, Henry Grethel, Liberty of London, Mikasa and Towle.

ALDERSON, JOHN (Advertising, Editorial)
3806 N. Kenmore, Chicago, IL 60613 (312) 281-2228

Born: 1944 *Subject Matter:* Special Effects, Products *Situations:* U.S. Locations, Studio *Awards:* Desi Award; Andy *Education:* Institute of Design; Bradley U.

A freelance photographer in Chicago, he shoots product illustration and editorial work while concentrating on special effects. Rigging an exploding salt shaker and plastic heart for an advertisement warning against hypertension is just one example of his creative solutions. His real expertise, however, is handling light, not as an accent but as the subject itself. Working with light tracings and aura effects, he uses light as a symbolic element in both his personal and his commercial work, with particular impact in the medical and editorial fields. Images are characterized by light streams, saturated colors and unusual light sources such as sparklers or fireworks and custom-gelled specialty bulbs. Special assignments in Chicago have included work for the Field Museum of Natural History photographing Osage Indian relics and documenting the otter tank for the Shedd Aquarium. He publishes in a variety of media, including textbooks, magazines, brochures, annual reports and multi-media presentations. He also writes occasional articles and teaches at Columbia College.

ALFORD, JEFFREY K. S. (Editorial, Photojournalism)
712 S. 2nd St., Laramie, WY 82070 (307) 742-5449

Born: 1954 *Subject Matter:* Travel, Food, Nature, People *Situations:* U.S. & Foreign Locations *Education:* U. of Wyoming

Raised in Wyoming, he has a special affinity for open spaces. He spent most of the last ten years traveling in Asia, the last three of those in Tibet and other remote regions of China. He seeks to convey vastness in his landscapes. Many of his other photographs document isolated peoples and their cultures. He spends time with his subjects so that his pictures convey understanding and familiarity. One of his common themes is food: his pictures show him sharing a butchered sheep with nomads in Western Tibet, flatbreads with Afghan refugees, and rice cakes with the Lisu in northern Thailand. He works through the photography and writing collective Asia Access.

ALFTER-FIELDING, JUDY (Advertising, Corporate/Industrial)
P.O. Box 2562, Bakersfield, CA 93303 (805) 323-1750

Born: 1959 *Subject Matter:* Fashion, Products *Situations:* U.S. Locations, Studio *Education:* Brooks Institute of Photography

While most of her work is product photography, she is skilled in fashion shooting as well, in particular in catching her subject's sexual presence. In all her work, she tailors the light to create an open atmosphere. Her street scenes are mostly candid black and whites, notably one of two old women outside a train station, another of a mother and daughter. She works with combinations of color and black and white for advertisements, catalogues and portfolios. Most recently she has completed a marketing brochure for Formica furniture. Other media publications include newspapers,

Frank Aiello

John Alderson, *Concept Illustration for Hypertension.*
Courtesy: Bruno Ruegg for Sieber & McIntyre, Inc.

magazines, industrial communications and multi-media presentations.

ALINDER, JIM (Editorial, Environment)
3079 Hermitage Rd., Pebble Beach, CA 93953
(408) 649-6059

Born: 1941 *Subject Matter:* People, Nature *Situations:* U.S. Locations *Awards:* NEA Grant; Woods Foundation Fellow *Education:* U. of New Mexico; Macalaster College

Although his images may seem to fall within the limits of the snapshot tradition, they are not shot without some thought and planning beforehand. He is primarily interested in making pictures of people, seen in the setting of their everyday concerns—at home, abroad, or, by implication, in their artifacts. "His early work provides a portrait of suburbia," writes Norman Geske, "the developer's architecture, the time-payment decor, the symbolic culture of the framed reproduction of the Mona Lisa, the comfort, good health and prim perfection of the American dream home." Since 1969 he has primarily used a panoramic camera with a 150-degree angle of view. In the exaggerated perspective of the panorama format, he casually places a figure or figures (his wife and children) as if in a straightforward snapshot; the contrast between the ordinary humans and the looming landscapes sets up a curious counterpoint in his work.

ALTHAUS, MIKE (Advertising, Corporate/Industrial)
5161 River Rd., Bldg. 2B, Bethesda, MD 20816
(301) 652-1303

Born: 1963 *Subject Matter:* Homes, Portraiture, Products *Situations:* Architectural Interiors, Studio *Education:* Art Institute of Pittsburgh

With an interest in photography in high school, he went on to study at the Art Institute of Pittsburgh. It was a short move east to Washington, D.C., where he began freelancing in a number of areas, although he considers himself a specialist in shooting architectural interiors. He has worked on public relations, corporate/industrial, portrait and product assignments, but continues to find architectural work the most satisfying, photographing hotels and private homes for developers. Shooting in color for catalogues and advertising, he trains his eye on the basic shapes, often creating geometric design in his photographs.

ANNERINO, JOHN (Photojournalism)
P.O. Box 1545, Prescott, AZ 86302
(602) 623-4819

Born: 1949 *Subject Matter:* Nature, Sports *Situations:* Hazardous, U.S. & Foreign Locations *Education:* Scottsdale Community College; Prescott College

He started out as a wilderness-survival instructor, a position which gave him the opportunity to photograph numerous rock climbing, mountaineering and river rafting expeditions. Photojournalism became a natural extension of this profession, allowing him to pursue his passion both for photography and adventure. Beginning with shots for *Arizona Highways*, his wilderness pictures gained him a contract for an IBM commercial and next an extended assignment with *Life*, in which he covered such diverse topics as prom night, rodeos, fast food, the homeless, gold mining and corporate America. In 1987 he began freelancing on what he considers his most important photographic project to date; titled "America's Killing Fields," the project documents in color the most dangerous border crossing on the 2,000-mile U.S.-Mexican border.

ANONYMOUS, ECLIPSE (Advertising, Editorial)
P.O. Box 689, Haines, AK 99827 (907) 766-2670

Born: 1933 *Subject Matter:* Wildlife, Fashion *Situations:* U.S. & Foreign Locations, Hazardous *Education:* Rochester Institute of Technology; Art Center College of Design

He began as an apprentice to his grandfather in Bavaria at the age of 16 and has been with a camera ever since. Proficiency in many languages has added to his professional opportunities, enabling him to travel worldwide, covering wars and turmoil in politically unstable and otherwise hazardous areas during his thirty-seven years as a photographer. He works in 35mm, 4" x 5", 16mm film and video. For the past eight years he has been working in Alaska, photographing its people, wildlife and natural sites for film companies and network television. He has recently been shooting a documentary on the behavior of eagles. In addition to his freelancing, he also owns and operates a stock house production company, his own stock exceeding one million photos. His work has appeared in a variety of media including newspapers, magazines, books, advertising and multi-media productions.

ARISTEI, SALLY (Advertising, Corporate/Industrial)
9005 Cynthia, #311, Los Angeles, CA 90069
(213) 278-7738

Born: 1955 *Subject Matter:* People, High Technology *Situations:* U.S. Locations *Awards:* Kodak Professional Photographer's Showcase *Education:* Art Center College of Design

Although she has covered editorial and advertising assignments involving newspaper, magazine and packaging media, she specializes in corporate photography. Known for creating strong graphic images, she is particularly sensitive to the lighting and design in her images, working to achieve an elegant look not usually associated with corporate photography. This style, both in black and white and color, has proved highly successful in satisfying the demands of her corporate clients. Her work has been publicly exhibited in the Professional Photographer's Showcase in the Kodak pavilion at Epcot Center.

ARNDT, JIM (Advertising, Editorial)
400 1st. Ave. N., #510, Minneapolis, MN 55401
(612) 332-5050

Born: 1950 *Subject Matter:* Portraiture, Fashion *Situations:* U.S. Locations, Studio *Awards:* Creative All-Star Photographer, *Adweek/Midwest*; Nominee, *American Photographer*'s New Faces in Advertising *Education:* U. of Minnesota

An advertising and editorial photographer, he specializes in location productions, studio portraits and fashion photography. He is best known for his photographs of the American West. His work has been featured on the cover of *Photo/Design* and in *Archive Magazine* and numerous *Communication Arts* annuals. His personal work has been exhibited in galleries in Minneapolis, Taos, Santa Fe and Austin. He is a member of numerous professional associations, and

Judy Alfter-Fielding, *Julie*

Jim Arndt, *Taos Elder*

he has taught classes at the Minneapolis College of Art and Design.

ARNOLD, EVE (Photojournalism, Fine Art)
26 Mount St., Flat 3, London W1, England

Born: 1913 *Subject Matter:* People, Portraits *Situations:* Studio, U.S. & Foreign Locations *Education:* New School for Social Research

Arnold's professional career as a photographer began when she did fashion shots for Alexey Brodovitch, then Art Director of *Harper's Bazaar.* In 1951 Arnold became the first woman to join the Magnum Photos cooperative agency in New York. She works in both black and white and color and established her reputation as a photo-essayist with her many series of images appearing in *Life, Look,* the *London Sunday Times* and *Vogue.* She has photographed a wide variety of subjects including childbirth, mental institutions, the black civil rights movements in the U.S. and life in small-town America. She has also concentrated on covering women's subjects such as the "Brides of Christ" in Surrey, England, and she has made a film, "Behind the Veil," about Arabian harems. Arnold is also well-known for her photographs of celebrities, including such figures as Clark Gable, Marilyn Monroe, Paul Newman and Joan Crawford. She recently traveled to China, where she spent five months photographing that nation's workers.

ARRUZA, TONY (Photojournalism, Editorial)
P.O. Box 6155, West Palm Beach, FL 33405
(407) 586-0565

Born: 1953 *Subject Matter:* Sports, Travel *Situations:* Foreign Locations, Hazardous *Education:* Florida Atlantic U.

Halfway through his science degree in college, he was introduced to a new specialized language—that of "f-stops," "shutter speeds," and "depth of field." Fascinated by image-making, he began his career by photographing the surfing arenas of the world and writing accompanying feature articles for *Surfing.* He loves both travel and photography, and he now accepts assignments around the world. He also has a particular interest in the exotic and sometimes dangerous. *Popular Photography* has published his work, as well as various travel, leisure and sports magazines. He has recently completed a shoot for three of APA Publishing's *Insight Guide* series books—those on Barbados, Portugal and Lisbon. He likes to tell the story behind his striking photograph, *Eucalyptus Trees:* while driving along an interstate in Portugal one afternoon, he came upon the beautiful scene and pulled off the road to take shots using a 600 millimeter lens on a tripod. The hazy skies and the use of the big telephoto lens contributed to the photo's reduced contrast. He was able to take two shots before the police arrived and told him to get back on the highway.

ASHLEY-WHITE, BRIAN (Advertising, Corporate/Industrial)
559 Broome St., New York, NY 10013
(212) 925-6465

Born: 1950 *Subject Matter:* Nature, People, Travel *Situations:* Studio, U.S. Locations *Education:* Royal Academy of Amsterdam

Originally a monochromatic color-field painter, he began making photographs as a way to get ideas for paintings. Using a Leica, he works with simple light both in the studio and on location. He has made black-and-white advertising portraits for Nike and Reebok. His photo illustrations of American urban, suburban and rural scenes have been used in annual reports, advertising brochures and posters. His personal work, featuring portraits and street scenes, has been shown in New York, Canada and Holland.

ASTOR, JOSEF (Advertising, Editorial)
154 W. 57th St., Studio 845, New York, NY 10019
(212) 307-5588

Born: 1959 *Subject Matter:* Portraiture, Fashion *Situations:* U.S. & Foreign Locations; Studio *Awards:* Merit Award, New York Art Directors Club; *American Photographer* New Faces in Advertising, 1989 *Education:* Syracuse U.

He studied painting and drawing at Syracuse University, and his training in photography came mainly through two contrasting apprenticeships. Working with Irving Penn in New York City, he gained the technical expertise necessary for commercial photography. This was balanced by a period in Paris working with Deborah Turbeville, whose style is loose and intuitive. His own work calls upon both influences; perhaps even more evident is his background in the fine arts. While he specializes in portraiture, his concern with space and light and their relationship finds him treating his subjects sculpturally—that is, of equal importance as other objects in the shot. His photograph of opera star Hei Kyung Hong for *Vanity Fair* demonstrates the characteristic surrealist flair in his work. In it, the singer's head and hand appear to be floating on a suspended plank, as if she were being served on a platter. While much of his work is editorial, covering people in the arts, he also shoots advertising photography.

ATKINSON, R. VALENTINE (Editorial)
1263 Sixth Ave., San Francisco, CA 94122
(415) 731-4385

Born: 1945 *Subject Matter:* People, Sports, Travel *Situations:* U.S. & Foreign Locations *Education:* Columbus College of Art and Design

He learned the rules of balance and composition while studying photography and illustration at the Columbus College of Art and Design. After graduation he worked in an ad agency until 1970, when he moved to California to pursue a career in travel photography. He currently freelances for *Sunset* and other clients. His photographs in brilliant color have appeared in *Newsweek, Esquire* and the *San Francisco Examiner* and in calendars. "One of my fortes is fly fishing photography, which is a pastime I enjoy as well," he says.

ATURA, FRANK (Editorial)
P.O. Box 207, New Milford, NJ 07646 (201) 265-4674

Born: 1956 *Subject Matter:* Environmental Portraits *Situations:* U.S. Locations

Disillusioned with a mainstream education, he left Boston University to pursue a career in photography. Arriving in New York, he scoured the phone book for a studio where he could assist. Eventually, he was hired by Gregory Heisler. Working for Heisler for some twenty months, he learned the technical side of developing a creative idea. This was followed by two years spent freelancing for photojournalist Brian Lanker, a job that took him to Tahiti and Australia to

Tony Arruza, *Portuguese Women*

Richard Avedon, *June Leaf, Sculptress, Mabou Mines, Nova Scotia*

shoot for the swimsuit issue of *Sports Illustrated*; he also had the opportunity to shoot for *Life* magazine. He credits Lanker for training him in the storytelling aspects of photography. In 1988 he set off on his own, concentrating on environmental portraiture and shooting annual reports for various design firms. Other work includes album covers for Atlantic Records and the poster for the Greater New York Blood Drive.

AUBRY, DANIEL (Advertising, Photojournalism)

365 1st Ave., New York, NY 10010 (212) 598-4191

Born: 1935 *Subject Matter:* Nudes, People, Travel *Situations:* Studio, Foreign Locations *Awards:* Creativity *Education:* Swarthmore College

With previous careers in film, real estate and tourism, he turned to photography in mid-life. He took classes at New York's School of Visual Arts and used his business and marketing experience to help him break into the field. Travel and location shots are his specialties. He has been on assignment in Greece, Egypt, Israel, Turkey, France, Peru, Japan and other countries. His clients include many corporate, advertising and editorial accounts, such as *Newsweek, Cosmopolitan*, the *New York Times*, Perkin Elmer, Sotheby's, Pan Am Airlines and The Greek National Tourist Agency.

AVEDON, RICHARD (Advertising, Fine Art)

407 E. 75th St., New York, NY 10021

Born: 1923 *Subject Matter:* People *Situations:* Studio, U.S. & Foreign Locations *Awards:* President's Fellow, Rhode Island Institute of Design *Education:* Columbia U.

From 1944 to 1950, he studied with photographer Alexey Brodovitch at the Design Laboratory of the New School of Social Research in New York. He has been staff photographer for *Harper's Bazaar, Junior Bazaar* and *Vogue*, as well as a visual consultant for Paramount Studios. Early work was concerned with interpreting motion, shooting subjects at slow shutter speeds. As his work evolved, the concept of arresting motion became further refined. He is known for his portraits of notable people in the world of high fashion, art and business, and his success lies in his ability to let his subjects "get close to the camera," as he captures their response to being photographed. He has recently published several monographs and continues to enjoy status as an interpreter of high style. His famous nude portrait of Nastassia Kinski surrounded by a giant python best typifies his expertise with sensual and erotic subject matter. Recent commissions include fashion assignments for major media.

AYICK, PAUL (Advertising, Nature)

262 Hollywood Ave., Fairfield, NJ 07006
(201) 227-2622

Born: 1947 *Subject Matter:* Fashion, Animals, Wildlife *Situations:* Studio, Nature *Education:* New York U.

Originally a jazz trumpeter, his interest in photography began as a hobby. While largely self-taught, he has learned much by working with other photographers in still-life studios. He primarily works for catalogue houses shooting fashion and housewares in color. Birds and nature are also a specialty. He uses 35mm, 2" x 4" and 4" x 5", and his work has appeared in *Bird Watcher's Digest, New Jersey Outdoors* and the *Clearwater Journal* as well as on greeting cards.

BACHMAN, BILL (Advertising, Editorial)

P.O. Box 833, Lake Mary, FL 32746 (305) 322-4444

Born: 1946 *Subject Matter:* Fashion, Travel *Situations:* U.S. & Foreign Locations, Studio *Awards:* Photographer of the Year, Florida Peoples Choice *Education:* Rochester Institute of Technology; London U.

Working as a photojournalist in Europe, he started his career on the move; while he is now based in Florida, he continues to travel, shooting in some fifty countries. He worked as a UPI stringer before becoming a resort and travel photographer. His photography has been used in advertisements for Sheraton, Florida Tourism, Pepsi, Wyndham Hotels and Atlantic Records. Selected Photographer of the Year by the Florida advertising community, he has also been honored with Photo of the Year in Florida magazines. On occasion he provides photography for corporate annual reports. In addition to his commercial work, he shoots 4" x 5" black-and-white landscapes. These fine art photographs have been exhibited in two one-man shows.

BADER, KATE (Advertising, Photojournalism)

41-41 46th St., 3J, Sunnyside, Queens, NY 11104
(718) 786-1440

Born: 1947 *Subject Matter:* Animals, Nature, People, Travel, Buildings *Situations:* U.S. & Foreign Locations *Awards:* Most Outstanding Women Photographers, National Organization For Women *Education:* Northwestern U.

She began making photographs while traveling to see the world's original art and design. In these photographs she expressed her feelings about and interpretations of the various cultures she saw. Current work captures the beauty of a place and the naturalness of its people. Shooting assignments and stock sales have enabled her to photograph in many areas of the world. Her pictures have been used on Pan Am and United Nations posters, UNICEF calendars and a UNESCO postage stamp. In addition, her images have appeared in *GEO, Time* and the *New York Times*, as well as many books and magazines.

BAER, GORDON (Photojournalism, Editorial)

P.O. Box 2467, Cincinnati, OH 45201 (513) 381-4466

Born: 1940 *Subject Matter:* People, Architecture, Documentary *Situations:* Aerial, U.S. Locations, Studio *Awards:* World Understanding Award, Nikon; NPPA; U. of Missouri *Education:* U. of Kentucky; U. of Louisville

In college he worked as a stringer for the wire services. Returning from the Air National Guard in 1965, he became director of photographic services at the University of Louisville. There he gained recognition for his photographs documenting the ravages of strip mining. From 1966 until 1971 he was staff reporter for the *Cincinnati Post*. Since 1971 he has freelanced, his assignments ranging from heavy industry to microsurgery, as well as encompassing executive portraiture, annual reports, aerials, architecture and reports on social issues. In his 1982 book, *Vietnam: The Battle Comes Home*, he documented the hardships and mental distress of Vietnam veterans.

BAER, MORLEY (Editorial)

P.O. Box 222537, Carmel, CA 93922 (408) 624-3530

Born: 1916 *Subject Matter:* Nature, Architecture *Situations:* Interiors, U.S. Locations *Awards:* Photo Medal, AIA *Education:* U. of Michigan

He has been influenced by Group f/64 and by the Carmel-area photographers, Edward Weston and Ansel Adams. He is dedicated to the 8" x 10" view camera and prefers to make contact prints (though he has recently also made 16" x 20" enlargements). Over the last four decades, he has been highly successful both in commercial architectural photography in color and personal abstractions in black and white. In his personal work he documents the places of California, communicating a sense of intimacy rather than vastness. His books include *The Wilder Shore, Room and Time Enough, Painted Ladies* and *Adobes in the Sun.*

BAILEY, OSCAR (Fine Art)
2004 Clement Rd., Lutz, FL 33549

Born: 1925 *Subject Matter:* Landscapes *Situations:* Studio, U.S. Locations *Awards:* NEA Photographers Fellowship Grant; Faculty Research Fellowship, SUNY *Education:* Wilmington College; Ohio U.

Bailey is probably best known for his landscapes—prints produced by an antique Cirkut 8 camera (with negative dimensions of 8" x 48"). Most of his photographs include images of people or imply their presence. His photographs tend to appear contrived, especially those taken by the Cirkut 8, which require much preparation to carry out his preconceived ideas. The majority of Bailey's work is straight photography. However, he does enjoy experimenting with manipulation and mixed-media, and he is known for his multidimensional photo-constructions.

BAK, SUNNY (Advertising, Editorial)
750 S. Spaulding Ave., #136, Los Angeles, CA 90036
(213) 937-6656

Born: 1958 *Subject Matter:* Fashion, People, Entertainment *Situations:* Studio *Education:* New School for Social Research

Beginning as a paparazzi in New York, she did production shots for Broadway shows as a teenager. At the age of eighteen she opened her own studio and started shooting fashion. She has recently returned to shooting entertainment, and in 1987 she received a triple platinum LP for her cover of the Beastie Boys' "License to Ill" album. Her current work is characterized by a glamorous, black-and-white, tungsten-lit look. In the past year her work has been featured in several media, including magazines, record covers, newspapers, advertising and T-shirts.

BAKER, KIPP (Editorial, Corporate/Industrial)
2328 Farrington, Dallas, TX 75207 (214) 638-0602

Born: 1950 *Subject Matter:* Fashion, Food, Portraiture *Situations:* Studio, U.S. Locations *Awards:* Gold Medal, New York Film Festival *Education:* Texas Christian U.; U. of Texas

Having studied illustration with the internationally renowned Don Ivan and fine art with Harry Geffert and Jim Woodson, he is skilled not only in photography but in graphic design and art direction as well. He has done photo work for a long list of corporations, including Tandy/Radio Shack, Texas Instruments, Alcon Labs, Allegheny International, Dr. Pepper and Ben Hogan Golf Equipment. The demands of such clients often involve the construction of elaborate sets. His editorial shots are often portraits, as in one shot of a conference room done with a wide-angle lens in order to give it a comfortable tone. He points to Stieglitz and Steichen as artistic influences.

BAKER, WILLIAM C. (Photojournalism, Corporate/Industrial)
1045 Pebble Hill Rd., Doylestown, PA 18901
(215) 348-9743

Born: 1928 *Subject Matter:* Corporate *Situations:* Aerial, Studio *Awards:* Gold Medal, American Institute of Graphic Arts; Philadelphia Art Director's Club *Education:* Penn State U.; Philadelphia College of Art

Following many years as a corporate photojournalist for a major pharmaceutical manufacturer, he has spent the last eighteen years as a freelance photojournalist, specializing in the needs of the corporate world. His work is used in annual reports, employee publications and public relations photography for such major American corporations as DuPont, Johnson & Johnson and Cigna Insurance. Working largely on location, he often accompanies his color and black-and-white photography with interviews and articles on his subjects. From his base in the Mid-Atlantic states, he accepts assignments from throughout the country.

BALDWIN, FREDERICK (Advertising, Editorial)
1405 Branard St., Houston, TX 77006 (713) 524-9199

Born: 1929 *Subject Matter:* People, Wildlife *Situations:* U.S. & Foreign Locations *Education:* Columbia U.

He is co-founder and director of Houston FotoFest, the international month of photography, and associate professor and director of the photojournalism program at the University of Houston, and he is widely experienced in documentary photography. His magazine credits include *National Geographic, Life, Sports Illustrated, GEO, Town and Country, Esquire, Vogue Bild* (Sweden) and *Photo-Reporter* (France), along with such newspapers as the *New York Times,* the *Christian Science Monitor* and the *Texas Observer.* He organized and coordinated a project with the Norwegian Navy to photograph the first underwater shots of codfish being caught in nets in the Arctic. Other expeditions include one to Spitsbergen in the first effort to mark and photograph polar bears. He is the recipient of many grants for documentary photography, and his work is featured in collections at the University of Texas, the Bibliotheque Nationale in Paris, the Museum of Modern Art in New York and the Museum of Fine Arts in Houston.

BALGEMANN, LEE (Editorial, Corporate/Industrial)
725 Monroe Ave., River Forest, IL 60305-1903
(312) 771-9427

Born: 1946 *Subject Matter:* Animals, People, Sports, Travel *Situations:* Hazardous, U.S. Locations *Education:* Knox College

A photographer from a young age, he published his first photograph at the age of twelve and parlayed school newspaper and yearbook work into his first job as a photo editor with the Associated Press in Chicago. Since that time he has been a regular freelance photographer. In 1981 he founded Lee Balgemann Photographics. His commercial clients have included the American Federation of Teachers, Burson-Marsteller, General Motors, Sunbeam and AT&T.

Because of his AP experience he knows what makes a good "wire" photo. His work has appeared in *U.S. News & World Report*, *International Management* (London), *Stern* (Germany), the *New York Times* and the *Los Angeles Times*.

BALTHIS, FRANK S. (Photojournalism, Scientific)
P.O. Box 255, Davenport, CA 95017 (408) 426-8205

Born: 1947 *Subject Matter:* Animals, Travel *Situations:* U.S. & Foreign Locations *Awards:* National Wildlife Photo Contest; California State Parks Photo Award *Education:* U. of Santa Barbara; Sonoma State U.

Influenced by his experience as a park ranger, naturalist and interpreter, he strives to communicate through his photography his concern for the value of our rich natural and cultural heritage. Subjects range from gray whales of the California coast to the people of China. His publishing credits include *National Geographic*, *National Wildlife*, *Natural History*, *GEO*, *Sierra*, *Sunset* and *Defenders of Wildlife*. In addition, he founded a company called Nature's Image/Design and has published over 100 greeting card designs. Books include *Winter at Old Faithful* and *Mirounga: A Guide to Elephant Seals*. An instructor of photography at the California State Park Training Center and at Monterey Peninsula College, he also serves as a photographer and naturalist on various natural history expeditions.

BALTZ, LEWIS (Industrial, Fine Art)
P.O. Box 42, Sausalito, CA 94966 (415) 332-4200

Born: 1945 *Subject Matter:* Urban and Industrial Landscape *Situations:* U.S. Locations *Awards:* Guggenheim Fellowship; U.S./U.K. Bicentennial Exchange *Education:* San Francisco Art Institute; Claremont Graduate School

Working primarily in 35mm black and white, Baltz is known for his urban and industrial landscapes. His common images include construction sites, houses and businesses. For example, he has produced five notable series to date on the following locations: Park City, Nevada; Maryland; The New Industrial Parks near Irvine, California; and "The Tract Houses." He cites his greatest influence as Walker Evans.

BANK, KENNETH (Advertising, Editorial)
135 N. Harper Ave., Los Angeles, CA 90048
(213) 930-2831

Born: 1954 *Subject Matter:* Fashion, People, Portraiture *Situations:* Studio, U.S. Locations *Awards:* Art Director's Award, *Print Magazine Education:* UCLA

He began making photographs as a high school student. During college he earned money shooting rock concerts for magazines and record companies. After earning a degree in psychology, he moved to New York and worked as a photography assistant. As a sideline he did fashion tests for agencies. He returned to Los Angeles to work for ABC Television and soon thereafter opened his own studio. There he shoots fashion and personalities for both editorial and advertising clients. His photos of Katherine Hepburn, Johnny Carson and Suzanne Sommers all feature flattering, natural-looking light. On location he carries his own lighting. Lartigue is his main influence.

BARBER, DOUG (Corporate/Industrial)
1634 E. Baltimore St., Baltimore, MD 21231
(301) 276-1634

Born: 1949 *Subject Matter:* People *Situations:* U.S. Locations *Awards:* New York Art Directors Club; Washington Art Directors Club *Education:* Maryland Institute College of Art

"Being curious by nature," he says, "photography has given me the ability to satisfy my obsession with how the world works. Guiding forces in my work have come from the full spectrum of life. This includes the masters in photography but also those individuals who approach life with a passion." He photographs blue-collar workers in America, farmers and other laborers. In his work he seeks to let the environment "speak for itself," and "speak of the world, the life the subject inhabits." Often he calls on a wide-angle lens to create the spirit he senses. He has recently hand-colored his photographs to fully capture the final image desired.

BARBOZA, ANTHONY (Advertising, Editorial)
853 Broadway, Rm. 1208, New York, NY 10003
(212) 529-5027

Born: 1944 *Subject Matter:* Portraiture, Fashion, Nudes *Situations:* Studio, U.S. Locations *Awards:* NEA Fellowship; New York State Council of the Arts

His photography career began in 1964 when he took the Kamoinge Workshop under Roy De Carava. From 1965 to 1968 he was a U.S. Navy photographer. His black-and-white portraits in black borders include author James Baldwin, poet Amiri Baraka and musician Lester Bowie. He has created album covers for Miles Davis, Cameo and others. His editorial and fashion work has been featured in the *Time-Life Photography Annual*, *U.S. Camera*, *Popular Photography*, *American Photography* and the *New York Times Magazine*. Exhibitions of his work have been held at the Museum of Modern Art in New York and at galleries throughout the world. He is presently working on an exhibition of 8" x 10" color nudes.

BARD, RICK (Portraiture, Advertising)
158 W. 81st St., New York, NY 10024 (212) 362-1260

Born: 1945 *Subject Matter:* Fashion, People *Situations:* U.S. Locations, Studio *Awards:* Certificates of Distinction, Creativity *Education:* Massachusetts Institute of Technology; Harvard U.

"My work has been shaped by the tension between the 'spontaneous joy' of children at play and the 'formal elegance' of society's wealthiest settings," he says. His work—shot for ads, portraits and fashion layouts—features subjects adorned in fine jewelry and placed in luxurious settings. He has published on the cover of and in *Manhattan*, for which he has also worked as art director. Other publications include the *New York Times*, *New York Magazine* and *Interview*. The photographs have been called "glamorous" and "exciting," and are best typified by his portraits of Dina Merrill, Polly Bergen and Charlton Heston. He first interviews his subjects for the assignment, looking for that which is the "most electric aspect" of their personality, and then he seeks to capture this essence on film.

BARNES, DAVID (Editorial, Corporate/Industrial)
P.O. Box 31498, Seattle, WA 98103 (206) 784-1793;
(213) 473-5757

Born: 1942 *Subject Matter:* People, Nature *Situations:* U.S. & Foreign Locations *Education:* U. of Southern California; Art Center College of Design

Carolyn Bates, *Oasis Diner,* Client: Jan Hubbard, Battery Graphics

Peter Bellamy, *The Artist's Project: Ralphael Soyer.* Courtesy:
Jack Tilton Gallery

With a career in photography spanning almost twenty years, he has worked on many different kinds of assignments. Beginning at the *Seattle Times*, he shot Sunday pictorials and low-budget commercial assignments. For two more years he continued as a photojournalist for *Sunset*. In the mid-1970s, he went to work for the U.S. Travel Service while he was establishing corporate accounts. In 1979 he shot the pictures for a book on Seattle, and by 1982 he decided to leave what was then his base in corporate and advertising photography to develop his own work, selling through stock agencies. He has spent much of the 1980s traveling through Europe taking stock photography for Aperture Photo Bank, The Stock Market and West Light International. He is published in many major magazines including *Life*, *Fortune*, *National Geographic*, *Business Week* and *Traveler*.

BARNETT, NINA (Editorial)
295 Park Ave. S., New York, NY 10010
(212) 979-8008

Subject Matter: Environmental Portraits, Industry/Architecture *Situations:* U.S. & Foreign Locations *Education:* U. of Wisconsin

After an eight-year career as an art production editor for such publishers as Viking, E.P. Dutton and Reader's Digest, she launched her career in photography. She learned her craft as an assistant in various studios in New York, and today she operates her own. Working in both black and white and color with a 35mm, she freelances on a number of assignments for such magazines as *Fortune*, *Forbes*, *Town & Country* and *Money*. She was invited to shoot for *A Day in a Life in America* and has worked on several "Day in the Life" projects; these photos are more photojournalistic than the core of her work, which consists of environmental portraits and industrial/architectural photography. Shot with a variety of lighting sources, from available light to tungsten and neon, her work is characterized by dramatics colors and contrasts. She says her personal photography is "even crazier, looser, more experimental."

BARRERAS, ANTHONY (Advertising, Corporate/Industrial)
P.O. Box 54887, Atlanta, GA 30308 (404) 681-2370

Born: 1958 *Subject Matter:* Still Life *Situations:* U.S. Locations, Studio *Awards:* Kodak/*Scholastic Magazine*

His photographic career began at the age of thirteen, shooting sports for the local newspapers. By age seventeen he had won five national awards in a contest sponsored by Kodak and *Scholastic Magazine*. Moving to Texas, he worked for a time in a film processing plant. With this experience he went to Atlanta, where he assisted for several years before opening his own studio, called Southern City Studio. He has been doing commercial work since then for magazines, advertisements and corporate industrial clients. Although he prefers location shooting because of the spontaneity, his main work and expertise is in table-top photography.

BARRON, SUSAN (Fine Art, Nature)
39 Plaza West, Brooklyn, NY 11217 (713) 636-4827

Born: 1947 *Subject Matter:* People, Nature, Photo-Collage *Situations:* U.S. Locations, Studio

In addition to straight photographs, she makes collages, etchings and other prints incorporating photog-

raphy. She has made a book consisting of seventy-seven mixed-media prints of different sizes and shapes from 5" x 4" to 21" x 17", with a binding that can be untied so that the prints can be laid out in sequence. Another book of twenty-seven photographs consists of portraits, abstracts and landscapes. *Another Song* features forty photographs in a limited edition hand-bound book. Her works are widely exhibited at such institutions as the Metropolitan Museum of Art, the Whitney Museum and the Philadelphia Museum of Art. Collections are kept at the New York's Museum of Modern Art, the J. Paul Getty Museum and the Israel Museum, in addition to the above museums. Her portfolios have been published in *Aperture*, *Camera Magazine* (Lucerne) and *Creative Camera* (London).

BARROW, THOMAS (Fine Art)
c/o Department of Art, University of New Mexico, Albuquerque, NM 87131 (505) 277-0111

Born: 1938 *Subject Matter:* Urban Landscape *Situations:* U.S. Locations *Awards:* NEA Fellowships; Honored Photographer, Society for Photographic Education *Education:* Kansas City Art Institute; Northwestern U.; Institute of Design, Illinois Institute of Technology

Barrow is best known for his series of urban landscapes called "Cancellation," in which an "X" appears across the prints. The purpose of this "X" is to suggest a cancellation similar to the way a printer limits the editions of a print by canceling the plate. Barrow held numerous positions at the George Eastman House in Rochester, New York. He studied under Aaron Siskind and Jack Ellis. He also studied painting and graphic design in addition to photography.

BARTHOLOMEW, BART (Corporate/ Industrial, Photojournalism)
P.O. Box 1143, Pacific Palisades, CA 90272
(213) 394-7449

Born: 1950 *Subject Matter:* People *Situations:* U.S. Locations *Education:* U. of Rochester; Paier School of Art; UCLA

After majoring in photography at the University of Rochester and Paier School of Art, he settled in Southern California. He found himself more absorbed by documentation and less interested in the slick commercial images he had been producing for a major advertising studio. Enrolling at UCLA, he studied the photojournalism of acknowledged masters like Robert Capa, Henri Cartier-Bresson and W. Eugene Smith. Over the last decade, he has further developed his personal attitude toward photojournalism through work and life in Africa, Europe and Central America. His work has appeared in *Newsweek*, *Time* and the *New York Times*.

BARTHOLOMEW, GARY A. (Advertising, Corporate/Industrial)
433 E. Golf Rd., Des Plaines, IL 60016
(312) 824-8473

Born: 1944 *Subject Matter:* Industry, Products, Special Effects *Situations:* Studio, U.S. Locations *Education:* American Academy of Art, Chicago

He describes himself as "a man with answers, looking for problems." He has his own commercial/industrial studio where he specializes in photo-composition, special effects, 20,000-volt Kirlian and creative product

photography. He began his career as a newspaper photographer in the Chicago area. After two years he moved to an audio-visual company as their sole still photographer. Six years later, he started his current studio. Aside from taking pictures, he also designs photographic equipment. His latest product, "Light Right," is a system of magnetically controlled reflectors. In 1986, he served as technical advisor for a video production on how to use the 4" x 5" camera.

BARTZ, CARL (Advertising, Editorial)
321 N. 22nd St., St. Louis, MO 63103 (314) 231-8690

Born: 1948 *Subject Matter:* Fashion, Food, People *Situations:* Studio, U.S. & Foreign Locations *Education:* Washington U.

Originally trained as an art director, he gradually moved into photography as a career. He specializes in fashion, beauty and people, using simple, single lighting to give his shots a relaxed, believable and unstaged look. His lighting technique has been influenced by Richard Avedon and Victor Skrebneski. He prefers black and white to color, shooting with 35mm and other cameras. He photographed the National Cosmetology Association's *Statement for Hair, Make-up and Beauty,* and he has recently been on location in Mexico shooting for his stock file.

BASCH, RICHARD (Portraiture)
2627 Connecticut Ave. NW, Washington, DC 20008 (202) 232-3100

Born: 1945 *Subject Matter:* People, Fashion, Nature *Situations:* Studio *Education:* Antioch College; London Film School; U. of Fine Art, Perusia, Italy

Originally trained as an actor, he has worked as a cameraman and lighting director in theatre and film. His approach to portraiture has been influenced by film-maker Robert Flaherty and by photographers Peter Basch and Yousef Karsh. Working in 35mm and 2 1/4", his photographs deal with the complexities of his subject's entire life experiences. Images of political figures and celebrities, including Rosalynn Carter, Liv Ullmann and George Bush are characterized by a sense of discovery. His theatrical background translates into photographs that are often heavily backlit, exuding mystery and conveying a romantic and fanciful point of view. As a consultant for the Smithsonian Institution, he has presented eight lecture series featuring the leading names in photography. Also active in television, he wrote and produced "The Burning Issue," aired on over eighty stations in the U.S. In addition, he is working on a twelve-part series, "Richard Basch's Profiles in Photography."

BATES, CAROLYN L. (Editorial, Corporate/Industrial)
P.O. Box 215, Burlington, VT 05402 (802) 862-5386

Born: 1944 *Awards:* "House of the Year," *Metropolitan Home Education:* Skidmore College; Boston State U.

She started freelancing with basic 35mm cameras in 1969 in Boston, setting up a children's program at Minor White's School Project, Inc. in Cambridge that same year. For the next seven years, the majority of her work was for national sailing magazines and for *Vermont Life, Horticulture,* the *New York Times* and others. IBM has over fifty wall murals of her work from this period. Architectural photography, a side interest then, has since become her specialty. Her work

in this field emphasizes her strengths—an eye for detail, an ability to light spaces effectively and an interest in color relationships. In 1986 and 1987, she served as architectural editor for *Window of Vermont.* She is best known for her ability to enhance interiors through composition, lighting and props. When possible, she likes to add a humorous touch to the shot.

BATTRELL, MARK (Editorial, Advertising)
1611 N. Sheffield, Chicago, IL 60614 (312) 642-6650

Born: 1953 *Subject Matter:* People *Situations:* Studio, U.S. Locations *Education:* Yale U.

Inspired by the weekly arrival of *Life* magazine, he became interested in photography as a child growing up in a small Midwestern town. Although not a photojournalist, he nevertheless achieves a level of visual strength that any viewer can relate to and appreciate. He is currently based in Chicago where he photographs people for annual reports, advertising assignments and for the fun and challenge of it. He uses both black-and-white and color film and enjoys working in the business environment. His work has appeared in *Forbes, Parade* and *Chicago Magazine,* and his photographs have been featured in the annual reports of Heller Financial and First Colonial Bankshares Corporation.

BEAN, JOHN (Advertising)
5 W. 15th St., New York, NY 10011 (212) 242-8106

Born: 1948 *Subject Matter:* People, Fashion *Situations:* U.S. Locations, Studio *Education:* U. of Texas; Art Center College of Design

Although he shoots for several media, including television, magazines, catalogues, annual reports and newspapers on a wide range of assignments, his forte is upscale fashion illustration. Many of these photographs are taken on location under natural lighting conditions, and all are shot in color. Outside of mainstream advertising, he spends his remaining time between catalogue and television production. Over the years, he has found his video work influencing his still camera work, as he attempts to bring the feel of a thirty-second film to a still photograph. He prefers to work with ten to thirty people, each scene set up as a master shot from which he makes the cutaway shots.

BEEBE, RODERICK (Corporate/Industrial, Editorial)
790 Amsterdam Ave., New York, NY 10025 (212) 678-7832

Born: 1953 *Subject Matter:* Nature, People, Sports, Travel, Fitness, Adventure *Situations:* U.S. & Foreign Locations *Education:* Lake Forest College; New York U.

He finds a certain magic and timeliness in late daylight, especially on location. His interest in sports and the great outdoors grew naturally from his wilderness experiences as a young photographer. In the 1970s he attended graduate school in film production and worked on television commercials in New York. He began his photo career working for a commercial studio, shooting special effects and sports motion for top New York ad agencies. In 1981 he started Kanu Productions (Sportlight carries his stock) and worked for corporations, magazines and design and public relations firms. Most of his work is coverage of corporate operations, installations and events, plus sports and adventure stories for magazines. He is always

looking to capture a perfect, fleeting moment of action or light.

BEGLEITER, STEVEN (Corporate/Industrial, Editorial)
2025 Broadway, Apt. 19K, New York, NY
(212) 580-7409

Born: 1956 *Subject Matter:* People *Situations:* U.S. Locations *Education:* Kansas State U.

He began his career as an Associated Press sports photographer in Cleveland. He then worked as a newspaper photographer in Troy, New York and finally moved to New York City to assist Annie Leibovitz and Mary Ellen Mark. A freelancer since 1983, he has established himself as an "environmental portrait photographer." His clients have included corporate design firms, and his work has appeared in *Esquire, Fortune, Forbes, Us* and *Elle.*

BEIGEL, DAN (Photojournalism, Corporate/Industrial)
2024 Chesapeake Rd., Annapolis, MD 21401
(301) 261-2494

Born: 1948 *Subject Matter:* Travel, Nature *Situations:* U.S. Locations *Education:* U. of Pennsylvania

Influenced both by pictorial photographers such as Ansel Adams and Elliot Porter and by social documentarians such as Eugene Smith, he first worked as a staff photographer for the *Miami Herald.* After leaving the paper for a brief stint in the theater, he returned to photography as a freelance producer and photographer for multi-image shows and as a photographer for the National Geographic Society Television and Book Divisions. He is known for the special effects he achieves in audio/visual presentations and spends a good deal of time producing such shows for various corporate clients. His works, shot mainly in 35mm, have been displayed at Kodak's Professional Showcase representing "The World's Outstanding Photography." Currently, he is contributing to National Geographic's *World* and *Traveler* magazines, as well as other national and regional publications.

BELLACK, RICHARD (Photojournalism, Portraiture)
18 Stuyvesant Oval, Apt. 12-D, New York, NY 10009
(212) 353-0911

Born: 1934 *Subject Matter:* People, Travel *Situations:* U.S. & Foreign Locations *Education:* American U.

Having studied portraiture with the late Philippe Halsman, he brings special skills to his work in photojournalism. Indeed, he is known primarily for his work photographing people, covering such groups as migrant farmers, Appalachian craftsman, banana workers in Guatemala, Atiteco Indians and street musicians. Producing in-depth photo essays, he has published in *Newsweek, Life En Español, Forbes* and *Saturday Review,* as well as camera-industry publications *Popular Photography Annual* and *U.S. Camera Annual.* Work in the performing arts includes shooting for "Open Theatre" and "Bread and Puppet Theater."

BELLAMY, PETER (Portraiture, Environment)
118 E. 28th St., Rm. 905, New York, NY 10016
(212) 686-1872

Born: 1954 *Subject Matter:* People, Architecture *Situations:* U.S. Locations; Studio *Education:* Pratt Institute

He began his "Artist Project" to take a "humanitarian view of American artists." He has created more than 500 portraits photographed in a classical documentary fashion, compiling in one book portraits of such artists as painter Susan Rothenberg, performance artist Vito Acconci and subway artist "A-1." The project includes artists of all kinds at all levels of success and notoriety. In addition, he specializes in photographing environmental situations, frequently publishes in art magazines such as *Art News, Art in America* and *Artforum,* and periodically exhibits his work. He has photographed most of New York's prominent artists, showing a particular interest in sculptors.

BENEDICT-JONES, LINDA (Portraiture)
43 Royal Ave., Cambridge, MA 02138 (617) 868-1364

Born: 1947 *Subject Matter:* People *Situations:* Studio, U.S. Locations *Education:* U. of Wisconsin; Massachusetts Institute of Technology

The American movement in women's self-portraiture, concerned with women's roles and identities, was later spawned in Europe by Linda Benedict-Jones. However, her approach differed from her American counterparts. Instead of emphasizing feminine uniqueness, her self-portraits convey a sense of ineffectual existence. In *Self-Portrait,* her nightgown blends into the tone of a window frame; her face cannot be seen. In one series, her body is coiled into a ball, then blurred by movement and time exposure. Double exposures often give her face a ghost-like presence. In some cases, she doesn't appear at all. One photograph reveals rumples in a couch's upholstery, suggesting only her recent presence. Benedict-Jones's work is sensitive and subtle in its investigation of the female condition. It is widely exhibited and published. She is one of the few photographers to be treated seriously by male-dominated British media.

BENGSTON, JIM (Fine Art)
Grakamveien 7C, 0389 Oslo 3, Norway

Born: 1942 *Subject Matter:* People, Architectural Landscapes *Situations:* U.S. & Foreign Locations *Education:* Lake Forest College; Princeton U.

Jim Bengston's documentary work approximates the narrative by recording daily events of family and friends. He interprets movement sensitively, influences being Robert Frank and Cartier-Bresson. His style, nevertheless, is highly individual and infused with playful optimism. Bengston is participant as well as observer, often appearing as a subject in his own work. Polaroid instant photographs allow him to experiment and rework the moment he intends to capture. Concluding that their hearts were not in the city, Bengston and his wife moved from New York to Oslo, Norway, where Bengston found environmental richness well tailored for his vision. In addition to live photography, Bengston's work has more recently involved landscapes, Norwegian mountain ranges, empty rooms and empty buildings. In this series, the human element remains despite a feeling of vacancy.

BENTON-HARRIS, JOHN (Photojournalism, Fine Art)
25 Morland Ave., Croyden CRO-6EA, Surrey, England

Born: 1939 *Subject Matter:* People *Situations:* U.S. & Foreign Locations *Education:* Alexey Brodovitch Design Workshop

An American photographer now living in England, John Benton-Harris documents societal barriers in both cultures. In England, his work penetrates the cryptic eccentricities of the elite class. He often records such events as Ascot, Henley and the Derby. In America, a country he sees as innovative yet lacking in unified identity, he records the ethnic groups, teams and clubs that form as a result of the individual's deep desire for cohesion amidst fragmentation and rootlessness. He has said, "The barriers in American society are club rather than class." As he records, he always establishes contact with at least one person in the group he is photographing. This contact beckons the viewer into the action; establishes intimacy. His work is compositionally strong and often filled with gentle, accepting humor. Benton-Harris does not take assignments which require instant results. He waits for the definitive moment as he works. Therefore, he teaches and promotes photographic exhibitions for his main income.

BERGE, MELINDA (Photojournalism, Advertising)

1280 Ute Ave., Aspen, CO 81611 (303) 925-2317

Born: 1944 *Subject Matter:* Travel, People *Situations:* U.S. & Foreign Locations *Awards:* Lowell Thomas Award *Education:* U. of Washington

Primarily a photojournalist, she spends six to eight months a year traveling, documenting various cultures and terrains. Most recently, she has returned from assignments in the Pacific, Australia and Asia. Her home base, Photographers/Aspen, is a stock and assignment agency in Aspen, Colorado with three other resident photographers, all regular contributors to National Geographic Society publications. Her own work concentrates on people and their cultures, such as Tasmania, Pitcairn and Norfolk Islands, Samoa and Micronesia, images of which have been published in *National Geographic*. Studies on the western United States have appeared in *Moda* (Italy), *Merian* (Germany), *Vogue Sport* (France) and many American publications.

BERK, OTTO M. (Advertising)

303 Park Ave. S., New York, NY 10010
(212) 477-3449

Born: 1946 *Subject Matter:* Nudes, People, Dance *Situations:* Studio, Theater

He began his career doing documentary work in Washington, D.C. for the U.S. National Park Service. For his dance photographs, taken in his studio or during dress rehearsals, he uses available light and antithetical media, producing very sharp images and a full range of tones without disturbing the integrity of the set lighting. The Merce Cunningham, Murray Lewis and Alvin Nikolas dance companies have all retained him. He prefers black and white unless an object is integrally colorful. His photographs have appeared in *Dance Magazine, Fit Magazine*, the *New York Times* Sunday Arts and Leisure section and in numerous other domestic and European magazines and journals. Exhibitions have included New York's Merce Cunningham Studio, Riverside Church and 92nd Street Y, as well as the Institute for Contemporary Dance in Boston. He is currently producing a show of nudes.

BERNDT, JERRY (Corporate/Industrial)

41 Magnolia Ave., Cambridge, MA 02138
(617) 354-2266

Born: 1943 *Subject Matter:* People *Situations:* Hazardous, U.S. & Foreign Locations *Awards:* NEA Fellowship; Publishers Award, Maine Photographic Workshop

With a professional career spanning twenty years, he has worked for many newspapers and magazines on a freelance basis, at one point working as a staff photographer for the *Boston Phoenix*. He has taught at the University of Massachusetts and at the Art Institute of Boston. Concerned with documenting the plight of the less advantaged, he has traveled to Guatemala and Haiti to photograph refugees. His book *Missing Persons—The Homeless* accompanied a fifty-image traveling show in 1986 funded by the Massachusetts Art Council. Not interested in sentimental portrayals of the downtrodden, his pictures are of people he knows, photographed in a dignified manner. He wants the viewer not only to "feel for the people in the picture, but to feel like them."

BERNHARD, RUTH (Fine Art, Portraiture)

2982 Clay St., San Francisco, CA 94115

Born: 1905 *Subject Matter:* Nudes, Nature, Still Life, Portraits *Situations:* Studio, U.S. Locations *Awards:* Dorothea Lange Award; Award of Honor for Outstanding Achievement in Photography, San Francisco Art Commission *Education:* Akademie der Kunste, Berlin

In New York, Bernhard was involved in advertising and design, later moving to California, where she pursued a teaching career. She is known primarily for her prints made with an 8" x 10" view camera. Her subject matter includes nude figures, nature, still lifes, children and movie celebrities. She describes herself as having been influenced by many photographers, in particular Dorothea Lange, Ansel Adams, Edward Weston and Wynn Bullock. She works in black and white.

BERNSTEIN, GARY (Editorial, Advertising)

8735 Washington Blvd., Culver City, CA 90232
(213) 550-6891

Born: 1948 *Subject Matter:* Fashion, People *Situations:* Studio, U.S. Locations *Awards:* Master of Contemporary Photography, Smithsonian Institute *Education:* Penn State U.

Since opening his studio in New York City and a production company in Los Angeles, he has produced advertising and editorial campaigns for clients all over the world. His fashion layouts and commercial photographs have appeared in many major magazines, including *Vogue, Harper's Bazaar, Esquire, GQ* and *Playboy*. Elizabeth Taylor, Joan Collins, Kenny Rodgers, Johnny Carson, Cybill Shepherd, Jay Leno, John MacEnroe and Natalie Wood are some of the sixty international celebrities he has photographed. Commercial clients include such companies as Revlon, Du-Pont, Ford and Pierre Cardin. He has published two books, *Pro Techniques of People Photography* and *Pro Techniques of Beauty and Glamour*. His instructional video, "The Magic of Photography," was released in 1986. Currently he divides his time between still photography and motion pictures.

BIBIKOW, WALTER (Advertising, Corporate/Industrial)
76 Batterymarch St., Boston, MA 02110
(617) 451-3464

Born: 1955 *Subject Matter:* Fashion, Travel *Situations:* U.S. & Foreign Locations, Studio *Awards:* Art Director's Club; Emmy Award *Education:* Tufts U.; Boston Museum of Fine Art School

A professional photographer for over fifteen years, he has taken a variety of assignments in the editorial, corporate and advertising fields, both in the United States and abroad. Shooting fashion, food, nature, people and foreign locales, he works in all formats. Seeing photography as a vehicle to explore the world of light and color, as well as a way to document the real world, he pursues personal work in addition to his commercial assignments. "The best photographs," he says, "do not come by accident, but rather as a result of personal involvement and experimentation."

BIEVER, JOHN (Photojournalism)
3008 N. Maryland Ave., Milwaukee, WI 53211
(414) 964-0246

Born: 1951 *Subject Matter:* Sports *Situations:* U.S. Locations *Awards:* News Photographer of the Year

Specializing in football photography on both the college and professional levels, he started covering the sport at a young age—his father is the official photographer for the Green Bay Packers. He and his father have photographed the Super Bowl Game from its inception—twenty-three games in all. He worked for the *Milwaukee Journal-Sentinel* for thirteen years, leaving to freelance in 1986. He has published in *Inside Sports* and *Sport* and recently became a contract photographer for *Sports Illustrated*. In considering his years shooting the big games, he points to two highlights: he captured Bart Starr scoring the winning touchdown against Dallas in the 1967 NFL Championship game; twenty-one years later he photographed Doug Williams of the Washington Redskins being injured before Williams went on to become the Super Bowl's Most Valuable Player.

BINDAS, JAN (Advertising, Corporate/Industrial)
205 A St., Boston, MA 02210 (617) 268-3050

Born: 1957 *Subject Matter:* Still Life, Annual Reports *Situations:* Underwater, Hazardous, U.S. Locations, Studio *Awards:* Award of Excellence, *Communication Arts*; Silver Award, Boston Art Director's Club *Education:* Rochester Institute of Technology

After completing a degree in photography at the Rochester Institute of Technology, she moved to Boston to find a larger audience for her work. Working first as an assistant at a medium-sized design/photography studio, she completed the carpentry as well as the photographs. Though her shooting time increased, her salary did not, so she decided to share a space with another struggling photographer. Later she opened her own studio. Most of her work consists of low-key still lifes with a very intimate use of light, yielding saturated colors and a high degree of detail. Shooting for advertisements and annual reports, she keeps her photographs elegantly simple, the image holding an ethereal quality. Forsaking film manipulation, she works mostly in large format in the studio, but turns to 35mm for location shots.

BISHOP, MICHAEL (Fine Art)
43 Surrey St., San Francisco, CA 94103

Born: 1946 *Subject Matter:* Landscapes, Objects *Situations:* Location *Awards:* NEA Fellowship *Education:* San Francisco State College

Formal elements dominate the photographs created by Michael Bishop. Ostensibly dreary objects such as steel surfaces, concrete forms and other materials seem to shut out beauty: a lonely traffic sign; a deserted lawn chair in winter. This stripped down, apparently simple vision, builds upon itself until we comprehend the surrealist notion that the world is increasingly faced with human creations of inhuman, sterile quality.

BISHOP, RANDA (Photojournalism, Science)
59 W. 12th St., New York, NY 10011 (718) 206-1122

Born: 1941 *Subject Matter:* People, Travel *Situations:* U.S. & Foreign Locations *Awards:* Kodak Professional Showcase *Education:* Wheaton College; New York U.

Perhaps most notable is her documentation, spanning ten months, of the "Solar Challenger," a solar-powered airplane developed by DuPont. While she has followed the subject of unusual vehicles over the years, most of her photographs are taken in foreign locations for a number of travel and tourism magazines and advertising and tourist offices. While not on the road, she produces executive portraits for both corporate and editorial use. She also writes feature stories as well as a regular column on travel photography for *Relax* magazine.

BLACKMAN, JEFFREY E. (Advertising, Editorial)
2323 E. 12th St., Brooklyn, NY 11229 (718) 769-0986

Born: 1947 *Subject Matter:* People, Sports, Travel *Situations:* U.S. & Foreign Locations *Education:* School of Visual Arts, NYC

He began his career as an illustrator but turned to photography because of one particularly short deadline. Over the past fifteen years he has photographed almost all the major sporting events of the world, including Super Bowls, Masters Golf Tournaments, rodeos and auto races. His book on professional football, *End Zone* was published by Holt. Today he works primarily in advertising and travel. In Japan he has covered Tokyo's Grand Kabuki, Sapporo's Ice Festival and the people and culture of Nagano. Most recently he was assigned to photograph Aberfeldy, Scotland, and the Orkney Islands of Great Britain. His work has appeared in *Horse and Sport*, *Newsweek* and assorted travel magazines. In addition, he maintains an extensive library of sporting and travel photographs.

BLAKE, MARC B. (Entertainment, Nature)
912 N. 2nd. St., Montebello, CA 90640
(213) 888-0222

Born: 1952 *Subject Matter:* Nature, People *Situations:* Scenic

Under the tutelage of his father, a painter, he has created photographs that often have an impressionist feel to them. He shoots a range of subjects, from still lifes to classical portraits, but his greatest interest lies in photographing scenic vistas. Landscapes from Yosemite, Death Valley, the Grand Canyon and Mesa Verde fill his portfolio. Other less mainstream work includes an album cover, *Flight to Moscow*, which fea-

tures Mathias Rust, the man who flew into Red Square, in multiple exposures, and the series "Journey into the Shadows," a collection of photos exploring hidden places. Freelance work for *R & R Magazine*, *Guitar World* and *Songtalk* has led to publicity shots of the Pointer Sisters, Randy Newman and Paul Simon.

BLAKE, TUPPER ANSEL (Photojournalism, Scientific)

P.O. Box 152, Inverness, CA 94937 (415) 663-8205

Born: 1943 *Subject Matter:* Nature, Wildlife *Situations:* U.S. & Foreign Locations; Aerial *Awards:* Ansel Adams Award for Conservation Photography; Outstanding Service Award, California Nature Conservancy

Tupper Blake is a naturalist and professional wildlife photographer. His photographs, known for their technical accuracy and artistic quality, have been featured in numerous books and in such journals as *Audubon*, *National Geographic*, *National Wildlife*, *Smithsonian* and *Sierra*. Exhibitions of his work have appeared at the United Nations and in museums all over the United States, including the Smithsonian Institution, the California Academy of Sciences and the Dallas Museum of Natural History A skilled practitioner of the difficult art of photographing animals in their natural habitats, he was selected as the official still photographer for the U.S. Fish and Wildlife Service/National Audubon Society's California Condor Recovery Program and has also received the Sierra Club's 1985 Ansel Adams photography award. He has recently been conducting a photographic survey called "The Wetlands of Western North America/The Pacific Flyway" for the Smithsonian Institution.

BLAU, ERIC (Photojournalism, Fine Art)

614 W. Lewis St., San Diego, CA 92103
(619) 291-5753

Born: 1947 *Subject Matter:* People, Travel *Situations:* U.S. & Foreign Locations *Awards:* Polaroid Artist Support Grant

Long a street photographer, he began meeting with dying people in 1984 and making taped oral histories and photographic portraits in their homes. This work lasted until 1987; it is currently in galleries throughout the U.S. He has exhibited widely on the West Coast and is the subject of many reviews, articles and television interviews.

BLOCK, STUART (Advertising, Corporate/Industrial)

1242 W. Washington Blvd., Chicago, IL 60607

Subject Matter: Fashion, Food *Situations:* Studio

A photographer with twelve years of professional experience, he specializes in shooting fashion and food and creating multimedia projects—in his 7,000-square-foot studio in the heart of Chicago's new photographic center—for national and local advertising and corporate/industrial clients. His work has appeared in a wide range of national publications. A photo comment on the American flag features the striking image of a female figure wrapped in red and white against a backdrop of stars in a field of blue, evidencing his mastery of color and forms. The image is sensual and at the same time strangely patriotic. "I may not have a great left hook, but you won't find a better Block," he says.

BLOSSER, ROBERT VANCE (Advertising, Corporate/Industrial)

741 West End Ave. #3-C, New York, NY 10025
(212) 667-0107

Born: 1952 *Subject Matter:* Portraiture, Products, Fashion *Situations:* U.S. Locations, Studio *Education:* Penn State U.

Born in rural Pennsylvania, he developed a strong sense of form and space and a feel for visual design in the rugged woods and mountains of his childhood environment. Moving to New York, he began his photographic career as an assistant for major photographers working on corporate and advertising accounts. Today, more than eight years later, he makes his living freelancing, dividing his time between corporate accounts, including beauty and soap opera work, and portraiture for public relations firms. Liberace, Sigourney Weaver, Corazon Aquino and Senator Ted Kennedy are among a long list of his portraits of famous personalities. Finished works and works in progress include a series of nudes, environmental images and portraits of various New York painters, actors and writers. These works are being prepared for publication and gallery shows.

BLOW, JERRY D. (Advertising, Corporate/Industrial)

P.O. Box 1615, Wilmington, NC 28402
(919) 763-3835

Born: 1946 *Subject Matter:* Architecture *Situations:* Studio, Architecture/Interiors *Education:* U. of Virginia; Smithsonian Institute

Architecture has been the dominant theme in both his personal and professional photographs since his studies at the University of Virginia and the Smithsonian. His architectural photography, involving commercial as well as residential spaces along the East Coast, has developed over the past ten years. He specializes in producing elegant presentations of small interior spaces, and he has won national recognition for his use of tight, two-dimensional compositions cast with three-dimensional lighting. He credits Minor White and Ron Stark for his sense of composition and line, the parabolic curve playing both a functional and symbolic role in his finished images. In all his work, an emotional quality emerges from behind the professional design.

BLUMBERG, DONALD (Fine Art)

16918 Donna Ynex Lane, Pacific Palisades, CA 90272

Born: 1935 *Subject Matter:* Family, Documentary, Anti-War Images, Portraits *Situations:* Studio, U.S. Locations *Awards:* CAPS Grant, New York State Council of the Arts *Education:* Cornell U.; U. of Colorado

Blumberg is one of the pioneers in experimental photography. He has used collage frequently, sewn found objects onto prints, used *cliche verre* and stain photographs and even experimented with filmmaking. Most notable are his antiwar images made in the 1960s during the Vietnam conflict. A recent series is "Collaboration with Rachel," which depicts his relationship with his daughter. He works in black and white and color. He has made several films with his wife, Grace.

BOCCACCIO, TONY (Editorial, Corporate/Industrial)

West 1102 Glass Ave., Spokane, WA 99205
(509) 326-6019

Born: 1948 *Subject Matter:* Nature, Travel *Situations:* Celestial, U.S. & Foreign Locations *Awards:* Gold Medal, U.S. Industrial Film Festival *Education:* U. of Rochester; Gonzaga U.

Just out of college, his first assignment was with *National Geographic.* Subsequently he signed on with the The Image Bank and began shooting for corporate and industrial clients. This work took him to sites in Europe, South America, Mexico, Canada, Hawaii and Iceland, as well as throughout the continental United States. Known for his strong design and color and for the sense of wonder and awe his images inspire, his photographs have appeared in all the major media worldwide for both editorial and advertising clients. In his recent work, he has begun experimenting with multiple space and futuristic images.

BONDARENKO, MARC (Editorial, Corporate/Industrial)

212 S. 41st St., Birmingham, AL 35222
(205) 933-2790

Born: 1955 *Subject Matter:* Nature, People, Travel, Fashion *Situations:* U.S. Locations, Hazardous *Awards:* Addys *Education:* U. of Alabama

He began his photographic career while working on his degree in journalism, shooting sports features and hard news as a staff photographer for the University of Alabama. For several years after graduating, he worked as a freelance photojournalist, but a desire for more creative freedom led him to establish a commercial clientele for himself. Today he photographs a wide variety of subjects, including people, products, food, travel, beauty and glamour. His clients range from corporate to editorial. While he maintains a large studio, he prefers to work on location. Shooting mostly color film, he often finds himself in hazardous situations, hanging from moving vehicles or helicopters to find the right angle. He is sought for his strong, simple, dramatically lit compositions.

BOOTH, ROBERTA (Advertising, Editorial)

5326 Sunset Blvd., Los Angeles, CA 90027
(213) 466-5767

Subject Matter: Fashion, Nature, People, Photo-Collage, Holographs *Situations:* Foreign Locations, Studio *Awards:* Grant, Museum of Holography, New York City *Education:* Art Students League; School of Visual Arts, NYC

She began her career as a high fashion model in New York City. Deciding to get on the other side of the camera, she studied formally with Alexey Brodovitch among others. Her first paying assignment, a cover for *Look,* allowed her to open a New York studio. Concentrating on fashion and beauty advertising, her work was seen in campaigns for Revlon, Smirnoff and Trivera, among others. *Vogue, Town and Country, Brides* and *Cosmopolitan* have all used her pictures. Now based in Los Angeles, she has widened her vision to include three-dimensional stereo photography and holography. In her current work she integrates slide projection and white-light transmission in an optical light projection collage, combining the static slide image of figures in landscapes with the ethereal world of holography.

BOOTZ, ANTOINE (Editorial, Fine Art)

400-A 9th St., Brooklyn, NY 11215 (718) 768-3260

Born: 1956 *Subject Matter:* Interiors, Portraits *Situations:* U.S. & Foreign Locations *Awards:* NEA Photography Fellowship *Education:* Sorbonne, Paris; Sciences Politiques, Paris; Université Saint Charles, Marseille, France

Born and educated in France, he came to the United States in 1981 to work as a freelance photographer. Working on location in either 35mm or 2 1/4" formats, he shoots interiors and portraits for a range of magazines, including *HG, Metropolitan Home* and the *New York Times Magazine,* as well as French magazines *Elle, Maison Francaise* and *Vogue Decoration.* On assignment for *Paris Match,* he has covered such personalities as tennis star Yannick Noah and the opening of his restaurant in Paris. Most of his portraits, however, involve designers and decorators in their created spaces. While the interiors he shoots might often be elaborate, his approach is straightforward, the compositions clean and precise. His personal photography is more conceptual in nature, and for six years Baudoin Lebon in Paris exhibited his work, including his series of photographs of cities as seen through the many binoculars set for tourists to spend their vacation change.

BORDNICK, BARBARA (Corporate/Industrial, Photojournalism)

39 E. 19th St., New York, NY 10003 (212) 473-4110

Born: 1944 *Subject Matter:* Fashion, People *Situations:* U.S. & Foreign Locations, Studio *Awards:* Clio Awards; Art Director's Club Award, New York, Chicago *Education:* Pratt Institute

After traveling and working in Europe, she returned to New York City, where she started her professional career with *Harper's Bazaar.* Today, although she is best known as a fashion and portrait photographer, her work spans a variety of assignments, including sports photography and annual reports, and as a result she has worked for virtually every major U.S. magazine. Considered a "romantic" by some, she is interested in creating her own reality on film, a penchant that extends from her portraiture into her advertising and corporate/industrial photography. Among her best known works is a calendar of 8" x 10" Polaroid portraits of great women in jazz for the Polaroid Corporation. Other highlights include her Clio television spots for J.C. Penney, her editorial work for *Harper's Bazaar,* and more recently her editorial photography for *GEO.*

BOSCHKE, LES (Corporate/Industrial, Editorial)

806 N. Peoria, Chicago, IL 60622 (312) 666-8819

Born: 1949 *Subject Matter:* People, Architecture *Situations:* U.S. Locations *Education:* U. of Wisconsin; School of the Art Institute of Chicago

Before going to college, he served as a U.S. Naval photographer. He attended the University of Wisconsin and worked as a corporate in-house photographer after graduation. He then attended the School of the Art Institute of Chicago and began freelancing. He opened his own studio in the early 1980s and currently takes location audio-visual assignments from large corporations. He recently spent several weeks traveling across the U.S. for Toyota and has currently been working on an editorial series on Chicago architecture.

BOYER, DALE (Advertising, Corporate/Industrial, Travel)

P.O. Box 391535, Mountain View, CA 94039
(415) 968-9656

Born: 1944 *Subject Matter:* Travel *Situations:* Foreign and U.S. Locations, Studio *Education:* Cornell U.

Originally trained in the sciences, he turned to photography in the early 1970s due to an interest in its unique requirements of visual and technical skills. His early work was mostly studio and location shots for high-tech products. His earlier training as an engineer allowed him to communicate easily with his clients. By the early 1980s he was doing more location and travel stock shots of people and their environments. His environmental shots are characterized by the use of strong colors and a simplicity of visual elements with strong graphic design, to create optimum visual impact. He works in all formats from 35mm to 4" x 5" and has extensive experience in strobe and available lighting in the studio and on location. Stock available through Allstock, Seattle, WA; Photo Researchers, NYC; Transglobe Agency, Hamburg, West Germany; Imperial Press, Tokyo, Japan; Stock Photos PTY. LTD., Melbourne, Australia.

BRAASCH, GARY (Editorial, Environment)

P.O. Box 1465, Portland, OR 97207 (503) 368-5091

Born: 1944 *Subject Matter:* Nature, Travel, Landscape *Situations:* Aerial, Hazardous, U.S. & Foreign Locations *Education:* Northwestern U.

His photography has grown out of a journalistic background and a love of landscape. His ardent interest in conservation has led to numerous assignments. *Life* sent him to cover the erupting crater of Mount St. Helens and *Audubon* asked him to climb ancient 250-foot firs and to kayak endangered estuaries. His balanced senses of color and design have earned him portfolio assignments from *Travel and Leisure, Communication Arts, Photo/Design, Nikon World* and *Popular Photography.* He continues to document ancient and tropical forests. In 1988 he had books published by Rizzoli and Beyond World.

BRANDON, RANDY (Advertising, Editorial)

P.O. Box 1010, Girdwood, AK 99587 (907) 783-2773

Born: 1948 *Subject Matter:* Nature, Travel *Situations:* U.S. & Foreign Locations, Studio *Awards:* AIGA; ASMP

In 1975 he started his Alaskan studio, Third Eye Photography. His work is diverse and he is as comfortable shooting in an elaborate studio as he is shooting aerials in Alaska's Prudhoe Bay. He has taken photographs in South America, Japan, China, Canada, New York City and most of the Western states. His pictures have appeared in *Alaska Magazine, Alaska Geographic, AlaskaFest, Esquire, Vogue, Playboy* (Japan) and National Geographic and Time-Life Books. Although he currently works extensively in industrial, architectural and advertising photography, he also maintains an avid interest in the natural world and pursues his personal work whenever time allows.

BRESKIN, MICHAEL (Advertising, Publishing)

324 Lafayette St., New York, NY 10012
(212) 925-2858

Born: 1952 *Subject Matter:* Fashion, Food, Nudes, People, Still Life *Situations:* Studio *Awards:* Photographic Scholarship, City College of San Francisco *Education:* San Francisco State U.

He owns Michael Breskin Studio and photographs for a variety of corporate, publishing, fashion and beauty accounts. He began making photographs at the age of six, but he didn't begin formal study until he was twenty-four. While at City College of San Francisco, he was influenced by Mori Camhi and Milton Haberstadt. Haberstadt encouraged him to go to New York, and he arrived in the city in 1978. After assisting for a year and a half, he opened Breskin-Eberling Studio. In 1984, he bought out his partner and reopened the studio under the name of Michael Breskin Studio. His clients have included Kodak, Smirnoff, Barton's Chocolates, Sanka Coffee, Lancôme, Endust, Macmillan Press and John Wiley Publishers.

BRIDGES, MARILYN (Editorial, Entertainment)

131 E. 19th St., New York, NY 10003 (212) 674-0148

Born: 1948 *Subject Matter:* Nature, Travel *Situations:* Aerial *Awards:* Guggenheim Fellowship; Fulbright Fellowship *Education:* Rochester Institute of Technology

In her photographs, she takes a "God's-eye" view of some of the world's ancient mysteries. Her aerial images, taken from low-flying airplanes, examine the various unusual earthworks of the world, capturing at unexpected angles the megalithic stones and mounds of Britain, the Mayan temples of the Yucatan, Native American designs etched into the Mojave Desert in California and the giant effigy earth mounds in the eastern U.S. She has recently concentrated on a series of photographs of the Nazca Lines in southern Peru. She has had a number of exhibitions that have toured both the U.S. and Europe, and a book of her black-and-white images, *Markings: Aerial Views of Sacred Landscapes,* has been recently been published by Aperture Press. Her work is found in collections at the Museum of Modern Art and the Metropolitan Museum of Art in New York and at the Bibliotheque Nationale in Paris.

BRILL, LAUREN (Corporate/Industrial, Editorial)

3531 Rhoda Ave., Oakland, CA 94602
(415) 531-1506

Born: 1958 *Subject Matter:* People *Situations:* Corporate Locations; Studio *Education:* School of the Art Institute of Chicago

She began her career as a press photographer in the suburbs of Chicago in 1978 while attending the Art Institute. She graduated with a speciality in architectural photography and then moved to Denver to work as a contract photographer for *Denver Magazine* and *Denver Business Magazine.* In 1983 she turned her editorial skills toward the corporate/industrial world, beginning with the Bell System. Her work during this time included documenting grocery stores—photographing employees, shoppers and food preparation from a commercial journalist's approach. These photos are shot primarily with available light, using black and white with fine grains and deep, saturated tones. Most of the work of this period, however, involved shooting architectural interiors in color. Today she is based in San Francisco, with clients such as AT&T, First Interstate Bank, Citicorp, Pacific Bell, Macy's California and General Foods. She is known

throughout the Bay Area for her executive portraits, which demonstrate her skill in using the surrounding environment to bring out the personality of her subject.

BRIMACOMBE, GERALD (Advertising, Nature)

7112 Mark Terr. Dr., Edina, MN 55435
(612) 941-5860

Born: 1934 *Subject Matter:* Nature, People, Sports, Travel *Situations:* U.S. Locations

He has spent more than thirty years traveling to the corners of the Earth, recording fleeting visual highlights that occur around us. His on-location photo illustrations can be seen in national advertising campaigns, annual reports and on the pages of *Life*, *Audubon* and Time-Life Books. Galleries in the U.S. and Canada are marketing his new, ongoing "Focus On America" fine art and poster series. He recently shot an advertising campaign for the Irish Tourist Board; many of his striking scenes of Ireland have also been featured in magazines there. He has also recently begun to paint.

BROWN, LAURIE (Fine Art)

539 Allview Terrace, Laguna Beach, CA 92651
(714) 494-6356

Born: 1937 *Subject Matter:* Landscape *Situations:* U.S. & Foreign Locations *Awards:* NEA Grant *Education:* Scripps College; California State U., Fullerton

As a practicing artist since 1975, her work has been exhibited at the San Francisco Museum of Modern Art, the Museum of Fine Arts in Houston, Newport Harbor Art Museum, the Oakland Museum and others. Her work revolves around her interest in man's relationship to the earth and to the natural cycles of change in the universe. Each of her pieces consists of a series of photographs, sometimes as many as ten, framed sequentially to create a terrain of her own making—a rhythmic panorama inspired by ancient ruins, NASA photographs and satellite weather maps. Most recently she has been creating black-and-white triptychs. *Earthedges* has published a portfolio of her work, and her photographs are included in two group portfolios, *L.A. Issue* and *West Coast Now*.

BROWNELL, DAVID (Advertising, Photojournalism)

P.O. Box 60, Andover, NH 03216 (603) 735-6440

Born: 1947 *Subject Matter:* Sports, Fashion, Travel *Situations:* U.S. & Foreign Locations *Education:* Clarkson U.

One of the leading outdoor sports, travel and leisure photographers in the United States, he began his career over fifteen years ago in Aspen, Colorado, where he gained a reputation as a premier ski photographer. In 1981, he moved to the East Coast to pursue larger accounts and shoot a greater variety of sports and leisure activities. Today, he has added water sports to his list of subjects, specializing in windsurfing and sailing photography. Assignments for major resorts, tourist bureaus, manufacturers and national and international publications take him throughout North America, the Caribbean and Europe. His work regularly appears in advertisements, brochures, posters and annual reports; he has over 100 national magazine covers to his credit, including *Ski*, *Skiing*, *Sail*, *Windsurf*, *Travel Holiday* and *National*

Geographic. His work displays his expertise with stop-action shooting and outdoor lighting.

BRUN, KIM (Advertising, Editorial)

5555-L Santa Fe, San Diego, CA 92109
(619) 483-2124

Born: 1947 *Subject Matter:* Food, Architecture *Situations:* Studio *Education:* Humboldt State U.; San Diego State U.

A surfer and self-taught in photography, during the 1960s he concentrated on covering surfing. His interests and skills have expanded, and for the last eight years he has been working for advertising and editorial clients, specializing in food and architecture. His photography can be found for the most part in magazines, *Better Homes & Gardens*, *Woman's World*, *Creative Ideas*, *McCall's* and *Popular Mechanics* among them, with several national magazine covers to his credit. Outside the United States, he has published in Japanese and German magazines.

BRYAN, DENVER (Editorial, Nature)

Rt. 4, Box 415, Columbia, MO 65201 (314) 657-2635

Born: 1955 *Subject Matter:* Animals, People, Nature *Situations:* U.S. Locations

A self-taught wildlife photographer, he works strictly in color. His pictures both document behavior and depict the beauty of nature in motion. Big game, birds of prey, wolves and other animals have all been captured by his photographic eye. He is a wildlife biologist, and his pictures have appeared in *National Wildlife*, *National Geographic World*, *Outdoor Life*, *Field & Stream* and in Sierra Club calendars. He markets prints of his work through mail order, art shows and galleries.

BRYANT, DOUGLAS DONNE (Editorial)

P.O. Box 80155, Baton Rouge, LA 70898
(504) 387-1620

Born: 1954 *Subject Matter:* People *Situations:* Foreign Locations *Education:* U. of Oregon

By producing images that spark wonder and curiosity in the viewer, he tries to bridge the cultural gap that separates Americans from their Spanish-speaking neighbors. In 1976, he joined the staff of the New World Archaeological Foundation in Chiapas, Mexico and over the next six years shot more than 100,000 images documenting anthropological and archaeological subjects. In 1982, he founded D. Donne Bryant Stock Photography, a specialized picture agency that emphasizes coverage of Latin America. Assignments take him to Latin America four to six times a year. His main clients are encyclopedias, travel magazines and high school and college textbook publishers.

BRYANT, ELIZABETH (Fine Art)

571 1/2 S. Arizona Ave., Los Angeles, CA 90022
(213) 262-5603

Born: 1951 *Subject Matter:* Visual Narration *Situations:* Studio *Education:* Moore College of Art, Philadelphia; U. of Florida

Working with a mixed-media process, she begins with a photogram, producing a silhouette or symbol that is then combined with other images; a painted stencil is then superimposed over the two. For example, the silhouette of a house may be filled with faces, a skeleton and other evocative imagery, with a stencil of a hand with a flashlight drawn over the top. Combining

David Brownell

John M. Burnley, *Baby Mountain Goat's Early Climbing Lesson*

generic signs and symbols with other images, she transforms the reading of the familiar. More recently, she has been introducing a color photograph with the photogram; in other cases she links the photogram with an object that mirrors some formal or thematic quality in the photogram. Her work has been exhibited across the country, both in the Holly Solomon Gallery in New York and the Fahey/Klein Gallery in Los Angeles. Most recently she was included in the exhibition "The Photography of Invention: Pictures of the '80s" at the National Gallery of American Art in Washington, D.C.

BULLWINKEL, PAULA (Fashion)
c/o Z Agency, 611 Broadway, Ste. 907B, New York, NY 10018 (212) 594-9282

Subject Matter: Fashion *Situations:* U.S. & Foreign Locations; Studio *Education:* U. of California, Berkeley

She studied English and theater in college but decided to turn her photography hobby into a career. She had experience in fine art photography, so she moved to New York to learn fashion photography by assisting in various studios. She has been in New York for more than six years, and she freelances there as well as Europe. Perhaps her most important break came when she shot the cover for the first Suzanne Vega album, which went gold. After that she went to London to concentrate on fashion, publishing in *British Elle, Blitz* and *19*. Today she continues to concentrate in fashion photography, publishing in a variety of magazines including *In Fashion* and *Sportswear International*. On occasion she still takes assignments in the music industry, photographing female performing artists for *Interview*. In either arena, her photography is characterized by a sense of theater or implied narrative; indeed, she often gets ideas for set-ups from literature.

BUMPUS, KEN (Editorial, Photojournalism)
1770 W. Chapel Dr., Deltona, FL 32725
(904) 789-3080

Born: 1927 *Subject Matter:* People, Boating *Situations:* U.S. Locations *Education:* Syracuse U.

Although he apprenticed in portrait and commercial photography from 1946 to 1947, it was his experience as a photographer in the U.S. Navy that established him in the field. Rising to Master Chief Photographer's Mate, he was chosen as one of the Navy's top ten documentary photographers and was in the first in a pioneering program at Syracuse University to train photojournalists. After three tours in Vietnam as a Navy combat photographer documenting Navy and Marine action, he was appointed supervising instructor in the Navy's Advanced Photography School in Pensacola, Florida. At the time of his retirement from the Navy in 1973, he was their most senior enlisted photojournalist. Since retiring from the Navy, he has opened his own studio, Visuals Unlimited, providing photo-documentary, travel, corporate and boating features for U.S. and foreign magazines and newspapers, including the *Washington Star*, the *New York Herald Tribune* in Paris, the *Manila Chronicle, Orbus*, the *San Diego Dispatch* and *Woman's World*.

BURCHARD, JERRY (Fine Art)
1014 Greenwich, San Francisco, CA 94133

Born: 1931 *Subject Matter:* Landscapes, Bodies *Situations:* U.S. & Foreign Locations *Awards:* NEA Fellowship; NEA Photo Survey Grant *Education:* California School of Fine Arts

Jerry Burchard has long been experimenting with extended night exposures, which have only reached popularity in the last five years. His dreamy compositions seem deliberate, yet intuitive in approach. There is a symbolic and mystical essence, as in the pictorialist genre, where light and form emerge more symbolically prominent than the objects themselves. "Some things get so overexposed that they turn into new objects," notes Burchard. The photographs exude personal emotion. The settings are often dramatic—Casablanca, Thailand and Shanghai. *Monsoon Thailand*, a piece shot in a luxuriant rain forest, becomes a romantic metaphor, yet the precise meaning is left open. Having worked primarily in black and white, Burchard now experiments with color film, making forays into fragmented views of the human body, often sexual in nature. Though there is less exposure and less distortion, these works remain characteristically mysterious and personal.

BURNLEY, JOHN M. (Scientific, Nature)
163 McKinley St., Massapequa Park, NY 11762
(516) 798-3872

Born: 1946 *Subject Matter:* Wildlife, Natural Landscapes *Situations:* U.S. Locations *Awards:* Associate Director, Long Island Institute of Natural History *Education:* Regents College

A field biologist with more than fifteen years of professional photographic and zoological research experience, he works primarily in the northeastern United States and the Pacific Northwest. He shoots still photographs in 35mm, 2 1/4" and 4" x 5" formats, predominantly utilizing color transparency film. Subjects include wild animals, trees and vegetation, natural landscape scenics, endangered species and man's effect on the natural environment. He is now working on a self-produced 16mm-film documentary on the endangered plant and animal life of the Long Island Pine Barrens of New York State. Other recent projects include still photographs of the mountains and other remote areas of eastern North America and series featuring the manatee, the mountain goat and other natural subjects. He emphasizes independent, creative and innovative approaches to photography and cinematography, based on a strong preservationist ethic. True-to-life, scientifically accurate content coupled with bold presentation are hallmarks of his work.

BURNSIDE, MARK (Advertising)
1201 First Ave. S., Ste. 316, Seattle, WA 98134
(206) 624-0070

Born: 1958 *Subject Matter:* Products, Fashion, Food *Situations:* Studio, U.S. Locations *Awards:* Creativity Award; Desi Award *Education:* Fishback School of Photography

Leaving behind California, where he was born and raised, he chose Seattle as his home and permanent base of studio operations for his photography business six years ago. Within a few years he developed his personal style of product, food and fashion photography. Coined "LifesStyle," it seeks to achieve a particular mood, a feeling of romance and sensation. The technique, often incorporating Greek motifs, creates a glamorous setting for a product. Today he offers his clients full studio production capabilities, and fre-

Ed Buryn, *Mission Bay Lives, San Francisco, California*

Cornell Capa

quently he takes his equipment on site to shoot location work. He has won numerous awards for his "LifesStyle" photography, including national Addys, *Communication Arts* Awards, Desi Awards and Art Directors Club Awards.

BURRELL, FRED (Advertising)
16 W. 22nd St., New York, NY 10010 (718) 861-6145

Born: 1932 *Subject Matter:* Still Life, Special Effects *Situations:* Studio *Awards:* Art Director's Club of Philadelphia, *Education:* Brown U.

From his studio in Manhattan, which he has operated since 1967, he is largely concerned with special effects and illustrative photography, much of it for editorial and advertising markets. His interest in building special equipment and systems has led to unique illustrative styles, which have been used on eleven covers of *Time* and nineteen of *Business Week*. Apart from assignments for Exxon, IBM, Pfizer, Kodak, DuPont and others, his work appears in the *Life Library of Photography* and Kodak's *Professional Portrait Techniques* and *Professional Photographic Illustration Techniques*. Self-taught, he has been a part-time teacher at the School of Visual Arts for nineteen years.

BURRIS, ZACHARY (Corporate/Industrial, Advertising)
445 W. Erie, Chicago, IL 60610 (312) 951-0131

Born: 1954 *Subject Matter:* Products, People *Situations:* U.S. Locations, Studio *Awards:* Print Merit of Excellence

Having worked with food and product firms in Chicago initially, he continues in these subject areas with the addition of an occasional nature, sport, or travel assignment. While he credits Irving Penn's influence for his sense of design, he also credits the painter Renoir. For his sense of light, he looks to Rembrandt as well as to Phil Marco. Recognizing a dearth of "affordable" art for Americans, he is pursuing art photography aimed at interior design. He is best known for his sensuous still lifes, photos achieved only with great patience and perseverance.

BURYN, ED (Photojournalism, Portraiture, Fine Art)
P.O. Box 31123, San Francisco, CA 94131
(415) 824-8938

Born: 1934 *Subject Matter:* People, Travel, Nature, Stock *Situations:* U.S. & Foreign Locations *Awards:* Nikon International Photo Contest Prizewinner (black and white; color) *Education:* San Francisco State College

Inspired by the teaching of anthropologist/photographer John Collier Jr., Buryn quit the field of corporate electronic technical writing in 1968 and became a roving street photographer, selling art prints and taking photo assignments at community art fairs. After traveling extensively abroad, he wrote several innovative and popular travel books illustrated with his photos, notably *Vagabonding in Europe & North Africa* and its sequel, *Vagabonding in the U.S.A.* He has produced two books of photographs: *Two Births*—a moving photo-essay on natural childbirth—and *Mission Creek/San Francisco*. Recent work includes an audio/visual project on traveling in America. His writing and photography both are characterized by wit and humanism. His many media credits and exhibitions represent twenty years of images that celebrate the rich diversity of life. In addition to his freelance photography, he is also an editor, small-press publisher, and partner in TAROT, a metaphysical organization founded by his wife, Mary K. Greer.

BUTLER, GEORGE TYSSEN (Entertainment, Photojournalism)
White Mountain Films, 165 E. 80th St., New York, NY 10021 (603) 986-3910

Born: 1943 *Subject Matter:* People, Wildlife *Situations:* U.S. & Foreign Locations *Education:* U. of North Carolina; Hollins College

He began as a writer of fiction, then worked for *Newsweek* and later founded and published a newspaper in Detroit for Vista. He credits his meeting photographer Enrico Natali with shaping his aesthetic. In 1971, he published *The New Soldier*, a book of photos about Vietnam veterans, and then went on to do the book *Pumping Iron*. Rejected by virtually every publisher in New York, it became the best selling photo book by one photographer of all time when finally published. He has subsequently moved into film, producing and directing the movies *Pumping Iron* and *Pumping Iron II: The Women*. He currently divides his time between films and photography and is finishing a new book due out in 1989.

BYERS, BRUCE (Advertising, Stock)
11 W. 20th St., New York, NY 10011 (212) 242-5846

Born: 1955 *Subject Matter:* U.S. & Foreign Locations; Studio *Education:* Rochester Institute of Technology

His camera time is divided between between travel assignments and photography for advertising and fashion. Traveling to such places as France, Mexico, Canada and the Caribbean, his assignments have ranged from shooting from helicopters to waiting for the perfect still on a beach. As a fashion photographer in New York, he is known for his ability to produce quality results within the tight deadlines and budgets characteristic of the business. In these shots, he works to create a "natural situation." In his ten years as a professional photographer, he continues to find equal interest and challenge in the variety of work he does.

CABLUCK, JERRY (Corporate/Industrial, Advertising)
P.O. Box 9601, Dallas-Fort Worth, TX 76107
(817) 338-1431

Born: 1941 *Subject Matter:* People, Sports *Situations:* U.S. Locations *Awards:* Addy

He has covered Texas as a news, sports and PR photographer for more than thirty years, documenting everything from presidential campaigns to NASA space launches, from football games to golf tournaments. Over the years, he has placed photos with the *New York Times, Newsweek, Topic Magazine, Time* and *Seventeen*.

CADGE, JEFF (Corporate/Industrial, Editorial)
341 W. 47th St., New York, NY 10036
(212) 246-6155

Born: 1957 *Subject Matter:* People *Situations:* U.S. Locations, Studio *Awards:* Award of Excellence, New York Art Directors Club; New Jersey Advertising Club *Education:* SUNY, Purchase; School of Visual Arts, NYC

Working in both still photography and video and film production, his frequently wholesome images express

Michael Carlebach, *Key West*

Gene Coleman

his appreciation for the uses of subtle, intimate lighting. His realistic photographic illustrations and reportage have been used by numerous corporate clients, including Bankers Trust, Ciba-Geigy, Coca-Cola, Johnson & Johnson and Lever Brothers. Recently he has expanded to film-making for Fortune 400 Companies, and he has made music videos, commercials and experimental films. A member of The Image Bank, he has exhibited at Neikrug Photographica Gallery in New York and is active with the Coalition for the Homeless in association with the New York One Club.

CALL, RAVELL (Photojournalism, Corporate/Industrial)
2731 Filmore, Salt Lake City, UT 84106
(801) 451-0878

Born: 1954 *Subject Matter:* Sports, Travel *Situations:* U.S. Locations, Studio *Awards:* NPPA; First Prize, Associated Press Journalists Annual *Education:* Brigham Young U.

After graduating from Brigham Young with a degree in communications emphasizing photography, he took a position at the *Sun Advocate*, a bi-weekly newspaper in the coal-mining community of Price, Utah. Leaving Price for Salt Lake City, he went to work for the *Salt Lake Tribune* but moved after four years to the *Desert News*, also a daily in Salt Lake, where he works today. Co-chairman of the Utah Press Photographers Association, he enjoys shooting in-depth feature stories, environmental portraits, sports and news. His editorial work took him to El Salvador in 1986 to cover the earthquake there. In the United States his sports coverage has included World Cup, pro circuit and NCAA championship skiing and professional and college football and basketball. He has been published nationally in such newspapers and magazines as *Newsweek, U.S. News and World Report, Parade* and *USA Today* and internationally through the Associated Press and United Press International.

CALLIS, JO ANN (Fine Art)
c/o Sequoia One, 929 East 2nd St., Studio 9, Los Angeles, CA 90012

Born: 1940 *Subject Matter:* People *Situations:* Locations, Studio *Awards:* Ferguson Award; NEA Fellowship *Education:* Ohio State U.; California State U.

Her photographs are at once inviting and disturbing. She is evidently fascinated by inexorable opposites in the realm of sensation. Narrative in nature, Callis's photographs establish situations from everyday reality that through tension and dislocation become unreal and dreamlike. A man and woman sit at a table, an empty bowl before the woman, a bowl of strawberries and cream off-center. A sense of unease invades this bland event. In another piece, beautiful flowers, netting and light envelop a female torso, but a subtle sickness in the color defiles the beauty just enough to leave the viewer both attracted and repelled. A minute gesture or detail, slightly skewed, becomes powerfully suggestive in Callis's work. "I find that pictures communicate sensations and feelings to others on a level just below their consciousness," says Callis.

CAMERON, ROBERT W. (Fine Art)
543 Howard St., San Francisco, CA 94105
(415) 777-5582

Born: 1911 *Subject Matter:* Landscape, Travel *Situations:* Aerial *Awards:* Presidential Award for Photog-

raphy; Silver Medal, Commonwealth Club of California *Education:* U. of Iowa

In 1934 he began his career as a news photographer for the *Des Moines Register & Tribune*. During World War II he took photographs for the War Department, documenting the construction and aerial perspectives of military bases within the U.S. After leaving a successful business career in New York, he brought his family to San Francisco to start his own photographic publishing firm. The photographs in his first book, *Above San Francisco*, were taken from a newly perfected helicopter. Other titles in print are *Above Los Angeles, Above Hawaii, Above Washington,, Above London, Above Paris* and *Above New York*.

CANDEE, MICHAEL (Advertising, Corporate/Industrial)
1212 W. Jackson, Chicago, IL 60607 (312) 829-1212

Born: 1954 *Subject Matter:* Products, Fashion, People *Situations:* Studio, U.S. Locations *Awards:* Printing Industry of America *Education:* U. of Wisconsin, Green Bay

Learning on a 1/2-frame Olympus, he has been shooting since he was twelve years old. Today he operates a 7,200-square-foot studio in downtown Chicago. Most of his clients are from the corporate sector. When he is not photographing CEOs for annual reports and corporate brochures, he is on location shooting a wide range of video presentations, on topics ranging from safety training and new products to motivational films for corporations. Recently he completed the program "Substance Abuse in the Workplace" for the Amoco Oil Company. In addition to corporate communications, he produces advertisements and posters on fashion and sports.

CAPA, CORNELL (Editorial)
1130 Fifth Ave., New York, NY 10128
(212) 860-1777

Born 1918 *Subject Matter:* People *Situations:* U.S & Foreign Locations *Awards* American Newspaper Guild Citation; Photojournalism Award and Honor Award, ASMP

The Hungarian-born Cornell Capa, younger brother of ground-breaking photographer Robert Capa, began his career in a photo lab in Paris in the 1930s, working with his brother and with such photographers as Cartier-Bresson and David Seymour. He and his mother fled to the U.S. in 1937 in fear of Nazism, and he began working with the Pix photo agency, there meeting Alfred Eisenstaedt. He joined the staff of *Life* in 1946, after working in the Air Force photo intelligence section during the war. In 1954, he left *Life* to join his brother's photo agency, Magnum, but he continued to contribute powerful photo essays until giving up the profession in 1974 to found and direct the International Center of Photography in New York. The younger Capa's work is infused with the humanitarian and political ideals of the concerned photographer—ideals which he continues to promote at ICP. His color images are boldly realized, while the heavy contrasts of his black-and-white shots strengthen their power. His series on the political and social struggles in Latin America was published in the 1974 book *Margin of Life*.

CAPONIGRO, PAUL (Photojournalism, Fine Art)
Rte.3, Box 960, Santa Fe, NM 87501 (505) 270-1842

Born: 1932 *Subject Matter:* Nature *Situations:* Studio, U.S. & Foreign Locations *Awards:* Guggenheim Fellowships; NEA Grant *Education:* Boston U.

A founding member of the Association of Boston University Heliographers in New York, he has taught at Yale and other major universities, in addition to publishing numerous books, including a Time-Life series and a critically acclaimed portfolio. His work has been shown at The Metropolitan Museum of Art in New York, the Smithsonian, and numerous other major cultural institutions. Musical studies early in his career and the influence of photographers Minor White and Benjamin Chin steered his interest toward the craft of photography. Eventually he developed a unique, poetic style depicting movement, typified by large-scale silver prints that capturing the magnificence of nature. Close-up, often abstract renderings of the natural environment convey the creative forces behind his work. "Through the use of the camera, I must try to express and make visible the forces moving in and through nature; the landscape behind the landscape," he says.

CARAS, STEVEN (Photojournalism, Portraiture)

11 Riverside Dr., New York, NY 10023
(718) 873-9220

Born: 1950

He danced with the New York City Ballet for fourteen years under the direction of the late George Balanchine. A "hopeless snapshot-taker," he decided to cultivate a long-time interest in photography. In 1983 he retired from dancing career, and a year after buying his first camera he found himself in Cuba to photograph a book for Doubleday on the Ballet Nacional de Cuba. He works in 35mm and has traveled across the U.S. and abroad. He says that "dance is about movement and that stopping dance in a photograph and yet continuing the illusion of movement is my greatest challenge." He has published six books of photographs and his extensive credits include *Time*, the *New York Times*, *Newsweek*, *Vogue* and other national and international periodicals. His color photograph of Balanchine's last bow has become a collector's item.

CAREY, ELLEN (Fine Art)

P.O. Box 69, Prince St. Station, New York, NY 10012

Born: 1952 *Subject Matter:* Nudes, People *Situations:* U.S. Locations *Education:* Kansas City Art Institute; SUNY, Buffalo

"The realization that I was now painting with light triggered a more minimal aesthetic, symbolizing integration," she said when beginning to re-evaluate her work process in 1984. "Previous references to body decoration or the cosmos, for example, now allude to the machine, science and mathematics, especially geometry." The dichotomy between the gestural markings of the artist and the smooth surface of the photograph is gone in recent work. We are left with an image that blends the human face and abstract patterning, writes Willis Hartshorn, through the seamlessness of the photographic print. In an untitled work from 1986, a red "starburst" pattern infuses the head completely, as if the mind and technology had become one. In her work, Carey balances the metaphysical imaginings of the inner self with references to the structured rationality of geometry and science.

CARLEBACH, MICHAEL (Photojournalism, Fine Art)

3634 Bayview Rd., Miami, FL 33133 (305) 446-4075

Born: 1945 *Subject Matter:* People *Situations:* U.S. Locations *Education:* Colgate U. ; Brown U.; Florida State U.

With a dissertation completed at Brown University on "The Origins of Photojournalism in America, 1839-1900," he brings a scholarly background to his editorial photography. Although he teaches photojournalism, he considers himself foremost a photographer. Having worked for the *Miami Herald* as a staff photographer and for the *Village Post* as a staff photographer and later as a managing editor, he also brings practical working experience to what he calls a more artistic approach. His work is as likely to be encountered in a gallery as it is in a newspaper. With nineteen years of experience, he has published in a variety of media including magazines, scholarly journals and corporate publications, including *Time*, the *New York Times*, *Viewpoint*, *Horticulture*, *Today's Health*, *Encyclopedia Britannica*, *Today*, *Ebony* and *Scholastic*.

CARLTON, CHUCK (Advertising)

36 E. 23rd. St., New York, NY 10010 (212) 777-1099

Born: 1955 *Subject Matter:* Miniatures *Situations:* Studio *Education:* Brooks Institute of Photography

Specializing in miniature and small-scale sets, he produces ads and calendars for a variety of toy and entertainment clients. Using a variety of techniques, including multiple exposures, beam splitting, camera masking combined with localized lighting, diffusion and colored gels, he creates "hyper-real" images. The "Robot" calendars published by Workman Publishing in 1985 and 1986 best illustrate his style and approach to the art of photo-illustration. Other clients include Tonka, Lego, Matchbox, American Express, Avis and Hilton. Always looking for the best creative solution, he sometimes collaborates with different artists to produce mixed-media and dimensional illustrations.

CARNELL, JACK (Editorial, Fine Art)

445 Hillside Ave., Jenkintown, PA 19046
(215) 885-8546

Born: 1952 *Subject Matter:* Sports, Travel, Events, Architecture *Situations:* U.S. & Foreign Locations, Studio *Awards:* NEA Fellowship; Pennsylvania Council on the Arts Photographer's Fellowship *Education:* U. of New Mexico; Tyler School of Art; Temple U.

A professional photographer for ten years, the last several years have found him photographing public events of an individual, local, national and international character. On the strength of such photographs, he was one of ten photographers chosen for a special project to photograph the 1984 Olympic Games in Los Angeles. The purpose of the project, co-sponsored by the Olympics Arts Festival, the Los Angeles Olympic Organizing Committee and the Los Angeles Center for Photographic Studies, was to photograph the Olympics from an artistic perspective rather than a journalistic one. At its completion, the photographs from the project were exhibited at the Institute of Contemporary Art in Los Angeles. In addition to public events, he has an ongoing project photographing other types of social

landscape and architecture. Most of his pictures are shot on color film.

CARRINO, JOHN (Editorial, Advertising)

160 Fifth Ave., New York, NY 10010 (212) 243-3623

Born: 1953 *Subject Matter:* Cosmetics, Fashion *Situations:* U.S. & Foreign Locations, Studio

After studying industrial design and apprenticing with top New York photographers, today he is highly respected for his fashion and beauty photography. Following Mies van der Rohe's principle, "less is more," his shots are clean, crisp and graphically powerful. But perhaps what is more distinctive is the very strong "subject involvement" he achieves. These are shots that break through the barrier of the posed model to a more intimate level of expression. Generally speaking, he finds black and white more rewarding. He is currently working on a black-and-white hardcover book of portraits.

CARROLL, JAMES (Fine Art, Editorial)

382 Central Park West, New York, NY 10025 (212) 865- 5321

Born: 1940 *Subject Matter:* Nature, People *Situations:* U.S. Locations *Awards:* CAPS Grant

Commercially, he has worked mainly in the education field, photographing for numerous publishers of textbooks, filmstrips and other instructional materials. He also teaches photography at both the high school and college levels. Concerned with people, who they are, their relation to one another and the interrelationship that exists between subject and photographer, his personal work finds him at county fairs, amusement parks and tourist attractions, photographing children, teenagers and families, along with the urban street life. Shooting in black and white, he searches for candid, psychologically revealing moments. His nature photography likewise inspects the complexities of life. Mosses and trees are shot in close-up, worlds of previously unseen detail brought to the viewer's attention.

CARTER, MARY ANN (Editorial, Photojournalism)

5954 Crestview, Indianapolis, IN 46220 (317) 255-1351

Born: 1952 *Subject Matter:* People, Sports *Situations:* U.S. Locations *Education:* Indiana U.

A freelance photojournalist based in Indianapolis, she covers sports and general news and particularly enjoys working in a documentary style. Her most compelling shots are of people, whether she is creating a portrait or capturing a significant, telling moment. Some of her self-assigned projects have been a photo essay on the career of a woman priest, a look at a group of black inner-city grade school chess champions and the documentation of the birth of a child as seen by a sibling, the latter work commissioned by the family.

CARTIER-BRESSON, HENRI (Fine Art, Photojournalism)

c/o Magnum Photos, 20 rue des Grands-Augustins, 75006 Paris, France

Born: 1908 *Subject Matter:* People, Documentary *Situations:* U.S. & Foreign Locations, Studio *Awards:* American Society of Magazine Photographers Award; Prix de la Société Francais de Photographie *Education:* Cambridge U.

Working almost exclusively in black and white, he is perhaps best known for his reportage on Russia, China and Cuba and on the death of Gandhi (for which he received four Overseas Press Club of America awards). Motion pictures first influenced him, later leading him to make several documentaries including "Le Retour," and "Victoire de la Vie." He studied film with Paul Strand, as well as painting in Paris with Cotenet and André Lhôte. Other influences on his work were Eugene Atget, Man Ray and Andre Kertesz. In 1947, Cartier-Bresson founded the Magnum Photos cooperative agency along with Robert Capa, David Seymour and George Rodger. He has published numerous books on his work, including such titles as *Images à la Sauvette/The Decisive Moment, The Europeans, Fragrants Delits* and *Henri Cartier-Bresson: Portraits*. He has won numerous awards including the Culture Prize, the Deutsche Gesellschaft fur Photographie and the Hasselblad Award.

CASSADAY, BRUCE T. (Corporate/Industrial, Legal, Fine Art)

Box 345, RD1, Lockwood, Peekskill, NY 10566 (914) 528-4343

Born: 1945 *Subject Matter:* Fashion, Nature, People, Industrial, Transportation *Situations:* U.S. Locations, Hazardous Situations *Awards:* Kappa Alpha Mu *Education:* Kent State U.

His commercial/fine art practice is the result of a combination of a fine art background and an interest in location photography. He finds that the play of lighting of one and the genre settings of the other feed on each other. In imagery he has been influenced by Eugene Smith, N.C. Wyeth, Scheeler and Penn. His fine art photographs of railroads and transportation have been exhibited widely. The work is an "ongoing refining and expanding of the creative process." He is good with crowds and he works in medium format with color and black-and-white film.

CASTANEDA, LUIS (Advertising)

14778 S.W. 81st St., Miami, FL 33193 (305) 387-1267

Born: 1943 *Subject Matter:* Performing Arts, Travel *Situations:* U.S. & Foreign Locations

After submitting a few photographs as a contribution to a magazine, he was asked to join the staff. Concurrently, he worked as a theatrical photographer specializing in ballet and modern dance photography. Leaving the magazine, he worked almost exclusively as a performing arts photographer for nearly eight years. Five years ago, he joined The Image Bank and began a slow transition to stock photography, which comprises 80% of his present work. His photographs have appeared in many European publications, especially in Spain, where for three consecutive years the Ministry of Tourism has used his slides for their annual campaigns. He has also illustrated several books with leading Spanish publishing companies. Moving to Miami two years ago, he has worked with the Coconut Grove Playhouse and several airlines. He is currently experimenting with multiple images and landscapes in available light, attempting to create a sense of travel without leaving home.

CEOLLA, GEORGE J. (Corporate/Industrial, Advertising)

5700 Engersoll Ave., Des Moines, IA 50312 (515) 279-3508

Luis Castañeda, *Rainflood, Segovia, Spain*

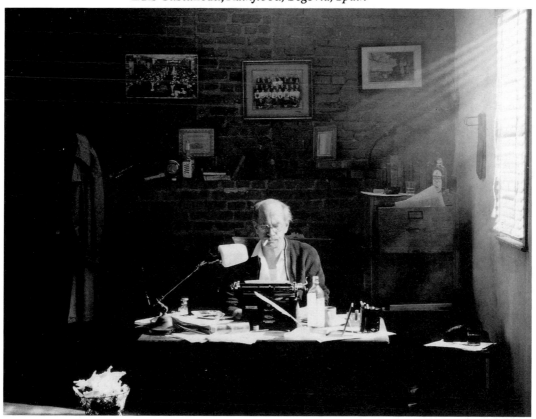

Steve Colletti, *Writer*

Born: 1940 *Subject Matter:* People, Agriculture, Interiors *Situations:* U.S. Locations *Awards:* Picture of the Year, NPPA; Picture of the Year, IPPA

He began his career at the *Milwaukee Journal* and subsequently joined the staff of the *Des Moines Register and Tribune*. For the last twenty-one years, he has been represented by the Black Star Agency in New York, and since 1982 he has worked as a freelancer. His interior shots have appeared in *Better Homes and Gardens*, while his location photographs of farm machinery have been featured in *Successful Farming*. He has been influenced by Howard Chapnick of Black Star and by Arthur Rothstein (an F.F.A. photographer in the 1930s). Ninety percent of his photographs are in color, and he works in all formats, including 35mm, 2 1/4" and 4" x 5".

CHAPPELL, WALTER (Fine Art)
P.O. Box 8736, Santa Fe, NM 87504 (505) 581-4615

Born: 1925 *Subject Matter:* Nature, Landscape, Portraits, Nudes *Situations:* U.S. Locations *Awards:* NEA Photography Fellowships *Education:* Ellison-White Conservatory of Music, Portland; Benson Polytechnical School; Frank Lloyd Wright's Taliesin West

An accomplished pianist and painter, Chappell began to study photography with devotion while hospitalized for tuberculosis. He studied photography with Minor White and published a series of studies with White in the late 1950s on the content of photography. Edward Weston was also influential. Chappell works in medium and large formats. His images include abstractions of nature, landscapes, portraiture, nudes and plant life. Chappell says he is drawn to photography for its close association to music as an agent of expression.

CHARLES, BILL (Editorial, Advertising)
265 W. 37th St., Ph. "D", New York, NY 10018
(212) 719-9156

Born: 1954 *Subject Matter:* Fashion, Food *Situations:* Studio *Awards:* Desi Awards *Education:* Grinnell College

Today, he shoots for a number of media, including magazines, catalogues, brochures, book covers, advertising and packaging. He began his career, however, freelancing for a small design firm in Manhattan. Eventually he became an agency art director and staff photographer and later opened his own studio, called Magic Image. His work is characterized by the expression of the sensuality and mystery of his models. His clients have included Avon, Clairol and Intergold. Beyond this, he has produced posters for Paramount and Columbia Pictures. The Alice Carroll Gallery in New York exhibited his one-man show, a series of twelve "Nude Landscapes."

CHAVENELL, JOE (Advertising, Editorial)
P.O. Box 790383, San Antonio, TX 78279
(512) 377-1552

Born: 1950 *Subject Matter:* Architecture, Interiors, Food, People *Situations:* Studio, U.S. Locations *Awards:* Addys; *Art Direction*'s Creativity Award *Education:* U. of Houston

Operating his own studio, where he produces commercial and editorial assignments for graphic designers, advertising agencies, corporations and publications, Chavanell specializes in architectural and interiors photography as well as in large-format commercial illustration. His work has appeared in such publications as *Time*, *Newsweek*, *Texas Monthly* and *Texas Homes*. In addition to his work primarily in 35mm or 8" x 10", he has also made film, video and slide productions. He conducts workshops on photography and lighting.

CHERNEY, BERLE (Advertising, Corporate/Industrial)
Visual Productions, 2121 Wisconsin Ave. NW, Suite 470, Washington, DC 20007 (202) 337-7332

Born: 1942 *Subject Matter:* Nature, People, Cities *Situations:* Studio, U.S. Locations *Awards:* Emmy; Gold Award, Association of Multiple Image *Education:* U. of Maryland

Since the early 1970s, when she worked for the United States Information Agency, she has specialized in multi-image presentations. Her work requires a cinematic approach, because the audience watches the images in a precisely timed and directed way. Rather than looking for single images, she creates sequences of long, medium and close-up shots, working from different angles and perspectives. Her company, Visual Productions, produces corporate multi-media presentations and has a special process called "animotion" for shooting still images on film and video. Clients have included the Smithsonian Institution, the Library of Congress, the *Baltimore Sun*, Marriott Corporation, NBC, PBS and many independent producers.

CHESLER, KEN AND DONNA (Advertising, Editorial)
6941 N.W. 12th St., Plantation, FL 33313
(305) 581-6489

Born: 1951, 1948 *Subject Matter:* Boats *Situations:* Aerial, Boat Interiors *Education:* Fairleigh Dickinson U.; U. of Maryland

Yacht photography specialists, they began their business in St. Thomas, U.S. Virgin Islands. Their early work focused on charter brochures, and after five years in the Virgin Islands they moved back to the mainland to shoot "the big boats." Currently located in Fort Lauderdale, Florida, they work for interior designers, private boat owners and the builders of multi-million dollar yachts including Broward Marine, Hatteras of Lauderdale and Lloyds of Australia. They shoot 4" x 5" interiors, as well as aerials from helicopters using a Pentax 6 cm x 7 cm. Their work is regularly featured in magazines, catalogues, brochures and advertisements.

CHESTER, MARK S. (Editorial, Photojournalism)
P.O. Box 640501, San Francisco, CA 94164
(415) 922-7512

Born: 1945 *Subject Matter:* People, Travel *Situations:* U.S. & Foreign Locations *Education:* U. of Arizona

Spending six weeks in Shanghai and in the agricultural hinterland of the Yangtze Delta photographing the Chinese people and way of life is one of the many worldwide tours he has taken with his camera. He searches for the humorous, the romantic, and the unusual, and his style with the offbeat is apparent in his photo of a Chinese man performing Tai Chi while an enormous billboard extolling the virtues of Diamond Zippers looms behind him; or in a collection of shots of American signs that forbid all sorts of behavior. His newspaper credits include the *New York Times*, *Los*

Angeles Times, Washington Post, Christian Science Monitor, Boston Globe and San Francisco's *Chronicle* and *Examiner*. His work also appeared in the book *Dateline America* by Charles Kuralt and is represented in the permanent collections of the Corcoran Gallery of Art, the Brooklyn Museum, the Baltimore Museum of Art and other museums and galleries.

CHWATSKY, ANN (Photojournalism)
85 Andover Rd., Rockville Centre, NY 11570
(516) 766-2417

Born: 1942 *Subject Matter:* People, Medical *Situations:* U.S. Locations *Awards:* Kodak Professional Photographers Award; Hofstra Distinguished Alumni Award *Education:* Hofstra U.

A well-known photographer, she is respected for her warm and human photographic collections, such as "Sisters" and "Men in the Streets." She has recently been lauded for her photographs for the book *Four Seasons of Shaker Life*, published by Simon and Schuster. The portrayal of the last remaining Shakers was, she says, "a good use of my special talent for 'getting the essence' of a people or place." Her work has been published in many major magazines and publications both here and abroad. She has been the recipient of the Hofstra Distinguished Alumni Award, the Kodak Professional Photographers Award, the Eastman Foundation Grant and the Polaroid Grant. When she is not teaching photography at Long Island University, she works on assignments for corporate clients on rural farm life and on pain clinics in the modern medical world.

CIRONE, BETTINA (Photojournalism, Portraiture)
57 W. 58th St., New York, NY 10019 (212) 888-7649

Born: 1933 *Subject Matter:* Wildlife, People *Situations:* U.S. & Foreign Locations

She discovered photography on a Kodak Box Brownie in 1942 at the age of nine and learned print technique in a mini-darkroom set up in her brother's room, but she worked for ten years as a photographer's model before wielding a camera for herself professionally. She began by photographing her model colleagues on exotic locations and producing photos for their composites. While shopping her shots to magazines, she continued to shoot beautiful places, people and things during her travels as a model. Within her first year she placed fourteen magazine covers and over 100 photos in travel-destination layouts. Some of her works were selected for an exhibit at the Guggenheim Museum. Encyclopedias and American Express books also numbered among her clients. A photo essay on New York Mayor John Lindsay and his family that appeared in a national magazine served as a turning point in her career, and she began concentrating on celebrities. Today she has a vast photo archive of notable personalities and thousands of tearsheets from leading magazines throughout the world.

CLARE, WILLAIM D. (Photojournalism, Advertising)
416 Bloomfield Ave., Montclair, NJ 07042
(201) 783-0680

Born: 1947 *Subject Matter:* Fashion, Sports *Situations:* Hazardous, Studio *Awards:* Pulitzer Prize Nominee, 1980; Bootstrap Award 1985, National Press Photographers Association *Education:* Fairleigh Dickinson U.

A one-time fireman, he has used his skills at maneuvering in hazardous situations in his job as a photographer, beginning with a series of military photos in combat "bars" and "brothels." Working for the *Herald-News* and the *New Jersey Newsphoto/Star Ledger*, he carried his equipment with him in order to capture breaking news images. Gradually, he stopped "ambulance-chasing" and began establishing himself in the studio, shooting corporate/industrial work. Today the bulk of his work consists of annual reports and corporate newsletters, but he continues to provide wire-service work in news, sports and features and on occasion provides photos for advertising and public relations clients; Black & Decker and Intel number among them.

CLARK, LARRY (Fine Art)
225 Hudson St., Apt. 6, New York, NY 10013

Born: 1943 *Subject Matter:* Drug Addicts, Sexuality, Street Scenes *Situations:* U.S. Locations, Studio *Awards:* NEA Photography Fellowship, CAPS Grant *Education:* Layton School of Art, Milwaukee

Clark catapulted into the limelight of American photography in 1971 with *Tulsa*, his book of photographs presenting the lives of several of Clark's hometown friends and their addiction to drugs. His photographs highlight beatings, death, shooting up and gunshot casualties—an exploration of drug addiction among American youth. For his next project, Clark produced a series called "Teenage Lust," which focused graphically on teenage sexuality. More recently he has worked on series concerning adolescent hustlers, pushers and dealers working on 42nd Street in New York City.

CLARKE, KEVIN (Advertising, Portraiture)
900 Broadway, 9th Floor, New York, NY 10003
(212) 334-8285

Born: 1953 *Subject Matter:* People *Situations:* U.S. & Foreign Locations, Studio *Awards:* Double Gold Medal, Art Directors Club for the Red Couch, W. Germany *Education:* Cooper Union

After graduating in Fine Arts he started doing conceptual photography in Basel, Switzerland. His first book, *Art and Media at D6*, documented a West German art exhibition, while his second, *Department Store World*, showed sales people in a sales environment. After returning to New York he produced *The Red Couch, A Portrait of America*. He is currently shooting a series of staged color portraits worldwide, some at night, for a book to be called *Awe*. He believes that fiction is truer than reportage because a staged point of view allows actual meaning to come through while preventing none of the discovery found in unstaged shots. He sees his commercial portraits and pictures of objects and people in environments as a discipline of his personal work.

CLARKE, LOLLY (Photojournalism, Advertising)
706 E. Stuart St., Ft. Collins, CO 80525
(303) 482-0724

Born: 1947 *Subject Matter:* Fashion, Nature *Situations:* U.S. Locations, Studio *Awards:* National Merit Awards; Top Ten, RMPPA *Education:* U. of Colorado

Prior to becoming a full-time photographer, she worked as a photographic artist, a printer and as an

assistant photographer to her husband. Today they work together operating a unique studio that contains a 40' x 48' atrium, a hot tub and "other useful sets." With access to two acres of land with a stream, the couple handles a variety of assignments. In addition to her studio and location work, she is the photographer for *Style* magazine, a publication mailed to a select, affluent audience. Her work is characterized by creativity and close attention to detail. As an artist, photographer and writer, she often includes text and layout design as part of her photographic services. Recently she co-authored and supplied photography for two travel articles in *Frontiers* magazine.

CLAY, WILLARD (Environment, Nature)

2976 E. 12 Rd., Ottawa, IL 61350 (815) 433-1472

Born: 1941 *Subject Matter:* Nature *Situations:* U.S. Locations *Education:* U. of Arizona

A native of Tucson, he left his teaching position in biology and biochemistry at the University of Arizona to pursue a career in professional photography. His wife does the marketing and assists him on the road while they are traveling, which is usually for over two-thirds of the year. With photographs of mountain ranges, jagged coast lines and close-ups of flowers, he has been published in Sierra Club and Audubon calendars, *National Geographic*, *Time* and *Arizona Highways*, among other publications. Working in 4" x 5", he is presently completing a book on the state of Illinois.

CLAYCOMB, EDWARD (Advertising)

17 E. 31st St. #5, New York, NY 10016

Born: 1950 *Subject Matter:* Glass *Situations:* Studio *Education:* U. of Wisconsin, River Falls; Tyler School of Art

To introduce himself, Claycomb writes, "My background is in fine art—God forbid," but it is a painterly sensitivity that distinguishes his work. For his commercial projects, working in the studio for various advertising clients, he specializes in photographing glass. His own work, which is often shown in galleries, is shot in black and white and on occasion partially hand-colored.

CLEMENTI, JOSEPH (Advertising, Editorial)

133 W. 19th St. #3, New York, NY 10011
(212) 924-7770

Born: 1953 *Subject Matter:* People, Products, Special Effects *Situations:* U.S. Locations, Studio *Education:* Antonelli School of Photography; Philadelphia College of Art

With beginnings as a theatrical photographer in 1975, he opened his first studio in 1981, specializing in still life, people, illustration and portraiture for advertising and editorial use. Advertising work has appeared in *Life* and *PC Magazine*. *Essence* published an editorial piece, and the book *The Moviegoer* featured his work on its cover. More recently, he has been concentrating on special effects. His work in this area has drawn national attention, appearing on the nationally syndicated television show, "The World of Photography." As a departure from his usual activity, he completed a project working outdoors at night using existing light. The results were exhibited in the Tompkins Square Arts Festival and in other New York openings.

CLEVELAND, ROBERT W. (Advertising, Corporate/Industrial)

1609 Deerhurst Lane, Rochester Hills, MI 48063
(313) 651-6471

Born: 1943 *Subject Matter:* People, Automotive Products *Situations:* U.S. Locations Studio

Coming from a background in commercial/fine art photography and science, he has combined these disciplines in a career in automotive advertising photography. Heavily influenced by impressionist painting, Abstract Expressionism and the Bauhaus, he is known for his strong designs and imaginative uses of all types of light. He has used controlled studio lighting techniques on flowers for FTD and trucks for Ford Motors. He is currently exploring new optical and mechanical "motion techniques" to create fresh points of view for work in the automotive industries. These include unusual lenses, exotic cameras, oversize light-walls and strobe and tungsten lighting. Not all of his work is automotive in nature; his work covering people has appeared in *Rolling Stone* and *Ebony*.

CLIFT, WILLIAM (Fine Art)

P.O. Box 6035, Santa Fe, NM, 87502

Born: 1944 *Subject Matter:* Landscapes, Architecture *Situations:* U.S. Locations *Awards:* NEA Fellowship; Guggenheim Fellowship *Education:* Columbia U.

Boston architecture, U.S. courthouses and Southwest landscapes serve as subjects for William Clift's photography. His understanding of light, tone and balance is exceptional. His prints are truly beautiful. There is life in the shadows and subtlety in the whites. In addition to ordered composition, there is an abstract level of order found in these works, whether intended or not. For example, from the series "Courthouses," in its quiet, intense simplicity, emerges the idea of law—order imposed upon chaos. Clift often photographs New Mexican landscapes near his home. Sacred Indian objects, stones or signs become symbolic of another culture's methods for taming nature. There are no human figures in Clift's photographs. The objects carry more symbolic weight as a result.

CLOUSE, MILDRED D. (Photojournalism)

15020 S.W. 89th Ct., Miami, FL 33176
(305) 235-3316

Born: 1909 *Subject Matter:* People, Nature *Situations:* Studio, Foreign Locations *Education:* School of Modern Photography

She began her photographic career in the Belgian Congo, where she documented the native people and their way of life. Returning to the States, she studied at the School of Modern Photography and freelanced for two years in Ohio. Moving to Miami, she opened a studio specializing in portraiture, aerial photography and architectural photography. She has also had exhibits in Miami and Toledo of her photographs of African life and her safaris into the bush and Ituri Forest. Although she no longer takes assignments, she still works in photography, selling from her vast file of transparencies and negatives.

COHEN, MARK (Fine Art)

Mark Cohen Studio, 32 W. South St., Wilkes-Barre, PA 18702 (717) 822-2766

Born: 1943 *Subject Matter:* People *Situations:* Studio *Awards:* NEA Award; Guggenheim Fellowship *Education:* Penn State U.; Wilkes College

Working in large format in black and white and in color, his photographs contain obvious elements which make them easily recognizable. His images of people are generally taken spontaneously, the objects or figures frequently cropped and the lighting usually severe. There is an intentional, fundamental element of chaos and disorder. The viewer's reaction is generally a feeling of discomfort and confusion about the intended meaning of the image. Cohen utilizes simple photographic equipment to produce his images, avoiding any etching, painting or the addition of collage.

COHEN, MAURY (Advertising, Portraiture)
c/o Design Photography, 920 Ripley St., Santa Rosa, CA 95401 (707) 576-7266

Born: 1955 *Subject Matter:* Portraiture, Still Life *Situations:* Studio *Education:* Art Center College of Design

Although she frequently photographs table-top still lifes, landscapes and industrial locations for her commercial clients, her first love is photographing people. From brides to corporate heads, infants to grandparents, she is known for capturing the warm and candid qualities in people. Her lighting is simple and natural, with location light blended in. Much of her work, however, requires quick set-up and fast-turn-around black and whites for press releases and local publications. Her work also appears in annual reports and in-house newsletters.

COKE, VAN DEREN (Fine Art)
San Francisco Museum of Modern Art, San Francisco, CA 94102

Born: 1921 *Subject Matter:* Landscapes, Seasides *Situations:* Studio *Education:* U. of Kentucky; Indiana U.

Van Deren Coke has vast knowledge and interest in 20th-century art. Man Ray, Christian Schad, Richard Hamilton and Andy Warhol have influenced his work in photography. Early black-and-white work employed the "flash" technique, in which he flashed a white light in the darkroom as the print was developing. This tended to blur the literalism of the image, while it retained its link to reality. Max Ernst-style juxtaposition can be seen in *U.S. Highway 441,* an image of a wrecked car at the peak of a hill, with a Coca-Cola sign lying below it. Coke's later autobiographical work made references to art, rather than banal, everyday events. He began to use color—again with the "flash" technique—producing exotic browns, plums and grays. As Henry Holmes Smith described Coke's work, ". . . Urban man can always see, without half-looking, irrational terror, cruelty, carelessness and waste. Coke's themes are based on those psychological reaches that we must now include in what we call 'reality,' and he uses this matter with great distinction. Coke's urban art is genuine, disturbing and true."

COLBROTH, RON (Photojournalism, Advertising)
4421 Airlie Way, Annandale, VA 22003
(703) 354-2729

Born: 1945 *Subject Matter:* Travel, Food *Situations:* U.S. & Foreign Locations *Education:* George Mason U.

Based in the Washington, D.C. area, he began his professional career in the fall of 1977. Since then he has concentrated mainly on editorial assignments, shooting a range of subjects from travel to sports to food. Recently, however, he has been working in ad-

vertising. His clients include the National Geographic Society, the *Washington Post* Company, Citicorp, Kiawah Island Company, *Chocolatier* and *Equus,* among others. He is a member of both the ASMP and NPPA, serving as Vice President of the Mid-Atlantic Chapter of the ASMP. His work is characterized by its strong graphic design and use of light.

COLEMAN, GENE (Advertising, Editorial)
250 W. 27th St., New York, NY 10001
(718) 691-4752

Born: 1937 *Subject Matter:* Still Life *Situations:* Studio *Education:* Brigham Young U.

A former actor turned photographer, he started his still life studio rather late in life. He works in both the advertising and editorial fields and has had work published internationally for posters and greeting cards. Primarily self-taught, he delights in creating strong, visually colorful variations in compositions of glass shapes, ice cubes, spheres, etc. One picture, for example, features a beautiful pink orchid shot against a black plastic background with a rising eclipse made from clay, heavily backlit and shot with filters. This picture and other pictures of flowers in environmental settings have been published internationally in poster form. He has recently been working on a series of abstracts, exploring what the camera can do with non-figurative images. In addition, he has completed a series of realistic 8" x 10" prints of Victorian jewelry.

COLLECTOR, STEPHEN (Editorial, Corporate/Industrial)
1836 Mapleton Ave., Boulder, CO 80302
(303) 442-1386

Born: 1951 *Subject Matter:* Fashion, Nudes, People *Situations:* U.S. Locations *Awards:* Best B&W Book, California Photo Annual; Meade Paper Award for Annual Report

In 1974 he began working in the darkroom of a Boulder studio. Within six months he was taking pictures and landing his own product accounts. In 1977 he shifted to location work, taking assignments from oil companies. Five years later he shifted to high-tech subjects and fashion. At the same time he continued doing editorial work for the major local magazines. His black-and-white series of portraits of the last of the old time stock detectives in Wyoming and Colorado, shot in 4" x 5", has been shown at the University of Wyoming. His work has been featured in *Forbes* and *Savvy,* and on album covers.

COLLETTI, STEVE (Advertising)
200 Park Ave., 5303E, New York, NY 10166
(212) 972-2218

Born: 1962 *Subject Matter:* Products, People, *Situations:* U.S. Locations, Studio *Awards:* Communication Arts Award of Excellence *Education:* School of Visual Arts, NYC

He began his career while still in school, spending three years working with David Langley. His specialty is color illustration photography in large formats. He shoots period pieces, ranging in style from turn-of-the-century to modern day. When necessary, he will use sets in a studio, but he also enjoys location work. His style ranges from the realistic—as a motorcycle in a workshop—to the to ridiculous—a man being swallowed head first by his television.

COLODZIN, BONNIE (Editorial, Portraiture)
20450 Oxnard St., Woodland Hills, CA 91367
(818) 884-8117

Born: 1952 *Subject Matter:* People *Situations:* Studio
Education: UCLA

She is a portraitist, who began as a student and protege of *Life* photographer Philippe Halsman. Throughout her career she has specialized in photographing young performers. Her subjects have included Harrison Ford, Tom Berenger, Amy Irving, Eric Roberts and James Woods. She has been a still photographer for feature length films, and her assignments have taken her to Europe, Australia and Mexico. Her editorial work has appeared in the *New York Times Magazine*, *People, US, Time, Paris Match* magazines and other publications.

CONNOLLY, DAN FORD (Editorial, Corporate/Industrial)
P.O. Box 1290, Houston, TX 77251 (713) 862-8146

Born: 1947 *Subject Matter:* People *Situations:* U.S. & Foreign Locations *Education:* U. of Houston

He began shooting professionally from his Houston base twenty-one years ago and has covered the gamut of Texas events as a staff photographer for one of Houston's two major dailies. After ten years of covering fashion, sports and general news, he set up shop as a freelancer, specializing in editorial and corporate/industrial photography. He followed the court battle between Texaco and Pennzoil for *Time*, as well as some feature stories on illegal aliens; he cites two *Time* photographers, Neil Leifer and Harry Benson, as important influences. His corporate/industrial work has been used by *Business Week*, *Stern* (West Germany) and *Fortune*.

CONNOR, LINDA STEVENS (Fine Art, Portraiture)
c/o Department of Photography, San Francisco Art Institute, 800 Chestnut St., San Francisco, CA 94133 (415) 771-7020

Born: 1944 *Subject Matter:* Still Life, Landscape, Architecture, People *Situations:* U.S. & Foreign Locations *Awards:* NEA Grant; Guggenheim Fellowship *Education:* Rhode Island School of Design; Institute of Design, Illinois Institute of Technology

Connor's portfolio includes portraits, still lifes, nature and landscapes. She has traveled extensively in Latin America, Europe, Asia, the Orient and the U.S. to take photographs of indigenous peoples. Nature and architecture are also two major sources for her art. She is most influenced by the work of Harry Callahan, Aaron Siskind and Walker Evans. In 1979 she published a book entitled *Solos*. In this monograph are soft-focused photos taken with an 8" x 10" Century camera. She toned these pictures with a special gold and chloride solution, resulting in a nearly abstract series of images. Some of her images involve the manipulation of negatives and prints—re-using old photographs, painting onto the surface and adhering found objects to the photograph's surface.

CONTE, MARGOT (Advertising, Reference)
165 Old Mamaroneck Rd., White Plains, NY 10605
(914) 997-8303

Born: 1935 *Subject Matter:* Wildlife, Travel *Situations:* U.S. & Foreign Locations

With her first show of 127 images at Abercrombie and Fitch in New York, she was reviewed in the *New York Times* and *Modern Photography*—articles that catapulted her work onto the "Today" show. Since then her specialization in wildlife photography has taken her on assignments from Africa to the Galapagos Islands, sometimes at her own peril—she has been chased by both a bull giraffe and a dying elephant. For her photographs of waterfowl and of polar bears with cubs in tow, she has been published in *National Wildlife, GEO, Sports Illustrated, National Geographic* and Time-Life Books. As a teacher, she pursues a thorough study of her subjects. She credits her ability to photograph wild animals and birds with their unpredictable movements and speed, to her knowledge of their behavior and of ecology. She has been known to spend hours in the field waiting for a particular moment when she can capture the most dramatic lighting conditions. "Studies of birds, primarily waterfowl in flight, can take months of work in order to coordinate all the factors involved," she says. "Contradictory to what may seem like a 'grab shot'—wildlife and bird photography takes a tremendous amount of planning and study. Rarely do you get a second chance."

COOPER, JOHN F. (Corporate/Industrial, Fine Art)
One Bank St., Summit, NJ 07901 (201) 273-0368

Born: 1956 *Subject Matter:* People, Nature, Still Life *Situations:* U.S. & Foreign Locations, Aerial, Studio *Awards:* Fellowship, New Jersey State Council on the Arts *Education:* Rochester Institute of Technology

To him, photography's greatest advantage as a chosen career is the fact that every day and every assignment presents a unique challenge. Early work, mostly black and white, of figure studies and landscapes, involved altering the image to create a soft, romantic tone. Current work is quite varied, from shots of corporate officers for annual reports, to album covers for Windham Hill, to aerial photographs of exotic locales. His favorite subjects include people, especially nudes, as well as fashion, landscape and still life. Working in all formats, he prefers large-format work, including panoramas. Best known for eerie, moody lighting and unconventional design and composition, he tries to incorporate light as a subject, emphasizing its tactile, sensual qualities. His work has been published in *American Photographer, Communication Arts, Photo/-Design* and *Print Magazine*, among others.

COOPER, RUFFIN (Fine Art, Corporate/Industrial)
285 Chestnut St., San Francisco, CA 94133
(415) 956-5099

Born: 1942 *Subject Matter:* Art, Architecture *Situations:* U.S. & Foreign Locations, Aerial *Awards:* New York Art Director's Club Merit Award *Education:* Boston U.

His career as an artist began with the creation in 1968 of Cerebrum, a New York entertainment "environment" that was the subject of stories in *Life, Time, Rolling Stone* and Alvin Toffler's book *Future Shock*. In 1970, he moved to San Francisco and began working in photography, first concentrating on landscapes of the American Southwest, then on architectural details, especially icons, the two best-known being the Statue of Liberty and the Golden Gate Bridge. Using color and scale, he emphasizes details and enlarges

Margot Conte, *Mute Swan*

John F. Cooper, *Nude Landscape*

them to reveal how a structure which seems monolithic from a distance is really a summation of more fragile elements. Recently, he has begun combining photography with sculptural techniques, creating photographic constructions whose three-dimensionality further heightens the impact of his images. These and other multi-image compositions combining human and non-human forms have been exhibited in Paris, Milan, New York, Los Angeles and Santa Fe.

COOPER, THOMAS JOSHUA (Fine Art)

c/o Glasgow School of Art, 167 Renfrew St., Glasgow G3 6RQ, Scotland

Born: 1946 *Subject Matter:* Landscapes *Situations:* U.S. & Foreign Locations *Awards:* NEA Fellowship; James D. Phalen Award *Education:* Humboldt State U., California; U. of New Mexico

The photographs of Thomas Joshua Cooper are meditations on myths and rituals of North America and the British Isles. Deep woods, moorland and seasides captured in bizarre light-tones, are frequently subjects. The works are sometimes autobiographical and always structured in sequence. From 1973 to 1977, Cooper absorbed himself with the British landscapes of Shropshire, Staffordshire and Derbyshire. These photographs characterize the sacredness of place and hint of eternal values. Cooper believes that photography, with its dual capacity to create credibility and illusion, is an effective vehicle for self-knowledge through myth. His main areas of inquiry are "Ritual Indications," "Ritual Guardians" and "Ritual Grounds." These "sightings" form the conceptual basis for Cooper's work.

COPPOLA, GEORGE P. (Advertising, Portraiture)

2117 Fairland St., Pittsburgh, PA 15210 (412) 884-6919

Born: 1947 *Subject Matter:* Sports, Fashion *Situations:* Studio *Awards:* Matrix Awards; Desi *Education:* Point Park College

In his work, he strives to capture the realism and uniqueness of each subject; indeed, he is best known for his simple and candid photos, for which he has won a variety of awards in print, motion picture and television production. In still photography, he works in all formats, in both black and white and color. His U.S. accounts include projects for the Pittsburgh Steelers football team and Pittsburgh Penguins hockey team; his most recent television work has been *Pittsburgh Penguin Hockey Minutes* for WPGH-TV. Internationally, British Airways draws upon his skills and services. In addition to pursuing his own work, he also takes time to teach photography and television production at two of Pittsburgh's universities.

CORPRON, CARLOTTA M. (Fine Art)

206 Forest, Denton, TX 76201

Born: 1901 *Subject Matter:* Light and Form *Situations:* Studio *Education:* U. of Omaha; Eastern Michigan U.

Carlotta Corpron's photographic studies can be called "designs with light." As a teacher of design, art history and photography, she encouraged her students to experiment with light and shadow and their effect upon form. She became more fascinated with abstract shapes and metaphorical imagery. In the "Light Drawings" series, Corpron captured moving lights at night, creating lively abstractions. "Light Patterns" is a series

in which light is reflected by and through various folded, translucent materials. In "Fluid Light Designs," light becomes the subject itself. Corpron's pieces are lyrical, metaphorical and imaginative.

COSINDAS, MARIE (Fine Art, Portraiture)

770 Boylston St., Boston, MA 02116 (617) 266-3487

Born: 1925 *Subject Matter:* Portraiture, Still Life, Nature *Situations:* Studio, U.S. Locations *Awards:* Guggenheim Fellowship; National Academy of Television Arts and Sciences Award *Education:* Modern School of Fashion Design; Boston Museum School

She was a student of Paul Caponigro, Ansel Adams and Minor White. It was Ansel Adams who first encouraged Cosindas to experiment with color photography. Taking this advice, Cosindas soon began experimenting with instant film. Her experimentation proved successful, and today she is considered an innovator in Polaroid photography. A purchase in 1961 of several of her photographs by the Museum of Modern Art in New York encouraged her to embark on a professional career in photography. She gained national recognition in 1966 with her one-woman show at the Museum of Modern Art in New York. Cosindas' work has appeared in many publications including *Esquire, Life, Newsweek, Saturday Review* and *Vogue.* She concentrates on portraits and still lifes. Her photographs are characterized by their rich, saturated colors and their contrived settings. She aims to express a sense of timelessness in her work.

COTTER, MIMI (Photojournalism)

33 East 38th St., New York, NY 10016 (212) 972-0176

Born: 1943 *Subject Matter:* People, Travel *Situations:* U.S. & Foreign Locations

Entering photography as a second career after ten years as a creative supervisor in advertising, for the past twelve years she has been a freelancer in New York. Accustomed to deadlines and creative challenges, she uses her advertising experience on a regular basis, arriving at quick, innovative solutions to the various problems that confront an editorial photographer daily. Drawn to working with people, especially children, she is currently a contributing photographer for *People.* In the fall of 1986 she spent six weeks in the U.S.S.R., traveling to Siberia on special assignment for *"People* Goes to Russia," which was published in the April 1987 edition.

COUPON, WILLIAM (Photojournalism, Advertising)

237 Lafayette St., New York, NY 10012 (212) 431-4956

Born: 1952 *Subject Matter:* Fashion, People *Situations:* U.S. & Foreign Locations, Studio *Education:* Syracuse U.

Before he began freelancing for *Elle, Vogue, Esquire, Rolling Stone* and the *New York Times Magazine,* among others, he developed a style influenced by portrait photographers Diane Arbus and Irving Penn. His skills in portraiture continue to distinguish his work, and he is best known for his formal portraits of notable people—shots marked by intimacy though taken at a classical distance. His portrait of Secretary of State Shultz, or that of Donald Trump holding a small white dove, best typify what is considered an overall formal style. He recently completed the twelfth

Mimi Cotter

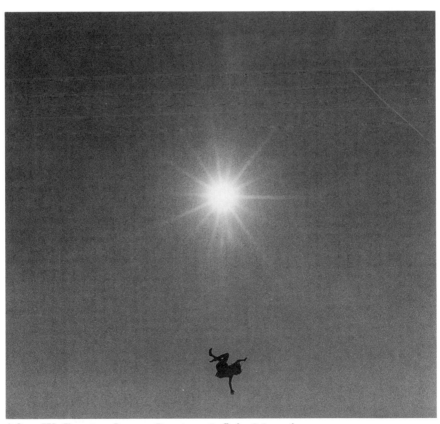

Adger W. Cowans, *Icarus.* Courtesy: Infinity Magazine

"Social Studies" portfolio, featuring a wide spectrum of subjects, including punks, Haitians, death row inmates, Australian Aborigines, drag queens, Scandinavian Laplanders, American Indians, American cowboys, Israeli Druse Arabs, Moroccan Berbers, Quechua Indians of Peru and the traditional native Dutch. He has recently been working primarily on assignments for fashion magazines, a book project with Japanese designer Issey Miyake and self-financed projects.

COUZENS, LARRY (Advertising, Editorial)
16 E. 17th St., New York, NY 10003 (212) 620-9790

Born: 1938 *Subject Matter:* People, Food *Situations:* U.S. & Foreign Locations, Studio *Awards:* Andy Awards; Creativity Certificate of Distinction *Education:* New School for Social Research

A leading still-life and food photographer, he has maintained his studio in New York City since 1969. Among his many advertising campaigns are the Benson & Hedges and Chivas Regal print ads. His advertising clients include Ogilvy & Mather, J. Walter Thompson and DDB. His editorial work has appeared in various national magazines including *Esquire*, the *New York Times Magazine, Cosmopolitan, McCall's, Harper's Bazaar* and *Americana*. Special editorial projects have taken him to Venice, Rome and Capri to shoot on-location drink shots for *Food & Wine*. For *Redbook*, he photographed the chefs of the United States Culinary Team and their prepared dishes at the Culinary Institute of America.

COWAN, RALPH (Advertising, Editorial)
452 N. Halsted, Chicago, IL 60622 (312) 243-6696

Subject Matter: People, Special Effects *Situations:* Studio *Awards:* New York Art Directors Club, Andy Award *Education:* School of the Art Institute of Chicago

His advertising assignments—from Morris the Cat to Coca-Cola—as well as his ethnographic documentation in New Guinea, the southwestern United States and the African continent, have been included in an exhibition which traveled to many locations in the Soviet Union. Versed in stop-action, strobe, multi-image, multi-exposure and ultra-violet light photography, he loves a "problem." A baseball moments from the bat, a futuristic motorcycle rising over a dark horizon, a bust with multi-colored fluorescent hair and eyes—these are some of the creative "solutions" he has provided over the years. His work has appeared in corporate/industrial brochures and catalogs, books, magazines, advertisements and various multi-media projects.

COWANS, ADGER W. (Motion Pictures, Editorial, Advertising)
136 W. Broadway, New York, NY 10005
(212) 732-7447

Born: 1936 *Subject Matter:* Fashion, Travel, Landscape, Still Life, Portraits *Situations:* Motion Pictures, U.S. & Foreign Locations *Awards:* John Hay Whitney Fellowship; 1st Place at Yolo International Exhibition *Education:* Ohio U.

Cowans' studies with Clarence H. White, Jr. and Minor White were early influences on his approach to photography as an art form. He later worked with Gordon Parks at *Life* and with fashion photographer Henri Clark. One of the founders of International Black Photographers, he is a member of the International Photographers of the Motion Picture Industry. His first major exhibition was in 1965 at the Heliography Gallery, one of the first galleries in New York to show photography as a fine art. Selected group exhibitions have included "Photography in the Fine Arts," curated by Ivan Dimitri; "New Trends In Photography" at the De Cordova Museum; the Kamoinge Workshop at the International Center of Photography, the Chicago School of Design, Harvard University and the Studio Museum in Harlem; and the Heliographers at Lever House and George Eastman House. His credits more than thirty major feature films, among them "Dirty Dancing," "The Cotton Club," "On Golden Pond" and "The Way We Were." He lectures at Wayne State University, the Cleveland Institute of the Arts and the University of Michigan. His work has been published in *Harper's Bazaar, Life, Time, Esquire, Look, Essence, Paris Match* and *Ebony*.

COX, D.E. (Corporate/Industrial, Editorial)
22111 Cleveland, #211, Dearborn, MI 48124
(313) 561-1842

Born: 1946 *Subject Matter:* China, Travel *Situations:* U.S. & Foreign Locations

Although he has shot photographs all over the world, he is a specialist on China. Having photographed there for more than twelve years, he has also led several photography workshop tours to China since 1981. His photographs of China have been published worldwide and notably featured on the covers of the *China Business Review* and the *Minolta Mirror*, among others. His stock photographs have appeared in many publications, including *Esquire, Parade* and *Modern Photography*. He is a regular contributor to *Midwest Living* magazine. A book of his photographs of Beijing will be published in 1989. Also a writer, he has contributed articles on the photography of China to *Camera Arts* and *Photographer's Forum*.

CRANE, TOM (Photojournalism, Advertising)
113 Cumberland Pl., Bryn Mawr, PA 19010
(215) 525-2444

Born: 1940 *Subject Matter:* Interiors, Furniture *Situations:* U.S. Locations, Studio *Education:* George Washington U.

His first foray into photography came after college while serving in the Peace Corps in Nigeria. There he became particularly interested in photographing the changing structural design of the villages along the Sokoto River. Returning to New York, he apprenticed with Ezra Stoller from 1967 to 1968 and then with Hans Namuth. In 1972 he opened his own business in Philadelphia, specializing in architecture and interiors. Today, six people and one associate photographer staff the company, which is located in a large converted barn where they also shoot many furniture catalog assignments.

CROFOOT, RON (Advertising, Corporate/ Industrial)
6140 Wayzata Blvd., Minneapolis, MN 55416

Born: 1950 *Subject Matter:* People, Food, Products, Still Life *Situations:* Studio *Education:* Brooks Institute of Photography

Specializing in food photography, his list of clients includes Land O'Lakes and Hardee's Fast Foods. Shot in the studio, his images create an environment, be it

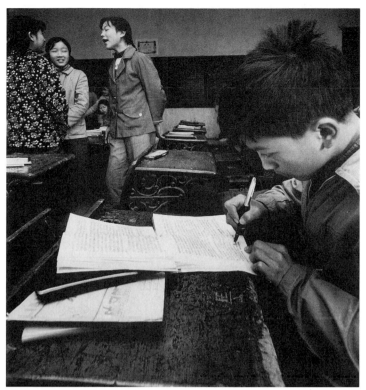

Dennis Cox, *Nanjing Middle School Classroom, China.* Courtesy:
China Photographic Book, Co.

Larry Dale, *Artist Photo*

high-tech or soft classic, for the product. His second speciality is people photography. Greatly influenced by Sid Avery, he works to achieve an emotional intimacy in his subjects. The shots are primarily in color with low-key lighting to enhance the presence of the person. Of particular interest is a series he shot for *Architectural Digest*, in which people were photographed along with a particular window that seemed to match their personality. Captured, too, was the reflection of the person in the window, making the link between the personality and the window literal.

CROMWELL, PATRICK (Advertising, Corporate/Industrial)

1739 Coolidge Hwy., Berkley, MI 48072
(313) 543-5610

Born: 1953 *Subject Matter:* Fashion, Food, Nudes, Products *Situations:* Studio *Awards:* MGAC Best of Show; CADDY, Detroit Creative Ad Club

He is a self-taught photographer who has been working professionally since the age of twenty-one. His influences include Hurrell, Ansel Adams and Irving Penn. He has been careful to aim his career towards the making of "sophisticated visual solutions" rather than mere "pictures" or money. He now does work for a number of major U.S. corporations headquartered in the midwest. His photographs have recently been seen in *Newsweek*, *McCall's* and the *Detroit News*.

CROWL, GARY M. (Portraiture, Corporate/Industrial)

112 W. 6th St., Topeka, KS 66603 (913) 233-4948

Born: 1955 *Subject Matter:* People *Situations:* Studio

With a career in photography for the past twenty-two years, his main emphasis has been on portraiture, especially wedding and business portraits. After an self-educational hiatus, during which he photographed primarily friends and family and tried some work in photojournalism, he opened GMC Photography in 1984. Endeavoring to "bring out the peak emotion of a person or object," he is now expanding into glamour and advertising work, and his photos have appeared in a variety of books, magazines and corporate and industrial publications over the past several years.

CUINGTON, PHYLLIS (Advertising/Editorial)

38 E. 19 St., 8th Floor, New York, NY 10003
(212) 477-5107

Born: 1944 *Subject Matter:* Fashion, People *Situations:* Studio

Influenced by Richard Avedon and Albert Watson, she began her career shooting covers for *Essence* magazine. She credits her success to an ability to create a persona for her subjects, who are often celebrities. Her aim is to capture on film the characteristics that draw the public to them. Her subjects have included such celebrities as Oprah Winfrey.

CUMMING, ROBERT H. (Fine Art)

1604 N. Grand, West Suffield, CT 06093
(203) 668-1180

Born: 1943 *Subject Matter:* Landscapes, Objects *Situations:* Studio, Location *Education:* Massachusetts College of Art; U. of Illinois

The conceptual art movement of the 1960s proclaimed ideas to be humanity's greatest offspring. This philosophy fueled the "less is more" phenomenon, conveyed through many art media. In photography,

Robert H. Cumming is one of the most important conceptual artists. His themes involve reappraisal of everyday objects, reversals of the expected, satires on natural phenomenon and the history of art and photography. His early work strove to impose order upon chaos—to understand the principles of cause and effect in the cosmos. As his work matured, however, so did his understanding of contradiction and paradox. He began to incorporate the presence of mystery in his photographs. Cumming likes to call attention to illusion and artifice. Often, floodlights or other technical instruments appear around the subject in the frame. By showing us his tools of fabrication, he challenges, with irony, the notion that photographs tell the truth. A self-taught child who was later educated, Cumming also studied drawing, painting and sculpture. He uses these skills in building his own subjects for photography. He is an adept craftsman, yet he places concept before craftsmanship. His photographs contain layered meaning and enjoyable metaphors.

CURRAN, DARRYL J. (Fine Art)

10537 Dunleer Dr., Los Angeles, CA, 90064
(213) 839-8964

Born: 1935 *Subject Matter:* Food, Nudes, Illusion *Situations:* Studio *Awards:* NEA Fellowship; Phelan Award, San Francisco *Education:* UCLA

Influenced by Franz Kline and Frederick Sumner, he traces his style to early interests in abstract painting, classical design and foreign cinema. He seeks ways to produce exciting, unexpected imagery by using toy cameras, old box cameras, view cameras, pinhole cameras and Leicas. Using the medium in a multitude of ways, he makes photo-sculpture, non-silver prints, dye-transfer prints, visual books, book images and multi-media and digitized images. His works have been exhibited internationally, most notably at the Museum of Modern Art in New York and the Los Angeles County Museum. He is a faculty member at California State University, Fullerton, where he developed degree programs in creative photography.

CURTIS, JOHN (Advertising)

S. Melcher St., Boston, MA, 02220 (617) 451-9117

Born: 1937 *Subject Matter:* Fashion, Food, People *Situations:* Studio, U.S. & Foreign Locations *Awards:* Clio *Education:* London School of Photography

After leaving the London School of Photography, he worked for various magazines in the U.K. He moved to South Africa and there worked as an advertising photographer, shooting major international accounts. At the same time he directed commercials and published a book of ballet photographs featuring Margot Fonteyn. In 1981 he moved to Boston, where he now shoots fashion and people for national advertising agencies. Every year he goes to Europe and Africa on assignment.

CUTLER, CRAIG (Advertising, Fine Art)

39 Walker St., New York, NY 10013 (212) 877-2601

Born: 1960 *Awards:* Gold Award, *Photo Design*; Communication Arts Photo Annual *Subject Matter:* Still Life *Situations:* Studio, U.S. & Foreign Locations *Education:* U. of Delaware, Newark; Georgia Tech

After studying architectural design, he became interested in photography, and for a time while still in school he worked assisting illustrative photographer David Langley in New York. In 1986, he opened his

Jay Daniel, *New Family*

Abraham D. Davidson, *Old San Juan, 1971*

own studio, shooting the gamut of camera formats, from 35mm to 8" x 10". His design background continues to inform his compositions, as they are often graphically structured. Publications include *Vanity Fair*, *Vogue*, *Architectural Digest*, *GQ* and *Sports Illustrated*. Interested in breaking new ground, he strives to "sell a feeling, not a product." Moving objects, video images and the like create new worlds for the product and the potential consumer. His personal work is quite distinct from his commercial photography. Shooting mostly black and white with available light, he works overseas on location, photographing villas and hotels. In their consideration for line and perspective, these photographs have a classical, timeless feel.

CZAPLINSKI, CZESLAW (Photojournalism, Portraiture)

90 Dupont St., Brooklyn, NY 11222 (718) 389-9606

Born: 1953 *Subject Matter:* People *Situations:* U.S. & Foreign Locations *Education:* Lodz U., Poland; New York Institute of Photography

Since 1981, he has been working on an album-exhibit entitled *Famous Faces of America*. The work will consist of several hundred portraits chosen from over 50,000 photographs of the most celebrated and creative people in America. "I am interested in specific means of expression in photography, with the abilities lying in the reality of the image accomplished by the camera. I try to bring out certain elements in my photographs by maximizing the means of expression to its simplicity and synthetics when selecting and holding the motive."

D'ALESSANDRO, ROBERT (Fine Art)

388 Broadway, Studio 4, New York, NY 10013

Born: 1942 *Subject Matter:* People *Situations:* U.S. Locations *Education:* Pratt Institute; Brooklyn College

Robert D'Alessandro is best known for his photographs satirizing the American myth. He was informed visually by early post-war television, which carried cultural traces not only of the 1950s, but of the 1920s, '30s and '40s as well. His work exposes moral flaws, public and private. But the images go further still, approaching the metaphysical. D'Alessandro finds what is humorous and ironic in the struggle for survival. He also reveals his acute awareness, as in his photograph of the ruins of Brooklyn. He invites our awareness as viewers.

D'ARAZIEN, ARTHUR (Advertising, Corporate/Industrial)

92 W. Hills Rd., New Canaan, CT 06840
(203) 966-2811

Born: 1920 *Subject Matter:* Industry *Situations:* U.S. & Foreign Locations *Awards:* Art Director's Club Awards of New York, Pittsburgh, Cleveland, Los Angeles and Chicago *Education:* Cooper Union

Melding the might of industry with the warmth and sensitivity of an artist, he has produced striking pictorial records of America's biggest corporations for the past three decades. Despite the overwhelming size and complexity of his subjects, he manages to maintain a human element in the photographs, lifting them above mere documentation. His clients include the top names in industry, both in the United States and overseas. Exhibited in the galleries of General Electric, IBM, the Smithsonian, the George Eastman House and the Kodak Gallery, he lectures to professional

groups and at the New School in New York. He is represented in the permanent collection of photography at the Metropolitan Museum of Art in New York; his work is also included in the Photography Hall of Fame.

DALE, LARRY (Corporate/Industrial, Editorial)

7015 Wing Lake Rd., Birmingham, MI 48010
(313) 851-3296

Born: 1951 *Subject Matter:* People; Automobiles *Situations:* U.S. & Foreign Locations, Hazardous *Education:* Wayne State U.; Cranbrook Academy, Bloomfield Hills, MI

Splitting his camera time between his studio and location work, he covers a range of subjects, from major CEOs to new prototype automobiles, for a variety of projects in advertising, corporate/industrial communications, portraiture, entertainment and photojournalism. His assignments have called for underwater and aerial shooting, as well as shooting in other hazardous situations. His clarity and his force of imagination are recognized and depended upon by major ad agencies and corporations throughout the world. His work has appeared in such magazines as *People*, *Fortune*, *Automobile Magazine*, *Time* and *Money*. AT & T, Ford, DuPont, GE, General Motors and Rockwell have turned to him for their annual reports.

DANIEL, JAY (Corporate/Industrial, Editorial)

517 Jacoby St. #11, San Rafael, CA 94901
(415) 459-1495

Born: 1953 *Subject Matter:* People, Nature *Situations:* U.S. Locations, Studio *Education:* U. of California, Berkeley

Leaving his position in research at Pacific Medical Center, he chose to pursue photography and art, his avocations. Through self-directed studies, he opened his own studio, out of which he now works for both corporate and advertising clients. Most of his work is done in the studio, but he also works on location for a number of corporate assignments. He is equally comfortable in color and black and white and often employs post-production techniques—hand-coloring, airbrushing, aerial maskings and multiple image making, to achieve striking effects. He specializes in black-and-white portraiture on location, recently completing a series of nudes, "The Naked Cafe," involving 120 people. His diverse list of clients includes American Express, Apple Computer, Biosearch, La Petite Boulangerie, Mrs. Field's Cookies and Fujitsu Micro Electronics.

DANTUONO, PAUL F. (Advertising, Corporate/Industrial)

433 Park Ave. S., New York, NY 10016
(212) 683-5778

Born: 1952 *Subject Matter:* Still Life, Beauty, Cosmetics *Situations:* Studio *Awards:* Andy Awards of Honor *Education:* Art Institute of Boston

Known for his problem-solving ability, he is a perfectionist who enjoys the challenge of making "difficult" products look their best. His product images are always sharp and well defined, but there is also a soft, romantic quality to his work that liquor, perfume and cosmetic accounts find attractive. He is continuing to explore new lighting techniques and images. Clients

Darwin K. Davidson

Heather Davidson, *Tundra Swans, Chestertown*

have included Borghese, Revlon and Martini & Rossi. His images have also appeared in the *New York Times*, *Vogue*, *Glamour* and *New York Magazine*.

DATER, JUDY (Fine Art)
P.O. Box 79, San Anselmo, CA 94960

Born: 1949 *Subject Matter:* Portraits, Landscapes *Situations:* Location, Studio *Awards:* Guggenheim Fellowship; NEA Grant *Education:* U. of California; San Francisco State U.

Photographer Judy Dater is most attracted by the human face and body. She began with black-and-white self-portraits. In recent work she has implemented color, video stills, painting, photo-lithography and hand-cast paper. In an urban setting, Dater photographed a series of Bohemian women in their homes, some of whom were nude, some dressed. Here, through costuming, she examines female identity as well as female sexuality and society's disposition toward it. Without foisting her own values upon her subject, Dater allows symbols to occur naturally. A woman stands in her kitchen, utensils hung above her head. This woman looks strong, yet we question her choice of roles. In Dater's portraits, mystery breathes inside rich, compelling detail.

DAVID, ALAN (Advertising, Corporate/ Industrial)
1186 N. Highland Ave. N.E., Atlanta, GA 30306 (404) 872-2142

Born: 1937 *Subject Matter:* People, Animals *Situations:* Studio, U.S. Locations *Awards:* Addy; Andy

He became interested in photography in college while studying music. After taking all his school's photography courses, he left for a year to work on newspapers in south Florida and also to apprentice with a Florida State Road Department engineering photographer. After finishing school and serving in the Navy he moved to New York City and began a two-year stint as staff photographer with McCafferty & McCall advertising. In 1966 he became a freelancer and moved to London for three years. In late 1970 he moved to Atlanta, where he continues to specialize in people photography. He serves a wide variety of advertising, public relations, corporate, medical and private portrait clients.

DAVIDSON, ABRAHAM A. (Fine Art)
1516 Addison St., Philadelphia, PA (215) 732-8618

Born: 1935 *Subject Matter:* Travel *Situations:* U.S. & Foreign Locations *Awards:* Group 17 Prize in Photography, Detroit Institute of Arts *Education:* Harvard U.; Boston U.; Gebrew Teachers Eollege, Boston; Columbia U.

Since the mid-1950s he has made black-and-white photographs, and his subject matter generally consists of landscapes and cityscapes either with or without figures. Politics generally do not interest him, an exception being the hooded figures who marched in a parade commemorating the twentieth anniversary of Hiroshima. He often attains a sense of poetic detachment and isolation: his favorite subjects are small, strategically placed figures in old parts of a city, sometimes beside ruined monuments. Trying for bizarre, strange, but not completely fantastic situations, he creates mildly surreal works.

DAVIDSON, BRUCE (Photojournalism, Corporate/Industrial)
c/o Magnum Photos, 251 Park Ave. S., New York, NY 10010

Born: 1933 *Subject Matter:* People, Urban Landscape *Situations:* U.S. Locations, Studio *Awards:* Guggenheim Fellowship, NEA Grant *Education:* Rochester Institute of Technology

Davidson worked as a photographic assistant at an early age and studied under Ralph Hattersley, Josef Albers, Alexey Brodovitch and Herbert Matter. He worked briefly for Eastman Kodak before joining the Magnum Photos cooperative agency in 1958. He is a recognized photo-essayist known for candid portraits of America's oppressed class. His work is about the trials and tribulations of less-privileged Americans, and through his lens he seeks to captivate the viewer with each subject's spiritual richness that comes from years of hardship and endurance. One of Davidson's best-known series is his "East 100th Street" project, an ongoing visual diary of daily life in New York City's Spanish Harlem. Davidson's work has appeared in magazines such as *Esquire*, *Life*, *Look* and *Vogue*. He is also a film director. His first feature film, "Living Off the Land" (1970), which appeared on CBS television, received the Critics' Award at the American Film Festival. Other notable productions include Isaac Bashevis Singer's "Nightmare" and "Mrs. Pupko's Beard," and "Enemies: A Love Story."

DAVIDSON, DARWIN K. (Editorial, Advertising)
32 Bank St., New York, NY 10014 (212) 242-0095

Born: 1937 *Subject Matter:* Products, Interiors *Situations:* Studio, U.S. Locations *Education:* Rochester Institute of Technology

After working for fifteen years at a commercial studio that specialized in interior products, he started his own business, taking photographs of interior products on location. In order "to make a manufacturer's showroom look like a real home," he uses movie lights and other innovative lighting techniques to create a "window effect" in order to avoid the expected commercial-studio look. He now does location work for public relations and advertising agencies, manufacturers, magazines, designers and architects. Current work consists of developing photography programs for new companies and updated images for existing ones.

DAVIDSON, HEATHER R. (Photojournalism)
R.D. 2, Box 215, Rock Hall, MD 21661 (301) 639-7368

Subject Matter: Wildlife *Situations:* U.S. Locations

Davidson lives on Chesapeake Bay's eastern shore, where she spends much of her time photographing the indigenous wildlife, especially the waterfowl. Her photographs have been exhibited at the National Museum of Natural History at the Smithsonian Institution in Washington, D.C., the National Wildlife Federation Headquarters, the Washington Cathedral and many other locations. Mrs. Davidson has also been a participant in many wildlife exhibitions, including the Waterfowl Festival at Easton, Maryland. She is a member of the American Society of Magazine Photographers and has had her work reproduced in many magazines, including covers for *Maryland*, *Outdoor America*, *The Nature Conservancy News*, *The Shoreman* and *Waterfowler's World*. In addition, she is

Mary Dean, *Portrait of Paul Crayton, The Farmers
Rock & Roll Trio*

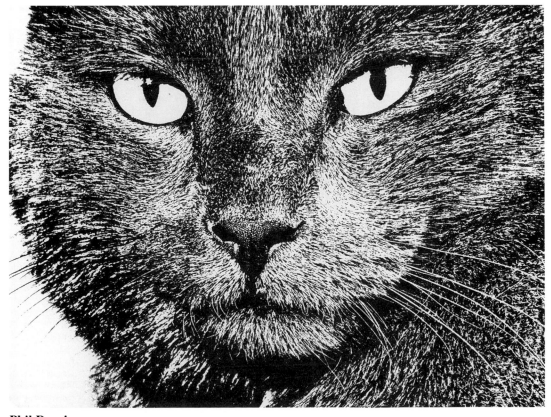

Phil Degginger

also a writer and a member of the Outdoor Writers of America. Mrs. Davidson has had many articles published, and she currently writes and hosts a weekly radio show, "Nature in Focus," on WCTR in Chestertown, Maryland.

DAVIDSON, JOSIAH (Corporate Industrial, Fine Art)

Box 607, Cloudcroft, NM 88317

Born: 1948 *Education:* Art Center College of Design

His subject matter is nature, and his clients include both industrial and fine art outfits. He works with a large-format view camera and looks for subtle, delicate, highly detailed images. These contrast with variations in scale to create a sense of impact and documentation. He is strongly influenced by Ansel Adams, although, unlike Adams, he works exclusively in color on diapositives. His scenic work is used by the Audubon Society, as well as in calendars, puzzles and large public displays.

DEAL, JOSEPH (Fine Art)

3540 Watkins Dr., Riverside, CA 92507
(714) 683-1199

Born: 1947 *Subject Matter:* Landscape, Nature *Situations:* U.S. Locations *Awards:* NEA Photography Fellowship, Guggenheim Fellowship *Education:* Kansas City Art Institute; U. of New Mexico

Originally from the Midwest, he is drawn to landscapes, architecture and nature. In his panoramic landscapes he seeks to reveal man's exploitation of the land. This theme of man's domination over his environment arose in the 1970s and is crucial to his prints. He exhibited a series of his photographs along with several of his contemporaries at the International Museum of Photography in 1975 in an exhibition entitled "New Topographics: Photographs of a Man-Altered Landscape." Another series, called "Beach Cities," is revealing for its depiction of man-inhabited beaches characteristic of Southern California.

DEAN, MARY (Portraiture)

838 E. 57th St., Apt. 3W, Chicago, IL 60637
(312) 947-0586

Born: 1964 *Subject Matter:* People, Events *Situations:* Nightclubs, Outdoors *Education:* U. of Chicago

Inspired in part by Scott Rankin, professor of photography at the University of Chicago, she got her start taking promotional shots for Chicago area rock bands. Many of these portraits were published in the *Chicago Reader* and the San Francisco punk monthly *Maximum Rock 'n' Roll.* Her "portraits of punks" were featured on the cover of Chicago's *Vice Versa.* Current work includes a series on female punk bands and a collection entitled "Cops in Restaurants." Her executive portraiture appears regularly in company reports, newsletters and trade journals. She prefers natural lighting and describes herself as "prejudiced against models and studios."

DEBOLD, BILL (Advertising, Corporate/Industrial)

1801 N. Halsted St., Chicago, IL 60614
(312) 337-1177

Born: 1946 *Subject Matter:* Food, Products, People *Situations:* Studio *Education:* Art Center College of Design

He worked as a photographer in Vietnam for more than two years. After leaving, he went to the Art Center, where he graduated *cum laude.* In 1977 he moved to Chicago and opened his own studio. He enjoys working on creative advertising projects with intelligent art directors. "It's really fulfilling to start with an empty palette and end up with a nice piece of work," he says. His photographs have appeared in many publications, including *Time, Newsweek, Ladies Home Journal, Readers Digest* and *Sports Illustrated.*

DEBOLT, DALE (Portraiture, Corporate/Industrial)

120 W. Kinzie St., Chicago, IL 60610 (312) 644-6264

Born: 1951 *Subject Matter:* Products, Fashion, Portraiture *Situations:* Studio, U.S. & Foreign Locations *Awards:* New York Directors Club, Chicago Creativity Award *Education:* Northern Illinois U.

Having studied both graphic design and photography in school, he began his career as a graphic designer and art director with extensive work in print production. As he began to photograph an increasing number of his own assignments, he decided to pursue photography as a full-time career. Starting first in editorial photography, he has consistently done more commercial studio work for such companies as Florsheim Shoes and Wilson Sporting Goods. His background in design and illustration allows him to take what might be ordinary table-top work and turn it into something unusual and exciting. Although most of his work is product photography shot in the studio, he has traveled to such exotic places as Morocco for location shooting. His portrait work, in the tradition of Irving Penn and Steichen, takes him into corporate America, where he photographs CEOs and others.

DECARAVA, ROY (RUDOLPH) (Photojournalism)

81 Halsey St., Brooklyn, NY 11216

Born: 1919 *Subject Matter:* People, Urban Scenes *Situations:* U.S. Locations, Studio *Awards:* Benin Creative Photography Award; Guggenheim Fellowship *Education:* Cooper Union; Harlem Art Center; George Washington Carver Art School

He first came to the attention of the art community in 1955 for his collaborative effort with writer Langston Hughes, entitled *The Sweet Flypaper of Life.* DeCarava is recognized for his contribution to the black experience through photography. He endeavors to present portraits of humanity—including children, jazz musicians, workers and street scenes in New York City. He initially used photography to document his painting, but eventually gave up painting in favor of photography. In 1952, he became the first black to be awarded a Guggenheim Fellowship. He has contributed to such magazines as *Fortune, Life, Look, McCall's, Newsweek* and *Time.* He has also served as a contract photographer for *Sports Illustrated.*

DEGGINGER, PHIL (Advertising, Corporate/Industrial)

189 Johnson Rd., Morris Plains, NJ 07950
(201) 455-1733

Subject Matter: Animals, Nature, People, Travel, Wildlife *Situations:* Studio, U.S. Locations, Aerial *Education:* Rochester Institute of Technology

He became interested in photography at age sixteen through his father, who is also a professional photog-

rapher, and he went on to study photography at Rochester, receiving a Fine Arts degree. His work has been heavily influenced by Ernst Haas, Pete Turner and David Meunch. He has been traveling throughout the country for the last fifteen years and maintains a stock file of more than a quarter of a million transparencies, ranging in subject from natural history to industry and science. Assignment work in New Jersey includes architecture, aerials, corporate PR, advertising and scientific photography. "People always ask me what my specialty is," he says. "The best answer I can come up is 'everything.' If there is a common denominator to my work, it is probably that of a scientific approach."

DEGLER, CURTIS J. (Advertising, Editorial)
1050 Carolan Ave., #311, P.O. Box 1165, Burlingame, CA 94010 (415) 342-7381

Born: 1949 *Subject Matter:* Fashion, Sports, Wildlife, Products *Situations:* Underwater, Special Effects *Education:* Hamilton College; U. of Chicago

Self-taught in underwater photography, he credits the underwater footage in "Seahunt" (a television show he watched as a child) and the underwater work of Jacques Cousteau for his love of underwater photography. While his own work takes him occasionally to the frigid waters of the Monterey, California, coast to document marine life, he can be found most frequently in swimming pools, where his subject matter includes swimsuit fashions, glamour and beauty shots, aquatic sports and pool equipment. Having devised aluminum housing for his 35mm and medium format cameras, he has mastered a number of special effects that he employs to create underwater fantasy worlds filled with mermaids and sea nymphs as well as to shoot commercial work depicting the latest pool filters, lights and cleaning systems. Some of the special effects he utilizes include reflections under water, images distorted by water, shots that simultaneously include both the space above and below the surface and special strobe filtration to compensate for skin tones. His work has appeared in *Popular Photography, Playboy, Self, Swimmer's World, Interview* and *Triathlete* magazines and has been used by advertising agencies for a number of client campaigns.

DELESPINASSE, HANK (Advertising, Corporate/Industrial)
2300 E. Patrick Ln., #21, Las Vegas, NV 89119 (702) 798-6693

Born: 1943 *Subject Matter:* Sports, Food, People *Situations:* U.S. Locations, Studio *Awards:* Addy; Best in the West, Creativity 13 *Education:* Brooks Institute of Photography

Much of his early work consisted of editorial photos for such publications as *Time, Newsweek, Fortune, Nation's Business, Smithsonian, People* and *Business Week.* Throughout the late 1970s and early 1980s, however, he became more interested in sports, shooting for *Sports Illustrated, Inside Sports* and *Sport.* Today, more of his clientele is in the corporate or advertising fields, although he still does an occasional editorial, such as work he did for a story for *Time* about the IRS seizing tips at hotels. Of his advertising assignments, many are in the food and candy business; people and location shooting make up the remainder. In addition to his commercial photography, his personal work is marketed through The Image Bank, where he is best

known for his highly graphic sunsets featuring airplanes, hang gliders, ultralight aircraft and other flying machines.

DELEVINGNE, LIONEL (Photojournalism, Corporate/Industrial)
25 Cherry St., Northhampton, MA 01060 (413) 586-3424

Born: 1951 *Subject Matter:* People, Travel *Situations:* U.S. & Foreign Locations *Awards: Art Direction* Editorial Design Award for Cover Art *Education:* ENI, Paris

A French photojournalist now residing in the U.S., he has traveled and photographed throughout the world, his work earning the praise of Christian Caujolle for its "perfect black and white, sure framing, rigorous choice of the moment." He seeks to redefine photojournalism, moving away from the current illustrative, studio look towards a feeling of being in the moment, capturing a sense of suspense. He has published in numerous venues, including photographs for feature articles in the *New York Times,* the *Washington Post Magazine, Business,* the *Village Voice* and others. His solo exhibitions enjoy international exposure: Fred McDarrah of the *Village Voice* writes, "His photos . . . bear the stamp of an inquisitive French eye; it enables Delevingne to grasp the unique subtleties of American life." His latest work includes the book, *The Franco Americans.*

DEMIRDJIAN, JACOB (Advertising, Corporate/Industrial)
3331 W. Beverly Blvd., Montebello, CA 90640 (213) 724-9630

Born: 1954 *Subject Matter:* Fashion, Food *Situations:* U.S. & Foreign Locations, Studio

The son of a Lebanese professional photographer, he began to work in his father's studio in 1965. Between 1970 and 1974 he worked with the Lebanese advertising agency, Promo 7. In 1975 he moved to Paris and there worked with Claire Promo Agency as well as the advertising studios for Galeries Lafayette and Prixunique. In 1979 he moved to California. His work there has included brochures, catalogs, portraits, weddings and bar-mitzvahs. In association with Geminor Inc. he has produced ads for Ten Spot Sodas, California Pantograph Engravers and Pool Doctors.

DEVINE, BILL (Advertising, Corporate/Industrial)
P.O. Box 67, Maple Falls, WA 98266 (206) 599-2927

Born: 1942 *Subject Matter:* People, Industrial *Situations:* U.S. Locations, Studio *Education:* West Washington U.

He uses photography as an opportunity to explore the world, and he has photographed a wide range of subjects. Beginning in the 1960s, when he ventured into the back country of Alaska, he has developed skills in nature and wildlife photography and cinematography. In 1971, he pursued a degree in visual communications and business, while at the same time opening a studio. For the next ten years, he concentrated on writing, designing and producing graphic photography and multi-media productions for a variety of corporate clients. The 1980s have been a period of expanding business and communications interests for him. Working from a home base near Glacier in the North Cascades of Washington,

he keeps busy with corporate, advertising and adventure travel assignments throughout the world.

DICKMAN, JAMES (Photojournalism)

c/o The Denver Post, 650 15th St., Denver, CO 80202 (303) 820-1010

Born: 1949 *Subject Matter:* Editorial *Situations:* U.S. & Foreign Locations *Awards:* Pulitzer Prize, 1983 *Education:* U. of Texas

His route to the Pulitzer Prize had as much to do with his social conscience as his photographic skills. In 1981 when he was a photographer for the *Dallas Times Herald*, he heard rumors that Salvadoran death squads were executing "enemies" and dumping the bodies in a lava field outside San Salvador. Dickman went down to investigate and found a graveyard beyond his most horrific imaginings. His photos of bullet-ridden skulls and other skeletal remains wrought an indelible image of brutality that shocked even the most callous observer. He left Dallas in 1986 and is currently a member of the photographic staff at the *Denver Post*.

DIEBOLD, GEORGE (Advertising, Corporate/Industrial)

416 Bloomfield Ave., Montclair, NJ 07042
(201) 744-5789

Born: 1953 *Subject Matter:* People *Situations:* U.S. Locations, Studio *Awards:* New Jersey Art Directors Club Award *Education:* Loretto Heights College, Denver

Taught theories of light through oil painting by Carol Jones, an illustrator for *Life*, he pays meticulous attention to detail in his photography. Before opening his own studio, he was a contract photographer for Bamberger's department stores, where he learned to photograph an enormous variety of products. Today, combining his sensitivity for detail and his various production skills, he often creates complicated shots, one such being a photograph for Gulf & Western of glowing footprints walking through the Grand Canyon, created in the studio in miniature. Such creative solutions have earned him contracts with AT&T, Federal Express, Duro Test Corp., Ingersol Rand and Ciba Geigy. He is currently photographing a collection of vintage guitars from the 1950s and 1960s that will be reproduced in poster form.

DIEDERICH, J. B. (Photojournalism)

Contact Press Images, 116 E. 27th St., New York, NY 10016 (212) 481-6919; (305) 274-8919

Born: 1963 *Subject Matter:* People, Events *Situations:* U.S. & Foreign Locations *Awards:* Honorable Mention, Pictures of the Year, National Press Photographers Association; Honorable Mention, Distinguished Reporting from Abroad, Overseas Press Club

Raised in Mexico City, at an early age he acted as a guide to foreign photographers and writers. At the age of fifteen he was given a camera by Alon Renenger of Contact Press Images in New York. By the age of seventeen he was publishing in local presses, freelancing on a part-time basis. He marks the start of his full-time career with the Haitian Revolution in 1986, at which time he was a member of the core of photographers allowed in the country. While he travels the world, he specializes in covering the Caribbean and Central America. Covering the political scene in Central America has taken him into the streets as well

as the government ballrooms of Guatemala, Nicaragua and El Salvador. In Haiti, he shot a feature story on AIDS in the country for *Life*. Other publications include *Time*, the *New York Times Magazine*, *Paris Match*, *La Republica* (Italy) and *Stern (W. Germany*.

DINN, PETER (Advertising, Photojournalism)

P.O. Box 264, 54-B Fore Rd., Eliot, ME 03903
(207) 439-7594

Born: 1950 *Subject Matter:* Fashion, Food *Situations:* U.S. & Foreign Locations, Studio *Education:* Academy of Art College; U. of California, Berkeley

Born in Trinidad, he came to the U.S. as an exchange student in the 1960s and pursued photography as an extracurricular activity in high school. It wasn't until he traveled to Spain, however, that he began his career, working as an assistant to advertising photographer Gary Chan. After two years with Chan, he began freelancing. His clients at the time included an oil company, local hospitals and advertising agencies McCann Erickson, Lonsdale, NCK and BB&B. He also began securing clients in England and in the States. In 1980, he moved to Maine where he now lives, and began working for fashion buyers and a variety of news, advertising and stock agencies. Today he additionally photographs sports events and corporate portraits. He brings to his work a rich multi-cultural perspective, which influences his unique color and people sense.

DIXON, MEL (Advertising, Editorial)

140 W. 22nd St., New York, NY 10011
(212) 645-8414

Born: 1939 *Subject Matter:* Fashion, People, Portraiture *Situations:* U.S. Locations, Studio *Awards:* Clio; Cebas *Education:* School of Visual Arts, NYC

While studying fine art at the School of Visual Arts, he worked as photo assistant. After three years of apprenticeship and two years in the U.S. Army, he had the opportunity to be assistant manager of Richard Avedon's studio, and later he managed Hiro Studio. After opening his own studio in 1969, he kept in mind the value of his training as an assistant, dedicating himself to training his assistants with high standards of photographic excellence. He has numerous clients in the fashion and beauty industries, as well as responsibilities as an executive portrait photographer. He brings his talents in people photography into advertising, working for such companies as Smirnoff and Clairol, setting up product shots involving people. He has done work for IBM Annual Reports and published in *Ebony*, *Harper's Bazaar* and numerous other magazines.

DODSON, RODNEY E. (Advertising, Portraiture)

P.O. Box 2357, Myrtle Beach, SC 29578
(803) 448-7214

Born: 1947 *Subject Matter:* People, Wildlife *Situations::* Studio, U.S. Locations

He began his career in photojournalism, becoming in 1971 one of the youngest newspaper editors and publishers in the country. Three years later, he opened a commercial studio specializing in creative portraiture, advertising and special events photography. His background in photojournalism is apparent in his commercial work, for which he uses his skills to develop a

Curtis Degler, *Nightswimmer*

Jay Dusard, *Buster Welch, Welch Ranch, Texas.* Courtesy: D.J. Stout, from "The Man Who Understands Horses" by Thomas McGuane

"story line" within a commercial format. Clients have included *Sports Illustrated*, New York Life Insurance Company and McDonald's. Much of his work is concentrated in advertising brochures, in which he shoots lifestyles and scenic panoramas for resort hotels and amusement parks. His studio is also responsible for various studio portrait assignments and wildlife stock photography, with an emphasis on water fowl and marsh life.

DOLE, JODY (Advertising, Editorial)
95 Horatio St., New York, NY 10014 (212) 691-9888

Born: 1955 *Subject Matter:* Still Life *Situations:* U.S. & Foreign Locations, Studio *Education:* Pratt Institute

He began making photographs and prints at age six, and fourteen years later he received his degree in visual communications from Pratt Institute. Today he shoots for both national and international advertising and editorial clients, including Smirnoff Vodka, American Express, Arista Records, Marithe & Francois Girbaud, and *Esquire*. Nominated for best new talent of 1989 by *American Photographer*, his work can be seen on ten pages of the *American Photography Annual Four* and on the cover and interior of the 1989 *Graphics Photo Annual*, as well as on the March 1989 cover of *Art Direction*. His recent still-life images are being exhibited in New York by the Bonni Benrubi Fine Arts gallery. A grainy, dreamlike quality characterizes his images, a quality perhaps best seen in his work for Smirnoff Vodka, shots for which he used holograms and laser light projected through a prism to create the effect.

DOMINIS, JOHN (Editorial, Photojournalism)
252 W. 102nd St., New York, NY 10025
(212) 222-9890

Born: 1926 *Subject Matter:* Animals, Food, People, Travel *Situations:* U.S. & Foreign Locations *Awards:* Magazine Photographer of the Year, U. of Missouri School of Journalism *Education:* U. of Southern California

In high school he studied photography under C.A. Bach and went on to take cinematography at the University of Southern California. In 1943 he joined the Air Force and, after his 1946 discharge, remained in Japan as a freelance photographer for the *Saturday Evening Post, Colliers* and *Life*. While there, he also completed a book on Japanese children, *The Forbidden Forest*. After joining the staff of *Life* in 1950, he covered a wide variety of events, including the Korean War, the beginning of the Laotian conflict, the early years of the Vietnam war and President Kennedy's term in office. In 1974 he became Picture Editor for *People* magazine, a position he held until 1978, when he moved to the same position at *Sports Illustrated*. He is now a freelance photographer, and in 1985 he photo-illustrated a 300-page cookbook, *Giuliano Gugialli's Foods of Italy*.

DONDERO, DON (Advertising, Photojournalism)
2755 Pioneer Dr., Reno, NV 89509 (702) 825-7348

Born: 1920 *Subject Matter:* People, Sports *Situations:* Aerial, U.S. Locations *Education:* U. of Nevada, Reno

He began his career as a pilot photographic officer in a dive-bomber squadron in the Pacific during World War II. Based on a carrier, he was shot down during a photo shoot over Manila Bay and he earned a Dis-

tinguished Flying Cross. When he returned to civilian life, he worked as a freelance photojournalist for local and national publications. A long list of magazines that have published his pictures includes *Fortune, Life, Sports Illustrated, True Detective* and the *National Enquirer*. After a period he expanded into commercial and advertising photography, as well as publicity shots for entertainers and public figures. On file are pictures of John and Ted Kennedy, Harry Truman, Richard Nixon, Ronald Reagan, Frank Sinatra, Marilyn Monroe, Bill Cosby, Lena Horne and many, many more. Presently he continues in a variety of avenues, including aerial and commercial photography, advertising and photojournalism.

DOWLING, JOHN S. (Photojournalism, Corporate/Industrial)
521 Scott Ave., Syracuse, NY 13224 (315) 446-8189

Born: 1948 *Subject Matter:* Travel, Sports *Situations:* U.S. Locations, Studio *Educations:* Syracuse U.

After eight years as a staff photographer for Syracuse newspapers and a brief stint as an art director for a regional magazine, he began a photography business engaged in studio, location and stock photography. He works in all formats in both black and white and color, using the former for "poetic-intellectual" qualities and the latter for emotional expression. He prefers to work with existing light and his speciality is action photography; his people-oriented, capture-the-moment style has enlivened many of central New York State's corporate and public relations communications. He has recently completed his course work for a masters degree in photojournalism and is seeking magazine assignments in news, features and travel. His past publication credits include *Time, Newsweek* and *Sports Illustrated*.

DOWNEY, MARK (Photojournalism, Entertainment)
1946 9th Ave., Oakland, CA 94606 (415) 533-2655

Born: 1960 *Subject Matter:* People, Travel *Situations:* Hazardous, U.S. Locations

His first years as a professional photographer were spent working for UPI and freelancing for such papers as the *San Francisco Examiner*, the *San Jose Mercury* and *Newsday*. The commercial work he does today still shows the influence of his time spent in photojournalism, which provides him a fine art/editorial slant for the pieces he shoots for ad agencies. He spends much of his time shooting for cruise lines such as Holland America and also maintains a steady schedule of photo essay work—for example, covering the Hmong people and their struggle to adapt to the American way of life, photos of which appeared in *World* magazine. Another in-depth photo assignments documented handicapped couples raising children. He also shares his expertise in photojournalism by appearing as a guest lecturer at many of the local colleges in the Bay area.

DOYLE, RICK (Advertising, Photojournalism)
232 N. Sierra Ave., Solana Beach, CA 92075
(619) 481-6742

Born: 1954 *Subject Matter:* Nature, Sports *Situations:* Hazardous, U.S. & Foreign Locations *Education:* San Diego State U.

He began taking pictures as a hobby while in the Navy and has since established himself as one of the leading photojournalists in the action-sports industry. His ar-

ticles and photographs appear regularly in several national and international publications. His sports-photojournalism focus, backed with his sense for top feature material, has enabled him to shoot many cover photographs and has taken him worldwide in search of the perfect environmental photograph in his favorite domain—the ocean. He has recently concentrated on product stills showing the product in peak action. Over his career, he has served as a photographer, contributing editor and photojournalist for a variety of companies and publication, including Nissan, BZ Pro Boards, *Sports Illustrated*, *Surfer*, *WaterSki* and *Outside*.

DREYER, PETER (Advertising, Corporate/Industrial)

166 Burgess Ave., Westwood, MA 02090
(617) 769-8323

Born: 1936 *Subject Matter:* Travel, Industrial & Computer Products *Situations:* U.S. Locations, Studio

Based in the Boston area, he is most often called upon to shoot computer and industrial installations, as well as people at work at and around computer terminals. He also produces a range of product pictures, from plain renderings to special effects. In addition to his industrial product work, he enjoys shooting architectural interiors and, occasionally, travel photography. Self-taught, he works in 35mm, 2 1/4" and 4" x 5" formats, clear samples of which appear in Volumes Seven, Eight and Nine of *American Showcase*. He has two books to his credit: *Nantucket in Color* and *Boston in Color*, both published by Hastings House, New York.

DUBLER, DOUGLAS (Portraiture, Fashion)

162 E. 92nd St., New York, NY 10128
(212) 410-6300

Born: 1947 *Subject Matter:* Fashion, Celebrities *Situations:* Studio, U.S. Locations *Awards:* Clio *Education:* Boston U.; Harvard U.

His first years as a professional photographer were spent underwater in Puerto Rico and the Virgin Islands, doing marine biology research. Completing this work, he opened a studio in Los Angeles and concentrated on fashion and beauty for six years, before moving to New York City, where he now shoots for advertising clients. Known for his extraordinary color and design, he has provided images for such companies as Avon, Revlon, Coty, Max Factor and Lily of France. His editorial photo essays have been included in the Italian *Vogue*, *Amica*, *Cosmopolitan* and *Redbook*.

DUHAMEL, FRANCOIS (Entertainment, Photojournalism)

7232 Sycamore Trail, Los Angeles, CA 90068
(213) 850-5853

Born: 1955 *Subject Matter:* People *Situations:* Film Sets, U.S. & Foreign Locations *Education:* Ecole Superieure de Journalisme Senterne, Lille, France

Trained in France, he began his career as a news photographer freelancing for the photo agency Sygma covering the Iranian revolution in 1978 and 1979. This was followed by a move to Los Angeles, where he went to work for Mega Productions, Inc., a Los Angeles-based photo agency. With an expertise in news features, he was published in major magazines around the world, his U.S. publications including *Time*, *Newsweek*,

Premiere and the *Los Angeles Times*. In 1983, his talents took him onto film sets, documenting the filming process from beginning to end for editorial and advertising purposes. By 1986 he was splitting his time between people and news features and film assignments that have included John Cassavetes' "Love Streams," John Huston's "Under the Volcano" and "The Dead," Ken Russell's "Crimes of Passion" and Peter Weir's "The Mosquito Coast." He has recently completed a photo essay on Los Angeles mural-painter Kent Twitchell as part of the 1988 "Artist's Images," an exhibition of images of artists by artists in Los Angeles.

DUNCAN, DAVID DOUGLAS (Photojournalism)

Castellaras 53, Mouans-Sartoux, Alps Maritime 06, France

Born: 1916 *Subject Matter:* War, People *Situations:* Foreign Locations, Hazardous Situations *Awards:* Overseas Press Club Award, Robert Capa Gold Medal *Education:* U. of Miami

A restless, inquiring photographer, Duncan has recorded the violence and beauty of life on five continents. Beginning as a combat photographer in World War II and continuing through assignments in Korea and Vietnam, Duncan captured war at its most horrific. Wounded himself in World War II and a recipient of the Legion of Merit, Duncan conveys a deep empathy for his subjects. From the lifeless eyes of a young soldier to more trivial aspects of clothing and appearance, his photographs are a haunting evocation of sadness and suffering. Duncan also has an eye for the idiosyncratic in life, capturing such details as painted sheep in Ireland or golfers teeing up amid Middle Eastern pipelines. His photographs of Picasso are perhaps the richest photographic record of any 20th-century artist.

DUNMIRE, LARRY (Advertising, Photojournalism)

P.O. Box 338, Balboa Island, CA 92662
(714) 673-4058

Born: 1950 *Subject Matter:* People, Sports *Situations:* U.S. & Foreign Locations *Education:* U. of Southern California

In search of the unusual photograph, he has climbed Alaska's 17,395-foot Mt. Foraker and rafted Venezuela's "blackwater rivers." An incurable travel photographer, he has photographed assignments in Europe, Central and South America, Australia, New Zealand, Tahiti and the Cook Islands and has commuted to the Hawaiian Islands three to four times a year to cover the Ironman Triathalon, the Pan Am Clipper Cup Series and the Transpac Yacht Race. Specializing in scenic cover shots, in particular ocean sites and activities, he has placed photos with some thirty-three different publications—*Sail*, *Boating*, *Discover Hawaii*, *Sea* and *New Worlds* among them. He has personally decorated the interior of McCormick's Landing restaurant in Costa Mesa, California, and with his expertise in boating/tropical/scenic motifs, he collaborates with Framing Concepts of Laguna Beach on numerous hotel decorating assignments.

DUNN, ROGER (Advertising, Corporate/Industrial)

544 Weddell, Suite 3, Sunnyvale, CA 94089
(408) 745-1630

Born: 1949 *Subject Matter:* Products *Situations:* Studio *Education:* Brooks Institute of Photography

Opening his studio upon graduating from Brooks Institute in Santa Barbara, he does the majority of work for businesses in the Silicon Valley. He is responsible for shooting a variety of products for annual reports, brochures, trade magazines and product releases and works with special effects from table-top to large-scale sets. His commitment to quality and his ability to manage the myriad of details encountered in the high-tech field have become his trademarks in the business.

DUNOFF, RICH (Corporate/Industrial, Advertising)

407 Bowman Ave., Merion Station, PA 19066

Born: 1952 *Subject Matter:* Nature, People *Situations:* U.S. Location *Education:* Temple U.

Though he is a skilled nature and travel photographer, he is known for his photography involving people. Usually working on location, he works for a number of corporate and advertising clients, including American Cyanamid, Conrail, Smithkline/Beckman, DuPont, Wyeth Labs and Scott Paper. Comfortable photographing both professional models and lay people, he achieves a natural look and combines this with a graphic sensibility defined by various lighting techniques and strong composition. As most of his work takes him on location, he frequently finds himself in the role of art director, creating the conceptual framework for the images. In addition to his corporate and advertising assignments, he has published editorial pieces in *Philadelphia Magazine, American Way, Ladies Home Journal* and *Health*. His recent work for *Philadelphia Magazine* featured directors of many of the city's cultural institutions.

DUNWELL, STEVE (Advertising, Corporate/Industrial)

20 Winchester St., Boston, MA 02116 (617) 423-4916

Born: 1947 *Subject Matter:* People, Nature, Industrial *Situations:* U.S. & Foreign Locations *Education:* Yale U.

He works on location, alternating between scenic and industrial assignments. His landscape photographs have been collected in a series of ten picture books on regional subjects, the most recent of which was entitled *Extraordinary Boston*. Major corporations have used his industrial photographs in annual reports and brochures. International assignments have taken him to more than thirty nations on five continents.

DURRANCE, DICK, II (Advertising, Photojournalism)

Dolphin Ledge, Rockport, ME 04856 (207) 236-3990

Born: 1942 *Subject Matter:* People, Wildlife *Situations:* U.S. & Foreign Locations *Education:* Dartmouth College

Born in Seattle and raised in Aspen, he started his professional career as a film and still ski photographer. Serving in the U.S. Army from 1966 to 1968, he worked in the Special Photographic Office in Vietnam, Thailand and Korea. Returning to the States, he joined the staff of *National Geographic*, where for seven years he shot assignments in Bangladesh, Calcutta and Leningrad, and on the North Sea and the Danube River. Book publications include *Lewis and Clark, Appalachian Trail* and *Rocky Mountains*. Since 1976 he has worked as a freelance photographer

shooting for corporate and advertising clients. These include Squibb, IBM, International Paper, Midland-Ross, SCM, and Pepsi on corporate assignments; General Motors, AT&T, Avis, J&B Scotch, Gallo Wines, Merit, Porsche and Amtrak are among his advertising accounts. He has also published his own book, *Where War Lives*.

DUSARD, JAY (Advertising, Photojournalism)

2221 View Dr., Prescott, AZ 86301 (602) 778-1999

Born: 1937 *Subject Matter:* Portraiture, Landscape, Composites, Photocollage *Situations:* U.S. & Foreign Locations *Awards:* Guggenheim Fellowship *Education:* U. of Florida

He is most famous for his quintessential portraits of cowboys, collected in *The North American Cowboy: A Portrait*. He works primarily in black and white, in 4" x 5" and 8" x 10" formats. While he has photographed landscapes and cityscapes, he eschews the scenic style, favoring more design-oriented abstract and experimental images. His background in architecture is evident in his concern with formal design elements in his photographs, including the possibilities of abstract collage and multiple imagery. Most recently, he has been on assignment on the American-Mexican border, documenting the drug trade, the plight of Mexican immigrants and the disparities between the two countries. He has exhibited at such locations as the Phoenix Art Museum and the Glenbow Museum in Calgary, Alberta.

DUSSINGER, MARSHALL (Advertising, Photojournalism)

329 Rhoda Dr., Lancaster, PA 17601 (717) 569-3551

Born: 1930 *Subject Matter:* People, Wildlife, Travel *Situations:* U.S. & Foreign Locations, Aerial, Hazardous *Awards:* Joseph Costa Award; Best of Show, Pennsylvania Publishing Association

Best known for his photographs of the Amish way of life, he has been a newspaper photographer for the *Lancaster Sunday News* for thirty years. During that time he has published a book of 100 color photographs of the Amish and more than 160 color post cards, primarily depicting Amish people. His travel photography includes shots of African landscape and wildlife, from elephants to birds. As a life member of the National Press Photographers Association, he has always been on the scene to cover news events, winning many prizes for his pictures. He also has experience as an aerial photographer. He produces, among other items, Christmas cards, business cards and brochures.

DUTTON, ALLEN A. (Editorial, Nature)

15235 N. 11th St., Phoenix, AZ 85022 (602) 942-0187

Born: 1922 *Subject Matter:* Nature, Travel, Nudes, People *Situations:* U.S. Locations, Studio *Education:* Art Center College of Design; Arizona State U.

A surrealist, he began by making realistic photographs when he received his first camera, an Argus C3, in 1947. In 1960 his first travel photographs were published, and during the following year he studied with Minor White. That same year, he founded the photography department at Phoenix University. By 1968 he had begun experimenting with photo-montages, buying an 8" x 10" in 1971 to document that work. In 1976 he worked in large format to make surrealistic images of nudes in the desert. In 1981 he began documenting every community in Arizona, a project

which continues to this day. His work is in the collections of the Museum of Modern Art in New York and the Bibliotheque Nationale in Paris. His pictures have appeared in numerous publications, including six books, most notably *The Great Stone Tit* and *Phoenix Then and Now*.

DWON, LAWRENCE (Corporate/Industrial, Advertising)

25 Broadway, Kingston, NY 12401 (914) 331-4620

Born: 1945 *Subject Matter:* Nature, Industry *Situations:* U.S. Locations, Studio *Education:* Utah State U.

A full service commercial-industrial photographer, he has worked for Design-X Communications—once a graphic house, now a full service advertising agent—for the past eight years. Seeing the need for a photography service in his area, he was responsible for starting the photography department within Design-X. Today, he is involved in every part of the process from concept to set and lighting design, shooting and film processing. With IBM contracts in four cities, Design-X is now branching into many other industrial and advertising arenas. Dwon attributes much of his photography dexterity to his various teaching experiences and a commitment to staying abreast of the latest developments in technique and processing.

DYKINGA, JACK (Photojournalism)

3808 Calle Barcelona, Tucson, AZ 85716
(602) 326-6094

Born: 1943 *Subject Matter:* Editorial, Landscapes *Situations:* U.S. & Foreign Locations *Awards:* Pulitzer Prize in Feature Photography; *Communication Arts* Annual Award *Education:* St. Procopius College

What has become a distinguished career in photography began in high school with his winning the *Look* National Snapshot Award. He next worked with Mike Rotunno photographing celebrities at O'Hare Airport in Chicago, making shots that paved the way for a position with the *Chicago Tribune*. He then moved across the street to the *Chicago Sun-Times*, where he won the Pulitzer Prize in 1971 for his pictures of the horrifying living conditions of those in the state mental health institutions. Leaving Chicago for Tucson in 1976, he worked as the picture editor for the *Arizona Daily Star* until 1981. As a freelancer, he has since concentrated on covering environmental issues. He collaborated in 1985 with author Charles Bowden to publish *Frog Mountain Blues*, a collection of color and black-and-white photographs that juxtaposed untouched wilderness landscape with decimated and torn-open land. He has recently worked on a book on the Sonoran Desert in Mexico. A collection of color shots, the series celebrates the beauty of the desert before the coming onslaught of civilization. He publishes regularly in *Time*, *National Geographic* and *Arizona Highways*.

ECKERT, ROBERT (Photojournalism, Editorial)

P.O. Box 217, El Rito, NM 87530 (505) 581-4460

Born: 1949 *Subject Matter:* Technology, Wildlife *Situations:* U.S. & Foreign Locations

Beginning at a weekly newspaper in San Diego, his career in photography advanced from covering editorial news to owning his own stock company, shooting mostly for himself. He freelanced for four years following his stint at the newspaper, taking on numerous assignments for news magazines and ad agencies. Today his company, EKM-Nepenthe, supplies stock photos to several agencies with long lists of clients. He is also spending more time on his artistic ventures and on self-publishing projects, as well as experimenting with infrared film and with work depicting technology. His latest project involves a series of oral-history interviews combining the voices and portraits of those interviewed with photos of the environment they inhabit. Over the years, he has published in a broad variety of media, from textbooks, audio-visual productions and in-flight airline publications to posters, newspapers and magazines.

EDINGER, CLAUDIO (Portraiture, Advertising)

456 Broome St., New York, NY 10013
(212) 219-8619

Born: 1952 *Subject Matter:* People *Situations:* U.S. & Foreign Locations *Awards:* LECA Medal of Excellence

His career as a photographer began in his native Brazil. Starting at the age of fourteen, he roamed the city of São Paulo taking pictures. He earned a degree in economics at MacKenzie University in São Paulo, but he saw himself making a strong political statement through photography. By 1975, he had placed featured pictures in *Veja*, a Brazilian newsweekly, and *EX*, a leftist political publication. His documentary of the ruin of the once-grand Martinelli Building in São Paulo truly established his career. Pictures capturing the "city within a city" appeared in major publications and were exhibited at the Museum of Art in São Paulo. Moving to New York in 1976, he spent his first two years photographing a community of Hasidic Jews. His following project documented the tenants and the architecture of the famed Chelsea Hotel. Primarily a black-and-white photographer, he shot the fortieth anniversary of India's independence from Britain in color. He has been widely published in major magazines, including *Time*, *New York Magazine*, *Vanity Fair* and *Connoisseur* and has three books *Chelsea Hotel*, *Venice Beach* and *The Making of Ironweed*—to his credit.

EDWARDS, ROBERT R. (Editorial, Scientific)

9302 Hilltop Ct., Laurel, MD 20708 (301) 490-9659

Born: 1945 *Subject Matter:* People, Still Life *Situations:* U.S. Locations; Studio *Awards:* Nikon Picture of Excellence *Education:* Prince George Community College

Although he was an art major in college, he mastered photography in the U.S. Army as a combat photographer in the Far East. He works as a photo illustrator, producing commercial and editorial work for local and national firms, publishers and audio-visual shows. Many of his audio-visual shows examine aspects of the agricultural industry. He has exhibited his work in a one-man show at the U.S. Department of Agriculture in Washington, D.C. and has shown in an exhibit in Beijing, China. His list of non-agricultural clients includes Delmar Publishers and Prentice-Hall Inc., Hong Kong Custom Tailors, the Joint Center for Political Studies and the Center for Science in the Public Interest. For these assignments, he produces many surrealistic still-life and table-top shots, created and done in the studio. Preferring not to retouch, he looks for lighting solutions that often result in the

dramatic colors and contrasts for which his work is known.

EGGLESTON, WILLIAM (Photojournalism)
4382 Walnut Grove Rd., Memphis, TN 38117
(901) 767-8673

Born: 1937 *Subject Matter:* People, Nature *Situations:* U.S. Locations *Awards:* Guggenheim Fellowship; NEA *Education:* U. of Mississippi

One of the premier color photographers of his generation, Eggleston was profoundly influenced by the work of Cartier-Bresson. Eggleston's bailiwick is the rural South and he photographs it with a practiced and uncompromising eye. His images are simple, direct and unadorned: they never allow the viewer the luxury of sentimentality. His colors are as rich and vibrant as his subjects are ordinary and unimportant. The result is a body of work that is accessible in a way that many more carefully wrought photographs are not. Today Eggleston lives and works in his native Memphis where his photographs continue to inspire new generations of photographers.

EGIDI, ARMAND A. (Portraiture)
3016 Tango St., Sacramento, CA 95826
(916) 364-5009

Born: 1935 *Subject Matter:* People, Portraiture, Fashion *Situations:* Studio, U.S. & Foreign Locations *Education:* St. John's U.

He began his photographic career in New York City while attending St. John's University, where he worked toward a degree in photography. Early in his career he worked for several studios, learning from several photographers in New York. Photographing weddings and model portfolios, he opened his own studio in 1981. As his wedding clientele grew, assignments took him north to New Hampshire, west to Colorado and south to the Caribbean. New York locations include the World Restaurant at the top of the World Trade Center, Helmsley Palace and the Ritz-Carlton Hotel. After four years he moved his base of operations across the country to California, where today he continues to cover weddings as well as models and television and corporate personalities.

EGLIN, TOM (Editorial, Advertising)
5150 S. Julian Dr., Tucson AZ 85706 (602) 748-1299

Born: 1945 *Subject Matter:* Fashion, Food, People, Electronics *Situations:* Studio, Aerial, U.S. Locations

His career began with a job on his high school yearbook. He later worked as a full-time photojournalist and then for ten years at the National Optical Observatory doing technical still photography, documentary films, research and public relations. Now, after twenty years of experience taking photographs, he has opened his own studio, where he specializes in commercial/industrial work for electronics firms and food photography for national magazines and books.

EGUIGUREN, CARLOS (Portraiture)
139 E. 57th St., New York, NY 10022 (212) 888-6732

Born: 1955 *Subject Matter:* People, Fashion *Situations:* Studio *Education:* Universidad Catolica, Santiago, Chile

After several years of freelance work in New York, he is finishing a book of portraits as well as several other projects for the record industry. He has exhibited some nudes photographed on Polaroid film and a series of portraits in Paris and has also worked in the fashion industry and for several magazines.

ELBINGER, DOUGLAS (Photojournalism, Advertising)
220 Albert St., East Lansing, MI 48823
(517) 332-3026

Born: 1949 *Subject Matter:* Fashion, Events, Wildlife *Situations:* U.S. & Foreign Locations, Studio *Education:* Michigan State U.

He has been a photographer since the age of twelve, and when in high school he had the rare opportunity to photograph the Beatles on stage during their 1966 concert at Olympia Stadium in Detroit. In the Soviet Union two years later, he photographed Russian tanks passing through Kiev as they made their way to Czechoslovakia. Those images and others made during that turbulent decade—of peace marches, love-ins and hippies—are all part of a portfolio that led him to realize his role as a historian. Now, in the footsteps of Mathew Brady more than a century ago, he takes photographs almost daily, taking care to capture the moments that will speak for today tomorrow. His work with museums and historical societies all over the U.S. has earned him a national reputation and a grant from the Bicentennial Commission to serve as a photographic history consultant. Elbinger Studios is recognized as a leading source for the copy and restoration of precious heirloom and historical photographs.

ELK, JOHN, III (Editorial, Nature)
3163 Wisconsin St., Oakland, CA 94602
(415) 531-7469

Born: 1945 *Subject Matter:* Nature, Travel *Situations:* U.S. & Foreign Locations *Education:* Carleton College; U. of California, Berkeley

Primarily an editorial photographer specializing in location and travel work, he has for the past five years been increasingly involved in stock sales and promotion. He creates his own stock assignments, marketing his own work personally and through agencies on both coasts and overseas. Files containing close to 100,000 images from nearly 100 countries and more than twenty-five states make up the bank from which he has published in national and international travel magazines, natural history magazines, corporate annual reports and calendars. Among his clients are Chevron USA, Winchell's, Explorer Cruise Lines and *Outdoor Photographer.*

ELLEFSEN, DWIGHT (Advertising, Photojournalism)
453 S. Wisconsin, Villa Park, IL 60181 (312) 832-5473; (312) 832-5209

Subject Matter: People, Technology, Science, Scenic *Situations:* Studio, U.S. Locations, Industrial *Awards:* Member, ASMP

The majority of his work is for advertising, annual reports and editorial assignments. He shoots in 35mm for photojournalism and works in formats ranging from 2 1/4" to 8" x 10" for his advertising work. One of his particular strengths is in color transparencies. He enjoys photographing children. "I attempt to photograph what I see with an artistic eye and create pictures that have feeling," he says. He has provided photos for the *Chicago Tribune* and McDonald's, as well as for annual reports for a number of cor-

Carlos Eguiguren. Courtesy: Living Music

Douglas Elbinger, *Mysterious Woman #52*

porate/industrial clients. His stock photography covers such subjects as children, people working, education, technology, science and industrial scenes.

ELMORE, STEVE (Advertising, Corporate/Industrial)

60 E. 42nd St., #411, New York, NY 10165
(212) 472-2463

Born: 1949 *Subject Matter:* Travel, Architecture *Situations:* Aerial, U.S. & Foreign Locations *Awards:* Certificate of Design Excellence, *Print Magazine Education:* UCLA; U. of New Mexico

Best known for his architectural work, he is assigned by developers and real estate agents to shoot interiors and exteriors of residential and commercial spaces. In the late 1970s he began his professional career while living in Italy. During the 1980s his pictures of New York City and travel photographs of Italy were featured in several calendars. He has photographed around the world for magazines, advertising agencies and designers. His work has appeared in over 200 publications, including The American Book Award Poster and the U.S. Express Mail Postage Stamp. He uses all formats, including 35mm, 2 1/4" and 4" x 5".

ENGEL, MORRIS (Photojournalism)

65 Central Park West, New York, NY 10023
(212) 362-1658

Born: 1918 *Subject Matter:* Editorial *Situations:* U.S. & Foreign Locations

A disciple of New York's Photo League, Engel was a particular admirer of Paul Strand. Engel's photographic essays of New York are justifiably famous: whether capturing lovers on a Coney Island beach ar a street scene in Harlem, he invested his subjects with dignity and individuality. Strand wrote of Engel's show in 1939, "He sees his subjects very specifically and intensely. They are not types, but people in whom the quality of the life they live is vivid, unforgettable." Engel served under combat photographer Edward Steichen in World War II before going on to further acclaim as a film producer and cinematographer.

ENGEL, MORT (Advertising, Publishing)

260 Fifth Ave., New York, NY 10001 (212) 889-8466

Subject Matter: People *Situations:* Studio *Education:* Art Students League

His training in illustration and design has provided him with the skills needed to bring a unique quality to his photography. Over a period of twenty years as an illustrator/photographer, he has received more than twenty-five awards for excellence from his peers and from professional creative societies. His photographic covers have appeared on books written by world-famous authors and published by Bantam, Dell, Warner, Avon, St. Martin's and Ballantine. Film advertisements for which he has produced images include "Once is Not Enough," "Peter Proud," "Manhattan," "Play It Again, Sam" and "Ragtime"; his poster for "Once is Not Enough" was chosen as one of the year's ten best.

ENGER, LINDA (Corporate/Industrial, Fine Art)

P.O. Box 17185, Phoenix, AZ 85011
(602) 252-5490

Born: 1955 *Subject Matter:* People, Nature, Fashion, Still Life, Architecture *Situations:* Studio, U.S. Locations *Awards: Communication Arts* Photo Annual *Education:* Southern Illinois U.

Bringing a background of theater and fine art to her commercial photography work, she strives to make the theatrical out of the everyday. Desiring mood and emotions to exude through composition, color and depth, her images are influenced by television and movies. Specializing in people with an emphasis on commercial illustration, she sometimes incorporates hand tinting into her work for annual reports, brochures, audio-visual productions and trade show work. Fine art work consists of landscapes, heavily manipulated with oil and pencil, as well as humorous greeting cards, which are also hand-tinted and painted.

EPPRIDGE, WILLIAM E. (Photojournalism)

518 Rothbury Rd., Wilmington, DE 1980
(302) 656-0173

Born: 1938 *Subject Matter:* People, Sports, Wildlife *Situations:* U.S. Locations *Education:* U. of Toronto; U. of Missouri

In the early 1960s, he studied under Cliff Edom at the University of Missouri. In 1963, he covered the International School of America's round the world trip for *National Geographic.* As a staff photographer for *Life* from 1964 to 1978, his assignments included the drug addicts of Needle Park, the anniversary of the Russian Revolution, the Beatles in New York City, and Robert F. Kennedy's presidential campaign. His photograph of Robert Kennedy's assassination is his most famous image. In 1978 he left *Life* and went first to *People* and then to *Sports Illustrated.* His assignments for *Sports Illustrated* have included the Winter Olympics, America's Cup races, fresh and salt water fishing, ice hockey, ice sailing and the environment. He is also a specialist in Arctic photography and cold weather gear.

EPSTEIN, ALAN (Advertising)

694 Center St., Chicopee, MA 01013

Born: 1946 *Subject Matter:* People, Products *Situations:* U.S. Locations, Studio *Education:* Columbia U.

Active as a professional photographer for twenty-four years, he has won numerous national, regional and local awards. After attending Columbia University, he worked as photojournalist and a portrait photographer. He was featured in several one-man shows in New York City and in Springfield, Massachusetts. Today he operates a commercial studio with his wife. A facility of 8,700 square feet, it contains a complete in-house processing and print lab. Multiple exposure, in-camera special-effects and metal and food photographs are the studio's specialties. Supplemental on-staff services available through the studio include fabric, floral and food styling.

ERGENBRIGHT, RIC (Advertising, Fine Art)

P.O. Box 1067, Bend, OR 97709 (503) 389-7662

Born: 1944 *Subject Matter:* Nature *Situations:* U.S. & Foreign Locations *Education:* U. of New Mexico; Art Center College of Design

A travel photographer and writer with over two decades of experience, he manages a stock file of some 250,000 images taken worldwide, and he works on assignment for such magazines as *Traveler, Stern, Adventure Travel* and *Darkroom Techniques.* His photographs appear regularly in numerous magazines,

Frank Aiello

John Alderson, *Concept Illustration for Airborne Infection.* Courtesy: Bruno Ruegg for Macmillan Professional Journals

Tony Arruza, *Eucalyptus Trees*

John M. Burnley, *Afterglow, Winter Deciduous Forest*

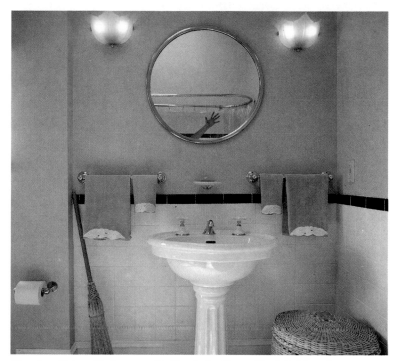

Carolyn Bates, *Bathroom with Hand.* Architect: Brad Rabinowitz

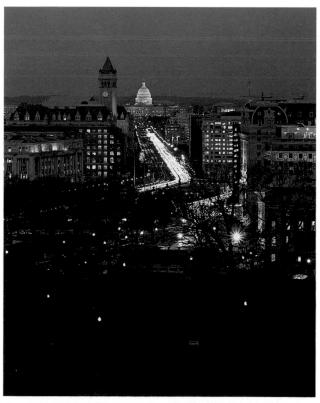

Carol M. Highsmith, *Pennslyvania Avenue, Dusk.* Courtesy: Pennslyvania Avenue: America's Main Street

Stu Block

Dale Boyer, *Billboard Painter*

Dale Boyer, *U.S. Marine with Flags*

David Brownell, *Zoom Shot of Ski Jumper-France*

Jim Arndt, *Reigning Cowboys.* Courtesy: Pat Burnham-Art Director

Ed Buryn, *Vagabond Self Portrait (White Sands, New Mexico)*

Michael Carlebach, *Watching Baseball, Coral Gables, Florida*

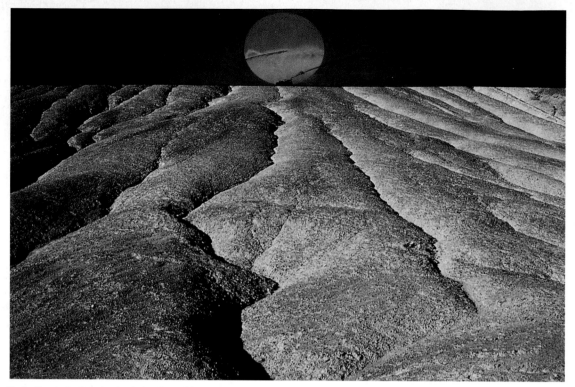

Luis Castañeda, *Agriculture Sprinklers and Dry Soil (Abstract)*

Gene Coleman

Steve Colletti, *Juke Box*

Margot Conte, *Polar Bear & Cub*

John F. Cooper, *Red Line/Dried Flowers*

Larry Dale, *Jeep Photo*

Darwin K. Davidson

Heather Davidson, *Sandhill Crane and Young*

Curtis Degler, *Underwater Swimmer*

Carlos Eguiguren, Courtesy: Paul Jenkins

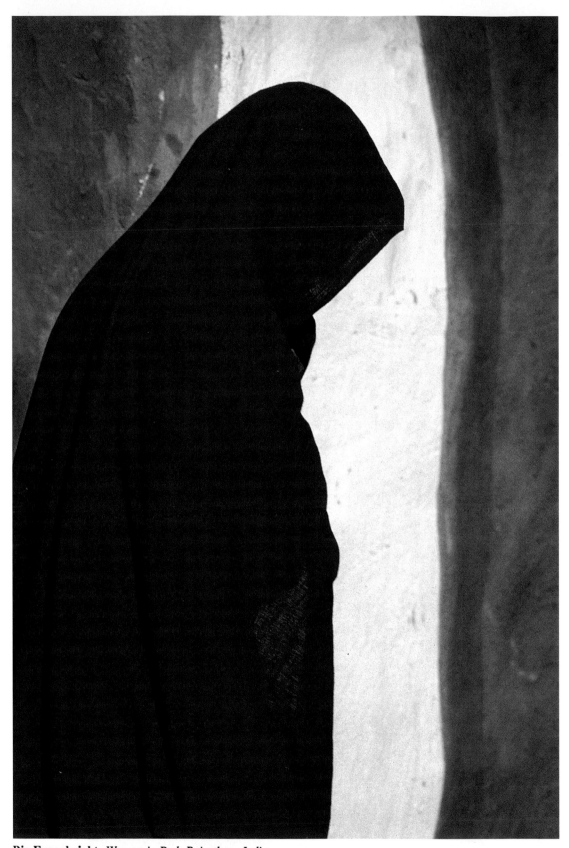

Ric Ergenbright, *Woman in Red, Rajasthan, India*

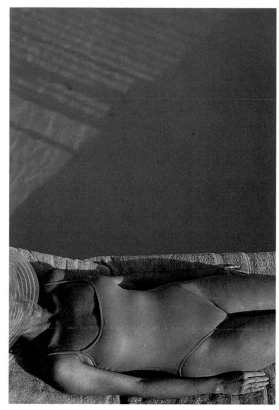

Faustino, *Woman in Pink One-Piece by Pool*

Derek Fell, *Deerfield Garden*

Jo Alison Feiler, *Round Tree/Blue Building/Black Windows (Reference #47)*

Jo Alison Feiler, *Cluny (Reference #35)*

books, ads and brochures and more than thirty complete calendars since 1984. "The Art of Photography at National Geographic," an exhibit at the Corcoran Gallery of Art and the International Center of Photography in New York, will include one of his images. Of his work he writes, "All things are on a journey, separately and together. To each it is different, to all it is the same. The difference beckons me to other lands, while the sameness allows me to understand. My photographs seek the unique and the universal in all that I see."

ERWITT, ELLIOTT (Fine Art, Photojournalism)

c/o Magnum Photos, 251 Park Ave. S., New York, NY 10010 (718) 966-9200

Born: 1928 *Subject Matter:* People, Dogs, Family, Events *Situations:* U.S. & Foreign Locations *Education:* New School for Social Research

Erwitt has produced humorous photographs of children, dogs, families, old people and people caught in awkward moments. He wants to capture moments that do not seem extraordinarily important to the average onlooker, as he finds these moments most intriguing. He uses a Leica M6 camera, which is small, quiet and inconspicuous. Erwitt spent two years studying film and worked as a photographic assistant in the U.S. Army Signal Corps and as a staff photographer under Roy Stryker for Standard Oil Company. His images have appeared in *Life, Look, Holiday* and other publications. He became a member of Magnum Photos cooperative agency in 1953 and has covered assignments all over the world. A recent project has resulted in perhaps the largest presentation of his work to date. "Personal Exposures," an exhibition and catalogue that opened in Paris in September, 1988, is a retrospective instigated by Erwitt himself who set out two years before to take stock of all the photographs he had produced since his high school days. Many of the selected photographs were taken for various clients over the years, and other images are memorable photojournalistic pictures that helped identify this photographer. There is, for example, the 1959 photograph of Richard Nixon and Nikita Khrushchev in a model American kitchen in Moscow engaging in a heated debate; the 1950 image of segregated drinking fountains in North Carolina that has been used in American history textbooks for generations; and the often reproduced images of President Kennedy in the Oval Office, among others. Erwitt has been most influenced by Cartier-Bresson and Doisneau.

ERWITT, MISHA (Photojournalism)

c/o New York Daily News, 220 E. 42nd St., 10017 (212) 210-1510

Born: 1954 *Subject Matter:* News *Situations:* U.S. & Foreign Locations, Studio

Working in his father's photo agency sorting photos at the age of fourteen, he was exposed a wide range of still shots. His own career in photography began, however, in film. For twelve years working in production as well as behind the camera, he spent time filming on advertising, documentary and feature sets. Shooting stills for location scouting, he became more and more interested in still photography. Finally, in 1983 he left film to shoot for the *East Side Express* tabloid for which he covered high society people and events. The paper was short-lived, so he began freelancing, publishing in Time Life Publications and in *People, Esquire* and

USA Today. In 1985 he was hired as a news/feature photographer at the *New York Daily News.* Recently, he spent two weeks in Israel covering relations between Israel and the U.S. He has published in several Collins Publishing books, including *Jews in America, A Day in the Life of Spain* and other *Day in the Life* books.

EVANS, MICHAEL (Editorial, Photojournalism)

1436 U St., NW, #450, Washington, D.C. 20015 (202) 387-4300

Born: 1944 *Subject Matter:* People, Politics, Location *Situations:* Studio, U.S. Locations *Education:* Brooks Institute of Photography

In 1967, he began his career as a staff photographer for the *Cleveland Plain Dealer.* From 1968 to 1974 he was staff photographer for the *New York Times.* In 1974 he became a contract photographer for *Time* magazine, turned to freelancing in 1976 and, through 1980, was affiliated with Contact, Gamma and Sygma. In 1981 he was appointed personal photographer to President Reagan, a position he held until 1985. He has now returned to *Time* as a contract photographer and remains affiliated with Sygma. He serves as executive director of "Homeless In America: A Photographic Project," in Washington.

FABER, JOHN (Photo Historian, Photojournalism)

Isle of Pines, Smith Mtn. Lake Rt. 1, Box 255, Moneta, VA 24121 (703) 297-5795

Born: 1918 *Subject Matter:* Historical, Research *Awards:* The President's Medal (3), National Press Photographers Association; Joseph Costa Award, National Press Photographers Association *Education:* U. of Alabama

Having worked as a technical specialist for Eastman Kodak for more than thirty years, today he is retired and pursues his interest in historical photography. As the top photo historian in the country, he provides information on memorable news photos and photographers and on historical news photography equipment to photographers, advertising firms, manufacturers, editors, publishers, students, authors, lecturers and television network news. He has published photos in five books, including *Great Moments in News Photography, Humor in News Photography* and *Great News Photos & The Stories Behind Them* and for numerous articles including "How Tom Howard Photographed the Electrocution of Ruth Snyder." He has been interviewed on television's "Today" show and in 1965 was introduced on "To Tell the Truth" as the first person ever to photograph the Tibetan Dalai Lama in exile in Dharamsala, India.

FALCO, RICHARD, (Photojournalism, Portraiture)

302 W. 87th St., New York, NY 10024 (212) 874-7967

Born: 1953 *Subject Matter:* People, Travel *Situations:* Hazardous, U.S. & Foreign Locations *Awards:* Grant, Department of Health, Education and Welfare *Education:* SUNY, Stony Brook

He practices a direct, socially conscious photojournalism. Among the topics of his photo essays and documentations of New York City are the homeless, AIDS, Bellevue Hospital and a chaplain at Rikers Is-

land Prison. In his first book, *Medics: A Documentation of Paramedics in the Harlem Community*, 1986, he depicted the paramedics as heroes in a gritty asphalt environment. He has recently finished a book of poetry and photos called *Cry From The Street* and has recently been expanding his activities to include corporate photography and teaching.

FALK, RANDOLPH (Editorial, Corporate/Industrial)

123 16th Ave., San Francisco, CA 94118
(415) 751-8800

Born: 1939 *Subject Matter:* People, Nature *Situations:* U.S. & Foreign Locations *Education:* San Francisco Art Institute; San Francisco State U.

Greatly influenced by the work of socially concerned photographers Kertesz, Lange, Smith, Steichen and Stieglitz, he devotes much of his time to documenting the workers of America whose jobs are threatened by automation and by foreign competition. His subjects include coal miners, steel workers, blacksmiths and others who make a living in labor-intensive jobs. Trained in fine art photography, he has published two books: *Bufano* documents the life and work of noted California sculptor Beniamino Bufano, and *Lelooska* is a photo essay of the nationally-known Northwest Coast Indian family and their art. In his commercial work, he specializes in people on location, working to achieve natural and intimate portraits. His work has been widely exhibited on the West Coast during the past decade.

FALK, STEVEN M. (Editorial, Advertising)

P.O. Box 88, Phoenixville, PA 19460 (415) 751-8800

Born: 1957 *Subject Matter:* Portraiture, Sports, Travel *Situations:* U.S. Locations

Eight of his ten years as professional have been spent covering the Philadelphia, southern New Jersey and Delaware areas for such major publications as *Time* magazine, *U.S. News & World Report, USA Today* and the *Philadelphia Inquirer.* Known for his location shooting and his use of obscure lighting, he enjoys photographing corporate executives in an environment away from their office, but one in which he can still capture their personalities. His one-on-one profiles are frequently used for cover shots, annual reports and advertising.

FALLS, ROBERT P. (Advertising, Editorial)

990 S. Shades Crest Rd., Bessemer, AL 35023
(205) 426-5689

Born: 1941 *Subject Matter:* People, Nature *Situations:* Studio, U.S. Locations *Education:* U. of Alabama

A founding member of the Photography Guild at the Birmingham Museum of Art and current director of an independent instructional workshop series, he participates in a full spectrum of projects involving photography. Shot with his 35 mm on a 4" x 5" format, his work has appeared in fine art galleries across the Southeast and in corporate collections. He has produced corporate and advertising illustrations and editorial work for several local and national publications. One photographic essay covered the street people in Birmingham, another a pictorial record of the seasons in the Smoky Mountains. His sports photography won the first Annual National Competition at the Kentucky Derby Museum and was exhibited there and at the Nikon Gallery in New York.

FARMER, TERRY (Corporate/Industrial, Photojournalism)

2218 Lynnhaven Dr., Springfield, IL 62704
(217) 793-3533

Born: 1959 *Subject Matter:* People, Travel *Situations:* Hazardous, Studio *Assignments Education:* Southern Illinois U.

He uses strong graphic design to add dimension to his photographs. Early in his career he covered the Illinois governor, state legislature and the political scene. In 1985 he opened his own business, Showcase Photography. He has since covered various assignments throughout the Midwest. At present he is most interested in creating environmental and candid portraits. His photographs have appeared in *USA Today, Forbes, Chicago Magazine, Insight* and the *Chicago Tribune.* The stock agency Click/Chicago carries a diverse selection of his work.

FAUSTINO (Advertising)

P.O. Box 2160, Durango, CO 81301 (702) 885-1948

Subject Matter: People, Travel *Situations:* U.S. & Foreign Locations *Awards:* First Prize, Television Advertising, Cartagena Film Festival; First Prize, Television Advertising, New York TV and Film Festival

He has had an extended career in advertising, both in the United States and abroad, in both still photography and in film. His style of photographing locations and people is well-known. From 1978 to 1982, he worked in South America, Europe and the Far East on major hotel and airline accounts and produced and directed over sixty television spots. He has studios in Houston, Dallas, Tahiti and New York and has exhibited all over the world. He works on a per contract basis, flying to locations from his ranch in Durango, Colorado, where he raises Morgan horses.

FEILER, JO ALISON (Editorial, Portraiture)

251 E. 51st. St., Suite #9G, New York, NY 10022
(212) 888-6945

Born: 1951 *Subject Matter:* People, Travel *Situations:* Foreign Locations *Awards:* Cash Award, 2nd All California Photography Show, Laguna Beach Museum of Art; Certificate of Art Excellence, Los Angeles County Museum of Art *Education:* UCLA; Art Center College of Design

At the age of thirteen, she began working as a photographer for a local Los Angeles newspaper. Her career broadened from straight editorial shooting to include film strips for McGraw-Hill educational films and publicity photos for various clients in the entertainment industry. In time she began concentrating on portraiture and editorial assignments for magazines in the United States and in Europe. Her black and whites show the influence of Edward Hopper's paintings, capturing a sense of isolation and contemplation, the inner world of experience feelings. Her color work, on the other hand, tends to be painterly and sometimes surreal. In addition to commercial publication, her works are widely exhibited, including solo shows in Los Angeles, New York and London. Collections reside in national and international museums including the International Museum of Photography, the Santa Barbara Museum of Art, the Metropolitan Museum of Art, the Museum of Modern Art, the Smithsonian Institute, the Bibliotheque Nationale in Paris and the National Portrait Gallery in London.

Dwight Ellefsen, *Children-Eskimo*

Ric Ergenbright, *Ronda, Spain*

FEININGER, ANDREAS B.L.
(Photojournalism)
c/o Daniel Wolf Gallery, 30 W. 57th St., New York, NY 10019

Born: 1906 *Subject Matter:* Nature, Architecture *Situations:* Location *Awards:* American Society of Magazine Photographers, Robert Leavitt Award; Art Directors Club of Metropolitan Washington, Gold Medal Award *Education:* Bauhaus, Weimar, Germany

Son of painter Lyonel Feininger, he graduated with high honors from the Bauhaus in 1925 and worked as an architect in Germany until 1931. In Sweden two years later, he worked as a photographer and became a staff photographer for *Life* after arriving in the United States in the 1940s. His work, both in color and black and white, includes careful depictions of architectural forms and street scenes that are documentary in approach. He has done a great deal of work in telephoto and close-up photography, including intricate nature studies. Images are often described as warm and intimate, European in style and sensibility.

FELL, DEREK (Editorial, Environment)
Box 1, Gardenville, PA 18926 (215) 794-8187

Born: 1939 *Subject Matter:* Gardens, Plants, Landscapes *Situations:* U.S. & Foreign Locations *Awards:* Best Book Award, Garden Writers Association of America

He may be one of the world's most widely published horticultural photographers, having contributed to newspapers, magazines, calendars and books worldwide, from assignments and also from a personal stock picture library of over 200,000 color transparencies of plants and gardens. Best known for the romantic quality he captures in his photographs of gardens, he composes images using fleeting climatic conditions, such as snow and mist, as well as the change of seasons, to show landscapes and gardens in mysterious and beguiling ways. In addition to his photographic work, he has also lectured extensively on camera technique and visual composition. He is the author of *How to Photograph Flowers, Plants and Landscapes.* "I work mostly with 2 1/4" format and avoid clichéd pictures of gardens flooded with sunlight, preferring to seek images that capture a sense of place and portray a definite season."

FELLMAN, SANDY (Advertising, Fine Art)
548 Broadway, 4E, New York, NY 10012
(212) 925-5187

Born: 1952 *Subject Matter:* Artwork *Situations:* Studio *Education:* U. of Wisconsin

A photographer of diverse talents, she has a wide reputation as a fine artist whose images are held in the collections of the Metropolitan Museum of Art, the Museum of Modern Art, the Center for Creative Photography and the Bibliotheque Nationale in Paris. She has an extensive commercial clientele, and her photographs have been used in many outstanding advertising campaigns. A wide variety of art and general interest magazines have given her editorial commissions as well. Among her published works is *The Japanese Tatoo.* She is represented by Witkin Gallery.

FERNANDEZ, JOSE (Photojournalism, Corporate/Industrial)
1011 Valencia Ave., Coral Gables, FL 33134
(305) 443-6501

Born: 1950 *Subject Matter:* People, Portraiture *Situations:* U.S. & Foreign Locations *Education:* Daytona Beach Community College; Cornell U.

His academic training complete, from 1974 to 1976 he was a staff photographer for the *Palm Beach Post* in West Palm Beach, Florida. In 1977, he moved to Venezuela where he set up a commercial studio, shooting mostly for corporate and industrial clients. From there he worked with J. Walter Thompson in Caracas, Venezuela as an in-house photographer for the next five years. He returned to the United States in 1983 and now resides in Miami, where he is a freelancer. He credits his diverse background and extensive commercial experience as having given him his eye for color and design, which provides him with an expertise in both corporate/industrial and photojournalistic photography.

FICHTER, ROBERT (Fine Art)
612 W. 8th Ave., Tallahassee, FL 32306
(904) 224-2715

Born: 1939 *Subject Matter:* Still Lifes *Situations:* Studio *Education:* Indiana U.; U. of Florida

With a background in painting and printmaking as well as photography, he uses photography as one more device for constructing an image. Many of his pictures are painted or drawn primarily in a primitive, gestural style—the photographic image offering another texture among several. Yet the photograph is integral to the magic of the final image. A carefully constructed, surreal world is built in his color Polaroids shot on his 20" x 24" camera. Toy Indians and soldiers, stuffed fish, old photographs, roses, souvenir scarfs and other objects both familiar and exotic create a world that one must contend with on its own terms, while it conjures forth an unsettling nostalgia. In the end, a personal iconography as well as a social commentary emerges.

FIELDS, BRUCE (Advertising, Corporate/Industrial)
71 Greene St., New York, NY 10012

Born: 1942 *Subject Matter:* Food, Products *Situations:* Studio *Education:* Washington Square College

His earliest influences were Irving Penn and Michael O'Neil for their elegance and technical refinement. His own fascination with light and line is explored with the camera, which he says he often uses "like an analytic tool." He describes his style as graceful and simple, eschewing trendiness for its own sake. His clients have included many major cosmetic companies and internationally known jewelers and designers. He has worked from his own studio since 1970. On assignment, he is frequently called upon to develop ideas with the art director, collaborating on layout and design for a given project. He has recently been working on a food portfolio to expand his range of clients.

FILIPE, TONY (Advertising, Corporate/Industrial)
239 A St., Boston, MA 02210 (617) 542-8330

Born: 1931 *Subject Matter:* Still Life *Situations:* Studio *Education:* U. of Rhode Island; Rochester Institute of Technology

"A still life is about light, not the object," he says by way of introduction. After receiving a degree in fine arts from the University of Rhode Island and studying an additional two years at the Rochester Institute of Technology, he approaches photography much the

Randolph Falk, *Coal Miner-Portrait*

Faustino, *Woman in White Hat with Necklace*

way a painter approaches a canvas. Indeed, as influences, he cites not only photographers Phil Marco and Irving Penn as influences, but the Dutch painter Rembrandt and the 20th-century American painter Edward Hopper. He works in all formats to produce meticulous, well-planned, organized shots, capturing a moment in time in *of the product*—creating a mood, a life the product lives in. Still life makes up the bulk of his work; he also produces corporate portraits for companies such as Lotus Development.

FILTER, KAREN (Editorial, Entertainment)
10024 Reevesbury Dr., Beverly Hills, CA 90210
(213) 273-2288

Born: 1956 *Subject Matter:* People *Situations:* Studio, U.S. Locations *Education:* Brooks Institute of Technology

She traveled around the U.S. and Europe photographing jazz musicians, and her show entitled "The Jazz Spirit" led to work for record companies, photographing rock & roll musicians. Influenced by Paul Outerbridge, Jr., she began experimenting with color in the darkroom and developed her own unique color process that resembles Technicolor. This extra dimension has attracted critical attention; a recently published book entitled *8 Visions* features some of her special color shots. She has recently been concentrating on celebrity photos for editorial use; stars who have taken advantage of her highly stylized and colorful technique include Melanie Griffith, Bette Midler and Jodie Watley.

FINE, SCOTT M. (Advertising, Editorial)
7320 S.W. 48th St., Miami, FL 33155 (305) 661-1211

Born: 1956 *Subject Matter:* Products, Fashion, Food *Situations:* Studio, U.S. Locations *Education:* Rochester Institute of Technology

Upon graduation from the Rochester Institute of Technology, he began his career in New York City as an assistant to some of the nation's leading product photographers. After one year, he opened his own studio where he photographed products, food and jewelry for numerous national and international corporations. Eight years later, he flew south to relocate in Miami, where he has extended his business operations to include full production of advertisements, brochures, catalogs, direct-mail and collateral material. Recognized for his techniques in lighting and design and his strict attention to detail, he is called upon by the nation's leading retailers, furniture and clothing manufacturers, and grocery and pharmaceutical distributors.

FINK, LAWRENCE (Social Documentary)
P.O. Box 295, Martins Creek, PA 18063

Born: 1941 *Subject Matter:* People *Situations:* U.S. Locations *Awards:* Guggenheim Fellowship; NEA Fellowship *Education:* Coe College; New School for Social Research

While he has taught at such institutions as Parsons School of Design, Yale University, the International Center of Photography and Cooper Union, the world he photographs has little use for such places. Touring the landscape of the lower-middle class in America, he takes photographs in the tradition of Robert Frank, Garry Winogrand and Diane Arbus. He works primarily in a framed, 2 1/4" image in black and white with flashed highlights and high contrasts to bring out detail, creating images in which he honors the brashness of this American class. While he "heroicizes" these scenes and people, critic Maren Stange writes, the photographs suggest that Fink shoots "a social milieu from which he himself has narrowly escaped. . . . In the un-self-conscious grins and the television-inspired, banal gestures of his subjects, all-too-lovingly caught, one senses the artist's faint sight of relief—'there but for the grace of God go I.'"

FIRAK, THOMAS (Advertising, Corporate/Industrial)
11 E. Hubbard St., Chicago, IL 60611 (312) 467-0208

Born: 1949 *Subject Matter:* Food *Situations:* Studio, U.S. Locations *Education:* Columbia College, Chicago

While still in college, he had his first professional opportunity photographing food for Kraft Foods. As a staff photographer for over five years, he covered a wide range of assignments which required 35mm location work and large-format studio shots. For the past ten years he has operated his own studio where he continues to work in the food industry. Attracted to challenges, he particurlarily likes sets which involve fire. For a Bulls Eye brochure, he wrestled with flames and a red hot branding iron. His work has appeared in newspapers, magazines, sales brochures and industrial books. Recently he finished a poster of chocolate for J. W. Allen Company.

FISHER, SHIRLEY I. (Editorial, Photojournalism)
P.O. Box 1081, Cupertino, CA 95015 (408) 446-1647

Subject Matter: People, Nature, Travel *Situations:* U.S. & Foreign Locations *Education:* Ohio U.

Trained in traditional, conventional photography techniques, she began her own darkroom research in order to devise a method to produce "inner landscapes." A result of combining unrelated images, these newly created ones seek to capture a universal, cosmic relationship between peoples. This work is done as an expression of her deep interest in world inter-cultural affairs. She works in either black and white or color and has written and illustrated her travels in the Canary Islands and Mexico. In search of the beginnings of mankind, she has done photographic essays on various cultures, including the remains and peoples of Machu Picchu, Easter Island, Pueblo, New Mexico and Chaco Canyon. Coordinator of the Photography Department at De Anza College, she exhibits, teaches and leads public seminars on both darkroom techniques and American photography.

FITCH, STEVE (Fine Art)
870 Helen Ave., Ukiah, CA 95482 (916) 462-2485

Born: 1949 *Subject Matter:* Landscape, Buildings *Situations:* U.S. Locations *Awards:* NEA Photography Grants *Education:* U. of California, Berkeley; San Francisco Art Institute; U. of New Mexico

Fitch is chiefly concerned with photographing emblems of America's Southwest, as seen in his publication, *Diesels and Dinosaurs*. Highways and strip developments are of greatest interest. His photographs tend to concentrate on drive-in movies, theaters, neon signs, billboards, motels and facades of buildings—he recalls being fascinated with these icons of the Southwest while vacationing as a child. He prefers to photograph at night, and thus he uses a variety of light sources, including the headlights of a vehicle, artificial

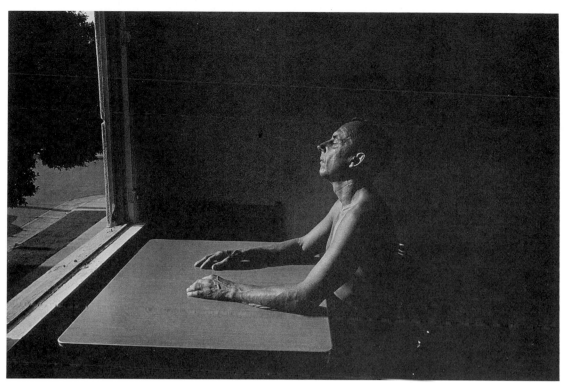

Jo Alison Feiler, *Man at Table by Window (Reference #36)*

Jo Alison Feiler, *Woman with Streaks of Light (Reference #30)*

light (neon or street lights) and moonlight. He also produces large-format color prints that are highly saturated with color. He seeks to achieve pulsating, luminous colors that sharply radiate through the darkness and foreboding of a desert night. Natural and artificial lights illuminate these empty landscapes with penetrating glimmers of light.

FITZGERALD, RALPH P. (Photojournalism, Editorial)

1333 Myers Rd., Ste. 101, Norfolk, VA 23513
(804) 855-0816

Born: 1960 *Subject Matter:* Sports, Concerts *Situations:* U.S. Locations

His interest in photography dates back to the second grade, when he won a second-place prize in a school-wide photography contest. By the time he reached high school, he decided to work on the school newspaper and yearbook staffs. He then joined the Navy, where he received his only formal education in basic photography as well as in advanced motion picture and television photography. He spent five years in the armed forces, handling assignments from ship launchings and intelligence gatherings to the Marines in Beirut. While in the Navy he began shooting concerts on his own. When he returned to civilian life, photographing concerts became his passion. In the last four years he has worked in black and white, developing his personal style of capturing live performances. He has published in such magazines as *Cosmopolitan*, *Rolling Stone*, *Record*, *Guitar Player*, *Guitar World*, *Creem*, *Teen Beat*, *Musician*, *Time Out* (UK) and *Imperial Press* (Japan). His photographs have also appeared in various newspapers and occasionally on album covers.

FLANIGAN, JIM (Advertising, Portraiture)

1325 N. 5th St. #F4, Philadelphia, PA 19122
(215) 236-4448

Born: 1942 *Subject Matter:* People, Products *Situations:* U.S. Locations, Studio *Education:* Westchester U.

He spent six years of his professional photography career as a staff pool photographer for the State of Pennsylvania. During that time, he learned the craft and discipline of photography, enabling him to open his own commercial studio in Philadelphia, out of which he operates today. His work has been described as "clean," although he prefers to call it "elemental." In confronting the "specialist versus generalist" dichotomy in the art of photography, he chooses to be a generalist with photographic specialties in shooting annual reports, corporate/industrial communications, architectural and design work, advertising, still life, product photography, executive portraiture and illustration. He is equally comfortable on location or in his studio.

FLESCH, VALERIE (Editorial, Corporate/Industrial)

41 Sutter St., Suite 718, San Francisco, CA 94104
(415) 956-4132

Born: 1940 *Subject Matter:* People *Situations:* U.S. Locations *Education:* Miami U.

For twelve years she worked out of New York and the Midwest as writer, photographer and editor on the public relations staff of a major telecommunications corporation. In 1974, she established her own photography studio in San Francisco. She now specializes in all types of location photography with an editorial point of view. Her business also includes portrait photography and audio-visual production. Her clients have included most of the major San Francisco Bay area concerns, and her images have appeared in the *San Francisco Examiner*, *Adweek* and *Underwriter's Report*.

FLOWERS, MOROCCO (Advertising, Corporate/Industrial)

520 Harrison Ave., Boston, MA 02118
(617) 426-3692

Born: 1952 *Subject Matter:* People, Still Life *Situations:* U.S. & Foreign Locations, Studio *Education:* Boston College

"I view my photographs as an outsider looking in, as an involved observer," he says. His work is intimate, shot close up and with directional lighting—a technique that provides a strong graphic sense, allowing the image to function powerfully whether in black and white or color. These photographs are detailed, with a light touch, a "simplified complexity" that conjures up memory. By viewing the obvious and the mundane from unusual angles, he nudges to the surface the ideas and the message latent in the subject. Currently, he is working on two series—a group of black-and-whites involving people and devoid of props and a project in color expanding on "slice of life" scenes.

FOREMAN, RICHARD (Advertising, Portraiture)

8033 Sunset Blvd., #438, Los Angeles, CA 90046-2427 (213) 850-3686

Born: 1953 *Subject Matter:* People, Travel *Situations:* Film Sets, Television Studios, U.S. Locations *Education:* Stanford U.

A Los Angeles publicity still photographer, he shoots for various production companies and film and television studios. His unit shots and scene stills regularly appear in trade magazines and film publicity. Credits include work with Francis Ford Coppola, Peter Bogdonovich, John Landis and Martin Brest ("Midnight Run"). The majority of his work is in color, and he prefers the 35mm format, using the 6" x 7" for portraits, wide-set shots and outside location work.

FOSTER, FRANK (Advertising)

323 Newbury St., Boston, MA 02115 (617) 536-6600

Born: 1935 *Awards:* First Place, New York One Show; First Place, Hatch, New England *Education:* Rhode Island School of Design

His photographic technique is based on the discipline of painting, which he has practiced from an early age. His shots have appeared in numerous magazine and newspaper ads. He is best known for his still lifes and his studies of people and food, although he also enjoys landscapes and seascapes. He has recently become fascinated by creating montages in the darkroom, manipulating and combining various and contrasting images.

FOTIADES, BILL (Advertising, Photojournalism)

R.R. 1 952 Rose Hill Road, Water Mill, NY 11976
(516) 726-4773

Born: 1935 *Subject Matter:* Food, Fine Art *Situations:* Studio

Shirley Fisher, *Stonehenge*

Shirley Fisher, *Celtic Pool*

He began working with Alexander Liebermann in the 1950s, photographing still-life and product advertising. Since then, he has expanded his interests, working extensively in food photography, where he innovated the use of moisture instead of lacquer on foods. His current work involves country panoramas and moonscapes, which he describes as "the most challenging and romantic photographs I have ever attempted." In the moonscapes, he works with a black backdrop, large graphic props and a bank of speedlights. His country panoramas explore the continual changes of the open sky.

FOULKE, DOUGLAS (Advertising, Portraiture)

28 W. 25th St., New York, NY 10010 (212) 243-0822

Born: 1953 *Subject Matter:* Fashion *Situations:* U.S. Location *Awards:* Andy, 1986 *Education:* Brooks Institute of Photography

His work, influenced by that of French painter J.J. Henner, is best known for its soft, ethereal quality. Shooting in all formats, he has developed a variety of techniques for each—using soft focus in his 8" x 10"s and a mix of color and black-and-white clips to create images in the smaller formats. He prefers "believable" light sources, again evidencing a painter's eye. Most of his work is in the fashion and advertising fields. In addition to obvious fashion applications in the areas of perfume and cosmetics, he is asked to create images for a wide range of clients; he recently completed jobs for Princess Cruises and Audi Automobiles.

FOX, FLO (Photojournalism)

30 Perry St., Apt 4., New York, NY 10014
(212) 255-1260

Born: 1945 *Subject Matter:* People *Situations:* U.S. & Foreign Locations

Robert Frank's picture of a trolley car helped her to notice the life in her immediate surroundings. Everywhere she goes she has been carrying a camera for the past fifteen years, searching for "ironic reality" while traveling, be it in the streets or in cemeteries. Shot in a photojournalistic style, her pictures have appeared in a myriad of publications, including her own books *Asphalt Gardens, 69 Photographs by Flo Fox* and *My True Story, A Photo Diary.* Her "photo-pointillist" work has been shown in the Philadelphia Museum of Art and has traveled nationwide in the "Art of the Eye" exhibit, which originated at the Minnesota Museum of Art.

FRANCOIS, ROBERT (Corporate/Industrial, Portraiture)

740 N. Wells St., Chicago, IL 60610 (312) 787-0777

Born: 1946 *Subject Matter:* Fashion, People, Architecture *Situations:* Studio, U.S. Locations *Education:* U. of Lausanne, Switzerland

Born in Switzerland, he began making photographs at age fourteen. In 1972 he moved to the U.S., splitting his time between graphic design and photography. By 1979 he became a full-time photographer. At present he primarily photographs annual reports for Fortune 500 companies such as Smith Barney and Harris Bank. This work includes portrait, table-top and location shots. He uses both color and black-and-white film. On location he specializes in available-light photography.

FRANK, JOHN A. (Corporate/Industrial, Editorial)

401 E. Prospect Ave., Mt. Prospect, IL 60056
(312) 253-6147

Born: 1942 *Subject Matter:* People, Health Care *Situations:* Studio *Education:* Illinois Institute of Technology

Early design work led naturally into a photographic career. The majority of his assignments have been for health care and health care related organizations. These have included shooting during a surgical operation. He has designed brochures, annual reports and newsletters for Zenith, Allstate Insurance and others, as well as editorial work for small magazines. He works in both black and white and color, commonly using 35mm and 2 1/4" formats.

FRANKEL, FELICE (Editorial, Corporate/Industrial)

202 Ellington Rd., Longmeadow, MA 01106
(413) 567-0222

Born: 1945 *Subject Matter:* Architecture, Still Life *Situations:* U.S. Locations *Awards:* ASLA Award for Landscape Photography

Trained in a photo lab, he achieves great precision in photographs that are both subtle and elegant. A keen sense of layout is apparent in each shot, and elements within his subjects that are not obvious at first glance are established and revealed. But it is the quality of light that is most important in his work, and for that quality he is sent around the country by national publications and landscape and architectural firms. Among the publications in which his work has appeared are *Garden Design, Landscape Architecture, Home, Decorating & Remodeling, Architecture* and the *New York Times.* He is also a member of the ASMP.

FREED, LEONARD (Photojournalism)

15 W. 46 St., New York, NY 10036

Born: 1929 *Subject Matter:* People *Situations:* U.S. & Foreign Locations *Awards:* NEA Grant

Viewing *Suspect in Police Car, New York* (1981), one's eye travels first to the sheen of the tightened back of a shirtless suspect, an instant later to the handcuffs drawing the hands together, the source of the contortion in the torso of the man. While there is a sculptural, abstract beauty in the form, it is immediately supplanted by the harsh reality of the situation. Self-taught in the art of photography, Freed photographs the lessons not taught in school—lessons that are hard to learn about others, but harder to learn about ourselves. Early photographs include a series on the life of the Jewish community in New York. Traveling to Europe after World War II, he returned with a deepened interest in the obstacles facing the Jewish people. Books include *Black in White America, Made In Germany* and *Police Work,* among others. His films include *The Negro in America.* He continues to publish in the *London Sunday Times Magazine, New York Times Magazine, Stern* and *GEO.*

FREEDMAN, JILL (Documentary)

181 Sullivan St., Brooklyn, NY 11231

Born: 1939 *Subject Matter:* People *Situations:* U.S. Locations *Awards:* 1st Prize, *New York Magazine* Photo Contest; NEA Grant *Education:* U. of Pittsburgh

Jim Flanigan

Morocco Flowers. Courtesy: Colonial Financial Services

Having studied sociology and anthropology in college, this self-taught photographer uses her camera to continue her exploration into the worlds we have carved out for ourselves, the worlds, to a degree, we have ourselves become. To do this she immerses herself in the life of her subjects. For her book *Circus Days*, she spent three months living with circus people. Her book *Old News: Resurrection City*, saw her participate in the poor people's march on Washington. Her last book, *Street Cops*, led to long hours on routes with the New York police. While she picks up an occasional magazine or newspaper assignment, she primarily devotes herself to book-length documentation, designing and writing the text as well.

FREEMAN, TINA (Editorial)
1040 Magazine St., New Orleans, LA 70130
(504) 523-3000

Born: 1951 *Subject Matter:* People, Interiors *Situations:* U.S. & Foreign Locations, Studio *Awards:* NEA Art in Public Places *Education:* Art Center College of Design

Trained as a commercial photographer at the Art Center College of Design in Los Angeles, she was first noted for her portraits. Today, while she still works in portraiture, her trademark is her use of natural light especially in interiors, landscapes and still lifes. During her fifteen years as a professional photographer, she has been involved in the field from a number of aspects: as curator from 1977 to 1983 of photography at the New Orleans Museum of Art; as author of articles on photography as well as the subject of articles; and, of course, as a photographer herself. Her work has been exhibited both in the United States and abroad. Magazine credits include *House & Garden*, the *New York Times Magazine*, *Southern Accents*, *Creative Camera*, *Architectural Digest* and *Art & Antiques*.

FRERCK, ROBERT (Editorial, Corporate, Stock)
4158 N. Greenview, Chicago, IL 60613
(312) 883-1965

Born: 1943 *Subject Matter:* People, Travel *Situations:* U.S. & Foreign Locations *Education:* Washington U.; Illinois Institute of Technology

He is a widely traveled freelance photographer, specializing in exotic people and locations. Immersing himself in his subjects to create images that capture the land, the people and their history, his work has taken him to every continent except Antarctica. Commercial assignments include corporate ads, brochures, annual reports and multi-media presentations, including the *Chicago Tribune*'s Water Tower exhibit, "Here's Chicago." A brief list of recent credits includes the *New York Times*, *Smithsonian*, *Encyclopedia Britannica*, American Express and Scott, Foresman.

FRIEDMAN, BENNO (Fine Art)
26 West 20th St., New York, NY 10011

Subject Matter: Multi-Media *Situations:* Studio *Awards:* Creative Arts Program Service Grant; Massachusetts Council on the Arts and Humanities Fellowship Grant *Education:* Brandeis U.

Controversy surrounds the work of this photographer. Some critics in the art community feel his manipulation of the photographs through painting, coloring, applying bleach and pencil drawing is so extreme that they question whether the results can still be referred to as photographs. Friedman maintains that any image made with a camera device is a photograph, regardless of the extent of transformation and he produces toned, hand-crafted, individualistic prints. Friedman has been a freelance photographer since 1966. He has contributed to *Esquire*, *Asahi Camera*, *Aperture* and *Popular Photography*. His work is included in the collections of the Boston Museum of Fine Arts, the Fogg Museum, Harvard University, the International Museum of Photography's George Eastman House, Massachusetts Institute of Technology and the Museum of Modern Art in New York.

FRIEDMAN, CAROL (Photojournalism, Portraiture)
60 Grand St., New York, NY 10013 (212) 925-4951

Subject Matter: Fashion, People *Situations:* Studio *Awards:* Art Directors Club

Primarily self-taught (though at one time she studied with the late Philippe Halsman), she divides her time between magazine assignments and album covers, for which she also often serves as art director. Her fashion photography has appeared in *GQ*, *Self*, *Mademoiselle* and *Connoisseur*. In the music industry, she has produced album covers for CBS, Elektra, Island, Manhattan and Blue Note. When doing an album cover, she works to achieve the image the artist wants to present while also capturing a visual sense of the music. For these shots, she uses custom-painted backgrounds. She is particularly interested in establishing the image of new artists—such as her album-cover work for singer Anita Baker. A collection of her work appears in her book *A Moments Notice: Portraits of American Jazz Musicians*; recently she has been working on a second book.

FRIEDMAN, TODD (Advertising, Editorial)
P.O. Box 3737, Beverly Hills, CA 90212
(619) 280-3595

Subject Matter: Sports *Situations:* U.S. Locations *Education:* Santa Monica College; UCLA

He is a sports photographer who established his own studio, Todd Friedman Photography, in 1974. He has been official photographer for World Team Tennis, the L.P.G.A. and the Virginia Slims women's tennis tournament. His photographs have appeared in *Business Week*, *Tennis* and *U.S. News and World Report*. His clients have included CBS Sports, Colgate, Phillip Morris, Bristol Myers and Home Box Office. He has taught photography privately and has been a guest lecturer at UCLA and the Art Center in Pasadena. He is currently represented by Focus West.

FRIES, JANET (Editorial, Portraiture)
4439 Ellicott St., N.W., Washington, D.C. 20016
(202) 362-4443

Born: 1949 *Subject Matter:* People *Situations:* U.S. Locations *Education:* Smith College; San Francisco State U.

She shoots environmental portraits for magazines. When she began her career as an art photographer in San Francisco, she often hand-colored her negatives. Since moving to Washington, she has worked regularly for *The Washingtonian*, including a monthly two-page spread of portraits called "People to Watch." "I love the one-to-one of portraiture . . . it's a continuing education," she says.

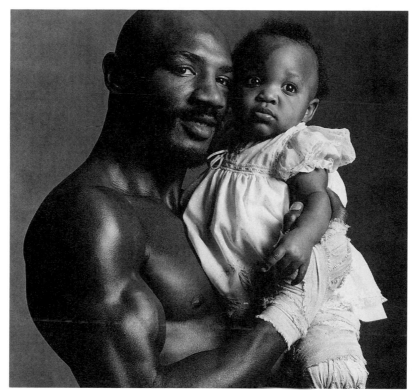

Frank Foster, *Marvin & Charelle Hagler*

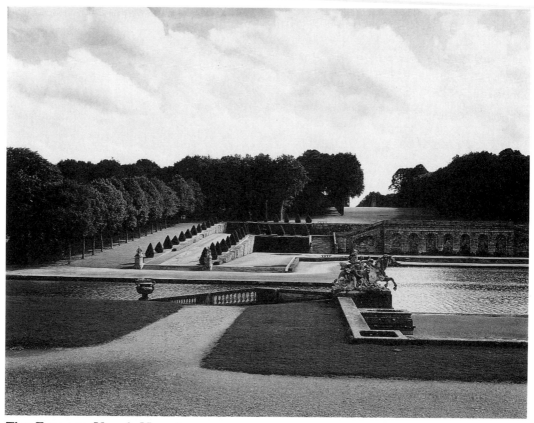

Tina Freeman, *Vaux-le-Vicomte*

FRISSELL, TONI (Photojournalism)

77 Harbor Rd., St. James, Long Island, NY 11780

Born: 1907 *Subject Matter:* Fashion; People *Situations:* U.S. & Foreign Locations

Trained as an actress, it was through her brother, a documentary film-maker, that she came to the art of photography. Primarily self-taught, she committed herself to a career in photography and for eleven years worked as a staff photographer for *Vogue* on the strength of the fashion photography for which she is still best known. As a fashion photographer, she was the first to photograph models outside, on location—developing the casual, spontaneous, sporty shots that are commonplace today. Her interest in people, however, goes beyond the clothes they wear. In 1968 she was one of only a few women photographers included in an exhibition called "Man in Sport." As a freelancer, she has criss-crossed the globe for travel and sports assignments. During World War II, she spent time with the Red Cross and the Air Corps, documenting people and their lives under extreme circumstances. For a period, her fascination with people focused on the lives of the upper class in Britain, a period that included a series of photographs of Winston Churchill and his family. Her own children have appeared in many of her photographs; dressed in costumes, they have been used to illustrate *Mother Goose* and Robert Louis Stevenson's *A Child's Garden of Verse*.

FRITZ, GERARD (Advertising, Photojournalism)

2420 Arnold Dr., Charlotte, NC 28205

(704) 536-6797

Born: 1950 *Subject Matter:* People, Industrial *Situations:* U.S. Locations *Awards:* Nikon Recognition Award

His interest in photography began when, armed with a Polaroid, he attempted to capture the brilliance of back-lit, ice-encrusted bulrushes. During his professional commercial career he has continued to refine his use of back-lighting and rim-lighting to delineate his subjects. This and a judicious use of a wide-angle lens are the key elements in his high-impact style. Most of his work keeps him traveling to various location assignments. Recently he has added photojournalism contract work to his already busy advertising schedule. His photographs appear on magazine covers and in advertising both in the United States and abroad, with his time between assignments spent shooting stock.

FUGATÉ, RANDY (Advertising, Corporate/Industrial)

6754 Eton Ave., Warner Center, Canoga Park, CA 91303 (818) 887-2003

Born: 1953 *Subject Matter:* Travel, Products, People *Situations:* Studio, U.S. Locations *Education:* Brooks Institute of Photography

First employed in a studio in Virginia with master photographer Morris Burchette at age fourteen, photography has continued to be a part of his life. He went on to study at Brooks Institute, with post-graduate work with the Alderman Company (one of the largest still studios in the world) where he did intensive work in the commercial advertising genre. Completing that work, he opened his own studio in Atlanta and for the next five years worked with such companies as Federal Express, Coca-Cola and J. Walter Thompson. He is now working on an exhibit of fine art photographs, selected from those accumulated during the past twenty years. Tentatively titled "Magister Et Luminis" these images explore the way light describes the world. He seeks in these photographs to depict not only objects and people, but also moods.

FULTON, JACK (Advertising, Fine Art)

109 Orange St., San Rafael, CA 94901

(415) 456-7469

Born: 1939 *Subject Matter:* Travel, Photo-Collage *Situations:* U.S. & Foreign Locations *Awards:* Eugene Atget Award, Ville de Paris; NEA Fellowship *Education:* College of Marin

Self-taught as a photographer, he was educated in art history, creative writing and architecture. Since the early 1960s, he has used writing in conjunction with much of his work; however, his major output is color imagery. Although he prefers his own art photography, he does work commercially and has won awards for this type of work. He has taught at the San Francisco Art Institute, introducing many new types of classes, since 1969. Recently he has been concentrating on shooting color photography in Paris, the French countryside, the American West, Kenya and Tanzania. Many of the African shots are hand colored and combined in a collage format. Often the photographs are truncated, challenging the viewer to complete the image.

FUNK, MITCHELL (Advertising, Special Effects)

500 E. 77th St., New York, NY 10162 (212) 988-2886

Born: 1950 *Subject Matter:* Animals, Nature *Situations:* Aerial, Underwater, U.S. Locations

He is best known for his design skills, strong graphics and bold colors. One of his specialties is multiple exposure. He has had cover and feature photographs in such magazines as *Life, Fortune, Newsweek, Business Week, Omni* and *New York* magazine. He has also done advertising for IBM, AT&T, Data General, Nikon and Oldsmobile. Most of his work is done on location.

FUSS, ADAM (Fine Art)

438 Bedford, Brooklyn, NY 11211 (718) 387-2890

Born: 1961 *Subject Matter:* Still Life, Portraiture *Situations:* Studio, U.S. & Foreign Location *Awards:* New Face 1989, *American Photographer*

"The technology of photography has superseded its images. My mission is to advance what we know of the image, " he says. To do so, he has returned to simple photographic processes. Interestingly, the simpler the process, the more complex the information, because it appears so foreign to eyes raised on television and *Time* magazine. His photogram—the image he derives from physical substances in contact with light-sensitive material—of a pile of powder, for example, looks something like the surface of a blue moon with a hole blown through it. Other images are made via photographic print-making processes where the positive is made from a non-photographically derived negative. He shoots in all formats, including the pinhole camera, though most recently he has experimented with a large 20" x 24" camera format.

Robert Frerck, *Museum of Anthropology, Mexico.*
Client: Odyssey Productions, Chicago

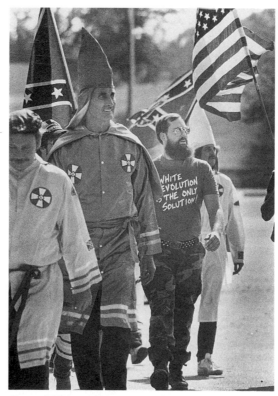

Gerard Fritz, *"White Evolution is the Only Solu-*
tion" Ku Klux Klan Marches in Charlotte, NC

FUSS, EDUARDO (Environment, Photojournalism)

P.O. Box 8400, Santa Fe, NM 87504-8400
(505) 988-9172

Born: 1938 *Subject Matter:* Nature, Travel *Situations:* U.S. Locations

He is a full-time freelance editorial photographer who takes assignments for a wide range of general interest and travel magazines. He is able to capture the moods and feelings of places and people, and he is best known for his photographs of the patterns, images and designs he finds in the ice of ponds, rivers and streams. He was formerly curator of the Joseph Hirshhorn private collection, and he now often works with writer Susan Hazen-Hammond. His photographs have been exhibited in galleries in New York, Connecticut and Maine and have been featured such magazines as *Audubon, Smithsonian, Travel & Leisure, Arizona Highways, Bunte Illustrierte* and *Regent*

GAFFGA, DAVIS A. (Photojournalism, Advertising)

P.O. Box 750, Koral Dr., Southhampton, NY 11968
(516) 283-9010

Subject Matter: People, Architecture *Situations:* U.S. Locations

While an architectural designer working "on the boards" eighteen years ago, he began taking photos of the projects he was working on. For the past eleven years, he has been a full-time photographer specializing in shooting interiors and exteriors of buildings. His background in architectural design provides him with a special understanding of the structures he photographs, evident in his innovative lighting solutions. Much of his photography is used editorially and in advertising, and photos have appeared in such magazines as *Home Entertainment, Cosmopolitan, Time* and *Newsweek*. He also shoots a number of annual reports each year.

GAGLIANI, OLIVER L. (Fine Art)

605 Rocca Ave., S. San Francisco, CA 94080

Born: 1934 *Subject Matter:* Nature *Situations:* U.S. Locations *Awards:* NEA Grant; Fisher Grant, U. of Arizona, Tucson *Education:* California College of Arts and Crafts; California School of Fine Arts (now San Francisco Art Institute)

If music lives in the assembled essence of sound, so do Gagliani's photographs live in the captured essences of the objects in the world around us. Trained in music and later self-taught in photography under the influence of the West Coast school, he orchestrates his palette of gray tones to draw forth the life within a chair, a broken window, a fallen wall, a vine scaling the height of a tree. "From these objects in the world, from their own lives which often far outlast our own," he writes, "we can acquire a wisdom which would otherwise be inaccessible to us. It is the photographer, through the medium of light, who must confront these objects directly, not as he would like them to be, but as they are in themselves." Carefully and precisely composed, the images in his photographs are both abstract and concrete, a tension that provides for metaphor.

GALANTE, DENNIS (Advertising)

9 W. 31st St., New York, NY 10001 (212) 239-0412

Born: 1956 *Subject Matter:* Food, Cosmetics *Situations:* Studio *Education:* City College of San Francisco

"I photograph each and every assignment as if I were working on my book," he says by way of introduction. Bringing the same intensity to his professional work that he does to his personal work, he is apt to turn down a project that will not allow for integrity. His results, however, speak for themselves, and his studio is kept busy providing work for the major ad agencies in New York City. Typical subjects include everyday objects shot in an unusual way, employing a characteristically simple, clean graphic style using primary colors. He has recently been shooting for *Food and Wine*.

GALTON, BETH (Advertising)

130 W. 25th St., New York, NY 10001

Born: 1953 *Awards:* Nikon Advertising Award; Art Director's Show *Education:* Hiram College

She began her career as a photo assistant and soon distinguished herself as one of the new wave of woman still-life photographers. She brings a feminine sensibility to her work, creating scenes and moods to produce integral images. In addition to her extensive work in advertising, her photo credits include such magazines as *Photo Resources* and *American Photographer*. She is a notable photographer of food; in 1986 she collaborated with author Martha Stewart on her book *Pies and Tarts*. She has finished a book on American folk crafts.

GARACCI, BENEDETTO (Advertising)

1821 W. Alabama, Houston, TX 77001
(713) 526-5278

Born: 1953 *Subject Matter:* Products, Special Effects *Situations:* Studio *Awards:* Communication Arts Photo Annual *Education:* Brooks Institute of Photography

Influenced by Salvador Dali, he is a specialist in camera special effects, using multiple exposures and a large-format 4" x 5" camera but eschewing retouching or darkroom tricks. At the age of six, he began making oil paintings, and in 1965, at age twelve, he was taking photographs. While in high school he worked for the yearbook and the *Daily Iberian*, the town newspaper. He joined the air force as a military photographer, and there went to photojournalism school. His air force assignments included photographing Tactical Air Command bases. He has had his own Houston studio since 1979. His work has appeared in magazines, advertising, newspapers and multi-media presentations.

GARTEL, LAURENCE M. (Editorial)

270-16B Grand Central Pkwy., Floral Park, NY 11005 (718) 229-8540

Born: 1956 *Subject Matter:* Special Effects, Photo-Collage *Situations:* Studio *Awards:* New Jersey Art Directors Award; Residency Grant, Experimental TV Center, NYC *Education:* School of Visual Arts, NYC

A pioneer in electronic imaging, he has been involved in exploring new photography since the beginning of his career as a photographer. Funded by Polaroid, he has worked with their SX-70, as well as Cibachrome, in developing this new imaging. Beginning with an image generated non-electronically, he then makes a collage that is design-oriented in color and form, each image capable of standing on its own—for example, he makes a pattern in the center and a separate one at the border. This process might involve up to 324 in-

dividual images that will be organized into one. Fascinated with taking the everyday and manipulating it in order to show an entire new universe, he works with such mundane objects as a doll or other toys. A ball can become a planet or the head of a dinosaur. He believes that his field, while currently avant garde, will eventually enter the mainstream of photographic imagery.

GATEWOOD, CHARLES ROBERT (Editorial)
50 W. 22 St., New York, NY 10010

Born: 1927 *Subject Matter:* People, Deviant Behavior *Situations:* U.S. Locations *Awards:* Leica Medal of Excellence, New York; Merit Award, Art Directors Club of New York

Pushing the Ink: The Fine Art of Tattooing and *Sidetripping* are two books of his photography that showcase his talent for capturing the slices of life that cut through the conclusions we have of others (or ourselves, for that matter). With his camera he finds the unusual, the fringe and, in particular, the sexually deviant, photographing, as critic Jack Schofield writes, "the twisted ones that convince us that normal people are actually quite bizarre and the human ones which persuade us that those bizarre-looking people are actually quite normal." The pictures are shot straight on—two girls on the subway comparing their bared breasts; a portrait of a participant in the occult, as in *Lord Balkin* (the *Forbidden Photographs*). Tightly cropped and free of extraneous detail, the image greets the viewer like a skilled panhandler, before the viewer can turn away.

GEIST, WAYNE DAVID (Advertising, Portraiture)
48-42 44th St., 1F, Woodside, NY 11377
(718) 361-2912

Born: 1955 *Subject Matter:* People, Architecture, Art *Situations:* Studio, Architecture *Awards:* Adam Meldum and Anderson Award, Albright Knox Art Gallery, 1980 Western New York Show *Education:* SUNY, Buffalo; U. of Rochester, NY

He has worked professionally as staff photographer for a number of museums and galleries. Shooting both color and black-and-white photos in 35mm, 2 1/4" and 4" x 5" formats, he has created pictures for museum catalogs, press releases, posters, books and record albums. His work is characterized by a stark expressionism derived from extremes of contrast, grain and scale in black and white. He takes varied portraits, some on location, some in the studio, using both natural and artificial light. Recently he has developed his own silver bromide emulsion used on hand-made artists' paper. His personal work consists of black-and-white experimental street portraits, 20" x 24" in size, characterized by forced perspective achieved through the use of telephoto lenses.

GERCZYNSKI, TOM (Advertising, Corporate/Industrial)
2211 N. 7th Ave., Phoenix, AZ 85007 (602) 252-9229

Born: 1947 *Subject Matter:* People, Landscape, Architecture *Situations:* Studio, U.S. Locations *Education:* Phoenix College

Although he has maintained a small studio in the same historic building for many years, his location work takes him across the country. Specializing in outdoor photography, from waving wheat fields to still desert

panoramas, he has published photos in such national magazines as *Popular Mechanics*, *Forbes* and *Arizona Highways*. The architectural work he does is largely residential. Striving for highly stylized, elegant shots, he often shoots with tungsten lighting. Partial to the light and people of the American Southwest, he sees his photography as a way to promote the area.

GERLACH, MONTE (Advertising, Corporate/Industrial)
705 S. Scoville, Oak Park, IL 60304 (312) 848-1193

Born: 1950 *Subject Matter:* People *Situations:* U.S. Locations, Studio *Education:* Illinois Institute of Technology

From the beginning he was a photojournalist who wanted to teach. After working for *Play Magazine* for three years, he began teaching at colleges and university and has done so, splitting his time between his commercial photography business and the classroom, for the last twelve years. His business finds him shooting executive portraits, colleges and other location work, specializing in creating a sense of harmony between the subject and his surrounding environment. Fifty percent of his work is studio and catalogue for clients such as Calumet Photographic and NEC. In these shots, he creates eye-appealing, highly graphic still lifes, often using a number of special lighting techniques, including studio strobes, reflectors and gels to produce the effect.

GERRETSEN, CHAS (Advertising, Entertainment)
1714 N. Wilton Pl., Hollywood, CA 90028
(213) 462-6342

Born: 1943 *Subject Matter:* People *Situations:* U.S. & Foreign Locations *Awards:* Robert Capa Gold Medal

His background as a photojournalist helps him to capture and anticipate photogenic and salable situations on movie sets as well as in advertising and publicity campaigns. Before beginning his entertainment career in Los Angeles, he spent ten years photographing wars, revolutions, elections, floods and other world events for major magazines around the world. His first major movie still assignment was for the film "Apocalypse Now." In 1976 he started Mega Productions, Inc. and he now works from his own 5,000-square-foot soundstage in Hollywood and on location.

GIANDOMENICO, BOB (Advertising)
13 Fern Ave., Collingswood, NJ 08108 (609) 854-2222

Born: 1931 *Subject Matter:* Products, People *Situations:* Studio *Awards:* Ad Club of Pennsylvania & New Jersey; Photographers Forum *Education:* Philadelphia College of Art

While serving in the Armed Forces in Korea, he bought his first camera, a Brownie, and so began his "life-long addiction" to photography. When he returned to the U.S., he attended Philadelphia College of Art, where he graduated in 1960. For a number of years he taught photography classes at night while manning the camera during the day as a staff photographer for Mel Richman, Inc. In 1966, he opened his own studio, converting an old art deco movie theatre in Collingswood, New Jersey into a 10,000-square-foot work area. He has contributed to successful and award-winning advertising campaigns, photographing everything from open-heart surgery to delicate porcelain figurines, sometimes

going to such lengths as hanging from a helicopter to achieve the right angle and shot. His national accounts include RCA, Campbell's Soup, Scott, DuPont and many more.

GIBSON, RALPH (Fine Art)
331 W. Broadway, New York, NY 10013
(718) 966-6307

Born: 1939 *Subject Matter:* People, Objects *Situations:* Studio *Awards:* NEA Photography Fellowship; Guggenheim Fellowship *Education:* San Francisco Art Institute

Gibson was first introduced to photography while serving as an assistant to a naval photographer in the mid-1950s. He later served as an assistant to Dorothea Lange. His images have appeared in journals such as *Camera, Camera International, Creative Camera, Camera 35, Popular Photography* and *Modern Photography.* Gibson is best known for his minimalist, surrealist style, shot mainly in black and white. In his work the picture is composed of generalized forms and human figures that are fragmented and thrust beyond the edge of the picture frame. He strives for heightened blacks and greater textures while sacrificing detail. He tends to work in series and often presents his work in book form to have some regulatory control over the viewer's response to his fragmented images. With this guidance he hopes to solicit the greatest potential viewer response to his enigmatic subject matter. He was the founder of Lustrum Press in New York.

GIDAL, TIM N. (Photojournalism)
16 Nili St., Jerusalem, Israel

Born: 1909 *Subject Matter:* People, Society *Situations:* Foreign Locations *Education:* U. of Berlin; U. of Munich

Most of his photographs have been meant for himself and shown only amongst friends, but both his private and photojournalistic work centers on the "tragi-comedy of human life." For example, in *Gas Mask Training, London,* the foreground shows a nun wearing a gas mask while being instructed on the use of the apparatus, and behind her sit two more nuns apparently taking notes. On the wall, a picture of Jesus witnesses the preparation for war. Poignant and comical at the same time, the image fuses together two primal human forces: love and hate. The viewer is caught between a vision of the absurdity of life and a deep compassion for the human condition. As a photojournalist, he has published in books and magazines. Among the books are *Picture Reporting and the Press, Israel Year, Modern Photojournalism: Origin and Evolution 1910-1933* and *Everybody Lives in Communities;* magazines include *Camera, Creative Camera, Look* and *Life,* as well as *Picture Post,* for which he worked from 1938 to 1940.

GIGLIO, HARRY (Advertising)
925 Penn Ave., Pittsburgh, PA 15222 (412) 261-3338

Born: 1950 *Subject Matter:* People, Product Illustration *Situations:* Studio *Awards:* IABC, Pittsburgh *Education:* Carnegie Mellon U.

After completing a degree in fine arts and design, he decided to pursue a career in photography. His work started out primarily as industrial photojournalism involving much travel but eventually developed into studio assignments for corporate and consumer adver-

tising. He is best known for his use of lighting, especially in regard to his work in product illustration. His achievements in lighting, he says, stem from his view that a photograph is created the same way as a painting is. High-technology special effects are his second specialty. Recently, he has been working on a series of food stills for animation for a television commercial. He is often given creative and conceptual control on a job, and in such cases he becomes an art director as well as a photographer.

GILMORE, SUSAN (Advertising, Corporate/Industrial)
8415 Wesley Dr., Minneapolis, MN 55427
(612) 545-4608

Born: 1954 *Subject Matter:* Interiors, Architecture *Situations:* U.S. Locations, Studio *Education:* Brooks Institute of Photography

After graduating from Brooks Institute in California, she moved to Minneapolis, where she began shooting interiors for a local magazine. This work continued and expanded, and eight years later, she shoots for a variety of *Better Homes and Gardens* books and magazines such as *Remodeling Ideas, Building Ideas, Kitchens and Baths, Needle Crafts, Crafts* and *Grandparents.* Additional skills in architectural photography have led her to assignments for corporate advertisements and brochures, as well as for architecture and interior design magazines.

GIRARDI, CAROL HERNANDEZ (Fine Art, Advertising)
448 Woodbluff Rd., Calabasas, CA 91302
(818) 712-0071

Born: 1952 *Subject Matter:* Fashion, Wildlife *Situations:* U.S. & Foreign Locations *Awards:* Bronze Quill; California Award of Excellence, IABC *Education:* Rochester Institute of Technology

Her early work explored non-silver processes, the results of which have been exhibited at the George Eastman Museum of Photography and at numerous other major cultural institutions. Versed in a variety of photographic and artistic (mixed-media) processes, she is known for her highly creative and eclectic style. Her photographic illustrations are used extensively in advertising and corporate/industrial communications, including a hand-oil-coloring project recently completed for a major Los Angeles publisher. Much of her recent work is in photographic illustration for clients. Assignments have taken her around the world, with some of her best photos appearing in Communication Arts' *Photography Annual.*

GLEASON, DAVID KING (Advertising, Corporate/Industrial)
1766 Nicholson Dr., Baton Rouge, LA 70802
(504) 383-8989

Born: 1927 *Subject Matter:* People, Travel *Situations:* Studio, U.S. Locations *Awards:* PPA Master Photographer

He has owned a full-service commercial studio in Baton Rouge since 1962. His studio serves the varied photographic needs of the paper mills, aluminum refineries and petro-chemical plants that line the Mississippi River in South Louisiana. His varied work involves aerial, architectural, documentary, advertising and portrait photography. He has had a long-term in-

Wayne David Geist

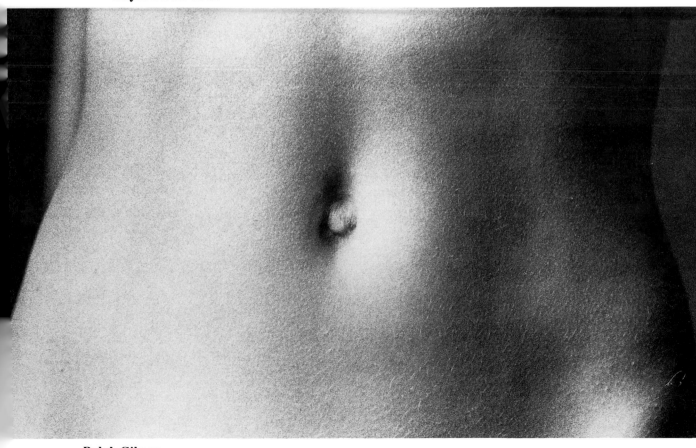

Ralph Gibson

terest in photographing the plantation homes of the deep South, and in 1982 he published the coffee-table book, *Plantation Homes of Louisiana and the Natchez Area*. His other architectural volumes include *The Great Houses of Natchez* and *Antebellum Homes of Georgia*. He has had two "helicopter books," *Over New Orleans* and *Over Boston*, published by L.S.U. Press.

GLENN, EILEEN (Advertising, Corporate/Industrial)
300 W. Superior St., Chicago, IL 60610
(312) 944-1756

Born: 1946 *Subject Matter:* Animals, People *Situations:* Studio, U.S. Locations *Awards:* Clio Finalist; *Adweek,* The Best Designed Ad *Education:* SUNY, Buffalo

With patience and calmness under fire, she creates a unique environment. She photographs both people and animals at ease, taking pride in being able to soothe even children, who make up a major portion of her business. Her clients have included Ralston Purina, Vivid Laundry Brightener, Mutual of Omaha, Bang & Olufsen, Baxter Travenol, Quaker Oats, Stouffer's, Ray-O-Vac and Wonder Bread. "I truly enjoy being involved in the creative process of capturing the soul of the subject," she says.

GLOBUS, RICK, RON & STEVE (Advertising)
44 W. 24th St., New York, NY 10010

Subject Matter: Sports *Situations:* Studio

The Globus Brothers are photographers, inventors and entrepreneurs—Rick is chief photographer, while Ron works on camera design and Steve balances the books. They are famous for "Globuscopes," a panoramic and scan-camera that they developed. They are also well known for their "photography in motion" stroboscopic multi-image photographs. Currently they are working on a "fly-eye" camera that will take three-dimensional photographs. Clients include the Smithsonian and the U.S. Government, for which they have produced official commerce exhibits. Over the years they have won numerous awards and received patents for their camera inventions.

GODDARD, WILL (Advertising, Photojournalism)
1496 N. Albert St., St. Paul, MN 55108
(612) 645-9516

Born: 1943 *Subject Matter:* Travel, Landscape *Situations:* U.S. Locations *Awards:* International Teaching Fellow, Australia *Education:* U. of Minnesota

A former English and Social Studies teacher, he is currently a freelance photographer and writer specializing in travel photography and writing. Known for his scenic photographs of the upper Midwest, his pictures have been featured in *Encyclopedia Britannica, Northwest Magazine* and the *Minneapolis Tribune,* as well as in brochures and advertising campaigns. Between 1984 and 1986 he taught at the North Country photo workshops.

GODFREY, MARK (Photojournalism, Corporate/Industrial)
3526 N. 3rd St., Arlington, VA 22201 (703) 527-8293

Subject Matter: People *Situations:* U.S. Locations, Aerial

A former contract photographer for *Life* and a member of Magnum Photos until 1980, he is founder and partner of ARCHIVE Pictures in New York. Working for magazine and corporate clients, he travels throughout the United States and abroad photographing subjects from industry, technology and science. A commercial pilot, he has also developed a speciality in aerial photography. His work has appeared in two books, published by the National Geographic Society: *Frontiers of Science* and *The Mighty Aztecs*.

GOFF, D.R. (Advertising, Corporate/Industrial)
66. W. Whittier St., Columbus, OH 43206
(614) 443-6530

Born: 1947 *Subject Matter:* Fashion, Architecture *Situations:* U.S. and Carribean Locations *Education:* Ohio U.

Two years into a photography degree at Ohio University, he was drafted and became an Army photographer stationed first at U.S.M.A. West Point and then as a divisional photographer with the 25th Infantry in Vietnam. After his release in 1970, he began a freelance career, starting in Indiana then moving to Ohio. During the past sixteen years, he has developed a commercial style known for its dramatic lighting. Using hard light, he creates a clean edge with dramatic shadows. One picture of a ballerina first shot for a local company (Ballet Met) has been reproduced as a poster and reissued internationally for the past seven years. He has concentrated in fashion and architectural photography, for which he has received numerous awards from the regional advertising community. Presently he is serving on the Board of Directors of the Ohio Valley Chapter of the A.S.M.P.

GOHLKE, FRANK (Fine Art)
1322 Adams N.E., Minneapolis, MN 55413

Born: 1942 *Subject Matter:* Landscape, Nature *Situations:* U.S. Locations *Awards:* Guggenheim Fellowship; NEA Fellowship *Education:* Davidson College; U. of Texas, Austin; Yale U.

Impressed primarily by his instructor, Paul Caponigro, and by photographer Walker Evans, Gohlke produces vibrant landscapes—panoramas that include signs of human presence such as telephone lines, grain elevators, highways, etc., showing that man has already touched this seemingly unspoiled land. More recently he has added less subtle clues, such as parking lots and sporting arenas. Nature retains its omnipresent role, stressed through the vastness of the horizons. His series showing the devastation of a tornado serves to underscore nature's eternal presence. He works in large-format and 16" x 20" silver prints.

GOLDBERG, LES (Advertising, Editorial)
40 W. 17th St., New York, NY 10011 (212) 242-3825

Born: 1952 *Subject Matter:* Fashion, People, Portraiture *Situations:* U.S. & Foreign Locations, Studio *Education:* Woodbury College

Self-taught, he began his career creating and photographing the original Polo/Ralph Lauren campaign. Shortly afterward he opened his first studio in New York City. There he did assignments for *Mademoiselle* and the Men's "Fashions of the Times" section of the *New York Times*. Concurrently he worked on national advertising campaigns for Elizabeth Arden and Germaine Monteil Cosmetics and continued working for Ralph Lauren. He has photographed for fashion magazines around the world. Among his credits are campaigns for Cover

D.R. Goff, *Maggie.* Client: Applause

Girl, Virginia Slims, Revlon and Saks Fifth Avenue. He enjoys making black-and-white portraits, and he is also working in films.

GOLDEN, JUDITH (Fine Art, Portraiture)
4108 W. Camino Nuestro, Tuscon, AZ 85745

Born: 1934 *Subject Matter:* People *Situations:* Studio *Awards:* NEA Photography Fellowship; Arizona Commission on the Arts Fellowship *Education:* School of the Art Institute of Chicago; U. of California, Davis

Golden has been able to incorporate her training as a painter and printmaker with photography to devise an innovative personal style. She utilizes the print medium and photography as an exploration of the worlds of both fantasy and popular beliefs. Characteristic of her work is the use of small personal items, such as a lock of hair, applying paint to the surface, or using color toners. She also makes straight color prints. She has produced a series of self-portraits in black and white, toned with paint and with collage applied. In her work she uses herself as a recurring image. She is especially interested in the effect the media has upon contemporary society. In her series called "People Magazine," for instance, she includes her face appearing through a hole cut out of a *People* cover that depicts stars such as Woody Allen. On a more humorous side, she presents us with her "Forbidden Fantasies" series which shows her—in reproductions of a Chinese marriage manual from the sixteenth century—having sex with famous contemporary artists such as Picasso, Edward Weston and Robert Heinecken.

GOMES, GEORGE (Advertising, Corporate/Industrial)
P.O. Box 741988, Houston, TX 77274 (713) 782-0005

Born: 1957 *Subject Matter:* Architecture *Situations:* U.S. & Foreign Locations, Studio *Education:* U. of Houston

Born in Brazil, he came to the United States in his twenties and began his career after earning a master's degree in Visual and Applied Arts. Architectural, advertising and corporate/industrial photographs have appeared in a variety of publications, including *Architectural Lighting, Professional Photography* and *Night Club & Bar.* His exhibition, "Views of Houston for Gerald D. Hines," was recently displayed in the Republic Bank of Houston.

GORCHEV, PLAMEN (Advertising, Corporate/Industrial)
Gorchev & Gorchev, 11 Cabot Rd., Woburn, MA 01801 (617) 933-8090

Born: 1952 *Education:* Northeastern U.

His expertise is in product, fashion and special effects photography. He has traveled worldwide on his assignments and his work has appeared in both domestic and foreign publications. His fully equipped studio—one of the largest in the Northeast—enables him to work on many projects simultaneously. Though his photographs are often highly technical, producing a final image from a combination of many different images, they are distinguished by simplicity and credibility. His clients have included Fisher Skis, Hyatt Hotels, Sheraton, Bostonian Hotel, Data General and Jordan Marsh. He recently opened a Boston gallery.

GORCHEV, THEODORE (Architecture)
Gorchev & Gorchev, 11 Cabot Rd., Woburn, MA 01801 (617) 933-8090

He established himself as an architectural photographer shortly after immigrating to the U.S. He has photographed buildings throughout the country, and his work has been appeared in publications worldwide, including *Architectural Digest, Progressive Architecture, Interior Design* and several Time-Life series. His expertise lays in the ability to portray the idea of what an architect has in mind, i.e. one artist understanding another's point of view. His clients include I.M. Pei & Assoc.; Cossutta & Assoc.; Cabot, Cabot & Forbes; and Architects Collaborative.

GOSSAGE, JOHN R. (Fine Art)
1875 Mintwood Place N.W., Apt. 30, Washington, DC 20009 (202) 234-0293

Born: 1946 *Subject Matter:* Landscape, Nature *Situations:* Studio, U.S. Locations *Awards:* NEA Short Term Project Grant; Photography Grant

Under the private instruction of Lisette Model, Alexey Brodovitch and Bruce Davidson, Gossage received an educational base in traditional photography. He has been able to develop this traditional foundation into something more than photographic documentation. His subjects are often unimportant; however, he seeks to make them surprisingly witty and of measurable photographic importance, making use of formal structure. More recently he has sought a greater spatial depth, as in the series entitled "Chevy Chase" (1979-80).

GOTFRYD, BERNARD (Photojournalism, Portraiture)
46 Wendover Rd., Forest Hills, NY 11375 (718) 261-8039

Born: 1924 *Subject Matter:* Travel, Nature *Situations:* U.S. Locations *Awards:* Page One Award

He worked as a photographer for the U.S. Army Signal Corps overseas, and when he returned to the U.S. in 1957, he was hired by *Newsweek.* He has now been at *Newsweek* some thirty years, covering assignments of every nature: the White House, people in the arts and letters, food, toys and technology, to name a few. He is considered a versatile craftsman and in 1976 received the Page One Award in Journalism for a photograph of Rudolf Nureyev doing "Lucifer" at the Martha Graham Dance Festival in New York City. Other notable photographs include a picture of Robert Kennedy's funeral in Washington. He has exhibited at the Brooklyn Museum of Art and the Terrain Gallery, among other locations around the country. Douglas Davis, in one of his recent critiques of his works, writes, "His flexible, sensitive style is the antithesis of style: each photograph is a study in itself."

GOWIN, EMMET (Fine Art)
c/o Light Gallery, 724 Fifth Ave., New York, NY 10019 (718)

Born: 1941 *Subject Matter:* People, Landscape *Situations:* Studio, U.S. & Foreign Locations *Awards:* Guggenheim Fellowship; NEA Grant *Education:* Richmond Professional Institute; Rhode Island School of Design

Many of Gowin's photographs appear to be images of people taken in small towns throughout America. They are, however, posed models, frequently family

members or relatives. The images he creates concern the nature of life: death, birth, families, etc. Recurring through his work are images of Edith, his wife. Gowin is also well-known for his landscape imagery.

GRAHAM, DONALD (Advertising, Editorial)
1545 Marlay Dr., Los Angeles, CA 90069
(213) 656-7117

Born: 1954 *Subject Matter:* People, Fashion, Sports, Travel *Situations:* U.S. Locations, Studio *Education:* U. of Texas

He shoots for advertising and editorial clients, primarily covering high fashion, beauty and glamour, sportswear, sport and fitness. Coca-Cola, Phillips Petroleum, Westin Hotels, Eastern Airlines and Maxell are some of his advertising clients. *Time, Sports Illustrated* and magazines in over twenty countries have purchased his editorial shots. He began his career shooting mostly sport and fitness ad stock, but he has always gravitated toward fashion and beauty, and today it makes up the bulk of his work. Based in Los Angeles, he finds his time split between studio and location shooting. He is known for his ability to execute large productions on time and within budget and publishes this type of work in a variety of media, from posters to catalogues and magazines.

GRAHAM, KEN (Advertising, Corporate/Industrial)
P.O. Box 272, Girdwood, AK 99587 (907) 783-2796

Born: 1947 *Subject Matter:* Nature, Industrial *Situations:* U.S. & Foreign Locations, Underwater, Hazardous *Awards:* Bonnie Awards

"If a picture is worth a thousand words," he says, "I try to get fifteen hundred into mine." Working as a deep sea diver in the oil fields of Indonesia and Singapore, he started accumulating an extensive library of stock shots, not only of the oil industry, but also of the people and cultures of Southeast Asia. Leaving Southeast Asia, he continued to travel; sixty countries and thousands of pictures later, he settled in a ski resort in Anchorage, Alaska. As a member of ASMP and PPA with a fully equipped studio, he attributes his success to customer satisfaction and a "can-do" attitude towards challenging assignments. He produces work for magazines, newspapers, books, posters, calendars, corporate and industrial reports and brochures, supplying several stock agencies throughout the country with photographs. Perhaps his most memorable photograph is one included on a large poster which has been distributed worldwide, commemorating Anchorage's bid to host the 1994 Winter Olympics.

GRANT, JARVIS (Advertising, Corporate/Industrial)
1650 Harvard St. N.W., Ste. 709, Washington, DC 20009 (202) 387-8584

Born: 1951 *Subject Matter:* People, Art *Situations:* U.S. Locations, Studio *Awards:* AVA 7 Nominee *Education:* Howard U.

He credits Edward Weston and Minor White for showing him how to use purity of form and light, while Bruce Davidson and Eugene Smith showed him how to bring that purity to bear on the human condition. Much of his work is in portraits, though he also specializes in photographing art objects and art spaces for museum and gallery brochures and catalogs. Recently, he completed work on an African art collection. As a commercial photographer his work has appeared in advertisements, newspapers, magazines and books. His personal work is "dreamlike but straightforward, composed to invoke a dream response." These photos may be of natural landscapes or storefronts and facades. Exhibits of his work include the Corcoran Gallery of Art, Pien-An-Mien Square in Beijing, China, and Amerika Haus in Hamburg, Germany.

GRANT, ROBERT (Advertising, Corporate/Industrial)
62 Greene St., New York, NY 10012 (212) 925-1121

Born: 1951 *Subject Matter:* Food, Product *Situations:* U.S. Locations, Studio *Education:* U. of Wisconsin, Milwaukee

He began his study of photography in Milwaukee and later moved to New York City to work as an assistant under J.P. Endress. In the fourteen years since, he has operated four studios and compiled a list of assignments that range from editorial spreads in magazines to international work for such companies as IBM, American Express and J.P. Stevens. He is primarily a still photographer and has photographed such diverse items as stereo equipment, food and textiles and subjects from as small as a diamond to as large as multi-room set. As a means of developing his style, he turns not only to his colleagues in photography but to painters of the Renaissance period and to a lesser degree those of the Romantic and post-Modern traditions.

GRAVES, TOM (Portraiture, Corporate/Industrial)
136 E. 36th St., New York, NY 10016 (212) 683-0241

Born: 1954 *Subject Matter:* People *Situations:* U.S. & Foreign Locations, Studio *Education:* Muhlenberg College

He began his career as a photojournalist, writing articles and illustrating them with his own photographs. An avid interest in photographing people brought him to New York to study portraiture with Philippe Halsman. A strong sense of design and composition characterizes his work for corporate and editorial clients. It is important to him to produce relaxed expressions and natural poses from subjects who are not used to being photographed, typically CEOs for annual reports and business people in many different fields. Working in 35mm and 2 1/4, in both black and white and color, he approaches each assignment with an understanding of the client's point of view. Location work has taken him to Mexico, the Netherlands, Portugal and Italy for such clients as Pfizer, BASF and 3M. Editorial work has included the *New York Times, Frequent Flier* and *Time*. He is a member of the Advertising Photographers of America, and he teaches at the New School for Social Research.

GRAY, CLAYTON "BUD" (Photojournalism, Portraiture)
16607 Prairie Ave., Lawndale, CA

Born: 1925 *Subject Matter:* People *Situations:* U.S. Locations, Studio *Awards:* California Press Photographers; LA Press Photographers

He began his career as an apprentice in a Sioux City portrait studio at the age of thirteen, where he discovered photojournalism and and decided to commit his life to it. Starting in the darkroom at the old *Chicago Times,* he then joined the U.S. Navy as a photographer during World War II. After the war, he went to work for the *Gazette* in Phoenix. His tour of American newspapers led him next to the *Mirror* and the *Examiner* in Los Angeles, then to United Press International and the *Los Angeles Herald Examiner.* In 1965, he entered the motion picture industry as a still, portrait and advertising photographer, and he continues in this capacity today. In his free time, he shoots scenics, particularly enjoying desert landscapes.

GRAY, MITCHEL (Advertising)

169 E. 86th St., New York, NY 10028 (212) 226-0223

Born: 1946 *Subject Matter:* Cosmetics/Beauty, Commercial Illustration *Situations:* Studio, U.S. Locations *Awards:* New York Art Directors Gold Award *Education:* U. of Virginia

His depictions of women show magnificent physical specimens. His work has been described as "tastefully hot." At the age of twenty-four, he had his first *Vogue* pictures published, and shortly thereafter he began to support himself through fashion advertising. His most intense training came through retail fashion work with Dayton's, Saks Fifth Avenue, Hudson's and Bloomingdales. At thirty-three he published the extremely successful *The Lingerie Book* through St. Martin's Press. He currently does more commercial illustration with fashion overtones than straight fashion photography. He works in all formats and shoots equal numbers of images in color and black and white.

GRAYBEAL, SHARON M. (Advertising, Editorial, Portraiture)

P.O. Box 896, Hockessin, DE 19707 (302) 774-1495

Born: 1959 *Subject Matter:* Products, Fashion, Sports *Situations:* Studio, U.S. & Foreign Locations *Education:* U. of Delaware; Massachusetts Institute of Technology

With a fine arts background and formal education in high-speed photography, she works in color and uses all formats, concentrating on promotional and editorial work for the entertainment industry. She enjoys graphics, the use of props and working with live models. Her corporate accounts include advertisements and annual reports for DuPont, and she has designed album covers for local performers Marcus Rhone and Tommy Conwell.

GREEN, MARK (Corporate/Industrial)

2406 Taft St., Houston, TX 77006 (713) 523-6146

Born: 1957 *Subject Matter:* People, Industry *Situations:* U.S. Locations, Aerial, Studio *Awards:* Art Director's Club, Houston; People's Choice Gold

He began his career as an industrial specialist in Houston, primarily working for clients in the oil and gas industry. Today his corporate work is more diverse and includes manufacturing, communications and executive portraiture. Of particular notice are his assignments shooting military aircraft in a variety of situations for a defense contractor and producing one of three limited-edition posters for Polaroid

Corporation's Professional Chrome campaign. As part of a cultural exchange, he exhibited a one-man show of Cibachrome abstract impressions of Houston in Florence, Italy. While in Florence, he worked on a series that was shown in Houston in an exhibit entitled "Mia Firenze." His photos employ a bold, graphic approach, are often abstract and are shot in color.

GREEN-ARMYTAGE, STEPHEN (Advertising, Corporate/Industrial)

171 W. 57th St., New York, NY 10019

Born: 1938 *Subject Matter:* People, Sports, Animals *Situations:* U.S. Locations *Education:* Cambridge U.

Starting in London shooting advertising in all formats, both in the studio and on location, he gradually gravitated toward magazine features. Moving to New York City and into the market there, he began to concentrate on feature photography, photographing a range of subjects including sports, travel, people and animals. For a while, a full ninety percent of his work came from that arena, with *Sports Illustrated* his biggest client. For the past six years, however, he has returned to advertising, working mostly on location, with a client base in corporate/industrial communications.

GREENHOUSE, RICHARD N. (Advertising, Corporate/Industrial)

7532 Heatherton Ln., Potomac, MD 20854 (301) 365-3236

Born: 1949 *Subject Matter:* People, Entertainers, Products, Architecture *Situations:* Studio, U.S. Locations *Education:* U. of Maryland

A self-taught freelance photographer, he has taken assignments from entertainment organizations, advertisers and publications. For example, working at their winter quarters, he has for the last seven years provided the photographs for the Ringling Brothers and Barnum and Bailey Circus. He also takes action and performance shots for the American Ballet Theatre. His retail catalogues, interior and exterior architectural photographs and defense capability brochures for defense contractors make up the majority of his advertising work. His pictures have appeared in the *Washington Post, Time* and *Professional Photographer.*

GRIMALDI, VINCE (Portraiture, Fine Art)

326 E. 65th St., #20, New York, NY 10021 (212) 879-0362

Born: 1929 *Subject Matter:* Nudes, Architecture *Situations:* U.S. & Foreign Locations, Studio *Awards:* Best of Photography Annual 1987 *Education:* Art Students League; New School for Social Research

His many years as a painter have sharpened his skills as a photographer, and indeed many of his rural and urban landscapes and nudes fall into the category of fine art photography. In "Beachscapes," a series concerned with ocean-front pollution, he eliminates extraneous details to find the potent image. Other pieces verge on the purely abstract. Recently, he has been experimenting with collage. His last show, "Give Me Miss Liberty Or . . . ," included many photographs, collages and box constructions featuring the Statue of Liberty. As a result of that exhibit, he was included in a major exhibition at the New York State Museum and at New Rochelle College Silvermine Gallery, as well as in the book *Bruce Gaylord Celebrates the Statue of*

Tom Graves, *Kim Chan*

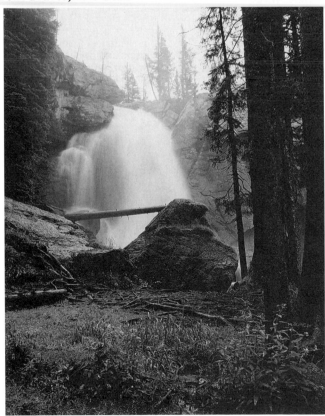

David Halpern, *Ouzel Falls, Summer Rain, 1984, Rocky Mountain National Park, Colorado*

Liberty. He publishes in a variety of media, including magazines, postcards, books and advertisements. His paintings and photos both are shown in galleries around the United States and abroad.

GROOVER, JAN (Fine Art)
c/o Sonnabend Gallery, 420 W. Broadway, New York, NY 10012

Born: 1943 *Subject Matter:* Still Lifes, People *Situations:* Studio *Awards:* Guggenheim Fellowship; NEA *Education:* Ohio State U.; Pratt Institute

Known primarily for her formalistic still lifes, she brings a painterly eye and aesthetic rigor to all her subjects. From the diptychs and triptychs that established her reputation to her more recent studies of plant forms and kitchen utensils, Groover's photographs represent a conscious departure from those of her more sociologically oriented contemporaries. By juxtaposing unlikely objects and using dramatic camera angles she forces the viewer to examine spatial relationships. Light and shadow are carefully orchestrated: color serves to heighten tension rather than resolve it. Recently she has begun to explore new venues for her talent, including black-and-white portraiture.

GROSS, STUART M. (Advertising, Corporate/Industrial)
32 Union Sq. East, #1017, New York, NY
(212) 674-6513

Born: 1955 *Subject Matter:* Architecture, Sports *Situations:* U.S. Locations; Aerial *Education:* Minneapolis College of Art & Design; Rochester Institute of Technology

His early interest in photography grew out of appreciation of the work of Gary Winogrand and Diane Arbus. He took his first pictures at the age of six, and by the age of twelve he was processing his own film. During his teens, he was interested in photographing old buildings and hotels in the Catskills, where he was born. He later became the first photographer to have a work accepted by the Woodstock Artist Guild Gallery. With that success, he went to art school at the Minneapolis College of Art and Design, later graduating from the Rochester Institute of Technology. By the time he reached New York City, he had a working knowledge of film-making, industrial printing and studio photography. He worked as a freelance assistant and studio manager for four years before opening his own studio. Today he works mostly for real estate firms and advertising. He also produces corporate work for CBS publications. He completed a project for the Canadian Mint for the 1988 Olympics.

GROSSFELD, STAN (Photojournalism)
c/o The Boston Globe, Boston, MA 02107
(617) 929-2000

Born: 1951 *Subject Matter:* Editorial *Situations:* U.S. & Foreign Locations *Awards:* Pulitzer Prize for Spot-News Photography, 1984; Pulitzer Prize for Feature Photography, 1985 *Education:* Rochester Institute of Technology

He is one of the few photographers who has managed to parlay his skills and experience into an editorial position on a daily paper. A two-time Pulitzer Prize winner for the *Boston Globe,* he is perhaps best known for his riveting 1984 photographs of the famine in Ethiopia. The photograph that earned him his second Pulitzer showed a group of refugees who had been denied permission to board a Sudanese food convoy. Rich Clarkson, the former president of the National Press Photographers Association, has called him "an excellent journalist who just happened to have picked up a camera." Grossfeld's most recent book, *The Whisper of Stars,* documents life in Siberia.

GROVER, RON (Photojournalism, Advertising)
10230 Zelzan Ave., #2, Northridge, CA 91325
(818) 996-8622

Born: 1943 *Subject Matter:* People, Nature *Situations:* Television Studios, Movie Sets

While a graphic artist and lithographer, he began to dabble in photography. Fifteen years after turning to photography professionally, he has established himself in the field. Much of his work is as a motion picture unit and special assignment photographer, on the set with such films as "The Right Stuff," "American Gigolo," "Escape From Alcatraz," "All the President's Men" and "A Star Is Born." Television assignments include "Scruples," "Kung Fu," "September Gun," "The Boy Who Drank Too Much" and many others. The range of projects covers network publicity, pilot promotion, publicity campaigns, features and mini-series. His work has been seen worldwide and has won several awards.

GRUNFELD, DAVID (Photojournalism)
66 South St., Apt. A, Auburn, NY 13021
(315) 253-5353

Born: 1961 *Subject Matter:* Social Issues *Situations:* U.S. Locations *Awards:* NPPA Region II College Photographer of the Year *Education:* Syracuse U.

Working for his father, who owned a group of weekly newspapers in Marathon, New York, he had an opportunity to learn photography early on. Later he studied photojournalism at Syracuse University. Since then he has published photography in numerous newspapers including the *Long Island Newsday,* AP and UPI wire services and *U.S. News & World Report* and *People.* For *People,* he covered the story of jailhouse lawyer Jerry Rosenbery. Today he works for the *Auburn Citizen;* shooting all black and white, he covers a range of politically engaged features. Christmas of 1988 found him up at 4:00 a.m., photographing farmers at work, then on to a cook in a maximum security facility, a toll-taker on the highway and a minister making his rounds in a hospital. These shots and others were part of a feature story entitled "Christmas Presence."

GUDNASON, TORKIL (Fine Art, Advertising)
58 W. 15th, New York, NY 10011 (212) 929-6680

Born: 1947 *Subject Matter:* Fashion, Still Life *Situations:* Foreign Locations, Studio

Born in Denmark, he began his career in photography as an assistant in Paris. Having since moved to New York City in 1977 and opened a studio in 1980, he has established himself in the world of high fashion. His shots are simple and elegant, using natural light as much as possible. Devoid of props, his sets focus attention solely on the models, and in these stark environments their impromptu poses become all the more startling, giving rise to new forms and ambiguous shapes. Active now for more than ten years, he publishes primarily in magazines, including *Harper's Bazaar* and *Vogue* in the United States, as well as the Italian and German *Vogue.*

GWINN, BETH (Photojournalism, Advertising)

P.O. Box 22817, Nashville, TN 37202 (615) 385-0917

Born: 1954 *Subject Matter:* People, Musicians *Situations:* Studio, U.S. Locations

In high school she started photographing bands performing on stage. She has been photographing people in the performing arts, with an emphasis in music, ever since. Shooting head shots, concerts and parties make up the bulk of her work. She has covered John Fogerty and Jackson Brown for *Rolling Stone.* Based in Nashville, she works most heavily in the country music industry, photographing fans and performers alike. Her portraits are unrehearsed and shot primarily on location. In addition to her magazine clients, such as *Spin, Country Music, Creem* and *Home & Studio Recording,* she has also produced album covers and advertising photography.

HAAN, RICHARD (Advertising, Corporate/Industrial)

Albert Whitten Airport Hanger #3, St. Petersburg, FL 33701 (813) 821-5505

Born: 1954 *Subject Matter:* Cars, Products *Situations:* Studio, Aerial, U.S. Locations *Awards:* Addy Awards *Education:* Brooks Institute of Photography

After graduating from Brooks Institute, he spent three years as a photography assistant in Detroit, photographing cars for Dick Reed in one of the largest car-shooting studios in the city. Taking his experience with him, in 1984 he headed south to Florida to join Gulfstream Studios, Inc. He continues to shoot automobiles, covering the St. Petersburg and New Orleans Grand Prix. Other specialities include lifestyle, corporate image, product illustration, aerial, industrial, architectural and special effects photography for a variety of media, from brochures and posters to magazines and newspapers.

HAGLER, ERWIN H. (Skeeter) (Photojournalism)

2919 Welborn, Ste. 107, Dallas, TX 75219 (214) 720-6186

Born: 1947 *Subject Matter:* People *Situations:* U.S. Locations *Awards:* Pulitzer Prize for Feature Photography; Regional Photographer of the Year, National Press Photographers Association

In his fifth year as an architecture student at the University of Texas at Austin, he took a photography elective. He spent the next year concentrating in the medium, taking a job at the *Waco News Tribune Daily.* From 1974 to 1988 he shot for the *Dallas Times Herald.* While at the *Herald* he earned the Pulitzer Prize for Feature Photography in 1980 for a series of photographs on the cowboy. Having left the paper to shoot solely freelance, he remains known for his candid "real-people" photography. He has worked on several "Day in the Life" projects for Collins Publishing as well as for numerous annual reports for high-tech firms and oil companies in the Texas region. Editorial publications include *USA Today, Texas Monthly* and *National Geographic.* He also photographed John Cougar Mellencamp for the singer's *Lonesome Jubilee* album and tour book.

HAHN, BETTY (Fine Art)

c/o Art Dept., University of New Mexico, Albuquerque, NM 87131 (505) 277-5861

Born: 1940 *Subject Matter:* People, American Heroes, Flora *Situations:* Studio *Awards:* NEA Fellowship, New York State Council on the Arts Award *Education:* Indiana U.; Visual Studios Workshop, Rochester, NY

Hahn actively explores a variety of techniques and imagery with her camera. Despite this nonconformist attitude, recurring motifs can be recognized throughout her work, including family album prints, contemporary heroes (such as the Lone Ranger) and flora. In addition to her various series on folk traditions, heroes and still lifes, Hahn has produced a series of investigative prints in which the photographer is the detective and the photographs are the clues for fictional crimes. She often alters her prints by stitching or painting on them. Influences are her instructors Henry Holmes Smith and Nathan Lyons.

HALING, GEORGE (Advertising, Corporate/Industrial)

231 W. 29th St., Suite 302, New York, NY 10001 (212) 236-6822

Born: 1937 *Subject Matter:* Nature, People, Industry, Manufacturing *Situations:* U.S. Locations *Education:* Yale U.

As a graphic designer newly graduated from Yale University, he worked as Art Director for several New York agencies before serving a stint as Pratt Institute's Publications Department Designer. In the late 1960s he decided to devote his full attention to photography. His black-and-white photo essays on lost teenagers and motorcycle gangs were published in *Camera* magazine. In the 1970s he entered the corporate market, shooting annual reports for Xerox and Exxon, among others. His work has been shown at Nikon House and published in numerous U.S. magazines.

HALL, ANTHONY (Portraiture)

3105 10th Ave. S., Minneapolis, MN 55407 (612) 722-1701

Born: 1946 *Subject Matter:* People *Situations:* U.S. Locations *Education:* U. of Minnesota

Committed to recording African values and dreams, he has worked on a number of projects documenting African life and culture. As one of sixty-seven photographers chosen to work on "Earth Treks: Kenya—An Adventure," he spent two weeks photographing the wildlife, scenic beauty and people of the land. Exhibits of his work include "Black on Blacks," "Sisters and Brothers" and "The Image of Women and Minorities in the Media." He specializes in personal and environmental portraits of people and has published photos in national and international books and magazines, annual reports and newspapers. He notes that while he enjoys the control of the studio, he prefers the challenge and excitement of location work.

HALL, GEORGE (Corporate/Industrial)

82 Macondray, San Francisco, CA 94133 (415) 775-7373

Born: 1941 *Subject Matter:* Military Aircraft *Situations:* Aerial, Hazardous, U.S. & Foreign Locations *Education:* U. of California, Berkeley

For twenty years he has specialized in photography related to aircraft—aerial views of much of the world including eight years shooting from Goodyear blimps, and, in the past decade, air-to-air photography of high-performance military and commercial aircraft. He

keeps current in required military survival, altitude-chamber and ejection-seat training so that he can ride along in state-of-the-art jets, taking shots for advertisements and for a large-format color calendar, which he publishes annually, called *Air Power*. Maintaining a large, computerized stock file of color images, he can provide photographs of virtually every current American military and commercial aircraft—under construction, in flight, on the runway, on the carrier deck, or from the cockpit. *Newsweek, U.S. News & World Report, Playboy, Air & Space, Aviation Week* and others have called on these archives.

HALLMAN, GARY LEE (Fine Art)
c/o 724 Fifth Ave., New York, NY 10019

Born: 1940 *Subject Matter:* Landscapes, Events *Situations:* Museums & Galleries, U.S. Locations *Awards:* NEA Photographer's Fellowship; Bush Foundation Fellowship for Artists *Education:* U. of Minnesota

While he supports himself teaching photography at the University of Minnesota, he is an accomplished fine art photographer. Collections include the Museum of Modern Art in New York, the International Museum of Photography at the George Eastman House in Rochester, the Boston Museum of Fine Arts, and Princeton University, among others. He has taught as a visiting professor of photography at Rhode Island School of Design and at Southampton College of Long Island University. Critical recognition for his photography came in the early 1970s with his series of impressionistic landscapes. With a background in film, sculpture and art history, he has been interested in conceptual as well as formal photography, and these concerns are apparent in his early metaphoric images, which explore the exchange of shape and surface in subtly toned, atmospheric pictures. He has recently been using his camera to investigate the environment of the museum and gallery. Other series have included conceptual works of events in and around his studio.

HALPERN, DAVID (Corporate/Industrial, Nature)
7420 E. 70th St., Tulsa, OK 74133 (918) 747-5900

Born: 1936 *Subject Matter:* Landscape *Situations:* U.S. Locations, Aerial *Awards:* Gold Award, Art Directors Clubs, Tulsa and Kansas City *Education:* Vanderbilt U.

He began his career as a landscape photographer, and his personal work continues to concentrate on black-and-white images of the American West. A generalist, he has also done a variety of other work, including low-level aerial photographs of oil rigs, plant sites and construction sites, usually taken by hanging out of a helicopter—outdoor photos appropriate to advertisements and corporate publications, particularly annual reports. He works in formats ranging from 35mm to 8" x 10". Not surprisingly, the most important influences in his professional life are Edward Weston and especially Ansel Adams. He has been an Artist-in-Residence at Rocky Mountain National Park in Colorado and Bryce Canyon National Park in Utah. His work has been exhibited at Philbrook Museum of Art in Tulsa, as well as at the Main Interior Department Building, Washington, D.C., in the "Images of Rocky Mountain National Park" exhibit.

HALPERT, LARRY (Fashion, Advertising, Entertainment)
3812 Illona Lane, Oceanside, NY (516) 536-6596

Born: 1962 *Subject Matter:* Fashion, Food *Situations:* U.S. Locations, Studio *Education:* School of Visual Arts, NYC

Although most of his contracts are for still life, his speciality is photographing people. Using his extensive knowledge of the sights in Long Island, he is able to simulate, with the use of time exposure and duping, scenes from Europe or beach scenes in the Caribbean. His unique speciality is night shooting, in which he achieves bright, colorful, otherworldly backdrops. Most of his work is in color, and it is his color that he is most noted for. Recently he has begun working with performers for their album covers, which he sees as part of his transition from still life to fashion illustration and advertising.

HALSBAND, MICHAEL (Editorial)
1200 Broadway, New York, NY 10001

Born: 1956 *Subject Matter:* People, Fashion *Situations:* U.S. Locations *Education:* School of Visual Arts, NYC

He opened a studio in 1979, and after graduating from the School of Visual Arts in 1980, he continued working for magazine and record companies as a portrait photographer. In 1981, he became the photographer for the Rolling Stones on their 1981 tour of America. When he returned to his studio, he began to integrate fashion photography with his portrait work. He often takes fashion work outdoors and combines it with various sports and social activities. By creating an environment in which his subjects are involved in a situation and therefore less aware of the camera, he is able to capture a natural vitality and spontaneity. He shoots in both black and white and color, and although most of his time is spent shooting on location, he remains active in the studio with portrait and fashion assignments.

HAMMARLUND, VERN (Advertising)
135 Park St., Troy, MI 48083

Born: 1931 *Subject Matter:* People, Cars, Products *Situations:* Studio, U.S. Locations *Education:* Brooks Institute of Photography

Drafted into the navy at the time of the Korean War, his hobby of photographing weddings led to aerial reconnaissance assignments over the Russian border. Discharged in 1954, he enrolled in the Brooks Institute of Photography. From there he went to work for another photographer before setting up his own studio two and half years later. He specializes in product photography, in particular in the transportation industry, and among his many clients are Toyota, Audi, all of the American automobile companies, Arctic Cat Snowmobiles, Mercury and Spirit Outboard Motors, Winnebago, Hiram Walker, Dow Chemical, Playboy Clubs International and Rubbermaid.

HAMMER, WYNN (Advertising)
3560 Hughes Ave., #211, Los Angeles, CA 90034 (213) 838-1267

Born: 1924 *Subject Matter:* People, Actors *Situations:* Motion Picture Sets *Education:* Art Center College of Design

He started his career as a U.S. Army signal corps photographer in 1945. Returning to New York City as a civilian, from 1948 to 1951 he shot fashion for such Hearst Publications as *Good Housekeeping* and *Town & Country*. Since then he has been working as a unit still photographer, shooting for some thirty-five major

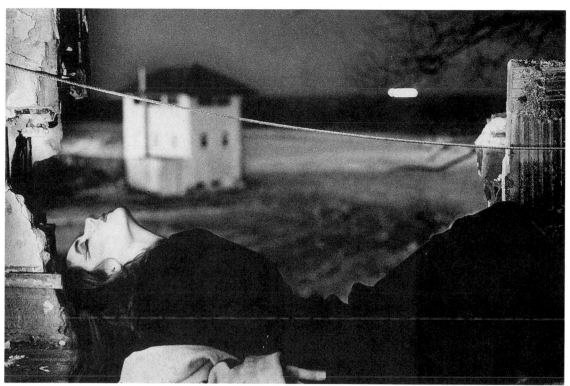

Larry Halpert, *Girl Under Boardwalk Listening to Radio.* Model: Jeanette de Lyra

Dorothy Handelman

feature films and numerous television shows. Freelancing for CBS, Lorimar, 20th Century Fox, MGM, Columbia, NBC and Blake Edwards Entertainment, he spends much of his time photographing actors, a job he finds very challenging and exciting, given that he rarely has control of either the situation or the subject.

HAMSLEY, DAVID (Editorial)

47 W. 90th St., New York, NY 10024 (212) 580-8667

Born: 1957 *Subject Matter:* Jewelry, Fashion Accessories *Situations:* Studio *Education:* Rhode Island School of Design

While his subject matter consists of "jewelry, boots, bags and belts," objects we see and use everyday, his approach is anything but mundane. "I have a reverence for these objects," he says. "I would place a shoe on a pedestal." Working with color film in either 4" x 5" or 8" x 10" formats, he uses clean sets with classical references. For example, by incorporating cutouts of Doric columns, furniture from the 17th century and other such images in something of a collage technique, each element in the photograph combines to create a greater world of meaning and honor for the given item. While his earlier photographs tended to include numerous elements, recent photos are cleaner and simpler. In each, he strives to marry an artistic sensibility with commercial appeal. He regularly produces work for *Connoisseur* and *Esquire*, with other work appearing in such magazines as *Forbes* and *Audio*.

HANDELMAN, DOROTHY (Advertising, Portraiture)

10 Gay St., New York, NY 10014 (212) 741-2627

Born: 1950 *Subject Matter:* Fashion, People *Situations:* Studio *Awards:* Best in Packaging, *Print* Magazine *Education:* Sarah Lawrence College; Visual Studies Workshop, Rochester, NY

One of the early photographers working for Hue Hosiery, she has carved out a niche for both herself and the company with photographs of shapely legs modeling Hue's latest line. Competing with the bold Calvin Klein and Burlington ads, she opts for a subtler sensuality, arguing "I don't mind the models looking available, but I don't want them served up. I want the pictures to be sexy without being pornographic." Shot with a Hasselblad in the square format, the larger negatives and transparencies provide for higher quality reproduction. She always crops the fashionable legs below the hips or at mid-calf. Although she has tried including the models face, she's convinced the better photography lets the viewer imagine the legs or feet as her own. In addition to operating the camera, she also designs the packages and supervises the press production.

HANDLER, LOWELL (Editorial, Photojournalism)

147 Main St., Cold Spring, NY 10516 (914) 265-4023

Born: 1956 *Education:* School of Visual Arts, NYC; New School for Social Research

His first major influence was his teacher at the New School for Social Research, Lisette Model. His favorite subject is people, and his work now consists of editorial and corporate location photography. He is a contributor to *Life*, the *New York Daily News*, *Hippocrates Magazine*, the *New York Review of Books*, Gannett-Westchester newspapers and many other publications. His groundbreaking work includes the first photo essay of people suffering from Tourette's syndrome.

HANSON, DAVID (Fine Art)

P.O. Box 3253, Providence, RI 02906 (401) 421-4503

Born: 1948 *Subject Matter:* Landscapes *Situations:* Aerial & Ground, U.S. Locations *Awards:* Guggenheim Fellowship; NEA Visual Arts Fellowship *Education:* Stanford U.; Rhode Island School of Design

With an undergraduate degree in literature, his work in photography began as an apprentice with Minor White in Boston and later with Frederick Sommer in Arizona. After teaching photography at Phillips Academy in Andover, Massachusetts for three years, he attended the Rhode Island School of Design, where he received his M.F.A. and where he now teaches photography as well as contemporary art history. Working in medium sized formats (2 1/4" and 4" x 5"), he completed a series of color shots coal-mining town in southeast Montana. This series, in addition to being featured in *Aperture* #106 and Sally Eauclaire's book *American Independents: Eighteen Color Photographers,* was exhibited in the Museum of Modern Art and has been traveling in a exhibit entitled "American Images." He has since completed two other major projects—aerial views of Minuteman missile silos and of toxic wastes sites around the U.S. In these photos, he is investigating the ways we represent landscape. Further, with these shots, he offers something of a critique of abstract art, for these photographs are often abstract in appearance, but very specific and controversial in content. He has also written critical essays on photography, including "Photography: Straight or on the Rocks?" published in *Aperture* #89 in 1982.

HARBUTT, CHARLES (Fine Art, Photojournalism)

c/o Magnum Photos Inc., 251 Park Ave. S., New York, NY 10010

Born: 1935 *Subject Matter:* People, Street Scenes *Situations:* U.S. & Foreign Locations *Awards:* Magazine Photography Award, U. of Missouri, Columbia; Photo Book of the Year Award, Rencontres Internationales de Photographie, Arles, France *Education:* Marquette U.

Harbutt joined Magnum Photos in 1963 and consequently developed a professional reportage style while covering events such as the Six-Day War for *Paris Match* and a variety of assignments for journals including *Life*, *Look* and *Newsweek*. Harbutt embarked on a career as a journalist only to find he was more stimulated by capturing the visual aspects of the events he covered than by making a written record of them. Harbutt introduced a new style of photography, initially called "superbanalisme", which focuses on everyday occurrences. This change in style led to one of his most notable accomplishments, a photo book entitled *Travelog*, which was highly experimental in its use of distortion and cropping of figures.

HARGROVE, TIM (Advertising, Fine Art)

5701 Buckingham Pkwy., Suite F, Culver City, CA 90230 (213) 649-0202

Born: 1957 *Subject Matter:* Cars, Nature, Sports *Situations:* Studio *Education:* Brooks Institute of Photography

Lowell Handler, *Moments of Disorder; Tourette Syndrome*

Len Hart, *Beauty Shot.* Model: Shelli Davies

Moving to Los Angeles after completing his photography degree at the Brooks Institute, he started assisting at Boulevard Photographic, initially working on small jobs for automotive catalogues. Today he is one of four staff photographers shooting a variety of cars—from Nissan, Mitsubishi and Hyundai to Ford and Chrysler. In addition to the cars themselves, he often shoots speakers, radios and other automobile accessories. He is most interested in high-market magazine assignments where he has the opportunity to photograph the exotic cars of celebrities. Other specialties include synchronized motion photography, in which he can create an 8" x 10" picture that appears to have been taken at 60 miles per hour. In his spare time he shoots sports, scenics and black-and-white fine art.

HARNEY, TOM (Photojournalism, Editorial)
5733 N. Sheridan Rd., Chicago, IL (312) 728-4818

Born: 1946 *Subject Matter:* People *Situations:* U.S. Locations *Education:* Michigan State U.

For the last two decades, he has been making black-and-white pictures of Chicago's everyday life. He is now planning to document the final days of the oldest baseball park in the country, Chicago's Comiskey Park, and his other current involvements include Jack Jaffe's *Changing Chicago Project* and *The Homeless in America: A Photographic Project*, which is a joint project of Families For the Homeless and The National Mental Health Association. His pictures are in the permanent collections of The Art Institute of Chicago, The Center for Creative Photography in Tucson and the Columbia Photography Museum in Chicago.

HARPER, DOUGLAS (Advertising, Corporate/Industrial)
#3 Cove of Cork Lane, Annapolis, MD 21401
(301) 266-5060

Born: 1944 *Situations:* Studio; U.S. & Foreign Locations, Hazardous

Working in formats from 35mm to 6" x 7", he describes himself as a generalist, able to sit down with clients and review objectives from image-making to a total marketing plan. On location, he carries his own portable darkroom, equipped with full-color capability, which enables him to view work immediately. A contributing photographer to *Time, National Geographic* and *American Heritage*, he has also worked for the Baltimore Interharbor Commission, for whom he photographed the historic "Pride of Baltimore," which was later swept away by the sea. The ship was lit sideways with deflectors and documented from all angles: aerial, exterior, underwater and on-board. Clients have included major advertising agencies and corporations such as IBM and Proctor & Gamble.

HARRINGTON, MARSHALL (Advertising, Editorial)
2775 Kurtz St., Studio 2, San Diego, CA 92110
(619) 291-2775

Born: 1953 *Subject Matter:* Products, People, Sports *Situations:* Studio, U.S. & Foreign Locations *Awards:* *Communication Arts*; The Belding Awards *Education:* U. of California, San Diego

As a student in communication, he studied media and its influence on society. His earlier photography was a means of illustrating ideas and concepts; articulate images communicated specific messages. In most earlier editorial work he used location and available light settings, but the current studio settings, where he shoots his advertising images, allow for more creative control. His goal is to expose the audience to visuals that create an emotional impact.

HARRIS, BART (Advertising, Editorial)
70 W. Hubbard St., Chicago, IL 60610
(312) 751-2997

Born: 1942 *Subject Matter:* People *Situations:* Studio, U.S. Locations

He began making money as a photographer at the age of fourteen shooting for small papers in Chicago's northern suburbs. At twenty-one he went to work at a catalogue studio and a year later apprenticed with Ralph Weiken at Omnibus Studios. Equally comfortable on location and in the studio, he has for the past twenty-three years worked for most national brands and on numerous advertising campaigns, including Walter Payton for Wheaties. Editorial and comic work, however, are the subjects from which he derives the most pleasure.

HART, LEN (Advertising, Corporate/Industrial)
2100 Wilcrest, #102, Houston, TX 77042
(713) 974-3265

Born: 1945 *Subject Matter:* People, Fashion, Travel *Situations:* Studio, U.S. & Foreign Locations *Education:* U. of Houston

Influenced by his early training in painting and design, as well as by his early exposure to theatrical lighting techniques, he uses light to reveal the way costume affects the wearer. He specializes in fashion, accessories and product still lifes and concentrates on the 35mm, 2 1/4" and 4" x 5" formats. His services include art direction, and his work has been featured in national and regional magazines as well as advertisements and catalogs for retailers in Chicago, Houston and San Francisco. He recently returned from a trip to London and has travel stock from the U.K., France and Mexico.

HARVEY, STEPHEN (Advertising, Editorial)
7801 W. Beverly Blvd., Los Angeles, CA 90036
(213) 934-5817

Born: 1951 *Subject Matter:* Fashion, People *Situations:* U.S. & Foreign Locations, Studio *Education:* Art Center College of Design

His first job was shooting an orange for Sunkist (through Foote, Cone & Belding); most of his early work was in food photography. After graduating from the Art Center, he opened a Los Angeles studio with two other photographers. There he shot food for a year and then switched to people, including celebrities. Growing too busy for a joint studio, he left his partners and opened his own studio in Los Angeles. He now shoots fashion, celebrities, beauty, movie posters and advertising. His swimwear accounts take him all over the world. He is represented in New York and Europe.

HATHAWAY, STEVE (Advertising)
400 Treat Ave., Unit F, San Francisco, CA 94110
(415) 495-3473

Born: 1952 *Subject Matter:* Fashion, People, Products *Situations:* Studio *Education:* U. of California, Berkeley; Brooks Institute of Photography

As an art student in the early 1970s, he was strongly influenced by the San Francisco Bay Area figurative

Steve Hathaway, *Cabinet Maker*

Marc Hauser, *Debbie Jacks.* Courtesy: Neidermaier Display

movement, featuring such artists as Nathan Oliveira, Elmer Bischoff and Joan Brown. Although he dabbled in photography while at Berkeley, he pursued a more technical course of instruction in industrial/scientific photography. These two complimentary programs have served him well, giving him the necessary technical and aesthetic skills to visualize a concept. His subject matter is divided evenly between still lifes and people. He has mastered a variety of styles to suit his diverse advertising clients, doing specialized designs for fashion photography and evocative portraits to showcase cosmetics. In recent work, he has combined grainy films with sponge-painted canvases to achieve a more painterly effect.

HAUSER, MARC (Advertising, Portraiture)

1810 W. Cortland, Chicago, IL 60622 (312) 486-4381

Born: 1952 *Subject Matter:* People *Situations:* U.S. Locations, Studio *Awards:* Award of Excellence, *Communication Arts*; Gold Award, The Art Directors Club 65th Annual Exhibition

At age fourteen he began a three-year apprenticeship with fashion photographer Stan Malinowski. Encouraged by Malinowski to show his work to *Playboy*, he published a photograph of folk singer John Prine in that magazine at the age of sixteen. During those early years, he was also influenced by the work of Irving Penn, Richard Avedon and Henri Cartier-Bresson. While still in his teens he shot a Rod Stewart concert for Album Graphics, Inc. and went on to produce eighty-nine album covers for them—all before his twenty-first birthday. Since then, his magazine credits include *Time, Newsweek, Life, People, Esquire, Vogue, Connoisseur* and *Money*. Commercial work runs the gamut from album covers to fashion catalogs. His portraits include Woody Allen, Jim Belushi, Walter Payton, Dolly Parton and John Cougar Mellencamp, some of which appear in his recently published *Portraits of Friends and Acquaintances.* He has recently completed "Halloween in Bucktown," a series of photographs featuring the children who live in Chicago neighborhood in which he lives and works, and has turned to film, shooting several prize-winning commercials.

HEATH, DAVID (Fine Art)

c/o Dept. of Film and Photography, Ryerson Polytechnical Institute, 122 Bond St., Toronto, Ontario M5B 1E8, Canada

Born: 1931 *Subject Matter:* People, Cities *Situations:* U.S. & Foreign Locations, Studio *Awards:* Guggenheim Fellowship; Ontario Arts Council Grant *Education:* Philadelphia College of Art; Institute of Design, Illinois Institute of Technology; New School for Social Research

Heath embarked on an exploration of the meaning of life several decades ago and has aided his search with the use of poetry, painting, literature and photography of past and present times. He was innovative in the development of the slide-tape program in the late 1960s. He went on to produce a number of slide-tapes including "Beyond the Gates of Eden," "An Epiphany" and "Ars Moriendi." He studied photography under Richard Nickel and W. Eugene Smith. In addition, he served as photographic assistant to Wingate Paine, Carl Fischer and Bert Stern for eight years. He has lived in Canada since 1970.

HEIBERG, MILTON (Advertising, Editorial)

71 W. 23rd St., New York, NY 10010 (212) 741-6405

Awards: First Prize, Group Show, NYC *Education:* New York U.; Cornell U.; Rutgers U.; International Center of Photography

A commercial still-life photographer with an emphasis on special effects, he counts advertising agencies, cosmetic firms and book publishers among his clients. He is also an accomplished nature and wildlife photographer with a background in the biological sciences and has taught nature photography at the NYC Audubon Society since 1982. A noted teacher and lecturer, he has authored five books on photography, with a sixth currently in the works. He has served as head photographer for several archaeological excavations in Israel and created a photographic series called "Methods of Archaeological Excavation" for the Archaeological Institute of America. He has the rare ability to work in the many areas and formats of photography, pulling them together into creative photomontage.

HEIL, PETER (Editorial)

222 S. Morgan St., Chicago, IL 60607 (312) 666-1025

Born: 1954 *Subject Matter:* Fashion, People *Situations:* U.S. & Foreign Locations *Awards:* PPA Merit Award *Education:* U. of Wisconsin; Brooks Institute of Photography

While in studying art at the University of Wisconsin, he worked as an architectural photographer. Pursuing further study at Brooks Institute, he then moved to Chicago where he assisted a number of Chicago photographers before opening his own studio. Turning from architecture to the human figure, today he shoots fashion, beauty and portrait assignments. Using a simple side light with a paint-rolled background, he strives to bring out the shape and character of his subject. "I like to show the model's personality," he says, "within the context of a fashion environment." Clients include Helene Curtis, Alberto Culver and Marshall Field's. Occasionally a catalog assignment takes him abroad, one landing him in Iceland for a series of location shots.

HEIST, H. SCOTT (Corporate/Industrial, Scientific)

616 Walnut St., Emmaus, PA 18049 (215) 965-5479

Born: 1949 *Subject Matter:* People, Products *Situations:* U.S. & Foreign Locations, Studio *Education:* New York U.

"Despite the increasing constrictions placed upon people by their societies and organizations," he writes, "people continue, in the best case, to form environments to suit themselves. Mostly, I put people and their places together to show these relationships." With such an approach, he generally maintains long-term relationships with his clients, developing over time a rapport that allows for the best visual results with a minimum of "fuss and theatrics." His IBM assignments alone number over 400, including major product announcements, advertisements and technical announcements. In addition to his corporate work, travel, portraiture and scientific photography make up the several hundred commercial photographs he produces each year.

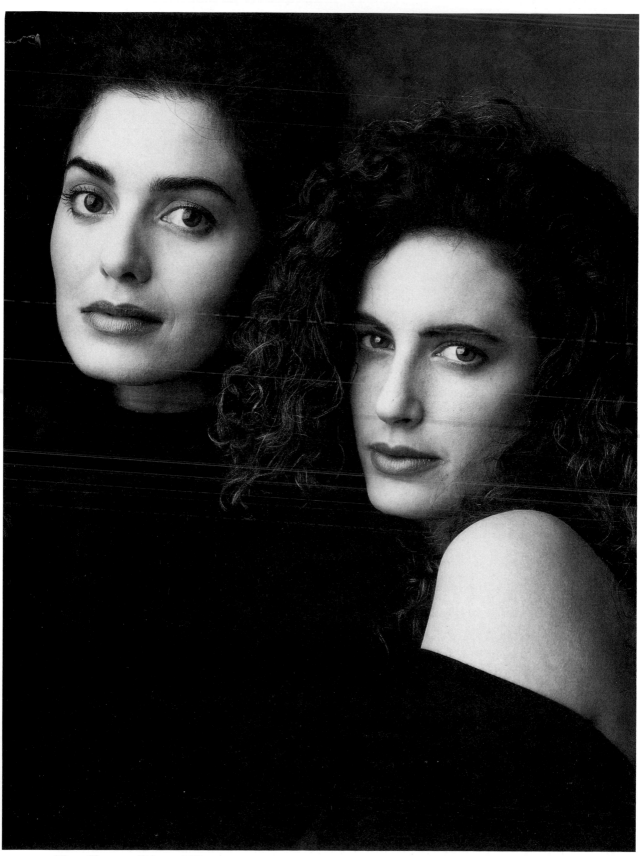

Marc Hauser, *Erin and Sharon*

HENDERSON, AL (Photojournalism, Corporate/Industrial)

828 S. Grant St., Hinsdale, IL 60521 (312) 655-0205

Born: 1930 *Subject Matter:* People, Travel *Situations:* U.S. Locations *Education:* U. of Illinois

As a copywriter, he was introduced to photography when he was assigned to the Sears Roebuck camera catalog. From Sears, he moved on to the University of Chicago, during which time he had his first photo stories published in the *Chicago Tribune Sunday Magazine*. Industrial editing came next, writing and shooting over a number of years for such organizations as the National Safety Council and Borg-Warner Corporation. For a period of ten years, he taught a one-week summer course in photojournalism at the Winona School of Professional Photography. He has written on photographic topics for *Photomethods*, *Lens on Campus* and *Imaging on Campus*. He freelances as both a writer and photographer. Most of his clients are corporations and non-profit organizations with specialities in the health sciences.

HENDERSON, CHIP (Advertising, Corporate/Industrial)

6005 Chapel Hill Rd., Raleigh, NC 27607 (919) 851-0458

Born: 1957 *Subject Matter:* People, Wildlife *Situations:* Hazardous, Studio *Awards:* Design Annual Certificate of Excellence, *Print Magazine*; Creativity Award, *Art Direction Magazine*

His professional career began at the North Carolina Department of Commerce/Travel & Tourism where he produced photographs for its award-winning travel account and Industrial Development Divisions. Upon leaving the state, he opened his own studio, serving advertising agencies and corporations throughout the Southeast. His work has been shown in numerous magazines and is featured in six books showcasing his studio's scenic photography. He is known for his graphic style and compositions incorporating unusual lighting, as well as for his experiments with angles and heights. He has recently been involved with several book projects.

HENLE, FRITZ (Photojournalism, Fashion)

P.O. Box 723, Christiansted, St. Croix, U.S. Virgin Islands 00820

Born: 1909 *Subject Matter:* People, Places *Situations:* U.S. & Foreign Locations *Awards:* Guggenheim Fellowship; NEA Photographer's Fellowship *Education:* School of Photography, Munich, West Germany

He was self-taught in photography at a young age, and by the time he went for instruction, he was accepted into the second-year curriculum at the Photographic School in Munich. Coming to America, he joined the staff at *Life*, where he worked with Alfred Eisenstaedt to create a trend in fashion photography, taking shots of models in the New England countryside. Later, in *Harper's Bazaar*, he would break new ground in the fashion world a second time, photographing "fashion in motion." In the late 1930s, he spent time in Paris, concentrating on photographing people and places. Initially rejected, the series was picked up by the *New York Times* in the closing years of World War II for a major spread on Paris. His career has seen him travel the world, photographing everything from the peaks of Japan, the beaches of the Virgin Islands, the fields of China, the streets of Mexico City and the countryside

of Italy to the quiet moments of a janitor sweeping the halls of New York's Museum of Modern Art. One of his most noted series featured Pablo Casals just before the famed cellist's death.

HICKS, MICK (Photojournalism)

1445 Granada Ave., San Diego, CA 92102 (619) 232-2333

Born: 1947 *Subject Matter:* People *Situations:* Studio, U.S. Locations *Awards:* San Francisco Cable Car Award for Photojournalism *Education:* Sacramento State U.

Starting in 1978, he began working for small community newspapers in San Francisco. Fascinated by the color, eccentricities and commitment of San Francisco's rapidly growing gay community, he began to document the community in a project that lasted ten years. Photographs from this period appeared worldwide, including Japan and Germany, as well as in the United States in *Newsweek*, *Sports Illustrated* and *California Magazine*. In 1983, he turned from the pageantry of the gay community to the devastation of AIDS; sponsored by the San Francisco AIDS Foundation, he spent one year photographing AIDS patients for a slide presentation to be shown to health care and hospice workers. He covered both Gay Games I in 1982 and Gay Games II in 1987. Today he continues to photograph the San Francisco gay scene; his stock photographs sell through Gamma-Liaison, New York.

HIGHSMITH, CAROL M. (Corporate/Industrial)

1300 G St. N.W., Washington, D.C. 20005 (202) 347-0910

Born: 1946 *Subject Matter:* Architecture *Situations:* Architectural Locations *Education:* Corcoran School of Photography; American U.

Influenced by the late Frances Benjamin Johnston, she is a historic documentarian whose commissions include documentary series on the refurbishing of Washington's Union Station and on the rebirth of the entire Pennsylvania Avenue corridor. Both series will be donated to the Library of Congress. She recently recorded the restoration of the historic Willard Hotel in Washington, D.C., and this work will be featured in a three- to four-year exhibit traveling to American Institute of Architecture chapters and to schools of architecture. Much of her work for developers, architects and government agencies involves documenting structures in all stages of renewal, from demolition to finished product. Shooting enormous spaces in uncertain lighting conditions, her large-format images reveal high quality and fine detail, capturing the splendor of the subject matter, whether it is a building in the midst of destruction or an elegant formal room.

HILLIARD, HENRY (Photojournalism, Corporate/Industrial)

59 Summer St., Somerville, MA 02143 (617) 776-7995

Born: 1952 *Subject Matter:* People, Travel *Situations:* U.S. & Foreign Locations, Aerial *Education:* Maine Photo Workshop

He began to become interested in professional photography through his training as an architect, where his initial assignments were photographing buildings. He then became intrigued by working with people and began working with the French photo

Marc Hauser, *James Belushi*

agency Gamma Liaison. Following a foreign assignment to Jamaica during the riots in 1985, he concentrated on photojournalism. He is represented by Picture Group Agency, and his clients range from news publications *Time* and *Newsweek* to business portraits for many business magazines, including *Business Week*. He is also active in the corporate market, doing corporate portraiture and industrial work; his clients include General Electric and NYNEX. In addition, he is involved in several ongoing long-term projects with communities struggling for economic survival on the islands off the coast of Maine and with people of Southeast Asia who are re-settling in America.

HIRSCH, BUTCH (Advertising, Editorial)
107 W. 25th St., New York, NY 10001
(212) 807-7498

Born: 1952 *Subject Matter:* Fashion *Situations:* Studio, U.S. Locations *Education:* U. of New Hampshire

He began his career as an underwater photographer in Miami, specializing in the photography of deepwater sponge life. He also conducted behavioral studies on sharks and environmental studies for oil companies. After moving to New York in 1981 he began working in fashion and beauty. His style, which has included fantasy and surrealism, is constantly changing. He always looks for the provocative and unusual, particularly in the use of make-up and color. He has recently been working on a book called *Women in Leisure*.

HOELTZELL, SIDNEY (Portraiture, Advertising)
165 Fifth Ave., Suite 920, New York, NY 10010
(212) 255-0303

Born: 1954 *Subject Matter:* Fashion, Still Life *Situations:* Studio *Education:* Fashion Institute of Technology; U. of Buffalo

During his ten-year career, he has shot for Bloomingdales, E.F. Hutton, Maxell, Nikon and Tiffany and has developed a campaign for Miller Beer, including billboards and illustrative ads. However, fine-art photography has become his main interest. Working with black and whites, he colors the prints by hand with special dyes to achieve "Miami Vice" colors. Infusing these otherworldly colors into real scenes, he is able to create a quasi-fantasy world. He is currently working on two books, one a series of battle photos, another depicting engraved crystal.

HOGG, PETER (Editorial, Advertising)
1221 South La Brea, Los Angeles, CA 90019
(213) 937-0642

Born: 1944 *Subject Matter:* Fashion, Food, Special Effects *Situations:* U.S. Locations, Studio *Education:* Brooks Institute of Photography

Following graduation from Brooks Institute in 1966, he returned to his home in Honolulu, where he went to work for one of the largest commercial studios, Camera Hawaii, Inc. For ten years he worked on such accounts as the Hilton and Sheraton Hotels, AT&T and Western Airlines, among others. After eight years he became president and co-owner of the studio. In 1977 he moved to Los Angeles to pursue a more challenging photographic career. Today he is well established with such accounts as Yamaha, Crown Corning and Bon Appetit. Although he prefers location shoot-

ing, most of his assignments call for special effects shot only in the studio. For one Reebok shot, he built a miniature forest from which a Reebok shoe was beamed up into a hovering spaceship; it is such creative solutions that have earned him his reputation.

HOLBROOKE, ANDREW (Photojournalism, Editorial)
50 W. 29th St., New York, NY 10001 (212) 889-5995

Born: 1946 *Subject Matter:* People, Travel *Situations:* U.S. & Foreign Locations *Education:* New York U.

With a degree in film from New York University, he began his professional career as a film-maker. Today, as a still photographer, he works extensively on international assignments, traveling to Nicaragua, Pakistan, Sri Lanka and Southeast Asia. In the "Family of Man" tradition of Eugene Smith, he hopes that his own photography can give a voice to those who would otherwise go unheard. He chooses as his subject matter people in their everyday lives, their traditions and customs. He has carried out numerous assignments for such clients as Exxon, UNICEF and *National Geographic*. His work has appeared in many publications, among them *Life*, *Time*, *Newsweek*, *GEO*, *Travel and Leisure*, *Smithsonian*, *American Photographer*, *Forbes*, *Cosmopolitan* and the *New York Times*.

HOLLAND, ROBERT (Photojournalism, Scientific)
P.O. Box 162099, Miami, FL 33116 (305) 255-6758

Born: 1959 *Subject Matter:* Marine Life, Travel *Situations:* U.S. Locations, Underwater, Hazardous *Education:* U. of Miami

Concentrating on magazine photojournalism, he works primarily in underwater, adventure and science photography. His assignment credits include *Smithsonian*, *Newsweek*, *Science Digest* and numerous others. He remarks that he is often asked to accept difficult and even dangerous jobs but finds it challenging to deliver good pictures despite the conditions. His commercial work revolves around tropical and recreational themes for resorts and manufacturers, illustrating people at play in and around water.

HOLMES, ROBERT (Editorial, Advertising, Fine Art)
P.O. Box 556, Mill Valley, CA 94942 (415) 383-6783

Born: 1943 *Subject Matter:* Nature, Travel, People *Situations:* U.S. & Foreign Locations *Awards:* Art Council of Great Britain Award *Education:* U. of London

With an invitation in 1976 from Ansel Adams, this British photographer moved to San Francisco in 1979 to begin a career as an editorial photographer with an emphasis on adventure and travel assignments. He has covered five Himalayan expeditions, including one to Mt. Everest, two Sahara crossings and several trips to the Arctic. His assignments for magazines and corporations keep him traveling from one side of the world to the other. Despite this busy schedule, he manages to teach occasional workshops in Yosemite and at the University of California at Berkeley and has recently completed the photography for a book on the Shona of Zimbabwe, a tribe known for its sculpture. His book on the University of Southern California was published in 1988. What time he does spend on his personal fine art photos shows the influence of his days

Milton Heiberg

Carol M. Highsmith, *Willard Hotel Prior to Renovation*

as an architect and city planner. Landscapes are abstracted to their absolute basics.

HOLT, CHARLES (Advertising)
535 Albany St., Boston, MA 02118

Born: 1948 *Education:* FSU; California Institute of Technology

His work is dramatic and graphic, full of texture. His product work is spare and clean, incorporating minimal form; he prefers to work with color and light. His portraiture is heavily influenced by the Dutch masters. His work for resort clients worldwide has taken to such places as Barbados, the Caribbean, Thailand and Japan. He works in large format and has photographed food, people, aerials and underwater images. Recently, a number of his personal photographs have been used for commercial posters.

HOLZ, GEORGE (Advertising, Editorial)
400 Lafayette St., 4D, New York, NY 10003
(212) 505-5607

Born: 1956 *Subject Matter:* Fashion, Nudes, Products *Situations:* Studio, U.S. Locations *Education:* Art Center College of Design

After graduating with a degree in photography, he started shooting for record album covers in Los Angeles. On Helmut Newton's advice, he set out for Europe, basing himself in Milan, Italy, where he began shooting for such magazines as the French *Elle*, the Italian *Vogue*, *Lei* and *Linea Italiana*. His work came to the States as well, appearing in *Mademoiselle*, *GQ* and *Harper's Bazaar*. In 1985 he returned to the U.S. and opened a studio in New York. Shooting fashion, beauty and liquor prints, he has since worked for Elizabeth Arden, International Gold Corporation and De Beers Diamonds. His advertisement entitled *Eye* was selected by the International Museum of Photography for their exhibit "Photography for Advertising: the History of a Modern Art Form." Influenced by Man Ray's conceptual point of view, he continues to expand his horizons. He is currently making a series of black-and-white nudes with animal bones which will be featured in *Collector's Photography*.

HOOD, ROBIN (Advertising, Corporate)
1101 W. Main St., Franklin, TN 37064 (615) 794-2041

Born: 1944 *Subject Matter:* Annual Reports, Advertising *Situations:* U.S. & Foreign Locations, Studio *Awards:* Pulitzer Prize for Feature Photography

Returning from Vietnam in 1971, he began working at the *Chattanooga Free-Press*. In 1977, he won the Pulitzer Prize for Feature Photography with a photograph of a fellow veteran of the war, a man who had lost his legs and was watching the Chattanooga Armed Forces Day Parade from his wheelchair. He left the paper in 1978 to work on a book commissioned by the governor of Tennessee entitled *The Tennesseans*. This led to a position as director of photography for the state, a position he held for three years. He began his freelancing career in 1983 with a book that took him to Japan. Entitled *Friends*, it offers a photographic comparison of Japan and Tennessee. He concentrates on advertising and corporate photography, shooting for such clients as Brown & Williamson Tobacco, Wild Turkey, Jack Daniels and NCR Corporation. His corporate-identity campaign for the CSX Corporation ran in *Fortune* and *Business Week*. In addition to this work, for

the past four years he has provided calendar photography for Rutledge Hill Press.

HOPE, CHRISTINA (Advertising, Corporate/Industrial)
2720 3rd St. S., Jacksonville Beach, FL 32250
(904) 246-9689

Born: 1949 *Subject Matter:* People, Nudes *Situations:* U.S. Locations, Underwater, Studio *Awards:* Nacio Award; Nikon International *Education:* California College of Arts & Crafts

Originally a graphic designer, she became interested in photography, especially underwater figure photography in Florida. Shooting underwater, her figures move dreamily beneath sheer gowns of cloth, bathed in light and shadow. She seeks to depict the body free from gravity, in a pure and ethereal form. One such photograph, *Angel*, won an award from Nikon Photo Contest International and was included in their 1985-86 Annual. She has been a commercial photographer for fifteen years, operating her own studio for five years. Assignments have ranged from photographing Olympic gymnasts to jazz greats Della Reese and Dizzy Gillespie, to industrial/corporate communications and advertising campaigns. Her work has been shown at numerous exhibitions across the U.S. and in Scotland.

HOPP, MAGGIE (Corporate/Industrial, Editorial)
103 Charles St., New York, NY 10014 (212) 242-7318

Born: 1945 *Subject Matter:* People, Nudes, Travel, Interiors, Exteriors *Situations:* U.S. & Foreign Locations *Education:* Bard College

An assignment in Colombia to make photographs for the Peace Corps sparked her interest in documentary and editorial photography. After many years in South America, Europe and Asia, she returned to New York in 1975 and began working on domestic and foreign assignments. More recently, she spent 1983 in Asia working for CARE and the United Nations Development Program, photographing their projects and taking pictures for her own portfolio, from working women to men and boats. Much of her current work involves environmental portraiture. For example, several of her recent New York commissions involved photographing specific neighborhoods before, during and after development.

HOUCH, JULIE (Advertising, Editorial, Corporate/Industrial)
535 Albany St., Boston, MA 02118

Born: 1953 *Subject Matter:* People, Travel *Situations:* U.S. & Foreign Locations *Education:* Indiana U.

Specializing in corporate, advertising and editorial photography, she works on location both in the U.S. and abroad. Environmental portraits reveal a sense of spontaneity supported by often very intricate light and set arrangements. Her industrial location work emphasizes graphics and composition based on color. Her direct approach to these elements produces clean images with a strong sense of design.

HOUSTON, ROBERT (Editorial)
1512 E. Chase St., Baltimore, MD 21213
(301) 327-2632

Born: 1935 *Subject Matter:* People, Nature *Situations:* Studio *Education:* U. of Maryland

Robert Holmes, *Sumo, Tokyo.* Client: American Express

Christina Hope, *Angel*

Two days after ending his career as a research biologist, he began his first photo assignment for Howard Chapnick, president of Black Star, Inc. That same day he contacted Gordon Parks of *Life* to contract to shoot the Poor People's Campaign in Washington D.C. A self-taught photographer, he sees these two highlights of his life as exceeded only by the publication of his book *Legacy to an Unborn Son*. He continues to work as a freelance photographer, concentrating on various series including one on storefront churches in Baltimore and another on the "Yo-Boys" or high-school dropouts who roam the streets and nightclubs. He has also had the opportunity to teach documentary photography at the Art Institute of Boston and basic photography at the Roxbury Photographers Training Program.

HOWARD, MAURINE (Advertising, Photojournalism)

Taylor Howard International, P.O. Box 441415, Houston, TX 77244 (713) 556-5015

Born: 1945 *Subject Matter:* Nature, People, Real Estate, Medical Operations *Situations:* U.S. & Foreign Locations, Hazardous, Aerial, Underwater *Education:* North Texas State U.

In the early 1970s she concentrated on the European yachting scene and produced a documentary on Francisco Franco. She has performed "high risk" and classified research operations for the U.S. Government and produced annual reports, brochures, catalogues, slide presentations and television commercials for commercial accounts. Among her corporate clients are Exxon, Hughes Tool Company, Ethan Allen, Share America and McCullough International. She is Head of the Department of Continuing Education at the Art Institute of Houston, and in 1978 she founded Taylor Howard International, a full-service marketing and advertising company.

HUJAR, PETER (Portraiture, Nature)

c/o Marcuse Pfeifer Gallery, 568 Broadway, Suite 102, New York, NY 10012

Born: 1934 *Subject Matter:* People, Animals *Situations:* Locations *Awards:* Fulbright Grant; NEA Grant

Early work consisted of fashion and advertising photography for publications and agencies. Since the 1970s he has been best known for his portraits and nudes of New York artists, writers and other friends. These photographs are often square format silver prints on 16" x 20" paper. The subjects are presented in their creative environments, often lofts. Hujar portrays his subjects in repose or in recline, capturing each individual's personality and vulnerability. He has also photographed a series of farm animals, of buildings in New York and of found objects. His work has been the subject of several books, most notably *Portraits of Life and Death*. Public collections include the San Francisco Museum of Modern Art and the New Orleans Museum of Art.

HUMBLE, JOHN (Fine Arts)

2328 6th St., #4, Santa Monica, CA 90405 (213) 396-4377

Born: 1944 *Subject Matter:* People, Landscape *Situations:* Art Documentary *Awards:* NEA Photo Survey Grant *Education:* U. of Maryland; San Francisco Art Institute

He uses a Widelux camera and color film to photograph downtown Los Angeles' Broadway. His Broadway pictures are long, thin, wide-angle (140 degrees) images that describe that street's teeming, chaotic, third-world nature in a highly formal way. Currently, he is using a 4" x 5" camera to photograph the ironic clash between the residential and industrial areas of the Los Angeles landscape. He has shown his work at the Corcoran Gallery in Washington, D.C. and his images are part of "Contemporary American Photography," an exhibition touring the Soviet Union. He teaches at Santa Monica College and Fullerton College.

HUNGASKI, ANDREW (Advertising, Fine Art)

Merriebrooke Ln., Stamford, CT 06902 (203) 327-6763

Born: 1950 *Subject Matter:* People, Still Life *Situations:* Studio, U.S. Locations *Education:* St. Michael's College; Germaine School of Photography

His evocative pictures display atmosphere, sensitivity and mood. His photographs exhibit a variety of styles because they reflect how or what he feels at the time he takes them and because his perspective changes as time passes. His work is often displayed at galleries such as Ward-Nasse in SoHo and in traveling exhibitions. "I choose to relate in photography because vision accurately portrayed, it is a most precise art and I believe that there is nothing so accurate as a photograph."

HYDE, DANA (Advertising, Photojournalism)

P.O. Box 1548, Southampton, NY 11968 (516) 283-1001

Born: 1940 *Subject Matter:* Interiors, People *Situations:* U.S. & Foreign Locations *Education:* Center of the Eye, Aspen

Her first love was travel photography, and for several years she traveled through Mexico, the Caribbean and Europe, compiling a file of photographs, many of which are still being sold today through Photo-Researchers, her stock house. She has recently been concentrating on photographing the lives of notable people—their gardens, houses and rooms—for private clients, advertising agencies and magazines such as *Town & Country* and the *New York Times Magazine*. When speaking of her influences, she lists Slim Aarons of *Town & Country*; her style is recognized for its idealized romantic view of the subject, whether it be a cityscape at night, ice sailing on the Hudson River or a woman sitting at ease in her garden.

HYDE, SCOTT (Fine Art)

215 E. 4th St., New York, NY 10009

Born: 1926 *Subject Matter:* Landscapes, Nature, People *Situations:* U.S. Locations *Awards:* Guggenheim Fellowship in Photography; CAPS Grant *Education:* Columbia U.; Pratt Graphics Center

He is known as one of the pioneers in the development of offset lithography. He considers lithography as a separate art form and not just a means of reproducing images. His images generally appear in color, but he rarely uses color film. Instead he shoots in black and white and subsequently makes several prints in a variety of colors. He pursues many subjects, including urban and rural landscapes, nature and people.

HYMAN, RANDALL (Editorial, Environment)

12130 Big Bend, St. Louis, MO 63122 (314) 821-8851

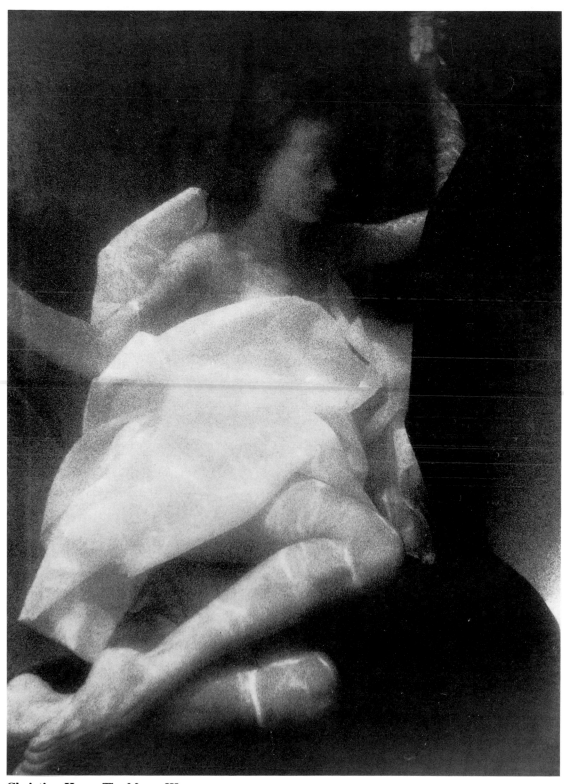

Christina Hope, *The Muses III*

Born: 1955 *Subject Matter:* Animals, Nature, People, Travel *Situations:* U.S. & Foreign Locations *Education:* Indiana U.

Doubling as a writer, he has written and photographed articles for *International Wildlife* and *Smithsonian.* He has also photographed for other authors in *National Geographic* publications as well as *Traveler.* His work as an editorial photographer has carried over into the area of corporate and industrial shoots, where he has developed a reputation for creating unique portraits of employees in their work environments. He is fluent in Icelandic, Portuguese and French, a skill which aids him in understanding the people and countries he photographs. His exhibit, "Iceland, Fire of the Arctic," has toured internationally under the auspices of the Smithsonian Institution and now belongs to the Icelandic government.

IANNAZZI, ROBERT F. (Portraiture, Corporate/Industrial, Fine Art)

450 Smith Rd., Pittsford, NY 14534 (716) 624-1285

Born: 1937 *Awards:* "Master of Photography," "Photographic Craftsman," Professional Photographers of America *Education:* Rochester Institute of Technology

He is most noted for large wall portraits mounted on artist canvas. In addition to his commercial work, he is currently involved as a Media Specialist and Assistant Professor at the National Technical Institute for the Deaf at the Rochester Institute of Technology. His duties there have led him to photograph such renowned personalities as Lou Ferrigno, Nanette Fabray, Lorne Green, Florence Henderson, Buddy Ebsen, Richard Thomas, Ronald Reagan and Surgeon General C. Everett Koop for national posters and media campaigns. He is also widely known for his fine-art photography, including a collection of unique flower photographs.

ICEBERG, KEITH (Photojournalism, Advertising)

99 Commercial St., Brooklyn, NY 11222
(718) 383-8528

Born: 1950 *Subject Matter:* Sports, Travel *Situations:* Hazardous; Foreign Locations *Education:* U. of Missouri; U. of Southern California

President and producer of Iceberg Productions, he is a specialist in freefall cinematography. Jumping with three cameras on a helmet mount, following a skydiving formation at a distance of only six to ten feet, he is able to obtain footage not possible from the ground or from an airplane. He has been the World Champion "Airbears" team photographer, and in 1987 he was invited by the U.S. Army's Golden Knights to be their videoman, an honor rarely granted a civilian. Aside from the numerous record-setting jumps he has recorded, including 90-person and 100-person jumps, he was the first person to parachute onto Blue Mountain Peak — a fifteen-square-foot area on Jamaica's highest mountain. He conceived, filmed and co-produced a documentary revolving around this event that aired on Jamaica television.

ICHI (SUICHI ICHIKAWA) (Advertising)

303 Park Ave. S., New York, NY 10010

Born: 1951 *Subject Matter:* Fashion *Situations:* Studio *Education:* Tokyo Photographic College

After working as an assistant for both Bill King and Art Kane, he moved into fashion advertising and still life. He specializes in special effects lighting.

INTVELDT, GAIL B. (Editorial, Advertising)

5510 Corral Ln., Frederick, MD 21701
(301) 473-4531

Born: 1950 *Subject Matter:* Nature, Travel *Situations:* U.S. Locations *Education:* Shepherd College

During the last three years, she has shot almost exclusively for stock, accumulating over 10,000 Kodachrome transparencies. The index reveals her interest in the outdoors, with shots of farm animals and crops, flowers (wild, garden and exotic), cactus, deserts, beaches, mountains, canyons, lakes and oceans, fields and woodlands, seasonals, energy, weather and national parks and monuments. After nature photography, her second interest is in capturing man in his environment. She also enjoys photographing children and families in candid situations, especially though not exclusively outdoors. Steichen, Smith, Adams and Szasz are her photographic influences; her overall aesthetic is influenced by the painters Monet and Cassatt. Her work appears most often in an editorial capacity in textbooks, magazines and newspapers. She is a member of ASMP.

IRWING, JERRY (Advertising, Environment)

P.O. Box 399, Paradise, PA 17562 (717) 442-9827

Born: 1936 *Subject Matter:* People, Agriculture *Situations:* Hazardous, U.S. Locations *Awards:* Gold Medal, Nikon International

A freelance photographer who specializes in rural and agricultural subjects, he has been photographing around Lancaster County, Pennsylvania since 1977. He has also visited many of the Plain settlements in the United States, Central America and Canada, photographing the Plain People for *National Geographic* in April, 1984. His photo-articles have appeared in *Life, Country Journal, Harrowsmith, GEO* and numerous foreign publications. He is a four-time winner of the Nikon International Photo Contest, winning a gold medal in 1982-83. He makes his home in Paradise, Pennsylvania and is currently working on several book and calendar projects.

ISRAELSON, NELS (Advertising, Portraiture)

311 Avery St., Los Angeles, CA 90013 (213) 680-2414

Born: 1958 *Subject Matter:* People, Photo Illustration *Situations:* U.S. & Foreign Locations, Studio *Education:* Loyola Marymount U.

After serving for three years as studio manager for entertainment photographer David Alexander, he moved to London and freelanced in 1983 and 1984, photographing album covers and book jackets for British clients. In 1984 he returned to Los Angeles to establish his own studio, and that same year his experimental work was included in *The Kodak Encyclopedia of Creative Photography.* Since 1985 he has worked in New York and Los Angeles as well as periodically shooting in London. He has created album-cover images for The Manhattan Transfer, The Stray Cats, James Brown, Richard Marx and other international recording artists. In the past year he has expanded into film advertising and posters, including projects with Charlie Sheen, Martin Sheen, Deborah Shelton, Peter Weller and Sam Eliot.

Robert Houston, *That's All*

Robert F. Iannazzi, *Three Sisters, Portrait of the Bocan Sisters*

IZU, KENRO (Advertising, Fine Art)
140 W. 22nd. St., New York, NY 10011
(212) 254-1002

Born: 1949 *Subject Matter:* Nature, Still Life *Situations:* U.S. & Foreign Locations, Studio *Awards:* NEA Grants *Education:* Nippon U.

Since his first trip to Egypt in 1979, he has split his time between studio work and location shooting. Traveling around the world, stopping in Scotland, England, Japan and Mexico, he has been photographing ancient stone ruins. In contrast, working in his studio in New York City, he photographs delicate objects such as dry flowers, twigs, crafted paper, wood and metal. These are produced in large-format platinum/palladium prints made from original 14" x 20" negatives, resulting in highly detailed images of contrasting tones. Some of his recent work, "Still Life II," was featured at an exhibition at Photofind Gallery in New York. For his commercial clients, he photographs jewelry and fine antique objects. He has produced work for such companies as Tiffany, Cartier and H. Stern and published in *Connoisseur*. He has collections in the Boston Museum of Fine Art and the San Francisco Museum of Modern Art. He has also exhibited at Ann Reed Gallery and the Catskill Center for Photography. "In my work," he says, "I like to observe and record the contrast or harmony of both those natural and man-made objects, time-tested by nature."

IZUI, RICHARD (Advertising, Editorial)
315 W. Walton, Chicago, IL 60610 (312) 266-8029

Born: 1950 *Subject Matter:* People, Cars, Products *Situations:* Advertising, Editorial *Awards:* Playboy Annual Award *Education:* Loyola U.; Columbia College

His early single-image photographs have evolved into the multiple and special effects images he achieves with his own in-house composition technique. He started making photographs while a medical student at Chicago's Loyola University, abandoned his medical education for photography and took classes at Chicago's Columbia College. He then worked as an assistant to several commercial photographers, and at the age of twenty-four he began working for *Playboy*. In 1977 he opened his own studio. He describes the most challenging part of his job as "being faithful to the needs of the art director, to give him an image he can be satisfied with."

JACHNA, JOSEPH (Fine Art)
5707 W. 89th Place, Oak Lawn, IL 60453

Born: 1935 *Subject Matter:* Nature, Landscape *Situations:* U.S. Location, Studio *Awards:* NEA Grant; Guggenheim Fellowship for Photography *Education:* Illinois Institute of Technology

Working chiefly in black and white, Jachna is first and foremost a photographer of nature. His education at the Illinois Institute of Technology, under the tutelage of Aaron Siskind and Harry Callahan, had a profound impact on his work. He became most interested in fundamental qualities such as light, form and tone. Many of his pieces include a juxtaposition of objects such as a mirror against a landscape, an egg against wood, or a fist against a nude. Often there is a symbolic significance to the contrast between black-and-white tones. In his most dramatic series of the late 1960s, he includes his own hand in the picture frame, making it a part of the landscape. In this hand he holds reflective objects such a mirror or some other reflective surface that serves as a self-portrait of nature. In the series, "Door County, Wisconsin," he is attempting to merge himself and nature into a harmonious form.

JACKSON, CAPPY (Advertising, Editorial)
914 Morris Ave., Lutherville, MD 21903
(301) 252-9144

Born: 1954 *Subject Matter:* Horses *Situations:* U.S. Locations, Hazardous *Awards:* Best Editorial Black and White Photograph, American Horse Publications; 1st Place, International Photo Society *Education:* Middlebury College

Although she has recently started expanding into stock photography and portraiture, she is best known for her award-winning photographs of horses and equestrian events. Her work has appeared in numerous equestrian publications and books, including *American Gold: The Story of the Equestrian Sports of the 1984 Olympics*. She shoots in available light, using a 200mm or 300mm lens in order to "get inside a space" and present it to the viewer. Influenced by Cartier-Bresson, she takes risks by getting close enough to follow a horse's movements exactly, capturing just the right stride at just the right movement. Her best photographs capture the beautiful form of both horse and rider and the special bond between them. She seeks to express in her work the "emotion of motion."

JACOBS JR., LOU (Editorial, Fine Art)
296 Avenida Andorra, Cathedral City, CA 92234

Born: 1921 *Subject Matter:* Nature, People *Situations:* U.S. Locations *Education:* Carnegie Mellon U.; Art Center College of Design

After World War II, he worked in industrial design. He then attended the Art Center College of Design and moved to Los Angeles, where he specialized in magazine photography and worked for a large variety of clients. In 1959 he began writing books about photography, and in the 1960s he began to use photographs to illustrate books for young readers. His fine art work has been exhibited at the Los Angeles County Museum, and his work is in the permanent collection of the California Museum of Photography. He is past president of ASMP, where he has been on the board of directors for the last twenty years.

JANN, GAYLE (Editorial, Corporate/Industrial)
352 E. 85th St., New York, NY 10028 (212) 861-4335

Born: 1952 *Subject Matter:* Travel, People *Situations:* U.S. & Foreign Locations *Education:* St. Lawrence U.

Her early experience as a fine art photographer is evident in her commercial work for various corporate and industrial clients, for which she travels the world. An early series of color portfolios of a variety of people in unposed street situations prepared her for a series of eight book projects illustrating career opportunities. Most recently, she spent sixteen months in Asia photographing for the Peace Corps and U.S. Aid and working on several of her own projects; her work in Nepal is an ongoing project that she plans to publish eventually as a book. In her work, both commercial and artistic, she is best known for her ability to work closely with people, capturing their unguarded responses to themselves, their world and the camera.

JARVIS, HARRY (Editorial)
728 W. 450 N., Clarfield, UT 84015 (801) 825-4070

Kenro Izu

Born: 1931 *Subject Matter:* Nature, Wildlife *Situations:* U.S. Locations

He uses the 4" x 5" and 2 1/4" formats to capture the wonders of the American West. He photographs its canyons, mountains, seacoasts, deserts, lakes, rivers, rock forms, flowers, wildlife and seasons, especially autumn and spring. He selects and portrays his subjects with a sensitivity to environment, time of day and how light enhances the scene. His work has been published in *Arizona Highways, Better Homes & Gardens, Chevron USA, Ford Times, Sierra, Ranger Rick's Nature Magazine, Texas Flier* and *Vista USA.*

JASEK, JAMES F. (Entertainment, Fine Art)
2900 Franklin Ave., Waco, TX 76710 (800) 825-4070

Born: 1941 *Subject Matter:* People, Wildlife *Situations:* Historic, Studio

From the devastation a tornado wrought in his home town as a child to the "devastation of a downtown by 'progress,'" he has been documenting human history. Although he has worked extensively in color, he prefers black and white, and his file of black-and-white negatives taken in the 1940s and 1950s covers a range of human-interest subjects. If he is not documenting a historic building, he is spelunking to photograph inside caves. He has years of experience in this challenging cave photography, which requires a vast number of innovative lighting techniques, and he has published numerous articles on the art. He works with 35mm, 120mm and 4" x 5" formats, dividing his work between advertising and historical assignments.

JENKINSON, MARK (Fine Art, Corporate/Industrial)
#6 142 Bleecker 57, New York, NY (212) 529-0488

Born: 1954 *Subject Matter:* Architecture, Interiors *Situations:* U.S. & Foreign Locations, Hazardous *Education:* Cooper Union

Trained in fine art photography, he is drawn to milieus less prominent than those his magazine work provides for—soup kitchens, sex clubs, prisons, morgues. Today he splits his time, spending some time on portraiture, architectural shots and product shots ranging from food to automobiles and other time on an extended project on Las Vegas. His most profound influences are the works of Walker Evans, Diane Arbus and Lee Friedlander, and these influences can be seen in his tightly controlled, sharply detailed compositions that expose the underlying structure of the "hidden" spaces in our culture. These primarily are minimally decorated back rooms adorned with tables, chairs and lights. It is in these objects, their arrangement and condition, that he finds the culture expressing itself. He explains, "I'm fascinated by the idea that a particular space, depending on who signs the lease, can become a storefront church or brothel replete with racks and thumbscrews."

JENSEN, JON (Editorial)
232 St. Johns Pl., Brooklyn, NY 11217 (718) 789-8069

Born: 1960 *Subject Matter:* Interiors *Situations:* U.S. Locations *Awards:* New Faces 1989, *American Photographer Education:* U. of Iowa

Originally interested in painting, he turned to photography for its ability to tell stories. For a period he worked for an underground newspaper, the *Daily Planet*, in Des Moines, shooting off-beat material. Eventually he moved to Chicago where for two years he worked for the architectural photography firm Hedrich-Blessing. While at Hedrich-Blessing, he learned many of the technical skills he would employ in New York. Today, shooting for such magazines as *Metropolitan Home, New York Magazine, Working Woman* and *Ladies' Home Journal*, he concentrates on home interiors. "It's getting the details of a room—finding what makes each room personal—that separates one interiors photograph from another," he says of his approach. His work is characterized by its tight composition and design quality.

JOHNSON, JOHNNY (Advertising, Photojournalism)
3605 Arctic Blvd., #881, Anchorage, AK 99503
(907) 562-0097

Born: 1947 *Subject Matter:* Nature, Wildlife *Situations:* U.S. Locations *Education:* Texas A & M

His photos, seen on the cover and pages of *Natural History, National Geographic* and *Alaska Magazine*, capture scenery and animals at their most expressive moments. Arriving in Alaska in 1968 to serve as a ranger, he has stayed, enthralled by the peaks and creatures around Mount Denali. Though officially he lives in Anchorage, in 1977 he built a cabin in the wilderness, a base from which he spends several months of year tracking the denizens of the national park. His "hunts," however, usually start in the library where he researches the animal he plans to follow. Using a Nikon FE2 and six to eight different lenses, he camps out, often in primitive conditions. A long way from his native Texas, where he grew up poaching game on private property, today he is an advocate for survival of wild animals and their habitats.

JOHNSON, MICHAEL (Editorial, Advertising)
6850 Casa Loma, Dallas, TX 75214 (214) 824 9860

Born: 1952 *Subject Matter:* Fashion, People *Situations:* U.S. & Foreign Locations *Awards:* TOPs Awards, Dallas Advertising League *Education:* Brooks Institute of Photography

A graduate of Brooks Institute, he moved to Dallas to break into the growing advertising market. Concentrating on developing his own fashion style, he became known for his skill in location shooting with natural light. In order to expand his style to include editorial photography as well as to receive more national exposure, he went to Europe. After two years in London, he returned to Dallas, bringing with him a new range of skills. Of equal importance is his skill in assembling teams of models, make-up artists and fashion stylists. The result of his efforts has been steady work in editorial fashion, lifestyle advertisements and children's wear photography, with a base of clients that includes Levi-Strauss, Neiman Marcus, Almay Cosmetics, Harrod's Department Store (London), Stanley Korshak (Dallas) and Ellis Inc.

JOHNSON, NEIL L. (Advertising, Editorial)
124 E. Prospect, Shreveport, LA 71104
(318) 221-2299

Born: 1954 *Subject Matter:* People, Travel, Art *Situations:* U.S. Locations *Education:* Washington and Lee U.

In 1976, after graduating with a journalism degree, he went to work for a custom color photo lab; his experience as a photo-technician prepared him for his present work. Since 1980 he has combined photog-

Shirley Fisher, *Azores*

Jim Flanigan

Morocco Flowers, *Yellow Lane #1*

Frank Foster, *Monomoy Point*

Milton Heiberg

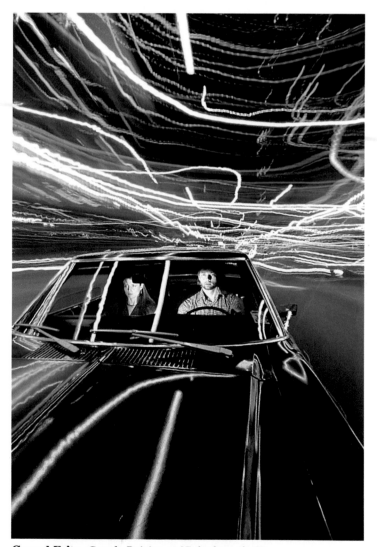

Gerard Fritz, *Couple Driving at Night through City*

D. R. Goff, *The Nutcracker.* Client: Ballet Met

David Halpern, *Thanksgiving*

Tom Graves

Larry Halpert, *Man on Roof Drinking Beer*

Len Hart, *Lovers/Girl in Denim.* Model: Lara McKenzie

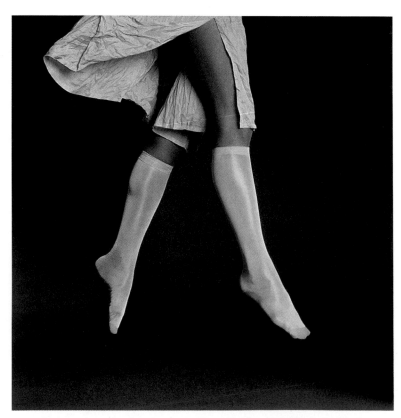

Dorothy Handelman, *Silx Package Photography,* Hue Hosiery, NYC

Steve Hathaway, *Woman in Pink Dress*

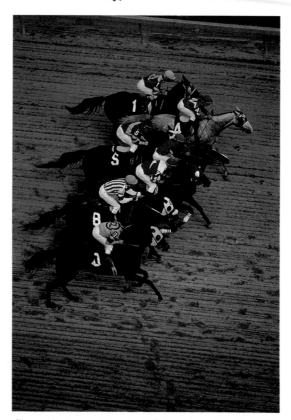

Cappy Jackson, *They're Off! Racing at Pimlico, MD*

Dennis Cox, *Dining Room Attendants, China.* Courtesy:
China Photographic Book, Co.

Frank Rossotto, *Stonehenge and Fire*

Robert Holmes

Gail B. Int Veldt, *Granary*

Robert F. Iannazzi, *President Reagan with Jessica Riley, Better Speech & Hearing Poster Child*

Robert F. Iannazzi, *The Dressing Room, Portrait of Erica Short*

Michel Legrand

Mark Johnstone, *Japan 1986*

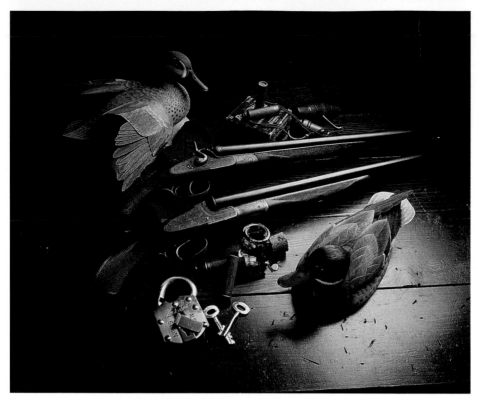

Arni Katz, *Shotguns and Decoys,* Self Promotion Calendar

Arni Katz, *Apples in aBowl*

Ralph Mercer

Art Kane

Mark Kozlowski, *Miss Havisham and Pip from Charles Dickens' Great Expectations*

Lucille Khornak

John Kleinman, *Blending Light*

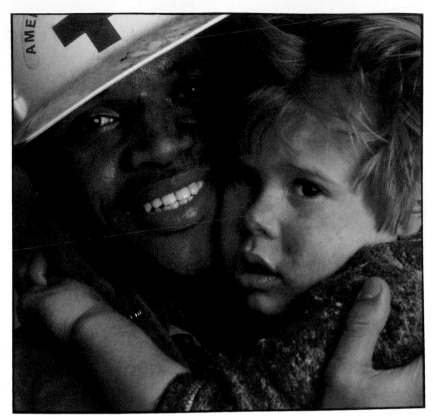

David Michael Kennedy, *Red Cross*

Karen Kent, *Brooklyn Bridge & Bow*

raphy and writing in a career that encompasses magazine, advertising and children's book publishing. He is now a generalist who has received assignments from *Time*, *National Geographic World* and *Travel and Leisure*. His strength is in people and places; for example, he has worked on a regular basis with *Louisiana Life*. In 1988 he published two children's books, one on China and the other on thoroughbred horses.

JOHNSTONE, MARK (Nature, Photojournalism)

P.O. Box 1279, Inglewood, CA 90308
(213) 671-3622; 345-7039

Born: 1953 *Subject Matter:* Environment *Situations:* U.S. & Foreign Locations *Awards:* Ford Foundation Venture Grant *Education:* Colorado College; U. of Southern California

He has worked in both black and white and color since 1972, treating these two kinds of work as separate media. Since 1978, he has also worked as a writer on art, having authored over 250 articles, reviews and book essays on photography and art in the U.S., Canada, Europe and Japan. His curatorial experience includes "Frames of Time and Context: The Development of Photographic Ideas" at the Los Angeles Security Pacific National Bank and "Eileen Cowin/John Divola—New Work, No Fancy Titles" for the La Jolla Museum of Contemporary Art, the latter traveling internationally. He served as the Series Content Advisor for the 1984 PBS television series, "The Photographic Vision." His own fine art work consists of shaped conceptual word and image combinations in black and white as well as urban and rural landscapes in color.

JONES, BOB JR. (Editorial, Corporate/Industrial)

8-A S. Plum St., Richmond, VA 23220
(804) 359-3921

Born: 1941 *Subject Matter:* Fashion, Nature, People *Situations:* Studio *Awards:* Clio; New York Art Directors *Education:* Virginia Commonwealth U.

After serving for four years as a U.S. Navy photographer, he began to freelance in both the editorial and advertising markets. Influenced by David Harvey and Bill Allard, his hard-hitting editorial photographs seek to bring out the power of human drama through lighting and other effects while at the same time retaining a human sensitivity. His work has appeared in *Time*, and his corporate clients have included Reynolds Aluminum. His books include *Richmond Today* and he is currently working on a book about stock car racing. His collection, *Virginians By the James* traveled as a one-man show for the Virginia Museum.

JONES, BRENT (Photojournalism, Corporate/Industrial)

9121 S. Merrill Ave., Chicago, IL 60617
(312) 933-1174

Born: 1946 *Subject Matter:* People, Animals, Sports *Situations:* U.S. Locations *Awards:* Public Arts Award, Columbia College; United Way Award *Education:* Columbia College, Chicago

A Chicago-based photojournalist, he provides photography for a number of media including newspapers, magazines and books, the most notable of which include *Time*, *Newsweek*, *USA Today* and the *World*

Book Encyclopedia. His assignments vary, from news and feature stories to corporate public relations and annual reports for such companies as AT&T and Scott, Foresman & Company. Additionally, he has published photography with a number of educational publishers. He specializes in photographing children and dogs for textbooks, as well as public relations shots. "I put people at ease," he says. "I know which fork to use."

JONES, HAROLD HENRY (Fine Art)

c/o Dept. of Art, University of Arizona, Tucson, AZ 85721

Born: 1940 *Subject Matter:* Nature, Objects *Situations:* Location *Awards:* Eastman House Fellowship; NEA Grant *Education:* Maryland Institute of Art; University of New Mexico

After working in various curatorial positions; most notably at George Eastman House, he was the director of both the Light Gallery and the Center for Creative Photography during the 1970s. Since 1977 he has been able to concentrate full-time on his own work. Color slides are used as photographic sketches or notes for the final black-and-white silver prints and Polaroids. Simple indoor or outdoor subjects, such as a landscape or a glass of water, are transformed into new images, often by drawing or painting color directly onto the photographs. The works are what he describes as, "a conversation with photography," in which "a number of signals swing into a moment of harmony," in order "to generate a sense of wonder." He has been director of photography at the University of Arizona since 1977. Public collections include the Museum of Modern Art in New York City and the National Gallery of Canada.

JONES, JOHN (Portraiture)

8774 Tyrone Ave., Panorama City, CA 91402
(818) 892-5376

Born: 1923 *Subject Matter:* People *Situations:* Studio *Education:* Rochester Institute of Technology; Art Institute of Pittsburgh

After leaving the armed forces he worked for Richard Little at the Little Studio. Later he bought the Little Studio and expanded it into three separate businesses under one name. His subjects have included portraiture, glamour, theater, industry, photojournalism and advertising. He is most noted for his black-and-white photographs and has been influenced by Yousuf Karsh. The author of a federal government publication on photography, he has taught at the Art Institute of Pittsburgh School of Photography and at the Earl Wheeler Schools.

JONES, LOU (Advertising, Corporate/Industrial)

22 Randolph St., Boston, MA 02118

Born: 1945 *Awards:* Art Director's Club of Boston *Education:* Rensselaer Polytechnic Institute

He is best known for his bold, graphic and color-saturated photographs. Most of his work, which consists of advertising and collateral, is conceptual in nature, conveying his own point of view. His photographs exhibit a lyricism—a study in motion that effectively traces the evolution of a product. His still lifes and photo-illustrations make use of bright sun to "pop out colors." His clients have included the Boston

Ballet, Polaroid, Chase Manhattan Bank, Price Waterhouse and Teledyne.

JONES, PIRKLE (Fine Art, Photojournalism)
663 Lovell Ave., Mill Valley, CA 94941

Born: 1914 *Subject Matter:* Urban and Rural Landscapes, People *Situations:* U.S. Locations, Studio *Awards:* Photographic Excellence Award, National Urban League, NYC; NEA Photography Fellowship *Education:* San Francisco Art Institute

Pirkle Jones studied photography under Ansel Adams and Minor White. Other influences he cites are Dorothea Lange, Edward Weston and Alfred Stieglitz. A freelance photographer since 1949, he served as photographic assistant to Ansel Adams for three years. He works in both large and small formats and is known for his landscapes, in particular those of the American Southwest depicting the beauty of beaches, indigenous vegetation and bodies of water. In contrast, he was also involved in a photo-essay project entitled "A Photographic Essay on the Black Panthers" in the late 1960s, presenting a series of photographs on Black Panther gang leaders and their meetings.

JONES, STEVEN W. (Advertising, Corporate/Industrial)
120 W. 25th St., New York, NY 10001
(212) 929-3641

Born: 1954 *Subject Matter:* People, Fashion *Situations:* Studio, U.S. Locations *Awards:* Atrium Award *Education:* Art Center College of Design

During his last year of art school he began his career as a corporate/industrial photographer. After graduation he moved to New York City, where he worked for a short time on Pete Turner's studio staff. His work is presently human interest-related. Children and families dominate both his studio and location work. He seeks to draw out and capture the magical moments of expression and gesture which are the special beauty of children. His work is characterized by strong graphics and contemporary colors. His photographs have appeared in national advertisements, leading parenting magazines, fashion spreads and on toy and baby-product packaging.

JOSEPHSON, KENNETH (Fine Art)
c/o School of the Art Institute of Chicago, Columbus Dr. and Jackson Blvd., Chicago, IL 60603
(312) 443-3751

Born: 1932 *Subject Matter:* Nature, People *Situations:* Studio, U.S. & Foreign Locations *Awards:* NEA; Guggenheim Fellowships *Education:* Rochester Institute of Technology; Institute of Design, Illinois Institute of Technology

He is concerned with photographic illusion and how it differs from perceptions of reality. He often uses photographs as his subject matter or includes them in three-dimensional assemblages and collages. He has received corporate commissions for assemblages and mural projects, and his work is in the collections of the Museum of Modern Art, the Art Institute of Chicago, the Bibliotheque Nationale in Paris and the Center for Creative Photography in Tucson. He currently teaches at the Art Institute of Chicago.

KAHL, M.P. (Editorial)
P.O. Box 2263, Sedona, AZ 86336 (602) 284-1054

Born: 1934 *Subject Matter:* Wildlife *Situations:* U.S. & Foreign Locations

In the 1960s he began his photographic career while researching birds in East Africa. The larger part of his files are made up of storks, flamingos, spoonbills and other water birds of Africa, Asia, Australia, and South and North America. He also has documentation of birds, mammals and other natural phenomena from the Antarctic and elsewhere. "I have found that science and photography work well together: the science allows extensive travel and furnishes better-than-average caption information, while the photography helps pay the bills." His images have appeared in *National Geographic, International Wildlife, Birder's World, Ranger Rick* and *Audubon.*

KAHN, R.T. (Photojournalism, Portraiture)
156 E. 79th St., New York, NY 10021 (212) 988-1423

Born: 1933 *Subject Matter:* Animals, People *Situations:* Studio, U.S. & Foreign Locations *Awards:* Associate, Royal Photographic Society of Great Britain

In the early 1960s he began his photographic career at *Life* magazine, where he was influenced by Eisenstaedt and later became an exponent of the "ambience" school of photography. He achieved his professional catharsis during a portrait session with cellist Pablo Casals. His first major assignment was to cover Pope Paul VI's mission to the United Nations. He has a large photographic portfolio of royalty and actors and his images are on permanent exhibition at the New York Metropolitan and Stockholm Operas. He has covered assignments for *Time, Newsweek, Sports Illustrated* and the *Saturday Evening Post.* Among his commercial clients are Eastern Airlines, McGraw-Hill and Young & Rubicam.

KAINZ, JAY F. (Advertising, Scientific)
115 S. Emerson, Allentown, PA 18104
(215) 821-0602

Born: 1959 *Subject Matter:* People, Medical *Situations:* Studio, Hazardous, U.S. Locations *Education:* Moravian College

With an undergraduate degree in science, he started as a biomedical photographer, later expanding into advertising and public relations. He is best known for his candid photography in which his subjects appear in their natural moods. A versatile photographer, he has been involved in hazardous situations, closely covering many auto racing events. While his studio is located just ninety minutes from New York City, assignments frequently take him to a variety of locations around the United States. He has recently been doing extensive work in health care reportage and advertising.

KAKUK, TED (Portraiture, Nudes)
P.O. Box 1030, Glendora, CA 91740 (818) 335-8729

Born: 1937 *Subject Matter:* Fashion, People *Situations:* Studio, U.S. & Foreign Locations *Education:* Brooklyn College

A former professional boxer and sparring partner of heavyweight champion Floyd Paterson, he spent time hosting radio and television before becoming a full-time photographer. With an eye for the unusual, he shoots high fashion, nudes and semi-nudes. His work has appeared in various media, including magazines, newspapers and advertising. Recently, he has been focusing his efforts on shooting for calendars. In shots of subjects ranging from lingerie to beer, he strives for

Gail B. Int Veldt, *White Waterlily*

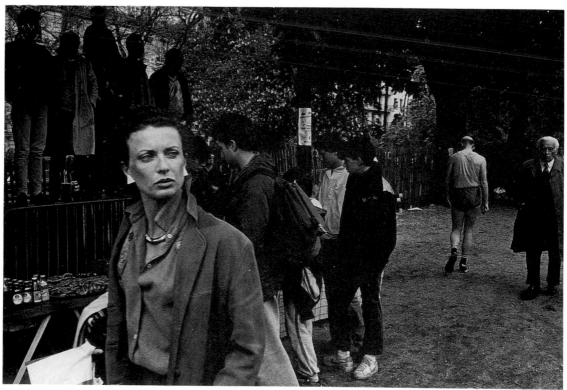

Mark Johnstone, *Paris, France, Marathon,* 1984

the elegance and high fashion suitable for a formal dining room.

KALDOR, CURT W. (Advertising, Editorial)
1011 Grandview Dr. S., San Francisco, CA 94080
(415) 583-8704

Born: 1921 *Subject Matter:* Fashion, Food, Products *Situations:* Hazardous, U.S. Locations, Studio, Aerial

At one time a sports photographer, he spent two years as a combat motion picture photographer for the Air Force, during which time he shot a story on a leper colony. Working as a civilian again, he became a commercial and stock photographer. Photographing everything from concrete pipes to beautiful women, from aerial to studio locations, he has placed pictures in newspapers, magazines, corporate communications, books and advertising. Recently he has been shooting very high speed studio work (speeds up to 1/500,000 of a second), photographing such events as milk spilling and drops of wine splattering in order to produce compelling advertising images.

KALICK, CLIFT (Entertainment, Convention Publicity)
8552 Sepulveda Blvd., Sepulveda, CA 91343
(818) 894-3613

Born: 1922 *Subject Matter:* People, Travel *Situations:* Hazardous, U.S. Locations

Semi-retired but still active as he approaches his 50th year as a professional photographer, he remembers his first camera, a twenty-nine-cent Univex that came with one roll of double-O film, twelve sheets of 2 1/4" x 2 1/4" paper and two vials of chemicals, plus instructions. Over the years he has worked as a convention photographer, an aerial photographer for the U.S. Army Air Force and a publicity photographer in Hollywood photographing film stars and political figures. After many convention and commercial industry assignments, he opened his own processing lab and two retail camera shops. His semi-retirement allows him to pick and choose his accounts, some to which he flies, others to which he drives in his motor-home, Mobile Lab Unit.

KAMPER, GEORGE (Editorial, Corporate/Industrial)
62 North Union St., Rochester, NY 14607
(716) 454-7006

Born: 1955 *Subject Matter:* People, Still Life, Products *Situations:* U.S. Locations, Studio *Education:* Rochester Institute of Technology

With a clientele that includes IBM, Kodak, Xerox and other Fortune 500 companies, he finds himself working in a variety of styles, drawing upon the influence of Avedon, Karsh and Penn, as well as Marco, O'Neil and other contemporary photographers. His own specialty is in still life and table-top, which calls for complex lighting and multiple cameras. Working in both color and black and white, he designs photo montage for many of his assignments and is known for his creative lighting. Approximately one-third of his work is in television, though most recently he has been focusing his time on health care products and people campaigns.

KANE, ART (Advertising)
1181 Broadway, New York, NY 10001

Born: 1925 *Subject Matter:* Fashion, People *Situations:* Studio, U.S. Locations *Awards:* ASMP Photographer of the Year, 1963 *Education:* Cooper Union

In the late 1950s, he began photographing celebrities, including the award-winning portrait of Louis Armstrong sitting in a desert in a rocking chair. In the following decade he was known for his portraits of musicians such as Bob Dylan and Jefferson Airplane and for illustrations of popular songs such as the Beatles' "Strawberry Fields." Shooting in available light, he used bright and bold colors to portray straightforward images, sometimes double exposed, sometimes using a wide-angle lens. Work for such magazines as *Life, Esquire, Seventeen* and *Look* include fashion and city portraits. In the early 1970s, he experimented with erotic subject matter in his capacity as art director at *Penthouse* and *Viva*. In 1975 he returned to freelancing. He recently took a series of hand-held flash photographs at night.

KANE, DENCY ANN (Nature, Fine Art)
340 E. 64th St., Apt. 9K, New York, NY 10021
(212) 371-3596

Born: 1946 *Subject Matter:* Nature, People *Situations:* Studio, U.S. Locations *Awards:* Residency, Millay Colony for the Arts, Austerlitz, NY *Education:* U. of New Hampshire; Boston U.

Influenced by African art, her early still-life photographs evoked powerful emotive and sensual responses. Like Georgia O'Keeffe, she enlarges natural forms like flowers and vegetables. The resulting black-and-white images are mysterious and sensual. Her work is often shown in galleries, and she has had photographic portfolios published in such European magazines as *Clichïs, Verlag Photographie* and *Photo Vision*. Her photographs are in the permanent collections of the Bibliotheque Nationale in Paris, the Victoria and Albert Museum in London, the Museum of Photography in Charleroi, Belgium and the New Orleans Museum of Art.

KAPLAN, JONATHAN (Photojournalism)
2955 Bayport Ct., Wantaugh, NY 11793
(516) 781-9152

Born: 1968 *Subject Matter:* News Events, Concerts *Situations:* U.S. Locations *Education:* Carnegie Mellon U.

Studying industrial management, graphic communications management and visual communications at Carnegie Mellon University in Pittsburgh, he has only recently begun shaping his hobby in photography toward a career in the field. Interested in capturing "those events that would not normally be recorded on film," he carries a Nikon FE2 for its fast-action shooting capacity. With publications in many local magazines and newspapers, Carnegie Mellon Alumni communications as well as Newsweek International, he has covered a variety of events, from local football and basketball games to the Gay & Lesbian Alliance Parade in New York. Concert coverage includes such rock 'n' roll performers as Madonna, Billy Joel, Squeeze and the Bangles. As he owns a calendar company, he also shoots fashion on occasion for various calendar editions.

KAPLAN, PEGGY JARREL (Portraiture, Fine Art)
510 E. 86th St., 16C, New York, NY 10028
(212) 535-6825

Cappy Jackson, *Roller Coaster Ride, Maryland State Fair*

David Michael Kennedy, *Bruce Springsteen, CBS Records*

Born: 1943 *Subject Matter:* Choreographers, Artists, Composers, Performing Artists *Situations:* Foreign Locations *Education:* Antioch College; Columbia U.

Since 1980, avante-garde artists, choreographers, composers and performers have been the subjects of her black-and-white portraits. Her studio images exhibit "noble" strength. She was portrait photographer for the Next Wave Festival at the Brooklyn Academy of Music, and her portraits have been exhibited in New York's Lincoln Center. Both *Andy Warhol Prints* and *Further Steps: Fifteen Choreographers On Modern Dance* featured her work prominently, and the publisher Fotofolio has printed postcards of her portraits which are distributed around the world. Her work is in the collection of the Museum of Modern Art.

KARGMAN, ALLEN (Advertising, Corporate/Industrial)
255 E. Howard St., Clayton, NJ 08312

Born: 1956 *Subject Matter:* Wildlife, People *Situations:* Studio, U.S. Locations *Education:* Antonelli Institute

Inspired by the quality of the photography in *National Geographic*, he tries to emulate their high standards and to fashion his work accordingly. Specializing in landscapes and portraits, with a particular strength in environmental portraiture, he is currently building up a selection of stock photographs for marketing. In the meantime he will continue to produce work for various advertising and corporate/industrial projects. His goal, however, is to be a staff photographer for a publication such as *National Geographic*.

KASER, KEN (Book Illustration, Corporate/Industrial)
1232 Cobbs St., Drexel Hill, PA 19026 (215) 789-7033

Born: 1953 *Subject Matter:* Wildlife, People *Situations:* U.S. Locations, Underwater *Education:* U. of Pittsburgh; Penn State U.

In 1980, he switched from a corporate management position in the health care industry to a career as a professional photographer. Because of his extensive experience in editorial photography while in college, he began his professional photography career in that market. Today, he provides photography for the *Philadelphia Inquirer*, but the bulk of his work serves corporate clients. His style is clean, crisp and straightforward; he looks to the work of Jay Maisel, David Doublet and David Meunch for inspiration and influence. He has an ability to find interesting views of ordinary subjects, and he seeks to capture the overlooked—for example, a spider building its web in a traffic light. His personal favorites are nature and underwater shots. He is interested in the environment and in research, occasionally working with scientists to provide editorial or documentary photography.

KATZ, ARNI (Advertising, Fine Art)
108 Ayers Ave., Ste. A, Marietta, GA 30060 (404) 421-8800

Born: 1954 *Subject Matter:* Landscape *Situations:* U.S. Locations, Studio *Awards:* Addys; National Print Awards *Education:* U. of South Florida

He is known for dramatic lighting and large-format studio work in black and white. Favoring strong design and fine detail, in his commercial work he seeks to achieve the quality of fine art prints, in both black and white and color. A subjectivity is expressed through his search for a "pure and uncontrived relationship be-

tween the seen and the printed image." With a meticulous approach, he fills the frame with as much information as possible, following the influence of Ansel Adams, Phil Marco and W. Eugene Smith. His work is characterized by a simplicity of lighting, texture and shape. Recently he published a book on the history of Georgia and particularly of Atlanta. He is also pursuing several personal fine art projects concerning rural America in addition to his commercial assignment work.

KATZENSTEIN, DAVID (Fine Art, Advertising)
21 E. 4th St., New York, NY 10003 (212) 529-9460

Born: 1954 *Subject Matter:* Still Life, People *Situations:* Studio, U.S. & Foreign Locations *Awards:* Photographic Work Grant, Maine Photographic Workshops

Having studied history in college, he has carried on his interest in events and other cultures via his photography. While his early photography involved mostly corporate product still life, he has since developed a wide range of clients and assignments. One week he may be shooting electronic equipment in the studio, the next covering blues musicians in southern Mississippi. When he can, he travels to third world countries, photographing the life and people in remote village areas. These photos have been exhibited in New York in the Marlborough Gallery, the Jayne Baun Gallery and the DTW Gallery; he is represented by Holly Solomon Editions. More and more he is finding his fine art photography accepted in commercial arenas. He shoots for CBS records, with covers for Grover Washington Jr., The Hooters and Pat Metheny, producing both the cover and back photography for the Dirty Dozen Brass Band's album "Voodoo" with his night photograph of a skull surrounded by lit candles, a shot taken on one of his trips abroad.

KEARNEY, MITCHELL (Advertising)
301 E. 7th St., Charlotte, NC 28202 (704) 377-7662

Born: 1956 *Subject Matter:* Fashion, People *Situations:* Studio & U.S. Locations *Education:* School of Visual Arts, NYC

He works in a romantic realist style. In the mid-1970s, he began his career by shooting the New York punk scene. His one man show "The Lunatic Fringe" appeared at the New York Camera Club. During the same period he assisted for a variety of New York advertising photographers, learning still life, fashion, special effects and photo illustration. He also did celebrity portraits of David Mamet, Dick Cavett, Lou Reed, Frank Zappa and William Burroughs. In the early 1980s he relocated to Charlotte, for peace of mind and to be involved what he perceived as an up and coming city. His work has appeared in *Vogue*, *Newsweek*, *Time* and *Sports Illustrated*.

KEENAN, LARRY (Corporate/Industrial, Advertising)
421 Bryant St., San Francisco, CA 94107 (415) 863-0263

Born: 1943 *Subject Matter:* Nature, People, Products *Situations:* Hazardous, Studio, U.S. Locations, Special Effects *Awards:* Phelan Award, AD Club, *Graphics Magazine Education:* California College of Arts & Crafts

Arni Katz, *Alain Prost, Detroit Grand Prix*

Arni Katz, *Antonio, Migrant Worker, Special Assignment*

In 1964, while still in college, he began his career by documenting the Beat Generation and working for book and record companies. A collection of these photographs is now in the Smithsonian Institution. In 1970 he opened a studio servicing advertising and corporate clients. He is known for his ability to understand complex technologies and to convey these technologies with conceptual images and innovative techniques. Special effects photography and surreal imagery are his current fascinations. He has been very successful in software packaging and advertising high-tech products and services.

KEHAYA, DOROTHEA (Fine Art)
RFD 3, 164 West Road, Putney, VT 05346

Born: 1925 *Subject Matter:* Nature *Situations:* Outdoors

Completely self-taught, she was a member of The Association of Heliographers of New York City in the early 1960s. She has continuously concentrated on the effects of light on color in nature. Color filters are used to create nature studies, manipulating color and light to express personal emotions. "All the pictures I make," she says, "are an expression about my feelings of life." She has taught photography at New York City's School of Visual Arts and privately since 1976. She has published a book of her photographs, and her public collections are held at the Metropolitan Museum of Art in New York City and the Museum of the City of New York.

KEISER, ANNE B. (Photojournalism)
3760 39th St. N.W., #F144, Washington, DC 20016 (202) 966-6733

Born: 1948 *Subject Matter:* Travel, People *Situations:* U.S. & Foreign Locations *Education:* Middlebury College

Her photographic career began as a staff assistant for *National Geographic* magazine. From there, she transferred to television, where she edited still pictures and eventually shot stills for the National Geographic television specials. Since leaving National Geographic in 1986, she has pursued a career as a travel photographer and travel consultant. Her skill in creating a rapport with people allows her to photograph her subjects candidly in their natural environments. She is currently working on a number of freelance assignments, including one for Princess Tours and another for *Audubon*.

KELLY, JAMES C. (Entertainment, Corporate/Industrial)
Rd. #1, Box 150, Panama, NY 14767 (716) 763-5214

Born: 1960 *Subject Matter:* Fashion, Animals *Situations:* Hazardous, Studio

Shooting aerial photography for a local resort led to industrial photography of gas wells. From that base, he began photographing food for a variety of accounts, enough to establish his own studio. In addition to food, he specializes in photographing animals, providing photographs for zoological studies for treating animals. His technical photography involves ballistics and high speed shooting, which is done mostly for advertising brochures and catalogs for electronics. Despite his skills in technical photography, he enjoys photographing people and families and has done much work in Christian Ministry Outreach, advertising for various evangelist ministers.

KELLY, MIKE (Editorial, Corporate/Industrial)
7514 N. Eastlake, Chicago, IL 60626 (312) 262-3562

Born: 1959 *Subject Matter:* People *Situations:* Hazardous

He specializes in location photography of people, often taken under adverse circumstances. In high school he apprenticed with his father, Tony Kelly, who was a corporate and industrial photographer. At age eighteen he began shooting for the *Evanston Review* on a freelance basis. Since then he has established a foundation of corporate and industrial accounts that includes P.C.A. Vision, Bell & Howell and AT&T Publications.

KELLY, TOM (Photojournalism, Editorial)
Box 208, Saratoga, Pottstown, PA 19464 (215) 327-1336

Born: 1947 *Subject Matter:* Nature, People *Situations:* Studio, U.S. Locations *Awards:* Pulitzer Prize; Robert F. Kennedy Award

He has been a self-taught and self-motivated news photographer since 1970. In 1979, he won the Pulitzer Prize for photojournalism, and since 1982 he has traveled extensively, building up a portfolio of America's travel, scenic and historic sights. His work has appeared in *Time, Newsweek, Life, U.S. News & World Report, Sports Illustrated* and over thirty textbooks and encyclopedias. He currently freelances for several corporate and business related clients in the Philadelphia area while at the same time maintaining a full-time staff job at a local newspaper. He serves as a photojournalism instructor at Temple University and is founder of the Northern Short Course in Photojournalism.

KELLY, TONY (Corporate/Industrial, Editorial)
828 Colfax St., Evanston, IL 60201 (312) 864-0488

Born: 1929 *Subject Matter:* Industry, People *Situations:* U.S. Locations *Awards:* New York Art Directors Club

While he began his career as a newspaper photographer and writer, today he is heavily involved in assignments for large corporations, taking on only an occasional editorial job. Concentrating on people and industrial photography, he has published in *Newsweek, Paris Match, Time* and *Life*. His work is characterized by a combination of warm human emotion and abstract composition, captured on film even under difficult circumstances. In addition to his commercial photography, his work has been featured in numerous shows including two in New York City, where he is represented by a gallery. When he is not teaching a photojournalism course at Northwestern University, he is busy working on several books of his own and a number of corporate annual reports.

KEMPER, LEWIS (Editorial)
P.O. Box 511, Yosemite, CA 95389 (209) 379-2828

Born: 1954 *Subject Matter:* People, Wildlife *Situations:* U.S. Locations *Education:* George Washington U.

Producing work on many levels, he has published fine-art photographs, wildlife and straight stock. He concentrates on nature shooting, encompassing "the pictorial as well as the imaginative." He works with both large-and small-format cameras on color film. He has authored two books, *The Yosemite Photographer's*

Handbook and *The Yellowstone Photographer's Handbook*. His work is included in the permanent collection of the Baltimore Museum of Art. He is handled by Dark Photo. As co-founder of Sierra photographic workshops, he has the opportunity of further exploration through his teaching.

KENNEDY, DAVID MICHAEL (Fine Art, Advertising, Editorial, Portraiture)
P.O. Box 254, Cerrillos, NM 87010 (505) 473-2745

Born: 1950 *Subject Matter:* People, Landscape *Situations:* Studio, U.S. Locations *Awards:* Clio Award; *Communication Arts* Award of Excellence

During his eighteen years in New York City, he became known primarily for his black-and-white portraits, initially shooting still life, before moving to advertising, editorial and fashion projects. In an attempt to break into the recording industry, he started a portrait project of top New York album cover art directors, which resulted in his shooting album covers for such entertainers as Bob Dylan, Bruce Springsteen, Julian Lennon, Isaac Stern and Muddy Waters, over 300 in all. He then began accepting more editorial and advertising assignments, working for The National Guard, NATO, Hasselblad Cameras and CBS News, among others, and publishing in such magazines as *Elle, Omni, Rolling Stone* and *Spin*. His portraits of Debbie Harry and Bob Dylan for *Spin* won him Art Directors Club of New York's Annual Exhibition Awards. He then moved to a small town in northern New Mexico to concentrate on his personal work, which has resulted in photographs of the New Mexican landscape, of his wife days before she gave birth, and portraits of "real" people, such as Capt. John Few of the Turquoise Trail Volunteer Fire and Rescue Department (of which Kennedy is a member). He accepts limited commercial work and is currently doing extensive work with 4" x 5" Polaroid positive/negative film and Palladium printing.

KENNEDY, WILLIAM (Advertising, Fine Art)
1300 Collins Ave., Miami Beach, FL 33139
(305) 595-1700

Subject Matter: People, Travel *Situations:* U.S. & Foreign Locations *Education:* Syracuse U.; Pratt Institute

Drawing on his experiences as a avid scuba diver, parachutist and boatman, he finds unique creative solutions for his many and varied clients. As an international concept photographer and designer, specializing in beauty accounts and in people for advertising illustrations, he has shot on assignment throughout the world for such companies as AT&T, IBM, American Express, TWA, Windjammer Cruises, Avon, General Electric, R.J. Reynolds and Nabisco and for the Turkish, Moroccan, Brazilian and Spanish National Tourist organizations. In addition to travel and product shooting, he has also turned to the art world: he photographed Andy Warhol standing with his silkscreen of Marilyn Monroe. This photograph was one of several by leading photographers in a show entitled "Homage to Marilyn Monroe."

KENNERLY, DAVID HUME (Editorial, Photojournalism)
4220 Klump Ave., N. Hollywood, CA 91602

Born: 1947 *Subject Matter:* People *Situations:* U.S. & Foreign Locations *Awards:* Pulitzer Prize for Feature Photography *Education:* Portland State College

His first professional jobs were with the *Lake Oswego Review*, the *Oregon Journal* and the *Oregonian*. In 1967 he joined UPI and had assignments in New York and Washington, D.C. before going to Saigon. In 1972 he won the Pulitzer Prize for Feature Photography in Vietnam. While in Southeast Asia he was a contract photographer for *Life* and *Time*. In 1973 he covered the release of the American prisoners of war in Hanoi. The same year he returned to the U.S. to cover the Watergate hearings and the resignation of Vice President Agnew. He was then assigned to cover the Ford Vice Presidency and he was personal photographer to President Ford. After Ford left office, he returned to *Time* and worked extensively in the Middle East and Asia. His photo of the Jonestown Massacre appeared on the cover of *Time*. After covering the 1984 Los Angeles Olympics, he attended the American Film Institute's directing program. He has directed two films and produced an NBC movie of the week. He is author of *Shooter*, a professional autobiography.

KENT, KAREN (Advertising, Fine Art, Corporate/Industrial)
29 John St., New York, NY 10038 (212) 962-6793

Born: 1941 *Subject Matter:* Nature, People, Travel *Situations:* Studio, U.S. & Foreign Locations *Education:* U. of Iowa

Influenced by painter Edward Hopper and poet William Carlos Williams, she defines the art of photography as "visual poetry." Both commercial work and fine art celebrate the ordinary, reflecting the colloquialisms of everyday life. Working in all formats, her images convey a powerful sense of mood and discovery, with subject matter ranging from steel mills to cranberry fields. Use of color often transcends reality, as each situation is presented as an enhanced vision. For example, a body in a hammock reveals both detail and silhouette, simultaneously suggesting the human form and that of a mountain landscape. Architectural work goes beyond the immediate and is often subjective, such as a building whose existence is defined by its reflection. In addition to corporate work, clients include design firms, advertising agencies and publications worldwide. She also maintains a stock library in excess of 100,000 images.

KENT, NORMAN A. (Advertising, Entertainment)
11622 Huston St., N. Hollywood, CA 91601
(818) 761-3281

Born: 1956 *Subject Matter:* Skydiving *Situations:* Aerial

Skydiving stunt man, film-maker and photographer, he has made over 4,500 camera jumps in the past eleven years. Known worldwide for the quality and creativity of his work, he holds several photo and film skydiving records, including the 100-way world record formation, the sixty-way girls world record and the twenty-seven-way night world record. Outside the skydiving community, his work is recognized by the television industry, and he has had contracts with ABC's "Good Morning America"—for whom he filmed Ron Reagan Jr.'s tandem jump—and for "Wide World of Sports", NBC's "Battle of the Network Stars", the BBC and National Geographic. His photos have been published in magazines and books all over the world, including *Parachuting's Unforgettable Jumps III, Skydiving Magazine, Parachutist, New Worlds, Fallschirm* (Austria) and *Skydiver Magazine* (Germany).

KEPES, GYORGY (Fine Art)
90 Larchwood Dr., Cambridge, MA 02138

Born: 1906 *Subject Matter:* Objects *Situations:* Studio *Awards:* Guggenheim Fellowship; Rhode Island School of Design Fellowship *Education:* Academy of Arts, Budapest

Born in Hungary, he studied art with Istvan Csók in the 1920s, then learned about photography from Laszlo Moholy-Nagy during the following decade. He emigrated to Chicago in 1937 with Moholy-Nagy, where Kepes was head of the Light and Color Department of the New Bauhaus School and later of the Institute of Design. Fascinated by the effects of light and shadow, he experimented with photograms—images made by a light source coming in contact with photographic paper, without the aid of a lens. The objects are placed in space and redefined by the light, turning into shapes and forms, often creating the illusion of movement. Images created by light are an expression of both art and science. Public collections include the Museum of Modern Art in New York City and the Art Institute of Chicago.

KERN, GEOF (Editorial)
c/o Cobb & Friend, Dallas, TX 75204 (214) 855-0055

Born: 1950 *Subject Matter:* Still Life, Fashion *Situations:* Studio, U.S. Locations *Awards:* American Photographer Annual; Silver Medal New York Art Directors Club; Best of Show, Los Angeles Art Directors Club *Education:* Brooks Institute of Photography

With a background in fine art and film theory and film production, when he completed his degree at Brooks Institute he moved to Dallas to start freelancing in still photography. For a period he developed his skill in special effects and as a result is widely versed in camera formats and lighting techniques. Today, he is interested in merging fine art and commercial avenues. As an editorial photographer his assignments vary. For *Taxi* magazine, he recently completed an eight-page spread on accessories shaped like fruit, including shoes, handbags and dishware. Other assignments include a home accessories feature, shooting furniture in a mid-sixties look for the *New York Times Magazine*. A contributing editor for *Spy*, he also regularly publishes in *Rolling Stone, Esquire, GQ, Fame* and *Texas Monthly*.

KESSEL, DMITRI (Photojournalism, Industrial)
46 Avenue Gabriel, 75008 Paris, France

Born: 1902 *Subject Matter:* People, Architecture *Situations:* U.S. & Foreign Locations *Awards:* Gold Medal of the City of Ravenna; Award of The Order of Excellence of Spanish Morocco *Education:* Rabinovitch School of Photography

Born in Kiev, he became a naturalized American citizen in 1929. His photography career began when as a young man he shot amateur photographs of a massacre which took place between Polish soldiers and Ukrainian civilians. After studying photography with Rabinovitch in New York in 1934, he photographed the urban landscape and eventually became a staff photographer for *Life*. He is well known for his images of war and news stories from such locations as Greece, Germany, Spain and the Middle East. More recently he has been known for majestic portraits of great architecture and fine art, such as St. Mark's in Venice and the sculpture of Michelangelo. His work can be found in New York City at the Metropolitan Museum of Art and at the Time-Life Library.

KEZYS, ALGIMANTAS (Fine Art)
4317 S. Wisconsin Ave., Stickney, IL 60402
(312) 749-2843

Born: 1928 *Subject Matter:* People, Nature, Architecture Situations U.S. Locations

A Lithuanian Jesuit, he takes black-and-white photographs of the many subjects that have interested him throughout his lifetime. His work is characterized by a formal quality and by the emphasis he places upon both seeing and sharing his personal vision. Eschewing the overly technical and formulaic, his photo essays of street scenes, landscapes and architecture, among other subjects, have illustrated many books, magazines and calendars. Although his photography work has always been an avocation, he has nonetheless published several books, notably *Form and Content, Chicago/Kezys, Nature, Faces of Two Worlds, Chicago Churches and Synagogues* and *Variations on a Theme: Worlds Fairs of the 80s*, as well as a collector's portfolio entitled *Society's Man*. Exhibiting frequently in the U.S., he also founded Galerija, a Chicago gallery, in 1980.

KHORNAK, LUCILLE (Advertising, Portraiture, Editorial, Fine Art)
425 E. 58th St., New York, NY 10022 (212) 593-0933

Born: 1953 *Subject Matter:* Fashion, People *Situations:* Studio *Awards:* Silver Medal, Art Directors Club

She had been working as a high fashion model for several years when she decided to move behind the camera to become a fashion photographer herself. What she enjoys most is stretching her creative potential to the fullest, expressing a personal, feminine vision. Her subjects and their own emotions are the essence of her color commercial work. She has worked with more than a hundred of the world's top fashion designers as well as dozens of other artists, and she credits them with giving her the inspiration and support she needs to do her best work. Her work has expanded beyond the realm of fashion photography, as she has made numerous television and radio appearances as an expert in photography and fashion. An exhibition of sensual black-and-white photographs, made over a ten-year period, was shown at a number of galleries in New York City and then traveled to the Gulbenkian Museum in Lisbon, Portugal. Her work has been published in her first book, *Fashion:2001*.

KIENITZ, MICHAEL (Editorial, Photojournalism)
P.O. Box 9241, Madison, WI 53715 (608) 251-1642

Born: 1951 *Subject Matter:* People *Situations:* Hazardous, U.S. & Foreign Locations *Awards:* UPI Best Picture Story *Education:* U. of Wisconsin

He specializes in photographic reportage, and his work has appeared in virtually every major publication in the U.S. and Germany. His assignments have included Beirut, Belfast, Afghanistan, El Salvador, Nicaragua, Cuba and Guatemala. He is represented by Picture Group. His book, *Bird of Life Bird of Death*, was published by Simon and Schuster. One editor has described Kienitz as having done it all: "In the morning he can photograph Yasser Arafat, in the afternoon a corporate executive."

154

Karen Kent

Lucille Khornak

KIMAK, MICHAEL D. (Editorial, Advertising)
1916 Septiembre Dr., El Paso, TX 79935
(915) 594-1491

Born: 1943 *Subject Matter:* Nature, Travel *Situations:* U.S. & Foreign Locations *Education:* Purdue U.; Winona School of Professional Photography

His photography career began while traveling in the military. Subsequently, he has concentrated on travel and nature photography for editorial and advertising markets. Study at the Winona School of Professional Photography introduced him to the work of Elliott Porter; this profoundly influenced his own nature photography, in which he seeks to document its simple beauty. His travel photography, on the other hand, captures the exotic, the glamour and splendor of faraway places, providing the viewer with an adventure in pictures. He has been affiliated with The Image Bank in New York for over ten years, and his many magazine credits include *Life* and a cover for *Americana*. His work has also appeared in books, namely *California* and *The Grand Canyon* in the series "This Beautiful World," and *South* and *West* in "Images of America" for The Image Bank.

KIMBALL, CHUCK (Advertising, Fine Art)
3421 Tripp Ct., San Diego, CA 92121 (619) 453-1922

Born: 1939 *Subject Matter:* Fashion; People *Situations:* Studio, U.S. & Foreign Locations

Self-taught, he has spent the last twenty years shooting both fine art and commercial photography, working to integrate the two wherever possible. His expertise in photographing the nude is in particular demand for projects related to fashion and people. In the past few years, he has turned to an alternative photographic process for his fine art pieces. He produces rare nudes as one of three or four photographers in the U.S. using the bromoil process, whereby the silver image in a print is bleached out. His art photos have been exhibited regularly over the past fifteen years.

KINCAID, CLARK (Advertising, Corporate/Industrial)
7420 Manchester Rd., St. Louis, MO 63119
(314) 644-4263

Born: 1950 *Subject Matter:* People, Products *Situations:* U.S. & Foreign Locations, Studio *Awards:* Flair Award *Education:* Rochester Institute of Technology

After graduating from the Rochester Institute of Technology in 1976, he went to work for Sayers Communications Group in St. Louis. During the next seven years, he established a studio and shot a variety of subjects for advertising and sales promotion. In January of 1984, he opened his own studio, with Anheuser Busch and Monsanto for clients. Known for his strong sense of design, he shoots table-top, people and corporate photography with high graphic elements. He has produced multi-media presentations, annual reports, brochures, posters and calendars and has photographed in Canada, South America and Western Europe.

KING, TOM (Advertising, Editorial)
2806 Edgewater Dr., Orlando, FL 32804
(305) 841-4421

Born: 1958 *Subject Matter:* Sports, Travel *Situations:* U.S. & Foreign Locations, Studio *Education:* Daytona Beach Community College

Recognized as one of the world's foremost photographers of water skiing, he seeks to elevate his coverage of water sports to an art form. *American Photographer* magazine writes, "Tom King relies on carefully crafted backlighting and sidelighting . . . to find the delicate beauty of a sport based on power and speed." In the past few years, he has expanded his work to include windsurfing, all types of boating, beach lifestyle, fashion, fitness and travel photography. Much of his editorial work is done for *Waterski, WindRider, Sport Fishing* and *Women's Sports & Fitness*, magazines where he holds the position of senior staff Photographer. In addition his work has been featured in such magazines as *American Photographer, Popular Photography, Sail, Outside*, Germany's *Sports International* and England's *WaterSki International*. His advertising photography is used in many campaigns by clients throughout the U.S. and Europe in the water sports industry. His stock photography is marketed worldwide through The Image Bank.

KIRKENDALL/SPRING (Environment/Nature, Corporate/Industrial)
18819 Olympic View Dr., Edmonds, WA 98020
(206) 776-4685

Subject Matter: Nature, Sports, Travel *Situations:* U.S. & Foreign Locations

They are a husband and wife team of nature photographers, working in both black and white and color, in 35mm, 2 1/4", 4" x 5" and 8" x 10" formats. Together they have provided illustrations for several popular guide books to outdoor recreation in western North America. In addition, they have produced book covers, industrial brochures and sports calendars. They maintain a growing collection of stock images expressing the natural beauty of the U.S. and Europe. They are also known for their intense sports images of bicycling, cross-country skiing and ice and rock climbing. Continuing to expand their horizons, they are applying their outdoor-oriented approach to corporate advertising and photography for annual reports. Their work is available through West Stock of Seattle.

KLEIN, WILLIAM (Fine Art)
5 Rue Des Medicis, 75006 Paris, France

Born: 1928 *Subject Matter:* People *Situations:* Locations *Awards:* Prix Nadar; Prix Jean Vigo *Education:* Sorbonne

After studying social sciences in his native New York City, he studied painting with Fernand Léger in Paris from 1948 to 1950. He later taught himself photography and worked for Alexander Liberman as a fashion photographer for *Vogue*. He is known, however, for his urban images of the 1950s and 1960s, in which he experimented with abstraction, the application of inks, extreme angles and various printing techniques. His photographs often reflect the grittiness and tension of modern city life. In 1965 he began making feature films. He made such movies as "Qui Êtes-Vous, Polly Magoo?" and "Muhammad Ali: The Greatest." Since 1979 he has returned to still photography. Public collections of his photographs appear in the Museum of Modern Art in New York City and the Bibliotheque Nationale in Paris.

KLEINMAN, JOHN (Corporate/Industrial, Advertising)
3367 Chicago Ave., Riverside, CA 92507
(714) 683-4229

Kirkendall/Spring, *Summer Fashion*

Kirkendall/Spring, *Zion National Park, Utah*

Born: 1948 *Subject Matter:* Landscape, Special Effects *Situations:* U.S. Locations *Education:* Art Center College of Design

From his studio in Riverside, he is only an hour away from the urban bustle of Los Angeles and the natural beauty of the desert, the mountains and the Pacific Ocean. His work is as diverse as these locations. *American Photographer, Modern Photography* and *Popular Photography* have published his photographs, as have UPI, the *Boston Globe*, the *Los Angeles Times* and the *San Francisco Chronicle.* Because photography is both his vocation and his avocation, he shoots a large quantity of stock photographs, enough to fill a file of 40,000. His major stock agency is Lewiphoto in Washington D.C. He also creates complex images by using colored flashlights on backgrounds and by making multiple exposures of his subject.

KNAPP, CURTIS (Advertising, Editorial)
448 W. 37th St., #8B, New York, NY 10018
(212) 564-7533

Born: 1951 *Subject Matter:* Portraiture, People, Fashion *Situations:* U.S. & Foreign Locations, Studio *Awards:* Best Ad of the Year #3, Tokyo; 2nd Prize, APA Exhibition, Japan, 1987

At one time an illustrator, he was encouraged to pursue photography after placing photographs for a *GQ* editorial, a *Soho News* cover and some album covers. He specializes in portraiture, and within a short time he had photographed many of the big names in the music industry, from Madonna to Laurie Anderson to Nile Rodgers. In 1984 his skills brought him an ADL show for his Jim Carroll record jacket. Leaving the United States for Japan two years later, he continued shooting portraits. Within a year, photographing people ranging from Seiko Matsuda to Ikko Tanaka, he published his first book of 100 portraits. Since then he has shot for music editorials, posters and advertising, his clean and simple style providing an intimate moment with the stars in the industry.

KNOTT, JANET (Photojournalism)
The Boston Globe, Boston, MA 02107 (617)

Born: 1952 *Awards:* 1st Prize, Boston Press Photographers *Education:* Barnard College

Oriented toward strong color and situations of high emotional impact, her work as a photojournalist has been international in scope. Among the feature stories she has covered for the *Boston Globe Sunday Magazine* are the 1980 earthquake in Italy, the explosion of the space shuttle Challenger and hostilities on the Gaza Strip. In addition to her work as a staff photographer for the *Globe*, she also photographs wildlife.

KNOWLES, JAMES L. (Corporate/Industrial, Photojournalism)
6102 E. Mockingbird Ln., Studio 499, Dallas, TX 75214 (214) 699-5335

Born: 1952 *Subject Matter:* People, Travel, Major News Events *Situations:* U.S. Locations, Hazardous *Awards:* Addy; Bronze Quill Major News Events *Education:* John Hancock College

Working at a medium-sized daily newspaper on the West Coast, he decided early on in his career that he wanted to be a member of the White House press corps. He freelanced in Los Angeles before moving to Washington D.C., where after three years he realized his goal, serving as a photographer during President Reagan's first term. Moving to Dallas after joining Picture Group, he began covering the Southwest, photographing people on location for most major magazines in the U.S. and abroad. His forte is environmental portraits of subjects ranging from CEOs to farmers and housewives. His experience at the White House taught him how to shoot quickly and effectively to capture moments and expressions that make often otherwise dull subjects interesting. His pictures have appeared in many newspapers and magazines including *Time, Newsweek, Forbes, Business Week* and *Fortune.*

KODAMA, KIYOSHI (Advertising)
424 N. Benton, St. Charles, MO 63301
(314) 946-9247

Born: 1958 *Subject Matter:* Fashion, People *Situations:* Studio, U.S. & Foreign Locations *Education:* Nippon Electronics Engineering College, Tokyo; Lindenwood, St. Louis

Born and educated in Tokyo, where he studied stage lighting design and concentrated on Kabuki and dance, he moved to the United States and began his career as an advertising photographer in St. Louis, Missouri. In 1987 he moved to New York to work for Watanabe Beauty & Fashion, specializing in photographs shot under a tungsten-strobe mix. In his stills he uses his knowledge of stage techniques to create a sense of drama. He has created images for magazines, store posters and packages, recently completing an album cover for Julio Iglesias in Rio de Janeiro.

KOGA, MARY (Fine Art)
1254 Elmdale Ave., Chicago, IL 60660
(312) 274-6479

Born: 1920 *Subject Matter:* Nature, People *Situations:* Studio, U.S. Locations *Awards:* NEA & Illinois Arts Council Grants *Education:* U. of Chicago; School of the Art Institute of Chicago

She is a former Assistant Professor of clinical social Work whose long-time interest in art and photography eventually led to her involvement in photography. Her subjects include portrait-like documentary photographs of people and floral and natural abstractions. Her images have been exhibited widely and are included in the collections of the Art Institute of Chicago and the San Francisco Museum of Art. She has taught photography at Chicago's Columbia College since 1980.

KONRATH, FRANK G. (Photojournalism, Advertising)
7518 W. Madison St., Forest Park, IL 60130
(312) 366-1770

Born: 1960 *Subject Matter:* People, Fashion *Situations:* U.S. Locations *Awards:* Eastman Kodak Medallion of Excellence *Education:* Columbia College, Chicago

Retrieving his father's photography equipment from basement storage for a seventh grade science project was the first step in what would become a career in photography. In high school he worked on the yearbook staff, and by his senior year he was stringing for several local newspapers. His editorial style developed at Columbia College, when he photographed people and events, capturing the sense of immediacy and spontaneity necessary in photojournalism. His client list grew from assignments for the Regional Transpor-

John Kleinman, *Custom Knife with Horses*

Mark Kozlowski, *Eskimo*

tation Authority in Chicago to covering the reservists in the Panama Canal. Looking for new ways to work, he co-founded the artist's cooperative called Pulse. Designed to fill the needs of business and institutional advertising, public relations, as well as market problem-solving, the agency plans and executes assignments that include graphic art, package design, illustration, modeling, architectural rendering, copywriting, music and photography. AT&T, General Electric, Compri Hotels, Nuti Bakery & Co. and WLS-TV are examples of the agency's many varied clients.

KORODY, TONY (Corporate/Industrial, Editorial)

350 E. Rustic Rd., Santa Monica, CA 90402
(213) 459-9984

Born: 1951 *Subject Matter:* People, Manufacturing Processes *Situations:* U.S. Locations *Education:* U. of Southern California

Beginning his career as a freelancer for *Newsweek* and *Life*, he was one of the thirteen founding members of Sygma Agence de Presse, Paris. He continued as a photojournalist in North America during the 1970s, covering such stories as the kidnaping of Patty Hearst, former President Nixon's resignation and exile and the death of Howard Hughes. A contributing photographer for *People* magazine for seven years, he began doing corporate location work with a speciality in multi-image photography. Aiming to "bring to life the true imagery and honesty of an editorial photographer with an understanding of the corporate philosophy," his work is now equally divided between corporate and editorial clients. His straight, clean photography may be found in the brochures and annual reports of such corporations as Michelin Tire and Apple Computers.

KOZLOWSKI, MARK (Advertising)

170 Myrtle Ave., Albany, NY 12202-1394
(518) 434-1481

Born: 1953 *Subject Matter:* People *Situations:* U.S. and Foreign Locations, Studio *Awards:* Art Directors Club Award, New York; Society of Publication Designers Award *Education:* Rochester Institute of Technology

Operator of his own advertising photography studio begun in New York City in 1976 and in Albany, NY in 1989, he has created illustrative photographs of people for over a thousand advertising and editorial clients. His photographs of opera stars include Luciano Pavarotti, Renatta Scotto, Hildegard Behrens, Teresa Strattas and Frederica Von Stade. Part of the 100th Anniversary Retrospective for the Metropolitan Opera, these photographs have been exhibited at the International Center for Photography in New York City. Magazines such as *Life, Newsweek, McCall's, Opera & Ballet News, Forbes* and *Business Week* make up a partial list of his editorial clients. Advertising agencies such as Young and Rubicam, Ogilvy & Mather, BBD&O, J. Walter Thompson, Grey Advertising and a host of others call for his photography. A recipient of many awards, he is frequently featured in *The Creative Black Book, American Showcase, The Art Directors Index to Photographers, Creative Source* (Canada) and in *Art Direction, American Photographer* and *AdWeek.*

KRAMER, DANIEL (Portraiture, Advertising)

110 W. 86th St., New York, NY 10024
(212) 873-7777

Subject Matter: People, Nature *Situations:* U.S. & Foreign Locations, Studio *Awards:* Grammy Nomination, Best Album Cover; Bronze Medal, Documentary Films, Atlanta International Film Festival *Education:* Brooklyn College

He studied first for several years with Philippe Halsman before opening his own studio. He is best known for his portraiture, which is characterized by a direct and open approach out of which the subject emerges. His first major work was a book of 140 photographs and text depicting the private and professional life of Bob Dylan. His pictures of notable personalities have appeared extensively in major magazines throughout the world. His portraits have been shown in such museums as the National Portrait Gallery, the International Center of Photography in New York and others. With awards from both New York's and Washington D.C.'s Art Directors Clubs, from the Society of Publication Designers and from *Art Direction* to his credit, he has now begun to direct television commercials and film documentaries. A major portion of his recent time has been spent photographing for advertising and annual reports.

KRASEMANN, STEPHEN J. (Photojournalism, Editorial)

265 Verde Valley School Rd., Sedona, AZ 86336
(602) 284-9808

Born: 1947 *Subject Matter:* People, Travel, Wildlife *Situations:* Aerial, U.S. & Foreign Locations *Education:* U. of Wisconsin

Early work as publicity photographer for the Rolling Stones rock group, cinematographer for "Sesame Street," and contributor to *Vogue* led to his current, nearly exclusive, relationship with *National Geographic.* His subjects have included the large mammals of the Arctic, bird life in Africa and the wild landscapes of Australia. A recent project has involved documenting the Nature Conservancy Organization for *National Geographic.* "My camera rescues moments of time, holding clear what the natural world was like; pieces of truth fixed on Kodachrome for the memory to recall over many generations."

KRAUSE, GEORGE (Fine Art, Advertising)

420 E. 25th St., Houston, TX 77008

Born: 1937 *Subject Matter:* People, Nudes *Situations:* Studio *Awards:* NEA Grant; Guggenheim Fellowship *Education:* Philadelphia College of Art

His work is characterized by the exploration of fantasies through surreal imagery. From approximately 1968 until the mid 1970s, Krause worked as a top advertising photographer for *Harper's Bazaar, Horizon,* Houghton Mifflin, *McCall's, Sports Illustrated* and Time-Life Books, among others. He is most interested in form and content, and he is highly regarded for his serial photographs. Krause is fascinated by life-and-death, change and renewal. Among his most memorable series are "Qui Riposa" and "Saints and Martyrs," both shot in the 1960s. He says he has been able to formulate over the years a keen instinctive ability to apprehend life and death experiences that evoke passion and compassion through the medium of photography. In 1976 he was the first American photographer to win the Prix de Rome.

KRETCHMAR, PHILLIP (Advertising, Editorial)

14509 Cyprus Point Dr., Dallas, TX 75234
(214) 247-4973

Born: 1931 *Subject Matter:* Food *Situations:* Studio *Awards:* 100 Best Billboards *Education:* School of the Art Institute of Chicago

His formal training in painting and design at the Chicago Art Institute led him to New York, where he spent much of his time in Jerome Rozen's art studio. It wasn't until he entered the Air Force during the Korean War that he would become a photographer. After his discharge, he attended the Art Center, returned to Chicago and finally left for Dallas a year and a half later where he has resided ever since. As a photographer of foods and beverages, he likes the so-called "classic" look, or what is found in old *McCall's* double-page spreads, rather than what he calls the high-tech "hamburgers on black plexiglas." His portfolio includes advertising campaigns for Jose Cuervo Tequila. Typically his work is very illustrative, with high side-lighting and rich, dark backgrounds.

KRIMS, LES (Fine Art)

187 Linwood Ave., Buffalo, NY 14209

Born: 1943 *Subject Matter:* People, Nudes *Situations:* Studio, U.S. Locations *Awards:* NEA Grants *Education:* Cooper Union; Pratt Institute

Recognized for his satiric photographs of daily life in America, he seeks in his photographs to captivate the viewer with his use of unconventional motifs and disturbing pictorial moments that instinctively draw the viewer's attention. For example, his photograph entitled *Giant Monster* is a nude shot of his aging mother. Equally disturbing is his 1975 concoction, *Fictcryptokrimsographs*, a small book of Polaroid SX-70s which explores sexual fantasies through photographs of naked women in domestic environments. Scoring and puncturing are used to alter the Polaroids, resulting in a set of vulgar prints of women who are mutilated or in extremely exploitative situations.

KRIZ, VILEM (Fine Art, Photojournalism)

1905 Bonita Ave., Berkeley, CA 94704

Born: 1921 *Subject Matter:* People, Places, Objects *Situations:* U.S. & Foreign Locations, Studio *Awards:* Award of Honor, San Francisco Arts Commission *Education:* State Academy of Graphical Arts, Prague; Ecole Cinematographique et Photographique, Paris

He studied photography under Jaromir Funke, Josef Ehm and Frantisek Drtikol in Prague before emigrating to the United States in 1952. In Paris from 1946 to 1952 he attended the Ecole Cinematographique et Photographique, where he worked with Jean Cocteau. He actively participated in the surrealist movement during this period and served as a press photographer and foreign correspondent for Czech newspapers. His work has remained firmly in the surrealist sensibility, and he is considered an accomplished photomontage artist. By utilizing photographs taken of real situations and places, the artist fits together these particular images in order to provide the viewer with a new visual awareness. His work is often likened by critics to photomontage artist Jerry Uelsmann. Recent publications include *Seance*; *Vilem Kriz: Photographs*; *10 Surreal Postcards*; and *Vilem Kriz, or The Thickness of Time*.

KROLL, ERIC (Editorial, Fine Art)

118 E. 28th St., New York, NY 10016 (212) 684-2465

Born: 1946 *Subject Matter:* People, Travel *Situations:* Studio, U.S. Locations *Awards:* NY State CAPS Photography Fellowship *Education:* U. of Colorado

In 1969 he opened the fine-art One Loose Eye Gallery of Photography in Taos, New Mexico. In 1971 he returned to New York City and began concentrating on photojournalism. He then taught at Antioch College's media center in Baltimore while doing industrial filmstrips around the country. At the same time he completed a photo documentary book called *Sex Objects*. He has taken still photographs for feature films and traveled around the country photographing America. In 1981 he returned to New York City and went back to editorial portraiture. He opened his own New York studio in 1987 and is now concentrating on nude photography. He teaches at the International Center of Photography.

KRUPER, AL (Advertising, Corporate/Industrial)

70 Jackson Dr., P.O. Box 152, Cranford, NJ 07016 (201) 709-0220

Born: 1939 *Subject Matter:* Food, Products, Sports *Situations:* Studio, U.S. Locations *Awards:* First Prize, *Industrial Photography* Annual; New Jersey Art Directors Club Awards

He began his career as a staff photographer for an advertising agency before starting his own company in 1969. Working in 4" x 5" and 8" x 10" format, his studio succeeds due to the diversity of photography available to his clients. Although his specialty is product photography, he has photographed advertisements with portraits of such celebrities as Reggie Jackson, Pete Rose and Rich Little. His company served as the official photographers for the Las Vegas Invitational Golf Tournament. Additional clients include one of the world's largest electronics firms and various agencies in the New York-New Jersey area. He is also the vice-president and partner of a full-service color lab.

KRUTEIN, WERNHER (Editorial, Corporate/Industrial)

1045 17th St., San Francisco, CA 94107 (415) 552-9682

Born: 1954 *Subject Matter:* People, Nature *Situations:* U.S. & Foreign Locations, High-Tech/Industrial *Awards:* Best of Show, Professional Photographers of California Western States; Award Winner, Hawaii International Film festival

Growing up in Los Angeles, he began his career in feature and documentary film production, shooting stills and second-unit cinematography. In this work, he acquired cinematic lighting techniques that he continues to utilize in his still photography. Through the inspiration of Wernher von Braun, his godfather, and through a close personal and professional association with Buckminster Fuller, he turned his attention to the role that photography could play in the communication of social issues. He began and continues to work on a project to document the people of Earth. To date he has taken some 500,000 photographs. Although his work ranges in subject matter from aerospace to Zimbabwe, he is best known for his emotionally riveting images of people, which have appeared in national magazines across the United States.

KUDO (Advertising, Editorial)
33 W. 17th St., 2nd Fl., New York, NY 10011
(212) 929-4825

Born: 1951 *Subject Matter:* Products, Special Effects
Situations: Studio

Self-taught as a photographer, he learned the trade assisting in studios in Tokyo. Coming to the United States in 1978 and spending time in San Francisco before moving to New York, he worked with still-life photographer Hashi for two and a half years and then photographic illustrator David Langley for a short period before going freelance. Today, he shoots both advertising and editorial assignments, publishing in such magazines as *Children's Business*, *Woman's World*, and the *New York Times Magazine*. Specializing in product photography and special effects, he shoots cosmetics, watches, perfume and liquor bottles. Often his projects call for duping five or six images and hand-coloring the prints. His photography is characterized by this technical handling as well as a subtle though full-ranging color composition. Recently he has been using traditional Oriental artistic elements to shape his photographs.

KUEHN, KAREN (Editorial, Photojournalism)
49 Warren St., New York, NY 10007 (212) 406-3005

Born: 1959 *Subject Matter:* People, Travel *Situations:* Aerial, U.S. Locations, Studio *Education:* Art Center College of Design

At one time a seasonal U.S. park ranger in Yosemite and Glacier National parks, today she works on location and out of her studio in New York City. Attending the Art Center College in the off-season, mentored by John Wycoff and Barry Wetmore, she eventually won a full scholarship and left the Park Service in 1985. Upon graduating she won an internship at *National Geographic*, and her first assignment took her back to the woods to cover mountain men in the Yukon. Since moving to New York she has also shot for television's "Saturday Night Live," the *New York Times Magazine*, *Interview*, *Life* and many others.

KUHN, CHUCK (Advertising, Corporate/Industrial)
206 3rd Ave. S., Seattle, WA 98104 (206) 624-4706

Born: 1944 *Subject Matter:* People, Products *Situations:* U.S. Locations, Studio *Awards:* New York Art Directors Club; Andy Awards *Education:* Art Center College of Design

Graduating with honors from the Art Center College of Design in Los Angeles, he then moved north to Seattle to begin his career as a photographer. Today, shooting for major advertising agencies and corporations throughout America, he has representatives in New York, Chicago, St. Louis, Dallas, San Francisco and Los Angeles, with stock photography available through The Image Bank in New York. His photography has appeared in a variety of media, including magazines, posters, newspapers, billboards and multimedia presentations. His advertising work has won him numerous awards including those from the Art Directors Club of New York, Andy Awards, Best in the West, *Communication Arts*, Northwest Addy, Unesco International Poster Exhibit, Oliver Awards, Seattle Design and Advertising and the Dallas Art Directors Club. In addition to his commercial work, he has begun to exhibit his series of fine-art western and rodeo prints.

KULKIN, NORMAN (Fine Art)
727 N. Fuller Ave., Los Angeles, CA 90046
(213) 451-2924

Born: 1946 *Subject Matter:* Nature, People *Situations:* U.S. & Foreign Locations

Largely self-taught, his exploration into photography began with travels in Europe, which eventually led to travels to India, followed by trips to Israel, Canada and Mexico. His stay in Italy produced his first published works. From India came a series of photographs entitled, "Sense of Light, Sense of Lightness." The magazine *Israel* published his pictures of that country and later he published both his Canadian and Mexican series. In all of his photographs is a sensitivity to the character and spirit of people, their relationship to their environment, how it has shaped them and how they have shaped it. For a period he worked in mixed media, making photo collages on wood and canvas, painting both on the photograph itself and on the surrounding backing. His work is increasingly concerned with the exploration of anthropological themes, as in his latest series, begun in 1986, which is a study of America entitled "Anthropocompositions In America."

KUMLER, KIPTON (Fine Art, Nature)
34 Grant St., Lexington, MA 02173

Born: 1940 *Subject Matter:* Landscape, Architecture, Plant Life *Situations:* U.S. Locations, Studio *Awards:* NEA Survey Grant; Massachusetts Arts and Humanities Foundation Grant *Education:* Cornell U.; Harvard U.

Kumler is a freelance photographer and has been working from his studio in the Boston area since the early 1970s. He has a genuine interest in nature, his primary subject matter including architecture, landscapes and plant life. He was initially influenced by Minor White and Paul Caponigro, under whom he studied. Kumler works chiefly with an 8" x 10" camera and is known for his unique technique of printing. To attain an almost dimensional quality, Kumler produces palladium and platinum prints, using a process he developed with extensive testing and careful research.

KUPER, HOLLY (Corporate/Industrial, Editorial)
5522 Anita St., Dallas, TX 75206 (214) 827-4494

Born: 1952 *Subject Matter:* People, Travel *Situations:* U.S. Locations *Education:* Arizona State U.

Combining a background in fine arts photography with two years of work for local newspapers in New Mexico and west Texas, she began freelancing in Dallas in 1979. Her magazine clients include *Business Week*, *Forbes*, *Money*, *Newsweek*, *Fortune*, *Venture* and *Farm Journal*, among others. In the corporate world she works for IBM, Frito-Lay, Pepsi, Taco Bell, Diamond Shamrock, Texas Instruments and many local companies. She also keeps an extensive stock-photo library, which features much of her personal work acquired on the job and through her travels. In all her work she seeks to capture the feel of a given location and most importantly, a sense for the personalities of her subjects.

LAIRD, RICHARD (Portraiture, Advertising)
414 W. 22nd St., New York, NY 10011
(212) 675-2138

Al Kruper, *Saving Time*

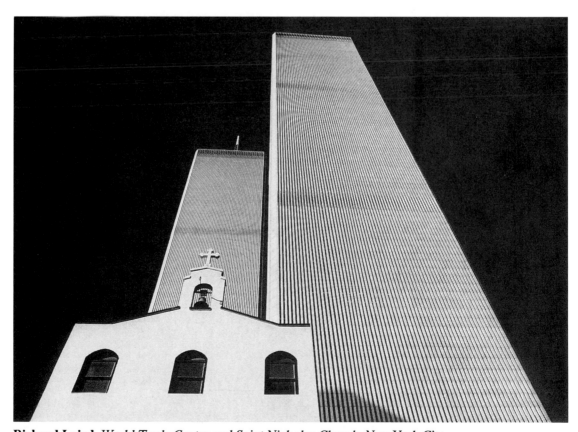

Richard Laird, *World Trade Center and Saint Nicholas Church, New York City*

Born: 1941 *Subject Matter:* People, Travel *Situations:* U.S. & Foreign Locations, Studio

Arriving in the United States in 1966 from Ireland on a music scholarship, he spent more than twenty years as a jazz bassist with such musicians as the Mahavishnu Orchestra, Chick Corea and Stan Getz before concentrating on photography. F.P.C. International, a stock photography agency, was instrumental in his development and his understanding of graphic design. Today, naturally enough, his work primarily involves covering recording sessions of major jazz artists for album covers and promotion. He recently completed a project to produce 350 black-and-white portraits of the attorneys of a Wall Street law firm.

LANDSMAN, GARY D. (Advertising, Editorial)
12115 Parklawn Dr., Rockville, MD 20852
(301) 468-2588

Born: 1956 *Subject Matter:* People, Architecture, Products *Situations:* Aerial, U.S. & Foreign Locations, Studio *Awards:* Honorable Mention, Art Directors Club of Metropolitan Washington

Beginning his career ten years ago as a photojournalist, he had his most memorable experiences when he was assigned to follow presidential candidate John Anderson. As part of that assignment he had the opportunity to travel throughout much of Europe and Asia. Since that time, he has worked as an architectural photographer and as an illustrative photographer, involved in both studio and location shots. Preferring not to specialize in any one subject or style, he chooses rather to make shots requiring elaborate sets and interesting story lines. In particular, he enjoys working with character models who enhance the set and tell the story.

LAND-WEBER, ELLEN (Fine Art, Editorial)
790 Park Pl., Arcata, CA 95521 (707) 822-5294

Born: 1943 *Subject Matter:* People, Travel *Situations:* Studio *Awards:* NEA Photographers Fellowship *Education:* U. of Indiana

In the early 1970s, she became interested in the collage possibilities of color photocopy machines and pioneered work with the 3M color-in-color machine. She was influenced by 18th- and 19th-century natural history illustrations and used natural materials and contemporary photographs and illustrations to create one-of-a-kind transfer prints. In 1976 she began using a view camera for documentary projects. This included a commission from the Seagram's Company to document county courthouses around the U.S. Her books include *The Passionate Collector*, a series of portraits of collectors with their collections, and *Rescuers*, a book of narratives and photographs of people who risked their lives to rescue Jews from the Holocaust.

LANGONE, PETER (Advertising)
516 N.E. 13th St., Ft. Lauderdale, FL 33304
(305) 467-0654

Born: 1949 *Subject Matter:* People *Situations:* U.S. Locations, Studio

Born in New York in 1949, he began his career in Ft. Lauderdale, Florida, in 1970, opening a studio specializing in large-format product photography. In 1979 he turned to lifestyle photography. Owner and operator of a commercial studio with national accounts such as Eastern Airlines, General Foods, Dixie Cup and McDonald's, he often works with out-of-state advertising agencies, shooting on location. Published in

a variety of media including posters, billboards, magazines, newspapers and books, his work is characterized by its vibrant colors. For a recent cruise line account, he created a carnival atmosphere in the ads depicting the points of destination. He has made the tricks of his technique available in a number of books on photography.

LANKER, BRIAN (Photojournalism)
1993 Kimberly Dr., Eugene, OR 97405

Born: 1947 *Subject Matter:* Events, People *Situations:* U.S. & Foreign Locations *Awards:* Pulitzer Prize for Feature Photography; National Photographer of the Year *Education:* Phoenix College

After two years studying photography and fine art, he left Phoenix College to work for a local Phoenix paper; this would mark the beginning of a successful career in photojournalism. On assignment with the *Topeka Capital-Journal*, in 1973 he won the Pulitzer Prize for Feature Photography with pictures of the birth of a child. While his photography takes aesthetics into account, he is, in his own words, "motivated by information," whether he is shooting for the swimsuit edition of *Sports Illustrated* or generating an in-depth photo essay on the gold-medal Olympians of 1932. He works with a variety of formats from 35mm to 2 1/4" to 8" x 10", shooting in both black and white and color. He has recently completed a book of black and whites, *I Dream a World (Portraits of Black Women Who Changed America)*, pictures of which have also been on exhibition at the Corcoran Gallery in Washington, D.C.

LANTING, FRANS (Editorial, Photojournalism)
714 Riverside Ave., Santa Cruz, CA 95060
(408) 429-9490

Born: 1951 *Subject Matter:* Science, Wildlife *Situations:* U.S. & Foreign Locations *Awards:* Picture of the Year; *Communication Arts* Award

Dutch-born and now living on the West Coast, Frans Lanting shoots editorial work for *National Geographic*, *GEO* and other major publications. He specializes in subjects dealing with man and nature, which means he is constantly traveling worldwide. He is best known for his innovative wildlife photography which has earned him awards from ASMP, Picture of the Year and *Communications Arts*. His work has been exhibited at Photokina and the British Museum. He is the co-author of three books; the most recent, entitled *Islands of the West*, was published by Sierra Club.

LAPERRUQUE, SCOTT (Advertising, Editorial)
59 W. 10th St., New York, NY 10011 (212) 473-8297

Born: 1957 *Subject Matter:* Food *Situations:* Studio, U.S. & Foreign Locations *Education:* Art Center College of Design

Inspired by the work of *Life* photographer John Dominis, he traveled extensively throughout the South Pacific and North America photographing in a journalistic style. Since moving to New York City in 1979, he has produced both fine-art and commercial photography, specializing in food. Named one of the top 100 photographers of 1987 by the Maine Photographic Workshops, his work has been included in the Photographers Forum 1987 *Annual*. As a member of the Salmagundi Club of New York City, America's oldest art

club, his work recently brought the highest price paid at their annual auction.

LAPIOUS, LARRY (Portraiture)
340 W. 57th St., 16-G, New York, NY 10119
(212) 245-1986

Born: 1948 *Subject Matter:* People *Situations:* Studio *Education:* U. of Illinois; U. of Chicago

Having apprenticed with Philippe Halsman before starting his own theatrical portrait studio, he continues to carrying on Halsman's tradition of emphasizing personality over beauty. In doing so, he has redefined theatrical portraiture for commercial usage. Before shooting, he spends a half-hour interviewing his subject, working to uncover the elemental in the person, the essence of character that he will capture on film. His portraits are recognized as classical and timeless in style. The clarity and directness of his work emphasizes the emotional depth and truth of character in each subject. It is this ability to seize *who* the subject is, not just what he or she looks like, that keeps actors, dancers and other performers knocking at his studio door.

LAROCCA, JERRY (Corporate/Industrial, Advertising)
3734 S.E. 21st Ave., Portland, OR 97202
(503) 232-5005

Born: 1937 *Subject Matter:* Fashion, Food, Nudes, People *Situations:* Studio, U.S. Locations

He was a staff photographer for Cartier jewelers in Manhattan and later a photojournalist for three major daily newspapers, but switched to advertising. He has owned commercial studios in San Francisco, Phoenix and Portland. Over the last fourteen years he worked on many national accounts, including Jantzen in San Francisco, AT&T and Greyhound in Phoenix, and Nike, Speedo, Pendleton and White Stag in Portland. He is represented through Tony Stone Stock agency in London and his work has appeared in *Newsweek, Time* (European edition), *GQ Regional* and *Runners Magazine.*

LARRAIN, GILLES (Advertising, Portraiture)
95 Grand St., New York, NY 10013 (212) 925-8494

Born: 1938 *Subject Matter:* Fashion, Nudes, People *Situations:* Foreign Locations, Studio *Awards:* Designer/Photographer, Art Director/Photographer, Art Directors' Club; Photographer of the Year, *Adweek Education:* New York U.; Ecole Nationale des Beaux Arts, Paris

His photographs have been seen in books, magazines and galleries and on record covers and posters. Two books, *Design and the New Aesthetics* and *The Four Seasons* featured him exclusively. *New York Magazine, Musician, GEO* and *Zoom* have all had spreads of his work, and his posters and record covers have included photographs of the American Ballet Theatre, Sting, Stanley Turrentine, Billy Joel and Miles Davis. He is represented in Paris by Agathe Gaillard Gallery and his work is in private and public collections throughout the world. "For me there is no formula but constant surprise. . . Photographs are my reaction to the provocation of beauty—whatever that might be," he says.

LARSON, WILLIAM (Fine Art)
152 Heacock Lane, Wyncote, PA 19095

Born: 1942 *Subject Matter:* Objects *Situations:* Studio *Awards:* NEA Fellowship; Triennale de la Photographie, Best Color Photographer Award *Education:* Illinois Institute of Technology

He earned an undergraduate degree in art from the State University of New York at Buffalo in 1964, then went to Chicago two years later to study photography under Aaron Siskind, Wynn Bullock and Arthur Siegel. Larson's color pictures are studies of the relationship between time and space and of the nature of photography itself. In *Fireflies*, photographs were transmitted by facsimile machine to create new, fragmented images. Later series of Polaroids show his interest in technology and in the photographic process itself, incorporating color patches, register marks and waxen crayons. He has also made holograms and continues to explore the properties of light, color and focus. "I like the balance achieved between descriptive photographic detail and a subjective color palette," he says, "which supports my basic instincts for picture-making."

LAWRENCE, JAMES A. (Advertising, Editorial)
Rt. 1, Box 201, Garderville, NV 89410 (702) 265-2128

Born: 1910 *Subject Matter:* People, Animals, Nature, Travel *Situations:* U.S. Locations *Education:* U. of California, Davis; Art Center College of Design

For many years he operated his own studio in San Francisco. There he did advertising and commercial photography for most of the leading West Coast and national advertising agencies, and his work has since appeared in many national magazines. His recent photographic work includes portraiture, landscapes and documentation for his paintings. He is also a successful watercolorist.

LAWSON, GREG (Advertising, Editorial)
P.O. Box 1680, Ramona, CA 92065 (619) 789-8878

Born: 1944 *Subject Matter:* Nature, Travel *Situations:* U.S. & Foreign Locations *Education:* Denver City College

An enthusiastic photographer since 1958, when his mother gave him his first camera, he works only on location. He specializes in bringing out the natural as well as the man-made aspects of the places he shoots. His colorful 35mm and 4" x 5" photographs are featured in his travel books, including *California* and *Los Angeles* (both with Ralph Cernuda), *San Diego, Beauty Spot—Santa Barbara* and *Hawaii.*

LAWTON, ERIC (Editorial, Fine Art)
2001 Wilshire Blvd., Penthouse Suite, Santa Monica, CA 90403 (213) 453-8784

Born: 1947 *Subject Matter:* People, Travel, Nature *Situations:* U.S. & Foreign Locations *Awards:* National Juried Art Competitions Finalist, ArtQuest; Nominee, Art Achievement Award, Artists' Society International *Education:* UCLA; Loyola U., Los Angeles

His photography career grew out of seventeen years of world travel. He has practiced both naturalistic and abstract photography, the former comprising the people and landscapes of over fifty countries. Drawing inspiration from ancient images and natural landscapes, his work reveals the spiritual qualities of a person or place through the exploration of color, light, form and space. His more abstract multi-media works are projected slide installations with performances, in-

cluding a large-screen slide montage accompanying a Los Angeles Philharmonic Orchestra concert at the Hollywood Bowl. Another recent work, *Floating Stone*, was a collaboration with choreographer Hae Kyung Lee and composer Carl Stone, in which his slide montages defined the visual narrative space, creating interior and exterior spaces and serving as linguistic elements to enhance a dance performance.

LEAVITT, DEBBIE (Editorial, Photojournalism)
2756-A Pine Grove, Chicago, IL 60614
(312) 348-2833

Born: 1954 *Subject Matter:* People, Fashion *Situations:* U.S. Locations, Studio *Education:* Brooks Institute of Photography; U. of Wisconsin

After graduating from the Brooks Institute of Photography, she photographed movie and rock stars for magazines, albums and other publicity. In 1984 she relocated to Chicago, where she is now combining entertainment photography with photography in the corporate, portrait, photojournalistic and publicity fields. She has done photo sessions with James Brown, George Benson, Jane Fonda, Rod Carew, Linda Evans, the California Angels and the Chicago Cubs. Among the her many publication credits are *Playboy*, *Ebony*, the *Saturday Evening Post*, *Rolling Stone*, *Creem*, *Musician*, the *Chicago Tribune*, the *Los Angeles Times*, *Chicago Magazine* and the *Chicago Reader*.

LE BON, LEO (Photojournalism, Advertising)
190 Montrose Rd., Berkeley, CA 94706
(415) 524-2609

Born: 1934 *Subject Matter:* Nature, Travel *Situations:* Foreign Locations, Mountains

Specializing in adventure, travel and action photography, he has been photographing the outdoors for more than twenty years. Leading expeditions on some of the world's greatest treks, from Annapurna to Patagonia, Everest to Kilimanjaro, Kanjiroba to the Inca Highlands, Kishtwar to Zanskar, he has photographed the world's most spectacular terrain, the most exotic and distant cultures and peoples. His book *Where Mountains Live* documents many of these trips. He has published in *Outside Magazine*, *California Magazine* and the *Los Angeles Times*, and in several traveler's guide and mountain catalogs. *Magic Mountains*, contracted with Abrams publishing, is due out in 1989.

LEDUC, LYLE (Corporate/Industrial, Travel)
320 E. 42 St., Ste. 1014, New York, NY 10017
(212) 697-9216

Born: 1951 *Subject Matter:* Wildlife, People *Situations:* U.S. & Foreign Locations *Education:* Art Center College of Design

His ten years' experience as a photographer began with a year at the Art Center College of Design in Los Angeles. This was followed by an assistant's position with John Harkrider that prepared him for his move to New York and his subsequent success there. Today he is known for his bold color graphics and for specialities in corporate/industrial annual reports and brochures. Editorial and travel stock photography comprise additional markets. His work appears in calendars, trade publications, audio-visual presentations, books and magazines. Major clients include

General Electric, Prudential Bache, Industrial Acoustics, Home Box Office, the New York Stock Exchange and State Street Bank of Boston; his publication credits include *Reader's Digest*, Hearst Publications, *Art Direction* and *Woman's World*. Future projects include American landscapes and a study of Carnegie Hall.

LEESON, TOM & PAT (Editorial, Advertising, Photojournalism)
P.O. Box 2498, Vancouver, WA 98668
(206) 256-0436

Born: 1950 *Subject Matter:* Travel, Nature, People *Situations:* U.S. Locations

Both self-taught, the two make up a husband and wife team specializing in outdoor photography. Best known for their in-depth studies of North American wildlife, their work frequently appears in national and international publications such as *Audubon*, *National Wildlife* and National Geographic Society publications, though in recent years they have broadened their coverage to include more scenic, portrait and travel photography. This more recent output has been featured in their two books, *Olympic Peninsula* and *Washington*, as well as in *National Geographic Traveler*. They do a variety of wildlife and nature photographs for the editorial and calendar markets and travel work for several tour companies. They are finishing a book on Montana for Skyline Press. While they are affiliated with several major stock photo agencies, they also maintain their own file of North American wildlife, western National Parks and Canadian Rockies transparencies.

LEGRAND, MICHEL (Advertising)
152 W. 25th St., New York, NY 10001
(212) 807-9754

Born: 1953 *Subject Matter:* Soft Goods, Home Furnishings, Architecture *Situations:* U.S. Locations, Studio

Specializing in creating moody, soft, romantic images in his studio, he custom-designs sets and lighting for commercial lifestyle pieces. Attention is paid to every detail, each prop carefully chosen. When not creating one of his own sets, he can be found on location, shooting spaces created by architects and interior designers.

LEIBOVITZ, ANNIE (Portraiture)
c/o Vanity Fair, 350 Madison Ave., New York, NY 10017

Born: 1950 *Subject Matter:* People *Situations:* Studio, U.S. & Foreign Locations *Education:* San Francisco Art Institute

One of America's best-known photographers, Leibovitz was Rolling Stone's "cover girl" for thirteen years. Acclaimed for her dramatic portraits of the famous and the infamous, Leibovitz's secret lies in her ability to strip celebrities of the affectation that usually accompanies their public personae. She achieves a rapport with her subjects that is playful and intimate. Her work is never marred by the self-consciousness which often affects less talented photographers: as a result even her most expressionistic work has an introspective quality. Leibovitz is currently a contributing photographer with Vanity Fair magazine.

LEIGHTON, THOMAS (Corporate/Industrial)
321 E. 43rd St., New York, NY 10017 (212) 370-1835

Eric Lawton

Michel Legrand

Born: 1951 *Subject Matter:* Architecture *Situations:* Interiors and Exteriors *Education:* U. of Pennsylvania

Although his professional training was in still life and fashion, he chose architectural photography. Having never studied architecture or architectural photography, his approach is personal and unconventional. He is known for his graphic shots of buildings with an accent on color. His close-ups and shots from unexpected angles are the hallmark of his style. He shoots both interiors and exteriors in a 35mm format. His clients are architects and professionals in real estate, construction and corporate industries.

LENNARD, ERICA (Advertising, Editorial)
519 W. 26th St., New York, NY 10017

Born: 1950 *Subject Matter:* Fashion, People, Landscapes, Archaeological Sites *Situations:* Studio, U.S. & Foreign Locations Award: NEA Grant *Education:* San Francisco Art Institute

A fashion, portrait and landscape photographer, she has been employed by fashion designer Perry Ellis, and her work has been included in several magazines, including *Interview, Elle, Femme, Marie Claire, Mademoiselle* and *Vogue.* A freelancer in Paris and New York since 1973, her exploration of beauty has taken her frequently in the past few years to archaeological sites in such locations as India, Mexico, Morocco and Sicily. For landscapes and fashion layouts alike Lennard's images are highly structured and reflect a precision characteristic of her prints.

LENNON (Editorial, Entertainment)
1015 N. Cahuenga Blvd., Los Angeles, CA 90038
(213) 469-2212

Born: 1959 *Subject Matter:* Fashion, People *Situations:* U.S. & Foreign Locations, Studio

"When I look through the lens, I experience another world," he says. "I preserve the present, which in seconds becomes the past. I've been very lucky. I've had some of the most famous and beautiful women and handsome men grace my lens." Himself a former fashion model and actor representing accounts such as Winston Cigarettes, Viceroy Cigarettes, Seiko and Levi-Strauss, he takes his camera into the world of fashion and glamour. His nudes and portraits have been exhibited locally as well as seen worldwide in every format, including television and film.

LENT, MAX (Fine Art, Corporate/Industrial)
24 Wellington Ave., Rochester, NY 14611
(716) 328-5126

Born: 1945 *Subject Matter:* Wildlife, People *Situations:* U.S. & Foreign Locations

For more than ten years he worked exclusively as a fine-art photographer, influenced by the black-and-white work of Edward Weston, Ansel Adams and Walker Evans and by the color work of Ernst Haas and Eliot Porter. These influences continues, image quality remaining very important in his photography. Using industrial location photography as an avenue into commercial photography, he says "I find the pleasure of working with oil tanks no different from that of working with the rocks and cliffs of California's Point Lobos" (Edward Weston's favorite photographic location). He shoots small and large formats, but most of his work is in 35mm and often shot through ultra-wide and ultra-telephoto lenses. In addition to his work as a photographer, he has also compiled a large computer database of information for the fine-art photography community. He published *Photography Galleries and Selected Museums: A Survey and International Directory* in 1978 and *The Art Photographer's Directory* in 1987.

LEONARD, BARNEY (Corporate/Industrial)
518 Putnam Rd., Merion Station, PA 19066
(215) 664-2525

Born: 1955 *Subject Matter:* People *Situations:* U.S. Locations *Awards:* Cinematography Award, Council on International Non-Theatrical Events *Education:* New York U.

With a background as a commercial cinematographer for seven years, shooting documentaries and television commercials, he has developed a distinctive style in his still images. The bulk of his work consists of corporate annual reports and other high-end collateral material exclusively photographed on location. Specializing in corporate location photography, he has modified the equipment he uses. Carrying a minimum of 9,600 watt-seconds of strobe power at all times, he can shoot an entire annual report on location using large format (4" x 5") without compromising film speed or set-up time. He also has extensive experience in multi-image photography, having shot many promotional and sales programs for Fortune 500 corporations. Additionally, he maintains a stock photography library of 20,000 images. His greatest interest is in photographing people in their natural or work environments.

LEONARD, JOANNE (Fine Art)
1319 Pomona Rd., Ann Arbor, MI 48103

Born: 1940 *Subject Matter:* People *Situations:* U.S. Locations *Awards:* NEA Photo Survey Grant; Phelan Award *Education:* San Francisco State College

She studied with anthropological photographer John Collier, Jr. in 1964. Four years later, her first solo exhibition, "Our Town," was a series of pictures documenting the daily lives of the people of a black community in West Oakland, California. Since then she has continued to take a documentary approach to her photographs, often in series. She is also known for her series of collages which express personal and often feminist views, such as *Dreams and Nightmares.* The collages combine photographs with drawing or painting, sometimes incorporating reproductions from other sources. She has been an Assistant Professor of Art at the University of Michigan since 1978, and her public collections include the San Francisco Museum of Modern Art and the George Eastman House.

LERNER, FRANK (Advertising, Corporate/Industrial)
392 Morrison Rd., Columbus, OH 43213
(614) 864-8554

Born: 1934 *Subject Matter:* Commercial, Portraiture, Documentaries *Situations:* U.S. & Foreign Locations, Executive Portraiture

He has had a lengthy and varied career, both as a commercial and a fine arts photographer. After fifteen years as a graphics designer in New York, he opened his own studio and began a successful freelance career. By 1973, he felt the need to express himself more fully in film. Taking the travel opportunities offered by corporate clients, he began doing portraiture and documentary work, particularly in the West Indies, Morocco and China. Later seeking a calmer lifestyle,

Thomas Leighton. Client: Chase Investors/Brochure

he moved to Columbus, Ohio where he continued to do commercial photography. Recently he founded Medical Educational Products, Inc., which produces brochures, flip-charts and other visual materials related to health education and medical products promotion.

LESHNOV, MICHAEL (Advertising)
30402 W. Penrod Dr., Agoura, CA 91301
(818) 706-1655

Born: 1943 *Subject Matter:* People *Situations:* Studio, U.S. Locations, Television Studios *Awards:* Clio; BPME

Given his experience as the high school yearbook photographer, upon induction into the Army he was trained as a combat photographer and soon became the senior still photographer for the U.S. Third Army. After his discharge in 1967, he was hired as the publicity and promotion photographer for "The Mike Douglas Show," for which he worked for the next ten years. In 1979 he received a promotion to director of still photography for Group W Productions (Westinghouse Broadcasting) and in 1986 he left to begin his own company. Presently he contracts photography with some of the largest production companies in Hollywood, shooting for such television series as "Dallas" and "Falcon Crest." He does both behind the scenes and promotional portrait work, traveling with up to twelve light sources to tailor the shots to the shows. Comfortable shooting both color and black and white, he has several book covers as well as posters and calendars in production.

LEVITT, HELEN (Fine Art)
4 E. 12th St., New York, NY 10003

Born: 1918 *Subject Matter:* Urban Scenes, People *Situations:* U.S. Locations, Studio *Awards:* Guggenheim Fellowship; Photography Fellowship, Museum of Modern Art, NYC *Education:* Art Students League

Levitt has been a freelance photographer and filmmaker for nearly five decades. Her images have appeared in many magazines including *Fortune*, *Harper's Bazaar* and *Time*. Best known are her images of street life in New York City, often including young people. She has photographed ethnic scenes since the late 1930s and frequently returns to the same neighborhoods. She works both in color and black and white. She had her first solo show in 1943, at the Museum of Modern Art, New York, in an exhibition entitled "Children: Photographs of Helen Levitt." Henri Cartier-Bresson, Walker Evans and James Agee were her influences. Through Agee, Levitt met Janice Loeb, with whom she collaborated on the film "The Street." Levitt won awards at the Venice and the Edinburgh Film Festivals for the film. She resides in New York City and continues to photograph street scenes there.

LEVY, RONALD (Advertising, Editorial)
Box 3416, Soldotna, AK 99669 (907) 262-1383

Born: 1957 *Subject Matter:* Wildlife, Nature, People, Travel *Situations:* Outdoor, Hazardous, U.S. Locations

After touring extensively throughout North America and parts of Europe, Levy began worldwide marketing of his scenic, wildlife and travel photographs. He says that "the beauty of the natural world is as inspiring and varied as that of human emotion." In his work he endeavors to capture the connections between the two.

His subjects range from a wading moose to totem poles to outdoor chess players. His photographs have appeared in promotional material for the state of Alaska, educational books and numerous national and international magazines. In addition, many multi-media programs have been produced for such groups as the Audubon Society, U.S. Fish & Wildlife Service and the National Park Service and his photographs have been exhibited by the U.S. Forest Service.

LEVY, YOAV (Photojournalism, Scientific Photography)
4523 Broadway, New York, NY 10040
(212) 942-8185

Born: 1947 *Subject Matter:* Science, Nature *Situations:* U.S. & Foreign Locations, Studio *Education:* Weizmann Institute of Science; School of Visual Arts, NYC

With an expertise in science and technology, he is able to interpret a variety of manuscripts in those fields and provide the appropriate photography. Editorial, corporate and advertising clients call upon him for his problem-solving ability, a skill he attributes to his scientific, systematic approach; the answer, however, comes as he plays intuitively with the factors, he says. Location work takes him into research laboratories, while he does other assignments in his studio. He has published in *Time* and *Newsweek* and is perhaps most noted for his photo essay on telecommunications published in *Smithsonian*.

LEWIS, DON L. (Editorial, Corporate/ Industrial)
P.O. Box 22841, Denver, CO 80222 (303) 690-6912

Born: 1957 *Subject Matter:* Nature, Sports *Situations:* Hazardous, Studio *Education:* Colorado Mountain College

His work on government audio-visual contracts early in his career exposed him to a wide range of photographic production, from documentary, product work and public relations to photojournalism, in assignments ranging from studio work to aerial and industrial photography. He chose to specialize in photojournalism, editorial and corporate/industrial photography and began freelancing in 1983. This led to his success as the first photographer to gain access to an air traffic control tower during the historic PATCO strike of the early '80s. Since then, he has shot for Rodale Press, the U.S. Air Force, the Department of Defense, Bicycle Sport, Southland Corporation, Augsburg Publishing House and the President's Committee on Employment of the Handicapped.

LEWIS, MATTHEW (Photojournalism)
8848 Woodland Dr., Silver Spring, MD 20910
(301) 585-5253

Born: 1930 *Subject Matter:* People *Situations:* U.S. Locations *Awards:* Pulitzer Prize for Feature Photography; White House News Photographers Association Award *Education:* Howard U.; U. of Pittsburgh

He has been at the *Washington Post* for a quarter-century, and he won the Pulitzer Prize for Feature Photography in 1975 for a series of photos published in the paper's *Sunday Magazine*. After completing five years on assignment work and six years on the *Sunday Magazine*, he began an eleven-year stint as the assistant managing editor of the paper's photography department. Responsible for everything from hiring to supervising darkroom activities, he found little time for

picture-taking and in 1987 requested camera work. He shoots for the paper's Metro Two section with a 35mm, taking color photographs on a variety of self-generated assignments, covering such subjects as Sandy Point Beach at the close of the season, inner-city youths learning gymnastics, and the top fashion model in the metropolitan area. He has also covered a range of sports stories, including a photo essay on Washington D.C.'s women's ice hockey team.

LEWIS, STEVEN (Portraiture, Advertising)
P.O. Box 782, Exeter, NH 03833 (603) 772-6442

Born: 1952 *Subject Matter:* People *Situations:* Studio, U.S. Locations *Education:* Rhode Island School of Design

He was trained as an art photographer at the Rhode Island School of Design, and he brings a good deal of creative and expressive energy to each assignment. He concentrates on magazine and editorial portrait work and advertising assignments using models, but he has also shot everything from wedding cakes for a cookbook to grandfather clocks for an antiques magazine ad. His visually striking, thought-provoking images have appeared in annual corporate reports, in publications such as *Boston Magazine* and the *Boston Globe*, and in the book *New Hampshire Portraits*.

LIDZ, JANE (Corporate/Industrial, Editorial)
433 Baden Hill, San Francisco, CA 94131
(415) 587-3377

Born: 1947 *Subject Matter:* Architecture *Awards:* Loeb Fellow, Harvard Graduate School of Design *Education:* Sarah Lawrence College; U. of Oregon

She is a professional architectural photographer whose work has been published in many magazines, including *Architectural, Architecture, Architectural Record, Fortune, Time* and *Progressive Architecture*. She photographs a wide range of interiors, exteriors and landscapes. Lidz has received major commissions from the Department of the Interior, as well as from corporate clients such as Skidmore, Owings and Merrill, RREEF Funds, Apple Computers and Chevron U.S.A., among others. In addition to her commercial work, she taught at the Harvard Graduate School of Design, where she continued to research her next book. She is the author and photographer of two books, *One of a Kind and Rolling Homes: Handmade Houses on Wheels*, which was nominated for a National Book Award. Her fine art photographs have been exhibited in museums and galleries throughout the U.S., including the Massachusetts Institute of Technology and the Montalvo Center for the Arts, and are in many permanent collections including the Library of Congress, the Polaroid Collection and the San Francisco Museum of Modern Art.

LIEBERMAN, H. JACK (Corporate/Industrial, Editorial)
3995 Prospect Ave., Los Angeles, CA 90027
(213) 663-2005; (213) 663-2307

Born: 1929 *Subject Matter:* People, Equipment *Situations:* Hazardous, Studio *Awards:* Golden Lion, Venice Biennale Film Festival *Education:* Pennsylvania Academy of Fine Arts

As a young corporate designer, he began shooting company products, eventually handling all product accounts. Branching into film, he made several documentaries, one of which received the prestigious Golden Lion award. He produced educational films for Universal, EBEC and Doubleday-ICF and continued shooting photography for multimedia producers, meanwhile adding editorial photography to his list of credits when he wrote articles and shot photos for *California Good Life, Valley, Westways* and *Beverly Hills*. In Washington, D.C., he did multimedia and editorial and marketing photos for The Silver Image. The death of a close friend prompted him to train in forensic photography, taking photos of downed planes and other accident scenes; his photography has affected the outcomes of both civil and criminal trials.

LIEBERMAN, KEN (Advertising, Scientific)
118 W. 22nd St., New York, NY 10011

Born: 1930 *Subject Matter:* Laboratory *Situations:* Laboratory *Awards:* Certificate of Merit, Professional Photographers of America Inc.; Certificate of Merit, Art Directors Club of New York *Education:* Brooklyn College

He directs all phases of photographic service for museums, corporations, governments, architects, designers, advertising agencies and commercial and industrial photographers. He advises his clients from beginning to end, from what kind of film to expose to the finished exhibition. He works to arouse concern for the preservation of photographic images and is on the board of directors of the Volunteer Service Photographers. Between 1951 and 1953 he served the army as part of the Psychological Warfare Division.

LIEBLING, JEROME (Fine Art)
39 Dana St., Amherst, MA 01002

Born: 1924 *Subject Matter:* People, Urban Landscapes *Situations:* U.S. Locations, Studio *Awards:* Guggenheim Fellowship; NEA Grant *Education:* Brooklyn College; New School for Social Research

For over three decades Jerome Liebling has been taking photographs and making motion pictures. He has presented us with individuals in a variety of circumstances, from work situations to images of corpses awaiting burial. Overall, he is interested in humanity as he explores human desires, emotions and destinies. His work is both black and white and color, in large and small formats. He studied art and photography in New York under Walter Rosenblum, Ad Reinhardt, Milton Brown and Paul Strand, and film-making under the tutelage of Lewis Jacobs, Leo Hurwitz and Paul Falkenberg. Notable films by Liebling are "The Tree is Dead," "Pow-Wow" and "The Old Man."

LINEON, JAMES J. (Advertising)
30 St. John Pl., Westport, CT 08880 (203) 226-3724

Born: 1948 *Subject Matter:* People, Products *Situations:* Studio *Awards:* New York Art Directors Club; National BPAA *Education:* Northeastern U.; Kansas City Art Institute

He is known for his sense of design and his production skills. Most of his assignments originate from his studio's design projects, which consist mostly of annual reports, ads and promotional work. Prior to becoming a photographer, he was a graphic designer for a number of ad agencies. "I find it both exciting and rewarding to watch my concepts as well as my staffs' concepts become reality as I set up and shoot," he says.

LISSY, DAVID (Advertising, Editorial)
14472 Applewood Ridge Rd., Golden, CO 80401
(303) 277-0232

Born: 1950 *Subject Matter:* Sports, People *Situations:* U.S. Locations *Education:* Northern Illinois U.

Beginning his career as a ski photographer in Aspen, he now covers all aspects of professional and recreational sports and activities. Known for tightly framed, action-packed compositions, which he achieves through the use of long lenses and fast film, his work has been featured in numerous books and magazines, including *Sports Illustrated*, *Time* and *Life*. Recently his photograph entitled *Teardrop Swimmer*, a tight shot of a swimmer's head, was featured at the Professional Photographer's Showcase in Kodak's pavilion at Epcot Center. In addition to sports work, Lissy also photographs interiors for real estate publications and keeps stock work of people from all age groups and walks of life involved in various activities.

LITOWITZ, DONNA BALKAN (Fine Art)
5189 Alton Rd., Miami Beach, FL 33140
(305) 866-7435

Born: 1928 *Subject Matter:* People, Street Scences, Animals, Plants *Situations:* U.S. Locations *Awards:* Merit Award, Photowork Competition and Exhibition of Southeastern Photography; 30th and 27th M. Allen Hortt Memorial Competition and Exhibition, Museum of Art, Ft. Lauderdale *Education:* Florida International U.; Miami-Dade Junior College

Early work featured travel and nature. Later inspired by Henri Cartier-Bresson and Robert Doisneau, she followed in their tradition as she sought to capture the "decisive moment," working in both black and white and color. In photographs of street scenes and people that appear to be spontaneous, she has actually taken great care to order the composition. "Photography enables me to outwardly express my inner vision," she says, calling the work "a way of creating order out of chaos." She seeks to express an element of surprise or mystery in even the most ordinary of subjects. "My intention is to observe, select, interpret and communicate." In current work shot with a Polaroid, she manipulates the film dyes to create a painterly, slightly textured effect, making gardens and landscapes come alive. She is a founding member of Photo-Group/Miami and an exhibiting member of Women's Caucus for Art, Florida Chapter.

LITTELL, DOROTHY (Photojournalism)
74 Lawn St., Boston, MA 02120

Born: 1960 *Awards:* Communication Arts 1986 Photo Annual *Education:* Boston U.

Drawing subjects from the music industry, sports, travel, nature and people, she produces images that are highly action-oriented. Her photographs are edited in the viewfinder and are concerned with translation of both light and subject. The majority of her work is in color, but she does specialize in black-and-white sports images. Her travel and outdoor assignments produce work that creates an emotional response by exposing the viewer to nature in a way that is both thrilling and fresh. Clint Clemens is a major influence.

LITTLE, BLAKE (Editorial, Portraiture)
601 N. Rossmore, Suite 506, Los Angeles, CA 90004
(213) 466-9453

Born: 1956 *Subject Matter:* People, Fashion *Situations:* Studio, U.S. Locations *Awards:* Nomination *American Photographer* New Faces *Education:* U. of Washington; Seattle Central College

Influenced by Irving Penn and Robert Mapplethorpe, he began his career in architectural and fine-art photography. He soon began to include people and architecture in his fine-art projects. At the same time, he began doing straightforward portraits of artists. He received his first major assignment from *Us*, shooting celebrities at home. Today he does celebrity and fashion portraits for magazines, record album covers and the film and entertainment industry. His work has appeared in many publications, including *Interview*, *Elle* and the *New York Times*.

LITTLE, T. SCOTT (Editorial)
4331 Woodlands, Des Moines, IA 50312
(515) 243-4428

Born: 1947 *Subject Matter:* Food, Fashion, People *Situations:* Studio *Education:* Kansas City Art Institute; U. of Iowa

After graduating from art school, he worked on the staff of a small daily newspaper, taking pictures for commercial accounts and news stories. He moved to Des Moines and there concentrated on commercial work. His agency assignments of the period included catalogues for mail order houses and fashion for the Yonkers Department Store chain. He then began his current association with Meredith Corporation, publishers of *Better Homes and Gardens*, *Midwest Living*, *Wood*, *Country Home*, *Grandparents* and many other titles. Although the majority of his present work is in food, he also shoots for stories about remodeling, crafts, furniture and features. His warmly lit pictures are almost exclusively in color. He uses the 4" x 5", 8" x 10" and 2 1/4" formats.

LLEWELLYN, ROBERT (Advertising, Corporate/Industrial)
P.O. Drawer L, Charlottesville, VA 22903
(304) 973-8000

Born: 1945 *Subject Matter:* People, Nature, Architecture *Situations:* Aerial, U.S. Locations *Education:* U. of Virginia

With specialties in photographing people, landscapes and architecture, he has published work in a variety of media, including newspapers, advertisements and annual reports, with a concentration on book publication. He has completed twelve books, including four on the cities of Philadelphia, Boston, Chicago and Washington, D.C. Others include a trilogy of photographic books on the life and philosophy of Thomas Jefferson: *Upland Virginia*, *Thomas Jefferson's Monticello* and *The Academical Village, Thomas Jefferson's University*. His other books include *Penn*, a photographic essay on the University of Pennsylvania; *Virginia: An Aerial Portrait*, a collection of aerial photographs; and *Pennsylvania*, pictures exploring William Penn's utopian land. Awards include *Communication Arts* Art Annual Award, the Art Direction Creativity Award and awards from the New York and Washington Art Directors' Clubs.

LOGAN, FERN (Corporate/Industrial, Fine Art)
600 W. 111 St., New York, NY 10025 (212) 666-1364

Born: 1945 *Subject Matter:* Fine Art, People *Situations:* U.S. & Foreign Locations, Studio *Awards:* Yaddo Fellowship; NYSCA Grant *Education:* Pratt Institute

She began her career as a serious photographer in 1974 in a workshop with Paul Caponigro; his influence

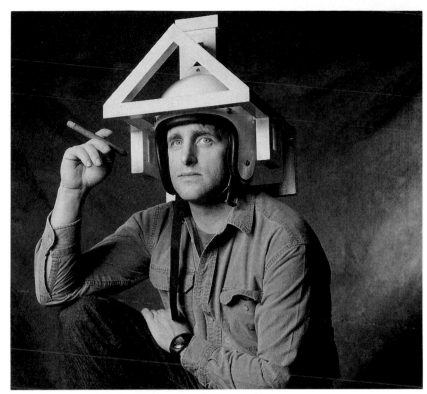

Steven W. Lewis, *Nick Dawson, Architect/Artist*

Jane Lidz, *French Doors*

can be seen in the subtle spiritual quality of her landscapes. She is best known, however, for her "Artist Portrait Series" for which she received a special projects grant from the New York State Council of the Arts in 1985. To date, the project consists of over seventy-five portraits of some of the most noted visual, theatrical, dance and literary artists and personalities in the black community. These include Bill Cosby, Adolph Caesar, Ed Bradley, Alvin Ailey, Arthur Mitchell and Arthur Ashe. Currently, she is exploring non-silver processes, gum bichromate, Vandyke and cyanotypes.

LOKEY, DAVID (Advertising)

P.O. Box 520, Vail, CO 81658 (303) 949-5750

Born: 1956 *Subject Matter:* People, Sports *Situations:* Hazardous, U.S. Locations *Education:* U. of Colorado

As staff photographer for Vail Associates Inc., he spent four years shooting every aspect of resort and mountain life. With this experience, he formed his own photography studio, broadening his work into national and international freelance circles. His special projects have included covering the Ku Klux Klan, documenting a skiing expedition to the glacial cross on Colorado's Mount Holy Cross and exposing conditions of poverty in the black shanty towns of the South. His work has appeared in *Newsweek, Travel and Leisure, Signature* and *Money*, and his clients include Head Ski Co., Eurohead Sportswear and Mizuno Sportswear.

LOWE, SHAWN MICHAEL (Advertising, Corporate/Industrial)

240 Prospect Ave., Hackensack, NJ 07601

Born: 1960 *Awards:* 1986 Fuji Film Award; 1984 Kinsa Photography Award *Education:* Syracuse U.

He works almost exclusively in available light, preferring the transparent brightness of the early morning sun. This combines with a strong concern for graphic design to produce images that are painterly both in approach and appearance. Subject matter varies widely and includes fashion and people; his recent work concentrates on buildings and includes a skyline of New York seen through the Brooklyn Bridge and a representation of the Empire State Building composed through a traffic light. Both his fine art and his commercial work emphasize quality of light and graphic impact.

LOWERY, RON (Advertising, Photojournalism)

409 Spears Ave., Chattanooga, TN 37405
(615) 265-4311

Born: 1944 *Subject Matter:* Fashion, Product *Situations:* Aerial, Underwater, Studio

Primarily a product photographer, he is known for his capacity to create an exciting environment for a shot. To do this he has taken aerial photos as well as underwater pictures. His product speciality is shiny objects such as jewelry and golf clubs; he has photographed for Arnold Palmer Golf Clubs. Included in his portfolio are fashion and architecture photos, both exterior and interior. Sixty percent of his work is done in the studio, where he uses computer graphics to enhance the image. Equal to the variety of methods he uses is the variety of media that have used his photography, from newspapers to magazines, brochures, annual reports and slide presentations.

LUBIN, JEFF (Portraiture)

6641 Backlick Rd., Springfield, VA 22150
(703) 563-5082

Born: 1949 *Subject Matter:* Portraiture *Situations:* U.S. Locations, Studio *Education:* Strayer U.

Working for the past ten years strictly in portraiture, he brings his own style to every sitting. As a portrait artist, he takes time with the people, designing the colors, style and location to custom tailor each collection, whether graduation pictures, an elegant bride, or a generation of families. He has won national and state award, and in 1987 the Maryland Professional Photographers of America recognized one of his portraits as the Family Portrait of the Year. Some of his portraits hang in the Library of Congress, and he has been featured on television's "Fairfax Magazine."

LUCAS, STEVE (Editorial, Advertising)

16100 S.W. 100th Ct., Miami, FL 33157
(305) 238-6024

Born: 1946 *Subject Matter:* Marine, Travel *Situations:* U.S. & Foreign Locations, Underwater *Education:* York College

Fascinated by the sea, he left a career as a midwest bank vice president to teach scuba diving in Florida. Shooting underwater scenes on weekend outings, he made prints of his better photographs for display. Soon he had sold two photographs to national publications. Since then he has completed assignments for over twenty magazines, including *U.S. News & World Report, Skin Diver* and *Endless Vacation* and others around the globe in Israel, Egypt, the Galapagos Islands, Singapore, the Caribbean and the Maldive Islands. In the States, he has produced two underwater calendars. Two twenty-foot murals of his photography permanently decorate the Miami International Airport. When not taking his own shots, he is busy teaching underwater-photography seminars for Nikon.

LULOW, WILLIAM (Portraiture, Corporate/Industrial)

302 W. 86th St., New York, NY 10024

Born: 1944 *Subject Matter:* Fashion, People *Situations:* U.S. Locations, Studio *Education:* U. of Wisconsin; U. of Colorado

For his skill in portraiture he credits Philippe Halsman, with whom he studied for one year, and for that in advertising and corporate photography he credits Carl Fischer, with whom he worked as an assistant before opening his own studio. In the portrait field, he is best known for his clean, well-lit shots of corporate executives, authors and artists. Among his clients are NBC, Allied/Signal, the Metropolitan Museum of Art, Lorillard, Bantam Books, Harcourt Brace Jovanovich and Random House. His photographs have been published in *Esquire*, the *New York Times* and *New York Magazine*. In advertising, his fashion photography is used by Hanes Hosiery and the Metropolitan Museum's Costume Institute, as well as in mailing pieces and brochures for Timberland Boots, The Wool Bureau, Jennings Ltd., Lane Bryant, J.C. Penney and Bradlees. Currently on the faculty of The New School for Social Research, he teaches a course in studio lighting for portraits.

Donna Balkan Litowitz, *Mongolian Horsemen.* Courtesy: Virginia Miller Galleries, Coral Gables, Florida

Lou Manna. Courtesy: New York Times

LURIA, RICHARD (Advertising)
5 E. 16th St., New York, NY 10003

Born: 1938 *Subject Matter:* People *Situations:* Studio

Coming to photography through the "back door"—as a television copywriter who shot his own table-tops to illustrate his storyboards—he soon exchanged typewriter for camera by first joining a small professional color lab. Ten years later, he found himself a principal at what had become one of the industry's leading labs. In 1966, he opened his own studio in New York's photography district. Though he learned photography shooting table-top, today his speciality is people. His most recent clients have included Citibank, Grey Advertising, Shell Oil and N.W. Ayer.

LUTZ, RICHARD (Advertising, Scientific)
R W Lutz Photography, 1705 1st Ave., Iowa City, IA 52240 (319) 354-4961

Born: 1938 *Subject Matter:* Nature, Architecture *Situations:* Studio, U.S. Locations *Awards:* NEA Fellowship *Education:* Coe College; U. of Iowa

In graduate school, he used photography to illustrate data presentations and scientific papers. He then developed an interest in microscopy and began making photo-illustrations for scientific journals using light microscopes and transmission and scanning electron microscopes. Currently he owns and operates a versatile photographic studio in Iowa City, where he serves private individuals and small and large corporations.

LUZIER, WINSTON (Advertising, Editorial)
1122 Pomelo Ave., Sarasota, FL 34326
(813) 952-1077

Born: 1955 *Subject Matter:* Sports, People, Travel *Situations:* U.S. & Foreign Locations, Hazardous, Aerial, Studio *Awards:* Addys *Education:* Daytona Beach Community College

Working freelance for the Associated Press, his coverage of Formula One racing in Europe established him in the field of hazardous photography. He would continue to take on projects calling for special cameras and gear, shooting speedboats from helicopters, downhill skiing and car racing, while at the same time cultivating clients in more traditional work, such as still life and multi-image, in his studio. Based in Florida, he still covers events, from football to the space shuttle, for the Associated Press. Currently he is expanding into marine and corporate/industrial photography. Publications include *Time, Life, Wooden Boat, Sports Illustrated, Clubhouse Magazine, Air-Nav Publications, Architectural Digest* and *Power and Motoryacht.*

LYMAN, DAVID H. (Corporate/Industrial, Editorial)
c/o The Maine Photo Workshops, Rockport, ME 04556 (207) 236-8581

Born: 1939 *Subject Matter:* Sports, Architecture *Situations:* U.S. & Foreign Locations *Education:* Boston U.

He started photographing in high school. Through college he worked as a yearbook photographer and camera salesman and for various Boston news and advertising agencies. In 1967 he was sent to Vietnam as a photojournalist for the U.S. Navy. He was attached to the Seabees, where he edited *The Transit,* an award-winning monthly news magazine. After a year in Vietnam, he worked as a sports photographer and writer, specializing in skiing, mountain and marine subjects and editing *Ski America* and *The Student Skier* magazines. In 1973 he founded The Maine Photographic Workshop, which has grown into one of the pre-eminent summer schools in the fields of photography, film and television. His current photographic subjects include landscapes, architectural details, marine environments and portraits of New England, the Caribbean and Europe.

LYNN, JERRY (Editorial, Illustration)
18 Letitia Street, Philadelphia, PA 19106

Born: 1953 *Subject Matter:* Fashion, Nudes *Situations:* Studio, U.S. & Foreign Locations *Education:* Tyler School of Art; New York U.

His work includes nudes, fashion, travel and people and his assignments range from portraiture to collage and illustration. While commercial in nature, much of his work retains a personal aesthetic that suggests more than it reveals. In his personal work, this idea is pursued by combining parts of people or objects into one organic image, like pieces of a puzzle. Editorially, his work is used in a variety of ways, and he works both in the studio and on location in the United States and abroad.

.MACADAMS, CYNTHIA (Nudes, Portraiture)
17 Bleecker St., New York, NY 10012 (212) 598-4296

Born: 1939 *Subject Matter:* Nudes, People *Situations:* Studio, U.S. Locations *Education:* Northwestern U.

Beginning as an actress, she came to photography in 1973. At first she photographed Colorado's natural phenomena, such as clouds and butterflies, but she soon turned her camera to what has since been her primary subject, women. In her first book, *Emergence* (1977), she depicted women in leadership roles. Her second book, *Rising Goddess* (1983), was a collection of compassionately photographed women at home in nature. Her subjects are clothed and unclothed women, "emerging" from a male-dominated world with their own identities. Her third book, *Nude Photography,* was published in 1985. Her recent work includes infrared studies of Mexican and Egyptian sacred sites.

MCCANNAN, TRICIA (Advertising, Editorial)
1536 Monroe Dr., Atlanta, GA 30324 (404) 873-3070

Born: 1953 *Subject Matter:* Fashion, People, Travel *Situations:* Studio, U.S. & Foreign Locations *Awards:* Gold & Silver National Awards for Bath and Kitchen Advertising *Education:* Florida State U.

She began working in theater and dance as an actress and director. Years later as a photographer, she tends to choreograph her shots with "pre-visualization." Also a fine artist, she has been able to bring a conceptualism and a certain "fantastic romanticism" to her commercial work. She has had her own Atlanta studio since the late 1970s, where she has developed campaign looks for American Fitness, Quaker State, Traveler's Insurance, Dunlop Sports and Beekman calendars and posters. "I believe in harmony as a prerequisite for the people illustration that I do," she says.

MCCARTHY, MARGARET (Photojournalism, Fine Art)
31 E. 31st St., Suite 11A, New York, NY 10016
(212) 696-5971

Born: 1953 *Subject Matter:* Nature, People, Travel *Situations:* U.S. & Foreign Locations

Her landscape images are informed by a painterly feeling, a strong sense of graphics and an awareness of formal artistic principles. In 1982, her show "Color Photographs of The Irish Landscape" appeared at New York's Overseas Press Club. More recently she has photographed the Grand Canyon area as part of a series on American landscapes and documented American political demonstrations and rallies for an ongoing photojournalistic project. Her staged photographs of women in Celtic Mythology show off her production skills and creative vision. Her images have appeared in *Petersen's Photographic Magazine, Combinations: A Journal of Photography* and the *New Orleans Review.* Her corporate and editorial clients include International Paper Company, Gannett-Westchester Newspapers and Unex Conveying Systems Corporation.

MCCOWAN, R.L. (Photojournalism, Advertising)

3905-B Botanical, St. Louis, MO 63110

Subject Matter: Industry, Products *Situations:* Studio, U.S. & Foreign Locations *Education:* Art Center College of Design; Studio Hedfords, Koping, Sweden

He has worked for a broad range of clients, including Aerojet General, Toastmaster Corporation, Volvo, the *Jefferson City News Tribune,* Sears and Good Time Jazz, producing photo essays, album covers, brochures, catalogues, advertisements and public relations releases. But he is best known for his "reinventing" the carbro printing process. It is an old method, wherein carbon pigment is suspended in a layer of gelatin and the image is transferred from a bromide print to the carbon pigment. Such a process, which may take three days to complete, allows for a range of tones that silver-based printing methods cannot achieve. His photographs are characterized by rich and moody shadow areas, the low-key palette influenced by the early masters of photography, Edward Steichen and Eugene Atget.

MCDONALD, JOE (Scientific, Natural History)

515 Dalton St., Emmaus, PA 18049 (215) 965-3405

Born: 1952 *Subject Matter:* Animals, Nature, Travel, Wildlife *Situations:* U.S. & Foreign Locations *Education:* Indiana U.

His in-depth knowledge of animal behavior permits him to catch such wildlife action sequences as owls flying, frogs leaping and animals catching prey. With in-studio habitats, he also captures behaviors that are hard to observe in the wild. He has worked in Kenya, the Galapagos Islands and the Florida Everglades. His seminars and workshops have been successful, as have his school and nature-group slide programs. His work has been published in all the major natural history publications and magazines, and he is currently working on a book detailing natural-history photo techniques.

MCGEE, E. ALAN (Advertising, Corporate/Industrial)

1816 Briarwood Ind. Ct., Atlanta, GA 30329 (404) 633-1286

Born: 1948 *Subject Matter:* People, Architecture *Situations:* Studio, U.S. Locations *Education:* Rochester Institute of Technology

With an academic background in both photography and architecture, he makes photographs for both architectural and advertising clients. In 1971 he received a degree in professional photography from the Rochester Institute of Technology and then studied architecture for three years at the Georgia Institute of Technology before opening his own Atlanta studio in 1973. His work has appeared in every major architectural and home furnishing magazine, as well as in the brochures of the Hilton, Marriott and Amarlite corporations. He is past president and present treasurer of ASMP/SE.

MCGRAIL, JOHN (Photojournalism, Corporate/Industrial)

522 E. 20th St., New York, NY 10009

Born: 1948 *Subject Matter:* Sports, Travel *Situations:* U.S. Locations, Aerial *Education:* Brooks Institute of Photography

Sitting in the open door of an aircraft became second nature for him as a paratrooper in the 82nd Airborne Division and later as a sport skydiver. This experience enables him today to make aerial photography his specialty. Most of his assignments, however, are shot at ground level, his subjects environmental portraits or people in action. His experiences in the editorial field, shooting for top magazines including *Life, Smithsonian, Fortune, Business Week, Discover* and *Time,* have exposed him to a vast variety of assignment challenges. Today he has successfully shifted to the corporate/industrial market. He continues, however, to bring an eye for action to his camera, choosing a shooting strategy for annual reports and brochures that brings forth the same level of energy he brought to his earlier magazine work.

MACGREGOR, GREG (Fine Art)

6481 Colby St., Oakland, CA 94618 (415) 658-8331

Born: 1941 *Subject Matter:* Nature *Situations:* Desert *Awards:* Unicolor Equipment Grant *Education:* San Francisco State U.

A former physicist, his work often deals with metaphorical or documentary issues of technology. In his first book, *Deus Ex Machina* (1975), he used multiple printing techniques to create surreal treatments of high tech's invasion of personal space. From 1977 to 1984, he created hand painted black-and-white images of a science fiction-like desert landscape full of leftover and decaying machinery. During the same era he created the "American Tractor Series," a series of color prints in which road building and other heavy duty machinery were made to resemble Tonka toys. Since 1978 he has been conducting and documenting whimsical explosions of gas powder for a proposed publication, *Explosions, a Self Help Book for the Handyman.* He is currently Professor of Photography at California State University at Hayward.

MCHUGH, STEVE (Advertising)

451 Taft St., N.E., Minneapolis, MN 55413 (612) 331-5866

Born: 1953 *Subject Matter:* Food *Situations:* Studio *Awards:* The Show Bronze Award *Education:* Brooks Institute of Photography

His photographs are graphically clean and gorgeously lit. He studied at the Brooks Institute in Santa Barbara and worked briefly in Los Angeles before moving to Minneapolis. In Minneapolis he worked for two

studios before opening his own business in 1983. He has since concentrated on food, table-top and high-tech. His clients have included advertising agency accounts for Pillsbury, General Mills and 3M. His promotional pieces have been featured in *Photo District News* and many local Minnesota magazines.

MCINTYRE, WILL (Corporate/Industrial, Editorial)
3746 Yadkinville Rd., Winston-Salem, NC 27106
(919) 922-3142

Born: 1954 *Subject Matter:* People, Travel *Situations:* U.S. & Foreign Locations *Education:* Western Carolina U.

With his partner Deni McIntyre, he works on location for corporations, advertising agencies and magazines. Since 1985, they have together shot major assignments for the German Wine Information Bureau, the Mexican Ministry of Tourism, Burroughs Wellcome Pharmaceuticals and other large companies. An exhibit of his black-and-white photography, "Points South," was hung at the Knoxville World's Fair. Their show of color portraits and street scenes of Brazil was mounted as "Running on Heart" and will soon be a book of the same name. Their stock-picture sales are handled by Photo Researchers in New York and Aperture Photobank in Seattle.

MCKEE, LARRY G. (Editorial, Portraiture)
707 E. Walton Ave., Altoona, PA 16602
(814) 942-1205

Born: 1942 *Subject Matter:* People, Travel *Situations:* U.S. Locations *Awards:* Grand Prize, *Pittsburgh Press* Photography Contest *Education:* Medina Community Hospital School of Radiologic Technology

He specializes in editorial photographs of people and nature. Among the his publishing credits are *Petersen's Photographic Magazine, Modern Photography, Rail Classics* and *Pennsylvania Magazine*. He was the writer and photographer of the *Blair County Shopper's Guide* and his images have appeared on album covers, cassette tapes, notebooks, calendars, newspapers and magazines. Twenty-two of his slides were featured in the Guideposts' book *Fragile Moments,* and he had a two-page spread in *One Day USA—A Self-Portrait of America's Cities* published by Harry N. Abrams, Inc.

MACKENZIE, MAXWELL (Corporate/Industrial)
2641 Garfield St., N.W., Washington, DC 20008
(202) 232-6686

Born: 1952 *Subject Matter:* Architecture, Interiors *Situations:* U.S. Locations *Education:* U. of Pennsylvania; Bennington College

With an architecture degree as well as one in photography, he shows a particular understanding of his subjects in his work as an architectural photographer. He cites the photographers of the Esto Group, headed by Ezra Stoller, and especially Peter Aaron, as the major influences on his work. Working in a 4" x 5" format with continuous tungsten lights, he strives to capture "the way space really is." In his shots, the viewer's eye typically is drawn into a space and led through it until something inanimate is seized and given life. He likes to work at unconventional hours, starting at four in the afternoon and often shooting until two in the morning in order to achieve his characteristic style. He has worked on hundreds of architectural and design as-

signments and has been published in all of the major architectural magazines.

MCKIERNAN, KEVIN (Photojournalism)
P.O. Box 91641, Santa Barbara, CA 93190
(805) 966-9770

Born: 1944 *Subject Matter:* People *Situations:* U.S. & Foreign Locations, Hazardous *Awards:* Armstrong Award, Excellence in Journalism; Pulitzer Prize Nomination

A photojournalist, he began his career as a radio reporter for National Public Radio and as a freelance writer for such publications as the *New York Times* and the *Minneapolis Tribune*. As a photographer he continues to publish in newspapers and magazines such as *Time, Newsweek,* the *Christian Science Monitor* and the *New York Times*. In recent years he has gone on assignment in Central America, Africa, the Philippines and Vietnam, covering news and feature stories. He is known for his photographs of people, especially children, caught in the midst of conflict. His exhibition "Images of Central America" has recently been on tour.

MCLAREN, LYNN (Photojournalism, Editorial)
P.O. Box 2086, Beaufort, SC 29901 (803) 524-0973

Born: 1922 *Subject Matter:* People, Travel, Products *Situations:* U.S. & Foreign Locations *Education:* Vassar College; Missouri School of Photojournalism

"Almost every photograph of yours is best reproduced full-frame—no cropping," a client remarked regarding an annual report on conduits and electric coils. "You have a way of making singularly uninteresting objects very interesting." Her career began as a photojournalist working for *Mademoiselle*. This was followed by several book projects—one on the life of a student nurse for Georgetown University, a second entitled *Berlin and the Berliner* and a third about a village in India entitled *This People India*. For a short period she worked for UNICEF in East Africa, returning to the States to set up in Beaufort, South Carolina. When not working on a book on the Beaufort area, she splits her camera time between environmental portraiture, travel coverage and location photography for annual reports and magazine assignments. Clients include IBM, United Brands, Time-Life Books, *National Geographic*, Hart-Carter America, the Rockefeller Foundation and Johnson & Johnson.

MACLAREN, MARK (Corporate/Industrial, Portraiture)
430 E. 20th St., New York, NY 10009

Born: 1956 *Subject Matter:* Fashion, Travel, Nature *Situations:* U.S. & Foreign Locations *Education:* Tufts U.

Operating out of New York City, he specializes in people, travel and beauty photography. In addition to maintaining extensive stock photography available in thirteen countries, six continents and fifty states, he frequently goes on assignment for ad and editorial work. Among his diverse clients are *Time, Life, McCall's*, General Motors, the Ford Motor Company, IBM, Kent Cigarettes and ITT. His particular strength lies in his use of vibrant color. This is perhaps best seen in his landscapes, which have been enlarged as decorative prints and murals for corporations.

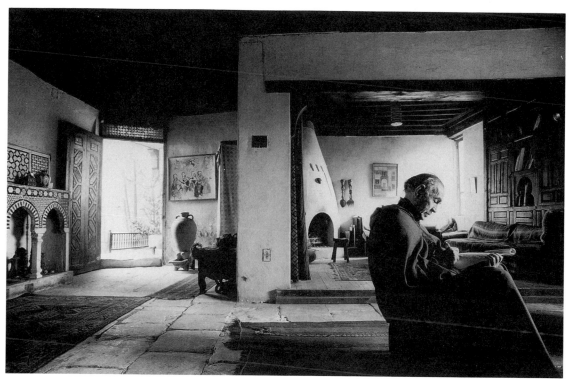

Fred J. Maroon, *Egyptian Architect, Hassan Fahti*

Lynn McLaren, *Exodus*

MACLEAN, ALEX (Corporate/Industrial, Fine Art)

65 E. India Row, Boston MA 02110 (617) 523-6446

Born: 1947 *Subject Matter:* Land *Situations:* Aerial, U.S. & Foreign Locations *Awards:* NEA Design Grant; Massachusetts One Percent for Arts Commission *Education:* Harvard U.

Upon receiving his masters degree in Architecture, he began his career in aerial photography and shortly thereafter started Landslides, a firm specializing in aerial photography serving publishers, architects, planners and real estate professionals. The work is issue-oriented, covering subjects ranging from site analysis for pollution control and waste management, to a catalogue of geological land forms to a survey of Rhode Island mills. Other recent work includes aerials for the 1988 U.S. Open golf tournament. MacLean's aerial and fine-art prints of abstract landscapes in urban and rural environments may be found in public and private collections and have been exhibited at the Alfred Stieglitz Gallery in New York City and the Wilhelm Gallery in Houston.

MCMANEMIN, JACK (Advertising, Corporate/Industrial)

662 S. State St., Salt Lake City, UT 84111 (801) 533-0435

Born: 1950 *Subject Matter:* Fashion, Food, People *Situations:* Studio, U.S. & Foreign Locations *Education:* Stanford U.

In the 1970s, while living in Vienna, he began photographing the Austrian people and architecture in black and white and the Alps in color. He then took his first professional job at a commercial studio in Vienna, where he did black-and-white printing, product photography and portraiture. After returning to the U.S. and settling in Salt Lake City, he pursued a career in advertising and corporate photography. He shoots products and food in the studio and people on location. He maintains his love of black and white, even in commercial assignments.

MCMULLIN, FOREST (Advertising, Corporate/Industrial)

183 St. Paul St., Rochester, NY 14604 (716) 262-3944

Born: 1953 *Subject Matter:* People *Situations:* U.S. Locations *Education:* Rochester Institute of Technology

He is a corporate/industrial photographer who works on location. People are his primary subjects and he approaches the janitor on the factory floor with the same respect and humor as he does with the chairman of the board. As a result, his photographs have an uncommon honesty and directness. He began his career in a Maine portrait studio and went to a rural weekly in Wisconsin before moving to his current base, Rochester, where he also teaches. His images appear in annual reports, advertising, slide shows and magazines.

MCNEELY, BURTON (Advertising, Editorial)

P.O. Box 338, Land O'Lakes, FL 34639 (813) 996-3025

Born: 1927 *Subject Matter:* Nudes, People, Sports, Travel *Situations:* Aerial, Underwater, U.S. & Foreign Locations

A pioneer in underwater photography, he designed and built many special-use underwater camera systems in the early 1950s. In the 1960s he worked regularly for major American magazines, covering the early race riots and Martin Luther King's work in the South. In 1968 he was a special consultant to Eastman Kodak for underwater projects and was instrumental in developing their first underwater Colorama for exhibition at Grand Central Station. With the demise of many national magazines in the late 1960s, he turned to advertising and specialized in outdoor location work in the recreation and leisure-time fields. He concentrates on stock photography and is associated with Image Bank.

MCQUEEN, ANN (Fine Art, Advertising)

791 Tremont St., Boston, MA 02118 (617) 267-6258

Born: 1948 *Subject Matter:* People *Situations:* Studio, U.S. & Foreign Locations *Awards:* Finalist: Massachusetts Artists Fellowship *Education:* Wheaton College; Boston U.

She is a commercial and fine-arts photographer who makes images of active people. Her commercial work includes assignments for stock companies, advertising agencies, magazines and publishers. Her fine-art work includes the studio project "Jumping Naked," a series of one-of-a-kind leaping nudes lighted with altered strobes and made with a Polaroid 20" x 24" camera, and an outdoor cross-cultural journal depicting street life, celebration, gesture and confrontation in the United States, Italy and China. Her fine-art work is often exhibited in galleries, colleges and magazines.

MCQUILKIN, ROBERT (Photojournalism, Illustration)

728 Hill Ave., Glen Ellyn, IL 60137 (312) 858-7004

Born: 1952 *Subject Matter:* Sports *Situations:* U.S. Locations, Hazardous, Underwater *Awards:* New York Art Directors Club Award; ASMP Award *Education:* Wheaton College

Most of his photographs deal with adventure sports such as mountaineering, kayaking, skiing and scuba diving. They are known as "participation sports," since they are not the kind of event easily photographed from the sidelines. His work consists of close-up action shots and a heavy use of remote photography. Wide-angle lenses bring the viewer completely into the event. For example, one photograph of a sled and dog team was shot just eight inches from the huskies, while lying in the snow. Remote photography shoots include cameras mounted on surfboards, on hang gliders and on the back end of a jeep in front of a group of women runners. These photographs render not only the sport's action, but a remarkable feeling of participating in the sport itself. He frequently contributed to *Forbes*, *Stern*, *Field and Stream* and other sports magazines and exhibited his work as part of the Professional Photographers' Showcase at Disney World's Epcot Center. He recently drowned while filming underwater.

MACWEENEY, ALEN BRASIL (Editorial, Fine Art)

36 Gramercy Park, New York, NY 10003

Born: 1939 *Subject Matter:* People, Travel *Situations:* U.S. & Foreign Locations, *Awards:* American Institute of Graphic Arts Certificate of Excellence; Certificate of Merit of the Art Directors Club of New York *Education:* Alexey Brodovitch's Design Lab

Robert McQuilkin

Ralph Mercer, *Media Dream*

Born in Dublin, he began as a press photographer, his early style influenced by William Klein and Irving Penn. In 1961 he came to the United States to work as Richard Avedon's assistant. Since then he has worked as a commercial photographer for such publications as the *New York Times, Life* and *Esquire*. His personal photographs are black-and-white portraits of landscapes, people (some nudes) and animals, rendered in a small or medium format. He has often worked in his homeland, resulting in series that include Dublin street scenes and Irish and Northern Irish landscapes. He has also has collected examples of Irish folklore, literature and music. More recent work depicts the urban landscape of New York City. Public collections include the Museum of Modern Art in New York City and the Philadelphia Museum of Art.

MAGNUS, RANDY (Editorial, Photojournalism)
307 H St., Modesto, CA 95351 (209) 578-2723

Born: 1955 *Subject Matter:* Editorial, Portraiture *Situations:* U.S. Locations *Education:* San Francisco Art Institute

When he was nineteen, the Oakland Museum purchased four prints from his series "Family Portraits, 1971-1976." At the age of twenty , he graduated from the San Francisco Art Institute, where he majored in alternative processes in photography. During his early twenties, he used video as a photographic image-making tool and ran rice paper through a color Xerox machine, which he used as a camera. When he was twenty-eight, he opened an alternative art gallery in Modesto, California, and when he was thirty, he became head of the photography department at the extension campus of the College of the Redwoods in Mendocino. He is presently documenting the California tomato industry using photographic images and computer-printed text. He has had major exhibitions in Europe and America.

MAGOFFIN, JAMES (Corporate/Industrial, Scientific)
5900 Olson Memorial Highway, Minneapolis, MN 55422 (612) 544-2721

Born: 1945 *Subject Matter:* People, Industrial Applications *Situations:* Hazardous, Corporate/Industrial Locations *Awards:* Industrial Photography Annual Award of Excellence *Education:* Rochester Institute of Technology

After taking a degree in Professional Photography and a minor in Communications Design from the Rochester Institute of Technology, he worked for three years as a commercial photographer for Merle Morris Studio in Minneapolis. Since the late 1970s, he has made images of aerodynamic and combustion air test activities for a Minneapolis-based aerospace engineering firm. As corporate photographer for the company, his responsibilities include still, cinema and video production, literature development, advertising and marketing communication. He also does freelance location and fiber-art photography for local small businesses and fiber artists.

MAHER, JOHN (Advertising, Photojournalism)
1425 S.E. Main St., Suite 3, Portland, OR 97214
(503) 238-3645

Born: 1950 *Subject Matter:* People *Situations:* U.S. & Foreign Locations *Education:* U. of Hawaii; U. of California, San Diego

Applying a personal vision to commercial needs, he depicts his subjects with heightened reality and brings a strong sense of design and color to his work. He began his career in photojournalism in southern California. He was first published nationally in *The Family of Children* and later joined *Oregon Magazine*, where he was chief photographer for five years. He then returned to freelancing and worked for corporate and editorial clients primarily on location. He now divides his time between advertising, corporate and magazine clients. He also shows and sells limited-edition art photographs through galleries.

MAHIEU, TED (Advertising, Editorial)
P.O. Box 42578, San Francisco, CA 94142
(415) 641-4747

Born: 1929 *Subject Matter:* People, Wildlife *Situations:* Studio, Foreign Locations *Awards:* Photography Hall of Fame *Education:* Grafische School, Amsterdam; Brooks Institute of Photography

Originally trained as a halftone-reproduction photographer in Holland, he left for New Zealand in 1952, where he began working as a photographer in a large industrial studio, eventually branching out on his own into fashion and architectural photography. He moved to the United States in 1960 and "by accident" began working in stock photography in San Francisco, first with The Image Bank and then also with The Stockmarket. He travels extensively, shooting in some sixty countries and building a file for a range of clients from *National Geographic* to Hyatt Hotels, producing everything from corporate reports to travel brochures. He says of himself "I am not really a photographer, just a problem-solver for designers and sometimes other photographers."

MAKI, MIKE (Advertising, Corporate/Industrial)
6156 Olson Memorial Hwy., Golden Valley, MN 55422 (612) 541-4722

Born: 1949 *Subject Matter:* Food, People *Situations:* Studio, U.S. Locations

He began his career by selling baby pictures door to door. Hired to do darkroom work by a prominent Minneapolis photographer, he began shooting on his own. Early in his career he did slide shows and catalog photographs for large corporations, and he worked his way up to become head photographer for the Fingerhut Corporation. After seven years there, he opened his own studio in partnership with studio manager Lynette Smith. He has since concentrated on food, fashion and product photography, doing 8 x 8-foot prints for store decorations and outside photography jobs for stores in Orlando and Cincinnati. He has invented an in-camera masking technique that enables him to add new backgrounds to model or still shots.

MAKRIS, DAVID (Corporate/Industrial)
6 Scott Court, Poughkeepsie, NY 12603
(914) 462-4502

Born: 1956 *Subject Matter:* Wildlife, Travel *Situations:* U.S. & Foreign Locations, Studio *Education:* Worcester Polytechnic Institute

A skilled mountain climber and survivalist, he is best known for his ability to make shots under extreme environmental circumstances in all seasons and climates. Using an array of specially designed equipment, he has compiled a storehouse of shots of ice-

climbing and other high-risk scenarios. Having studied with industrial photographer Carol Zachrisson, he has also developed industrial clients, including such giants as IBM. He has recently begun to lead workshops on extreme-condition winter mountaineering and photography. He travels through the United States, continuing to build his already burgeoning file of stock images that are the staple of his income.

MALANGA, GERARD (Portraiture, Editorial)
203 E. 14th St., New York, NY 10003 (212) 260-5659

Born: 1943 *Subject Matter:* Nudes, People *Situations:* Studio *Awards:* The Great Wall International Sports Photo Competition Award, Peking

From 1963 to 1970 he was associated with Andy Warhol as a silk-screen technician, photo-researcher and cinematographer. In 1969 he and Warhol co-founded and edited the magazine *Interview,* during which time he started taking pictures again, making portraits of friends, many of whom were artists and poets. In 1980 he started a series of nude portraits. In these shots the views are mostly partial and fragmented, the body surface close to the camera. Persons are less individuals than types, the attention always drawn from what is represented to how it is represented. In 1985 he was appointed photo archivist of the New York City Department of Parks & Recreation, where he presently is the curator of exhibits from an historic negative collection concentrating on Robert Moses's civil service legacy. "Artistic revolution in photography advocated by photographer-artists is not revolutionary unless it includes changes in the channels of communication," he says. "In one sense, I use photography not for its own sake but to express other ideas that are representative of the very process of cultural mythmaking."

MALDRE, MALTI (Fine Art, Documentary)
1727 W. 104th Pl., Chicago, IL 60643 (312) 233-6873

Born: 1947 *Subject Matter:* Nature, Architecture *Situations:* U.S. Locations *Awards:* Illinois Arts Council Fellowship *Education:* U. of Illinois; Institute of Design, Illinois Institute of Technology

Early in her career she experimented with in-camera tricolor filters. Since 1970, she has been documenting historic and architecturally significant structures in Illinois. Her first subjects were the town of Galena and the Chicago neighborhood of Pullman. Later, grants from the state and private foundations enabled her to document Chicago's bath houses and its Beverly Hills and Morgan Park communities. She has recently begun using a wide-view, panoramic format, allowing her to record the relationships of individual structures to each other and their landscapes. She is currently Professor of Art and Photography at Chicago State University.

MANGELSEN, THOMAS (Advertising, Photojournalism)
P.O. Box 2935, Jackson, WY 83001 (307) 733-6179

Born: 1946 *Subject Matter:* Wildlife, Nature, Travel *Situations:* U.S. & Foreign Locations *Education:* Doane College

A native Nebraskan, he spent his youth observing birds and other wildlife in the state's sandhills and river valleys, there gaining an appreciation for nature that has become the foundation of his career as a wildlife photographer. He began photographing in 1969. Since then he has received a degree in biology and has completed graduate work in wildlife biology. Today he has over 80,000 35mm transparencies, mainly Kodachrome, of North American wildlife, natural history and scenery. They range in style from behavioral to action to portrait and landscape shots. His many subjects include waterfowl, birds of prey (especially bald eagles) and mammals such as the grizzly bear, moose, caribou, bison and fox. Habitat scenes span the tundra, prairie, marsh, desert and mountains. His specialties include ten years' work on the endangered whooping crane—its migration, habitat and mating rituals—and the sandhill crane "foster parent" program. *Audubon, National Geographic, Smithsonian, National Wildlife, GEO, Natural History* and Time-Life Books are among his publications, in addition to advertising work for U.S. Postal Service Express Mail. He has also worked as a cinematographer and film editor, co-directing the 1984 *National Geographic* television special "Flight of the Whooping Crane," which was nominated for an Emmy award.

MANNA, LOU (Portraiture, Corporate/Industrial)
20 E. 30th St., New York, NY 10016

Born: 1954 *Subject Matter:* People *Situations:* Studio *Awards:* IABC Awards for Excellence *Education:* SUNY, Stony Brook

He approaches his photographic images as an artist and technician who can understand, interpret and illuminate the beauty as well as the reality of a chosen moment. Through frequent assignments for the *New York Times*, national magazines, corporations and advertising and public relations agencies, he has had the opportunity to diversify his technique. He has photographed a wide range of subjects from world leaders and television personalities to gourmet chefs, such as Craig Claiborne. While he feels it is important to understand a client's goal and to work with the client to produce a "selling" photograph, he also strives to produce photographs which will touch people and convey a message.

MANNING, ED (Photo Transformation, Advertising)
972 E. Broadway, Stratford, CT 06497
(203) 375-3384

Born: 1920 *Situations:* Studio *Education:* U. of Chicago; Columbia U.

In 1972 he invented an optical processor that allows for "photo transformation," a process whereby images are spatially "quantized." Once quantized, images can be separated into blocks of color, from which new, related images can be generated. Today, he is incorporated as "Blocpix" and spends most of his time producing work for advertising, although occasionally he uses the technology for wall murals, either painted or constructed of colored tile. A small group of eminent scientists also consistently uses Blocpix for experimental work on brain processes involving perception and recognition. He continues to modify the technology and instrumentation, and as far as he knows, it is unique.

MANOS, CONSTANTINE (Corporate/Industrial, Editorial)
Magnum Photos, Inc., 72 Spring St., New York, NY 10012 (212) 966-9200

Born: 1934 *Subject Matter:* People *Situations:* U.S. Locations *Education:* U. of South Carolina

He began his professional life at the age of fifteen, covering the early civil rights efforts of Martin Luther King Jr. At age nineteen, he became the official photographer of the Boston Symphony Orchestra at Tanglewood, a position which led to his first book, *Portrait of A Symphony*, in 1961. After college, he spent two years in the Army as staff photographer for *Stars and Stripes* and in 1964 joined the staff of Magnum Photos. In 1974 he was commissioned to produce 152 mural-sized photographs for Boston's Bicentennial Pavilion. He was recently commissioned to produce photographs of Athens for Time-Life's Great Cities series. His work has appeared in *Look, Life, Esquire* and *Sports Illustrated*, and his images are in the permanent collection of the Museum of Modern Art.

MAPPLETHORPE, ROBERT (Fine Art)

24 Bond St., New York, NY 10012 (212) 228-6849

Born: 1946 *Subject Matter:* People, Nature *Situations:* Studio, U.S. & Foreign Locations *Education:* Pratt Institute

Early work explored the human form, such as his photos of bodybuilder Lisa Lyon. Most recent work continued in this vein; however, recent photographs are more visually stylistic and subtler than many earlier images, which tended to be sexually explicit. A recent show at the Robert Miller Gallery in New York consisted of oversized, linen-soaked platinum prints of flowers, faces and torsos stretched on canvas. The images are often flanked by squares and rectangles in silk and velvet, creating a diptych and triptych effect and conveying a sense of tangibility. His studies of calla lilies framed in deep, black backgrounds reveal a continuous theme of "floating in a void." In addition to his traveling show, Mapplethorpe shot on location for *Traveler* magazine. His photographs have been the subject of numerous books. Public collections include the Metropolitan Museum of Art, Museum of Modern Art in New York and the Corcoran Gallery of Art. Mapplethorpe died while this volume was in production.

MARCUS, HELEN (Portraiture, Corporate/Industrial)

120 E. 75th St., New York, NY 10021 (212) 879-6903

Subject Matter: Food, People, Travel *Situations:* U.S. & Foreign Locations *Awards:* Cosmopolitan Club *Education:* Smith College

After many years as a television producer for such programs as *To Tell The Truth, What's My Line* and *Beat The Clock*, she became seriously interested in photography. Strongly influenced by Philippe Halsman, with whom she studied, she specializes in corporate portraiture, annual reports and food and travel worldwide. In addition, she has photographed many literary and film personalities. Editorial assignments have included *Vogue, Food & Wine* and *Forbes*. Portraits for such clients as International Paper Company, Western Union, New York Telephone Company and *Fortune* are characterized by strong, evocative lighting and a keen sensitivity for her subjects. Often presented with difficult assignments, such as shooting portraits of seventy executives in two days for American Express, she prefers the mobility of a handheld 35mm camera with an 85-105mm lens. Over the past several years, she has frequently lectured on executive portraiture and business practices in photography.

MARGOLIES, JOHN (Editorial, Photojournalism)

222 W. 72nd St., #3-A, New York, NY 10023 (212) 787-8180

Born: 1940 *Subject Matter:* Architecture, Resorts, Commercial Attractions *Situations:* U.S. Locations *Awards:* Guggenheim Fellowship; NEA Grant *Education:* U. of Pennsylvania

Over the last twelve years, he has made eight two-month-long trips, driving around the continental United States and photographing America's unique and prototypical examples of commercial attractions, roadside and Main Street architecture, and seaside and mountain resorts. He has published four books, including *The End of the Road: Vanishing Highway Architecture in America* and *Miniature Golf*. His work has been featured in the *Toronto Globe* and in *Smithsonian, Americana* and *USAir Magazine*. He uses a 35mm camera and shoots color photographs.

MARGOLIS, RICHARD (Fine Art)

113 Cypress St., Rochester, NY 14620

Born: 1943 *Subject Matter:* Landscape, Bridges *Situations:* U.S. & Foreign Locations *Awards:* CAPS Grant; Photography Grant, New York State Council for the Arts *Education:* U. of the Americas, Mexico City; Kent State U.; Rochester Institute of Technology

Margolis produces classical photographic landscapes of America and England. His earlier portfolio contained primarily darkly toned nocturnal images, while more recently he has been shooting day scenes, usually in straight black and white. His landscapes are serene and calm. He maintains a balance between cityscape images and country and garden photographs. Form and content are important concerns in his work.

MARK, MARY ELLEN (Photojournalism)

143 Prince, New York, NY 10012 (212) 982-8775

Born: 1946 *Subject Matter:* People *Situations:* U.S. Locations *Awards:* NEA Fellowship; New York State Council for the Arts; CAPS Grant *Education:* U. of Pennsylvania

She has been making social documentary photographs on specific themes since the mid-1960s. In the late 1960s she did a series of pictures on the drug problem in England. In the early 1970s she made several trips to Asia and photographed both Protestant and Catholic women in war torn Northern Ireland. She has traveled to India often and in 1978-1979 spent several months photographing a community of prostitutes in Bombay, a project which became a book entitled *Faulkland Road*. She has continued to pursue social themes around the world, and in 1986 she did three long photographic essays for the *London Sunday Times*, one on political upheaval in the Philippines, another on Hong Kong and a third on the extreme right wing in America.

MARKEL, BRAD (Portraiture, Corporate/Industrial)

485 Sundale Dr., York, PA 17402 (717) 757-2962

Born: 1953 *Subject Matter:* People, Wildlife, Feature Stories *Situations:* U.S. Locations, Studio

He started taking photographs after high school and worked for his college yearbook and newspaper. After

Robert Mapplethorpe, *Robert Sherman in Profile.* Courtesy: Robert Miller Gallery, NYC

graduation, he was a staff photographer for a small newspaper in Pennsylvania. He moved to Washington, D.C. and there freelanced for *Time*, *People*, *Fortune*, *Business Week* and other domestic and European publications. He specializes in photojournalism, editorial and location work, as well as portraiture. "Learning to work and think quickly without sacrificing quality is very important," he says. "You have to slow the process down while at the same time being very efficient. This I do well."

MARLOW, DAVID (Advertising)

111 Atlantic, Aspen, CO 81612 (303) 925-8894

Born: 1946 *Subject Matter:* Fashion, Food, Interiors, Celebrities *Situations:* Studio, U.S. Locations *Education:* U. of Colorado

Living in the mountains, and particularly in the Aspen community, has provided him numerous and varied opportunities. Shooting fashion, jewelry, homes and food keeps his darkroom busy. Recently he finished the first *Jill St. John Cookbook*, and he has been doing most of her photo work, as well as shooting for other celebrities, such as Robert Wagner, Jack Nicholson and John Denver. Most of his time is spent on domestic shots from California to Florida for a wide range of clients and magazines.

MAROON, FRED J. (Photojournalism, Corporate/Industrial)

2725 P St., N.W., Washington, DC 20007
(202) 337-0337

Born: 1924 *Subject Matter:* People, Travel, Fashions, Food, Architecture *Situations:* U.S. & Foreign Locations *Awards:* 1st Place, White House News Photographers Annual; Gold Medal, Art Directors Annual; Newhouse Citation *Education:* Catholic U.; Ecole Superieur Des Beaux Arts

His architectural studies did much to influence him personally and professionally as a photographer. In addition, early in his career he had the opportunity to work with a number of major art directors, including Frank Zachary at *Holiday* and Allan Hurlbust at *Look*. He photographs a wide variety of subjects—fashion, food, people, buildings, wildlife, travel—and has authored or co-authored eight books, with three more in the works. His book topics include the U.S. Navy, the White House, Washington, America and Egypt. He has published a book exploring the English Country House and has just completed, in his studio with world-famous chef Jean Louis Palladin, a food book due to be published in September, 1989. He recently served as visiting professor at Syracuse University, and the fourteen lectures he delivered there will be incorporated into a book on his life and photography as a freelance photographer. His work is characterized by its flawless technique, with portrait, fashion and food shots through his wide-angle lenses taking on a surrealist flavor.

MARQUEZ, TOBY (Portraiture, Corporate/Industrial)

1709 Wainwright Dr., Reston, VA 22090
(703) 471-4666

Born: 1936 *Subject Matter:* Fashion, Products *Situations:* Studio, U.S. & Foreign Locations *Awards:* Directors Guild of America Award; Cine Golden Eagle *Education:* U. of Southern California; Syracuse U.

As a photographer, film-maker and writer, his assignments have taken him to thirty-two countries in the Orient, Africa and Europe. He has filmed and directed such prominent individuals as Ronald Reagan, Alex Haley, Charlton Heston and Kirk Douglas. He received the Directors Guild of America Award for his film on the Chemehuevi Indians in California and was also awarded the Cine Golden Eagle Award for a documentary on the U.S. Navy in West Africa. He holds two master's degrees from the University of Southern California and is a graduate of Syracuse University's Photojournalism Program. He now heads Studio M Inc., a company specializing in the creative application of photography, film and video in corporate communications.

MARTEL, DANNA (Advertising)

Camera Hawaii Inc., 875 Waimanu, Room 110, Honolulu, HI 96813 (808) 536-2302

Born: 1960 *Subject Matter:* Food, People, Products, Still Life *Situations:* Studio

She is a versatile young photographer who shoots many different subjects and is adept in all formats. She began her career by working in the black-and-white lab of the Camera Hawaii studio, eventually becoming an assistant there and learning how to use photography to enhance advertisement. After four years, she became a staff photographer. She now works closely with such clients as advertising agencies and jewelry manufacturers. Her images have appeared in annual reports and on packaging, calendars and greeting cards. Her hobby is sports photography. "The variety is stimulating," she says of her many interests.

MARTEN, BETHANY (Corporate/Industrial, Editorial)

514 Merrick Rd., Baldwin, NY 11510 (516) 546-2776

Born: 1959 *Subject Matter:* People, Products *Situations:* Studio *Education:* Rochester Institute of Technology

She began her career photographing models on Long Island, then turned to public relations photography and volunteered her services to the Fire Island Lighthouse Preservation Society. This volunteer work led to her documentation of the Lighthouse Restoration Project. In 1987 she was exclusive photographer for a Long Island theatre group. Presently, she is concentrating on larger corporate accounts, and her work is published in American and Canadian trade magazines. Her images have appeared in the *New York Times* and *Newsday*.

MARTIN, CURTIS (Corporate/Industrial, Editorial)

P.O. Box 11132, San Francisco, CA 94101
(415) 864-5410

Born: 1949 *Subject Matter:* People, Sports, Travel, Nature *Situations:* U.S. Locations *Education:* U. of Colorado

Born and raised in rural Colorado, his insight into the people, land and history of the interior West may be seen in his 35mm location work, photographing "real people doing real things." With his images of cowboys, farmers, industrial workers, river rafters and other "salt-of-the-earth types," he seeks to express the spirit and determination of their passion for life. Originally an archaeologist, where he refined his skills as a scientific photographer, he now concentrates on advertising

and editorial work for corporate and industrial clients including Bechtel, AT&T, Pepsi Company and the San Francisco Chamber of Commerce.

MARVY, JIM (Advertising)
41 12th Ave., N., Hopkins, MN 55343 (612) 935-0307

Born: 1945 *Subject Matter:* Food, Vehicles *Situations:* Studio

He is a self-taught, self-employed photographer whose studio is located outside of Minneapolis. Since 1970, he has worked in the advertising field, making images for such national companies as General Mills, Miller Brewing, Apple Computer, Honeywell, 3M, Winnebago, Kimberly Clark, Hormel and Harley Davidson. His photography has appeared in *Advertising Age, Time, Sports Illustrated, Redbook* and *Architectural Digest*, and his work has been displayed at Epcot Center's Kodak Pavilion and been featured in Kodak's "Visions in View" program.

MARX, RICHARD (Advertising)
8 W. 19th St., New York, NY 10011 (212) 929-8880

Subject Matter: People, Products *Situations:* Studio *Awards:* 1st Place in Art Direction and Creativity, New Jersey Advertising Club

Influenced by Alan and Diane Arbus, whom he assisted for three and a half years, he takes pride in lighting people and products and in having the experience to handle difficult assignments. He is now a commercial photographer, shooting still lifes and illustrations for such clients as Goodyear, Longines Watches, Pepsi, Harry Winston, Sony, 20th Century Fox and many others. He has produced and directed films and videos for television and industry and recently received awards for his still photography.

MASAMORI, RONALD S. (Advertising, Corporate/Industrial)
5051 Garrison St., Wheatridge, CO 80033
(303) 423-8120

Born: 1953 *Subject Matter:* Fashion, Sports *Situations:* U.S. Locations *Awards: Communication Arts* Award of Excellence *Education:* Metro State College; U. of Denver

For the first seven years as a professional photographer, he worked at KRMA-TV in Denver and as a freelancer. In 1984 and 1986, he received recognition for his work in the field of communication arts and was exhibited in the Denver Art Museum. He spends the majority of his time in the advertising and corporate communications areas, recently producing a weekly calendar for a U.S. West subsidiary. Keeping his photographs to their graphic elements, he lets his subject dictate his shots; if a subject is in action, he likes to make it move within the still frame. One such shot captures a skate boarder in mid-air. Other pictures feature elements of American life not often seen together—for instance, the picture of an apple pie and television set in a hotel room.

MASSAR, IVAN (Photojournalism, Corporate/Industrial)
296 Bedford St., Concord, MA 01742 (617) 369-4090

Born: 1924 *Subject Matter:* Nature, Travel *Situations:* U.S. & Foreign Locations *Education:* Art Center College of Design; Acadamie André Lhôte, Paris

He is best known for his nature photography and for the industrial photographs he has taken for *Fortune* magazine. He worked with Roy Stryker on his three-year-long project documenting the Pittsburgh steel industry, and he has been associated with the Black Star Agency for more than twenty-five years. His photojournalistic work has appeared in *Life, Look, Paris Match* and other journals. His two books are *The Illustrated World of Henry David Thoreau* (Grosset & Dunlop) and *Take Up The Song—Photographs by Ivan Massar, Poetry of Edna St. Vincent Millay* (Harper & Row).

MASSIE, KIM (Photojournalism, Corporate/Industrial)
Route 1, Box 165A, Accord, NY 12404

Born: 1930 *Subject Matter:* Sports, Travel *Situations:* U.S. Locations, Aerial *Education:* Yale U.

Combining his interests in people, nature, sports and travel, he began his photography career shooting skiing, mountaineering and sailing for *Sports Illustrated*. During this time he studied with many photographers, including Alexey Brodovitch, Berenice Abbott and Gordon Parks. His work has expanded to include corporate/industrial clients. Whenever possible, he is involved in environmental projects, one in particular aimed toward a U.S.-Soviet exchange.

MASUNAGA, RYUZO (Advertising)
57 W. 19th St., # 2D, New York, NY 10011
(212) 807-7012

Born: 1946 *Subject Matter:* Products, Still Life *Situations:* Studio *Education:* Tama Art U., Tokyo; Academy of Art, San Francisco

High technical standards and a strong graphic sensibility characterize his work. The son of a Kimono maker, he was born in Kyoto, Japan, and from the age of five, he attended art school and studied painting and sculpture. At twenty-five, he moved to the United States to study photography in San Francisco at the Academy of Art, moving to New York upon his graduation. His background in art is apparent in his photography. Working in large format, he creates space and color similar to that in a painting. His images are simple and unobstructed by unnecessary props; the subjects are focused and elegant. Among his clients are Canon, Zenith, GE, Sony, Macy's and Bloomingdales.

MATHENY, R. NORMAN (Photojournalism)
1 Norway St., Mail Stop P-214, Boston, MA 02115
(617) 450-2343

Born: 1935 *Subject Matter:* Animals, Nature, People, Travel *Situations:* U.S. & Foreign Locations *Education:* Pacific U.; Syracuse U.

He is a lover of humanity who, for more than two decades, has been a staff photographer for the *Christian Science Monitor*. His liberal education and diverse employment record have prepared him to deal with the wide variety of subjects he has encountered. He has covered the White House, Congress and events in Washington, making two or three overseas trips as well each year. He is confident on assignment and relishes working in the Middle East, Africa and the socialist countries. He has had formal studies in Russian, German and Spanish and speaks enough of several related languages to get by without an interpreter.

MATHER, JAY B. (Photojournalism, Editorial)
2759 Knollwood Dr., Cameron Park, CA 95682
(916) 677-7944

Born: 1946 *Subject Matter:* People, Sports *Situations:* U.S. Locations *Awards:* Pulitzer Prize for International Reporting; Robert F. Kennedy Award for Distinguished Photoreporting of Problems of the Disadvantaged *Education:* U. of Colorado

He has been involved with socially conscious photojournalism since serving as a Peace Corps volunteer in the late 1970s. His work has ranged from the routine to the exotic and from his own backyard to the other side of the world. He documented the demise of the Amtrak Floridian, the pain and suffering of cancer, the inhumanity of man against man in Cambodia, and the destitution of the hungry and homeless in America. In a 1983 one-man show at the Center for Creative Photography in Tucson, he displayed photographs of Cambodian refugees and of Mother Teresa's Missionaries of Charity in the South Bronx. In 1987, he received the World Hunger Award for his photographs of hunger in California.

MATTHEWS, CYNTHIA (Editorial, Photojournalism)
200 E. 78th St., New York, NY 10021

Born: 1942 *Subject Matter:* People, Sports *Situations:* U.S. & Foreign Locations *Education:* U. of Arizona

She specializes in developing feature stories in which she evokes a mood, a sense of place and an emotional chemistry in scene. Much of her current work is for *Town & Country.* These assignments normally involve various sporting events or sports-related subjects around the world—from attending England's elegant Royal Ascot races and the World Carriage Driving Championships in Hungary to tramping through rough bird-dog trails in the American South. In addition, she has produced stories for many other magazines including *GEO, Forbes, Time, Newsweek* and *New York,* as well as corporate assignments for industry and business.

MAUSKOPF, NORMAN (Corporate/ Industrial, Portraiture)
615 W. California Blvd., Pasadena, CA 91105
(818) 578-1878

Born: 1949 *Subject Matter:* People, Still Life *Situations:* U.S. Locations *Education:* Art Center College of Design

His first book, *Rodeo: Photographs by Norman Mauskopf,* documents the life of the American rodeo cowboy. The book won an award for book design from the Art Directors Club of Los Angeles. A second book is a study of thoroughbred racing at various racetracks in the U.S. and Europe. When he is not working on a book, he is out shooting for a variety of clients on assignments ranging from corporate reports to architecture and still life. His work has been exhibited in group and one-man shows, and for the past six years he has taught photography at the Art Center College of Design in Pasadena.

MAYES, ELAINE (Fine Art)
18 Mercer St., New York, NY 10013 (212) 431-8016

Born: 1938 *Subject Matter:* People, Travel, Wildlife, Nature, Animals, Street Life *Situations:* U.S. Locations *Awards:* NEA Grant *Education:* Stanford U.

After seven years as a commercial photographer in San Francisco, she began teaching photography in order to free herself from the restrictions of commercialism. In the late 1960s she moved to the Northeast

and over the last twenty years has made photography her vehicle for discovering and representing aspects of her immediate surroundings. Through landscape, street photography, portraiture, close-ups, conceptual ideas, social situations and images in series, she has continually investigated issues of documentation, aesthetic potentials, perception, content and the medium itself.

MEAD, ROBERT (Corporate/Industrial, Portraiture)
711 Hillgrove, La Grange, IL 60525 (312) 354-8300

Born: 1953 *Subject Matter:* People, Products *Situations:* Studio, U.S. Locations

After making photographs in a portrait studio for four years, he began to freelance for corporate and industrial clients. He capitalized on his background in portraiture by opening "Photo Pros," a studio in suburban Chicago that specializes in executive portraits and office and industrial-plant situations. His work includes annual reports, corporate image brochures, product service brochures, trade magazines and stills for audio-visual productions.

MEARS, JIM (Advertising)
1471 Elliott Ave., W., Seattle, WA 98119
(206) 284-0929

Born: 1950 *Subject Matter:* Food, Products *Situations:* Studio, U.S. Locations *Education:* Seattle Central College

After leaving school, he assisted Bruce Harlow, a food photographer, for three years, gaining experience in studio lighting and still-life composition. He later opened his own studio specializing in food and product illustration. Known for his dramatic use of light, he has been influenced by cinematic lighting effects, especially those of film noir. On location, he likes to use natural light if it is available. Light and its response to different surfaces has interested him throughout his career. He often finds similarities in seemingly disparate images, and although most of his work is taken on table tops, he has also built some elaborate sets for his work.

MEIER, RAYMOND (Editorial, Advertising)
532 Broadway, New York, NY 10013
(212) 219-0120; (212) 807-6286; Michael Ash, Agent

Born: 1957 *Subject Matter:* Still Life *Situations:* Studio *Awards:* Still Life Photographer of the Year; New Faces 1989, *American Photographer;* 1st Prize, Self-Promo, Photo District News *Education:* Kunstgewerbe Schule, Zurich

In school he was interested in the precision required in photochemistry, and this same interest in precision and control is evident in his still-life photography. Apprenticing as a commercial photographer in Switzerland and at one time shooting corporate as well as fashion photography, he came to the United States in 1986 to work in New York and devote himself to still life, a genre that would allow him optimal control over his images. He produces editorial work for such magazines as *GQ, Esquire, Self, Harper's Bazaar* and *Rolling Stone* and advertising work for such clients as Columbia Coffee, Tiffany, GTE, Mercedes Benz and Estee Lauder. He uses a variety of lighting techniques, from flashlight to 35mm-film-projector light, to achieve his unusually highly textured, simple, graphic and conceptually imaginative images in which mundane objects are newly seen.

MEJUTO, JAMES (Advertising, Editorial)
62 Stone Ave., Ossining, NY 10562 (914) 762-3751

Born: 1937 *Subject Matter:* People, Animals *Situations:* U.S. Locations, Studio

He began his career as a local photographer, covering weddings and proms and placing an occasional photo in the town newspaper. Soon he branched out into advertising and editorial photography, eventually finding his niche as a freelance stock photographer. Photographing for textbooks and magazines, he likes to shoot the insignificant, often overlooked things that touch people in their daily lives. One such photo essay is of a cartoon museum, with close up pictures of a porcelain figure of Betty Boop and other cartoon heroes and heroines. Among his clients are Fly Inc., Phelps Hospital and IBM.

MELGAR, FABIAN (Advertising)
14 Clover Dr., Smithtown, NY 11787 (516) 543-7561

Born: 1932 *Subject Matter:* People, Products *Situations:* Studio *Awards:* Gold Award, New York Advertising Directors Club; Clio; Andy

He began his career as a comic book artist in 1952, then spent four years as an artist in the Air Force and became an advertising illustrator on his discharge. He worked as an art director for numerous advertising agencies and in 1967 opened his own design studio. In 1969 he became a partner in an advertising agency, a position which, however, he left two years later to re-open his studio. He had been doing photography throughout his career and, with the reopening of his studio, let it become a larger part of his work. Although he still periodically dabbles in advertising, he has returned to the design/photography business. His work has appeared in the *New York Times Magazine*, in many ads and on numerous packages.

MELILLO, NICHOLAS (Advertising, Portraiture)
118 W. 27th St., New York, NY 10001

Born: 1952 *Subject Matter:* People *Situations:* U.S. & Foreign Locations, Studio *Education:* Syracuse U.; Fashion Institute of Technology

Commenting on his progress, he points to his biggest failures as his greatest moments, as those were the times he was called upon to persist and succeed. He studied with a variety of accomplished commercial and fine-art photographers for two years in New York City, and he now works primarily in commercial advertising. His recent personal project, "People and Their Favorite Things," consists of a group of portraits revealing how "even the toughest of individuals care for their favorite possessions in a childlike manner."

MELLON, TYTELL (Portraiture, Editorial)
69 Perry St., New York, NY 10014 (212) 242-3472

Subject Matter: Fashion, Nudes, Portraiture *Situations:* Foreign Locations, Studio *Education:* New School for Social Research

Since working as Ralph Lauren's first photographer in 1971, she has shot for Givenchy, Christian Dior and Manhattan Industries. But fashion is just a part of what she does currently. She has photographed such celebrities as James Taylor, Linda Hunt and Christian LaCroix, as well as Beat writers Ken Kesey and William Burroughs. She often works in Paris and has been exhibited widely in Europe. Her nudes, mostly male, concentrate on the animal and spiritual sides of human nature, depicting intense emotion and movement. She also specializes in exotic subject matter, such as Haitian voodoo ceremonies and opium dens in the Golden Triangle. In the United States, she covered the Dalai Lama's stay in New York.

MELTZER, STEVE (Corporate/Industrial, Photojournalism)
1617 Taylor Ave., Seattle, WA 98109 (206) 284-5822

Born: 1945 *Subject Matter:* People, Travel, Crafts *Situations:* U.S. & Foreign Locations, Studio *Awards:* Silver & Gold PRSA; IABC *Education:* City College of New York

After studying with Cornell Capa, Duane Michals, Judy Dater and Oliver Gagliani, he began a career as a photographer and founded West Stock, the largest stock agency in the Northwest. He works in the fields of corporate and public relations photography, specializing in travel. During his journeys he conducts instructional workshops on the photography of art and craft objects, as well as publishing a monthly crafts photography column in *Crafts Report*. His book *Photographing Your Craftwork* recently went into its second printing. His travel articles and photographic essays, including one on marketplaces around the world, have appeared in such publications as *U.S. News & World Report*, *National History* and *Newsweek*.

MENASHE, ABRAHAM (Advertising, Photojournalism)
306 E. 5th St., New York, NY 10003 (212) 254-2754

Born: 1951 *Subject Matter:* People, Health *Situations:* U.S. Locations *Awards:* Carl Allison Evans Award; One to One Media Award

"I make photographs that celebrate and affirm life," he says. "You might call it 'photography as theology.'" Whether the subject be our natural resources, the ordeal of the unfortunate, or an individual in pursuit of excellence, he portrays it in its "best light," and for this, art directors and magazine and annual report editors call on him to handle assignments that require an emphasis on human achievement. The bulk of his work comes from social and health service agencies, as well as national advertisements for agencies such as the Salvation Army and the United Way. He is the author of two books published by Knopf: *Inner Grace*, a book about multiple-handicapped Americans; and *The Face of Prayer*, a book of images from around the world on the nature of reverence. His photographs are in several museum collections, including the Metropolitan Museum of Art in New York.

MENDEZ, ROLF (Advertising, Corporate/Industrial)
11820 Larrylyn Dr., Whittier, CA 90604
(213) 943-1622

Born: 1948 *Subject Matter:* Nature, People *Situations:* Studio, U.S. & Foreign Locations *Education:* UCLA

A lover of landscape photography, he began taking stills at age six and still prefers landscape to people. A student of Ansel Adams, he specializes in capturing both clarity and brilliance, and although he is capable of many kinds of camera work, including film and video, he considers his western landscapes and seascapes done on corporate assignments to be his best. His portfolio also includes medium- and large-format still work for advertising. A member of International

Photographers of the Motion Picture and Television Industries, he operates both film and video cameras and also engineers the audio mix. Credits include work on feature films "Star Trek III," "Rocky III" and "Altered States," on the television series "Hart to Hart," "The Love Boat" and "Starsky and Hutch," and on various other commercials and pilots.

MENSCHENFREUND, JOAN (Portraiture, Editorial)
168 W. 86th St., New York, NY 10024
(212) 362-8234

Born: 1941 *Subject Matter:* People, Travel *Situations:* Studio *Education:* SUNY, Buffalo

With his background in painting and graphics, his photography tends toward the psychological and surreal. He uses paintings and collage techniques to manipulate images, often working for such publishing houses as Random House, Clarion Press, John Wiley and E.P. Dutton. He frequently acts as both designer and photo-illustrator. He also does straight photography and is active in the stock marketplace with people and travel photos. His work has appeared in magazines, filmstrips, corporate brochures and trade and educational books. He is a member of the ASMP and a board member and past Vice President of the ASPP.

MEOLI, RICK M. (Advertising, Corporate/Industrial)
710 N. Tucker, Suite 306, St. Louis, MO 63101
(314) 231-6038

Born: 1951 *Subject Matter:* Fashion, Food *Situations:* Studio, U.S. Locations

Commercial corporate assignments evolved into food and fashion photography for this member of the St. Louis photo community. Catering to clients such as Anheuser-Busch, Pet, Ralston Purina and Monsanto in his expansive, well-lit studio, his photographs have been featured in national publications, billboards, television and national ads.

MERCER, RALPH (Corporate/Industrial)
451 D. St., Boston, MA 02210 (617) 951-4604

Born: 1947 *Education:* Rhode Island School of Design

He works illustratively with products and still lifes, demonstrating his ideas through the use of special effects and surrealistic imagery and lighting. The artistic influence of Dada and Surrealism has carried over into his commercial work and is communicated particularly through the use of improbable colors, perspective effects and floating objects. Other conceptual and visual influences, including Magritte, reflect his background in fine art. His images have been used editorially, in advertising and corporate publications.

MERKEL, DAN (Advertising, Editorial)
Box 722, Carpenteria, CA 93013 (805) 648-6448

Born: 1946 *Subject Matter:* Sports, Landscape, Travel *Situations:* U.S. & Foreign Locations, Underwater, Aerial, Hazardous *Awards:* Emmy, Television Academy of Arts and Sciences

He is an accomplished action/water photographer, working in both still photography and film since 1968. He works strictly on aquatic locations, from Bali to Indonesia and Japan. His pictures have appeared in water sports magazines here and in Japan, and his film work has appeared in numerous television commer-

cials and feature films and on ESPN. He has developed many items of special equipment for his work, including fiberglass housings for cameras, waterproof leadwires and radio-controlled equipment that can be mounted on surfboards and ships' masts. He has also done a wide variety of action and aerial photography, such as hang gliding, gliding, kayaking, river rafting and motorcycling. Recently, he has been expanding into scenic landscape photography. He has a stock library of many action and sports shots.

MERTIN, ROGER (Fine Art)
18 Upton Park, Rochester, NY 14607

Born: 1942 *Subject Matter:* People, Landscape, Street Scenes *Situations:* U.S. Locations *Awards:* CAPS Fellowship; NEA Photography Fellowship *Education:* Rochester Institute of Technology; Visual Studies Workshop, Rochester, NY

His work has ranged from medium- to large-scale formats, including a series on such subjects as trees and basketball courts. He says his work reflects an appreciation of beauty on the one hand and of American culture on the other. Mertin has produced images of human figures in which the figure is of minor consequence, as in "Plastic Love Dream," his 1969 series of plastic-wrapped figures who seem less significant than the plastic.

MEYER, JON (Photojournalism, Scientific)
2808 N. Glade St., N.W., Washington, DC 20016
(202) 363-1547

Born: 1956 *Subject Matter:* People, Medical, Scientific *Situations:* U.S. Locations *Education:* Rochester Institute of Technology

After working at three midwestern newspapers and freelancing at several others, he studied scientific photography at the Rochester Institute of Technology. He documented medical and scientific findings at the Universities of Illinois and Texas before organizing his studio in Washington D.C. There he combines detailed recording techniques with innovative lighting to make images of high-tech computers, which technology companies use in their dealings with federal purchasing agents. Other specializations include Capitol Hill news, editorial photography, architectural photography and environmental portraiture. His photographs have appeared in the *Washington Post*, *Medical World News* and *Extraordinary Properties Magazine*.

MEYEROWITZ, JOEL (Photojournalism, Fine Art)
817 West End Avenue, New York, NY 10025

Born: 1938 *Subject Matter:* People *Situations:* Studio, U.S. Locations *Awards:* Guggenheim Fellowship; NEA Fellowship

Early work as an art director and designer sparked his interest in photography. Seeking out scenes from urban and rural life, he instantly captures the spectacle of human activity. Early black-and-white work, which depicted social situations from the vantage point of a moving car, explored coincidental occurrences, and this theme continues to be his trademark. His aim is not social commentary; instead he asks the viewer to explore a way of seeing. Asymmetrical images display contrasts between color, light and shadow, space and activity. He often employs flash to create sharp profiles, deep shadows and glaring surfaces, providing

Dan Merkel

Ian Miles

information that the observer would normally not notice. Recently, his style has shifted to include large-format, highly detailed landscapes of Cape Cod in the manner of Walker Evans.

MEZEY, PHIZ (Photojournalism, Portraiture)
209 Upper Terrace, San Francisco, CA 94117 (415) 564-

Born: 1925 *Subject Matter:* People, Events *Situations:* U.S. Locations *Awards:* Fine Arts Award, San Francisco Art Commission

A professor in the Educational Technology Department at San Francisco State University, she teaches courses in photography and multi-image production. She considers herself a documentary/historical photographer and for more than thirty years has been specializing in on-site assignments, annual reports and informal portraiture. Her spontaneous portrait and location work has been exhibited in fine-art museums and galleries, and her photographs have been published extensively in a number of local magazines. Her expertise in film design and production and in location photography has provided for the publication of three books, *Multi-Image Design and Production, Our San Francisco* and *Something That's Happening.*

MICHALS, DUANE (Fine Art)
c/o Sidney Janis Gallery, 110 W. 57th St., New York, NY 10019

Born: 1932 *Subject Matter:* People *Situations:* U.S. Locations, Studio, Special Effects *Awards:* CAPS Award *Education:* Parsons School of Design, New York; U. of Denver

Michals is best known for his sequences of black-and-white photographs depicting death, spiritual transcendence and dreamlike states. He is attempting to induce thoughts about the role of photography in art, maintaining that reality cannot be portrayed in art. A series of photographs showing common public places, i.e. hallways, coffee shops, buses, laundromats, etc., does not include people. He titled this project "Empty New York." His influences include Zen Buddhism and surrealist painters such as René Magritte and Giorgio de Chirico. With the use of multiple exposure portraits and other images, he sometimes creates bizarre sequences of prints, often pursuing fantasies dealing with sexuality, perversion, homosexuality, death, masturbation and violence. These events are recorded in a documentary fashion. He uses natural lighting, blurring and superimposition to create supernatural visual effects. He began adding small captions to his pictures in 1971 to provide narrative elements. As an extension of this, more recent work includes painting directly on the print. His images have appeared in magazines such as *Esquire, Horizon, Mademoiselle* and *Vogue.*

MILES, IAN (Advertising, Editorial)
313 E. 61st St., New York, NY 10021 (212) 688-1360

Born: 1949 *Subject Matter* Fashion, People *Situations* Studio, U.S. Locations *Awards:* International Gold Award *Education:* Washington U.

He began his career as a press photographer in the Midwest, subsequently moving on to underwater and aerial assignments. Shortly after arriving in New York, he opened his own studio, concentrating on fashion and beauty. Although known for close-up, direct and often symmetrical images, his emphasis is on the eyes of his models. Shooting between a gap in reflective flats gives the eyes a cat-like, hypnotic quality. His career has been the subject of numerous magazine articles, and his work has been featured in several books. His long list of clients includes Avon, Bill Blass, American Express, CBS, Yves St. Laurent and Sears. A recent project, "The World's Most Beautiful Faces," has been exhibited nationally and internationally.

MILES, KENT (Editorial, Photojournalism)
465 9th Ave., Salt Lake City, UT 84103
(801) 364-5755

Born: 1950 *Subject Matter:* People, Social Documentaries *Situations:* U.S. & Foreign Locations *Awards:* Gold Medal, Chicago Film Festival; Silver Medal, New York Film Festival *Education:* U. of Utah; Art Center College of Design

"In the nearly twenty years I've been seriously pursuing photography as a means of communication and self-expression," he says, "it has become more than just 'what I do.' It is more a matter of 'what I am.'" Listing Richard Avedon, Henri Cartier-Bresson, Ernst Haas, Arnold Newman, Irving Penn and Eugene Smith as his influences, he continues in their path, seeking to allow the individuality of the subject to dominate each photograph, instead of imposing his own ego upon the work. He endeavors to create images that will last through the years, avoiding fads. He produces photography for a wide spectrum of clients in the corporate/industrial, entertainment and editorial fields, including assignments for brochures, advertisements, book covers, magazines and newspapers.

MILLARD, HOWARD (Advertising, Portraiture, Travel)
220 6th Ave., Pelham, NY 10803 (914) 738-3689

Subject Matter: Travel, Nature *Situations:* Studio, U.S. & Foreign Locations *Awards:* Phi Beta Kappa *Education:* Michigan State U.

He likes to travel and work with people, especially on location. His computerized, 50,000-image color file includes images of art deco architecture in Miami Beach, grazing bison in Yellowstone, cheese-making in Finland and white-water rafting in Costa Rica. His photographs of travel, people and landscapes have been published internationally for such editorial and advertising clients as *Travel and Leisure, Signature, Diversion, GEO,* Scali, McCabe, Hertz, Harper and Row, Ogilvy & Mather and Harcourt Brace Jovanovich. His assignments can range from Rio's Carnival and fireworks in France to marketplaces in Mexico.

MILLER, BUCK (Advertising, Photojournalism)
P.O. Box 33, Milwaukee, WI 53201 (414) 672-9444

Born: 1937 *Subject Matter:* Portraiture, Sports, Nature *Situations:* U.S. & Foreign Locations *Awards:* NPPA; Addy *Education:* Southern Illinois U.

He began his career as a newspaper photographer for the *Milwaukee Journal* in 1964. One of his photo essays, in which he contrasted the rural and urban elderly, was nominated for a Pulitzer Prize. Since 1977, he has worked for a variety of advertisers and corporations, and his photographs have been featured in *Time, Fortune, Life* and *Newsweek.* He specializes in 35mm portraiture on location. He has worked on a location project for the Royal New Zealand Photography Society and covered sporting events such as the In-

Karen Kuehn

Karen Kuehn

Eric Lawton, *Macchapuchare, Nepal*

Lowell Handler

Frank Lerner, *Fashion.* Client: New York Furs

Frank Lerner, *Fine Jewelry Catalog.* Client: Goodman & Sons

Frank Lerner, *MRI Brochures.* Client: Technicare

Steven Lewis, *Nicholas B. Clark, Art Historian*

Dan Merkel

Donna Balkan Litowitz, *Alexandra's Flamingo.* Courtesy: Virginia Miller Galleries, Coral Gables, Florida

Lynn McLaren, *Haitan Doorway*

Lou Manna

Fred J. Maroon, *Overfly at Dawn*

Robert McQuilkin

Jane Lidz, *Wateridge*

Ian Miles

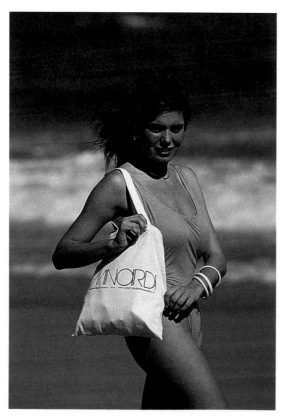

Michael Minardi, *Perfection in Photography*

Buck Miller, *Fishing Nets*

Jean Mogerly, *Chung King*

Dianora Niccolini, *Mona Lisa Recycled*

Claus Mroczynski, *Tibetan Woman*

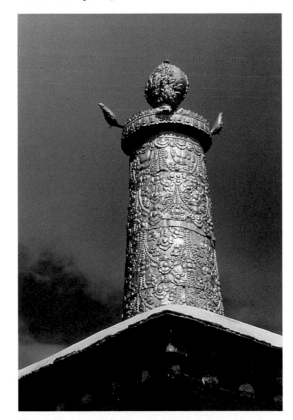

Claus Mroczynski, *Part of a Temple near Lhasa, Tibet*

Claus Mroczynski, *Temple in Lhasa, Tibet*

Claus Mroczynski, *Tibetan Children*

Sheryl Noday, *Suprise*

Helen Norman

Morgan Rockhill, Client: Samaritans Suicide Prevention

Jan Oswald, *Bright Shadows III*

Eric Oxendorf, State Capitol Dome, Texas

white and color photographs have been of himself, nude, in outdoor settings, often in or near lakes, rivers, snow, or other natural landscapes. The poses are contrived, conveying a certain magical or dramatic quality, as in *Beach Pond, Connecticut*, in which his naked legs, huge and cropped at the top of the picture, appear to walk on water. Strongly personal, the images are evocative of many emotions, sometimes humorous or surreal. "None of my self-portraits are multiple images," he says. "But if they appear to have that quality, that's when, to me, they're most successful."

MISHLER, CLARK (Corporate/Industrial, Editorial)

1238 G St., Anchorage, AK 99501 (907) 279-8847

Born: 1948 *Subject Matter:* People, Travel *Situations:* Aerial, U.S. Locations *Awards:* Award of Excellence, *California Magazine Education:* Art Center College of Design

He was a design student at the Art Center in Los Angeles, where he took a beginning photography class; four years later he won the "Most Improved Photographer" award while attending the Missouri Photo Workshop. As a result of his work in the workshop, he was offered a job with *National Geographic*, and four months later he went to work in Washington as their layout editor. He returned two years later to his home state of Alaska, where he has worked as a freelance photographer for the past ten years. Specializing in photographing people and their environments for advertising and corporate clients, as well as in editorial photo essays, his work has appeared in over fifty magazines, including *GEO, Outside* and *Alaska Magazine*.

MITCHELL, JACK (Portraiture)

356 E. 74th St., New York, NY 10021 (212) 737-8984

Born: 1925 *Subject Matter:* People *Situations:* Studio, U.S. & Foreign Locations

He makes honest and direct images of people in the creative and performing arts. Since the late 1960s, his images of theater and film stars, dancers, musicians and painters have appeared regularly in the Arts and Leisure Section of the *New York Times*. His photographs of dancers have graced the cover of *Dance Magazine* more than one hundred times. His most widely disseminated image is a photo of John Lennon and Yoko Ono that appeared on the cover of the *People* Lennon Memorial issue. His work is in the permanent collections of the International Center of Photography and the Albright-Knox Gallery.

MITCHELL, MIKE (Corporate/Industrial, Entertainment)

1512 Clayton Ave., Nashville, TN 37212 (615) 333-1008

Born: 1953 *Subject Matter:* People *Situations:* U.S. Locations, Studio *Education:* Brooks Institute of Photography

Receiving his initial training in photography while serving for the United State Navy, he went on to study at the Brooks Institute where, he says, he was stubborn enough to obtain a degree in Illustrative Photography. When he returned home to Nashville in early 1981, he began at one of the larger commercial studios. He has since had the opportunity to concentrate on portraiture, dividing his camera work between corporate personnel and people in the music business. His work has

been used in a variety of media, from corporate brochures to album covers, magazines to audio-visual presentations. He is known for his clean, minimal compositions.

MITZIT, BRUCE (Advertising, Corporate/Industrial)

1205 W. Sherwin, Chicago, IL 60626 (312) 508-1937

Born: 1946 *Subject Matter:* Nature, Architecture *Situations:* U.S. Locations *Education:* School of the Art Institute of Chicago

He is able to bring a delicacy of form and subtle qualities of light to architectural masses. He uses monochromatic lighting to achieve a level of detail that remains even on microscopic examination. After graduating from art school in 1975, he honed his skill and expertise in color working in color labs in Chicago. In 1980, he began his professional career by illustrating a brochure for the 35 E. Wacker building. In 1982 he opened his own studio, The Architectural Photograph. With a recent trip to the American West, he has expanded his work into landscape photography. His pictures are in numerous private collections and have hung at the Art Institute of Chicago.

MIZONO, ROBERT (Advertising, Corporate/Industrial)

14 Otis St., San Francisco, CA 94103 (415) 558-8663

Born: 1950 *Subject Matter:* Portraiture, Still Life, Products *Situations:* U.S. Locations, Studio *Awards:* Clio; New York Art Directors Club Award *Education:* U. of California, Berkeley

Moving to New York in the late 1970s to work as a photography assistant to Michael O'Neill was the first step in his photography career. After spending two years there, he returned to San Francisco to open his own studio, shooting still lifes. His personal work had always concentrated on portraiture, and he thus expanded his commercial work to include advertising portraits for clients such as Levi-Strauss. He then began shooting automotive photography, and today his list of clients has expanded to include British Sterling Automobiles as well as California Cooler, Avia Shoes and Pacific Bell. Magazine publications include *Time, Life, Newsweek* and *Health*.

MOGERLY, JEAN (Photojournalism)

1262 Pines Lake Dr., W., Wayne, NJ 07470 (201) 839-2355

Subject Matter: People *Situations:* Foreign Locations *Education:* Pratt Institute

For the past five years, she has traveled extensively in China, especially in Yunnan Province, near Burma, and also in Tibet and in Xinjiang Province, near the Soviet border. She documents the culture, religion, dress and society of the country's many ethnic minorities. She shoots with a variety of lenses and five different cameras, each loaded with either 200 ASA or 400 ASA film. Instead of bracketing her shots, she likes to take the same picture with three different cameras, often resulting in strikingly different pictures. The need for spontaneity and ease of movement precludes the use of lights, so she has become adept at taking the best possible picture with available light. She plans to finish three books and a documentary video, all of which will feature her work in China.

Buck Miller, *Don Nedobeck*

Michael Minardi, *Ultralight*

MONTEITH, JAMES RODERICK
(Portraiture, Corporate/Industrial)
RD 2, Box 132, Annuille, PA 17003 (717) 867-2135

Born: 1941 *Subject Matter:* People *Situations:* Studio *Awards:* Master Photographer and Photographic Craftsman, Professional Photographers of America, Inc. *Education:* Bucknell U.; U. of Pennsylvania

A lecturer, teacher and consultant to other professionals, he has authored three instructional manuals on photographic portraiture and the marketing of photographic portraiture. He also serves as director of Countryhouse Studios, a 7,000-square-foot studio, laboratory, and teaching facility, as well as Monteith Portrait Studio and Gallery, a portraiture business located in the restored city center of historic Lancaster, Pennsylvania. The gallery houses his personal collection of classically styled portraits, as well as his wife's photos. She is also a portrait photographer, and he collaborates with her on much of his work.

MONTES DE OCA, ARTHUR (Advertising, Corporate/Industrial)
4302 Melrose Ave., Los Angeles, CA 90029
(213) 665-5141

Born: 1949 *Subject Matter:* Food, People *Situations:* U.S. Locations, Hazardous *Awards:* ADLA *Education:* U. of California, Santa Barbara; Brooks Institute of Photography

In 1974 he graduated from Brooks Institute of Photography and immediately started working in Los Angeles. He opened his own 5,000-square-foot studio in 1978 with multiple shooting areas and a full kitchen for food preparation and shootings. His work consists mainly of advertising and corporate photography. Each year he shoots more than twenty annual reports nationwide for Fortune 500 clients, including AT&T, IBM, Exxon, Kraft, Playboy, Texas Instruments, Getty Oil, Rockwell and Xerox. He is known for his problem-solving skills and the capacity to bring a unique perspective to any assigned task. He considers his own forte to be his ability to put those in front of the camera, as well as those peripherally involved in the shoot, fully at ease.

MOORE, C. RAY (Fine Art, Nature, Photojournalism)
P.O. Box 1251, Nevada City, CA 95959
(916) 346-8709

Born: 1938 *Subject Matter:* Architecture, Nature, People, Fine Art *Education:* U. of California, Berkeley

After buying a camera while traveling in Europe in 1963, he sent his first scenes of Amsterdam's people to *Life International.* In the later 1960s he began his affiliation with the Black Star Agency and was staff photographer for Berkeley's *Daily Californian.* In the late 1970s, he prepared a slide presentation for the Northern California Photo Communications Conference. In this comprehensive multi-media work, he depicted all phases of nature—animal life, natural child-birth, growth, alternative life styles, spirituality among the topics. Nature and the details of light and form are the concerns of his fine-art work. He has also written and edited films and videos.

MOOT, KELLY (Advertising, Corporate/Industrial)
2331-D Wirtcrest Ln., Houston, TX 77055
(713) 683-6400

Born: 1944 *Subject Matter:* Food, People *Situations:* U.S. & Foreign Locations, Studio *Education:* Oklahoma State U.

His interest in photography did not emerge until the mid-1970s when he received an income tax return and a deal on a used 35mm camera simultaneously—that kindled a long dormant creative urge that "has been out of control ever since." He began reading and taking any available seminar on photography as well as assisting photographers on both coasts. The work paid off, and today he specializes in corporate/industrial and advertising photography. He is capable of working in all formats, either in the studio or on location, and willing to work anywhere and anytime—as witnessed by his working both Christmas and New Year's last year to deliver on a client's needs.

MORATH, INGE (BORG) (Portraiture, Photojournalism)
c/o Magnum Photos, 251 Park Ave. S., New York, NY 10010

Born: 1923 *Subject Matter:* Events, Portraiture, Travel *Situations:* U.S. & Foreign Locations *Awards:* Certificate of Appreciation, Smithsonian Institution *Education:* Berlin U.; U. of Bucharest

A freelance photographer and writer, Morath was once an assistant to Henri Cartier-Bresson. She is the wife of playwright Arthur Miller. Her work is in both black and white and color and generally in a small format. Her work consists of portraits, reportage and photographic diaries of her extensive travels to Russia, China, Tunisia, Iran, Europe, etc. Her prints are attempts to express insightful visions of indigenous cultures. She joined Magnum Photos cooperative agency in 1953.

MORGAN, BARBARA (Portraiture, Fine Art)
c/o Barbara Morgan Studio, 120 High Point Rd., Scarsdale, NY 10583

Born: 1900 *Subject Matter:* Dancers, People *Situations:* Studio, U.S. Locations *Awards:* NEA Grant; Trade Book Clinic Award, American Institute of Graphic Arts *Education:* UCLA

Morgan is known for her photographs of dancers and children. Trained as a painter, she became interested in abstraction, an influence that would later surface in her photomontages. She is virtually self-taught in photography, except for instruction she received from her husband, photographer Willard Morgan. She has frequently photographed the indigenous tribes of the American Southwest, including the Hopi and Zuni Indians. Her prints are an exploration of life and dance and are visual expressions of the energies of life. In New York City Morgan became fascinated with modern dance, in particular Martha Graham's dance troupe. For five years, Graham and her dancers had their pictures taken at Morgan's studio. Morgan has shot a variety of dancers including such celebrities as Merce Cunningham, Erick Hawkins and Jose Limon. She is also known for her photomontages, through which she composes a complex network of social, political and humanistic imagery. Many of her prints have a humorous and playful quality about them.

MORGAN, JEFF (Editorial, Advertising)
27 W. 20th St., New York, NY 10011 (212) 924-4000

Born: 1954 *Subject Matter:* Nudes, Still Life *Situations:* Studio *Awards:* Award of Excellence, Nikon Response

Richard Misrach. Courtesy: Grapestake Gallery, San Francisco

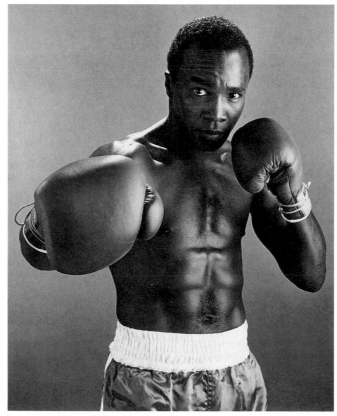

Lawrence Ruggeri, *Sugar Ray Leonard*

and Recognition Photo Contest *Education:* Ithaca College

After working for several years for Cosimo and Steve Steigman, he opened his own studio in 1980, specializing in still life. Over his career he has developed a style that is both graphic and colorful, a style which has landed him contracts with major advertising agencies such as BBDO, N.W. Ayer, Ketchum and Benton & Bowles. Of his commercial work, ninety-five percent is in advertising, the remainder being editorial assignments for such magazines as *World Tennis, Outdoor Life* and *Esquire.* In his non-commercial photography, he focuses on objects from everyday life, portraying them in a graphically unusual manner. One such photo is that of a cherry sitting in a puddle, lit by a bank of overhead lights, the lighting creating a meticulous, crisp shot.

MORRILL, DANIEL D. (Advertising, Editorial)
1811-B N. Sedgwick St., Chicago, IL (312) 787-5095

Born: 1938 *Subject Matter:* Nature, Travel *Situations:* U.S. Locations *Education:* Cornell U.

After graduating from Cornell, he assisted Mel Kasper in Chicago. He spent several years as an assistant and then began freelancing, specializing in location shots and doing some studio work. His assignments often involve either nature and calendar scenes or special effects like double exposure, solarization and infrared. His commercial clients have included Pullman, Turtle Wax, International Harvester and Amoco. His images have appeared on more than eighty book covers, and he has worked for such editorial clients as Harper and Row, Scott, Foresman & Co. and *Encyclopedia Britannica.*

MORRIS, BILL (Advertising, Editorial, Portraiture)
34 E. 29th St., New York, NY 10016 (212) 685-7354

Born: 1947 *Subject Matter:* Fashion, People, Beauty, Cosmetics *Situations:* Studio, U.S. Locations *Education:* Pratt Institute

The classic black-and-white fashion photographs and portraits he now makes have a glamorous and strong look; he cites Richard Avedon as an influence. He opened his own studio in 1976, after a five-year apprenticeship with leading editorial and fashion photographers in New York. He is working on a book of black-and-white beauty portraits. His clients include fashion magazines and advertising agencies.

MORRIS, LARRY A. (Photojournalism)
506 W. Walnut, Brownstown, IN 47220
(812) 358-4123

Born: 1944 *Subject Matter:* U.S. Locations *Situations:* Sports, Nature, People

He began his photographic career while editing a newsletter for the Indiana division of a telephone company, Contel. In 1984, he began working as a press reporter and photographer. The *Brownstown Banner* employed him as a full-time reporter, and at the same time he freelanced with the *Seymour Daily Tribune.* In these capacities, he has reported on and photographed all types of news, including accidents, sports and social events. He is well known for his scenic, special effects and sports photography, especially basketball and football, and has a file of 5,000 slides in stock. He is a member of Associated Photographers International.

MORSE, RALPH (Photojournalism)
21 Lakeshore Dr., Box 686, Rockaway, NJ 07866

Born: 1917 *Subject Matter:* Space Program *Situations:* U.S. Locations *Education:* City College of New York

During his thirty years as a staff photographer for *Life,* he covered every assignment from science to theater. Encyclopedias and history books abound with his coverage of World War II—the marines at Guadalcanal, the Doolittle raid on Tokyo, Patton's drive across France. He was the only civilian photographer to cover the surrender of the German armies to General Eisenhower. *Life* later assigned him to the space program, and he spent fifteen years using inventive photography to explain space flight to the magazine's readers and to document the lives of astronauts. Since 1972 he has been a staff photographer for *Time.*

MORTON, CAROL TREAT (Photojournalism)
1032 Chislett St., Pittsburgh, PA 15206
(412) 661-0895

Born: 1951 *Subject Matter:* Food, People *Situations:* Studio, U.S. Locations *Awards:* Golden Quill (7) *Education:* Simmons College; U. of Pittsburgh

As a staff photographer at newspapers—the past seven years at the *Pittsburgh Press*—she has worked on a full range of subjects, from breaking news to sports and illustration. In the past few years, she has developed specialties in food illustration, black and white as well as color, and in editorial illustration. She styles her own shots and does page layout and design in addition to shooting. She increasingly splits her time between camera work and editing copy.

MOSLEY, KIM (Fine Art)
326A St. Francois, Florissant, MD 63031
(314) 921-2756

Born: 1946 *Subject Matter:* People *Situations:* Personal *Awards:* NEA Fellowship *Education:* U. of Illinois; Bradley U.

His narrative, autobiographical pictures are filled with fantasy, comic characters and bright, playful patterns drawn in a childlike manner. His work is a combination of photography, painting and text that often contains humorous and irreverent commentary on the absurdities of the human condition. His work is in the collections of the Art Institute of Chicago, the Dallas Museum of Fine Arts and the Center for Creative Photography. He is Associate Professor and Fine Arts Program Coordinator at St. Louis Community College.

MOSS, JEAN (Corporate/Industrial, Editorial)
1255 S. Michigan Ave., Chicago, IL 60605
(312) 786-9110

Born: 1945 *Subject Matter:* People, Portraiture *Situations:* Studio, U.S. & Foreign Locations *Education:* U. of Wisconsin

She is a graduate of the University of Wisconsin, where she studied Asian theater and was introduced to the possibilities of the camera. She served an apprenticeship with Ansel Adams and also had a stint with the well-known director of unconventional commercials, Joe Sedelmaier. From these experiences, she brings an intimate and elegant approach to her portrait photography. Working with a "less is more" lighting philosophy, she achieves an almost journalistic style in

Jean Mogerly, *Chung King Market Day*

Willie Moy, *The 18 Immortals Gazing at the South Sea*

a studio situation. She is well known in advertising, celebrity photography, corporate work and magazine publication. For the last two years *Esquire* magazine has employed her for the majority of their cover shots.

MOY, WILLIE (Advertising, Fine Art)

364 W. Erie St., Chicago, IL 60610 (312) 943-1863

Born: 1942 *Subject Matter:* Shoes, People, Travel *Situations:* U.S. & Foreign Locations, Studio *Awards:* Consultant for the Advertising Photographer's Association of China

When he was just starting out in photography, he tested his equipment, light and ingenuity on shoes. This has become his commercial speciality, and he takes great pride and pleasure in his ability to make a mundane subject exciting and visually interesting. His personal work is very different—the documentation of the experiences of Chinese immigrants in America. Beginning with the experiences of his own family, he has photographed the Chinese who have made their own communities in this country and the rewards and problems they have encountered as they have sought to join the mainstream of American society. He has also been active on behalf of the homeless, particularly the most recent Asian immigrants who have arrived since the Vietnam War. In China, he has participated in the reawakening of commercial and fine-art photography. His numerous trips have yielded many photographs, some of which are collected in his "Huangshan Mountain" portfolio. One recent project was a group shoot of the Great Wall of China with four Chinese photographers.

MROCZYNSKI, CLAUS (Travel, Landscape, Advertising)

529 W. 42nd. St., #2L, New York, NY 10036
(212) 947-2767

Born: 1941 *Subject Matter:* Nature, Travel *Situations:* U.S. & Foreign Locations, Studio *Awards:* 2nd Prize, Nikon International Contest; 2nd Kodak International Competition *Education:* Fachhochschule, Dortmund, West Germany

"Although he admires and has learned from Ansel Adams and others in that tradition," writes one critic, "Mroczynski's vision is quite separate from theirs. In place of a peaceful contemplation of the physical world and a heightened sense of its beauty, he attempts to capture a more fragmented and anthropomorphic sense of the natural world, where the self sees nature as every bit as moody, defiant, lyrical and changeable as human nature." His approach to his subject matter is exemplified by his shots of gnarled driftwood raising a spiked head into a stark sky and by those of the somber, luminous rock formations of Utah's Mono Lake. In all his photos, however, it is his use of light that transforms his subjects. As in 19th-century visionary painting, light penetrates everything in his photos, revealing nature's configurations, textures and surfaces and its multitude of forms.

MUCH, MICHAEL REESE (Corporate/Industrial, Fine Art)

73 W. Wilshire Dr., Phoenix, AZ 85003
(602) 253-7839

Born: 1949 *Subject Matter:* People, Architecture, Industry *Situations:* U.S. Locations *Education:* Phoenix College; Arizona State U.

After serving in the U.S. Army from 1969 to 1972 as an aerial photographer, he moved to Phoenix, where he put his skills to work at a local firm. In 1977 he started his own business as an architectural and location photographer and has been his own boss ever since. From 1979 to 1981, he worked on a personal project of twenty-eight female nudes, shot primarily in 8" x 10" and contact-printed. Characterized by a sensual back lighting, the nudes are both abstract and romantic. His work has appeared in one-man shows and invitationals in the U.S., in salons in Europe and in the People's Republic of China. Presently he concentrates on corporate photography.

MUDFORD, GRANT (Fine Art)

5619 W. 4th St., Apt. #2, Los Angeles, CA 90036

Born: 1944 *Subject Matter:* Architecture *Situations:* Locations *Awards:* NEA Photography Fellowship; Australia Council for the Arts Visual Arts Travel Grant *Education:* U. of New South Wales

Born in Sydney, he studied architecture, but turned to commercial photography in 1965. Early personal work in the late 1960s focused on the rural landscape and buildings of the Australian outback. Later he became interested in the architecture of American locales. Compositional elements are arranged in his large format photographs to create geometric patterns and abstractions. The ambiguous spatial planes that result often bring a two-dimensional aspect to the work that challenges the viewer to guess at the actual objects being photographed. His main concern seems to be to transform architectural structures and spaces into abstract shapes and to change tonal surfaces in order to redefine space and light on the surface of the photographic paper. Mudford has lived in Los Angeles since 1977. In addition to photography, he has worked as cinematographer on many short films. Public collections include the Museum of Modern Art in New York City and the Australian National Gallery.

MULLINS, WILLIAM H. (Photojournalism, Scientific)

2254 Independence Dr., Boise, ID 83706
(208) 344-6231

Born: 1947 *Subject Matter:* Nature, Wildlife *Situations:* U.S. Locations *Education:* Oregon State U.; U. of Idaho

He hopes to document many of the remaining wild areas of the West and emphasizes the wildlife, vegetation and habitat of the Pacific Northwest and Great Basin. Most of his work is aimed at the nature magazine/calendar/textbook market. His images have been published in such magazines as *Audubon, National Wildlife, Wilderness, Sierra, Orion* and *Field & Stream.* His work has appeared in the large format *Idaho—A Pictorial Overview* and *Nevada—Land of Discovery.* He also writes a column on wildlife photography for *Idaho Wildlife* magazine and teaches workshops on nature and wildlife photography through a local university.

MURRELL, GERARD (Photojournalism, Portraiture)

93 E. 7th St., #4, New York, NY 10009
(212) 475-0537

Born: 1950 *Subject Matter:* People, Travel *Situations:* U.S. & Foreign Locations, Studio *Education:* U. of Southwestern Louisiana; Columbia U.

Claus Mroczynski

Nancy Ney, *Pamela*

Using a background in painting and the fine arts, he approaches his photography with attention to the drama of the colors and the composition and concern for the overall mood above that for the subject itself. The style is characteristically elegant and lean. An interest in anthropology has led to photographs of art objects, artifacts and the archaeological ruins of Central and South America, works that do not merely visually represent the objects and places but probe their character and their presence as well. In addition to this work, he has done production stills for film and television, working on a regular basis with WNET Public Television in New York. His magazine and newspaper credits include *Time*, *Architectural Digest*, *Business Week*, *Scholastic Magazine*, *Dial*, the *Village Voice*, the *New York Times* and the *Saturday Review*.

MUSTO, TOM (Advertising, Corporate/Industrial)
225 S. Main St., Wilkes-Barre, PA 18701

Born: 1952 *Subject Matter:* People, Products *Situations:* U.S. & Foreign Locations, Studio, Hazardous

With training in graphic design as well as in photography, he opened a studio that caters to a variety of clients for assignments which often call upon him to double as an art director. His diverse operations include photography for advertising, corporate communications, industrial and editorial assignments. He also shoots and directs film and video for television, corporate sales and industrial training. Perhaps the strongest example of his skills can be seen in his high-tech presentation for industry, with effects that create surrealistic and arresting images. While based in Wilkes-Barre, Pennsylvania, he often shoots on location, and for such assignments he has traveled around the world for both aerial and subterranean projects.

MUTRUX, JOHN L. (Advertising, Corporate/Industrial)
5217 England, Merriam, KS 66203 (193) 722-4343

Born: 1946 *Subject Matter:* People, Products, Fashion, Cars *Situations:* U.S. Locations, Studio

From 1969 to 1970, while in the Air Force in the Philippines, he specialized in both electronics and photography. In the States, he was employed as a design engineer and advertising manager before starting his own business in 1976. He specializes in product illustration, making often dull-looking products glamorous by using colored light and natural or abstract backgrounds. In his 1,200-square-foot studio he creates quartz and crystal environments for a variety of electronic products; then he manipulates the film with a variety of dyes and bleaches to create a range of optical effects. In addition to electronic merchandise, he photographs people for fashion and catalogue illustration, as well as corporate and business portraiture. He is also interested in automobile photography and illustration.

MUTTER, SCOTT (Advertising, Editorial)
410 Cumberland, Park Ridge, IL 60068
(312) 823-1856

Born: 1944 *Subject Matter:* People, Nature, Composites *Situations:* Exteriors

"My aim is to make pictures that bring to consciousness an idea that, once seen, is accessible and accepted. In terms of aesthetics, it turns the glance into a gaze and reaches its apex point when the viewer feels as if a dream has just slipped out of the unconscious." So he describes his photography, in which we find such images as a forest with parquet floors, a skyscraper whose crown becomes the top of a Corinthian column supporting an ancient structure, and a businessman walking through ocean waves on his way to mounting a huge escalator. Educated in history and social science, he studied photography and film in order to go to China and document the Chinese revolution. From this experience came his present photomontage technique. Although his images are often perceived as humorous and ironic, his approach is straightforward, concerned with the theme of natural organization verses man-made organization. Surrealism is also another unintended by-product as his pictures aim to examine historical and mythical influences.

MYDANS, CARL (Photojournalism)
212 Hemmocks Road, Larchmont, New York, NY 10538

Born: 1907 *Subject Matter:* People *Situations:* U.S. Locations *Awards:* Gold Achievement Awards; U.S. Camera *Education:* Boston U.

Carl Mydans's early photographs for the Farm Security Administration are now held in the Library of Congress and considered a major historical document of the Depression years. In the face of white planters opposed to his inquiry, Mydans documented the exploited poor with compassion and sensitivity. He moved on to join *Life* in its infancy, where he excelled as a journalist and photographer for many years. He was a strong influence on the magazine's style and direction. He said of his work there, "We had an insatiable drive to search out every fact of American life, photograph it and hold it up proudly like a mirror to a pleased and astonished readership . . . America had an impact on us and each week we made an impact on America."

NAKAMURA, TOHRU (Advertising, Editorial)
112 Greene St., New York, NY 10012 (212) 334-8011

Born: 1942 *Subject Matter:* Fashion, Still Life *Situations:* Studio *Awards:* New York Art Directors Club *Education:* Naniwa Art College, Tokyo

His Japanese heritage is reflected in the clean graphic quality of his work. Fashion assignments for *Vogue*, *New York Magazine* and *Ladies Home Journal* reveal a simplified approach: uncluttered backgrounds and minimal propping. Product and still life shots, for which he initiates both concept and design, utilize bold primary colors as the central theme. Large-format still lifes—for example, a peach suspended in water—magnify the elegance of the subject and give it a vibrant, almost liquid texture, as if the object were floating in a space of its own.

NAMUTH, HANS (Portraiture, Fine Art)
20 W. 22nd St., New York, NY 10010

Born: 1915 *Subject Matter:* Artists, Landscape *Situations:* Studio, U.S. & Foreign Locations *Awards:* Merit Award, Film Council of Greater Boston; Public Service Award, U.S. Department of State *Education:* Humboldt Oberrealschule, Essen; New School for Social Research

A freelance photographer for over five decades, Namuth has worked for a variety of magazines, including *Harper's Bazaar*, *Life*, *Look*, *Newsweek*, *Time*, *Vogue*, *Vu* and others. He is probably best known for

his portraits of over two hundred artists and sculptors, including Francis Bacon, John Cage, Alexander Calder, Willem de Kooning, Helen Frankenthaler, Adolph Gottlieb, Ad Reinhardt and Mark Rothko. The artists are shown at work and in their studios. Namuth has, in addition, produced a number of films since 1951, when he collaborated with Paul Falkenberg on his first film, "Jackson Pollock." Other films feature artists and sculptors Josef Albers, Brancusi, Alexander Calder, Willem de Kooning and Louis Kahn. Namuth studied with Joseph Breitenbach and Alexey Brodovitch in New York at the New School for Social Research.

NARCISO, MICHAEL (Editorial)

837 Traction Ave., #3-4, Los Angeles, CA 90013
(213) 626-2510

Born: 1946 *Subject Matter:* Fashion, People *Situations:* Studio *Education:* San Jose State U.; California State U.

Owner and operator of the advertising photography studio called Trout Studios from 1980 to 1986, he now freelances in Los Angeles for the record industry, fashion magazines and Los Angeles weekly papers. His experience as a sculptor is apparent in the way he establishes a three-dimensional environment for his subjects, shooting the majority in black and white. For record albums, he has provided photographs for jazz artists David Benoit, Shadow Fox and Luis Conte. He credits Lee Frielander's unique eye for expanding his own way of looking at things, and Arnold Newman's graphic approach to people and backgrounds for giving him his own sense of design.

NEBBIA, TOM (Editorial, Advertising)

6 Alpenrose Way, Horse Shoe, NC 28742
(714) 891-8343

Born: 1929 *Subject Matter:* People, Wildlife *Situations:* U.S. & Foreign Locations, Aerial *Awards:* NPPA; Professional Photographer's Showcase

His introduction to photography came on the battlefields of Korea as an army combat photographer. Upon discharge, he was promptly employed by a state newspaper in South Carolina, and within three years he gained prominence in photojournalism as an award-winning press photographer. Shortly thereafter, he joined the staff at *National Geographic*, where his high-quality work brought him more prizes and further recognition. Capturing the mood and excitement of fine art, his pictures are often compared to paintings and have been displayed in museums and educational institutions throughout the United States. Working by the premise that "every subject is worthy of portrayal," he looks for beauty in everyday things and experiences, things ordinarily considered outside the bounds of photojournalism.

NELEMAN, HANS (Advertising, Portraiture)

348 W. 14th St., New York, NY 10014

Born: 1960 *Awards:* Photographer of the Year, Kodak UK 1982-83; *American Photographer*, New Faces, 1987 *Education:* New York U.

His approach in large format often involves creating still lifes by combining seemingly unrelated elements, one example being the image of onions on a dented car door. Applying the specificity and control used in still lifes to his portraiture, he creates a shifting of tension that works to elicit energy and individuality.

NELSON, MICHAEL (Advertising)

7 E. 17th St., New York, NY 10003 (212) 924-2892

Born: 1951 *Subject Matter:* People *Situations:* Studio *Awards:* Andy *Education:* Rochester Institute of Technology

In 1973, after graduating from the Rochester Institute of Technology, he started his own New York-based business, making images for book covers and pharmaceutical advertising. He also often uses in-camera multiple exposures to illustrate concepts for book manuscripts and magazine articles. In 1975, after taking a bicycle trip from Scotland to Egypt, he came back to New York City and began photographing people in real-life situations for advertising clients. At present he works out of two studios, one in New York and the other a daylight studio sixty miles north of New York City at the foot of the Storm King Mountains.

NELSON, WALTER W. (Editorial, Fine Art)

208A Gonzales Rd., Santa Fe, NM 87501
(505) 982-6818

Born: 1942 *Subject Matter:* People, Travel, Products, Multi-Media *Situations:* U.S. & Foreign Locations, Studio

Since 1967 he has worked on a great variety of projects, from fashion, corporate, editorial and advertising illustration in Houston, to beauty and fragrances, editorial and corporate work in New York, to corporate and advertising illustration in Dallas. In addition to a full range of commercial clients, over the years he has also developed a reputation for his fine-art photography. Many of the black and whites are images of the mesas and deserts of New Mexico, Baja and Chiapas, Mexico, and Australia. His color work combines both color shots and painting. In these pieces he goes into the print with paints to create a work which is "beyond the photograph, beyond the painting."

NESTE, ANTHONY (Editorial, Entertainment, Photojournalism)

P.O. Box 602, Deer Park, NY 11729 (516) 667-3453

Born: 1951 *Subject Matter:* People, Sports *Situations:* U.S. Locations *Education:* U. of South Florida; New School for Social Research

He is a sports photographer who mixes action, graphic color and design. He began his photographic career after getting a degree in film production and working on several New York films. His first photographic work was with a Long Island portrait studio. However, his interest in sports soon led him to *Sport* magazine and then to *Sports Illustrated*. His photos are used extensively throughout editorial and sports advertising circles and have recently appeared in *Sports Illustrated*, *Time*, *Newsday* and the *New York Times*.

NETHERTON, JOHN (Photojournalism)

3726 Central Ave., Nashville, TN 37205
(615) 269-6494

Born: 1948 *Subject Matter:* Wildlife *Situations:* U.S. Locations *Education:* U. of Tennessee

He is director of Cumberland Valley Photographic Workshops, where he also teaches environmental portraiture. His books include *Tennessee: A Homecoming* and *Radnoor Lake: Nashville's Walden*. His images of Radnoor Lake have appeared in *Audubon* and his work has been included in such

magazines as *Popular Photography, Modern Photography, Natural History, Nikon World* and others. His stock file is handled by The Image Bank.

NETTLES, BEA (Fine Art)
Box 725, Urbana, IL 61801

Born: 1946 *Subject Matter:* People, Still Life *Situations:* Studio *Awards:* NEA Photography Fellowship; New York Creative Artists Public Service Grant *Education:* U. of Florida; U. of Illinois

After studying painting and printmaking, Nettles turned to photography in 1967 and later began to make photographs on linen, sewing them together into mixed-media pieces. Since the 1970s, she has incorporated plastics, drawing, coloring, quilting, mirrors and other elements to create unique sculptural presentations. For several years she experimented with offset printing and published limited editions of visual books, children's books and the playing card decks "Old Maid" and "Tarot." She has also made a series of pinhole photographs entitled "Close to Home," which recorded her life with her young children. More recently, her work has consisted primarily of photo-etchings. Subject matter includes dreams, the subconscious, motherhood, childhood and rituals. The objects presented are like still lifes that evoke mythological meanings. Nettles describes her photographic creations as an "investigation and sharing of experience."

NEUBAUER, JOHN (Photojournalism, Corporate/Industrial)
1525 S. Arlington Ridge Rd., Arlington, VA 22202

Subject Matter: Travel, People, Food *Situations:* U.S. & Foreign Locations, Studio

He began taking pictures to illustrate the stories he wrote for various magazine assignments. Discovering he enjoyed photography more than writing, he decided to switch careers. As a photographer, he is known for his portraits, which capture the characteristic moods of his subjects, whether produced in a formal studio style or in a relaxed environment. He is equally known for his photographs of gardens and for his sensually interpreted photographs of food, six of which have been reproduced as gallery posters and distributed and sold worldwide. He is also working on travel assignments and has started writing again, taking time between projects to stock his picture library.

NEVILLE, DANIEL (Photojournalism, Corporate/Industrial)
East Bay Studios, 43 New York Ave., Huntington, NY 11743 (516) 427-3495

Born: 1949 *Subject Matter:* Fashion, Food, People *Situations:* Studio, U.S. Locations, Aerial *Awards:* NPPA Picture of the Year *Education:* Woodbury College; C.W. Post (Long Island University)

He began his career at *Newsday*, spending eight years organizing the New York City office. His journalistic approach has been effectively applied to commercial work for local and national clients, including AT&T, McDonald's and Canon.

NEWMAN, ARNOLD (Fine Art, Portraiture)
c/o Arnold Newman Studios, 39 W. 67th St., New York, NY 10023

Born: 1918 *Subject Matter:* Celebrities *Situations:* Studio *Awards:* Gold Medal, Venice Biennale; Life Achievement Award, American Society of Magazine Photographers *Education:* U. of Miami

Newman is best known for his portraits of celebrity artists and famous personalities taken with symbolic objects surrounding them that reveal their occupation. His photographs have included personalities such as Cocteau, Dali, Duchamp, Eisenhower, Ernst, Hockney, John F. Kennedy, Nixon, O'Keeffe, Picasso and Stravinsky. As a freelance photographer, his images have been seen on the pages of *Esquire, Fortune, Harper's Bazaar, Life, Look, Town and Country* and *Travel and Leisure. Life* selected Newman to produce several of their covers, the first appearing in 1947. Newman was named Advisor on Photography to the Israel Museum in Jerusalem, a post he has occupied since 1965. In 1979 Newman was commissioned by the National Portrait Gallery to produce a series of fifty photographs for the exhibition "The Great British." He has, in addition, authored several publications, including *One Mind's Eye: The Portraits and Other Photographs by Arnold Newman, Faces U.S.A., The Great British, Artists: Portraits from Four Decades* and *Arnold Newman—Five Decades.*

NEY, NANCY (Advertising, Portraiture)
108 E. 16th St., New York, NY 10003 (212) 260-4300

Born: 1952 *Subject Matter:* Fashion, Beauty, Editorial, Nudes *Situations:* U.S. Locations, Studio *Education:* American U.

Having studied acting, she often chooses fantasy as a theme in her photographic word. While working at home, on location or in her studio, she brings her fantasies to life through the skillful manipulation of lighting, make-up, hair and styling to create a "look" much in the way a film director might. Her experience in both fashion photography and video has given her the opportunity to execute many of her concepts for commercial clients. She currently uses Nikon and Hasselblad cameras for prints and shoots her fashion videos on both tape and film. Self-taught in the art of photography, she has operated her own studio for ten years.

NICCOLINI, DIANORA (Portraiture, Fashion, Photo Illustration)
356 E. 78th St., New York, NY 10021 (212) 288-1698

Subject Matter: Medical, Nudes, People, Portraits, Photo Illustrations *Situations:* Studio

She was a medical photographer for twenty years and established photography departments at both Lenox Hill Hospital and St. Clare's Hospital and served as head of the medical and audio-visual health education department for the latter. She became fascinated by the play of light and color and was greatly influenced by Weegee's experimental work with light and prisms. In the 1980s, she published two books of nudes, *Women of Vision,* an anthology of women photographers, and *Men in Focus,* which was published as "a turnaround to the female-watching books." A third book, as yet untitled, is in the works. Her images of the human body recall the work of Renaissance painters, particularly Michelangelo, whose work she first discovered as a child living in Florence, Italy. Currently, she specializes in portraiture, fashion and photo illustration for book and record covers. Her photo illustration is a combination of photography and painting collages used to illustrate fantasy and fiction. An example is her Mona Lisa altered image.

Dianora Niccolini

Sheryl Noday, *Self Portrait*

NIELSEN, RON (Advertising, Photojournalism)
1313 W. Randolph St., Suites 315 & 326, Chicago, IL
60641 (312) 226-2661

Born: 1942 *Subject Matter:* Fashion, Industrial, Travel
Situations: U.S. & Foreign Locations, Studio *Awards:*
Kodak Professional Showcase *Education:* U. of Illinois; U. of California

For over twenty-five years he has been a successful
photographer specializing in industrial location
photography and editorial work. Accepting assignments
both in the United States and overseas, one
week he finds himself in Seattle for an oil company, the
next on an off-shore oil platform in the Gulf of Mexico.
Bound for the Bahamas the following week for some
location travel work, he might close a month of work
in New York shooting a spread on a locomotive factory.
He began shooting professionally when he was
just sixteen, with work published in such national
magazines as the *Saturday Review.* He has covered
fashion for an Italian magazine and food for catalogs,
with studio work ranging from nudes to high-tech
science photography. He has made his reputation
primarily as a location photographer, both in editorial
and advertising work. Publications include *DuPont
Magazine, Epcot/Walt Disney World, AR Book '87* and
Industrial Photography.

NIXON, NICHOLAS (Fine Art,
Photojournalism)
c/o Massachusetts College of Art, 625 Huntington
Ave., Boston, MA 02215 (617) 232-1555

Born: 1947 *Subject Matter:* Aging, AIDS Victims,
Landscape, Poverty *Situations:* Studio, U.S. Locations
Awards: NEA Photography Fellowship, Guggenheim
Photography Fellowship *Education:* U. of Michigan;
U. of New Mexico

He is recognized for his mastery of large-format
cameras with which he produces 8" x 10" prints, mainly
of men and women. Although employed briefly as an
architectural photographer, he is best known for his
portraits. Notable is his annual photograph of the
Brown sisters (one of them, Bebe, is his wife). The
series began in 1975, and along the way it has evolved
into a revealing documentary of change. We can
measure change in the women's bodies, clothes and
postures over the past fourteen years. He has pursued
a variety of subjects, including the themes of growing
old, cityscapes, the impoverished areas of Boston, and
landscapes of Kentucky. A recent series, "People with
AIDS," is a powerful photographic documentation in
six segments, each segment devoted to an individual
afflicted with the disease. Nixon continues to be fascinated
with the extremities of life.

NODAY, SHERYL (Editorial, Entertainment)
1645 N. Vine St., #601, Hollywood, CA 90028
(213) 461-5650

Born: 1959 *Subject Matter:* People, Portraits, Still Life
Situations: Studio *Education:* El Camino College; Art
Center College of Design

She began using a camera in high school, always
photographing people, seeking expression in the images
and emotional response from her viewers. This
idea led her to understand "that photography is the
highest form of visual communication." At that point,
she enrolled at the Art Center College of Design to
begin four years of intensive study. Upon graduating,
she began shooting in a commercial capacity, moving
from still lifes to exotic celebrity portraiture. Some of
her clients include *Los Angeles Magazine, LA Style,*
ABC Entertainment Center, Fox Broadcasting, Enigma
and Capitol Recording Artists, and she has shown
her work in most Hollywood galleries. In her search
for more striking photographs, she uses hand coloring
in combination with film and process mainipulations to
achieve even more individuality. Recently, she has
been re-exploring still life and is currently shooting for
her first published book, *A Gift for the Heart,* a photo
essay on trance-channels.

NOGGLE, ANNE (Fine Art)
1204 Espanola, N.E., Albuquerque, NM 87110
(505) 268-5091

Born: 1922 *Subject Matter:* People *Situations:* U.S.
Locations *Awards:* Guggenheim Fellowship; NEA
Grant *Education:* U. of New Mexico

She began photographing at the age of forty-two after
a career in flying. She studied with Van Deren Coke and
is now adjunct Professor of Art at the University of New
Mexico. Her photographs are primarily portraits of
older people, which she calls "The Saga of the Fallen
Flesh." A book of her images, *Silver Lining,* was published
by the University of New Mexico Press.

NOREN, CATHERINE H. (Corporate/
Industrial, Editorial)
143 E. 13th St., New York, NY 10003 (212) 473-3979

Born: 1938 *Subject Matter:* People, Travel *Situations:*
U.S. & Foreign Locations *Education:* Bennington College

She began her career in a photo-documentary and fine-
art tradition, combining words and photography.
During this period, she published three books on
various aspects of photography before abandoning writing
entirely in 1983. Today she specializes in corporate/industrial,
editorial and travel photography, the
last frequently taking her south of the border into
Mexico and South America. Happy in these arenas, she
has the freedom to do what she does best, and that is to
bring a personal and humanizing eye to subjects and
situations that are not inherently personal or intimate,
as well as to bring a strong sense of design to the graphic
ordering of the unfamiliar.

NORFLEET, BARBARA (Portraiture,
Editorial)
79 Raymond St., Cambridge, MA 02140
(617) 354-4469

Born: 1926 *Subject Matter:* People, Animals *Situations:*
Studio, U.S. Locations *Awards:* Guggenheim Fellowship;
NEA Fellowship *Education:* Swarthmore College;
Harvard U.

She is an art and documentary photographer whose
images of people appear in books, catalogues, reviews
and museum publications. In the mid-1970s, she gave
up previous work in the social sciences and became a
full-time photographer, teacher of photography and
curator of photography at Harvard University. She has
had one-woman exhibitions at the International Center
of Photography and the California Museum of Photography.
One of her books, *All The Right People,* was
published by New York Graphic/Little Brown; the
other, *Commitment to Vision,* was published by the
Oregon Museum of Art.

Helen Norman. *Client: Cignal; Art Director: Steve McLerran*

Ric Noyle, *Ken*

NORMAN, HELEN (Advertising)

3000 Chestnut Ave., #217, Baltimore, MD 21211
(301) 235-4771

Born: 1960 *Subject Matter:* Fashion *Situations:* U.S. Locations *Education:* Syracuse U.

After working as an assistant for two years, she began working for national fashion clients such as Head Sportswear, Britches of Georgetown and various retail chains and manufacturers. She works with a small number of models, paying close attention to the mood created by the models, their clothes, the locations and the lighting. Working with a scenario, she depicts clothes as they are worn, as they fit into a lifestyle. This means working primarily on location. She uses a combination of continuous and strobe lighting, higher definition films and a variety of filters to achieve a gentle look.

NOYLE, RIC (Advertising, Corporate/ Industrial)

733 Auahi St., Honolulu, HI 96813 (818) 524-8269

Born: 1951 *Subject Matter:* People, Food, Fashion *Situations:* U.S. Locations, Studio *Awards:* Pele Awards, Photographer of the Year, Hawaii

Born in South Africa, he has lived for the last thirteen years in Hawaii, where he has done work for advertising agencies, record companies, hotel chains, department stores and airlines, both in Honolulu and nationwide. Self-taught, his subjects include people, fashion, constructed sets and food displays. His ability to work with people and light is the key to his success. He brings a well-trained team to his assignments to produce images that capture the essence of the subject. He specializes in pictures taken in the Pacific Ocean, claiming to know "every nook and cranny in Paradise." He maintains a stock of many photographs and is listed in *American Showcase* and *The Black Book.*

OBREMSKI, GEORGE (Advertising)

1200 Broadway, New York, NY 10001
(315) 437-1794

Born: 1947 *Subject Matter:* Food *Situations:* Studio *Awards:* Art Direction Awards (12); Fulbright Fellowship *Education:* Florida Institute of Technology

He writes of his photography, "I never think of my work in terms of style. That would be counterproductive. When I'm shooting, I try to remain open to all possibilities. If I were to hold myself back, waiting for one particular situation to unfold, I might miss something important. There should be only one 'don't' in photography, and that's 'don't restrict yourself.' I take straight photographs, whatever they are, and I manipulate photographs, whatever that is. In each case, I'm striving for that ultimate image, one where all the parts come together . . . In many instances, a photograph can be produced so easily and quickly that it tends to confuse a lot of people. They come to the conclusion that photography is a simple art form. I think that a photographer should spend as much time and thought on a finished picture as a painter would spend on a painting."

O'CONNOR, MICHAEL (Corporate/ Industrial, Editorial)

6429 Cow Pen Rd., #114, Miami Lakes, FL 33014
(305) 821-2912

Born: 1954 *Subject Matter:* Travel, Architecture *Situations:* U.S. & Foreign Locations *Education:* Boston U.

He is known for his extremely colorful and graphic, almost abstract, photos of architectural details. He specializes in travel, architecture and design assignments. A writer and editor as well as a photographer, he is the author of seven books and scores of magazine articles. He is well-versed in the publishing industry and in printing and production technology. He maintains extensive files on Florida and Caribbean travel and is represented for stock by The Image Bank.

OKONIEWSKI, MICHEAL J.
(Photojournalism, Corporate/Industrial)

131 Hasbrouk St., Syracuse, NY 13206
(315) 437-1794

Born: 1956 *Subject Matter:* Sports, News *Situations:* U.S. Locations *Awards:* Best Feature Picture, Syracuse Press Club

His photographs display a keen sense of light and composition. These, along with his strategic position in the heart of New York State, have won him such editorial clients as the Associated Press and the *New York Times.* He heads a Carrier Dome-based sports darkroom where his duties include covering Syracuse University's football and basketball programs as well as major NCAA track meets and high school sports. His range includes most of Upstate New York and Southern Canada. In 1987 he covered Pope John Paul II's tour of the U.S. for the National Catholic News Service. He is currently the senior photographer for the AP in Syracuse.

O'LARY, BOB (Advertising, Photojournalism)

P.O. Box 292, Tallahassee, FL 32302 (904) 877-2339

Born: 1953 *Subject Matter:* People, Sports, Travel *Situations:* U.S. Locations, Studio *Awards:* Smithsonian Institution; Moscow Hall of Culture

Exposed to photography in college, his first assignments dealt with transparencies and color balance in the studio environment. For the last ten years he has been a photojournalist, while at the same time sustaining a thriving commercial freelance business. His ready-for-anything attitude has made him a specialist with existing light in environmental locations and interiors. He markets his large stock library of transparencies electronically and has stock pictorial and feature images on file with the Black Star and Frederic Lewis agencies in New York. His photographs have recently been displayed in the Smithsonian Institute as well as at the Hall of Culture in Moscow.

OLBRYS, ANTHONY (Advertising, Scientific)

41 Pepper Ridge Rd., Stamford, CT 06905

Born: 1937 *Subject Matter:* Fashion, Boating, Products, People *Situations:* Aerial, Underwater, Studio *Education:* Art Students League; National Academy of Design

With a background in commercial illustration, for many years he used the camera as a tool for gathering detailed descriptive information to complete projects on technical subjects, architecture, products and portraits. Now he combines this experience with a knowledge of new technology in the production of computer images using "device imaging systems." He offers a unique service, utilizing computers to combine or enhance existing images or to create new ones. Packaging and products are designed and developed

Bradley Olman

Jan Oswald, *Potatoes Are In Vogue.* Courtesy: Potato Board / A. J. Otjen. Designer: Bronwyn Moore. Food Stylist: Bunny Martin

225

on the computer system, then photographed with multiple exposures of real or imagined scenes, which are then combined into a final photograph. His work is not limited to high-tech graphics; he has spent some time on his personal work photographing sensuous portraits of semi-nudes.

OLMAN, BRADLEY (Advertising, Photojournalism)

15 W. 24th St., New York, NY 10010 (212) 243-0649

Born: 1944 *Subject Matter:* Interiors, People, Travel, Gardens, Food *Situations:* U.S. & Foreign Locations *Awards:* Desi; Garden Writers of America *Education:* Cornell U.

He has been a photographer for over fifteen years and has worked extensively with photographic interiors, still lifes, gardens, food, travel and people for a wide variety of clients. His assignments have taken him from the world-famous hotels and restaurants of New York City to the flowering fields of Holland and the plains of Africa. He enjoys working closely with art directors and editors, so that everyone plays an important part in creating the final image. The most noted aspect of his work is a natural lighting technique he has developed which enables him to render a wide range of moods with light.

OLSEN, LARRY (Advertising, Corporate/Industrial)

Courtyard 1523 22nd St., N.W., Washington, DC 20037 (202) 785-2188

Born: 1953 *Subject Matter:* People, Architecture *Situations:* Aerial, U.S. Locations *Awards:* Washington Art Directors Award; 1st Place, SMPS *Education:* Brooks Institute of Photography

A problem-solver, he seeks to understand his clients' needs, paying special attention to communicating their ideas. He is a graduate of the Brooks Institute in California, which he left for Washington, D.C. to join the staff of Adams Studio, Inc. He uses 4" x 5", 2 1/4" and 35mm, and his current accounts include advertising, corporate/industrial and architectural clients. He teaches a seminar in architectural photography at the International School of Photography. He regards his brochure for the George Hyman Construction Company as his best work.

OLSON, JON (Editorial, Advertising)

4045 32nd St., S.W., Seattle, WA 98126 (206) 932-7074

Born: 1957 *Subject Matter:* Products, Nature, People *Situations:* U.S. & Foreign Locations, Studio, Aerial, Hazardous *Education:* San Diego State U.

The day after his high school graduation, he began shooting for the *Port Angeles Daily News*. For the next five years he worked as a photojournalist on a variety of newspapers. He went on to study photojournalism at San Diego State University and worked as a media specialist for the San Diego School District. Eventually he began shooting commercial assignments for a range of clients, including Olympic Stain Co., First Mutual Bank, Pacific Northwest Bell, Ogilvy & Mather Public Relations and U.S. West, among others. Today he has developed a speciality in marine photography and high-angle/high-risk photography. He has photographed ocean liners and barges both from the ground and in the air. He has traveled to Alaska and South America to cover several mountain-climbing expeditions. To photograph volcanoes, he finds himself hanging out of planes in a harness. Recently he has been shooting black-and-white photographs of body builders to promote body building shows.

OLSON, ROSANNE (Fashion, Portraiture)

5200 Latona Ave., N.E., Seattle, WA 98105 (206) 633-3775

Born: 1950 *Subject Matter:* Fashion, Portraiture *Situations:* Studio, U.S. Locations *Awards:* Pictures of the Year, NPPA *Education:* U. of Oregon; Minot State U.

Studying at the University of Oregon, she became interested in photography and for a number of years was heavily involved in an art capacity. Eventually she took a part-time position at the *Register-Guard* in Eugene, taking shots of people and food. This experience led to more work in fashion, advertising and editorial photography for magazines. Working both in the studio and on location in 35mm and 2 1/4" formats, she specializes in hand-tinting her black-and-white shots, and this reveals her background in fine art. Her fashion work, while fairly classical in line, strives for capturing a sense of passion in the models. Her editorial photography is less experimental, while still zeroing in on an emotional impact; for these photos she often uses simple backdrops. Her personal work is more akin to her fashion photography: shot in color, it is dramatic—often provocative in its representation of human interaction.

OLVERA, JIM (Corporate/Industrial, Editorial)

235 Yorktown St., Dallas, TX 75208 (214) 760-0025

Born: 1955 *Subject Matter:* Food, People, Still Life, Architecture *Situations:* Studio, U.S. Locations *Awards:* AIGA Merit Awards; New York Art Directors Club *Education:* Washington U.

After working as an art director, he opened a commercial photography business in 1981. Since then, he has photographed a wide variety of subjects for clients ranging from a museum of art to a manufacturer of robots. He maintains an avid interest in his personal work and has published a small book on his own. He has taught at Texas Christian University and given lectures at several other universities around the country. The Library of Congress holds one of his images in their permanent collection.

O'NEAL, CHARLES T. (Advertising, Editorial)

416 W. 20th St., New York, NY 10011 (212) 691-7768

Born: 1937 *Subject Matter:* Still Life *Situations:* Studio *Education:* U. of Florida

After leaving the University of Florida with a degree in design and a minor in photography, he went on to study under Van Deren Coke. He then joined the J. Walter Thompson agency in New York as a designer and photographer in the creative department. In 1974 he became the company's Director of Photography, and in 1981 he opened his own New York Studio. He has completed assignments for Eastman Kodak, Ford, Reynold's Aluminum, Pan Am, Air India, W.A. Taylor, Burger King, Memorex and the United States Marine Corps.

ORANS, ARTHUR NORMAN (Advertising, Corporate/Industrial)

P.O. Box 1392, Corvallis, OR 97339 (503) 758-1216

Born: 1950 *Subject Matter:* Horticulture, Travel *Situations:* Hazardous, U.S. & Foreign Locations *Awards:*

New York Art Directors Award *Education:* Pratt Institute; Oregon State U.

A New York-based photographer, he has photographed for architectural clients and for the Brooklyn Botanic Garden, illustrating the latter's annual report and its "Plants & Gardens" series. With this base established, he began a stock photography library. He continues to shoot horticultural subjects, traveling 1,000 miles per week to all parts of North America to photograph a wide range of specimens and environments. Much of the plant photography is used in advertising, principally for catalog prints. His slide set enumerating all the types of U.S. fruits and vegetables won the *Redbook* Award. A member of the Garden Writer's Association of America, he is the nation's premier source for Kodachrome transparencies in his field.

ORLING, ALAN S. (Photojournalism, Corporate/Industrial)

Hawley Rd., North Salem, NY 10560 (914) 669-5405

Born: 1948 *Subject Matter:* People, Industry *Situations:* U.S. Locations *Education:* New York U.

Inspired by such photographers as Gene Smith, Kertez and Brassi, he began working on his own after finishing college. Rooting his photography in a belief in his subject's dignity, he keeps his photographs simple, using color discreetly as an element of the subject rather than as an end in itself. Shooting predominantly in 35mm, he is unencumbered by an excess of equipment and shoots with the same effortlessness and spontaneity as "lungs breathing in and out without our thinking about it." His editorial work has appeared in publications ranging in size from the *New York Times* to *Seaport.* For the past fifteen years he has also worked on assignments for major firms in corporate and industrial communications.

O'ROURKE, J. BARRY (Advertising)

578 Broadway, New York, NY 10011 (212) 226-7113

Born: 1933 *Subject Matter:* Fashion, People *Situations:* Studio, U.S. Locations *Awards:* Art Directors Awards, NYC, Los Angeles, Boston *Education:* Art Center College of Design

A graduate of Art Center College of Design, he worked in Los Angeles and Chicago before opening a studio in New York City. He now operates a large studio in Manhattan, where he shoots beauty, fashion and people for advertising and editorial clients. He is part owner of "The Stock Market," one of the largest stock photography agencies. He has published a book on photographing women and his pictures have appeared in *Ladies Home Journal, Newsweek, Bride's,* the *New York Times* and the *Wall Street Journal.* He is a former president of the New York Chapter of the Advertising Photographers of America.

OSWALD, JAN (Advertising, Fine Art)

921 Santa Fe Dr., Denver, CO 80204 (303) 893-8038

Born: 1947 *Subject Matter:* People, Still Life, Food *Situations:* Studio *Awards:* Art Director's Club Award *Education:* U. of California, Berkeley; Brooks Institute of Photography

Her career started in San Francisco where she concentrated on still-life photography for such clients as Yamaha, Hills Brothers, Ortho and Foremost. Five years later, she moved to Denver to continue still-life work as well as food photography for numerous clients, including Head Sports, Celestial Seasonings, Village Inn and Mountain Bell. She is known for her intelligent and disciplined approach to problem-solving and her skillful lighting as a way to bring out the most in the subject. In addition to her commercial work, she has recently begun shooting fine-art still lifes. Here she concentrates on the abstract forms, pursuing the idea that "we perceive the world in 'layers,' as if through veils and reflections, like a patina that builds up over time and must be carefully removed to reveal the underlying forms." These photographs have appeared in local and international publications.

O'TOOLE, JOANNE R. (Editorial)

30825 Euclid Ave., Wickliffe, OH 44092
(216) 942-5455

Born: 1939 *Subject Matter:* Travel *Situations:* U.S. & Foreign Locations *Education:* John Carroll U.

For the last ten years she has traveled the world with her husband, Tom, producing high quality travel photography. They use Nikon equipment and shoot PKR-64 for their color slides and TMX-100 for black and white. Their work has been published in newspapers and magazines in the U.S., Canada and Australia, including *Private Practice, Tours & Resorts, Cruise Travel, The Elks Magazine* and *Golden Years Magazine.* They maintain an extensive stock file.

O'TOOLE, THOMAS J. (Editorial, Nature)

30825 Euclid Ave., Wickliffe, OH 44092
(216) 942-5455

Born: 1935 *Subject Matter:* Travel, Nature *Situations:* U.S. & Foreign Locations *Education:* John Carroll U.

A well-published photographer and journalist, he has focused his attention on travel photography, working exclusively with his wife, Joanne (see previous listing). They use Nikon equipment and have an extensive stock of color slides and black-and-white prints for newspapers. In addition to the publications mentioned above, their work has been published in the *Sarasota Herald-Tribune,* the *San Diego Union,* the *Baltimore Sun* and many other newspapers and magazines. He is a member of ASMP and a number of other professional journalistic and press organizations.

OWENS, BILL (Photojournalism)

Buffalo Bill's Brewery, 1082 "B" St., Hayward, CA 94541

Born: 1938 *Subject Matter:* People, Events *Situations:* U.S. Locations *Awards:* NEA Grant; Guggenheim Fellowship in Photography *Education:* Chico State College

Owens' photography serves as a documentation of American culture, specifically middle-class America. Working as a photographer and publisher of the *Livermore Independent* in California, Owens was assigned to cover such events as church and school functions, political and social group meetings, beauty contests and senior citizens' housing. Many of his images are accompanied by a quote by one or more of the participants. Owens has authored several successful books of his photography, including *Suburbia, Our Kind of People: American Groups and Rituals, Working: I Do It For The Money* and *Documentary Photography: A Personal View.* Owens retired from photography in 1983.

OXENDORF, ERIC (Architectural, Corporate/Industrial)

1442 N. Franklin Pl., P.O. Box 92337, Milwaukee, WI 53202 (414) 273-0654

Born: 1948 *Subject Matter:* Architecture, Industrial *Situations:* U.S. Locations *Education:* Layton School of Art, Milwaukee

He initially pursued fashion photography as a freelancer but became interested in doing large-format work. Following a two-week stay in Chicago photographing nothing but building details, he decided to pursue architectural and industrial photography. Among his most notable works in this area are shots of capitol domes taken from their interiors. To date he has taken thirty-one such photographs, gathered while on various assignments, a number of which were featured in the *Domes of America* poster. The project reflects his strong design and graphic sense. Other architectural work is characterized by the use of dynamic perspectives and lighting. His clients have included such national firms as AT&T, McDonald's and Phillip Morris, as well as nationally known architects. He has studied with Arthur Lazar, Ruth Bernhard and Ansel Adams.

PALMER, GABE (Advertising, Corporate/Industrial, Editorial)

30 Rockledge Rd., West Redding, CT 06896 (203) 938-9049

Born: 1943 *Subject Matter:* People, Corporate Executives *Situations:* Studio, U.S. Locations

He has a clean, graphic style, and he shoots and travels for corporate clients and advertising agencies in the U.S. and abroad. He first picked up a camera at the age of twenty-eight. A few months later he took a job as a photo assistant and abandoned a brief but promising career as an advertising account executive. He has a studio in West Redding with a staff of six.

PALMISANO, VITO (Advertising, Editorial, Nature)

1713 N. Mohawk, Chicago, IL 60614 (312) 565-0524

Born: 1956 *Subject Matter:* Architecture, Graphic Design, Nature *Situations:* Aerial, Underwater, Hazardous, U.S. & Foreign Locations *Education:* Triton College

A self-taught photographer, he shoots hazardous, aerial and underwater scenes for corporate clients and advertising agencies. He shoots from helicopters or hangs from roof-tops supported by safety cables and straps to shoot large-scale panoramas of factories and cityscapes. Using time-lapse photography, filtration and patience, he makes "the unattractive look beautiful," he says. His corporate clients have included NBC, American Airlines, Centel and Harris Trust Savings. Understanding the limitations of advertising, he has branched into editorial photography. His most challenging shoot was from the top of the Verrazano-Narrows bridge in New York City, where he used a time exposure to capture the color-shift above Staten Island at dusk. More than 6,000 of his photos are carried by Nawrocki Stock Photos.

PAMFILIE, A. EARL (Portraiture)

768 Sandy Lake Rd., Kent, OH 44240 (216) 673-0774

Born: 1939 *Subject Matter:* Nudes, People *Situations:* Studio *Awards:* Loan Print, Professional Photographers of America *Education:* Winona School of Photography; Kent State U.

He is a studio photographer who specializes in "personal expressions" and concentrates on portraits of couples, families, weddings and high school seniors. He began his photographic career in 1967, when a friend who was a professional photographer reviewed some of his snapshots and advised him of his great potential. He has studied photography at Kent State University, Winona School of Professional Photography and the Triangle Institute. He has won numerous first place and blue ribbon awards, and his work has appeared in *Professional Photographer*, *Rangefinder*, the *Record Courier* newspaper and the Hartcraft catalog.

PAPADOPOLOUS, PETER (Advertising, Editorial)

78 Fifth Ave., New York, NY 10011 (212) 675-8830

Born: 1936 *Subject Matter:* People *Situations:* Studio, U.S. Locations *Awards:* Gold Medal, Art Directors Club of New York; Andy Awards *Education:* Rochester Institute of Technology

Since completing his study at the Rochester Institute of Technology under Minor White, he has worked as a commercial photographer. Over the past twenty years, he has shot for such clients as Audi, AT&T, Miller Brewing Company and American Express. He is best known for his work in portraiture. Liv Ullman, Joe Piscopo, Tony Randall, Angela Lansbury and Joanne Woodward head his list of celebrity portraits. In each portrait, he seeks to capture "the power, strength and beauty of the person before the camera."

PAPAGEORGE, TOD (Fine Art)

6 Varick St., New York, NY 10013

Born: 1940 *Subject Matter:* People, Urban Scenes *Situations:* U.S. & Foreign Locations *Awards:* Guggenheim Fellowship; NEA Grant in Photography *Education:* U. of New Hampshire

He photographs a wide variety of subjects, from people to city scenes of New York. He generally uses a 6" x 7" format. Garry Winogrand, Walker Evans and Robert Frank have influenced his work. He has published two books concerning these artists: *Public Relations: The Photography of Garry Winogrand* and *Walker Evans and Robert Frank: An Essay on Influence*. Papageorge's work is a continuation of the traditionalist approach to photography associated with artists like Evans and Frank. He photographs American culture and society in a variety of situations, including park scenes, pool scenes, family outings and beaches.

PAPPAS, BILL (Advertising, Corporate/Industrial)

1937 Prospect Ave., Cleveland, OH 44115 (216) 861-7972

Born: 1945 *Subject Matter:* People *Situations:* U.S. Locations, Studio *Awards:* New York Art Directors Club Award; Cleveland Society of Communication Art Award *Education:* John Carroll U.; Cleveland U.

For the last seventeen years, he has operated his Cleveland-based studio, specializing in "people ads" and corporate communications. In each case, he strives to present a believable marriage between people and their high-tech workplaces, achieving an unposed look even if the pictures have been propped, directed and filled with models. On location in other

Eric Oxendorf, *Georgia State Capitol Dome*

Christian Peacock, *Man at the Piano*

cities, he uses the actual personnel on the job, with simple results. His photography has been published in annual reports, direct mailings, slide presentations, newspapers and magazines. Galleries have shown a spectrum of his photographs, from large facial studies to shots of barns and sheds. Inspired to pursue personal work between commercial assignments, he is working on a series of strong and soft shadow images.

PAREDES, CESAR (Advertising, Editorial, Corporate/Industrial)
332 Clarksville Rd., Princeton Jct., NJ 08550
(609) 987-8626

Born: 1950 *Subject Matter:* People, Travel *Situations:* U.S. Locations, Studio *Awards: Communication Arts* Award of Excellence *Education:* Rochester Institute of Technology

Born in Peru, he came to the United States with a background in printmaking, painting and primitive art. These influences are apparent in his photography, which is graphic, featuring bright colors and intricate geometrical forms. He has worked with still life on location and in the studio for most of his professional life, although recently he has begun photographing people. He is also experimenting with special effects. Working in 4" x 5" and 8" x 10" formats, he produces photography for editorial and advertising clients, as well as occasional annual reports for his corporate/industrial contacts.

PARIS, MICHAEL (Photojournalism, Advertising)
8611 Lookout Mt. Ave., Los Angeles, CA 90046
(213) 654-6941

Born: 1952 *Subject Matter:* People, Celebrities *Situations:* U.S. & Foreign Locations, Television and Movie Sets, Studio

Moving between Los Angeles and New York, he began his career as an assistant to fashion and advertising photographers. There he discovered his particular love of photographing people—but he preferred to photograph the models and stars without make-up, at impromptu moments. In these shots, he seeks to bring out their character, something not seen in their previous photographs, something often upbeat or silly. After five years in advertising, he had the opportunity to work in the art department for a motion picture business. He has stayed in that industry, where he has photographed literally hundreds of movie and television stars. As a unit photographer, he has worked on feature films, as well as television series, specials and movies. He has also worked extensively in live stage coverage of musical and dance productions and music videos.

PARKER, OLIVIA (Fine Art)
c/o Vision Gallery, 216 Newbury St., Boston, MA 02116

Born: 1941 *Subject Matter:* Landscape, Still Life *Situations:* Studio, U.S. Locations *Awards:* Artists Foundation Fellowship *Education:* Wellesley College

Essentially a self-taught photographer, Olivia Parker produces still lifes and landscapes with a view camera. She works in 8" x 10" and 20" x 24" Polaroid and in black and white. Parker uses collected artifacts in her still lifes—such as books, old photographs, bones, feathers and ballet slippers—to attain a surrealistic juxtaposition of elements. Trained as a painter, Parker

has been influenced by classical 17th-century Dutch and Flemish landscape and still-life painters.

PARKINSON, PAULA J. (Photojournalism, Nature)
15 Santa Clara, Belleville, MI 48111 (313) 699-4735

Born: 1952 *Subject Matter:* Nature, People, Travel *Situations:* U.S. & Foreign Locations, Studio *Education:* U. of Michigan; New York Institute of Photography

She began her photography career doing both studio and location portraiture in the Midwest, subsequently moving on to nature and environmental work, foreign travel photography and photojournalism. Much of her work centers around ageless landscapes, although she often shoots for spot news and feature stories. A recent project covering the Loyal Order of the Moose Centennial Celebration depicted in stark reality the plight of the homeless and the handicapped. In addition to her work in studio portraiture, she is also currently working on two books portraying seascapes and depicting more than 200 lighthouses around the Great Lakes, a project done in cooperation with the U.S. Coast Guard and the Department of Natural Resources.

PAVLIK, PAUL A. (Photojournalism, Nature)
RD #4, Box 172A, Tarentum, PA 15084
(412) 265-3383

Born: 1937 *Subject Matter:* People, Nature, Landscape *Situations:* U.S. Locations

His career in photography began as his way to earn extra money to pay for family vacations. Photographing these trips, he wrote about them and sold the material. His biggest interest is photographing people and scenery, especially sunsets. Using ordinary people without modeling experience, he works with all age groups, favoring children, teenagers and young women. Articles and pictures have appeared in such publications as *Guideposts, Travel Trailer, The Apostle* and *Organic Gardening.*

PAVLOFF, NICK (Corporate/Industrial, Editorial)
P.O. Box 2339, San Francisco, CA 94126
(415) 452-2468

Born: 1943 *Subject Matter:* People, Landscape *Situations:* U.S. & Foreign Locations *Education:* San Jose State U.; California College of Arts & Crafts

After studying design and photography, he traveled to Japan in 1965 and studied with landscape photographer Yoichi Midorikawa, whose use of strong vertical parallel lines is recalled in Pavloff's way of "dissecting images." Upon his return, he taught photography, graphic design and publications for four years. Since 1968 he has freelanced in corporate and industrial photography. His commercial assignments take him around the world, from the Orient to Europe, from Canada to Hawaii and Alaska. In 1983 he completed his first picture book, *A Vineyard Year,* for Chronicle Books in San Francisco. Concentrating on desert and mountain shots, in 1985 he started documenting the rapidly changing California landscape.

PEACOCK, CHRISTIAN (Advertising, Corporate/Industrial Portraiture)
930 Alabama St., San Francisco, CA 94110
(415) 641-8088

Paula J. Parkinson, *America's Industrial Heritage*

Paula J. Parkinson, *Hall of Busts, Paris, France*

Born: 1957 *Education:* City College of San Francisco

Inspired by Arnold Newman, Irving Penn and August Sander, he originally worked in San Francisco as an industrial photographer, moving to New York in 1980. The origins of his career were in corporate portraiture; he still shoots photographs of corporate presidents and CEOs that are normally used for ads and annual reports. But he does not limit himself to the corporate/industrial market. He enjoys photographing all sorts of people and has an uncanny knack for depicting the spirit of human nature in its countless forms. His projects include a series documenting children at the "Fresh Air Fund" camp in upstate New York and an advertising campaign for AT&T.

PEARSON, VICTORIA (Fashion)
696 Moulton, Studio E, Los Angeles, CA 90031
(213) 225-0919

Born: 1955 *Subject Matter:* Fashion, Album Covers *Situations:* Studio, U.S. Locations *Education:* Orange Coast College; Art Center College of Design

A professional photographer for eight years in Los Angeles, she cites her exposure to the work of Joanne Callis, Robert Coming and Robert Heinecken as her most influential experience. She discovered photography as a career potential in college. Today she shoots in both black and white and color. Her recent work has been moving away from 35mm format to 8" x 10" Polaroid. Editorial credits include *L.A. Style, Self* and *Rolling Stone.* She also frequently shoots for Nordstrom's catalogue and advertisements for Barbara Barbara clothes. Outside of her fashion and editorial illustration, she has shot for a number of album covers, with photos for such performers as Kenny Loggins, Jeffrey Osborne, Jody Watley, Siedala Garrett and K. D. Lang.

PECK, JOSEPH (Advertising, Editorial)
878 Lexington Ave., New York, NY 10021
(212) 472-1929

Born: 1951 *Subject Matter:* Fashion, Swimsuits *Situations:* U.S. & Foreign Locations *Education:* Middlebury College; School of the Boston Museum of Fine Arts

His photographs of athletes and women in swimsuits are honestly sexy and straightforward. He strives for a sense of naturalness and uses few "artificial" techniques. The work is done on location with available light. Instead of manipulating his subjects, he allows them to display their feelings about themselves, within a larger framework and composition. He has competed in sports himself, and his exposure to high-intensity training has made him especially comfortable with the athletic bodies he photographs. He specializes in shots of women in swimsuits, and he believes that composition should complement the human form.

PENISTEN, JOHN (Editorial, Photojournalism)
570 Iwalani St., Hilo, HI 96702 (808) 959-6986

Born: 1945 *Subject Matter:* People, Travel *Situations:* U.S. & Hawaiian Locations *Education:* Drake U.

Before beginning his photography career, he was a Peace Corps volunteer in the South Pacific. That experience, coupled with his current teaching career at the University of Hawaii at Hilo, has given him a unique appreciation of Pacific peoples and cultures. He now freelances for the travel industry in Hawaii and the Pacific Basin. He has covered subjects in the Pacific Islands, Australia, New Zealand, the Far East, the mainland U.S. and Alaska and has done work for government tourist offices, publishers and guide books. Also a writer, he has successfully produced many travel destination-cultural pieces. The Travel Image of Marina del Rey, California represents him for stock photography.

PENNY, MIKE (Corporate/Industrial, Editorial)
6628 Eastside Dr., N.E., #25, Tacoma, WA 98422
(206) 838-6355

Born: 1950 *Subject Matter:* People, Products, Architecture *Situations:* Studio, U.S. Locations

While in high school he was a news photographer for a small-town weekly. Since then, he has worked primarily on public relations assignments for corporate internal communications. Using a photojournalistic style, he produces slide shows for video conversion, closely editing them to best manage the message. In his studio he shoots special effects and small products. An increasing amount of his assignments are for builders and architects who need "perspective-controlled" images for their technical presentations. For his textbook projects, he specializes in working with both normal and disabled children.

PEPIS, AARON A. (Corporate/Industrial, Editorial)
40 N. Route 9W, West Haverstray, NY 10993
(914) 429-3999

Born: 1947 *Subject Matter:* People, Travel *Situations:* Studio, U.S. Locations *Awards:* Gold Service Award for Service to the New York State Professional Photographers Association *Education:* Brooklyn College

He began his career as a darkroom assistant in the Navy. After leaving the service, he freelanced for several New York City catalogue houses. He honed his technical skills in the freelance market for several years and then took a position as a technical representative for a large photographic marketing company. As a representative he became well acquainted with virtually all the types of photographic equipment on the market. He now has his own studio, where he shoots a wide variety of subjects for magazines, catalogues and annual reports. His images have appeared in *The Spotlight,* the *Yankee Plak Catalog* and the annual and quarterly reports of Nyack Hospital, the State of New Hampshire and the Nyack Foundation.

PERESS, GILLES (Fine Art, Photojournalism)
304 Bowery, New York, NY 10012 (212) 505-5555

Born: 1946 *Subject Matter:* People, Travel *Situations:* Hazardous, U.S. & Foreign Locations *Awards:* NEA Fellowship; Gahan Fellowship, Harvard *Education:* Institute des Etudes Politiques, Paris; Université de Vincennes, Paris

He is a member and former president of Magnum Photos, the photojournalist's cooperative begun by Henri Cartier-Bresson, Robert Capa and others. His published volumes include *An Eye For An Eye: Northern Ireland 1970-1987* and the award-winning *Telex: Iran* (Aperture, 1984). His fine-art photography has been shown at the Walker Art Center, the Palais de Tokyo in Paris and the Musée de l'Art Contemporaire in Paris. He is active commercially, and his photojournalistic and editorial work has appeared in many pub-

lications, including *Parkett, Graphis,* the *New York Times Magazine, Stern* and *Connoisseur.* He has taught photography at Harvard and other major universities.

PERRETTI, JOSEPH (Corporate/Industrial)
20 Inca Ln., #6, San Francisco, CA 94115
(415) 921-0562

Born: 1928 *Subject Matter:* Architecture, Construction *Situations:* Hazardous, Aerial

He is a "high rise" photographer who is known for the graphic angles he gets on building exteriors and interiors during and after construction. He began his career as a cameraman/union organizer, working for ABC and the teamsters. He shot the first images for Telestar's intercontinental video transmission and helped to design the world's first mobile television studio. In the early 1950s he gave up photography and went to California to study painting. In the early 1960s he picked up the camera again and began documenting the changing face of San Francisco. Today his assignments are often hazardous, requiring him, for example, to walk steel girders high above the street while holding a 4" x 5" camera, in order to photograph construction workers.

PETERSON, BRIAN (Photojournalism)
11903 River Hills Cr., Burnsville MN 55337
(612) 894-8843

Born: 1959 *Subject Matter:* People, Events *Situations:* U.S. Locations *Awards:* Minnesota Photographer of the Year *Education:* Bemidji State U.

Leaving the University of Minnesota in Duluth and his degree program in biology in his junior year for Bemidji State University and a degree in photojournalism, he committed himself to a career in photography. Starting with a bi-weekly paper upon graduating, in a two-and-a-half year period he climbed the ranks from a small daily to a position in 1987 at the *Star Tribune* in Minneapolis. Working at the *Star,* he strives to provide not just a record of events but a record with historical depth. This means his shots often include reference information, that of buildings, street design and architecture. He also is involved with an ongoing project with Wilderness Inquiry II, an organization that integrates disabled and able-bodied poeple in wilderness activities. He will be traveling to the Soviet Union to photograph the group's activities there.

PETERSON, BRUCE (Advertising, Corporate/Industrial)
2430 S. 20th St., Phoenix, AZ 85034 (602) 252-6088

Born: 1949 *Subject Matter:* Products, Special Effects *Situations:* Studio *Awards:* Houston Art Directors Award; New York Art Directors Club Award *Education:* U. of New Hampshire; Arizona State U.

He specializes in high-tech special effects photography primarily for hardware, software and telecommunications companies. Dissatisfied with the widely-held impression that such work is primarily "industrial," he strives to achieve a synthesis of artistic expression, futuristic design and a "state of the art" appearance. He shoots multiple images in different cameras in order to carry out the chief task of his assignments, which is to fully illustrate a concept. Images are therefore carefully constructed from various photographed elements.

PETERSON, RICK (Advertising, Editorial)
733 Auahi St., Honolulu, HI 96813 (808) 536-8222

Born: 1948 *Subject Matter:* People, Travel *Situations:* U.S. Locations *Awards:* Award of Merit 1983-1987, American Advertising Federation *Education:* Brooks Institute of Photography

Upon completing his illustration photography degree program at Brooks Institute, he returned to his home town of Honolulu to open his own studio. Working in Honolulu's exotic geography and large tourist market, he specializes in travel and resort images. He has worked exclusively for Sheraton Hotels in the Pacific, traveling throughout the Hawaiian Islands to the resort properties and the lush surroundings. He also works extensively for Pacific Resources, a Fortune 500 company, shooting ad, trade ad and annual report photography. Through his California agent, Ostan-Prentice-Ostan, he is now shooting travel, resort and people on location in California, Hawaii and the Pacific region. Black Star sends him occasional editorial assignments, which depart from his straight commercial work. Such photos have appeared in *Newsweek, People,* the *Wall Street Journal, So Far* (Apple Computers) and *Family Circle.*

PETERSON, SKIP (Photojournalism, Sports)
37 S. Ludlow, Dayton, OH 45402 (513) 225-2230

Born: 1951 *Subject Matter:* Fashion, People, Sports *Situations:* U.S. Locations *Awards:* NPPA, 1st Sports Feature *Education:* Ohio U.

The chief photographer for the *Dayton Daily News & Journal Herald* since 1982, he has many academic and other credits to his name. He is currently the president of the Ohio News Photographers Association and director of Region Four of the National Press Photographers Association. He is also a part-time faculty member at the University of Dayton, where he has taught photojournalism for the past nine years. His work has appeared in *Life, Time* and *Newsweek* and in five volumes of *The Best of Photojournalism.*

PFAHL, JOHN (Fine Art)
c/o Robert Freidus Gallery, 158 Lafayette St., New York, NY 10013

Born: 1939 *Subject Matter:* Urban Scenes, Landscape *Situations:* U.S. Locations, Studio *Awards:* CAPS Grant; NEA Photography Fellowship *Education:* Syracuse U.

Pfahl is interested in photographic illusions and perception. His photographs are laboriously staged and take several hours of preparation to achieve visually intriguing photographic perspectives. He includes props such as food (often fruit or bagels) and other elements, such as lace, string, tape, foil and yarn, that alter the appearance of the photograph and in many cases leave the viewer to believe he has made marks on the print when, in actuality, these elements are strategically placed in front of the camera before the photograph is shot. He also experiments with picture-making processes and has used, for instance, sugar to print photographs. He works mainly in large-format color photography.

PHILIBA, ALLAN (Advertising, Editorial)
3408 Bertha Dr., Baldwin, NY 11510
(516) 623-7841; (212) 286-0948

Born: 1928 *Subject Matter:* People, Travel *Situations:* U.S. & Foreign Locations *Education:* Franklin School of Professional Arts

After graduating from art school, he pursued a career as an art director in advertising. At that time he also began to take on product and corporate photography in conjunction with his designs and layouts on a freelance basis. Following a series of photographic trips taken in search of unusual and fresh graphics for a number of advertising campaigns, he decided to become a travel photographer. His work has included assignments for Fortune 500 corporations, advertising agencies, airlines, travel retailers, cruise lines and magazines. He now concentrates on maintaining and promoting his own stock collection of color photos from around the world. Future projects include books, art prints and exhibitions.

PIERLOTT, PAUL (Advertising, Corporate/Industrial)
P.O. Box 1321, Merchantville, NJ 08109

Born: 1945 *Subject Matter:* People, Architecture, Nature *Situations:* U.S. Locations

He has always been enthralled by the beauty and presence of nature, and as a professional photographer he seeks to capture this presence on film. Bringing this sensitivity to his commercial work, he shoots architectural photography for *Homes & Living* publications, working to express an architectural statement much the way he approaches the wilderness landscape. He also concentrates on personal work that is more photojournalistic, producing portraits and historical photo essays for local parishes and other non-profit organizations.

PIERONI, FRANK (Advertising, Corporate/Industrial)
2432 Oak Industrial Dr., N.E., Grand Rapids, MI 49505 (616) 459-8325

Born: 1934 *Subject Matter:* Fashion, Food, Furniture *Situations:* Aerial, Studio, U.S. Locations *Education:* Ray-Vogue Photography School, Chicago

After graduating from photography school in 1952, he moved to New York and began making portraits. He soon realized his interests lay in advertising and illustrative photography. In 1960 he moved to Michigan where he has since run several commercial/industrial studios. He seeks to bring out dramatic highlights in furniture, appliances, fashion, food and industrial equipment. His state-of-the art studio includes strobes, quartz and large- and small-format cameras and lenses and is large enough for the sets he often builds to shoot furniture and appliance ads. He has worked on advertising campaigns for Sears, Amway and Frigidaire, among others.

PIERSON, SAM C., JR. (Corporate/Industrial, Editorial)
1019 Forest Home Dr., Houston, TX 77077
(713) 497-3176

Born: 1929 *Subject Matter:* People, Travel, Corporate *Situations:* U.S. Locations *Awards:* Sprague Award; NPPA Region Photographer of the Year *Education:* U. of Houston

He was with the *Houston Chronicle* for thirty-five years, and his background in photojournalism has given him excellent experience for the corporate, industrial, people and travel assignments he now special-izes in. He has served on the board of directors and is past president of the National Press Photographers Association. During his tenure at the NPPA, the Association took many actions to advance photojournalism as a profession. He has lectured at numerous universities and served as photo contest judge at both college and national levels.

PITZNER, AL (Advertising, Corporate/Industrial)
8192 Nieman Rd., Lenexa, KS (913) 492-0396

Born: 1931 *Subject Matter:* Fashion, Food, Nature, People *Situations:* Studio, U.S. Locations *Awards:* Best of Show, Kansas City Art Directors; Best of Show, Kansas City AD Club Omni Awards *Education:* Dartmouth College; Art Center College of Design

After formal training in painting and art history, he switched to photography, beginning as creative director for Cessna Aircraft. He has twenty-two years of experience in studio and location advertising photography, covering not only North America but the Bahamas and Europe. His background in art and art history shows in his work; his pictures, including award-winning non-commercial work, achieve a painterly effect. His strong design, rich color and dramatic lighting creates a clear visual statement, drawing the viewer into the richness of the image and eliciting a reaction, if only vicarious, to its beauty. He works in formats from 35mm to 8" x 10", and among his clients are RAF & Scotland Yard fashions, Lee Company, Pfizer Drugs, Raytheon, Lear Jet, Beech Aircraft and Pizza Hut.

PLANK, DAVID (Advertising, Editorial)
28-32 Carpenter St., Reading, PA 19602
(215) 376-3461

Born: 1946 *Subject Matter:* People, Architecture *Situations:* Hazardous, Studio

He began his photography career freelancing for a small newspaper in Boston, and in a short time he abandoned his career in medical technology to shoot photos full-time. Moving back to Reading, Pennsylvania, he worked for regional magazines, gradually progressing to corporate/industrial and advertising assignments. He works out of his studio in a renovated warehouse, producing work used regionally and nationally for editorial, advertising and packaging. Outside New York, he operates as a generalist and is known for his flexibility, his quality work and his quick turnaround. He is a licensed pilot and does his own flying for aerial pieces.

PLATTETER, GEORGE (Advertising, Editorial)
82 Colonnade Dr., Rochester, NY 14623
(716) 334-4488

Born: 1929 *Subject Matter:* Food, Portraiture, Products *Situations:* Studio, U.S. Locations, Special Effects *Education:* Wisconsin School of Photo Arts & Sciences

After graduating from college in the late 1940s, he worked in various advertising studios in the Milwaukee-Chicago area. In 1963 he moved to Rochester, New York and went to work full-time for the Xerox Corporation. While there, he established their photography lab and made illustrations for advertising and media. Since 1984 he has operated his own Rochester studio where he specializes in special effects. He has

Richard Peterson, *Isaac Stern*

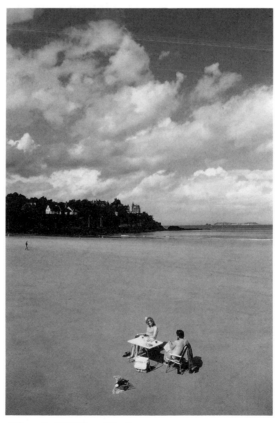

Allan A. Philiba, *Picnic*

also done formal portraits for executives of Xerox and Kodak.

PLOWDEN, DAVID (Editorial, Fine Art)
609 Cherry St., Winnetka, IL 60093 (312) 446-2793

Born: 1932 *Subject Matter:* People, Rural and Urban Landscapes *Situations:* U.S. Locations *Awards:* Guggenheim Fellowship; American Library Association Award; Award of Excellence, American Institute of Graphic Arts *Education:* Yale U.

He studied photography under the tutelage of Minor White and Nathan Lyons, and he was also a close friend of Walker Evans. He has accepted assignments from various publications, including *Architectural Forum, Fortune, Horizon, Life* and *Newsweek*. He is also known for his books, which often incorporate text along with the photographs. The work features primarily urban and rural landscapes, with a particular emphasis on the environment. *The Hand of Man on America*, for instance, is a visual assault on pollution and waste disposal in the U.S. Other books are explorations of the better aspects of life in America, as in *Commonplace*, which presents the life and architecture of small towns.

POERTNER, KENNETH C. (Photojournalism, Editorial)
613 Hillview Dr., Boise, ID 83712 (208) 336-0499

Born: 1945 *Subject Matter:* People, Travel *Situations:* U.S. Locations *Education:* Mary Darl Vocational School

After four years as a photographer in the Air Force, he worked for five years as a staff photographer for a daily newspaper. He then turned to stock photo work and began taking assignments for various greeting card, calendar, textbook, magazine and religious publishers. He uses 35mm and 2 1/4" formats and strives to make every stock photo as simple and direct an image as the stock photo market demands. He is now working to expand his travel stock with a trip to Peru, and he plans to photograph the Mayan ruins of Mexico and Guatemala. Publishers who have used his work include New Readers Press, Baker Book House and Scott, Foresman.

POLIS, JOHN (Editorial, Entertainment)
2002 Chestnut, Albert Lea, MN 56007
(507) 373-1729

Born: 1933 *Subject Matter:* People, Nature *Situations:* U.S. Locations, Studio *Education:* Wartburg College

A self-taught photographer, he spent time during the 1940s in a D.P. camp in Germany. For six years he worked as a press photographer in the Midwest on a daily newspaper, and it was there that he developed his ability for capturing the magic in the ordinary. His photograph of cows coming over a hill in winter won him a Best of Show. Other notable shots include one taken at a wedding in which the bride is caught at the instant she is falling out of the carriage while others look on. Many of his shots are humorous; he uses a telephoto lens to photograph people at their unguarded, particularly human moments. He continues to work as a freelance photographer, publishing in newspapers, yearbooks, and advertisements.

POLSKY, HERB (Advertising, Editorial)
1024 6th Ave., New York, NY 10018 (212) 730-0508

Born: 1949 *Subject Matter:* Fashion, People *Situations:* U.S. & Foreign Locations, Studio *Education:* Philadelphia College of Art; Los Angeles City College

He began by studying illustration in art school, but following a term in the U.S. Marine Corps, he returned to school to study film in Hollywood. Finding that work in film was not forthcoming, he picked up a still camera and subsequently earned steady work in fashion photography. In 1979 he moved to New York and a year later opened his own studio, in which he shoots beauty and fashion layouts. Two-thirds of his work, however, is shot on location. Assignments for clients have sent him to such places as Mexico, the Caribbean and Grenada. The majority of his work is for companies in the garment industry, such as DuPont Fibers, Celenes Fabrics and Rocky Mountain Underwear; others clients include Optyl Eyewear, *Stores*, Gilla Roos Agency, J.H. Collectibles and Windjammer Cruise Lines.

PORCELLA, PHILIP (Advertising)
572 Washington St., Suite 16, Wellesley, MA 02181 (617) 239-1770

Born: 1946 *Education:* Northeastern U.; Art Center College of Design

His vision has been inspired by contemporary photographers from Irving Penn to Sarah Moon, but his style and point of view have been influenced more by artists, especially by Alphonse Mucha and Sir Edward Byrne Jones. He is best known for photographing people in soft, romantic situations in portraits, full-figure compositions and nudes. His photographs are gentle and reflect his skill and sensitivity as a storyteller as well as a photographer. His current projects include a portrait book on celebrities to benefit UNICEF, a photo book, *Woman—A Secret Folio*, and a film, "The Wizard of Loneliness."

PORTNOY, LEWIS (Photojournalism, Corporate/Industrial)
5 Carole Ln., St. Louis, MO 63131 (314) 567-5700

Born: 1941 *Subject Matter:* Sports, People, Events *Situations:* U.S. & Foreign Locations *Awards:* Emmy Award; Flair Award *Education:* Menlo College; U. of Missouri

A specialist in high-speed action and sports-related photographs, Portnoy began his career inadvertently, with an amateur photo of a fight at a baseball game. He was soon covering the National Hockey League, where he developed an innovative radio-activated strobe system which has since become an industry standard. His ability to creatively capture dramatic moments in virtually all sports has led to contracts with NBC and CBS Sports, Anheuser-Busch, Canon USA and the 1984 Summer Olympics, among others. In the course of his twenty years as a professional photographer, his work has appeared in almost every major national publication, from *Newsweek* to *Sports Illustrated*. In addition to covering about 250 major sporting events a year, Portnoy founded *Goal* magazine. He has published four books, including *Horse Camping* (Dial Press) and *Stealing is My Game* (Prentice-Hall). He has also established Spectra-Action, Inc., a stock photography agency with over 500,000 transparencies.

POST WOLCOTT, MARION (Photojournalism)
400 E. Pedregosa G, Santa Barbara, CA 93103

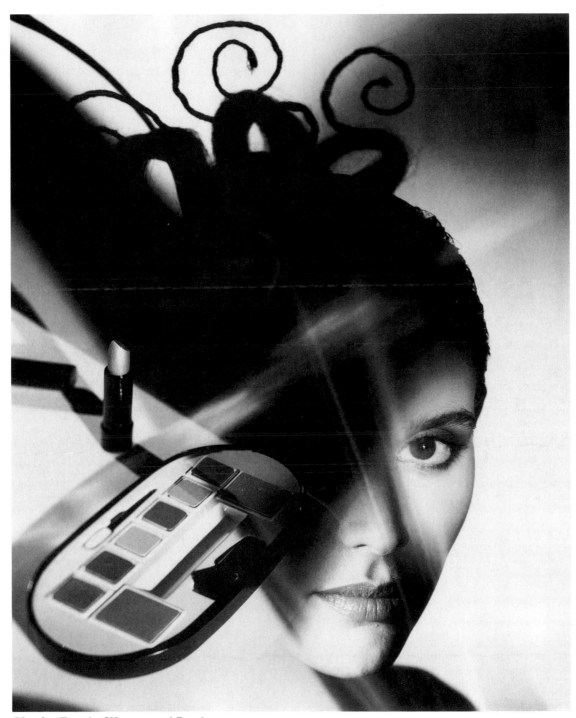

Charles Purvis, *Woman and Borghese*

Born: 1910 *Subject Matter:* Documentary *Situations:* U.S. Locations *Awards:* Dorothea Lange Award *Education:* New School for Social Research; New York U.; U. of Vienna

She worked as principal photographer in the Documentary Photography Section of the U.S. Farm Security Administration in the late 1930s, where she began photographing the poor in America, especially in rural areas. To contrast with this, she also photographed people of the the upper middle-class and the affluent. The contrast was intended to heighten awareness of separation that existed in America between the classes, thus rallying support behind the programs of the New Deal. She returned to photography in the early 1970s in an attempt to capture the socio-political changes that occurred following the Vietnam War. She has only recently returned to producing and exhibiting her photography. A substantial portion of her FSA photographs belong to the Library of Congress. She also worked for *Life* and *Fortune* in the late 1930s and was a staff photographer for the *Philadelphia Evening Bulletin*.

POWERS, DAVID (Advertising, Editorial)

17 Brosnan, San Francisco, CA 94103 (415) 864-7974

Born: 1944 *Subject Matter:* People *Situations:* Studio, U.S. Locations

Inspired by the black-and-white work of Frank, Smith and Cartier-Bresson, he began working for local California magazines. Later his work expanded to include assignments for *Time*, *Newsweek* and other national magazines. Throughout his career he has been inspired by photographing people, and he brings this interest to his present work for design studios and small advertising agencies responsible for annual reports, in-house magazines and marketing pieces. He works in all formats, but his first love is still black-and-white 35mm work.

POWERS, GUY (Advertising, Corporate/Industrial)

534 W. 43rd St., New York, NY 10036
(212) 563-3177

Born: 1946 *Subject Matter:* Animals, Food, People *Situations:* Studio, U.S. Locations *Awards:* New York City Poster Contest *Education:* Pratt Institute

Known for his images of food, hard goods, people and products, he has explored everything from painterly techniques to high-tech special effects. He has sold his photographs for use in billboards (Coors), posters, advertising (including AT&T, among others), packaging, television, newspapers and brochures. He lights both reflective and non-reflective surfaces and uses 8" x 10", 4" x 5" and 35mm. He pays special attention to working within budget constraints; he operates his own studio on the west side of Manhattan. "I enjoy creating works of art that stand the test of time, a quality image that makes me feel good and the viewer feel good," he says.

PREIS, DONNA (Corporate/Industrial, Advertising)

1526 N. Halsted, Chicago, IL 60622 (312) 787-2725

Born: 1952 *Subject Matter:* Architecture, Interiors, Still Life, People *Situations:* Studio, U.S. & Foreign Locations *Education:* School of the Art Institute of Chicago

Formal training emphasized the importance of a particular point of view, as well as non-traditional techniques such as print toning, hand coloring, cyanotypes and photo etchings. With the ultimate goal of enhancing reality, she brings to her corporate clients a combination of respect for the purity of the photographic image and an enjoyment of reworking that image. In addition to brochures, advertisements and posters for clients such as Schwinn, Bally, A.C. Nielsen and a variety of design and construction firms, Preis's photographs appear on greeting cards and in multimedia presentations. Editorial work is done in the studio for Chicago-area publications.

PRICE, PAMELA (Photojournalism)

321 A St., N.E., Washington, DC 20003
(202) 543-8116

Born: 1954 *Subject Matter:* People, Travel *Situations:* U.S. & Foreign Locations, Hazardous *Education:* Emerson College

Her daily calendar in Washington is filled with such photographic assignments as the President's daily photo-opportunities and senators' press conferences on Capitol Hill. She started her career at UPI in Boston; there, shooting for a set space, she learned to capture the "picture that told the story." From UPI she moved to the *Providence Journal*, where she "relearned the art and beauty of making many images work together to make a point." Wielding her 35mm camera and a variety of zoom lenses, she currently covers Washington for the agency The Picture Group, which syndicates and sells her work to publications all over the world. She shoots additional assignments for *Newsweek* and the Canadian *MacLean's*.

PRINCE, DOUGLAS DONALD (Fine Art)

173 Cypress St., Providence, RI 02906

Born: 1943 *Subject Matter:* Multi-Media *Situations:* Studio, U.S. & Foreign Locations *Awards:* Prix de la Ville d'Avignon, France; NEA Photography Fellowship *Education:* U. of Iowa

Prince has been influential in his experimentation with three dimensional photography. While in graduate school, he developed the idea of placing transparencies of images one behind the other in a plexiglas box to create a three-dimensional image. He has continued his search for new symbols, meanings and relationships in photography, juxtaposing a diversity of images into a single photographic image, in photo sculptures and black-and-white prints. He cites surrealist and symbolist painters, as well as Jerry Uelsmann, as influences in his work.

PURCELL, CARL (Photojournalism, Advertising)

5913 Skyline Heights Court, Washington, DC
(703) 845-1103

Born: 1928 *Subject Matter:* Travel, Wildlife *Situations:* U.S. & Foreign Locations *Education:* Indiana U.

His work frequently appears in major travel magazines, such as *Signature* and *Travel & Leisure*, and he also covers assignments for advertising and PR firms in the travel industry. He has written a column for *Popular Photography* for more than fifteen years. In addition, he co-writes a weekly syndicated column for Copley News Service that appears in more than 250 newspapers. His work is highly conceptual and often graphic; his strength lies in his ability to transform the mundane by adding elements of surprise, such as unexpected bits of color, to what might otherwise be an ordinary scene. When photographing wildlife, he relies

Philip Porcella

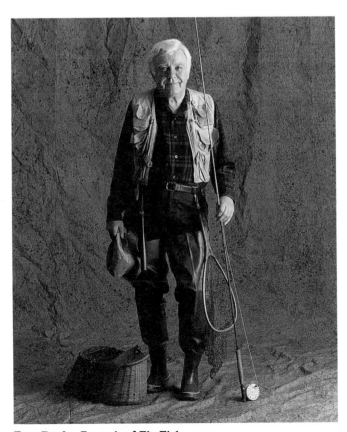

Ron Rack, *Portrait of Fly Fisherman*

on the spontaneity of his subject matter to provide the telling interaction that makes an image unique.

PURIN, THOMAS (Advertising, Editorial)
14190 Harbor Ln., Lake Park, FL 33410
(305) 622-4131

Born: 1941 *Subject Matter:* Fashion, Products, Travel *Situations:* U.S. Locations, Studio, Underwater, Aerial *Awards:* Addys; Silver Award, Underwater Society *Education:* New York Institute of Photography

Born in Tallinn, Estonia, he came to the United States in 1950. Growing up in New York, he worked first as an assistant, learning to shoot portraits. Early photographs included Carol Burnett, Joey Bishop, Sammie Kay, the entire Ballet Russe de Monte Carlo and the American Ballet Theatre. Next he spent seven years with an oceanographic film corporation, photographing underwater motion picture and still photography. Using custom Ribikoff, Bolex and Kodak equipment, he traveled from Rhode Island to Florida shooting footage of various underwater scenes. He became a press photographer for the *Post-Times* in 1968 and went to work on assignments ranging from portraits of King Hussein of Jordan to labor riots, space shots and the Democratic National Convention. Two years later, he was asked to establish the first photography department for *Palm Beach Life*, the oldest society journal in the country, and he became its director of photography. His assignments included lifestyle, fashion, architecture, yachting and travel. In 1978 he began his own studio; his major areas of interest and expertise remain fashion, industrial, architectural, product, marine, aerial and underwater photography.

PURVIS, CHARLES (Advertising, Editorial)
84 Thomas St., New York, NY 10013 (212) 619-8028

Born: 1954 *Subject Matter:* Still Life, People *Situations:* Studio *Education:* Art Center College of Design

His preferred subjects have changed over the years from food to products and people, with recent interest in still life and beauty. He enjoys using photographs as a medium of expression, exploring the possibilities of multiple exposures and multiple images. The pictures, in black and white and in color, are expressions of a mood, a drama created with light. His use of direct incandescent light allows him not only to dramatically capture the subject, but also to compose with highlight and shadow. He also uses multiple exposures to redefine scale, perspective and space. Working in many formats, up to and including the 20" x 24" Polaroid, what he really enjoys most is the photographic process, as he strives to produce images "that speak of the magic and beauty that results when light touches film."

QUAT, DANIEL (Advertising, Editorial)
57 Leonard St., New York, NY 10013 (212) 431-7780

Born: 1948 *Subject Matter:* Nature, Products *Situations:* Studio, Location

Influenced by Caponigro, Weston and Tice, he began his career making large-format portraits and nature images. His early commercial work included annual reports, architectural photography and corporate photography. He later used laser light and fiber optics as props and backgrounds for his photographs of cameras, televisions and stereos. Currently, graceful styling and dramatic lighting characterize his work.

Whenever possible, he incorporates natural artifacts into his table-top compositions of perfumes, liquor and glassware. His clients include Estee Lauder, Bloomingdales, Cardu Scotch, Commodore Computer, Sony and wine and food magazines.

QUINNEY, DAVID, JR. (Advertising, Editorial)
423 E. Broadway, Salt Lake City, UT 84111 (801) 363-0434

Born: 1952 *Subject Matter:* People, Products *Situations:* Studio, U.S. Locations *Education:* Brooks Institute of Photography

He started his professional career in 1982 when he opened a commercial studio in Salt Lake City, specializing in advertising and corporate/industrial photographic illustration. Particularly skilled in black-and-white photography, he is known for his characteristic high contrasts. Unlike most photographers, he sets up a shot by removing light rather than adding it, creating a system of lighting that generates depth and dimension. His fine-art photographs of the scenic outdoors are shot with available light. His work has appeared in newspapers, magazines, corporate brochures and annual reports and advertisements.

QUIST, DAVID (Advertising, Editorial)
Number One Broadway, Salt Lake City, UT 84111
(801) 359-4470

Born: 1955 *Subject Matter:* People, Fashion *Situations:* Studio, U.S. & Foreign Locations *Education:* U. of California, Berkeley

Formally trained as a mechanical engineer, he began using photography as an aesthetic counterpoint to the rigors of engineering. Eventually, he chose photography as career because it allowed for the full integration of his vision and resources. Soon after his decision to become a full-time photographer, he won recognition as a live-performance photographer with an invitational one-man show at the Utah Arts Festival. He has since gone on to develop a unique style in fashion and editorial work, while bringing new focus, energy and insight to commercial, corporate and industrial projects. He splits his camera work between black and white and color, his black and white noted for its strong backgrounds, his color for its depth. He utilizes all formats, with an eye for capturing the "critical moment."

RABINOWITZ, NEIL (Advertising, Editorial)
P.O. Box 10171, Bainbridge, WA 98110
(206) 842-7270

Born: 1952 *Subject Matter:* Nature, People, Sports, Travel *Situations:* U.S. & Foreign Locations

He is a location photographer, perhaps best known for his photographs of dynamic water sports, industrials and cultural portraits. His work is also characterized by the production of strong graphic abstracts. He had his first magazine cover published in the mid-1970s and has since produced three or four features and/or covers per month. He works with American publishers and also has a steady clientele in Europe, Japan and Asia. His images appear in books, posters and graphics, including such magazines as *National Geographic*, *Sports Illustrated*, *Sail*, *Outside* and *Cruising World*.

RACK, RON (Advertising, Corporate/Industrial)
1201 Main St., Cincinnati, OH 45210 (513) 421-6267

Born: 1958 *Subject Matter:* People *Situations:* U.S. Locations, Studio *Education:* Ohio Institute of Photography

He had been a mechanical designer for four years when he decided to pursue a career in photography. His background makes him an efficient trouble-shooter, able to design difficult lighting set-ups, build complicated sets and perform difficult overhead and approach shots. He works half in color, half in black and white, splitting his time between studio and location shoots. He most enjoys photographing people in situations that reveal their character, in "slice of life" moments.

RAMEY, MICHAEL (Advertising, Editorial)

612 Broadway, Seattle, WA 98122 (206) 329-6936

Born: 1955 *Subject Matter:* People, Products *Situations:* Studio, U.S. Locations *Education:* Art Center College of Design

Working in photo-advertising for some ten years now, he began at the Art Center College of Design in New York, moved to Dallas, then finally set up his own Studio in Seattle, Washington. Specializing in "people/product" illustrations, he has worked for such companies as Weyerhauser, Boeing Aerospace and Kenworth Trucks. Much of his photography appears in periodicals, brochures and annual reports. Attracted to a challenge, he prides himself on interpreting a designer's vision on film, no matter what it takes to get the job done. He specializes in unusual studio work, creating images such as lobsters dressed for dinner, landscapes of huge whirling gears, or floating racks of microchips.

RANNEY, EDWARD (Nature, Photojournalism)

Route 2, Box 299, Santa Fe, NM 87501
(505) 471-2431

Born: 1942 *Subject Matter:* Nature, Archaeology *Situations:* U.S. & Foreign Locations *Awards:* Guggenheim Fellowship; NEA Fellowship *Education:* Yale U.

In 1964, he began photographing seriously during a Fulbright fellowship in Cuzco, Peru. His work there involved the discovery and printing of the Martin Chambi archive. His first book, *Stonework of the Maya*, was published in 1974. In 1979, his one-man exhibit of photographs of Inca monuments opened at the Museum of Modern Art and in 1982 he published his second book, *Monuments of the Incas*. His recent work includes commissions for exhibits and publications in England, Peru and New Mexico. His work has appeared in *Artspace, Exposure, Albuquerque Living* and the *Santa Fe Reporter*.

RANSBURG, TOM (Advertising, Corporate/Industrial)

8620 Green Braes N. Dr., Indianapolis, IN 46234
(317) 291-6562

Born: 1942 *Subject Matter:* Fashion, Products *Situations:* Studio, U.S. Locations *Education:* Rochester Institute of Technology

He is an advertising illustration and commercial photographer who believes in doing one project at a time and doing it extremely well. He began his studio operation in 1974 working for advertising agencies, design firms and industrial and commercial clients. He uses only top of the line equipment and travels with extensive equipment when necessary. He is a member of the Professional Photographers of America and has work in the permanent exhibit of the International Photography Hall of Fame. "I do not manage employees. Instead, I make photographs and work with clients to understand and solve their problems."

RANSON, JAMES (Scientific)

P.O. Box 501, Laguna Beach, CA 92652
(714) 497-2621

Born: 1949 *Subject Matter:* Radiographs, Medical Instruments *Situations:* Medical, Research *Education:* Art Center College of Design

He was trained as a product illustrator and commercial advertising photographer. In 1982 he gave up commercial freelance photography to become the head photographer for a large radiology department in a teaching hospital. He is responsible for all of the department's visuals and his work includes everything from making photographs from electron microscopes to shooting laser-angioplasty procedures. Some of his projects have included working with university researchers and providing slides and prints for documentation and publication. His latest project involved making photographs from holographic glass plates for plastic surgeons. He is currently working on photographing the corpus callosum (found in the mid-section of the brain) from magnetic-resonance imaging films.

RASHAKOOR (Advertising, Editorial)

5275 S. Wells, 2nd Floor, Chicago, IL 60607
(312) 663-4412

Born: 1946 *Subject Matter:* Fashion, People *Situations:* U.S. & Foreign Locations *Awards:* Member, ASMP

She began her career as a fine-art painter in New York City. Finding spontaneity missing from her documentation of contemporary American culture, she expanded into what she thought was an instant art form—photography. She then began shooting editorial and fashion, merging her contemporary cultural statements with fashion, beauty and personality concerns. Her first advertising assignments were for American Express. She now shoots internationally, and her clients have consisted of some of the most innovative and creative magazines in the world. She is presently working on a one-woman show at Chicago's Neal Gallery. Her work has appeared in *Vogue, Bazaar, L'-Espresso, Women's Wear Daily, Apparel News* and *GQ*.

RASKIN, LINDA (Fine Art)

55 W. 70th St., #5B, New York, NY 10023
(212) 580-0038

Born: 1949 *Subject Matter:* Nature, People *Situations:* Fine Art *Education:* International Center of Photography; School of Visual Arts, NYC

She photographs situations not with sharp, well-defined edges, as one would perceive them in everyday life, but altered, as one might see them in a dream. Her images are infused with an emotional charge, which she achieves through primitive plastic cameras and alternative printing techniques. She is drawn to the mysterious and unexplained, and her landscapes and studies of people have an enigmatic and disquieting quality to them. The photographs range in size from 13" x 13" to 36" square. They have a subtle pink-brown tonality and a textural, grainy quality evocative of drawings or etchings.

RAUCH, BONNIE SUE (Advertising, Corporate/Industrial)

Crane Rd., Somers, NY 10589 (914) 277-3986

Born: 1944 *Subject Matter:* People, Nature *Situations:* U.S. & Foreign Locations, Aerial *Education:* CUNY; Miami Photo Workshop

Primarily self-taught, she began dabbling in photography as a hobby, photographing flowers. She then started photographing children. Today, she is a photographer and entrepreneur with an M.B.A. to her credit, and she has successfully incorporated her marketing expertise into her creative work to develop clients in the corporate/industrial arena. The bulk of her shots are of world headquarters, production facilities, executive portraits, interior decor and design, although she also occasionally does small product/studio work. While her images employ a strong sense of graphic design, it is never at the expense of the spirit of her subjects. Her stock is handled worldwide by The Image Bank, in such categories as people, food and scenic/travel.

RAYMOND, LILO (Fine Art)

212 E. 14th St., New York, NY 10003

Born: 1922 *Subject Matter:* Still Life *Situations:* Studio

Born in Frankfurt, she emigrated with her mother to the United States in 1939 and worked odd jobs until 1961, when she studied photography with David Vestal in New York City. Highly influenced by painting, her simple and ordered still lifes can be said to be reminiscent of Cezanne. She uses a 35mm Nikon to take serene, controlled silver prints of inanimate objects, which she calls "the quieter evidences of people." She is concerned with grain and texture, the tonal gradations resulting from subtle changes in light. She uses sidelight and backlight to best capture the minute tonal variations of a subject. Recently she has been interested in the way sunlight comes in contact with windowpanes "to create a dramatic glare." Since 1978, she has worked as an instructor at the School of Visual Arts in New York. Public collections include the Metropolitan Museum of Art in New York City and the Bibliotheque Nationale, Paris.

RAYMOND, TOM (Advertising, Scientific)

Route 6, Box 424C, Jonesborough, TN 37659 (615) 753-9061

Born: 1947 *Subject Matter:* People, Nature, Architecture *Situations:* Hazardous, U.S. Locations *Education:* U. of Tennessee; U. of East Carolina

A doctor turned photographer, much of his work involves photographs for hospitals and health care, including pictures of actual operations. Outside of the medical and scientific domain, he has also done photo essays for *Sports Illustrated*, documenting college football events, as well as travel work for the *New York Times*. His work for corporations includes shots for annual reports, corporate portraits and architectural subjects. In all his work, he specializes in photographing people, and in addition to his corporate clients, his portfolio includes work for advertising and editorials.

REED, STEVE (Advertising, Corporate/Industrial)

83 S. King St., Suite 611, Seattle, WA 98104 (206) 624-2531

Born: 1947 *Subject Matter:* Nature, Human Environments *Situations:* Studio, U.S. Locations *Education:* U. of Washington

An amateur photographer for many years, he began to supplement his writing income with photography in 1977. In 1979, he opened his own studio, specializing in visual communication. He now combines his writing and photographic skills to present his clients with a consistent, cohesive package. He also writes, shoots and produces small format multi-image slide presentations for corporations and public agencies. His work is often seen in annual reports, newspapers, newsletters, advertising, catalogues, brochures and other printed materials. He holds the contract for audio-visual services with King County, Washington.

REICHMAN, AMY (Advertising, Editorial)

Studio 21, Howard St., New York, NY 10013 (212) 966-0216

Born: 1953 *Subject Matter:* Food, People, Products *Situations:* Studio, U.S. Locations *Awards:* Scholarship, Art Center College of Design *Education:* Colorado College; Art Center College of Design

She was a painter since childhood, but she began making photographs for her high school annual at the age of fifteen. In her late twenties she began concentrating only on photography and now operates her own Manhattan studio. She has developed a point of view involving the unexpected, provoking responses such as "playful," "left-handed," "offbeat," and "humorous." In one piece she juxtaposed pieces of raw fish to create a "McSushi Burger." Her clients have included Hebrew National, AT&T, Avon, NYNEX and American Express.

REISS, PETER (Portraiture)

412 S. Cloverdale, #8, Los Angeles, CA 90036 (213) 936-0562

Born: 1953 *Subject Matter:* People *Situations:* Studio *Awards:* NEA Photography Fellowship; Ferguson Grant *Education:* California Institute of the Arts; Kenyon College

He started making photographs under the guidance of his father, who was a photojournalist. He now works as a fine arts photographer in Los Angeles. His subjects are groups of people who have gone through some traumatic occurrence and have become survivors. The mentally retarded, developmentally disabled, and the physically handicapped, as well as the defeated athletes at the Olympics, have all been subjects for his photographs. In 1987, he was awarded the Ferguson Grant from the Friends of Photography in Carmel, California for his work with the mentally retarded. He is currently photographing heroin addicts who are undergoing methadone treatment. He is a full-time photography instructor at Otis-Parsons School of Art and Design.

REXROTH, NANCY LOUISE (Fine Art)

2631 Clearview Ave., Cincinnati, OH 45206

Born: 1946 *Subject Matter:* People, Landscape *Situations:* Studio, U.S. Locations *Awards:* NEA Grant *Education:* Marietta College; American U.; Ohio U.

Early in her photographic career, Rexroth used a Diana camera to capture a series of images for her book, *Iowa*, which deals with memories and dreams as well as the American Midwest. More recently, she

Larry Reynolds, *Staffordshire Bull Terrier.* Client: Mercedes Benz of North America

Jack Richmond

works with the SX-70 transfer process, photographing abstract images and landscapes.

REYNOLDS, LARRY (Advertising, Editorial)

3630 W. 183rd St., Homewood, IL 60430
(312) 799-6851

Born: 1937 *Subject Matter:* Animals, Travel, People *Situations:* U.S. & Foreign Locations *Awards:* Artists Guild of Chicago *Education:* Governors' State U.; U. of Chicago

Growing up on a farm in Indiana, he became fascinated with the exhibition of animals and zoology. A biologist, his photographic files of dogs and other animals are widely used in advertising, textbooks, encyclopedias and kennel magazines. He does little studio work, preferring to work on location with natural light. He has landscaped his suburban Chicago acreage for specific seasonal shots. Serving as a consultant, judging at dog shows and visiting kennels in the Orient and in the Americas have all given him the opportunity to photograph animals and people at all levels of society—working class and aristocratic, urban and rural. He is greatly influenced by Tausky's animal photography and has recently branched out into livestock subjects.

RICE, LELAND DAVID (Fine Art)

Box 4100, Inglewood, CA 90309

Born: 1940 *Subject Matter:* People, Interiors, Landscape *Situations:* Studio, U.S. Locations *Awards:* NEA Grant; Guggenheim Photography Fellowship *Education:* Arizona State U.; Chouinard Art Institute; San Francisco State College

Influential on Rice's work were Jack Welpott, Don Worth, Oliver Gagliani and Paul Caponigro, all of whom he encountered during his years of formative education. Rice's large-format images in black and white and color are abstracted, minimalist and surreal. He presents furniture in an unoccupied interior to allude to human presence. He produced a series of portraits using unoccupied chairs. He has also created a series of stark interiors, devoid of any accoutrements.

RICE, MARK (Corporate/Industrial, Entertainment)

2337 El Camino Real, San Mateo, CA 94403
(415) 345-8377

Born: 1953 *Subject Matter:* People, Products *Situations:* Studio, U.S. Locations *Awards:* Monterey Ad Club

Whether his subject is living or inanimate, his goal is to illustrate inner beauty through expressive lighting techniques. He began making photographs at the age of nine. In 1975 he started a career in industrial photography in Detroit. In 1978 he moved to Los Angeles and took a job as production manager with Harry Langdon. In 1980 he opened his own studio and has since worked for Paul Jasmine on such films as "An Officer and a Gentleman" and "Rocky III." He is currently working in Northern California, shooting for corporate and advertising accounts. The hallmark of his work is a consistency of style through varying subject matter.

RICHARDS, EUGENE (Photojournalism)

251 Park Ave., S., New York, NY 10010

Born: 1944 *Subject Matter:* People, Travel, Documentary *Situations:* U.S. Locations *Awards:* Guggenheim Fellowship; NEA Grant *Education:* Northeastern U.

His work takes him on the road to various locations in which he documents "players and scenes in the human drama." His recent book, *Below the Line,* won the 1987 International Center of Photography Journalism Award. Chronicling the lives of poverty-stricken Americans, Richards' black-and-white photographs are combined with excerpts of taped interviews in which the subjects talk about their lives. His photographic style highlights the off-balance and disjointed, using seemingly inconsequential details or manneristic juxtapositions to capture the essential quality of the subject. He is represented by Magnum, Inc., and his other publications include *Dorchester Days* and *Few Comforts or Surprises: The Arkansas Delta.*

RICHMOND, JACK (Advertising, Corporate/Industrial)

Jack Richmond Studio, 12 Farnsworth St., Boston, MA 02210 (017) 482-7158

Born: 1947 *Subject Matter:* People, Food *Situations:* U.S. & Foreign Locations, Studio *Awards:* Hatch Award, One Show, Graphic Design *Education:* Art Center College of Design

In school, he was heavily influenced by Charles Potts' instruction on "the essence of light" and its application to the photographic media, and this has continued to influence the way he lights his work. His lighting has also been inspired by Edward Steichen and Yousuf Karsh. After graduation in 1971, he moved to Boston and worked with Frank Foster for five years, further refining his photographic skills. He opened his own studio in 1977, now one of the leading commercial photography studios in Boston. In 1980, he spent several months living with the Masai tribe in Africa, an experience which, he says, "had a profound effect on the way I approach my work today." His commercial work includes a wide range of subjects, from cars to ice cream to major photographic illustrations. His pictures have been featured in *The Creative Black Book,* among other publications, and he has done both corporate and advertising work for numerous local and national clients, including Honeywell Bull, NEC, Lotus Software, Molson, Spalding, Prima Computors, Pan Am and Polaroid.

RICHTER, CURT (Editorial)

200 W. 86th St., New York, NY 10024
(212) 580-2724

Born: 1956 *Subject Matter:* Still Life, Portraiture *Situations:* Studio, U.S. & Foreign Locations *Awards:* New York State Council of the Arts Award; Grant, Fellowship of Southern Writers *Education:* SUNY, Purchase

Coming to New York with a fine art background in photography, he learned the technical aspects of commercial work assisting several corporate photographers in the city. He shot corporate portraiture on assignment, while in the studio he refined his still-life photography. After five years assisting, he began showing his personal portfolio to various magazines and soon he was shooting for catalog, trade ads and even political campaign coverage. He has since established himself, shooting still lifes and portraiture for *Esquire, House & Garden, People, Connoisseur, Condé Nast Traveler* and the *New York Times Magazine,* among

other national magazines. In the past year, travel assignments have taken him to Venice, Italy as well as up the Hudson Valley to Albany, photographing the towns and landscape. In each, he worked with black-and-white platinum and palladium film, using a process that produces a image that looks more like a lithograph or etching than a standard photo. Much of his commercial work, however, is in color while his personal work is primarily in black and white.

RIGGS, ROBIN (Advertising, Editorial)
3785 Cahuenga Blvd. W., Studio City, CA
(818) 506-7753

Born: 1950 *Subject Matter:* Cars, Motorcycles *Situations:* Studio, U.S. Locations *Awards:* New York Art Directors Award; Clio

His primary subjects are cars and motorcycles. His commercial clients have included Honda, Yamaha, Kawasaki, Suzuki, AMC/Jeep, Isuzu, Alpine Stereo, Luxman Stereo, Armor-All and Goodyear. His editorial clients have included *Cycle, Cycle Guide, CycleD, Cycle SI, Cyclist, Motorcycle, Motorcyclist, Car and Driver, Road & Track, Automobile, Das Moto Rad, AutoWeek* and *Auto Motor and Sport.*

RILEY, RICHARD (Advertising)
34 N. Ft. Harrison Ave., Clearwater, FL 34615
(813) 446-2626

Born: 1950 *Subject Matter:* Fashion, Food *Situations:* Studio *Awards:* Clio; Addy

Owner of Richard Riley Productions, he has been shooting award-winning photography for over twenty years. In that time he has shot all kinds of subjects both in still and in motion picture photography, his speciality being his ability to take a still-life concept and transfer it to film. He has published in magazines, newspapers, print ads, annual reports and television commercials, as well as in a scenic pictorial book on the Gulf Coast of Florida. His work has been well received outside the U.S. in such countries as Japan, the Netherlands, Germany, England and Canada. Recently he has been concentrating on shooting food in stills and film.

RIPPE, RALPH (Advertising, Editorial)
1001 E. Sheridan St., Phoenix, AZ 85006
(602) 254-7366

Born: 1953 *Subject Matter:* Interior Design, Architecture *Situations:* Studio, U.S. Locations

He is a generalist whose philosophy is to work quickly and accurately. He began his career by opening a custom black-and-white lab, servicing a select group of photographers and advertising agencies. He has traveled through the Northwest shooting scenics and wildlife. He now owns a small but fully equipped studio and handles assignments for such editorial and corporate accounts as *Arizona Trend, Phoenix Metro Magazine,* Ramada Corporation, Alfa Romeo and McCormick/Schilling.

RISS, MURRAY (Fine Art)
1306 Harbert Ave., Memphis TN 38104

Born: 1940 *Subject Matter:* People, Nature, Interiors *Situations:* U.S. Locations, Studio *Awards:* NEA Fellowship *Education:* City College of New York; Rhode Island School of Design

His black-and-white prints capturing children at play are illustrative of his interest in the primordial conflict between what is real and what is imaginary. For ex-

ample, a young boy lies on a lawn with three similarly shaped logs, later appearing next to his silhouette in leaves, finally joined with others, as only their hands reach out of a dense thicket. "All are part of the apparitions which try to ascertain the proximity between photographic possibilities and the turmoil in my mind," he says. A professor at the Memphis Academy of Arts, he published *The Sleep Book* with Shirley M. Linde in 1974 and *Portfolio* in 1975. His work has appeared in the anthology *Vision and Expression* as well as in periodicals such as *Creative Camera, Modern Photography* and *Popular Photography.* Collections include the Art Institute of Chicago, the Museum of Modern Art and the Bibliotheque Nationale in Paris.

RITTENHOUSE, RON R. (Photojournalism, Portraiture)
11 Faimor Dr., Morgantown, WV 26505
(304) 296-3871

Born: 1945 *Subject Matter:* Animals, Nature, People, Sports *Situations:* Studio, Hazardous *Awards:* 1st Place, Sports, News, National Press Photographers' Association

As chief photographer for the *Morgantown Dominion Post* in Morgantown, West Virginia, he has been most influenced by the people who see his work every day. He is a stringer for the Associated Press, and his pictures have been published in *Time, U.S. News & World Report* and *National Geographic.* He does portraits, commercial work and creative weddings and is most noted for his color outdoor scenes, sports photography and feature photography.

RIVELLI, WILLIAM (Advertising, Corporate/Industrial)
303 Park Ave. S., New York, NY 10010
(212) 254-0990

Born: 1935 *Subject Matter:* Fashion, Architecture *Situations:* Studio, U.S. & Foreign Locations *Awards:* Art Directors Club Award *Education:* Brown U.

Known for his wide diversity of expertise, he shoots still lifes, portraits, architecture and people on location. He began his professional career as an assistant to Nina Leen at *Life.* Later he apprenticed to Ralph Steiner, William Vandivert and Rudy Miller. He now has his own Park Avenue studio. His graphic images have a bold, sharp quality. He is comfortable with all formats (35mm, 2 1/4", 4" x 5", 5" x 7") and is equally competent with color and black and white. His work has appeared in annual reports, advertisements, corporate brochures and site-specific theatre productions. Both *Photomethods* and *Communication Arts* have showcased his images and techniques.

ROBBINS, LOUISE (Editorial, Photojournalism)
12322 Woodthorpe Lane, Houston, TX 77024
(713) 464-6572

Subject Matter: Nature, Travel *Situations:* U.S. Locations, Studio *Education:* U. of Illinois

She began her career as a craftsman-artist photographer, and her skills as a writer soon made it possible for her to work as an editor for the Houston West Chamber of Commerce. As such she was able to shoot for many articles and newsletters and brochures, producing editorial illustrations for trade shows and community health care programs as well. Her stock photography includes photos from her travels in the

U.S. and abroad. Some of this work has been used by various environmental groups; she often captures the beauty in the landscape with close-ups of wild flowers and cactuses.

ROBERTS, EBETS (Advertising, Entertainment)

245 W. 107th St., Apt. 10C, New York, NY 10025
(212) 316-3696

Subject Matter: People *Situations:* Studio, U.S. Locations

He photographs all kinds of entertainment personalities, especially people in the music field. He has a studio in New York and travels extensively, covering music events throughout the U.S. and occasionally abroad. His photographs have appeared on album covers, posters, advertisements, promotional materials and in such publications as the *New York Times, USA Today, Newsweek* and *People.*

ROBERTS, INES E. LABUNSKI (Fine Art)

3340 Cliff Dr., Santa Barbara, CA 93109
(805) 682-1088

Born: 1929 *Subject Matter:* People, Found Objects, Nature *Situations:* U.S. & Foreign Locations *Awards:* Bronze Medal, Nikon International, 1989; Gold Medal, London Salon of Photography, 1988; 1st Prize, Sierra Annual Contest; BBC Wildlife Award *Education:* U. of Essex, England

Her serious involvement in photography began in 1968 after she emigrated from Scotland to California. She documented the efforts of the international assistance organizations Direct Relief International and Amigos de las Americas in Guatemala. Her prints have been exhibited in the U.S., England, West Germany, Switzerland and Czechoslovakia, and her work has been featured in *Minolta Mirror, Artweek, Foto Creativ* and *London Photo News.* She has taught numerous workshops in San Francisco, and for the last eleven years at the University of California at Santa Barbara. She works with Cibachrome in delicate pastels, transforming light and shape into abstract elements, some of her work recalling the strong compositions of Georgia O'Keeffe's paintings. She is also one of the pioneers in multi-media presentations, in which music dictates the theme, mood and rhythm of a slide sequence, creating a new dimension and harmony. These works have premiered at the Brooks Institute and Santa Barbara Museum of Art and have been shown widely throughout California and Illinois. Her concern is to find and render what is essential in a subject—to create a harmony out of bewildering confusions, or to free images from their accepted context and give them a new meaning as uniquely *her* interpretations. The final picture conveys mystery and is the result of a deliberate planning sparked by an initial intuitive reaction.

ROBINSON, CERVIN (Corporate/Industrial, Editorial)

251 W. 92nd St., Apt. 10E, New York, NY 10025
(212) 873-0464

Born: 1928 *Subject Matter:* Architecture *Situations:* U.S. & Foreign Locations *Awards:* Guggenheim Fellowship; Institute Honor, American Institute of Architects *Education:* Harvard U.

In the late 1950s, he began photographing new buildings for the *Architectural Review* and old ones for the Historic American Buildings Survey. He presently photographs for architects and historians, and his pictures appear in magazines, books and exhibitions on architecture. He is co-author of two books: *Skyscraper Style: Art Deco New York* (Oxford, 1975) and *Architecture Transformed: A History of the Photography of Buildings from 1839 to the Present* (MIT Press, 1987). The catalogue of a retrospective of his work is *Cervin Robinson: Photographs, 1958-1983* (Wellesley College, 1983). He has taught a summer course in architectural photography at Columbia University since the late 1970s.

ROBINSON, DAVE (Advertising, Corporate/Industrial)

911 Western Ave., Seattle, WA 98104 (206) 624-5207

Born: 1943 *Subject Matter:* People, Products, Special Effects *Situations:* Studio, U.S. Locations *Education:* Art Center College of Design; Orange Coast Junior College

After a short stint as an assistant, he became an in-house photographer for a Los Angeles mail order house. In 1976 he moved to Seattle where he continued shooting for catalog companies before opening a studio with a partner, his wife Gayle. A photo illustrator, he shoots products in a clean, straightforward style, and people in a way that seeks to express their character. His imagery often speaks to the human condition. Adept at special effects, one of his best-known images is a shot of the Seattle skyline in which plastic buildings are occupied by fish. His accounts are primarily high-tech industrial and commercial firms such as Boeing Aerospace, Microsoft and Hewlett-Packard.

ROBINSON, DAVID (Fine Art)

159 W. Canton St., Boston, MA 02118

Born: 1936 *Subject Matter:* People, Travel *Situations:* U.S. & Foreign Locations *Awards:* NEH Fellowship

After a formal education in African Studies, Sociology and Education, he studied photography at workshops in Carmel, California and in Arles, France. He had been taking photographs since his field work in Ghana and Nigeria, when he first took pictures of the local people, most notably close-ups of children. After coming to Boston in 1970, he became a freelance photographer and made a series of high-contrast abstract prints of a woman doing yoga, in which his main concern was to capture the flowing energy of her movements. Since then he has made several other series, including one made in the late 1970s in Italy, entitled "Reflections." These color photographs, made without multiple exposure or other manipulation, show reflections in glass or water, as in *Piazza Navonna Cobblestones,* in which a passerby and a church are reflected in a puddle. He has also made a series of pictures taken in Mexico and is now experimenting with computer techniques.

ROBINSON, MICHAEL D. (Advertising, Corporate/Industrial)

2413 Sarah St., Pittsburgh, PA 15203 (412) 431-4102

Born: 1953 *Subject Matter:* Products, People *Situations:* Studio, U.S. Locations *Awards:* Philadelphia Art Directors Club; Mead Paper Co. *Education:* Rochester Institute of Technology

He is a Pittsburgh commercial photographer who services advertising agencies, graphic design firms and

Ines E. Labunski Roberts, *Flying Forks*

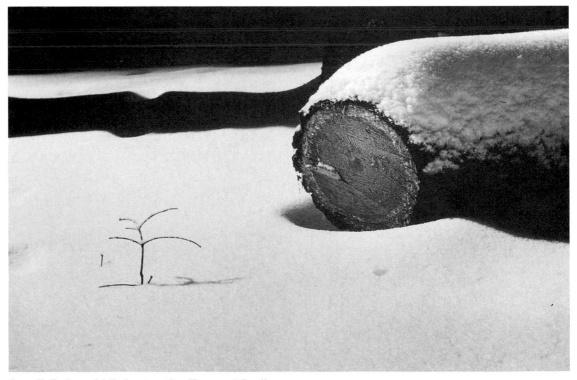

Ines E. Labunski Roberts, *Cut Tree and Sapling*

corporations. He built his business by shooting products and people for advertising and public relations brochures and by displaying problem-solving capabilities in the studio and on location. While most of his work is for commercial use, he maintains a strong commitment to photography as a pure art form, often employing abstract color and motion. Among his clients are PPG Industries, Cyclops Corp., NCR, Quaker State Oil Co., Carnegie-Mellon University and General Nutrition Centers.

ROBSON, HOWARD (Nature, Fine Art)
3807 E. 64th Pl., Tulsa, OK 74136 (918) 492-3079

Born: 1919 *Subject Matter:* Wildlife, Sports *Situations:* U.S. & Foreign Locations

After a long career in business, he retired in 1977. In 1983 he bought his first Nikon and set out to teach himself photography. He now works with many Nikons as well as medium- and large-format cameras. He shoots architectural, commercial/industrial, nature and wildlife photographs. His photographs have been used for books, magazine covers, postcards and calendars and have been published in *Grit, Guidepost* and *Sierra.* In 1986 he mounted a thirty-three print show called "China Remembrances." In 1987 he had an exhibition of wildlife images at the Pictures Gallery in Tulsa.

ROCKHILL, MORGAN (Advertising)
204 Westminster Mall, Providence, RI 02903

Born: 1949 *Education:* Rhode Island School of Design

He specializes in photographing both food and glass, developing as much mood as possible with custom-built lights and clean use of special effects. Within the mood created, there is an emphasis on showing the product clearly and distinctly, thus creating precise images of products often difficult to photograph. His background in engineering contributes to the elaborate set constructions he uses when not working on location. This background lends an overall consciousness of detail to all his shots of products, particularly those that are high-tech.

RODNEY, ALLEN (Advertising, Fine Art)
375 Hickory Grove, B-Hills, MI 48013 (313) 338-4586

Born: 1932 *Subject Matter:* People, Fine Art *Situations:* Studio, U.S. Locations

He owned and operated a prosperous commercial studio near the United Nations for twenty years. During that time, his clients included Dannon Yogurt, American Ultramar Oil, Macmillan Publishing, General Motors Corporate Affairs and *Good Housekeeping* Magazine Sales and Promotion. In 1974, he sold his business and became photographer for the Metropolitan Museum of Art, where his duties included photographing a great variety of renowned treasures for publication and house record. In 1978 he moved to Michigan to take the position of director of photography for the C.B. Charles Auction Galleries in Pontiac. There, he produced a high volume of studio and location fine-art photography for catalogs and newspaper and magazine ads. In 1984 he began his Bloomfield Hills, Michigan studio operation. He now photographs fine arts, glamour portraits and room interiors for private clients.

RODY, JOHN (Portraiture, Public Relations)
205 E. 78th St., Suite 1D, New York, NY 10021 (212) 584-3887

Born: 1950 *Subject Matter:* People *Situations:* Studio, U.S. Locations *Education:* New York U.

He has a knack for making people feel at home in front of the camera. His subjects look comfortable and at ease. His work is divided between public relations and portraiture, two situations he sees as similar, since both deal with people who are influential in their field. He has been influenced by photographers past and present, outrageous and ultra-conservative. He has an open mind toward new techniques and ideas. "I believe that without experimentation one cannot learn, and without learning, one cannot succeed," he says.

ROEPKE, LARRY W. (Portraiture, Advertising)
3324 Grand Ave. S., Minneapolis, MN 55408 (612) 827-0904

Born: 1953 *Subject Matter:* People *Situations:* U.S. Locations, Studio *Education:* Minneapolis College of Art and Design

He began his career as a photographer in the U.S. Navy, securing a solid technical background. After four years there, he attended the Minneapolis College of Art and Design, where he earned a B.F.A. degree in photography. His experience there prepared him for his first job as a photojournalist at the *Worthington Daily Globe* in southern Minnesota. Finding himself more interested in editorial and advertising photography, he returned to Minneapolis to begin as a studio assistant, then opened his own studio in 1980. Concentrating on photographing people, he works for a number of ad agencies and editorial magazines. His shots are characterized by their straightforward, simple quality. Working as close to his subjects as possible, he prefers using available light, opting for a "window light" effect. In the past two years, he has become best known for his portraits of corporate executives.

ROHR, ROBERT (Fine Art, Editorial)
325 E. 10th St., New York, NY 10009 (212) 674-1519

Born: 1943 *Subject Matter:* People, Travel *Situations:* Studio, U.S. & Foreign Locations *Awards:* Salmagundi Club

In the late 1960s, he began publishing in commercial newspapers, book club brochures, publishers' catalogs, periodicals and art and literary magazines, including the *Chicago Review.* Until recently he used only black-and-white film. He now uses color film for travel photography featured in such magazines as *Robb Report, World, Nightlife, Fine Homes* and *Where.* His work has also appeared in the *New York Times, Advertising Age* and *New York Night Life.* He has exhibited at Parrish Museum in Southampton, New York and the Heckscher Museum in Huntington, New York.

ROITZ, CHARLES J. (Fine Art)
U. of Colorado, Fine Arts Department, Campus Box 318, Boulder, CO 80309 (303) 492-6645

Born: 1935 *Subject Matter:* Nature *Situations:* U.S. Locations *Awards:* NEA Fellowship and Photo Survey Grant *Education:* San Francisco State U.

He began his career in 1954 as a photographer and motion picture specialist for the U.S. Navy. After his discharge, he served in similar capacities with the defense contractors Martin Marietta and Dow Chemical. In 1963, he became a Producer/Director for KOA Television in Denver. In 1966 he returned to college, receiving his Masters in art and photography from San

Morgan Rockhill. Models: Faith Phillips and daughter

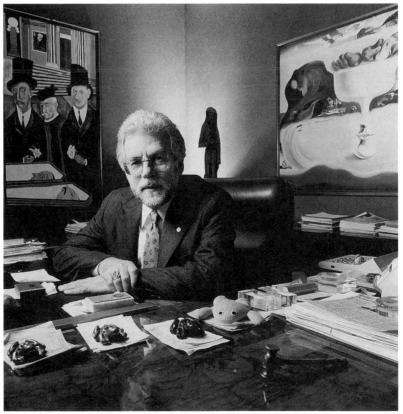

Larry W. Roepke, *Ron Meshbesher-Lawyer.* Client: Corporate Report, Minnesota

Francisco State. Since 1968 he has pursued a career in education and fine-art nature photography. He has exhibited widely, and his work is in the collections of the International Museum of Photography at the George Eastman House, the Museum of Modern Art and the Art Institute of Chicago. He is a professor of fine arts at the University of Colorado in Boulder.

ROKACH, ALLEN (Advertising, Photojournalism)
New York Botanical Gardens, Bronx, NY 10458 (212) 220-8698

Born: 1941 *Subject Matter:* Nature, Wildlife *Situations:* Studio, U.S. Locations *Awards:* National Geographic Grant *Education:* Brooklyn College; Queens College

His photographic vision is an outgrowth and continuation of the innovative work of Ernst Haas. He uses natural and artificial light in dramatic ways, especially outdoors. A former geologist, he is best known for using nature to enhance corporate images, showing products in natural settings, or in front of gardens or sculptures. His photographs have appeared in *Audubon*, *Natural History*, *Smithsonian*, *Modern Photography*, the *New York Times*, National Geographic Books and Time-Life Books. He is director of photography at the New York Botanical Gardens and director of the Center for Nature Photography.

ROKEACH, BARRIE (Fine Art, Editorial)
32 Windsor, Kensington, CA 94708 (415) 527-5376

Born: 1947 *Subject Matter:* Architecture, People *Situations:* U.S. & Foreign Locations, Aerial *Education:* U. of California, Berkeley

Having worked as a photographer for over fifteen years, he shoots in all formats, from 35mm to 4" x 5" and 8" x 10". As a pilot with some twenty years of experience, he has also developed his own unique and innovative aerial photography. For these skills, he was one of a select number of international photographers chosen to work on documentary books focusing on Thailand, Ireland and Los Angeles. Photographing architecture, farms and cityscapes, people and nature, his work has appeared on the covers of more than thirty books. Because of his reputation as a pioneer in aerial photography techniques and his ability to create visually stunning images, he is often called in to solve complex and difficult aerial assignments. "It is not enough simply to take advantage of the aerial frame of reference," he says. "That is easy to do. One must create an image that fully realizes the subject's potential—an image that has integrity and design value irrespective of perspective."

RONE, SILVIO (Corporate/Industrial, Portraiture)
9783 E. Camino Del Santo, Scottsdale, AZ 85260 (602) 860-0858

Born: 1948 *Subject Matter:* Portraiture, Fashion, Travel *Situations:* U.S. & Foreign Locations, Studio

Owner and operator of the first wedding and senior portrait studio in Toledo to use all color photography in 1970, five years later he moved his studio out of the city to start a business in outdoor portraiture. Two years later he re-established his senior and wedding studio, but as a new, high-standard portrait studio. For nine years he continued to develop the business, but in 1986 he relocated to Scottsdale, Arizona, where he began the process of putting on a one-man show of fifty individual "Portraits of Self-Made Men" in and of Scottsdale, to be followed by a show of "50 Self-Made Women." Themes from earlier shows include women of distinction and men and their toys, from gold lighters to stunt airplanes.

ROSE, KEVIN C. (Advertising, Editorial)
134B Walker St., Atlanta, GA 30313 (404) 521-0729

Born: 1960 *Subject Matter:* Architecture, People *Situations:* Studio, Interiors, U.S. Locations *Education:* Rochester Institute of Technology

His interest in photography, which began at age thirteen, led him to earn a degree in photography from the Rochester Institute of Technology. Three years later he opened his own studio in Brooklyn. One year later he moved his studio to Atlanta, where he now resides. Although he shoots a variety of subjects, he specializes in the photography of architecture and people. His residential and corporate interiors have been published in such magazines as *Architectural Digest*, *Southern Homes* and *Southern Accents*. His advertising and editorial work typically emphasizes people in relationship to their environment. To do this he travels to interesting sights or creates them in the studio.

ROSENBERG, LEONARD (Advertising, Corporate/Industrial)
2077 S. Clinton Ave., Rochester, NY 14618 (716) 244-6910

Born: 1916 *Subject Matter:* Travel, Industrial, Landscape *Situations:* U.S. & Foreign Locations, Studio, Industrial Plants *Awards:* Gold and Silver Awards, *New York Art Direction* Magazine *Education:* Rochester Institute of Technology

Beginning in 1938, he took up photography as a hobby while working as an industrial designer and advertising artist. It wasn't until 1946 that he called himself a professional, earning a living behind the eye of a camera. Three-fourths of his work is shot in the studio, mostly photography for packaging, but away from the studio, he travels to rural areas in the U.S. and abroad, photographing behind-the-scenes life and landscapes. In addition to this location work, he photographs both table-top and location assignments for high-tech companies and heavy industry, producing brochures. He is known for his lighting and extensive prop design. He was chosen for Kodak's centennial series, and he was also one of ten national photographers selected for their "Imaginations" brochure. Other clients include Mobil, Xerox, R.T. French Co. and Curtice Burns. As part of a 1987 Swedish International award, he produced a Rochester Collection jigsaw puzzle. Currently he is involved in producing one of New York State.

ROSENBLUM, WALTER (Fine Art)
21-36 33rd Rd., Long Island City, NY 11106

Born: 1919 *Subject Matter:* Urban Scenes, People *Situations:* U.S. & Foreign Locations *Awards:* NEA Fellowship; Guggenheim Fellowship *Education:* City College of New York; Photo League, New York

Early in his career Rosenblum was a staff photographer for the U.S. Department of Agriculture, the Agricultural Adjustment Administration and the Unitarian Service Committee. He was employed by Survey Graphic and by *Mademoiselle*. His work is mainly the documentation of growing up on the Lower

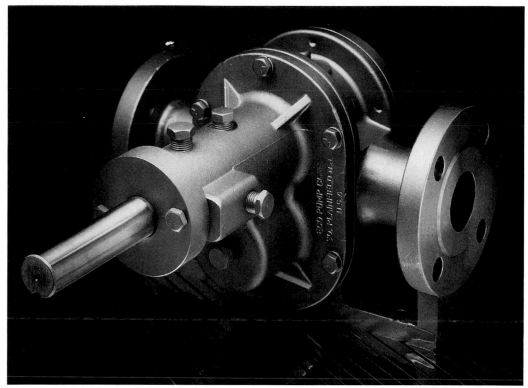

Len Rosenberg, *Pump.* Client: Pulsafeeder Products Interpace Corporation, Rochester, NY

Ron Rosenstock, *Achill Island, Ireland*

East Side of New York City. His better known work consists of people in the South Bronx, Spanish Harlem and Haiti, and occupants of Spanish refugee camps in France after the Spanish Civil War. While studying at the Photo League in the late 1930s he interacted with several top photographers, including Paul Strand, Eliot Elisofon and Lewis Hine. Rosenblum and his wife Naomi were deeply involved in the preservation and eventual exhibition and publication of works from the Lewis Hine Collection in the 1970s.

ROSENSTOCK, RON (Nature, Fine Art)
91 Sunnyside Ave., Holden, MA 01520
(617) 829-6052

Born: 1943 *Subject Matter:* Landscape, Ireland *Situations:* Foreign Locations *Education:* Goddard College

A student of Minor White and Paul Caponigro, he has been an instructor of photography since 1967 and is currently on the faculty at Clark University in Worcester, Massachusetts. For more than fourteen years, he has led over fifty groups across the Atlantic to photograph the majestic beauty of Ireland. Specializing in the subtleties of scenic photography, he seeks to capture the grandeur of landscapes, seascapes and ancient stones and ruins. His photographs have been exhibited in over fifty shows throughout America and Ireland. "My photographs are an attempt to understand the process of creation. They represent a personal search for answers to which the questions, as well as the answers, are wordless. I regard photography not just as a way of seeing but as a way of living, a search or an exploration," he says.

ROSENTHAL, MARSHAL M. (Advertising, Photojournalism)
231 W. 18th St., New York, NY 10011
(212) 807-1247

Born: 1952 *Subject Matter:* Children, Teenagers *Situations:* Studio, U.S. & Foreign Locations *Awards:* 1st Prize, Gallerie Ligoa Duncan, Paris *Education:* Brooks Institute of Photography

His photographs of children and teenagers are characterized by natural compositions, beautiful lighting and brilliant colors. One of his advertising clients was so impressed by his photographs that she married him. He has traveled throughout the United States, Europe, Latin America and the Philippines on advertising and editorial assignments, and he is an American contributing editor for the London magazine *Computer and Video Games.*

ROSS, PAT FRIEDMAN (Editorial, Portraiture)
P.O. Box 1614, Carmel, CA 93921 (408) 624-6543

Born: 1938 *Subject Matter:* Portraiture, Nature *Situations:* U.S. Locations *Education:* U. of California, Berkeley; Conservatory of Santa Cecilia, Rome

Her earliest artistic training was in music—she began playing the piano at the age of four. Later she taught piano and was director of the Monterey Peninsula Community School of Music. She has taught photography at Monterey Peninsula College and is currently teaching at Santa Catalina School in Monterey. Her career in photography began as a paying hobby when she worked as a portrait photographer at the Claremont Hotel in Berkeley while attending the University of California. She attended several workshops and worked for two years as one of Ansel

Adams' assistants at his Yosemite workshops. Her first exhibit was in Italy, where she spent much of her childhood, and she has had photographs reproduced in Italian and American publications. Some of her work is in Polaroid's International Collection. She has enjoyed the challenge of working with Polaroid film, stating, "It represents where I am at the moment. There's only one original print. As with music, the moment of creation is the moment of death. You have to let it go." More recently she has been working in Cibachrome.

ROSSOTTO, FRANK (Fine Art, Editorial)
19 Pearl, Westfield, NY 14787 (716) 326-2792

Born: 1953 *Subject Matter:* Nature, Travel *Situations:* U.S. Locations, Studio

Self taught, he built his reputation by developing his own style in multiple image photography. Taking slides of various images and laying them one on top of the other over a light table, he moves and alternates the photographs until he discovers a harmonious, unique composition, which is then captured through a series of superimposed shots. The resulting photographs have been published nationwide. Writer John Hamilton of *Photomethod* comments, "Rossotto takes seemingly ordinary objects—trees, a barn, the moon, an oil derrick—and combines them into images that force the viewer to give up all preconceptions of reality. He creates his own private world of surrealistic imagery through the use of graphic design, bold colors and impossible juxtapositions." In the past two years, he has been teaching photography and writing instructional articles in addition to his own camera work.

ROTHMAN, STEWART N. (Corporate/Industrial, Nature)
921 Woodway, Fairbanks, AL 99709 (907) 474-0685

Born: 1930 *Subject Matter:* Fashion, Nature, Nudes, People *Situations:* Aerial, U.S. & Foreign Locations, Studio *Education:* Wayne U.

In 1948 he began his career as a U.S. Army photographer serving at General MacArthur's Tokyo Headquarters. In his first major assignment he covered the War Crimes trials in the Far East. From 1952 to 1957 he operated a studio in Detroit. Moving to Alaska in 1959 he opened his current studio, The Lens Unlimited. His work has included house and training films, brochures (writing, layout and photography), documentation of construction, and stills of tugboats and pipelines for oil companies. He makes extensive use of front projection. On location he often shoots from a helicopter. Among his five books are *Nudes of 16 Lands* and *A Window on Life.*

ROUNDTREE, DEBORAH M. (Advertising, Fine Art)
1316 3rd St., Studio 3, Santa Monica, CA 90401
(213) 394-0388

Born: 1953 *Subject Matter:* People, Luxury Products *Situations:* U.S. & Foreign Locations *Awards:* California Arts Council; Washington State Arts Commission *Education:* Universidad de Cultural, Guadelejara, Mexico; Western Washington U.

She began in 1979 as a fashion photographer, then moved into the corporate/industrial field and has since returned to fashion. Within this ten-year period she has developed a number of techniques that single her work out. With an eye for the erotic, she often manipu-

Frank Rossotto

Eva Rubinstein, Nude Sitting on Bed, Rhode Island

lates her photographs with paints and dyes in the post-production phase, highlighting the person or product. Notable also is the sense of drama she creates by placing the product in the background of some unrelated event. For instance, a piece in which the product was a scarf featured a man in a park near a couple; another for bathing caps pictured the products in a cluttered resort hotel room as iguanas and stockinged women lounge on the bed and a maid walks by. She has exhibited internationally and lectures on contemporary trends in American photography.

ROWELL, GALEN (Advertising, Editorial)
1483A Solano Ave., Albany, CA 94706
(415) 524-9343

Born: 1940 *Subject Matter:* Landscape, People, Travel *Situations:* U.S. Locations *Awards:* Ansel Adams Award *Education:* U. of California, Berkeley

He began taking photographs in order to share his hiking experiences with family and friends. In 1972 he became a full-time photojournalist and less than a year later landed a cover assignment for *National Geographic*. In his brand of landscape photography, the photographer is an active participant in the events he covers. The images of people show them in delicate harmony with a selected part of their environment; the landscapes feature unexpected convergences of light and form. His work has been featured in *Time, Sports Illustrated, National Geographic* and numerous other periodicals and advertising campaigns. He has supplied both photographs and text for several books, including *Mountain Light*.

ROWIN, STANLEY (Advertising, Corporate/Industrial)
791 Tremont St., #515, Boston, MA 02118

Born: 1949 *Subject Matter:* People, Products *Situations:* Studio, U.S. & Foreign Locations *Education:* Clarkson U.; Boston U.

He is a former corporate executive who fuses a marketing background with a knowledge of photography, creating images that sell products and ideas. He began by shooting products, but he has gradually moved toward people photography. He now captures the personalities of corporate executives or celebrities in a quick, efficient manner. His images appear on annual reports and record album covers and in editorial pieces and advertisements.

RUBENSTEIN, MERIDEL (Fine Art)
c/o West, Route 2, Box 305A, Santa Fe, NM 87501

Born: 1948 *Subject Matter:* Portraiture *Situations:* U.S. & Foreign Locations *Awards:* NEA Exhibition Grant; Santa Fe Council for the Arts Achievement Award *Education:* Massachusetts Institute of Technology; U. of New Mexico

In the 1970s, she studied under Minor White, Beaumont Newhall and Van Deren Coke. Early work consisted of documentary photographs of the people of New Mexico, such as the series entitled "La Gente de la Luz," black-and-white portraits of people in the landscape. "Lowriders," produced in large format, portrays Hispanics with their decorated cars. After working on the "Habitats" series of 1983-1985, in which different dimensions of various types of houses were explored in sequence, she has been more concerned with making more complex images. She arranges photographic fragments and objects, then re-photographs them with a copy camera to make large-scale collages, which "reconstruct or extend the portrait, enhancing rather than distorting the reality of the subject," in her words. Themes include rites of passage, rituals and the "unconscious versus the conscious self." Her work, she says, is about "relationship, displacement and change."

RUBIN, DANIEL (Advertising)
126 W. 22d St., New York, NY 10011

Awards: New York City Big Apple Award; numerous Art Director Awards *Education:* Rochester Institute of Technology

He majored in photography in high school and college and was an Army photographer during World War II. His commercial studio work ranges from high-tech to stills of antique furniture. Early in his career he photographed major racing events such as those at Le Mans, Monte Carlo and Indianapolis, and he was credited with the first motor-racing cover for *Sports Illustrated*. He was also the first staff photographer covering the NFL. He dislikes being pigeon holed and says "A good photographer can photograph almost anything."

RUBINSTEIN, EVA (Fine Art, Photojournalism)
145 W. 27th St., New York, NY 10001

Born: 1933 *Subject Matter:* Portraiture, People, Documentary *Situations:* Studio, U.S. & Foreign Locations *Education:* Scripps College; U. of California, Los Angeles

Formerly a professional actress and dancer, Rubinstein began to pursue her career as a serious photographer in the early 1970s. She specializes in portrait, editorial and documentary work. Her documentary skills are primarily devoted to a humanitarian viewpoint, which is the focus of her self-titled monograph. This series of prints consists of portraits of children and adults taken in Europe. She has attended workshops and received instruction from Lisette Model, Jim Hughes, Ken Heyman and Diane Arbus.

RUDNICK, MICHAEL (Advertising)
1414 6th Ave., New York, NY 10019

Born: 1960 *Subject Matter:* Food, Still Life *Situations:* Studio *Education:* Ithaca College

Working in a graphic, simple style, he keeps his props to a minimum and relies instead on his ability to create moods and feelings through lighting. While he enjoys working in black and white, he more frequently shoots in color, often creating sets of bright, bold primary colors. All of his work is in an 8" x 10" format, which enables him to get close to his subjects in order to devote his attention to detail and lighting. He shoots food and still lifes for advertising purposes and is developing his editorial photography on yacht racing, a skill he hopes someday will become more than a hobby.

RUDOLPH, JOYCE (Advertising)
8833 Sunset Blvd., Suite 407, Los Angeles, CA 90069
(213) 855-1349

Subject Matter: People *Situations:* U.S. Locations, Studio *Education:* California State U., Northridge; UCLA

Frank Rossotto

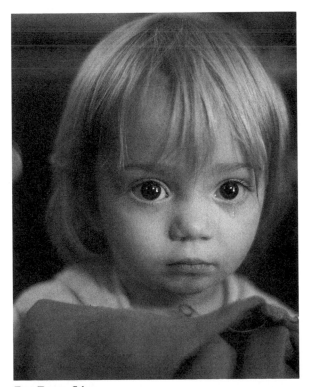

Pat Ross, *Lisa*

Graduating from the University of California with a degree in photography, her first feature film assignment was Robert Altman's "Nashville," in which she played the role of a photographer. She continued in film after a brief period of teaching, but on the other side of the lens—shooting stills for films such as "The Terminator," "Teen Wolf," and "Nightmare on Elm Street." Before she shoots for a film, she reads the script, then works with a series of stills, outlining what will best symbolize the story, and looking finally for two exemplary shots. She works in both color and black and white. Her recent credits have departed from the horror genre and include "Made in Heaven," "Planes, Trains, and Automobiles," "Back to School," and "Arthur II."

RUDOLPH, NANCY (Photojournalism)

35 W. 11th St., New York, NY 10011 (212) 989-0392

Born: 1923 *Subject Matter:* People, Travel *Situations:* U.S. & Foreign Locations *Awards:* Excellence in Photography, AIGA *Education:* Arts Students League; Cedar Crest College

Deeply concerned with the issue of how we live and our fundamental relatedness, she seeks in her photography to highlight our common bonds. As a photographer she considers herself a "social documentarian." Known for her work on the education, play and home life of children, she is the co-author of *Play and Playgrounds* and the author of *Workyards: Playgrounds Planned for Adventure.* Both are studies of how children play and what is provided for them to play on, the latter providing an alternative "recipe book" explaining how to build an exciting play environment from discarded materials. In addition, she has traveled the world photographing people, from coal miners in Appalachia, farm workers in California and Mexican-Americans in Texas to laborers in India, England and the Middle East. In her home town of New York City, she has worked for the Housing Authority and various Settlement Houses, and she has also illustrated annual reports for foundations and schools. Her "glamour" portraits include Anouk Aimee for *Cosmopolitan*, Floyd Patterson for *Sports Illustrated* and Nelson Rockefeller for the Astor Foundation.

RUE, LEONARD LEE, III (Advertising, Photojournalism)

RD 3, Box 31, Blairstown, NJ 07825 (201) 362-6616

Born: 1926 *Subject Matter:* Nature, Wildlife *Situations:* U.S. & Foreign Locations

One of the most published wildlife photographers in the world, in forty years he has sold photography to over 1,200 different companies and publications in forty-two countries, appearing in thousands of books, magazines, calendars, encyclopedias, brochures, catalogs, advertisements, cards, puzzles, games and posters. He has over 1,000 national magazine covers to his credit. He is also a well-known naturalist and has authored nineteen books on wildlife, including the recently released *How I Photograph Wildlife and Nature.* He writes monthly columns in *American Hunter, Deer* and *Deer Hunting, Turkey World* and *Outdoor Photographer.* He conducts a great number of lectures and seminars around the country on white-tailed deer, turkey and nature photography. He also appears on radio and television, at one time representing Upjohn Pharmaceutical as a nationally known photographer

and woodsman for their radio and television campaigns.

RUGGERI, LAWRENCE (Advertising, Corporate/Industrial)

10 Post Office Rd., Silver Spring, MD 20910 (301) 588-3131

Born: 1953 *Subject Matter:* Fashion, People *Situations:* Studio, Aerial *Education:* University of Maryland

He works primarily for commercial and editorial clients, and his images cover a wide variety of subjects and formats. His castle-like, 3,000-square-foot studio has the capacity to handle four to five sets simultaneously, and he is often asked to shoot complicated assignments that call for unconventional props. One such assignment for a corporate client involved renting an airplane and lighting it as if it were airborne. His images have been widely used by the computer industry, providing a fresh point of view on what has become a commonplace product. His photographs have been described as dramatic and punchy, sporting bold graphic overtones and vibrant colors. His stock file, consisting of approximately 10,000 black-and-white and color images, represents industry, beauty and points of interest and is sold through four different stock houses worldwide, including Australia and Canada.

RUNION, BRITT (Advertising, Corporate/Industrial)

7409 Chancery Ave., Orlando, FL 32809 (305) 857-0491

Born: 1951 *Subject Matter:* Sports, Travel *Situations:* Studio, U.S. & Foreign Locations *Awards:* Addy Awards; Golden Image Awards

Having set up a darkroom to process his own photographs at the age of ten, he was already skilled in all aspects of picture taking by the time he went to college to study photojournalism. Degree in hand, he moved to Orlando, Florida where he supervised the set and operations of the photography department for Sea World. After seven years in that position, he resigned and left for a three month shoot in South America for the Sheraton Corporation. Since then he has continued to travel, taking pictures for corporations and advertising clients. When not on location, he is working on shots in his 3,000-square-foot studio.

RUSSELL, KIRK W. (Advertising)

16 Brentford Berwick, Ledyard, CT 06339 (203) 536-4646

Born: 1949 *Subject Matter:* People, Travel, Products *Situations:* Studio, Aerial, U.S. & Foreign Locations

After receiving a degree in business administration, his career began with press photography, working as a photojournalist for four years before opening Russell Studios in 1975. Well-equipped for most types of shooting, Russell is especially known for his ability to complete corporate assignments at a moment's notice, even if it means traveling around the world. His clients include Sheraton Corporation, Dow Chemical, Pfizer and Day's Inn.

RUSSO, RICH (Advertising, Corporate/sIndustrial)

11 Clinton St., Morristown, NJ 07960 (201) 538-6954

Born: 1950 *Subject Matter:* Fashion, Architecture *Situations:* U.S. Locations, Studio *Awards:* New York

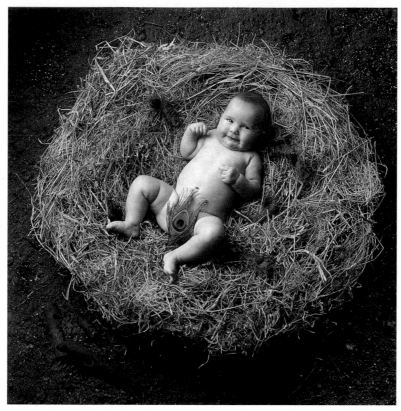

Christian Peacock, *Baby in Nest*

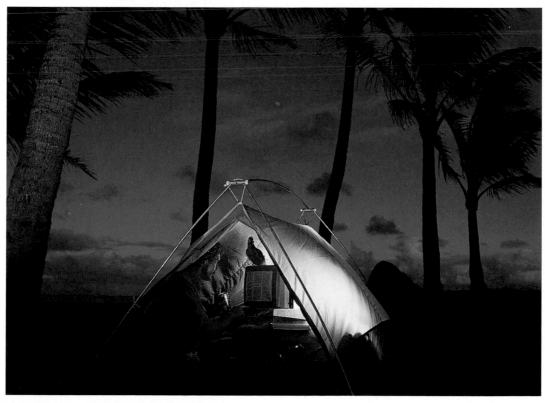

Rick Peterson, *Field Research, Hawaii*

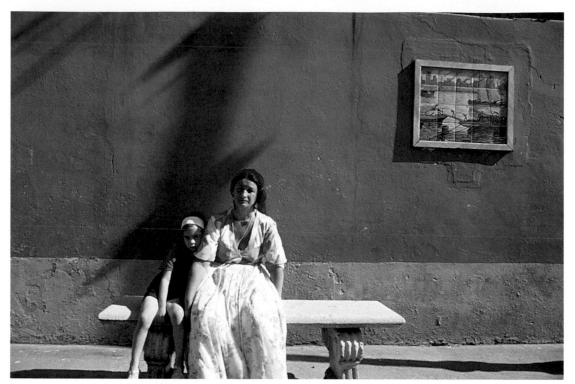

Allan A. Philiba, *Gypsies-La Boca District, B. A. Argentina*

Al Pitzner, *Sable & Flag*. Client: McGrew Colorgraphics, Art Director: Mike Peterson

Philip Porcella, *Meg with Butterflies*

259

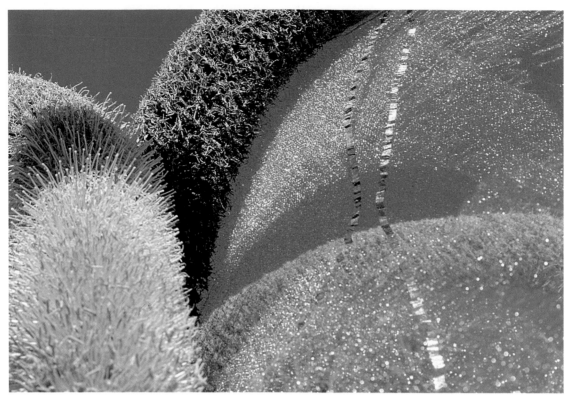

Ines Labunski Roberts, *Stokes-Flow Space Parachute over Agave*

Ines Labinski Roberts, *Dune-Shaft of Light*

Len Rosenberg, *Extrusion Dies.* Client: PGM Manufacturing Corporation, Rochester, NY

Pat Ross, *Sperlonga, 1981*

David Scharf, *Ragweed Pollen (Ambrosia Psilostachya),* Scanning Electron Micrograph-2000X

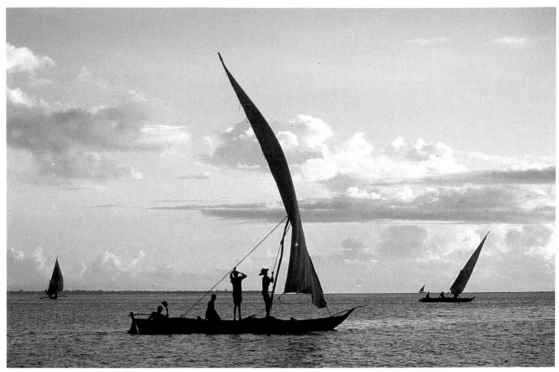

Russ Schleipman, *Dawn, Dar es Salaam*

Ron Sherman, *Atlanta Skyline*

Larry Silver, *Woman in Steamroom,* Client: United Technology

Ric Noyle, *Aloha Lei*

Bradley Olman

Walt Seng, *Passerby, Olivet, France*

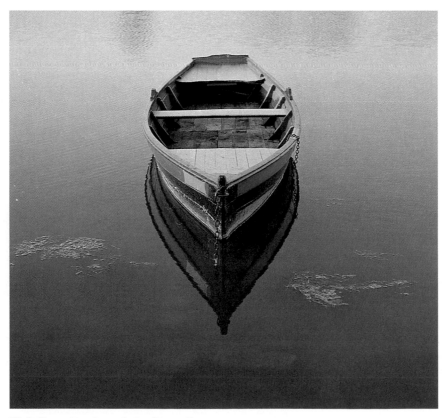

Walt Seng, *Rowboat, Loire River, France*

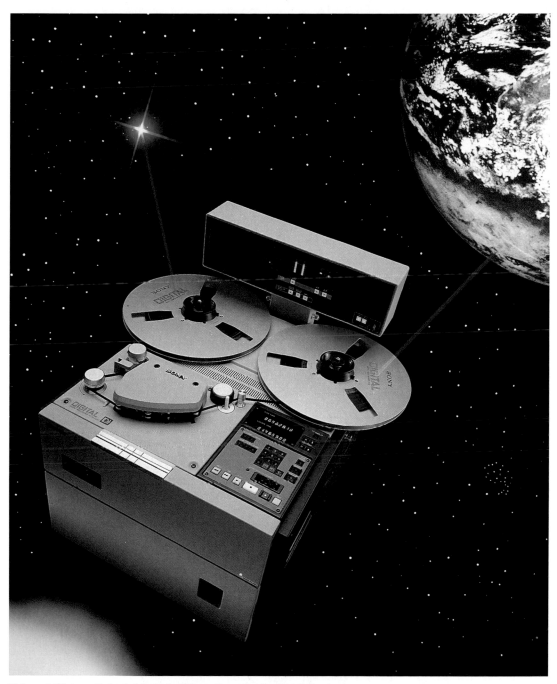

Edward Slater, *Celestial Sound.* Client: Sony Professional Products

Bill Stanton, *Oberlin College*

Arthur Swoger, *Tawny Frogmouth*

John M. Tarchala, *Discover.* Client: Michigan Department of Commerce, Communication Group

Thomas C. Tennies, *Sunny*

Tim Terrell, *Two Personages*

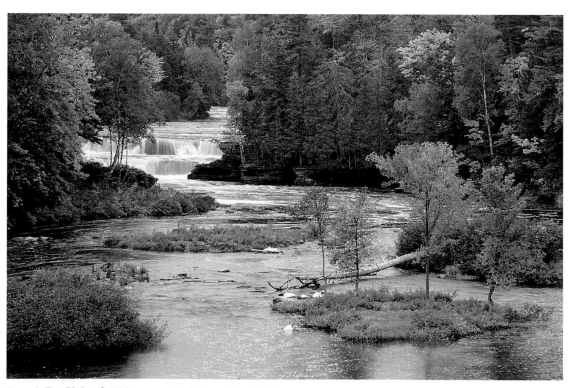

Don & Pat Valenti, *Tahquemon Falls State Park, MI*

Art Directors Club Merit Award *Education:* Rutgers U.; Germaine School, NYC

His career in photography started with a fine-art education and commercial photography training. After a short stint exhibiting in Soho galleries, he found his time better spent fine-tuning his training as an assistant in still life and architectural studios. Today, he operates his own studio, shooting primarily for advertising purposes. His artistic training, however, influences his work, whether he is shooting interiors or jewelry, for which he designs and creates his own backdrops. He works in a range of formats and with a variety of lenses to generate high-tech images. He works with his assistants on location and in the studio, one day shooting for fashion, the next for a corporate client. He prefers to shoot unrestricted by layout constraints.

RUSTEN, SHELLY (Photojournalism, Fine Art)
225 First Ave., New York, NY 10003 (212) 982-7063

Born: 1938 *Subject Matter:* People, Nature *Situations:* U.S. Locations *Education:* Boston U.

Originally a jazz musician, he turned to photography in 1965 through his association with photographer Larry Fink. By 1970 he had been published by several major book publishers and national magazines in the U.S. More interested in aesthetics than in commerce, he turned away from freelancing to study with Lisette Model and later sought instruction at the New School and the School of Visual Arts in New York. He has been exhibited in both solo and juried group shows in the New York area. He calls his work a "personal document, which includes whatever my life experience is at any given time, whether that means landscape, or people, or social comment." Recent work includes two series, one documenting the landscape and culture of the Upper Delaware Valley, the other documenting the life of downtown New York City.

RYAN, WILL (Advertising)
16 E. 17th St., New York, NY 10003 (212) 242-6270

Born: 1945 *Subject Matter:* People, Beauty *Situations:* Studio *Awards:* Clio; Andy, Art Direction

Working in an art studio while studying painting and illustration, he "found himself the studio photographer." Forsaking painting shortly thereafter, he began exploring and expressing himself in photography. He has worked on numerous advertising campaigns with accomplished art directors and designers and continues to learn the art of photography. He shoots primarily 35mm and 8" x 10" and is known for his striking use of light to create emotion in an image. His clients include Godiva, Yves St. Laurent and Remy Martin. Over the years, he has covered many diverse assignments, ranging from an ad campaign for lingerie to a documentary film on the homeless.

SACHA, BOB (Editorial, Corporate)
370 Central Park, W., New York, NY 10025
(212) 749-4128

Born: 1957 *Subject Matter:* People, Travel *Situations:* U.S. & Foreign Locations, Aerial, Hazardous *Education:* Syracuse U.

Interested in psychology, in "what makes us tick," he approaches photography like something of a detective. Shooting both travel photography and portraiture, he looks for the telling detail, the quirk or oddity that will communicate. He finds the unusual in the usual, un-

covering clues to his subjects' personalities in what their front yards look like, the books they read, where they've placed their televisions. He has worked on a wide range of assignments for such magazines as *Life*, *Fortune*, *Sports Illustrated*, *National Geographic*, *Time* and *Newsweek*; one day finds him in a barn on a farm, the next in a hospital operating room. Assignments outside the United States have taken him from Peru to Mexico, Canada to Greenland. Portraits include boxer Mike Tyson and actress Robin Givens and former president Ronald Reagan. In the past two years he has been increasing his work in corporate photography.

SACILOTTO, IRENE HINKE
(Photojournalism)
542 C Riviera Dr., Joppa, MD 21085 (301) 426-5071

Born: 1948 *Subject Matter:* Nature *Situations:* U.S. Locations *Education:* Towson State U.

She is nationally recognized for her ability to combine technical wizardry and photographic artistry. She travels widely, from the Louisiana bayous to the arctic tundra to capture her subjects in their natural surroundings. Her work has appeared in national magazines and publications such as *Defenders*, *Natural History* and *Chesapeake Bay*, as well as in calendars produced by *National Geographic*, Chesapeake Bay Foundation, Bo-Tree and Tide-Mark Press. For such work she takes many months to plan the shoot and to obtain specialized equipment, including custom-designed electronic flash units, blinds and scaffolding. In addition to her busy schedule as a freelance photographer, she teaches photography and conducts numerous workshops in the U.S. and Canada. Her work is displayed in many museums and nature centers across the country.

SAFRON, MARSHAL (Advertising, Editorial)
506 S. San Vicente Blvd., Los Angeles, CA 90048
(213) 653-1234

Born: 1948 *Subject Matter:* Interior Design, Architecture *Situations:* U.S. & Foreign Locations *Education:* Brooks Institute of Photography

With a father in the business, his career in photography started at an early age. Before he became the architectural photographer he is today, however, he first spent several years as a "newspaper shooter." It wasn't until he had the opportunity to work as an assistant for an advertising photographer that he began to really develop his creativity. Next he went on to Brooks Institute, where he began to hone his skills in architectural photography. Today his credits include publication in *Zoom*, *Architectural Digest*, *Interior Design*, *Better Homes & Gardens*, *Interiors* and *Professional Builder*; his clients include Westinghouse, Knoll, Atlantic Richfield, Modern Mode, Allied Corporation and GF Furniture.

SAGE, LINN (Editorial, Fine Arts)
320 Central Park West, New York, NY 10025
(212) 724-9267

Born: 1937 *Subject Matter:* Social Documentary, Travel *Situations:* Foreign & U.S. Locations *Education:* Barnard College; Columbia U.

With a background in art history, she began as an art and photo editor for the small literary magazine *Contact* in San Francisco. In the 1960s, she found herself in the streets covering the social turmoil of that era as

SANTOW, LOREN (Corporate/Industrial, Editorial)

3057 N. Racine Ave., Chicago, IL 60657
(312) 929-1993

Born: 1955 *Subject Matter:* People *Situations:* Studio *Education:* Northeastern Illinois U.; Columbia College, Chicago

He began as a street photographer, where he saw in street life those "decisive moments" that reveal the universal. In 1982 he began his professional career by working as a newspaper stringer. For five years he honed his craft, obtaining such corporate accounts as Continental Bank, General Mills and Ryerson Steel, and such editorial clients as *Smithsonian*, the *Christian Science Monitor* and *Chicago Lawyer*. Whether his subject is the CEO of a major corporation or a death row inmate, he continues to shoot with an eye toward the unstudied and spontaneous.

SARTORE, JOEL (Photojournalism)

c/o Wichita Eagle-Beacon, Box 820, Wichita, KS 67202 (316) 268-6468

Born: 1962 *Subject Matter:* People *Situations:* U.S. Locations *Awards:* Top Five Finalist, Pulitzer Prize in News Feature Photography; Region Seven Photographer of the Year, National Press Photographers Association *Education:* U. of Nebraska

He interned at the *Wichita Eagle-Beacon* while a journalism student at the University of Nebraska and returned to the paper with a full-time position upon graduating. He worked first as a reporter but found that he could tell stories better through pictures and was soon wielding a camera for the paper. He has since published work in papers such as the *Sacramento Bee* and the *Denver Post*, as well as *Newsweek*. Interested in portraiture and documentary, he recently completed a six-month project on AIDS. For this project, he followed a victim of the the disease and the three volunteers who assisted the victim until his death in June, 1988. In addition to his photography assignments, he recently took over as assistant manager of the *Eagle-Beacon*'s photo department.

SATO (Advertising, Photojournalism)

152 W. 26th St., New York, NY 10001
(212) 741-0688

Born: 1951 *Subject Matter:* Fashion, Food *Situations:* Studio *Education:* Tokyo College of Photography

Born in Sapporo, Japan in 1955, his passion for photography started with the gift of a camera for his ninth birthday. After a childhood spent obsessed with taking pictures, he studied at the Tokyo College of Photography. Upon graduation, he came to New York and served as chief assistant to the master still-life photographer Hashi for three years. It was there, in the advertising center of the world, that he nurtured his love for advertising design. Using unusual props, surfaces and textures, he compliments products by his strong sense of design. "Sato solves problems that seem unsolvable," says David Caplan, art director at N.W. Ayer. His talent has been recognized in work for such clients as Gillette, Hitachi and Nina Ricci and for numerous magazines. In the tradition of Diane Arbus and Henri Cartier-Bresson's photography, his black-and-white photographs have graced the walls of galleries in Italy and Switzerland.

SATTERWHITE, AL (Advertising, Editorial)

80 Varick St., New York, NY 10013 (212) 219-0808

Born: 1944 *Subject Matter:* People, Travel *Situations:* Studio, U.S. & Foreign Locations *Education:* U. of Florida; U. of Missouri

He shot for his high school and college yearbook and newspaper and simultaneously freelanced for the *St. Petersburg Times*, and this experience influenced him to change his career direction from aerospace engineering to photography. After leaving school, he took on a six-month assignment as Florida Governor Claude Kirk's personal photographer during the governor's campaign for Vice President. Following that, he joined Camera 5, a picture agency, and started doing assignments for such magazines as *Time*, *Newsweek*, *Sports Illustrated* and *Life*. Over this period he became interested in advertising, and in 1979 he moved to New York to begin work in the field as well as place pictures with the Image Bank, a slide stock house that was fast becoming prominent worldwide for the caliber of photographers it was signing exclusively. Over the years, he has won many awards for his editorial, corporate and advertising work, and he continues to shoot for clients in all three areas.

SAVAGE, NAOMI (Portraiture, Fine Art)

41 Drakes Corner Rd., Princeton, NJ 08540

Born: 1927 *Subject Matter:* Landscape, Portraiture, Sculpture *Situations:* Studio, U.S. & Foreign Locations *Awards:* NEA Photography Fellowship; Art Directors Club of New York *Education:* New School for Social Research; Bennington College

Savage was encouraged to develop her photographic skills and techniques by schoolmate Berenice Abbott, and by her uncle, Man Ray. She has worked for *Vogue*, *Bucks County Traveler*, Elizabeth Arden and others. Early in her career she made portraits of composers, as well as photographs for album jacket covers and greeting cards. Subjects include landscapes, sculpture and people. She uses a variety of techniques and methods in developing her creations, including photo-engraving, photo-collage, intaglio prints, double exposure, photo-grams, texture screens, solarization and photo toners. When commissioned in 1971 to create a photo-mural of presidents' portraits for the Lyndon Baines Johnson Library in Austin, she used a photo-engraving process to create a 8 x 50-foot mural.

SCHABES, CHARLES (Advertising, Photojournalism)

1220 W. Grace St., Chicago, IL 60613-2806
(312) 787-2629

Born: 1954 *Subject Matter:* Food, Travel, Still Life, Portraiture *Situations:* U.S. & Foreign Locations, Studio *Education:* Columbia College, Chicago

Working as an assistant with a number of photographers in the Chicago area gave him a wide range of experiences in a variety of situations and studios. Today, he draws upon that experience in his own studio, where he photographs food and food-related products, such as cappucino makers and high-tech kitchenware for Bloomingdales. His photojournalism assignments take him on location, for magazines such as *Chicago* and additional publications in Europe. He published a major story on Chicago restaurants in the West German gourmet magazine, *Feinschmecker*, in June 1987. Other work includes portraiture, as well as

Edward Slater, *Reclining Nude*

Richard Riley

a black-and-white series in progress of still lifes, which has already been exhibited in London.

SCHARF, DAVID (Photojournalism, Scientific)

2100 Loma Vista Pl., Los Angeles, CA 90039
(213) 666-8657

Born: 1942 *Subject Matter:* Nature, Microscopic Subjects *Situations:* Studio, Scanning Electron Microscopy *Awards:* Award of Excellence, National Press Photography Association

Trained in physics, he worked as an electronic engineer for twenty years, pursuing photography as a hobby. In 1973, in charge of a vacuum physics lab, he taught himself to use a scanning electron microscope and in the process developed new techniques to photograph living subjects in their natural state. He has since become an authority on the subject. His first year of publication saw photographs in *Newsweek, National Geographic* and on the cover of a McGraw-Hill Science-Technology Yearbook. He has since placed work with *GEO, Discover* and various textbooks and advertisements. He has taken pictures of such subjects as sea salt crystals, the head of a Mediterranean fruit fly, the eye of a moth and a human hair rising tall as a tree from the scalp. In 1977 a book of his work entitled *Magnifications—Photography with the Scanning Electron Microscope* was published. Of it a *Time* reviewer wrote, "With this book we now have an Ansel Adams of inner space."

SCHIFF, DARRYLL (Advertising)

8153 W. Blackburn Ave., Los Angeles, CA 90048
(213) 658-6179

Born: 1948 *Subject Matter:* Fashion, Celebrities *Situations:* Studio, U.S. Locations *Education:* Institute of Design; Illinois Institute of Technology

Leaving design and film, she studied fine art photography in Chicago and then moved to San Francisco to open her own studio. This however was short-lived, and soon she moved to Los Angeles to shoot fashion and then actors, celebrities and film advertisements. Known for her ability to relax her subjects and draw out their own unique qualities, her clients include Robin Williams, Pam Dawber, Harry Hamlin and Joanna Cassidy. Film credits include "Peggy Sue Got Married," "Hope and Glory," "Fourth Protocol" and "Best of Times." Solutions for her advertising clients are often found in her unique lighting techniques.

SCHLEIPMAN, RUSSELL (Advertising, Corporate/Industrial)

298A Columbus Ave., Boston, MA 02116
(617) 267-1677

Born: 1949 *Awards:* Nikon Photo Contest International, 1983; Communication Arts Photo Annual, 1984, 1987, 1988 *Education:* Dartmouth College

Essentially all of his shooting is done on loction and embraces a wide range of clients, from resorts and nautical to corporate and high tech. While adept at artificial lighting, he prefers the beauty and elegance of available light when its use applies. His work has a strong graphic appeal, the result of exacting composition and careful use of bold color. His images are governed and defined by the old adage "less is more," a philosophy he applies equally to the Sydney Opera House, a Saharan dune or a stateside steel mill.

SCHLESINGER, TERRENCE (Advertising, Corporate/Industrial)

P.O. Box 32877, Phoenix, AZ 85064 (602) 957-7474

Born: 1956 *Subject Matter:* Nudes, Architecture *Situations:* Studio, U.S. Locations

His dual career includes personal fine-art photography and commercial architectural and interior photography. For his commercial work, he plans as much as possible, finding that pre-visualization helps limit time and cost. He finds shooting interiors challenging because of the type of lighting involved and the difficulty of showing four or five different planes at once. In his fine-art work he prefers to let things happen naturally. He photographs everyday subjects in an abstract manner, achieving images that communicate without words. His fine art shows consist of elegantly framed cibachrome prints which are usually 20" x 30" or larger.

SCHNAIBLE, GERRY (Advertising, Corporate/Industrial)

651 Morse Ave., Schaumburg, IL 60193
(312) 351-4464

Born: 1945 *Subject Matter:* Fashion, Food, People *Situations:* Studio, U.S. Locations *Education:* California College of Arts and Crafts

His early studies of women and children progressed to public relations work for musical groups and eventually led to portrait and VIP assignments as a civilian employee of the U.S. Air Force. He has photographed President Reagan, Vice President Bush and Queen Beatrix of the Netherlands as well as other heads of state. His ability to adapt to changing situations and his attention to detail led to a joint commendation from the Department of Defense/Chicago Police Department. In 1981 he began corporate/industrial location assignments, doing brochures, annual reports and other corporate work. He opened his new studio in March of 1987.

SCHNEIDER, JOSEF A. (Portraiture, Advertising)

119 W. 57th St., New York, NY 10019
(212) 265-1223

Born: 1913 *Subject Matter:* People, Children *Situations:* Studio, U.S. Locations *Awards:* Clio *Education:* St. John's U.; City College of New York

Dubbed the "De Mille of the Diaper Set," this former child psychologist has thirty years of experience in child photography. He has done baby designs for every major baby product, including Pampers, Luvs, Johnson & Johnson and Ivory and has won international acclaim, including the coveted Clio award. He has published three books, *Child Photography Made Easy, Child Photography the Modern Way* and *Home Study Course in Child Photography.* He has been called upon to photograph the members of the Royal House of Sweden, the grandchildren of former Governor Muñoz of Puerto Rico, the grandchildren of the Chairman of the Board of Eastman Kodak and the children of Shirley Temple Black. In addition to print work, he does the casting and stage managing for the majority of television commercials involving young children and babies. Film work includes the movie "Raising Arizona."

SCHNEIDER, MARTIN (Photojournalism)

1501 Broadway, Suite 2907, New York, NY 10036
(212) 840-1234

Russ Schleipman, *Vermonter*

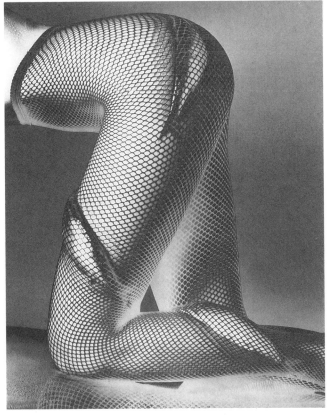

Craig Scoffone

Subject Matter: People, Environmental Issues *Situations:* Hazardous, U.S. Locations *Awards:* CAPS Fellowship, TV Franny *Education:* City University of New York

Politically explosive, the crusading work of this "Ralph Nader of photography" has been the basis for legislation in the tradition of sociologist Lewis Hine (whose images led to child labor laws). Such muckraking, however, has made him the target of censorship, intimidation, seizure of his residence and possessions, and even sabotage of his mobile laboratory which he designed and built for testing pollution and automobile safety. A photo essay covering the phosphate industry in Florida—the damage caused by the combination of sulfuric and hydrofluoric acids expelled into the environment, the paint stripped from cars, the emphysema and ulceration caused in humans, and the death of thousands of cattle—was destroyed twice, then finally published in an edited version a year late. Despite all this, he continues to wield his camera and to teach and lecture nationally.

SCHNEIDER, TOM A. (Advertising, Nature)
1605 Ferndale, Ann Arbor, MI 48104 (313) 665-4239

Born: 1953 *Subject Matter:* Wildlife, Travel *Situations:* U.S. & Foreign Locations *Education:* U. of Michigan

"My photography is always trying to catch up with my abilities as a naturalist," he says. "The familiar backyard animal could be as much a subject as some exotic creature of the wild." In each instance, he strives to seize in film that "behavioral moment" that speaks for and matches the intensity witnessed in his field observations. Much of his photography is used for advertising purposes, and in March of 1985 his photograph of the common chickadee perched on sumac berries enlivened the cover of *Natural History.* Currently he is building his stock files and developing wildlife photography workshops. His work finds him both in the United States and in scenic places abroad.

SCHORRE, CHARLES (Fine Art)
2406 Tangley Rd., Houston, TX 77005
(713) 522-2663

Born: 1925 *Subject Matter:* People, Nature, Landscape, Mixed Media *Situations:* Studio, U.S. Locations *Awards:* NEA Grant, Mobil Oil Grant *Education:* U. of Texas

An ex-university professor, and a graphic designer and illustrator, he has always been a full-time fine artist who learned photography as a result of gathering source material for his illustrations and designs. He currently uses photography in paper and paint collages. Working in both color and black and white, he frequents the deserts of the American Southwest for much of his nature work. Shots also include images from Indian ceremonies which he often juxtaposes with female nudes. "My work is about drawing, painting, nature, natural images," he says, "about their differences and similarities and how we perceive them, about polarities, contrasts, fragments, juxtaposition, about seeing verses looking, about common visions of the uncommon and uncommon visions of the common."

SCHREMPP, ERICH (Advertising, Corporate/Industrial)
723 W. Randolph St., Chicago, IL 60606
(312) 454 3237

Born: 1955 *Subject Matter:* Products, Special Effects *Situations:* Studio Assignments *Awards:* Advertising Photographers of America *Education:* Rochester Institute of Technology

After graduating *magna cum laude* from the Rochester Institute of Technology, he was apprentice to Chicago photographer Dick Krueger for four years. In 1981 he opened his own studio specializing in product and effects work. The business twice outgrew its locations and he is currently located in the heart of Chicago's new photo district. He designs and builds his own special effects apparatus and manipulates images either optically in camera or through the creation of separate compatible images for digital assembly. His clients have included Motorola, Northrop, Ingersoll, Illinois Tool Works and Eastman Kodak. He also writes articles for *Photo District News* and for the Advertising Photographers of America publication, the *Contact Sheet.*

SCHUYLER, JOSEPH (Advertising, Editorial)
305 Hamilton St., Albany, NY 12210 (518) 436-1199

Born: 1943 *Subject Matter:* People, Architecture, Interiors *Situations:* Studio, U.S. Locations *Education:* Suffolk U.

He has studied with Minor White and Paul Caponigro and is known for his dramatic, direct, candid images, especially of children. In his architectural work he uses the playful variances of natural light to create appealing still lifes. On interior design assignments he captures a detailed and relaxed ambiance which invites viewers inside. He has had his own studio for the last fifteen years; among his accounts he includes Warner Communications, The Business Council of New York State and Filenes Department Store. The *New York Times, Newsday* and the *Washington Post* have all used his photographs, as have most of the major book publishers.

SCHWARTZ, LINDA (Advertising, Corporate/Industrial)
2033 N. Orleans, Chicago, IL 60614 (312) 327-7755

Born: 1951 *Subject Matter:* Architecture, People *Situations:* U.S. Locations, Studio *Education:* Columbia College, Chicago; Illinois Institute of Technology

Since she does not specialize, she is known as a "photo-generalist." Her work, however, includes some of the most comprehensive records of architectural development in Chicago, including the 333 East Wacker building from its ground breaking to completion, as well as the new atrium entrance to the Sears Tower. Although she is known for her location photography, she has recently acquired a studio in the Midwest, where today she is also working in portraiture. Elaine May, Peter Falk, Tony Bennett, Burt Bacharach, Bruce Jenner and the Chicago Bears are counted among the hundreds of celebrities who have called upon her skills.

SCLIGHT, GREG (Advertising)
146 W. 29th St., New York, NY 10001
(212) 736-2957

Born: 1952 *Subject Matter:* Products, Still Life *Situations:* Studio *Education:* Rutgers U.

He works primarily in large formats, such as 4" x 5" and 8" x 10", shooting products for advertising, but also works in 35mm to photograph people; his work is both black-and-white and color. His editorial clients include *Glamour, Gentleman's Quarterly,* the *New York Times,*

Walt Seng, *Winter, Stuttgardt*

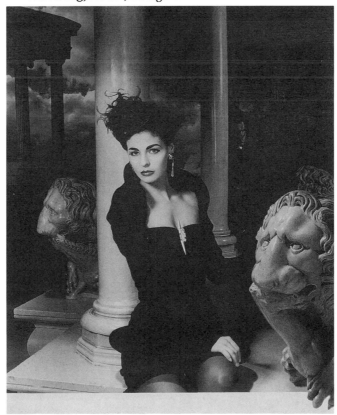

Walt Seng, *Woman at Gazebo with Admiring Fiend.* Client: Sorbie Hair Products. A.D.: Richard Madden

papers across the country. He also covered the follow-up peace march in the Soviet Union made up of Americans and Soviets walking from Leningrad to Moscow. He continues to be interested in covering social issues and has been working on an ongoing project photographing street children around the world. The project began in Guatemala and has so far included images from Brazil, Costa Rica and Ecuador. He is currently in Africa working on a project for the Tree People, a California organization involved in helping other countries develop their forests.

SHEA, JIM (Advertising, Entertainment)
893 1/2 S. Lucerne Blvd., Los Angeles, CA 90005
(213) 653-8520

Born: 1953 *Subject Matter:* Advertising, Entertainment *Situations:* Studio, U.S. & Foreign Locations *Awards:* Grammy for Best Album Cover

In high school he shot weddings and portraits and worked as night news photographer for a Bridgeport, Connecticut newspaper. He opened his first studio at the age of 18 and continued with his wedding, industrial and advertising work while learning about lighting and advertising by assisting Frank Moscati and George Hausman in New York. He then shot advertising on his own for several years and finally moved to Los Angeles to work for the entertainment industry, where he primarily shot personalities for album covers, one sheets and editorial and publicity purposes. He now splits his time between photography and music video direction.

SHERIDAN, SONIA LANDY (Fine Art, Scientific)
718 Noyes, Evanston, IL 60201 (312) 864-1646
(312) 864-1646

Born: 1925 *Subject Matter:* Nature, People *Situations:* Studio *Awards:* Guggenheim Fellowship; NEA Grant *Education:* Hunter College; California College of Arts and Crafts

Her work with high speed copiers brought her to the attention of the photo art world in 1970. Since 1982 her main tools have been computer graphic systems, the most recent of which is Lumena/Time Arts, Inc., developed by her student, John Dunn. Her images range from portraits to interactive portraits (often incorporating drawing) to time/space studies using computer/video and paint systems. From 1961 to 1980, she taught at the School of the Art Institute of Chicago. In 1970, she established the Generative Systems program there and in 1980 she became Professor Emeritus. She now exhibits, lectures and consults in the U.S. and Europe.

SHERMAN, RON (Corporate/Industrial, Advertising)
P.O. Box 28656, Atlanta, GA 30328 (404) 993-7197

Born: 1942 *Subject Matter:* People, Sports, Industry *Situations:* U.S. & Foreign Locations, Aerial *Education:* Rochester Institute of Technology; Syracuse U.

Today he is an experienced aerial photographer, covering oil and gas exploration and cityscapes for corporate annual reports, but he began working for newspapers while attending college in Cleveland, Ohio and Rochester, New York. He moved from New York to be a staff photographer at the University of Florida while freelancing for UPI and national magazines. Starting a freelancing business in Atlanta in 1971, he

expanded beyond news into sports, business magazines, public relations and advertising. He keeps on file an active stock of 30,000 images and works on location throughout the United States, with an occasional foreign assignment. He continues to use a journalistic approach in his work, favoring candid shots with natural lighting even in arranged situations, effectively photographing people, whether they be production workers, corporate presidents, or professional models.

SHOOK, M. MELISSA (Fine Art)
18 Short St., Brookline, MA 02146

Born: 1939 *Subject Matter:* Portraiture, People *Situations:* Studio, U.S. Locations *Education:* Godard College

Photo essays are biographical and autobiographical, including a project in which she chronicled the life of her daughter, Kristina, motivated by the lack of imagery from her own childhood. Taken over a span of twelve years, the images portray her daughter in relation to her surroundings and to her family and friends. This series is intended to serve as an ordering process, generating a personal history still open to interpretation. She works also with Polaroid photography, primarily in an autobiographical vein, and is working on a series depicting charismatic healing practices. On the faculty of the University of Massachusetts, her work is included in the collections of the Metropolitan Museum of Art, the Museum of Modern Art (New York) and Fotografiska Museet in Stockholm. Her work has appeared in such publications as *Creative Camera, Picture, Photograph* and *Camera 35.* She is a member of SPE and of the Word Guild in Boston.

SHORE, STEPHEN (Fine Art)
5075 Jackson Creek Rd., Bozeman, MT 59715

Born: 1947 *Subject Matter:* Landscape *Situations:* U.S. Locations *Awards:* NEA Fellowship; Guggenheim Fellowship

His work is characterized by near desolation and the apparent insignificance of the scenes depicted. He concentrates largely on small towns and his images are simply visual experiences, without seeking to make any social comment on the locales. His images, most often in color, are recognizable for their clarity, marvelous color, and seeming inconsequentiality. He is essentially a self-taught photographer although he did receive instruction from Minor White at the Kotchkiss Workshop, 1970.

SHULTIS, LORNA REICHEL (Advertising, Fine Art)
P.O. Box 63, East Greenbush, NY 12061
(518) 477-7822

Born: 1953 *Subject Matter:* Food, Nature *Situations:* Studio, U.S. Locations *Education:* Buffalo State College; SUNY

After concentrating in fine art photography and teaching at Roanoke College from 1978 to 1981, she moved to New York City, where over several years she learned the techniques and business of commercial photography. During that period, she shot toys, jewelry, food and other still lifes for advertising, catalogs and packaging. In 1985, she moved to Albany and opened The Photo Studio with her husband-partner John Shultis. Over her career, she has developed her talent for fine-art photography. She initially shot black and

Ron Sherman, *Milwaukee Biker*

Larry Silver, *Headstand, Muscle Beach, California, 1954.* Courtesy: Metropolitan Museum of Art

white, but gradually began to hand-color her prints with pencils, oils and acrylics. Most of her current work is shot in color. These pieces, as well as her editorial photographs, tend to be conceptual and surreal in nature—depicting situations in which nothing is what it appears to be. Influences include Michael Waime, Ryszard Horowitz, Dennis Manarch, Michel Tcherevkoff and Duane Michals.

SHUNG, KEN (Editorial, Commercial)
236 W. 27th St., New York, NY 10001
(212) 807-1449

Born: 1954 *Subject Matter:* People, Fashion *Situations:* U.S. & Foreign Locations, Studio *Awards:* Scholarship, Wilson Hick Conference on Visual Communication, Miami *Education:* SUNY, Fredonia

His fifteen-year career in photography began at age twelve when he discovered the beauty of the medium in the pages of *Life*. He concentrated in music and art in college, but retained his passion for photography. Assisting a number of important photographers including the late Bill King, Irving Penn and *Rolling Stone*'s Annie Leibovitz, he learned both fashion and editorial photography. In 1983 and 1987, he traveled to China, photographing a series of portraits that were exhibited at West Beth Gallery in New York. He has published in a variety of magazines, among them *In Fashion, Venture, Discover, New York* and *How*. Commercial clients include Avon, Bloomingdales and Giorgio Armani. He has agents in Hamburg, West Germany and Tokyo, Japan and recently placed an exhibition of portraits in Amsterdam, Holland. While he states that he is "not a photojournalist," the "filter" through which he looks and designs his photos is colored by the tracks of real experiences.

SIEDE, GEORGE (Corporate/Industrial, Editorial)
1526 N. Halsted, Chicago, IL 60622 (312) 787-2775

Born: 1949 *Subject Matter:* Industrial, People *Situations:* U.S. Locations, Studio

Trained in advertising and public relations, he is primarily self-taught in photography; he has been involved in photography since the age of seven. Equally comfortable with location and studio photography, he produces work for newspapers, magazines, advertising, text books and corporate/industrial illustrations. He particularly enjoys designing, building and lighting sets, both miniatures and room size. He brings this same sensibility and commitment to design to his location work.

SILANO (Advertising, Editorial)
138 E. 27 St., New York, NY 10016 (212) 889-0505

Born: 1934 *Subject Matter:* Fashion, Food, Nudes, Landscape *Situations:* Studio, U.S. & Foreign Locations *Awards:* Gold Award

After studying with Alexey Brodovitch, in the late 1950s he started photographing models on location around New York City. When pictures of models on benches or in parks began appearing in portfolios around the city, clients like Bergdorf Goodman and Irving Serwer started calling for his work. In the early 1960s he worked for three years in London and Paris, shooting for *Elle, Vogue, Harper's Bazaar* and other major fashion magazines. Since 1966 he has freelanced for *Harper's Bazaar*, living in New York City where he also has a studio. Mostly shot in color, his fashion 8" x

10" shots emphasize elegance and excitement. His personal projects consist of nudes and landscapes in both color and black and white. The landscapes are characterized by their close detail, and the nudes are rendered as figures or abstractly, making a landscape of their own.

SILBERT, LAYLE (Editorial)
505 LaGuardia Pl., #16C, New York, NY 10012
(212) 677-0947

Subject Matter: People, Writers *Situations:* U.S. & Foreign Locations, Studio *Education:* U. of Chicago

She discovered photography by accident when her husband, a United Nations functionary, lent her a camera in Karachi, Pakistan. There she began photographing the human face. Since then she has photographed people and street scenes in Latin America, Africa, the Far East and Europe. In New York she has primarily photographed writers (she is also a writer herself), a practice which has led to book jacket and textbook work. Her pictures have appeared in the *New York Times, Time, People* and the *Village Voice*. Exhibitions of her work have been held at the Museum of American Jewish History in Philadelphia and at over thirty other galleries throughout the world.

SILK, GEORGE (Photojournalism)
Owenoke Park, Westport, CT 06880 (203) 227-5757

Born: 1916 *Subject Matter:* Sports, War *Situations:* U.S. & Foreign Locations *Awards:* Encyclopedia Britannica Photographer of the Year Award; Art Directors Club of New York Gold Medal

Born in New Zealand, he dropped out of school as a teenager. He did not start taking pictures until World War II, when he worked as a combat photographer for the Australian Army. He came to the United States in 1943 to work for *Life* as a photographer of the Allied forces in Europe. Always a traveler, a decade later he photographed a North Pole weather station. Since the 1950s he has been best known for his sports photography. He was one of the first people to use the Foton sequence camera to photograph sports in action. He also developed his own version of the "slit camera" to better capture moments in sports with split-second timing.

SILVER, LARRY (Advertising, Fine Art)
236 W. 26th St., New York, NY 10001
(212) 807-9560

Born: 1934 *Subject Matter:* People *Situations:* Still Life, Studio *Education:* High School of Industrial Art, New York City; Art Center College of Design, Los Angeles; Carlson Gallery; U. of Bridgeport; Rhode Island School of Design

Influenced by the Photo League during the 1950s, his early work was of New York and Muscle Beach, California. Favoring black and white for its impact and archival quality and his control of print quality and cropping, he currently does both fine art and advertising studio projects. His background in fine art influences how he depicts people and sets up products, creating images that are multi-faceted in their appeal. His images, whether under studio conditions or on location are directed to achieve a natural and spontaneous look, and his still lifes show an excellent command of lighting. Clients include IBM, Canon USA, Citibank, Xerox, American Express, Eastern Airlines

and Merrill Lynch. His work has appeared in numerous national magazines and trade magazines.

SIMMERMAN, NANCY L. (Advertising, Editorial)

P.O. Box 548, Girdwood, AK 99587 (206) 282-8116

Born: 1937 *Subject Matter:* Nature, People *Situations:* U.S. Locations *Education:* Oberlin College; U. of Alaska

Moving to Alaska to study, teach, and research chemistry, she fell in love with the magnificence of the state and found exploring the wilderness with a camera far more interesting than the laboratory. Preferring to study and view her subjects from a number of perspectives, she has found her niche in stock photos, books and long-term assignments. Traveling by dog sled, skis, snowmobile, kayak, sailboat, foot, light plane or helicopter, she has covered thousands of miles to document the geography and various cultures in Alaska. In addition to an annual calendar of her work, she has four books to her credit: *Southeast Alaska, Alaska II, Alaska's Parklands* and *55 Ways to the Wilderness in Southcentral Alaska.*

SIMMONS, ERIK LEIGH (Advertising, Corporate/Industrial)

241 A St., Boston, MA 02210 (617) 482-5325

Born: 1946 *Subject Matter:* Nature, People, Industry *Situations:* U.S. Locations *Awards:* Thomas J. Watson Foundation Fellowship *Education:* Bowdoin College

During and after his studies at Bowdoin College, he studied extensively in Europe on a series of Thomas J. Watson Fellowships. In 1972, he entered the world of professional photography. He has developed a reputation as a fearless industrial and annual report photographer who often works in dirty, greasy, or what he calls "sow's ear situations." He works in all formats and among his clients, he lists Polaroid, Anheuser-Busch and Digital Equipment Corporation. "Though oftentimes extremely trying, it is endlessly challenging to create yet another 'silk purse.'"

SISKIND, AARON (Photojournalism, Fine Art)

15 Elm Way, Providence, RI 02906 (401) 267-1234

Born: 1903 *Subject Matter:* Architecture *Situations:* Studio, U.S. & Foreign Locations *Awards:* Gold Star of Merit, Philadelphia College of Art; Guggenheim Fellowship *Education:* City College of New York

A former English teacher, he developed an interest in photography in the 1930s after seeing exhibitions of the Photo League in New York City. Without any formal training, he went on to create a social documentary series which included "Harlem Document" and "The Bowery." Seven years later, more interested in the geometric beauty of architectural cityscapes, he abandoned formal concepts of perspective and space. Influenced by the Abstract Impressionist movement and the artists who became his steady friends, he began to explore the expressive possibilities of pure form. "When I make a photograph I want it to be an altogether new object, complete and self-contained, whose basic condition is order." Experimenting with close-up abstractions of isolated objects, such as urban walls, battered stone, cracking paint and graffiti, he created compositions which transcend the realm of ordinary reality, thus becoming an experience in their own right. A front-runner in the evolution of contemporary photography, he joined Harry Callahan at the Institute of Design in Chicago where he taught for twenty years.

SITEMAN, FRANK (Advertising, Corporate/Industrial)

136 Pond St., Winchester, MA 01890 (617) 729-3747

Born: 1947 *Subject Matter:* People, Travel *Situations:* U.S. & Foreign Locations, Studio *Awards:* International Competition for Photographic Murals, P.P.A. & Eastman Kodak; Award for Illustrative Photography, Art Directors Club of Boston *Education:* Tufts U.

A commercial photographer, fine art photographer and teacher, he founded the Tufts University Photography Department in 1969. His work has appeared in *Time* and *Atlantic Monthly*, in over five hundred trade and textbooks and in numerous advertising campaigns. He specializes in horizontal images. In 1979 he produced a series of twenty-six vandal-proof panels of porcelain enamel on stainless steel measuring 4 by 4 feet. Produced for the Boston Transit Authority, he colored these black-and-white scenes of Boston with silk screen. His stock photo files include more than 80,000 black-and-white images and over 150,000 color transparencies.

SKARSTEN, MICHAEL (Advertising, Editorial)

1062 N. Rengstorff, Studio E, Mt. View, CA 94043 (415) 961-6012

Born: 1954 *Subject Matter:* Special Effects, Products, Landscape *Situations:* Studio, U.S. & Foreign Locations *Education:* Brooks Institute of Photography

Specializing in photo illustration in the high-tech industry, he works primarily with companies in Northern California's Silicone Valley. Apple, Tandem, Memorex and Racal-Vadic head his list of clients who come to him for his special effects and product shooting. For an assignment demonstrating a "computer made to withstand a harsh environment," he dried a tray of mud until it cracked, placed the computer on top, and lit the shot from beneath, a red light shining up through the cracks. With a reputation for such innovative solutions, he has been flown to such dramatic locations as the Swiss Alps to shoot product photos against a mountain landscape. Other work includes editorial stock of Ireland, its landscape and architecture, and the World Bank in Luxembourg.

SKOFF, GAIL (Fine Art)

c/o Jones Troyer Gallery, 1614 20th St., N.W., Washington, DC 20009

Born: 1949 *Subject Matter:* People, Travel *Situations:* Locations *Awards:* NEA Photography Fellowship *Education:* University of California, Berkeley; San Francisco Art Institute

An interest in foreign cultures led her to France and to Bali, where she photographed people in exotic environments. She hand-colored these early black-and-white photographs in order "to create photographs where time and space are suspended." This is still her main concern in her landscapes, which are empty of any human presence. Black-and-white photographs of oceans, deserts and other vast, barren landscapes, recently taken in the American West, are applied with paints and dyes in order to heighten and transform various aspects of the terrain and the sky. Thus, she says, "the feeling of being in these places is recreated."

SKOOFORS, LEIF (Corporate/Industrial)
415 Church Rd., B-2, Elkins Park, PA 19117
(215) 635-5186

Born: 1940 *Subject Matter:* People *Situations:* U.S. &
Foreign Locations, Studio

Of his twenty-two years as a professional photographer, the early years were spent in fine art photography and photojournalism. During this period he covered wars in Northern Ireland, Nicaragua and El Salvador. Back in the United States, he taught photography while working for such national magazines as *Newsweek* covering the White House, Three Mile Island and other national and international events. In 1983 he decided to switch his field of focus, which saw him quit teaching to concentrate on corporate photography. Today he spends his camera time shooting for annual reports and other corporate projects for Citicorp, DuPont, Smith Kline Beckman and others. In the last five years *Businessweek*, *Forbes*, and the *New York Times* have published his photos.

SLATER, EDWARD A. (Advertising, Corporate/Industrial)
3601 W. Commercial Blvd., Suite #33, Ft. Lauderdale, FL 33309 (305) 486-7117

Born: 1944 *Subject Matter:* High-Tech Equipment, Special Effects *Situations:* Studio *Awards:* NPPA Honors, Addy Award *Education:* Miami-Dade College; New York Institute

He began his career as a photojournalist, doing assignments for national magazines, corporations and advertising agencies. His specialities are in large-format special effects and high-tech photography. Using specialized equipment and facilities, he creates the slick, futuristic look appropriate to modern technological equipment of all types. His photographs feature close-up and wide-angle shots, with deep shadows and contrasting backgrounds emphasized with highlighted metallic surfaces. In his work he endeavors to "capture the essence of the twentieth-century electronic and communications industry." Slater has also started Souther Stock Photos, now the largest private stock photo agency in the south, representing over 100 leading photographers.

SLAVIN, NEAL (Fine Art, Photojournalism)
62 Greene St., New York, NY 10012

Born: 1941 *Subject Matter:* People *Situations:* Studio, U.S. & Foreign Locations *Awards:* Fulbright Photography Fellowship; NEA Grant *Education:* Cooper Union; Oxford U., England

He has worked on a variety of projects, including group portraiture, book and magazine covers, and photo essays. In addition to photography, he has also studied graphic design, painting and sculpture. As a freelance photographer and graphic artist, he has received assignments from *Esquire*, *Fortune*, *Newsweek*, *Stern*, the *New York Times* and the *London Sunday Times*. He works in both large and small formats, black and white and color. An example of his photo essays is a series of black-and-white prints of social repression under a dictatorship entitled "Portugal." He is probably best known for his group photos, such as the series entitled "When Two or More Are Gathered Together," a series of color portraits of American professional and social organizations.

SLEET, MONETA J., JR. (Photojournalism)
1128 James Court, Baldwin, NY 11510
(212) 97-4500; (516) 623-0410

Born: 1926 *Subject Matter:* People, Events *Situations:* U.S. & Foreign Locations *Awards:* Pulitzer Prize in Feature Photography; Photojournalism Award, National Association of Black Journalists *Education:* New York U.; School of Modern Photography, NYC

Completing his degree in business upon returning from service in World War II, he decided to turn his hobby in photography into a career. He attended the School of Modern Photography in New York City, and for five years he was both writing and shooting for *Our Magazine*. In 1955 he was hired by *Ebony* and has been with Johnson Publications ever since. During the late 1950s and 1960s, he covered Dr. Martin Luther King and the civil rights movement. He was present to photograph Dr. King receiving his Nobel Peace Prize in Sweden and to cover his funeral in Atlanta; his photographs of Coretta Scott King earned him the Pulitzer in Feature Photography. He has traveled to Africa some thirty times, covering Black issues for both the African and the American editions of *Ebony*. Today, he photographs a broad range of subjects for *Ebony* and *Jet*. Recently he flew to the Soviet Union to document the Dance Theater of Harlem in Leningrad. In 1986, a cross-section of his work consisting of 120 photographs was exhibited at the New York Public Library and is still touring cities across the United States.

SLENZAK, RON (Advertising, Entertainment)
7106 Warring Ave., Los Angeles, CA 90046
(213) 934-9008

Born: 1948 *Subject Matter:* Food, People *Situations:* U.S. Locations, Studio *Education:* Art Center College of Design

Starting with a small Polaroid at the age of fifteen, he discovered his passion for creating innovative images and while over the years his equipment has certainly changed, his project in photography has not. While attending the Art Center College of Design, he began working as an assistant to photographer Jim Wood. Following his graduation he worked under well-known Los Angeles photographers Marty Evans and Reid Miles, opening his own studio two years later. Specializing in the entertainment field, creating posters and advertisements for such movies as "Bright Lights Big City" and "Purple Rain," he is known for both his studio and location shooting, for his ability to arrive at something original. He has won awards for album covers, packaging and annual reports, and, outside of entertainment, he shoots for the banking, fashion, high-technology and publishing industries.

SLOCUM, CAM (Fine Art)
2421 E. 16th St., Los Angeles, 90021

Born: 1957 *Subject Matter:* Politics, Social Issues *Situations:* Studio *Education:* U. of California, San Diego

A performance artist for ten years, he turned to painting for a short period but found his true interest was in information, not the rendering of it. "Photography is a way for me to start with an image and work my way out," he says, "rather than work my way in through painting." Reading an archaic photography dictionary, he re-discovered a 19th century bi-chromate non-silver process. Using this process, which involves generating a positive image on a canvas, exposing it in the sun,

and developing it with pigmented colors, he produces large (6 by 6-foot) images. Most recently he is using found photographs in conjunction with linotronic printing, a process which involves the digitalization of the visual information via a computer. With this process he can distort areas of the image and produce a new 8" x 10" negative which is then used to generate a 8 x 10-foot photograph. All of his images explore political and social issues.

SMITH, BILL (Fine Art, Advertising)
498 West End Ave., New York, NY 10024

Born: 1952 *Subject Matter:* Still Life, Nature *Situations:* U.S. Locations, Studio *Awards:* Andys (2); Creativity 83 *Education:* New England School of Photography

For his fine art photography, his strong design and European color sensibility, he credits the influence of painters Magritte and Escher. Commercially, he chooses not to specialize, shooting instead for a diverse group of companies on a diverse set of projects, including location and still life for advertising, corporate and editorial use. A brief list of clients includes Avis, AT&T, IBM, Polaroid, Clairol, Ford, Sheraton, Cannon, *Savvy,* Pony, Chivas and Ben Gay. Over the years his work has been widely exhibited, and he has lectured at ILP, Maine Photographic Workshop, and the New England School of Photography. In addition, he has authored and supplied photography for the book *Designing a Photograph.*

SMITH, KEITH (Portraiture, Fine Art)
22 Cayuga St., Rochester, NY 14620

Born: 1938 *Subject Matter:* Portraiture *Situations:* Studio *Awards:* Guggenheim Fellowship; NEA Award *Education:* School of the Art Institute of Chicago; Illinois Institute of Technology

Smith actively pursues several media including silk-screening, lithography, etching, photography and engraving. Best known are his photographic portraits. A majority of his portraits of men are erotic. In the mid-1980s Smith began publishing numerous books illustrating his serial imagery.

SMITH, LELAND C. (Editorial, Environment)
3800 Dewey Ave., Ste. 5102, Rochester, NY 14616-2579

Born: 1925 *Subject Matter:* People, Products *Situations:* Studio & U.S. Locations

He is self-taught. As a teenager he was the campus photographer for an exclusive girls' finishing school. After serving in World War II and getting an education, he began using photography as a teaching tool. For him the visual image became the universal language, a multi-dimensional way of transmitting everything from simple physical details, to complex abstract philosophical thoughts. His work has appeared in trade journals, books and documentary reports. Currently his work is influenced by the simple photographic honesty of Adams, Fred Pickers and others.

SMITH, MICHAEL A. (Fine Art, Environment)
Box 400, Bunker Hill Rd., Ottsville, PA 18942
(215) 847-2005

Born: 1942 *Subject Matter:* Nature, Urban Landscape *Situations:* U.S. & Foreign Locations *Awards:* NEA Photographers Fellowship; Best Photographic Book of the Year, Arles *Education:* Temple U.

He likens photographs to poems and 8" x 10"s to sonnets. In the late 1960s and 1970s he made large format black-and-white photographs of nature. His elegant monograph of that era's work, *Landscapes 1967-1969,* has been called, "perhaps the finest photographic book made in the 20th century." Today he photographs the urban landscape and has added 8" x 20" and 18" x 22" prints to go along with the sonnet-sized 8" x 10"s. He has been commissioned to photograph Toledo, Princeton and New Orleans. His photographs are in many major museum collections, including the Metropolitan Museum of Art and the Museum of Modern Art.

SMITH, R. HAMILTON (Photojournalism, Advertising)
1021 W. Montana Ave., St. Paul, MN 55117

Born: 1950 *Subject Matter:* Sports, Wildlife *Situations:* U.S. Locations, Aerial *Awards: Communications Arts Awards*

A self-taught photographer, he has been influenced by the work of Ernest Haas and David Muench. He started shooting in 1971, when a college roommate gave him a camera instead of rent money, and Smith began publishing in 1975. Since then he has worked for many national magazines, including *National Geographic, Sports Illustrated, Fortune, Newsweek, Outside, Bon Appetit* and *Time,* among others. He won awards in *Communication Arts* for his first solo book on Minnesota published in 1984 by Graphic Arts Publishing. He is currently in demand as a location photographer for major corporations and advertising agencies.

SNIDER, LEE (Editorial, Portraiture)
221 W. 82nd St., Suite 9D, New York, NY 10024
(212) 873-6141

Born: 1939 *Subject Matter:* People, Travel *Situations:* Studio, U.S. & Foreign Locations

He became a professional photographer after spending fourteen years as a Senior Editor/Art Director at Chappell Music Publishers. Influenced by his earlier career, his photography has always been oriented towards the theater. He specializes in photographing resume portraits for the performing artist, and publicity and production shots for theatre companies. He is the staff photographer for the renowned New York Gilbert and Sullivan Players. He also travels to Europe each year, building up large stock files which he sells to travel magazines, newspaper travel sections and book publishers. His work has recently appeared in the *New York Times* and the *Los Angeles Times.*

SOMMA, LAURENCE (Advertising, Editorial)
2018 Rosilla Pl., Los Angeles, CA 90046
(213) 650-0525

Born: 1942 *Subject Matter:* People, Travel *Situations:* U.S. Locations, Studio, Television and Movie Sets *Education:* Art Center College of Design; UCLA

He began his professional career in 1969 working on feature films and documentaries in Hollywood. Over his eighteen years in the business, he has shot for ABC, CBS, NBC, Disney, 20th Century Fox and other major motion picture companies. Today he also runs a portrait studio when he is not out shooting publicity campaigns for motion pictures and television networks in Los Angeles. Additionally, he is known for his reportage of life in the streets in the Los Angeles area and his ability to capture the many facets of its diverse

cultural background. Most of these photographs are black-and-white in an attempt to strip the image down to its emotional essence.

SOMMER, FREDERICK (Fine Art)
c/o Light Gallery, 724 5th Ave., New York, NY 10019

Born: 1905 *Subject Matter:* Landscape, Nature, Animals, Found Objects *Situations:* Studio, U.S. Locations Award; Guggenheim Photography Fellowship *Education:* Cornell U.

He was originally a landscape architect, but when he developed tuberculosis he was forced to forego his career. He settled in the American Southwest to convalesce, and there discovered photography. Virtually a self-taught photographer, he feels influenced by Alfred Stieglitz, Paul Strand and Edward Weston. Early photographs were of Arizona, and proved to be some of his most lasting images of dead carcasses, animal innards and spatially bizarre desert landscapes. These desert landscapes take on an almost abstract quality, appearing two dimensional. Charles Sheeler and Max Ernst encouraged Sommer to experiment with photographic principles, and this led him to cut out paper images, to photograph collages, to paint on cellophane and to a variety of other experiments including the incorporation of found objects. He likes to include pipes, machine parts, dolls, skeletons, posters and decaying body parts. Often he seems obsessed with the exploratory investigations of decaying carcasses and amputated appendages, often horrific and disturbingly detailed. He remains, however, fascinated by the disintegration of organic matter.

SONNEMAN, EVE (Fine Art)
98 Bowery, New York, NY 10013

Born: 1950 *Subject Matter:* Nature, Rural and Urban Landscape, Still Life *Situations:* U.S. & Foreign Locations *Awards:* NEA Awards: Polaroid Corp. Grant *Education:* U. of Illinois; U. of New Mexico

Her images are frequently presented in pairs of two or four. During the early portion of her career, she explored the subtle variations of perspective, resulting in a series of photographs taken in New York City and outlying areas. In her more recent work, scale has acquired new importance, and her diptychs have been joined by new 20" x 24" Cibachromes of single images.

SPELIOTIS, STEVEN (Portraiture, Advertising)
853 7th Ave., New York, NY 10019 (212) 582-7080

Born: 1956 *Subject Matter:* Performing Arts, Fashion *Situations:* Studio, Theater *Education:* Essex Photographic Workshop, Essex, MO

A practitioner of ballet and modern dance, he has worked for the past eight years as a professional photographer, covering dance, theater and fashion in the greater Boston area. He was recently appointed principal photographer for Kenn Duncan Ltd., for whom he has assisted on special assignments for the past several years, and he carries on the tradition of the late John Lindquist and Kenn Duncan, two of the world's foremost dance photographers. Since his appointment in New York City, he has completed photographing for the Broadway musical *Song and Dance*, with Bernadette Peters, Betty Buckley and cast members. Nikolais Dance Company, Anna Sokolow Dance Theatre, Mary Anthony, New York Theatre Ballet, Ballet Hispanica, LeRitz Productions, Be Be Miller Dance Company and Andre DeShields are among his other clients.

SPELLINGS, IRIS (Fine Art)
321 Dean St., Brooklyn, NY 11217 (718) 875-8251

Born: 1953 *Subject Matter:* Still Life, Portraits *Situations:* Studio *Awards:* Grant, David Bermant Foundation & the New York Foundation for the Arts *Education:* Herron School of Art; Indiana U., Indianapolis

More interested in the essence of the objects she shoots than in the objects themselves, she constructs her subjects with the eye of a sculptor or painter, often using bits of paper, plastic and household objects to add color and to capture that which is "animate behind the surface." She uses a range of lighting techniques as well as light-reflective materials; light itself becomes a significant element in her work. The resulting pieces are often somewhat abstract, challenging viewers to decipher what is before their eyes—an interaction deliberately set in motion by the photographer. She has recently begun introducing the human figure into her photographs. While still exploring her subjects' essential character, she is sensitive to her models, working in a way to produce a collaborative result.

SPIVAK, IRWIN H. (Corporate/Industrial, Advertising)
19 Crosby Dr., Bedford, MA 01730 (617) 251-6813

Born: 1926 *Subject Matter:* Products, Industry *Situations:* U.S. & Foreign Locations, Studio *Awards:* Art Directors' Club of New York Award *Education:* New York U.; Queens College

For the first twenty-five years of his long career, he traveled the world as an editorial photographer, shooting for such magazines as *Life, Look, Fortune, National Geographic* and many picture publications world-wide. Shifting from editorial work to industrial advertising, he began doing work for such Fortune 500 companies as DuPont, AT&T, ALCOA, IBM, Polaroid, Eastman Kodak, Gulf, Mobil and U.S. Steel. After relocating to Boston from New York in 1975, he moved into high-tech and electronic assignments, providing annual reports, audio-visual productions, location and studio photography to many of the "128" belt companies. Having recently acquired Sears Roebuck as a client, he is also working heavily in catalog photography and production. Of the hundreds of books he has illustrated with his photographs, however, he points to his children's series entitled "I Have Feelings" as his favorite.

SPRATT, JACK (Advertising, Photojournalism)
P.O. Box 1620, North Kingstown, RI 02852
(401) 295-2574

Born: 1940 *Subject Matter:* People *Situations:* U.S. & Foreign Locations *Education:* Silvermine Guild; Art Students League

He freelances as a photojournalist for the *New York Times, Newsweek, Time* and other national and international periodicals. His initial interest in photography came through the work of Robert Frank, Diane Arbus and Paul Capinago. He continues to pursue creative photography while supporting himself with an ever-expanding base of commercial and corporate clients. His personal work is evenly divided between social justice concerns and photography as pure art.

David Stahl

Bill Stanton, *Sugar Cane Field, Nicaragua*

STAHL, DAVID (Advertising, Editorial)
4752 Huntley Ln., Sarasota, FL 33580 (813) 377-0246

Born: 1948 *Subject Matter:* People, Marine Subjects *Situations:* U.S. & Foreign Locations, Aerial, Hazardous *Awards:* Explorer's Club Flag, NYC *Education:* New College, Sarasota, FL

His photography career began at age 18 with publication of an article and photographs in *Surfer.* He studied art as a boy with his father, an internationally renowned painter and writer, and has lived in Spain and Mexico. Magazine publication credits include *Vogue Australia, Boating, Yachting, Discovery, GEO, Backpacker, Outside, Working Woman* and *Signature.* Advertising clients include Gulfstar Marine, Irwin Yachts, Excalibur Marine, Wellcraft Marine and DuPont. His assignments have taken him around the world, to locations in the U.S., Europe, North Africa, the Middle East, Polynesia, Indonesia and Australia. In 1987 he served as creative director, writer, still photographer and researcher for an hour-long PBS documentary on the aboriginal cave paintings in Cape York, Australia, entitled "Australia's Art of the Dreamtime."

STALLER, JAN (Editorial, Fine Art)
37 Walker St., New York, NY 10013

Born: 1952 *Awards:* NEA *Education:* Maryland Institute

She works with urban landscapes both concretely and in the reflections of buildings in other buildings. Shooting at twilight, she manipulates the interaction between artificial and natural light to underscore the relationship between man-made structures and natural environment and form. In particular, weather is transformed into a theatrical, dramatic backdrop for her surreal illustrations of modern cityscapes.

STANDART, JOE (Photojournalism, Advertising)
5 W. 19th St., New York, NY 10011

Born: 1950 *Subject Matter:* Travel, Products, Interiors *Situations:* U.S. Locations, Studio *Education:* Williams College

Although he does an occasional travel piece and various product shots, his love is architecture, especially interiors. Over the years he has developed his own personal approach, producing photography for clients in the fields of insurance, flooring, kitchenware and other domestic lines. He is perhaps best known for his ads for Martex, Dan River and Chubb Insurance. In addition to his commercial advertising work, he has recently finished photos for a book entitled *The Scented Room.*

STANTON, BILL (Photojournalism, Corporate/Industrial)
160 W. 95th St., Apt. 9D, New York, NY 10025 (212) 662-3571

Born: 1946 *Subject Matter:* Travel, People *Situations:* Foreign Locations *Education:* Oakland U., Oakland, MI

He grew up in the Midwest and began taking pictures when he was 13 years old. Inspired by the work of Cartier-Bresson, he spent a semester shooting the sights and people of Hong Kong. For the last ten years, he has been working for a variety of corporate and industrial clients in travel locations around the world.

His intention is always to understand thoroughly a client's needs and to translate that knowledge into photographs of clear content and clean composition. Personal work is shot on Tri-X, a black-and-white film stock. He uses his camera journalistically, attempting to capture the decisive moment that emotionally crystallizes a scene or encounter. Working in Central America, he seeks to depict all aspects of society, the timeless and universal. This work has been exhibited in a book edited by Susan Meiselas and Kay Rubenstein and published in El Ealvador.

STARR, RON (Fine Art, Advertising)
P.O. Box 339, Santa Cruz, CA 95061 (408) 426-6634

Born: 1947 *Subject Matter:* Found Objects, Figures, Architecture, Interiors *Situations:* Studio, U.S. & Foreign Locations *Education:* Case Western Reserve U.; Boston U.; Goddard College

He describes himself as "a photographer who wears two hats." Under one hat, he pursues personal work with found objects, making amorphous, other-worldly figure studies, concentrating on shape and texture, searching to reveal the subliminal using special lighting techniques. Under the other hat, he shoots commercial location photography for architects and design professionals, the travel and resort industry, corporate clients and advertising agencies. His photographs have been reproduced in many magazines, including *Designers West, Garden Design Architecture* and *Interior Design.* He approaches commercial work in the manner of a set designer, creating and lighting a photograph to give it a theatrical or cinematic quality.

STEELE, KIM (Fine Art)
640 Broadway, New York, NY 10012 (212) 777-7753

Subject Matter: People, Industry *Situations:* U.S. Locations

Her photographic career began while she was a student journalist at Syracuse University. She then took the Critics Program at the graduate school of the University of New Mexico. She has since directed all her energy into fine arts photography, has exhibited widely and is represented in many important collections, including the Museum of Modern Art. In the last few years she has applied her artistic interest in technology to the commercial marketplace. Her work has appeared in *Fortune* and *Forbes.*

STEGBAUER, JAMES W. (Photojournalism)
421 Transit Ave., St. Paul, MN 55113 (612) 484-2384

Born: 1949 *Subject Matter:* People, Sports, Travel *Situations:* Hazardous, Foreign Locations *Education:* College of St. Thomas

Of all his experiences abroad, including Europe and Australia, the most profound were those he experienced in Calcutta and Bombay, India. There as a photojournalist, photographing children and old people, he began creating a portfolio that speaks for the universality of human feelings and desires. Working in Venice, Italy he was struck by the powerful symbolism of a mother and child, and this has become a recurring theme in his larger vision. Not all of his photography is somber, however. Working for the Air and Space Museum of France, he documented the flight of a replica of the 1783 Montgolfier Balloon which took place in conjunction with the Lindberg Foundation's celebration of the anniversary of Lindbergh's historic transatlantic flight. In Australia,

Ron Starr, *Spider Woman.* Courtesy: Ledel Gallery, New York City

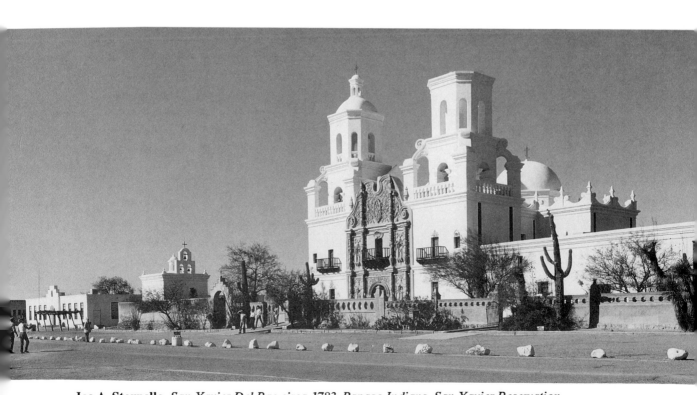

Joe A. Stornello, *San Xavier Del Bac circa 1783. Papago Indians, San Xavier Reservation*

shooting Kodachrome, he captured the drama of the Australian Bicentennial balloon race.

STETTNER, BILL (Advertising, Celebrities)
118 E. 25th St., New York, NY 10010 (212) 460-8180

Born: 1938 *Subject Matter:* Fashion, Travel *Situations:* Studio, U.S. & Foreign Locations *Awards:* Andy, Gold; Art Directors Club, Gold

He is a high-powered, strong-willed and emotionally daring New York photographer. Though his current images are glamorous and exotic, he began his career assisting his father who was a successful wedding and portrait photographer. He was a U.S. Naval Photographer for two years and later he assisted Maxwell Coplan, Bernie Gold and Arnold Newman in New York. In 1964 he formed a partnership with John Paul Endress. Since 1970 he has had his own studio. Since 1981 he has worked from an 8,000-square-foot studio on New York's East 25th Street. He has served on the board of trustees of the American Society of Magazine Photographers and was a founding member of the Advertising Photographers of America.

STETTNER, LOUIS J. (Photojournalism, Advertising)
Stettner Studio, 172 W. 79th Street, New York, NY 10024

Born: 1922 *Subject Matter:* People *Situations:* Locations *Awards:* NEA Photography Fellowship; Yaddo Creative Photography Fellowship *Education:* Princeton U.; Institut des Hautes Etudes Cinematographiques

Since 1949, his photographic portraits of people have appeared in such magazines as *Time, Paris-Match, Fortune, National Geographic* and many others. In straightforward, simple compositions, Stettner captures people unawares in unlikely places, when the moment and the light feel right. "Photography," he says, "has always been to me a passionate way of interpreting the world around me." He has published two series of photographs, *Workers* and *Women.* Also a writer, he has been a columnist for *Camera 35* for many years. Public collections include the Museum of Modern Art in New York City and the Victoria and Albert Museum.

STEVENSON, MONICA (Editorial)
130 W. 25th St., New York, NY 10001
(212) 633-0879

Born: 1960 *Subject Matter:* Still Life, Interiors *Situations:* Studio, U.S. Locations *Awards:* Upcoming Photographer, *Art Direction Education:* U. of North Carolina; Ohio U.

She has operated her own studio since 1987. While she has worked in the past in fashion photography, today she works almost exclusively on editorial still-life projects, for which she creates colorful, often whimsical sets. Her photographs are characterized by their vibrant color, their texture and their depth, and she often incorporates fabrics, video images, clay and painted surfaces with objects both in the foreground and background. In reviewing her training, she cites not so much her academic instruction as her time assisting fashion photographers Albert Watson and Chris Callis, the former for his technical precision, the latter for his pursuit of the experimental and the creative. Her publication credits include *HG, Vogue, Family Circle, Savvy, Child, Parenting* and *New York.*

STILLER, RICK (Advertising, Corporate/Industrial)
1311 E. 35th St., Tulsa, OK 74105 (918) 749-0297

Born: 1949 *Subject Matter:* Architecture, Interiors *Situations:* Studio, U.S. Locations *Education:* U. of Wisconsin

He got his start in photography as a color lab technician. When an interior designer asked him to photograph some of her work, she was so happy with the results she the she began recommending him for other work. His interior work then led to work with architects on their projects. As more and more of his work fell in the advertising/corporate area, he opened his own studio to accommodate the need for still lifes and the control of the studio environment. He now divides his time among architecture, interiors and advertising/corporate work. He is a founder and secretary/treasurer of his local chapter of the ASMP and has taught photography at the University of Tulsa.

STOELKLEIN, DAVID R. (Advertising)
P.O. Box 856, Ketchum, ID 83340 (208) 736-5191

Born: 1949 *Subject Matter:* Sports *Situations:* Foreign & U.S. Locations *Awards:* IAF Awards

Working as a professional photographer for advertising in the ski and outdoor industries for 18 years, he is published daily in the United States, and his work is sold extensively in Europe and Asia. He produces work on location for clients in every field from travel to sports as well as editorial material that is used throughout the world.

STONE, ERIKA (Photojournalism, Portraiture)
327 E. 82nd St., New York, NY 10028
(212) 737-6435

Born: 1924 *Subject Matter:* People *Situations:* Studio & U.S. Locations *Education:* U. of Wisconsin; New School for Social Research

She was an early member of the New York Photo League and was influenced by their documentary and educational ideas. Her commercial photographs of babies, children, pregnancy, birth, pediatrics and family interactions have appeared in magazines, textbooks and advertisements. Her personal work involves underprivileged children and people from all over the world. She has illustrated four children's books for Walder Publishing Company and her book *Pro Techniques for Photographing Children* was published by HP Books in 1986. She has exhibited at Neikrug Photographic in New York City and at the Howland Center for Cultural Exchange in Beacon, New York. She has a stock file of over 5,000 images.

STORNELLO, JOE A. (Editorial, Advertising)
4319 Campbell St., Kansas City, MO 64110
(816) 756-0419

Born: 1951 *Subject Matter:* People, Architecture *Situations:* U.S. Locations *Awards:* Artist Development Grant, Michigan Council for the Arts *Education:* Michigan State U.; U. of Toronto

A Ph.D. student in English literature at the start of 1977, he ended the year as an assembly line worker at Buick Motors. Without formal training in photography, he took up shooting in the documentary traditions, choosing as his subjects people, urban scenes and architecture. In time his eye became more analytical and he began concentrating on the interrelation-

ships between people, architecture and place, using the camera to explore the historical tension between past and present witnessed in public, religious and commercial architecture. In 1979 he began showing widely in juried and solo exhibitions in his native state of Michigan and was soon receiving commercial assignments which were shot in black and white. When the assembly plant laid him off in 1982, his decision to go professional was made. Though his work up until this time had been in black and white, he contracted with architectural firms to shoot color. His interior color photography maintains, however, something of his black-and-white sensibilities. He has shot for brochures, annual reports, trade shows and advertising. He also continues to exhibit his camera work through midwest galleries and juried exhibitoins. He is a general member of ASMP and one of the founding members of the Mid-America ASMP chapter.

STOY, WERNER (Corporate/Industrial, Editorial)

287 Chestnut St., San Carlos, CA 94070
(415) 591-4155

Born: 1913 *Subject Matter:* Travel *Situations:* U.S. & Foreign Locations *Awards:* Special Advertising Recognition Award, Advertising Agency Association of Hawaii

He pioneered available light photography in the mid-1930s after mastering hyper-sensitizing slow films. In 1938 he was hired by the *San Francisco Examiner* for special assignments and in 1940 he was engaged by the Pan Pacific press in Honolulu. During World War II he stayed in Hawaii, working for the Red Cross, USO and War Bonds. In 1950 he started Camera Hawaii, a versatile studio that has produced every class of photography including editorial, advertising, aerial, architectural, food and travel. The studio's large stock library includes images of Hawaii, the South Pacific, the Orient and parts of Europe, Canada and the U.S. Though now in semi-retirement in the San Francisco Bay Area, he continues his affiliation with Camera Hawaii Inc.

STRATHY, DONNA R. (Editorial, Fine Art)

P.O. Box 12575, Seattle, WA 98111 (206) 325-1837

Born: 1946 *Subject Matter:* Animals, Fashion, Nature, People, Travel *Situations:* Studio, U.S. & Foreign Locations *Awards:* King County, Washington Arts Commission Grant

She began her career as a fine art photographer. She exhibited around the country in 1981 from the Nikon House to the Rockefeller Center, and the same year her work was featured in *Popular Photography, Studio, Camera 35* and the *New York Times*. She has been sent to Africa and Portugal by travel magazines, and her work was featured on a national fine art card line. She recently formed a video production company and has produced video documentaries for travel agencies, corporate and fashion shows. She is represented by the Black Star Agency.

STREANO, VINCE (Advertising, Corporate/Industrial)

P.O. Box 662, Laguna Beach, CA 92652
(714) 497-1908

Born: 1945 *Subject Matter:* Animals, Nature *Situations:* Hazardous, U.S. & Foreign Locations

In 1968, he began his career as a staff photographer with the *Los Angeles Times.* In 1973 he left to start a freelance business working first for editorial clients but gradually expanding into corporate and advertising shooting. His editorial credits include *National Geographic, Smithsonian, Sports Illustrated, People* and *Time.* His images have been featured in advertising campaigns for Viceroy, Yamaha, Raymond Forklifts, Mobay Chemical Corporations and others. His annual reports work includes Great Western Bank, Internorth Corporation and URS Corporation.

STRESHINSKY, TED (Editorial, Corporate/Industrial)

P.O. Box 674, Berkeley, CA 94701 (415) 526-1976

Born: 1933 *Subject Matter:* Travel, Nature *Situations:* Foreign & U.S. Locations *Awards:* Gold Medal Award, New York Art Director's Club *Education:* U. of California, Berkeley

His career in photography spans some 30 years, his work appearing in publications the world over. From early innovative work in photographing the performing arts, he went on to editorial work for the *Saturday Evening Post, Life, Look, Sports Illustrated, Smithsonian, GEO* and numerous others. Among ten book credits are series for Time-Life on science and on cooking. The 1960s found him in a period of heavy photojournalism, doing photo essays with Tom Wolfe and Joan Didion on Ken Kesey and other notable people and events of that era. Most recently, his interest has turned to corporate travel assignments overseas, including Asia and the Pacific Islands, and continued editorial work for such publications as *Smithsonian, Esquire* and *Travel & Leisure.*

STUPAKOFF, BICO (Fashion)

c/o Mary Beth Welsh, Oversee Agency, 153 Mercer St., New York, NY 10012 (212) 219-0707

Born: 1961 *Subject Matter:* Fashion, Portraits *Situations:* U.S. & Foreign Locations, Studio *Awards:* Merit Award, New York Art Directors Club

Landing his first assignments with *GQ,* he developed a portfolio of portraits of famous personalities, including baseball's Keith Hernandez, that he has published with *GQ* and *New York Woman.* Soon he was shooting fashion assignments for *Self,* traveling to the Bahamas to photograph a promotion for clothes by Ralph Lauren. He has since completed a cover and 22 pages of fashion for *Seventeen,* as well as photo illustrations for the *Cosmopolitan* bathing suit edition. In variety of locations—from the Brazil's Amazon to the beaches of the Caribbean—he works with the "props" that are available, preferring natural light in order to capture the inherent atmosphere of the sites. Flouting traditional fashion photography in which models pose and assume defined expressions, he strives for a "snapshot with quality."

STURTEVANT, PATTY (Advertising, Editorial)

1868 Mission Hills Ln., Northbrook, IL 60062
(312) 564-0363; (312) 531-3358

Subject Matter: Nature, People, Sports *Situations:* U.S. & Foreign Locations, Underwater

Inspired by brilliantly colored sponges, sea fans, tiny coral shrimp and huge sweeping manta rays, her interest in photography was born out of her love for scuba diving. Seeking to display faithful images of these creatures led her through a series of courses in underwater

photography. Eventually, as she traveled to different parts of the world, she became equally interested in photographing the people of other countries and their activities, particularly children. She uses both color and black and white, preferring black and white to emphasize lines and textures. As a freelancer she has placed photographs in magazines, newspapers, textbooks and promotional brochures. She has also done underwater work for Chicago's Shedd Aquarium.

SUAU, ANTHONY (Photojournalism)

c/o Black Star, 450 Park Ave., New York, NY 10016

Born: 1956 *Subject Matter:* Editorial *Situations:* U.S. & Foreign Locations *Awards:* Pulitzer Prize, 1984 *Education:* Rochester Institute of Technology

He first gained national attention with a series of photographs documenting the plight of famine victims in Ethiopia. Suau took a leave of absence from the *Denver Post* to cover the story and the images he brought back helped shock an indifferent nation out of its complacency. "Wherever I looked I saw people dying," he said. "The inhumanity of the situation was overwhelming." His photographs gave a much-needed boost to U.S. relief efforts and eventually earned him the Pulitzer Prize.

SUGAR, JAMES A. (Editorial, Scientific)

45 Midway Ave., Mill Valley, CA 94941
(415) 388-3344

Born: 1946 *Subject Matter:* Aviation, People, Travel, Wildlife *Situations:* Aerial, Hazardous, U.S. & Foreign Locations *Awards: Napa* Magazine Photographer of the Year; Top Photographic Award, Aviation Space Writer's Association *Education:* U. of Pennsylvania; Wesleyan U.

In the summer of 1967 he began work as an intern for *National Geographic*, and two years later he signed a full-time contract with the magazine. At *National Geographic* his piloting and scuba diving skills were put to use as assignments included articles on manatees, starfish, the flight of the Gossamer Albatross across the English Channel, as well as aviation advances and balloon racing. Other assignments took him into the heartland of America where he worked on articles on wheat cutters, truck drivers and the Iowa family farm. Assignments covering an Ethiopian village and Ukrainian Easter eggs have taken him overseas. In addition to making photographs, he has also offered his expertise to students in workshops at the Center of the Eye in Aspen, Colorado and at the University of Missouri.

SULLIVAN, SHARON (Editorial, Advertising)

115 Columbia Ave., Jersey City, NJ 07307
(201) 795-1930

Born: 1961 *Subject Matter:* Products, Fashion *Situations:* Studio, U.S. Locations *Education:* School of Visual Arts, NYC

Still considered a "new kid on the block," she studied with Stan Staffer at the School of Arts and assisted large-format still-life photographers Irene Stern, Sigfried Owen and Charles Leshot. She has been freelancing since the mid-1980s shooting advertising, fashion and people with products. Her sensuous and animated depictions of couples have consistently appeared in *Cosmopolitan.* Some of her clients include John Henry, Laura Ashley, Geer DuBois, Minolta and

many 7th Avenue designers and catalogues. She also teaches photography in her New Jersey studio.

SULTAN, LARRY (Fine Art)

119 Boardwalk, Greenbrae, CA 94904

Born: 1946 *Subject Matter:* People, Events *Situations:* Studio, U.S. Locations *Awards:* Guggenheim Fellowship; NEA Grants *Education:* U. of California, Santa Barbara; San Francisco Art Institute

Working from assumptions about the "good life," his photographic series have questioned the values and rewards of the American Dream using images of an autobiographical nature. Stills from home movies, portraits of his parents at various stages in their lives, and self-portraits are vehicles for exploration into the concepts of fiction and metaphor, and for "sneaking into his dad's closet and trying on his shoes." In addition to holding a faculty position at the San Francisco Art Institute, he has collaborated on two books with Mike Mandel: *Evidence* and *How to Read Music in One Evening.* His work has appeared in *Camera, Exposure: SPE, Afterimage: VSW, Popular Photography* and *Artweek,* among other publications, and he has exhibited at the Washington Project for the Arts in Washington, D.C., Pace/MacGill Gallery in New York and the Center for Contemporary Art in Seattle. His work is found in the collections of the Museum of Modern Art in New York, the Atlantic Richfield Corporation and the Center for Contemporary Photography in Tucson.

SUMMERS, CHARLES G., JR. (Nature)

6392 S. Yellowstone Way, Aurora, CO 80016
(303) 690-5532

Born: 1936 *Subject Matter:* Nature, Wildlife *Situations:* U.S. Locations *Awards:* World Wildlife Photographer of the Year, London Museum of Natural History

He started his career as a freelance nature photographer specializing in the birds and animals of North America. With his partner and wife Rita, he has expanded his range to World wildlife. He has also been assigned to cover catastrophic events and such college and professional sports as the Super Bowl. In 1985 he co-authored the popular Phototrack stock photography management program. He currently has over 50,000 select images on file.

SUPER, DREW (Advertising, Corporate/Industrial)

P.O. Box 7162, Hicksville, NY 11802 (516) 935-9595

Born: 1947 *Subject Matter:* Animals, People, Products *Situations:* Studio, U.S. Locations *Awards:* Best Color Print, Best Transparency, Germaine School of Photography *Education:* New York Institute of Technology; Germaine School of Photography

While he hasn't specialized in any one field, in his product shots, location photography, architectural and interior work, and illustration photography he aims for a clean, sharp, high-tech look. He treats his interior and product shots as small still lifes, using diffused area light, an overhead spotlight and blue and purple gels to give them a glowing effect.

SUTPHEN, CHAZZ (Advertising, Photojournalism)

22 Crescent Beach Dr., Burlington, VT 05401
(802) 862-5912

Arthur Swoger, *Phillip Guston*

John M. Tarchala, *Custom Oak.* Builder: Dave Mulder. Client:
Nordstrom, Fitzpatrick & Partners Agency

Born: 1930 *Subject Matter:* People *Situations:* U.S. Locations *Awards:* Industrial Photography Annual Award *Education:* San Francisco City College

A leading New England industrial/editorial photographer whose base of operations is Burlington, Vermont, he specializes in capturing the mystique of Vermont and New England. Touring the region's many historic areas, he photographs restored farm houses, whose interiors tell of the lives of the owners, and the little villages along the coast—capturing New England's unique inhabitants and the area's transformation through the seasons. Traveling up Route 2 to Lake Champlain and to Canada, he takes pictures of places that are threatened to disappear ten years hence. The Bank of Vermont, Radisson Hotels, National Life of Vermont, IBM and Owens-Corning comprise part of his client list.

SWAN, MILTON (Advertising)
P.O. Box 39745, Los Angeles, CA, 90039
(213) 661-7928

Born: 1941 *Subject Matter:* Fashion, People, Products *Situations:* Studio, U.S. Locations

While manager of sales and marketing for a large corporation, he fell in love with photography. Two years later he left his job to become a professional advertising photographer. His early work was in product photography, but he has since branched into fashion and beauty assignments. His studio offers a full line of services to the fashion and beauty industry, from the photography itself to design and layout including every step of production to the final product.

SWEENEY, EUGENE M. (Photojournalism)
1200 Monkton Rd., Monkton, MD 21111
(301) 343-1609

Born: 1954 *Subject Matter:* Sports *Situations:* U.S. Locations *Awards:* 1st Place Sports, Chesapeake Ad Contest; 1st Place News, Maryland-Delaware Press Associations *Education:* U. of Minnesota

A photojournalist for ten years, he has spent the last five specializing in sports photography. In a field of photography where there is no second chance, no "one more time," he has been influenced by the pioneers in "action" photography—George Silk, Neil Leifer and Walter Iooss, Jr., among others. He studies the players in the sports he photographs in order to anticipate their moves, but he says he often doesn't know what he has captured until the film is developed. In his most recent project, he has followed the comeback of boxer Sugar Ray Leonard.

SWEET, OZZIE C. (Advertising)
P.O. Box 190, Francestown, NH 03043
(603) 547-6611

Subject Matter: People, Travel *Situations:* U.S. Locations *Education:* Art Center College of Design

He produced his first magazine cover for *Newsweek* in 1942. Since then he has photographed well known public figures in the arts, sciences, business, politics and sports. He has shot over 1,770 magazine covers and along the way he has photographed Dwight D. Eisenhower, Helen Hayes, Billy Martin, Albert Einstein, Sean Connery, Sinclair Lewis, Paul Whiteman, Hank Aaron, Rocky Marciano, Pope John Paul II and hundreds of others.

SWEETMAN, GARY W. (Advertising, Portraiture)
2904 Manatee Ave., W., Bradenton, FL 34205
(813) 748-4004

Born: 1951 *Subject Matter:* People, Products *Situations:* Studio, U.S. Locations *Awards:* Florida Service Award, Florida Professional Photographers

Since 1971, he has shot portraits, wedding photographs and innovative commercial illustrations for clients all over the Southeastern U.S. Since 1973, he has been production photographer for Asolo, the state theatre of Florida. From 1983 to 1985 he was production photographer for the Sarasota Opera Company. In 1984 he opened a new 4,000-foot-studio/office space on Florida's West Coast. Designed by William Zoller, this unusual and highly efficient three-story structure features a compound cyclorama, a full kitchen set for food photography, additional small product studios, as well as specialized space for art, finishing and framing. His work has been featured in *Architectural Digest, Time, Southern Living* and other major newspapers and magazines.

SWIFT, DICK (Advertising, Photojournalism)
31 Harrison Ave., New Canaan, CT 06840
(203) 996-8190

Born: 1936 *Subject Matter:* Executives, Industrial Processes *Situations:* Studio, U.S. Locations *Awards:* Phi Mu Alpha, Kappa Kappa Psi *Education:* U. of Arizona

In 1963 he began his career as a food photographer for the Shigeta-Wright Ad Agency in Chicago. He has since moved into freelance work, and over the last twenty years his images have been seen in hundreds of magazines, books and advertisements. Both Xerox and PepsiCo have used his pictures in internal and external campaigns. In 1976, he acted as visiting professor of photography at the Rochester Institute of Technology, and W. Eugene Smith, Eliot Porter and Cornell Capa all chose him to portray them for slide sets on their personal work. He has recently opened a new studio in Wilton, Connecticut.

SWOGER, ARTHUR (Nature, Photojournalism)
61 Savoy St., Providence, RI 02906 (401) 331-0440

Born: 1912 *Subject Matter:* Nature, People *Situations:* Studio, Aerial, U.S. Locations *Awards:* Gold Cup, Industrial Advertising Club of Pittsburgh *Education:* Cooper Union; Professional Photographers Association of America

In his teens, he decided to become a natural history photographer, following in the footsteps of Carl Akely and Martin Johnson. To earn a living and to further his photographic knowledge and technique, he opened a studio in Pittsburgh shooting industrial, advertising, portrait, aerial and motion picture photography. He also produced a film, "The Birds of Pymatuning." In 1953, he opened a studio in New York and documented the Abstract Expressionist art movement. His work has been widely published in Time-Life, *National Geographic* and other trade and textbooks as well as magazines such as *Natural History, Garden, Popular Photography* and art publications, including several manuscripts. Various television programs, such as "Sesame Street," have used his work. Among the highlights of his career have been Animal Eye-shine photographs used as backgrounds for jewelry in Tiffany's windows, and fourteen large murals for the

Audubon Society of Rhode Island's new headquarters building. He teaches natural history photography at the Rhode Island School of Design.

SZABO, STEPHEN LEE (Fine Art)
3615 Ordway Street N.W., Washington, DC 20016

Born: 1940 *Subject Matter:* Nature *Situations:* Locations *Awards:* The Hague World Press Photography Award; White House News Photographer Award *Education:* Penn. State U.; Art Center School of Design, Philadelphia

After working as a photojournalist for eight years, in 1971 he left the *Washington Post* in order to freelance. He began making large-format photographs of the American landscape, namely in Maryland and on the Chesapeake Bay. To capture the finest variations in tone, he employs the painstaking process of printing on platinum paper. His landscapes do not include people, but often the evidence of them, such as a boat, an empty house, an abandoned car. His views are calm and pastoral, far away from the modern urban life of Washington, D.C., where Szabo still resides. Public collections include the Museum of Modern Art, New York City and the International Museum of Photography at the George Eastman House, Rochester, NY.

SZASZ, SUZANNE (Books, Textbooks)
15 W. 46th St., New York, NY 10036 (212) 832-9387

Born: 1915 *Subject Matter:* People, Child Development *Situations:* U.S. Locations *Awards:* Encyclopedia Britannica Journalism Awards; Art Directors Awards *Education:* Budapest U.

After spending twenty-five years photographing children as they really are, she began putting together her child development books *The Body Language of Children* (Norton, 1983) and *Sisters, Brothers and Others* (Norton, 1985). Her book on the life of her cat, *The Silent Miaow*, sold more than half a million copies. In 1987 she published *Professional Child Photography*. She has had one-woman shows at ICP, the Hungarian National Art Gallery and at Neikrug Gallery.

TARCHALA, JOHN M. (Advertising, Corporate/Industrial)
4549 W. Dickman Rd., Battle Creek, MI 49015 (616) 968-0044

Born: 1941 *Subject Matter:* People, Nature, Products *Situations:* U.S. Locations, Studio *Awards:* Top Ten Photographers; Photographer of the Year, Eastman Kodak International *Education:* NYI of Photography, Winona; Navy A & B Schools

An interest in photography that began during his U.S. Navy aerial training led to industrial and fashion assignments in Chicago. This, and a keen interest in creative food photography, formed the basis for his unique and imaginative style. Out of his love for nature comes limited edition prints for interior decorating for homes and offices. Such a range of specializations has led to a diverse clientele, including Ann Jillian, C3PO, Kellogg Cookbooks, Upjohn Company and advertisements for Hiram Walker, *Time*, *Playboy* and the *Saturday Evening Post*. He has produced an international brochure for U.S. Exports, a cover for *1001 Home Ideas* and fine art and industrial photos for a 53-week calender for the State of Michigan. As one of Michigan's Top Ten Photographers for the last fifteen years, he has lectured before the Professional Photographers of Michigan and the Chicago Ad Club.

TAYLOR, RICK (Advertising, Editorial)
P.O. Box 29745, Atlanta, GA 30359 (404) 634-8333

Born: 1953 *Subject Matter:* People, Travel *Situations:* U.S. & Foreign Locations, Studio *Education:* Rochester Institute of Technology

Simplicity, animated lighting, color, blur-motion and ultra cleanliness distinguish all of his work. His black-and-white portraits make anyone look great. Early in his career, he took many fashion pictures in the Caribbean. He is currently located in Atlanta and has a diverse practice including beauty, people, product and interior photography. The emotions he captures are well suited to the ideas he attempts to convey. His work has appeared on editorial pages, annual reports, design brochures, national magazine covers and advertising pages in magazines and newspapers.

TCHEREVKOFF, MICHEL (Advertising, Corporate/Industrial)
873 Broadway, New York, NY 10003

Born: 1946 *Subject Matter:* Still Life, Special Effects *Situations:* Studio

Born and educated in Paris, he came to the United States in 1968 and today is well known in the fields of conceptual and special effects photography. In a career spanning eighteen years, he is known to have set new trends, often as a result of having broken from tradition to create the image he envisioned. His photographs are characterized by their balance of form and color. One critic says he has "turned commercial photography into an art form." AT&T, American Express, General Electric, McDonnell Douglas, Estée Lauder and Lancôme are counted among his clients. In addition, his photography has been featured in photography magazines in the United States and Europe, with exhibitions worldwide.

TEIWES, HELGA (Nature, Photojournalism)
2611 N. Teresa Ln., Tucson, AZ 85745 (602) 621-6311; 622-4148

Born: 1930 *Subject Matter:* Landscape, Native Americans, Documentary, Historical Buildings *Situations:* U.S. Locations *Awards:* Best Western Cover, Grand Prize, World Photographers Society *Education:* U. of Arizona

She received her photographic education in Germany, worked in New York as a commercial photographer's assistant, then settled in Arizona. She enjoys photographing the austere desert landscape and documenting the lives and art of the Native American people in New Mexico and Arizona. She photographs many artifacts and fine art objects for illustrations. She has been the staff photographer for a large archaeological excavation in southern Arizona and presently works for the Arizona State Museum. One of her most memorable projects was photographing the interior of Mission San Xavier del Bac, the oldest and most elaborate Spanish Baroque mission church in the U.S. still in operation. Her photographs have been widely published in books and magazines, and she has also produced two 16mm documentary films.

TEKE (MATESKY, SONDRA) (Advertising, Editorial)
4338 Shadygalde Ave., Studio City, CA 91604 (818) 985-9066

Subject Matter: Fashion *Situations:* Studio *Awards:* 1st Place, 22nd Annual Lulu Awards, Men's Fashion As-

sociation & World's Congress of Menswear; Best Cover, *Teen Education:* Art Center College of Design; U. of Southern California

Once a model herself, she chose to pursue a new career behind the camera. She credits her study with Ansel Adams for the technical expertise and tonal control for which she is known. Working primarily in color, but also in black and white, she likes to capture "slice of life" situations and to render the emotion of a particular moment. Her work has appeared in a variety of fashion and beauty magazines, as well as an Emmy-nominated documentary on her work as a fashion photographer, produced at KABC-TV in Los Angeles.

TELFORD, JOHN (Nature, Photojournalism)
1571 Casper Rd., Sandy, UT 84091 (801) 571-2492

Born: 1944 *Subject Matter:* Nature, Travel *Situations:* Studio, U.S. Locations *Education:* U. of Utah

His early photographs are black-and-white explorations of the abstract and objective qualities of the natural world. He spent ten years photographing the Great Salt Lake, a project which culminated in the publication of *The Great Salt Lake Portfolio.* He then became interested in color and began studying intrinsic and reflected color by photographing the abstract patterns of color and light that he found in the Colorado Plateau. His current images of man-controlled landscapes are metaphysical explorations into the superficial influence of man on a landscape that is unchanging.

TENIN, BARRY (Photojournalism, Corporate/Industrial)
P.O. Box 2660, Westport, CT 06880 (203) 226-9396

Born: 1946 *Subject Matter:* People, Sports, Travel, Marine *Situations:* Aerial, Studio, Hazardous, Underwater, U.S. Locations *Education:* Art Center College of Design; Quinnipiac College

He is known for his interesting, exciting and natural looking shots of people, yachts and travel. He began his career as a photojournalist for Time Inc., working for *Time, People* and *Sports Illustrated.* He has continued to work for magazines, especially in the yachting field, but now spends an equal amount of time doing corporate/industrial assignments for Fortune 500 companies.

TENNIES, THOMAS C. (Product Illustration, Corporate/Industrial, Architectural)
P.O. Box 14989 Albuquerque, NM 87191
(502) 292-8466

Born: 1942 *Subject Matter:* Products, Exteriors, Interiors, People, *Situations:* U.S. & Foreign Locations, Studio *Awards:* Professional Photographers of America National Award for Meritorious Contributions to Professional Photography *Education:* Milwaukee Institute of Technology

Tom's interest in photography began at age 12 and has been his vocation and avocation ever since. In his full-service state-of-the-art studio, Tom creatively brings art and technology together with his 25 years of experience in commercial photography. This allows him to guarantee your satisfaction with his photography. Tom has done photography for many nationally-known companies such as Honeywell, DuPont, General Dynamics Corporation, *Geo* magazine, Hilton Hotels, Holiday Inn, General Electric, IBM, EG&G, Trammell Crow, Siemens Corporation, Terra Cor-

poration and Westinghouse. He creates simple, seductive sets relying on a wide range of lighting techniques.

TEPPER, RANDY (Advertising)
2925 Passmore Dr., Los Angeles, CA (213) 851-3662

Born: 1952 *Subject Matter:* People, Entertainers *Situations:* U.S. Locations, Movie and Television Studios

The past ten years have found him on the sets of CBS, ABC, NBC, Universal Studios, Columbia Pictures, Warner Brothers, Walt Disney and other entertainment industry companies. A publicity photographer, he has photographed Chevy Chase, Milton Berle, George Burns, Sid Ceasar, Sissy Spacek, Anne Bancroft, Nancy Reagan and many others. With advertising and publicity shots in newspapers and magazines throughout the world, he has had the opportunity to photograph large-scale productions, shooting the recreation of Pearl Harbor Day, for example, in "The Winds of War," a television project which required numerous remote radio-controlled cameras. He puts his expertise with special action effects to use shooting for the television series about Vietnam, "Tour of Duty." Not all his motion picture work is serious. His list of movie credits includes Chevy Chase in the movie "Fletch."

TERRELL, TIM (Fine Arts, Nature)
PO Box 5731, Whittier, CA 90607 (213) 692-8719

Born: 1950 *Subject Matter:* Abstracts *Situations:* U.S. Locations, Studio *Education:* Chicago Academy of Fine Arts; U. of Michigan; Babson College

A sculptor as well as a photographer, his eye is trained to see the unusual in the everyday and to render it in a fashion akin to abstract painting. One picture, *Icon,* a large ektacolor mural, features one of the most characteristic aspects of his work, close-up shots of deteriorated painted surfaces of metal objects. Rather than attempting to capture a subject, he uses the camera to present the subject as it could be experienced only through meditation.

TESKE, EDMUND (Fine Art)
1652 N. Harvard Blvd., Los Angeles, CA 90027

Born: 1911 *Subject Matter:* Nudes, People, Urban and Rural Landscape *Situations:* Studio, U.S. Locations *Awards:* NEA Fellowship; Certificate of Recognition, Photographic Society of America

He is known for his photomontages on a variety of themes. He invented a process known as "duo-toning" which combines solarization and chemical toning. His imagery is an exploration of his personal inner spiritual world of dreams and visions, featuring nature, people and human sexuality. His later work was influenced by Vendatic thought which he learned through the teachings of the Hindu Swami Prabhavananda. He is self-taught in photography, but he once served as a photographic assistant to Berenice Abbott, and also was a resident in the theater department of the Jane Addams Hull House in Chicago.

THALER, SHMUEL (Editorial, Photojournalism)
P.O. Box 8211, Santa Cruz, CA 95061 (408) 425-5115

Born: 1958 *Subject Matter:* People, Travel *Situations:* Studio *Education:* New York U.

He specializes in creating strikingly graphic environmental portraits. His photography career began in

Helga Teiwes, *Sandy*

Thomas C. Tennies, *Hopi*

to location photography for corporate and advertising accounts. In addition to one-man and group shows, his photography has appeared in various national magazines, including *Smithsonian, Time* and *Fortune*. He has five *National Geographic* feature assignments to his credit.

TICE, GEORGE (Fine Art)
323 Gill Ln., # 9B, Iselin, NJ 08830

Born: 1938 *Subject Matter:* Rural and Urban Landscape, Seascape, Portraiture, People *Situations:* U.S. Locations *Awards:* Grand Prix, Festival d'Arles, France; NEA Photography Fellowship

He developed an interest in photography as an adolescent and received his first serious training as a photographic assistant on board the U.S.S. Wasp. A photograph he took of an explosion occurring on the naval vessel was eventually brought to the attention of Edward Steichen, then Director of the Photography Department at the Museum of Modern Art, New York. Tice is now an experienced portrait photographer and has produced numerous books on landscapes, seascapes, small town scenes, etc. He works in black-and-white platinum and silver prints and uses formats ranging from 35mm to 8" x 10". His latest project, "Hometowns, An American Pilgrimage," is a photographic look at the home towns of James Dean, Ronald Reagan and Mark Twain.

TIERNAN, AUDREY C. (Photojournalism, Advertising)
99 Edwards St., #2C, Roslyn Hts., NY 11577
(516) 621-5327

Born: 1955 *Subject Matter:* News, Sports, People *Situations:* U.S. & Foreign Locations *Awards:* 1st Place, Sports Action, Baseball Hall of Fame Photo Competition; Long Island Press Photographer of the Year *Education:* Muhlenberg College

She is a versatile photographer with a strong journalistic background. Her work is very direct and representational, as she avoids any manipulation or contrived setups. She works well independently, and although she is used to "we need it yesterday" deadlines, she works best when she has time to "sink her teeth into a photographic challenge." She prefers to be involved with the entire process from conception to completion, be it a single image for an advertising campaign, or a series of related images for a photo essay. She is a staff photographer at *Newsday*, and for the past year and a half much of her time has been devoted to a project on Amerasian children. This required a trip to Vietnam to document the lifestyle of those children left behind by American soldiers, as well as trips to various cities in the United States with large Amerasian populations.

TIFFT, WILTON S. (Photojournalism, Corporate/Industrial)
77 Russell Blvd., Bradford, PA 16701 (814) 368-3877

Born: 1941 *Subject Matter:* Architecture, People, Still Life *Situations:* U.S. Locations, Aerial *Awards:* New York Art Directors Club Awards; Publication Designers Award *Education:* Pratt Institute

Attracted to the presence of Ellis Island, he began photographing the facilities and surrounding landscape in the 1960s. Shooting with 35mm in black and white using a Carboro printing process to produce archival quality images, he then offered his work to the public in a book entitled *Ellis Island*, published by W.W. Norton. He continues to take photographs of the famous entryway, making available an updated version of his book. Although he works primarily with architecture, interiors, annual reports and documentation for corporate and industrial clients, he also does aerial work for oil companies and the Los Angeles Fire Department, photographing their boats. His studio work centers around still-life and table-top assignments for catalogs and brochures, shot in black and white and color, in all formats.

TILL, TOM (Editorial, Advertising)
P.O. Box 337, Moab, UT 84532 (801) 259-5327

Born: 1949 *Subject Matter:* Nature *Situations:* U.S. Locations, Aerial *Education:* Iowa State U.

Three hundred days out of the year he travels across the United States with his 4" x 5", capturing on film the country's most scenic vistas. His 50,000 miles on the road takes him through desert flats, mountain ranges and woodlands. He has collected some 20,000 images of these areas. In addition to contributing to a large array of calendars and books, he publishes in such magazines as *Omni, Audubon* and *Wilderness*. Perhaps most notable is his aerial photography, some of which will be featured in upcoming books about Colorado and Utah.

TORREZ, BOB (Photojournalism, Advertising)
P.O. Box 103, Laguna Beach, CA 92651
(714) 497-4527

Born: 1950 *Subject Matter:* People, Fashion, Sports *Situations:* U.S. Locations

Shooting first in black and white for a local newspaper, then as a part time stringer for the Associated Press, early in his career he turned to color and began submitting his work to magazines. This resulted in several assignments and eventually a job as a photo editor. He continues to cover fashion, people and sports throughout the United States, his photographs appearing in advertisements, magazines and newspapers, including the *Los Angeles Times, Surfer* and *Sports Illustrated*. His photos also decorate the walls of Chart House Restaurants across the country, including Hawaii.

TRAFFICANDA, GERRY (Advertising)
Trafficanda Studios, Inc., 1111 N. Beachwood Dr., Los Angeles, CA 90038 (213) 466-1111

Born: 1935 *Subject Matter:* People, Products, Cars *Situations:* Studio *Awards:* Beldings; Clio *Education:* U. of Notre Dame; Los Angeles Art Center

He opened his own Hollywood studio immediately after graduating from the Art Center in 1960. For fifteen years he was known as a "people" photographer, shooting ads with children, beautiful women and real "slice of life" people. By 1975, the squeeze between model agency costs and advertising budgets had begun to push him away from people into what he terms a "love affair" with products. He began shooting merchandise such as car stereos, table tops, toys, automobiles and automobile collateral. He recently designed and built the largest individually owned photography and sound stage studio in Los Angeles. A 10,000-square-foot facility, the studio has two full shooting stages, a black-and-white and color lab, shooting kitchen and a working crew of ten people.

Tim Terrell, *Personage*

Clark Thomas, *Portrait of a Family.* Client: Silver Projects

TRAGER, PHILIP (Editorial, Fine Art)
1305 Post Rd., Fairfield CT 06430 (203) 255-6138

Born: 1935 *Subject Matter:* Architecture, Landscape, Dance *Situations:* U.S. & Foreign Locations *Awards:* Distinguished Alumnus, Wesleyan U.; Lay Person Award, Connecticut Society of Architects *Education:* Columbia U.; Wesleyan U.

A self-taught photographer, he has specialized in architecture and landscape for the past 20 years. Working in the tradition of Eugene Atget and Edwin Smith, his recent black-and-white and duotone photographs of the villas of Palladio emphasize their elegant proportions and geometric forms. With minimal usage of filters, and working only in natural light, his work with 4" x 5" and 5" x 7" cameras provides a precisionist view of structures and their settings, emphasizing intellectual complexity through visual simplicity. Known for the graceful and reserved approach he takes to his subjects, which in addition to architecture have included American and Japanese avant-garde dance troupes, Trager has published award-winning books, including *The Villas of Palladio, Wesleyan Photographs, Philip Trager: New York Photographs of Architecture* and *Echoes of Silence.* Trager has also exhibited widely, and his work is included in the collections of the Metropolitan Museum of Art, the Museum of Modern Art, the Corcoran Gallery of Art and the Smithsonian Institution, among others.

TRAINOR, CHARLES (Photojournalism)
P.O. Box 2365, Fort Lauderdale, FL 33303
(305) 476-7768

Born: 1953 *Subject Matter:* People, Events *Situations:* U.S. Locations *Awards:* Southern News Photographer of the Year, 1988; Best Portfolio & Best in Show, Atlanta Seminar on Photojournalism; New Faces 1989, *American Photographer Education:* Miami-Dade Community College

Starting as a stringer on the South Florida Bureau of UPI, he had the opportunity to cover a range of stories, including the Cuban refugees in Miami and the day/night-long Daytona auto race. With a position at the *Miami Herald* since 1981, he has continued to document the peaks and valleys of human endeavor, and his work is characterized by its intimate sense of the subject's character and life: a swimmer taking a gasp of air, policemen, guns in hand, unloading from a van. Recently he completed an award-winning series entitled "The Corridor." The photo essay is made up of six portraits covering the stages of life from birth to death and documents the lives of the people living in the strip of land between the highway and railroad tracks in Broward County.

TRAUB, CHARLES HENRY (Portraiture, Fine Art)
39 E. 10th St., New York, NY 10003

Born: 1945 *Subject Matter:* Portraiture *Situations:* U.S. Locations *Education:* U. of Illinois; U. of Louisville; Institute of Design, Illinois Institute of Technology

Working in black and white and color, he is best known for his photographs depicting non-traditional portraits of ordinary people. His primary concern is with the images these people present rather than who they are. There is a concentration on appearance, including facial expressions, attire, stance and gestures. His photographs tend to be taken in very close proximity and are made with a wide-angle lens. He also experiments with a variety of perspectives and lighting. He has produced a series of beach scene portraits. A major influence on his work were his instructors at the Illinois Institute of Technology (Chicago), Aaron Siskind and Arthur Siegel. He was the founder and initial chairman of the Center for Contemporary Photography, Columbia College, Chicago.

TRESS, ARTHUR (Fine Art, Portraiture)
2 Riverside Dr., New York, NY 10023

Born: 1940 *Subject Matter:* Nudes, Portraiture, Urban and Rural Landscape, Still Life *Situations:* U.S. & Foreign Locations, Studio *Awards:* NEA Grant, R. and D. Logan Foundation Grant *Education:* Bard College

His images are obviously staged and inherently theatrical. Having studied film directing and theater, he utilizes his background to produce several series on varying themes. He began his career pursuing the themes of pollution, ecology and urban life. He then set out to create visual symbols by depicting the dreams of children. This series of youthful fantasies, published under the title *The Dream Collector,* was followed by a series entitled *Shadow: A Novel in Photographs* in which his shadow is the main character relating a story through a suite of pictures. *The Theater of the Mind* followed, consisting of a collection of portraits of children and adults. He has spent the past few years examining homosexuality in addition to other avenues of imagery.

TRIMBLE, STEPHEN (Editorial)
102 W. San Francisco, Suite 16, Santa Fe, NM 87501
(505) 455-2333

Born: 1950 *Subject Matter:* Nature, People, Travel, Wildlife *Situations:* U.S. Locations *Awards:* National Park Service/Natural History Association Publication Award *Education:* Colorado College; U. of Arizona

His photographs are distillations of a detailed knowledge of the West that communicate a sense of place and display bold designs and magical light. He began his career as a park ranger/naturalist. Since 1981, he has worked full-time as a freelance writer and photographer. In 1983 he moved to Jaconita, New Mexico. His current book projects include an introduction to contemporary Pueblo Indian pottery and text for an illustrated children's book on prehistoric Southwestern Indian people. He wrote his first book in 1974; since then, he has written, among others: *The Bright Edge: A Guide to the National Parks of the Colorado Plateau* and *Long Peak: A Rocky Mountain Chronicle.* His photographs have appeared in *Audubon,* and National Geographic books and he has been a major contributor to the *Sierra Club Guides to the National Parks.*

TROLINGER, CHARLOTTE (Editorial, Photojournalism)
530 N. Montana, Bozeman, MT 59715
(406) 587-3414

Born: 1949 *Subject Matter:* People, Landscape *Situations:* U.S. Locations *Education:* Institute of Design, Illinois Institute of Technology

She began her career in Chicago where she taught photography at local colleges and freelanced for editorial, architectural and advertising clients. In 1981 she moved to Bozeman, Montana to teach at Montana State U. She has worked in color since the early 1980s

Philip Trager, *Villa Rotunda*

Don and Pat Valenti

and is currently involved in a long term project to document the vanishing way of life of Montana farmers and ranchers. Some of her flash-slow shutter work was published in the 1978 *Photography Annual*. She is represented by Elizabeth Leach Gallery in Portland and by Silver Image Gallery in Seattle.

TROXELL, PETER (Entertainment, Advertising)

1000 Alba Rd., Ben Lomond, CA 95005
(408) 336-2173

Born: 1938 *Subject Matter:* People, Stage *Situations:* U.S. Locations, Theatre

Apprenticing with Hank Kranzler, he began his career as a theater photographer. In 1967, he opened his own photography business in San Francisco that focused principally on theater and performing arts. He worked with the American Conservatory Theatre and KQED-TV on the West Coast and for Lincoln Center Repertory and the New York City Ballet on the East Coast. In 1970, he moved to Santa Cruz, California, where he has since shot for Bear Republic Theatre, Mountain Community Theatre and many performing arts organizations. His photographs are published frequently in magazines and newspapers throughout the Monterey Peninsula, including *Prelude*, the *Good Times*, the *Sentinel* and the *Sun*.

TRUEWORTHY, NANCE S. (Photojournalism, Advertising)

P.O. Box 8353, Portland, ME 04104 (207) 774-6181

Born: 1950 *Subject Matter:* Nature, Fashion, People, Travel *Situations:* U.S. & Foreign Locations, Studio, Hazardous

Author of a photographic essay, "Maine in Four Seasons," she is a self-taught professional whose images of Maine landscapes, Shakers and herb markets have appeared in Europe, the Caribbean and the United States. Owner of a small stock agency, her specialities include location assignments, stock work and photographs of both celebrities and unknowns, for which she travels widely. Work may be found in brochures, pamphlets and video productions as well as in magazines, postcards and calendars. Clients include *New England Business Week*, Landmark General Corporation and Blue Cross.

TRUMBO, KEITH (Advertising, Corporate/ Industrial, Editorial)

221 W. 78th St., New York, NY 10024
(212) 580-7104

Born: 1944 *Subject Matter:* Fashion, People, Still Life *Situations:* Studio & U.S. Locations

His passion for photography was awakened by a television documentary on photographer David Hurn. He started his career in the early 1960s as an assistant at the Carlton studios in London. Later, he trained under still-life photographer Barry Bullough and fashion photographer Tony Cleal. In 1965 he joined the studio of fashion and beauty photographer Barry Lategan and in 1968 moved to New York to become studio manager for Irving Penn. In 1973 he left Penn and began freelance assisting. His first solo client was *Vogue* in 1974. In 1976 his photographs were featured in a book for the Metropolitan Museum entitled *Hollywood Creations*. Over the last fifteen years he has worked with most major magazines and advertising agencies.

TUCKER, TOBA (Portraiture, Fine Art)

476 Broome St., New York, NY 10013
(212) 925-1478

Subject Matter: Nature, People *Situations:* U.S. Locations *Awards:* NEA & New York State Council for the Arts Fellowships

The subjects of her portraits are people who strive to retain their values and heritage in the midst of cultural change. She has documented Native Americans in the Southwest, making extensive studies of the Navajo and Zuni peoples, and she has recently completed a series on the Shinnecock Indians of Long Island. Her strong and elegant subjects project pride and sensitivity. She works in black and white and in color, using natural light and medium- and large-format cameras. She does all her own processing and printing for her fine art prints. Her portraits are in the permanent collections of the Museum of Modern Art and the Museum of the American Indian in New York.

TUCKERMAN, JANE (Fine Art)

116 Commonwealth Ave., Boston, MA 02116

Born: 1947 *Subject Matter:* People, Landscape, Travel *Situations:* U.S. & Foreign Locations, Studio *Education:* Art Institute of Boston; Rhode Island School of Design

Having studied under such masters as Harry Callahan and Aaron Siskind, she now teaches Studio Arts at Harvard University. From 1971 to 1975 she developed photography programs for juvenile delinquents at reform and alternative schools. Prior to that she served as photography critic for *Boston After Dark* and was a photographer for MGM Studios. Working primarily in infrared black and white as well as watercolored carbo prints, she counts among her projects a series documenting the death rituals in Banaras, India for a group effort that included the making of Robert Gardner's film "Forest of Bliss." Atmospheric images of boats, pilgrims, birds and the Ganges generate a sensation of stillness through the sensitive contrasts of clear and hazy focusing. Her work may be seen in books such as *Lightworks, Darkroom Dynamics, Art From Dreams, Self-Portrayal* and *SX-70 Art*, and is part of the collections of the Metropolitan Museum of Art in New York, the Polaroid Collection, the Addison Gallery of American Art in Andover, Massachusetts, the University of Massachusetts and the Minneapolis Institute of Arts.

TURCOTTE, JAMES W. (Advertising)

455 Camino Norte, Palm Springs, CA 92262
(619) 323-4347

Born: 1944 *Subject Matter:* People, Automobiles *Situations:* Studio & U.S. Locations

In 1973, after apprenticing in New York, Los Angeles and Detroit, he opened his own Detroit studio, specializing in automotive and people products. He is best known for his combination of people with automotive products and his images have appeared in *Road and Track, Esquire, Life, Time* and *Newsweek*. He has carried out photography campaigns for Pontiac, GMC trucks and Head tennis rackets and he has worked for Corvette since 1985. He currently resides in Palm Springs.

TUTTLE, TOM (Editorial, Travel)

P.O.Box 91529, Victoria Station, Santa Barbara, CA 93190 (805) 683-2812

Born: 1943 *Subject Matter:* Nature, Travel *Situations:* Aerial, U.S. Locations *Education:* U. of Santa Barbara Art Institute; Brooks Institute of Photography

Originally trained as a photo editor for 20th Century-Fox, he apprenticed under George Hurrel and Jimmy Mitchell. That training showed him that "capturing beauty in a subject is an attitude, a state of mind, a way of seeing." He looks for the unusual for his travel photos, where people are interacting with their environment harmoniously. After twenty years working in various fields of photography, from architecture to glamour, he discovered that it all contributed to his ability as a travel photographer. His tools, he says, "consist of a 35mm with very little equipment, a love and knowledge of California, and an eye for beauty." His work has appeared on all three networks, in advertisements and publications worldwide. His fine art black and whites have been exhibited both in the U.S. and Europe. A lecturer for several institutes and colleges, he has authored six books and is currently producing two more.

TWEEL, RON (Advertising, Corporate/Industrial)
241 W. 36th St., New York, NY 10018
(212) 563-3452

Born: 1954 *Situations:* Studio, U.S. Locations *Education:* Rochester Institute of Technology

Influenced by photo illustrator Steve Steigman, his images must be visually exciting and technically perfect. His most challenging work involves blind supported light, which provides special effects without retouching. He works in all formats using various background materials, such as colored gels, to add interest to the composition. With portraiture he prefers to get in close to his subject matter, evoking emotion and conveying warmth. His personal work, in both color and black and white, involves landscape studies that are often graphically abstract.

TYTELL, MRS. MELLON (Editorial, Fine Art)
69 Perry St., New York, NY 10014 (212) 242-3472

Subject Matter: Fashion, Nudes *Situations:* Foreign Locations *Awards:* 1st Prize, Color, *America's Magazine* Competition *Education:* New School for Social Research

She specializes in humor and is interested in subjects related to art. Although most of her subjects are exotic and marginal, such as opium in Thailand and voodoo in Haiti, she has done every type of photography from fashion to industrials to nudes. She has worked for *Figaro, W* and *People.* Her portraits were shown in Paris, and her nudes were included in an exhibition at the Munich Museum. She photographed a catalogue for a French leather company and has often worked with Sipa Press in Europe.

UELSMANN, JERRY (Fine Art)
5701 S.W. 17th Dr., Gainesville, FL 32608

Born: 1934 *Subject Matter:* Composites *Situations:* Studio, U.S. Locations *Awards:* NEA Fellowship; Medal, Arles, France *Education:* Rochester Institute of Technology; Indiana U.; U. of Florida

Categorization of his work is difficult by traditional means. From critics to viewers alike there is an eagerness to label his work surrealist, neo-romantic or Jungian. It is his ability to elude a stylistic label, however, that imbues his work with intrigue and mystery. His work is at once abstract, fantastic and surreal. He knows no limit to his juxtaposition of images. Instead, he prefers to shoot without any formulated notions as to what an image should look like, relying on his subconscious to guide his selection of images. There are, however, themes from nature that he uses repeatedly—water, rocks, eyes, hands, mirrors and floating images. "Ultimately, my hope is to amaze myself. The anticipation of discovering possibilities becomes my greatest joy." He was a student of Henry Holmes Smith, Ralph Hattersley and Minor White. A report published by *American Photographer* in 1981 named him as one of the ten most collected artists in the U.S.

ULRICH, LARRY (Environment, Nature)
P.O. Box 178, Trinidad, CA 95570 (707) 677-3916

Born: 1949 *Subject Matter:* Nature, Travel *Situations:* U.S. Locations

He is a self-taught stock photographer who makes color images of the American natural landscape, especially the West. His most important concerns are light, color and subject with location being secondary. His formats include 4" x 5", 2 1/4" and some 35mm. His books include *Arizona, Magnificent Wilderness, Oregon* and *Northern California.* He is a Contributing Editor at *Arizona Highways* and *California Scenic* and a frequent contributor to *Sierra* and *Wilderness Society.*

URBAN, JOHN (Advertising, Corporate/Industrial)
1424 Canton Ave., Milton, MA 02186

Born: 1918 *Subject Matter:* Nature *Situations:* U.S. Locations, Studio *Education:* Princeton U.; Harvard U.

Although a large part of his recent work has called for careful studio photography, with a strong emphasis on the technical control necessary for trade magazines, he has recently been involved in producing very large-scale murals. Utilizing silk-screen, transparencies and high-contrast conversion techniques, he designs pieces to be used as interior architectural decorations. His current favorite, located at Harvard University, is a mural sixty feet long featuring a coastal village in southern Massachusetts located on a thin peninsula.

USHER, AARON, III (Advertising, Fine Art)
111 Ridgewood Rd., Pawtucket, RI 02861
(401) 725-4595

Born: 1957 *Subject Matter:* Architecture, People *Situations:* Studio & U.S. Locations *Awards:* Best of Show, Graphics, Edgewood Art Festival *Education:* Rochester Institute of Technology

He completed the Photo Pro program at the Rochester Institute of Technology and studied with Verena von Gagern at Salzburg College in Austria. While in Austria, he photographed reflections and unusual juxtapositions and began his two long-term projects, "What is Art?" and "Sights and Insights." He is currently a partner in Horsman and Usher Photography, a firm which specializes in architectural and corporate work. He continues to do personal work, using black-and-white film to reduce scenes of daily life to tones of gray and abstractly grouping his subjects in ways that would conflict in color photography. He is also assistant director of the Silver Bullet Gallery in Providence.

UZZLE, BURK (Photojournalism)
267 S. Van Pelt St., Philadelphia, PA 19103

Born: 1938 *Subject Matter:* People, Rural and Urban Landscape *Situations:* Studio, U.S. Locations *Awards:* Page One Award, Newspaper Guild of New York; NEA Photography Fellowship

A self-taught photographer, he worked as a staff photographer for the *News and Observer* in Raleigh, and a contract photographer for the Black Star news agency in New York, Houston, Atlanta and Chicago. He is a member of Magnum Photos cooperative agency, and a contract photographer for *Life.* Many of his images are humorous, and his subjects tend to be nothing extraordinary, as he seeks to express an insightful view of ordinary occurrences in the day-to-day world.

VAETH, PETER (Advertising, Romantic Illustration)
295 Madison Ave., New York, NY 10017

Born: 1944 *Subject Matter:* People, Travel *Situations:* U.S. & Foreign Locations, Studio *Education:* Rochester Institute of Technology

His rural American background has allowed him to develop a style of romantic illustration that conveys the richness of American small-town life. His representations of these scenes are at once direct and subtle, employing an impressionistic use of light and concentrating on conveying emotional complexity and depth in the models' interactions. He recently drew on his childhood experiences in a Hudson Valley farm community for part of a two-hour feature focusing on two carpenters living in the foothills of Vermont. He works both in the studio and on location

VALENTI, DON AND PAT (Editorial, Corporate/Industrial)
2784 Mavor Ln., Highland Park, IL 60035
(312)432-7653

Born: (Don) 1942; (Pat) 1944 *Subject Matter:* Travel, Natural History, General Stock Photography *Situations:* U.S. Locations, Studio

Their love of the natural world led to an interest in photography as a way of capturing the beauty they found there. They began their careers shooting natural history subjects, such as birds, animals and habitats. While maintaining an active nature file, their work now includes travel, corporate, architectural, advertising and general stock photography, shot primary on location. Their photographs have been published in textbooks, magazines, calendars, catalogs, advertisements, travel brochures and annual reports. Crediting much of their success to their work together as a team, they believe the two keys to good photography are a mastery of technique and the ability to see meaning and order where others might overlook it. Their training in photographing nature, combined with backgrounds in business and education, gives them a unique visual perspective. They use a broad range of techniques to create images appropriate to each situation.

VAN BLAIR, DALE R. (Advertising, Corporate/Industrial)
17 Birch Dr., Belleville, IL 62223 (618) 233-4932

Born: 1921 *Subject Matter:* Nature, Abstraction *Situations:* Studio *Education:* Quincy College; Drake U.

A retired English department chairman who also shoots nature and travel photography, he specializes in producing abstract photographs. His unusual graphic approach results in abstracts of an almost endless variety of shapes, colors, textures and movement. The colors—sometimes vibrant, other times delicate—range from psychedelic to earth tones. In recent years, his photos have been used not only in the United States but also in 13 foreign countries. They have appeared on album, book and magazine covers; in catalogs, brochures, leaflets and mailers; and in film strips, sales presentations, books, educational materials and encyclopedias.

VAN DE ZANDE, DOUG (Advertising, Corporate/Industrial)
307 W. Martin St., Raleigh, NC 27601 (919) 832-2499

Born: 1954 *Subject Matter:* Nature, People, Travel *Situations:* U.S. Locations, Studio *Education:* Brooks Institute of Photography

Catalogues, industrial brochures, magazines, slide shows and newspapers make up his broad list of publications, and such versatility has established him in the field. His beginnings were in a respected portrait studio in Poughkeepsie, New York, where he learned the fine points of people photography, studio lighting and darkroom printing. In 1976 he was accepted to Brooks Institute of Photography and began studying product, architectural, industrial and advertising photography. Restless for adventure, he took his summers off to travel in 48 states, hitch-hiking, freight-train riding and backpacking. On these journeys he took his camera, producing some of what he holds to be his best photographs, still used today by clients. He now has a studio in North Carolina, which, although headquartered in Raleigh, actually "features 197 million square miles," as sixty percent of his work is done on location across the country.

VANO, TOM (Advertising, Editorial)
965 Mission St., San Francisco, CA 94103
(415) 896-0624

Born: 1936 *Subject Matter:* People, Food *Situations:* U.S. Locations, Studio *Education:* School of Modern Photography

With a career that spans over 43 years, beginning with shots of his father's delicatessen in Astoria, Long Island in 1939, to those made as Official Photographer for the U.S. Army behind the Iron Curtain in Warsaw, Poland, to his current speciality shooting food for Beatrice, Pillsbury, Sara Lee and a host of other national food distributors, he is known as one of the premier American photographers. He seeks "a quality of surprise," one that marries photographic technique and aesthetic integrity to produce pictures that are unique and exciting. In the field of illustration, he has created and produced work for United Airlines, Bank of America, Del Monte Corporation, California Milk Advisory Board and many other national and local organizations. He has been the recipient of many awards presented by both commercial and artistic organizations, including the Professional Photographers of America as well as special commendation by the California State Legislature. His works have been widely published and exhibited in major museums and galleries in the U.S. and abroad.

VAUGHN, GREG (Editorial, Corporate/Industrial)
P.O. Box 1250, Captain Cook, HI 96704
(808) 328-8052

Born: 1948 *Subject Matter:* People, Wildlife, Landscape *Situations:* U.S. & Foreign Locations *Education:* U. of Hawaii

Although recently he has been focusing his efforts in the high-tech industries, his portfolio includes photographs on such general subjects as agriculture, scenics, transportation, industry, wildlife, nature, leisure sports, outdoor recreation and people. Beyond his extensive coverage of the Hawaiian Islands, his work has taken him to Australia, Mexico and the western United States, with photographs published in magazines, newspapers, books, annual reports, corporate publications and brochures. He has shot audiovisual presentations and print and television advertising campaigns. He has been the official photographer for the Ironman Triathlon and for the election campaigns for the last two governors of Hawaii.

VENER, ELLIS (Advertising, Corporate/Industrial)
3601 Allen Parkway, #123, Houston, TX 77019
(713) 523-0456

Born: 1957 *Subject Matter:* People *Situations:* Hazardous, Studio *Education:* U. of Texas

Following Robert Capa's maxim, "If your pictures aren't good enough, then you are not close enough," the thrust of his work illustrates abstract concepts from subjects shot on location. Particularly drawn to architecture, he approaches the shooting like he would putting together a puzzle. The end result is not merely documentary, but a picture that engages the imagination. With this eye for art, he nonetheless maintains that the work, a portrait, for example, presents the subject's impression, not the photographer's—the subject providing the feeling, regardless of whether it is a "CEO or a blind man eating in a diner."

VERA, ARTURO (Corporate/Industrial, Advertising)
1837 Divisadero, San Francisco, CA 94115
(415) 346-8066

Born: 1951 *Subject Matter:* Fashion, Food, People, Travel, Special Effects, Products *Situations:* Studio, U.S. & Foreign Locations *Awards:* IFPA Cindy Award; "Best in the West" *Education:* San Francisco Academy of Art

Using a full range of lighting including highlights to achieve clean, subtle effects, he works in 4" x 5" or 8" x 10" formats, frequently with multiple exposures. His work is characterized as illustrational or educational and has been used in motivation kits for various corporate clients. Becoming interested in photography during a trip to Japan, he initially concentrated on fashion, shooting for boutiques and retail stores. He then moved into multi-media and special effects work, with an emphasis on advertising and corporate needs.

VESTAL, DAVID (Fine Art, Photojournalism)
P.O. Box 309, Bethlehem, CT 06751

Born: 1924 *Subject Matter:* Urban and Rural Landscape *Situations:* Studio, U.S. Locations *Awards:* Guggenheim Fellowships *Education:* School of the Art Institute of Chicago

He shoots a diverse range of subjects from landscapes to environmental and weather conditions such as a gloomy, foggy afternoon. He tends to avoid depictions of people and human interaction. He moved to New York City in 1946 following a brief period at the School of the Art Institute in Chicago where he studied painting. In New York, he studied with Sid Grossman and joined the Photo League. He has worked for a variety of national photographic magazines in addition to writing articles, the first of which appeared in *Popular Photography* in 1963. He has authored numerous books including *The Craft of Photography* and *The Art of Black-and-White Enlarging.* He works with conventional black-and-white prints and strives for simplicity and clarity.

VIESTI, JOE (Advertising, Photojournalism)
P.O. Box 20424, New York, NY 10028-9991
(212) 734-4890

Born: 1947 *Subject Matter:* Festivals, Travel *Situations:* Foreign & U.S. Locations, Aerial *Education:* Temple U.

Combining his skill in photography with his love for travel, his fascination with other cultures and his desire to document our festive, joyous qualities, he has spent the past ten years photographing celebrations around the world. In 1984, his colorful collection was tapped for UNICEF's Engagement Calendar, marking the only time the work of a single photographer has been used for that piece. Collections of his images are on permanent loan to over 40 museums, libraries and children's hospitals throughout North America. He has dedicated himself to expanding this project, now over 100 "celebrations" strong, to include at least one major event from every state in the U.S., as well as one from every country in the world. In the past year, he converted his extensive domestic and international files into a stock photo agency, with offices in New York City and Austin, Texas.

VIGNES, MICHELLE (Photojournalism, Portraiture)
654 28th St., San Francisco, CA 94101 (415) 550-8039

Born: 1928 *Subject Matter:* People *Situations:* U.S. Locations *Awards:* Photographer of the Year, Media Alliance

Starting her career overseas, she first worked in Paris as a picture editor at Magnum Photo from 1953 to 1957, and for UNESCO from 1957 to 1961. Arriving in San Francisco in 1965, she started freelancing, specializing in human interest stories. Concerned with capturing moments of intense feeling and emotion, she has documented the hopes and struggles of American Indians, the Blues musicians of Oakland, a truck stop, and now, as an extension of her work on the Blues scene, she is working on a series about gospel singing in Oakland. She has been widely published in the United States and Europe. *Le Monde, Image* and *Parenting* are among her many magazine credits. In addition, her work has been shown in numerous shows, and has been published in a book.

VILLA, ARMANDO (Photojournalism, Corporate/Industrial)
1872 W. Clybourn, Chicago, IL 60614 (312) 472-7002

Born: 1948 *Subject Matter:* People, Nature *Situations:* U.S. & Foreign Locations, Studio *Awards:* 1st Prize, UPI Features and Spot News *Education:* U. of Illinois

Born in Columbia, he came to the United States to study English and pursue a Master of Arts in photography. After graduating from the University of Illinois, he worked for the *Urbana News Gazette* and the

Chicago Tribune. In 1982 he began a freelancing career, opening his own studio and shooting largely for corporations on location. Eighty percent of his work is shot in black and white, with attention to the design element in what is functional. He has exhibited throughout the Midwest; his own gallery, the Silver Light Gallery, is solely dedicated to the showing and promotion of contemporary photography.

VILLET, GREY (Editorial, Photojournalism)
R.F.D. #1, Shushan, NY 12873 (518) 854-7535

Born: 1927 *Subject Matter:* People *Situations:* U.S. & Foreign Locations

At the age of nineteen, he began an eight-year stint as a newspaper photographer in Africa and England. In 1954, when he came to the United States, he freelanced for *Life,* joining the staff in 1955 and remaining there until its close in 1973. Since then work has taken him to the major U.S. cities and back overseas to Beirut and South Africa on assignments for the revived *Life.* He has worked extensively with his wife, a former *Life* reporter and editor, collaborating on two books, *Those Whom God Chooses* and *Blood River.* A photographer of people, his portfolio includes pictures of celebrities, criminals and presidents—including Kennedy and Nixon. He abhors contrived studio shots, choosing instead to photograph his subjects in their natural surroundings.

VITALI, JULIUS (Fine Art)
P.O. Box 75, Flicksville, PA 18013 (215) 588-7366

Born: 1952 *Subject Matter:* Still Life, Photo Montage *Situations:* Studio *Education:* SUNY, Fredonia

Interested in errors as moments of opportunity, he invented "puddle art," a process which takes a single composition through a number of media and techniques. Beginning with a color slide, the image is painted, then projected as a video image, and finally recreated as a black-and-white montage. In other processes, he photographs his watercolor paintings whose reflective qualities produce two focal planes. Shot at forty-five degree angles, the two focal planes come together to form a surreal image; most of these are in color. He also photographs clay objects and other constructions, exploring various spatial relationships.

VIVERS, KEVIN (Scientific, Photojournalism)
4012 Springfield, Kansas City, KS 66103
(913) 262-1356

Born: 1954 *Subject Matter:* Medical, Wildlife, Travel, Landscape *Situations:* U.S. Locations, Studio *Education:* U. of Kansas

His photographic roots started in newspaper photojournalism after graduating from the University of Kansas. Freelancing in Kansas City for two years, he accepted a position as Chief of Photography at the University of Kansas Medical Center. He stayed for five years managing a staff of four photographers, providing photography for audio-visual slide shows and several publications, shooting in such specialized areas as photomicrography and surgical photography. He has since begun freelancing again, working on location assignments for magazines, corporate, industrial and advertising clients, as well as providing stock photography in medical, travel and wildlife subjects. In addition to his assignments, he is active developing his own landscapes. These works have appeared in several one-man and group shows; one of his photographs was one of 52 chosen from nearly 500 entered in the International Natural World Photography Competition sponsored by the Carnegie Museum of Natural History in Pittsburgh.

VLAMIS, SUZANNE (Photojournalism)
405 E. 82nd St., New York, NY 10028

Subject Matter: People, Architecture *Situations:* U.S. & Foreign Locations, Hazardous *Awards:* Top Performance Award, Associated Press *Education:* School of Visual Arts; Long Island U.

A native New Yorker born and raised in Manhattan, she is a self-taught photographer whose love has always been urban photography. Joining the Associated Press as a staff photographer in 1973, she began covering the top stories in the nation and around the world. She covered the Montreal Olympics in 1976 and the Los Angeles Games in 1984. She traveled to Russia with President Nixon and to South America with President Reagan. In addition, she has worked on multi-image productions for AP Managing Editor conventions. Beyond her news skills is an expertise in architectural photography which has led to photo essays of the restorations of both St. Patrick's Cathedral and the Statue of Liberty over a two-year period. Her photographs have been published in magazines, newspapers and books worldwide, and she has exhibited in several New York photo shows.

VOLPERT, DON (Advertising, Editorial)
1750 N. Serrano Ave., #601, Los Angeles CA 90027
(213) 462-8000

Born: 1944 *Subject Matter:* People, Travel, Fashion *Situations:* Studio, U.S. Locations *Education:* North Texas State U.

Trained as a photographer, he resigned from an executive position in Los Angeles to pursue his original calling. He began working in the small theaters around Los Angeles doing head shots for actors and actresses. This led to several commercial and table-top jobs. Annual reports, portrait commissions and advertising work soon followed. The high-fashion collector Balince Agaa commissioned him to photograph a collection of gowns. Current work includes advertising, portraits and abstract fine art photos in color.

VOLPI, RENE (Advertising, Editorial)
121 Madison Ave., #11 I, New York, NY 10016
(212) 532-7367

Born: 1952 *Subject Matter:* Fashion, People *Situations:* U.S. & Foreign Locations, Studio

His international career has taken him from Brazil to Paris, where he worked for three years, to London, Amsterdam and Milan, where he completed a book on teen models with Judith Lasch. Other associations include work with Andy Warhol and "The Factory." His specialization in black-and-white, in particular his exotic male figures, has him regularly shooting for *Vogue, Interview* and *Cosmopolitan,* with a recent assignment shot in Cancun for the Mexican *Vogue.* His advertisements for men's fashion and sportswear include International View, Oman's Men and Calvin Klein. Most recently he has expanded his camera work into video and he is also writing a script for a Mexican television special.

VON DORN, JOHN (Advertising, Editorial)
685 W. Ohio, Chicago, IL 60610 (312) 243-8578

Doug Van de Zande, *Train Station Waiting Room*

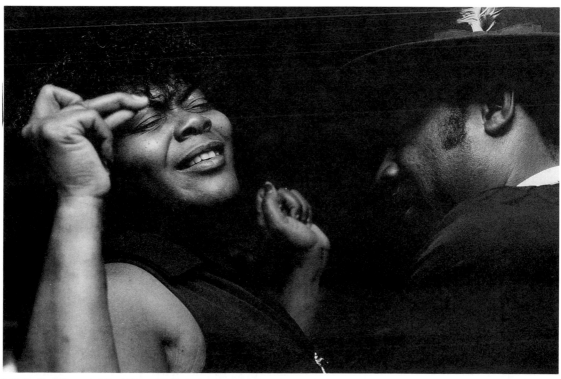

Michelle Vignes, *The Blues "I feel good, I feel fine."*

Born: 1949 *Subject Matter:* Fashion, People, Still Life, Special Effects *Situations:* Studio, U.S. Locations *Education:* Columbia College, Chicago; Southern Illinois U.

Combining his love of illustration with an already established career in fashion photography, his signature style combines stark imagery with electrifying special effects. Characteristically, images are set within cool, darkly luminous backgrounds on which vibrant patterns are etched, creating an effect similar to neon lights on a hazy night. This effect is achieved through a process created by Von Dorn which includes scraping the emulsion with modified exacto knives. Working with both people and table-top shots as subjects, his slick, often outrageous images have appeared in advertisements for Fruit of the Loom, Addidas, Coca-Cola, Kellogg's and Stroh's, among others.

VON KOSCHEMBAHR, ALEX (Advertising, Corporate/Industrial)

12 Fitch St., East Norwalk, CT 06855 (203) 866-0032

Born: 1946 *Subject Matter:* Products *Situations:* Studio, U.S. Locations *Awards:* International Film and TV Festival; Connecticut Art Directors Club

He has more than 16 years of diversified experience in studio and location photography and multi-image audio-visual conception and production. A background as a creative director has enabled him to manage all facets of a project from initial concept and story boards to final editing. He created the concept for the high-tech introduction of the Pitney Bowes postage meter, in which the meter appears to be levitating above a surface of hardened and broken clay against a hand-painted, glowing background. His own 5,000-square-foot studio, Click, has a four-set capacity, and he employs four assistants. Clients have included Avis and IBM.

WACHSTEIN, ALISON E. (Photojournalism, Portraiture)

5 Jana Dr., Weston, CT 06883 (203) 226-5296

Born: 1947 *Subject Matter:* Nature, People *Situations:* Studio *Awards:* 1st Prize: Spot News, 1st Prize: Lifestyle, New Jersey Press Association *Education:* Northwestern U.

Although today she is primarily a portrait photographer, she began her training in photojournalism. Upon completing her undergraduate degree at Northwestern, she spent a year and a half on the *Aspen Times* in Colorado, and then worked for a chain of weeklies in New Jersey. This period climaxed with the 1979 publication of *Pregnant Moments: The Experience of Pregnancy and Childbirth* by Morgan & Morgan. This also marked her serious growth toward portraiture. She now concentrates on shooting contemporary children's portraiture and family and group environmental portraiture, working either outdoors or in the client's home. She is also known for her 35mm nature and flower photography.

WADE, ROGER W., JR. (Advertising, Environment)

P.O. Box 1138, Condon, MT 59826 (406) 754-2793

Born: 1957 *Subject Matter:* People, Travel *Situations:* Studio, U.S. Locations *Education:* Rochester Institute of Technology

Passionate about photography since his early childhood, he began his career as a professional photographer after graduating with a degree in photography from Rochester Institute of Technology. A New York-based, corporate/industrial photographer, he specialized in audio-visual communications, covering assignments for companies such as Seagram's, AT&T, Lufthansa, Lederle, Vintners International and Volkswagen, assignments that took him throughout the United States and Europe. After five years, he relocated to western Montana in order to devote more energy to fine-art photography. With the art of Ansel Adams and Paul Strand in mind, he is currently working on a photographic survey of Montana's wilderness. Through carefully composed, large-scale color landscapes of these areas, he hopes to generate awareness and support of the need for wilderness. In the past year, these photos have been accepted in numerous national juried competitions.

WAGGAMAN, JOHN F. (Editorial, Architecture/Interiors)

2746 N. 46th St., Philadelphia, PA 19131
(215) 473-2827

Born: 1923 *Subject Matter:* Architecture

Strongly influenced by the work of Irving Penn and David B. Eisendrath, he began his photographic career by shooting American art and architecture for the Carnegie Corporation. He is an architectural and interiors photographer, and his clients include architects, interior designers, magazines and hotel and commercial building owners. He works in all formats and is recognized for his ability to retain the flavor of the original design by augmenting natural light, enabling the film to see as the eye does. He developed a workshop in general photography at the University of California, San Diego, where he taught for four years. He currently photographs house exteriors and interiors for the *Philadelphia Inquirer Sunday Magazine* and other publications and commercially.

WAGNER, CATHERINE (Fine Art)

28 Precita Ave., San Francisco, CA 94110
(415) 826-9227

Subject Matter: People, Education *Situations:* U.S. Locations *Awards:* Guggenheim Fellowship; Ferguson Award *Education:* San Francisco State U.; San Francisco Art Institute

"Rural or urban, private or public, specialized or general," she says, "schools define the nature of our society perhaps more than any other institution." Since 1982 she has been photographing educational environments. She has traveled around the United States making photographs of various classroom settings, including the the Astronaut Training Facilities at NASA, a dog grooming school, a Baptist Sunday School and a college classroom in Charlottesvile, Virginia. Although they are photographed in documentary style, these photographs transcend the limits and responsibilities of the genre; despite the apparent simplicity, beneath the surface of her work lies a psychological complexity. "As meditations on the educational experience, the 'American Classroom' photographs are funny, ironic, strange and perhaps even a touch nostalgic," writes critic Hal Fischer. "A sense of human idiosyncrasy, and our faith that education can overcome its setting, effectively undercut the specter of stifling order and technology that permeates many of these images."

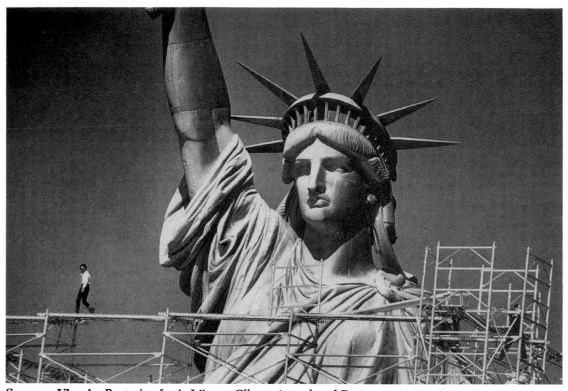

Suzanne Vlamis, *Restoring Lady Liberty.* Client: Associated Press

John F. Waggaman II

WALDRON, D'LYNN (Corporate/Industrial, Photojournalism)
617 Ocean Ave., Santa Monica, CA 90402
(213) 529-6700

Born: 1936 *Subject Matter:* People, Travel, Wildlife *Situations:* U.S. & Foreign Locations, Hazardous *Awards:* Fellow, Royal Geographic Society *Education:* Washington U.; Claremont College

Her first book, *Far From Home,* was done on an overland trip alone around the world in 1957-58. In 1960, she hitchhiked through Africa and was the last photographer to journey across the Congo. Her early Kodachromes are an historical record of such countries as Cambodia, Nepal and the Congo. Today, her commercial clients include major magazines, for whom she writes and photographs color features on food, travel and art; advertising agencies, national tourist boards, resorts and hotels. Her portraits have included the late J. Paul Getty. She enjoys most of all spending a year or more doing a comprehensive photographic study of a traditional way of life in an unspoiled setting. Her recent major studies have been of Western Ireland, the mountains of Andalucia, and the Island of Crete. Her next major project is life on the rivers and canals of China.

WALKER, DIANA (Photojournalism, Editorial)
3414 Lowell St., N.W., Washington, DC 20016
(202) 362-0022

Born: 1942 *Subject Matter:* People, Politics *Situations:* U.S. Locations *Awards:* White House News Photographers Association; World Press

A contract photographer for *Time* in Washington, D.C., she began freelancing ten years ago, covering people and politics for the *Village Voice, Time, People, Fortune* and other magazines and newspapers. Her coverage of politics has included photographing the Carters and the Mondale campaign, and she now shares the White House coverage with Dirck Halstead. On international assignments, she covered the Geneva and Iceland Summits and traveled to the Philippines to photograph Corazon Aquino as *Time*'s Woman of the Year for 1986.

WALPOLE, GARY (Advertising, Fine Art)
284 N. Cleveland, Memphis, TN 38104
(901) 726-1155

Born: 1950 *Subject Matter:* People, Travel, Industry *Situations:* Studio, Aerial, U.S. & Foreign Locations *Education:* State U. of New York; Colorado Mountain College; Memphis State U.

A product advertising photographer, he specializes in industrial and aerial work. He investigates every possible angle before starting work. In his black-and-white brochure for a symphony orchestra he endeavored to emphasize simple graphic strengths while keeping a humorous lightness about the photographs. He has traveled extensively abroad for Holiday Inn and International Paper. His fine art photographs include many picturesque American and European scenes. A sensitivity to natural resources and a respect for natural beauty come partially from his American Southern heritage, but also from a period when he worked as a photographer for the U.S. Forest Service.

WALSH, BOB (Medical Advertising, Editorial)
401 E. 34th St., Suite 12M N., New York, NY 10016
(212)684-3015

Born: 1938 *Subject Matter:* People *Situations:* Studio, Hazardous, U.S. Locations *Awards:* Art Director Award; Triangle Award

He started his career by shooting medical photographs in hospitals for advertising agencies. Because of his fifteen years of medical education, he can assure clients of medically accurate set ups. He now has his own studio, where he also produces medical films, and over 100,000 medical stock photos available for composition and layout work. His black-and-white campaign for the Pro Cardia Company won the Triangle Best Ad of the Year Award and his images have appeared in medical journals and magazines as well as on billboards and in annual reports.

WALTERS, DAVID (Photojournalist)
6920 Bottlebrush Dr., Miami, FL 33014
(305) 556-2806

Born: 1954 *Subject Matter:* People, Events *Situations:* Hazardous, U.S. & Foreign Locations *Awards:* Pictures of the Year, U. of Missouri; Runner-up for the Pulitzer in News Photography *Education:* U. of Missouri

After an internship at the *Columbia Daily Tribune* in Missouri, he worked a brief period on a small daily press in Bartlesville, Oklahoma before moving to the *Miami Herald.* Nominated for the Pulitzer for News Photography for his coverage of the earthquake in Mexico in 1985, he has published in a number of magazines and newspapers including *Time, Newsweek, National Geographic,* the *New York Times* and the *Philadelphia Inquirer.* While he covers feature stories in Florida, many times he covers politics in Central America, South America and the Caribbean. Both in the United States and abroad he often finds himself in hazardous situations, for instance the race riots in Miami in 1980 and the 1988 riots and protests in Panama to oust President Noriega.

WALTERS, DAY (Photojournalism, Corporate/Industrial)
P.O. Box 5655, Washington, DC 20016
(202) 362-0022

Born: 1940 *Subject Matter:* Nudes, People, Travel, Architecture *Situations:* Studio, Aerial, U.S. Locations

He photographed the original postcards for the Air & Space Museum in Washington and has traveled throughout the country documenting the paintings of John Koch for a book on the artist. His work, done in 35mm through 4" x 5", exhibits a dramatic and inventive style. Adaptability and efficiency are necessary qualities in such assignments as his documentation of the rooms Michael Szell designed for the Iranian Embassy that appeared in the November, 1985 *Architectural Digest.* The Embassy's interior—mirrored metal rooms and intricate persian rugs—presented one of his greatest challenges: Calculating angles, balancing ambient and reflected light, and setting exposure times required exact methodology. Other assignments have included documenting the interior of the Department of Justice, where he worked from two lifting-platforms twenty feet in the air. His photos have appeared in the *New York Times, Life, People* and *Smithsonian* and in annual corporate reports and trade journals.

WARD, FRED (Photojournalism)
7106 Saunders Ct., Bethesda, MD 20817
(301) 983-1990

Born: 1935 *Subject Matter:* Portraiture, Events, People, Nature *Situations:* Underwater, U.S. & Foreign Locations *Awards:* 1st Prize, White House News Photographers Association; 1st Prize, U. of Missouri Contest *Education:* U. of Florida

Working primarily in the news and corporate worlds, he is a regular contributor to *Time, Newsweek, Fortune, Life, National Geographic,* ABC television, *Paris-Match* and *Stern.* Diverse assignments have included coverage of Soviet leader Mikhail Gorbachev and of radio personality Larry King's heart surgery. He has provided executive portraits, and pictures of "our people at work" for the annual reports of Exxon, DuPont, SOHIO, Sears and PepsiCo. Almost all of his work is in color and the great majority is made with available light. His photographs are in the collections of the Metropolitan Museum of Art in New York and of the Library of Congress. A retrospective show of his work was the premier exhibit at the Washington Press Club.

WARD, TONY (Corporate/Industrial)
704 S. 6th St., Philadelphia, PA 19147 (215) 238-1208

Born: 1955 *Subject Matter:* People *Situations:* U.S. Locations *Awards:* Design Excellence, Print Regional Design Annual *Education:* Rochester Institute of Technology

He began his professional career in 1980 after receiving an M.F.A. from the Rochester Institute of Technology. Upon graduation, he was hired by Smith Kline Beckman Corporation as its principal staff photographer, responsible for numerous advertising and corporate shots. After four years with Smith Kline, he opened his own studio in 1984. A partial list of his clients includes Smith Kline, DuPont, RCA, Rohm & Hass, Turner Construction, Shared Medical Systems, The Money Store, Rouse & Associates and Citibank of New York. He is best known for his strong color graphics and for people photographed on location.

WARNECKE, GRACE KENNAN (Photojournalism)
40 W. 67th St., New York, NY 10023 (212) 580-4973

Born: 1932 *Subject Matter:* People *Situations:* U.S. Locations *Education:* Radcliffe College; Corcoran School of Art; San Francisco Art Institute

A photojournalist, she specializes in people, events in the U.S.S.R. and in Eastern Europe, and location work for films and documentaries. In 1980 she covered the Moscow Olympics for *Newsweek,* and her photos of this event were eventually shown at one of her three San Francisco exhibitions. She did the photography for the *No-pressure Steam Cookbook.* Now residing in New York, she combines photo assignments with work as a television producer.

WARREN, MARION E. (Corporate/Industrial, Editorial)
34 City Gate Ln., Annapolis, MD (301) 269-5318

Born: 1920 *Subject Matter:* People, Nature *Situations:* U.S. & Foreign Locations

Serving as a photographer in the U.S. Navy from 1942 to 1945 as part of the office of the Secretary, he was assigned to the White House, Joint Chiefs of Staff and Navy Department to handle portraiture, news conferences and press releases. Upon discharge from the Navy, he began as part of the photographic staff at Harris & Ewing Studio in Washington, D.C. He estab-

lished his own business, and from 1947 to 1962 kept busy behind the camera with portraits and weddings, industrial and architectural photography, as well as covering sports at the U.S. Naval Academy. After 1962 and up to the present, he has continued to freelance, specializing in industrial and architectural assignments. For the past two years he has placed a special emphasis on photographing the ecology of the Chesapeake Bay, its beauty, bounty and industry. With forty-plus years operating a camera, he has published in numerous national magazines and newspapers.

WATANABE, DAVID Y. (Portraiture, Corporate/Industrial)
14355 132nd Ave., N.E., Kirkland, WA 98034
(206) 823-0692

Born: 1941 *Awards:* ADLA; West Coast Show; Mead Annual Report Show; STA 100 Show; SDA; CA Design Award; Society of Graphics Designers of Canada. *Education:* Bob Jones U.; London Film School

With a Master of Arts in filmmaking, he began his career as a director of educational films. Within a few years, his interests had shifted to fine-arts photography. This work was exhibited throughout the Pacific Northwest, including the Seattle Art Museum. In 1975, he began doing photography for corporate annual reports that consists of various kinds of location photography from executive portraits to large industrial interiors. More recent commercial work has included studio product photography. A photojournalistic fine-arts book on rodeo cowboys is in the works.

WATRISS, WENDY (Editorial, Photojournalism)
1405 Branard St., Houston, TX 77006

Born: 1943 *Subject Matter:* People, News *Situations:* U.S. & Foreign Locations *Education:* New York U.

Having studied art and literature at the University of Madrid and at the Sorbonne in Paris, she brings an uncommon sensitivity to her coverage of world affairs. In addition to working as a writer, reporter and teacher, she has produced documentary films, including films covering the effects of Agent Orange on the lives of U.S. Vietnam veterans, refugees from drought in West African Sahel, and Central American refugees in the U.S. She is the recipient of grants for photography and oral history from the National Endowment for the Humanities, the Rockefeller Foundation and the Sid Richardson Foundation, as well the recipient of awards for photography from The World Press Foundation, XI Interpress Photo and the Women's International Democratic Federation. Her photographs have been published in the *New York Times, Christian Science Monitor, GEO, Life, Newsweek* and *Stern.*

WEAVER, DANNY (Advertising)
19 E. Main St., Cary, IL 60013 (312) 639-5723

Born: 1923 *Subject Matter:* Animals *Situations:* U.S. Locations *Awards:* Q Award; DPA

He makes portrait and conformation photos of dairy animals, beef animals, horses, goats and other livestock. He began his career in the early 1960s as an apprentice with the pre-eminent livestock photographer of the time. He is thoroughly knowledgeable and adept in the specialized techniques of handling

ly colored image of a diver with a giant octopus was made using carefully balanced multiple strobes. Wildlife, landscapes and aerial photography all figure prominently in his work. His pictures have appeared in Dow Chemical advertising campaigns, *National Geographic* filmstrips, an Audubon Calendar, in *Science* and in other publications.

WHITE, JOHN H. (Photojournalism)
c/o Chicago Sun-Times, 401 N. Wabash, Chicago, IL 60611 (312) 321-3000

Born: 1945 *Subject Matter:* People, Events *Situations:* U.S. Locations *Awards:* Pulitzer Prize in Photojournalism; Photographer of the Year *Education:* Central Piedmont College

With fifty cents and ten Bazooka bubble gum wrappers, he sent away for his first camera, with which he took pictures for his high school yearbook. He went on to study commercial art and design, but although his first desire was to paint, he soon found that the camera was "quicker than the brush." Photography became his chosen medium. After graduating from Central Piedmont College, he joined the Marines and served as a photographer for the Armed Services for two years. After a year in a commercial studio, he was invited to join the *Chicago Sun-Times* staff; he has now been there twenty years, covering people and events throughout Chicago and the country. His twenty photos of Chicago, from mounted police to Suzuki violin classes, earned him the first Pulitzer Prize in photojournalism for a series on life styles. Shooting with a Nikon 35mm, he continues to cover people and events, finding his richest reward in the opportunity to reach and share with people on a daily basis. When he is done with a day's work, he goes home to his hobby—taking color shots of Chicago sunsets.

WHITE, LEE (Advertising)
1172 S. La Brea Ave., Los Angeles, CA 90019 (213) 934-5993

Born: 1952 *Subject Matter:* People *Situations:* Studio, U.S. Locations *Education:* Art Center College of Design

He portrays people in a light that makes them real to the viewer. His images have a narrative quality. His subjects are given dimension and substance, drawing the viewer into the picture. He has shot celebrities as they rode the wave of their latest hits and photographed farmers from helicopters as they harvested fields. The images tell the viewer about the product or service he is advertising. He runs his own studio in Los Angeles.

WHITLOCK, NEILL (Editorial, Advertising)
122 E. 5th St., Dallas, TX 75205 (214) 948-3117

Born: 1947 *Subject Matter:* Fashion, Nudes *Situations:* Studio, U.S. Locations *Awards:* TOPS; Dallas Advertising League *Education:* Art Center College of Design

Originally a fine arts photographer, he now shoots everything from large production, location and fashion to sensitive nudes. His black-and-white pieces display an attention to lighting, texture and form, while his color pieces reflect his background in people-oriented advertising. An example of this is his recent promotion for Best products, set in a 1950s drive-in. Since moving from Los Angeles to Dallas, he has produced stills for television and slide shows, as well as reportage for publications such as *Glamour, Fortune* and *Texas Monthly.*

Studio and location shots may be taken with 35mm or 4" x 5"; subject matter is not his primary concern, as his first love is the process of shooting. Desiring to "continue to grow... stay on the edge of what's happening in the industry," he has developed a broad base of return clients, including American Airlines, Maybelline and Texas Instruments.

WHITMAN, ED (Advertising, Corporate/Industrial)
613 N. Utah, Baltimore, MD 21201 (301) 727-2220

Born: 1956 *Subject Matter:* Fashion, Food, Architecture, Special Effects *Situations:* U.S. Locations, Studio *Education:* Maryland Institute of Art

Beginning as an apprentice for the Associated Press in London, he started his career in photography in journalism. Attending art school, however, he began to realize that he was "more interested in making images, than taking them," which led him to advertising photography. Here he saw himself starting with nothing, adding a product or subject and creating an environment for it with light and space. After many years of working experience, he took this concept and opened Lightstruck Studio in 1983, and with a partner began specializing in fashion, food, product and architectural photography. In creating various men's fashion advertisements, such as Mistrel ski and bath wear, his studio developed a reputation for its ability to handle special effects. Today, his studio is responsible for the production of numerous catalogues, brochures, advertisements and portraits, for a variety of clients, from food merchants to corporate industries.

WIECK, DALE (Commercial/Industrial, Legal)
2123 Durand at Davenport, Saginaw, Michigan 48602 (517) 755-1953

Born: 1936 *Subject Matter:* Commercial *Situations:* Studio, U.S. Locations

He acquired his basic darkroom and studio experience with the large commercial firm where he began his career. Since the late 1950s he has had his own commercial/industrial/legal photography business. He presently is most involved with industrial, product and brochure work though he also does some food and public relations portrait photography. He is known for his concern for details and his legal photography is his best and most challenging work.

WIENER, RAY M. (Advertising, Corporate/Industrial)
4300 N.E. 5th Terrace, Ft. Lauderdale, FL 33334 (305) 565-4415

Born: 1933 *Subject Matter:* People, Still Life *Situations:* Studio, U.S. Locations, Aerial *Education:* Arizona State U.; Art Institute of Ft. Lauderdale

After completing technical photography school, he began working part-time as a newspaper lab technician and a portrait studio understudy. Within a year he opened his own studio and began seeking advertising and industrial clients. For several years he worked in a variety of subjects, producing photography for catalogues and brochures for fashion, food and architectural accounts. He also shot aerial photography and still life; today he is in greatest demand for his still-life and industrial photography for annual reports and brochures. His work is characterized by soft lighting. For example, recently he did a cover shot for a

Jack Richmond

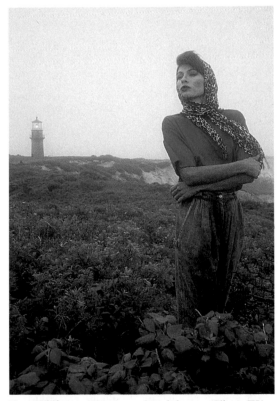

Ron Williams, *Woman and Lighthouse.* Client: TJ's
Fashion Catalog

Doug Van de Zande, *Construction Worker*

Suzanne Vlamis, *San Francisco Rising*

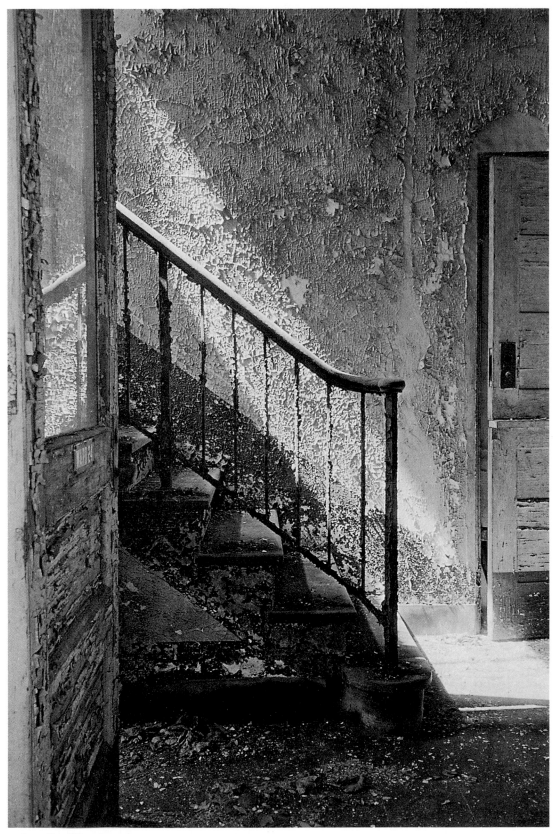

Wilton S. Tifft, *Ellis Island*

James E. Woodley, *A Long Walk*

John F. Waggaman II, *Dining Room-Vista Hotel*

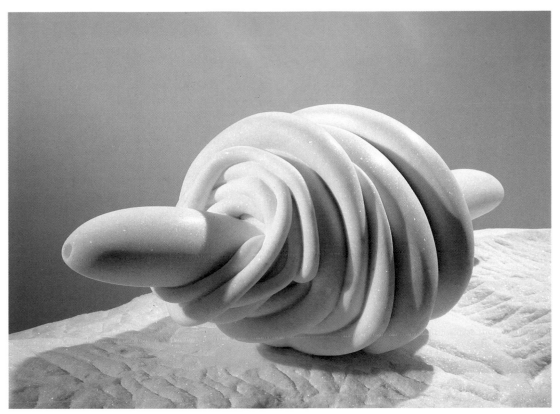

Peter Bellamy, *Nature Study by Louis Bourgeois,* Courtesy: Robert Miller Gallery

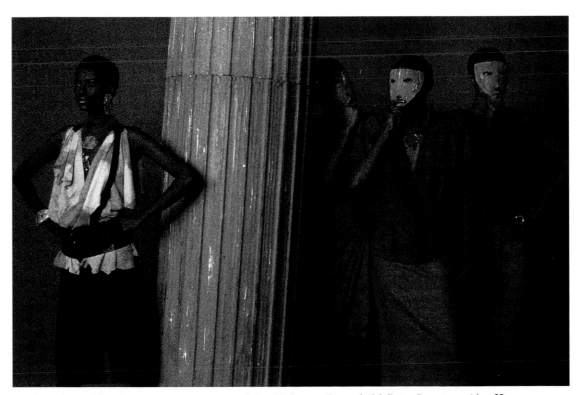

David Zahner, *Pompeii.* Client: Lisandro Sarasola. Make-up: Donyale McRae. Courtesy: Alex Herman

Robert Frerck, *Rajasthan , India.* Client: Odyessey Productions, Chicago

Lawrence Ruggeri, *Don't Put All Your Eggs in One Basket*

Ron Rack, *Ballerina with Flower in Hair with Fan & Trunk*

Randolph Falk, *Propellor-Aerial View*

Douglas Elbinger, *Diane*

328

basket distributor, featuring food and floral arrangements against a portrait background, using a lighting technique he compares with the paintings of Rembrandt.

WIGGINS, WALT (Photojournalism, Nature)

1085 Mechem Dr., Ruidoso, NM 88345
(515) 258-4583

Born: 1924 *Subject Matter:* Nature, Wildlife, People *Situations:* U.S. & Foreign Locations, Studio *Awards:* Art Directors Award, Detroit *Education:* U.S. Army Pictorial Service

"Walt Wiggins' photographs are important in the history of photojournalism because they expanded that medium's limits and increased the reach of what photography was in the years from World War II on," writes Wesley Rusnell, curator of the Roswell Museum and Art Center. "While his action photography (more than 600 published feature stories) established his reputation in the world of photojournalism," he continues, "the range of his work reaches beyond such subjects of obvious appeal." Subjects range from a cheetah pursuing its prey to a Jivaro Peruvian shrunken head. His photography captures that which is transient and unusual. Primarily an action and adventure photographer, he has photographed water buffalo on the island of Marajo and condors in the Andes. Publications include *Life, Time, Look, Sports Illustrated, True, Outdoor Life, Picture Annual, U.S. Camera* and others. He has also published several books, *The Legendary Speedhorse* among them.

WILCOX, SHORTY (Advertising, Corporate/Industrial)

19 W. 21st St., Ste. 901, New York, NY 10010
(212) 246-6367

Born: 1935 *Subject Matter:* Nature, Sports, Landscape *Situations:* U.S. & Foreign Locations *Education:* U. of Colorado

For seven years after graduating from college, he traveled Europe and the Scandinavian countries as a folk singer and photojournalist. Returning to the United States in 1966, he went to work for Vail Associates, where he developed a unique style of sports photography. He expanded his expertise from basic sports assignments when he took trips to the 1972 Sapporo Winter Olympics and the 1976 Montreal Summer Olympics. Leaving Montreal, he took to the open road to develop his agricultural and industrial portfolio. His particular love of the land and its people led him to a five-year association with *Farm Journal* where much of his agricultural photography graced their covers. Now based in Breckenridge, Colorado, his clients and collections include ABC Wide World of Sports, Xerox, Kodak, American Express, TWA, Merrill Lynch, the State of Alaska, the State of Colorado, *Newsweek* and *Smithsonian.*

WILD, TERRY (Corporate/Industrial, Fine Art)

RD 3, Box 141, Williamsport, PA 17701
(717) 745-3257

Born: 1947 *Subject Matter:* Portraiture, Sports, Food *Situations:* Studio *Awards:* Golden Rooster Award, Ad Club, Erie, PA; Gold Award, Commonwealth Bank and Trust Co. *Education:* Art Center College of Design; Lycoming College

Believing that photography is both a means of self-expression and a way of meeting the expressive needs of others, he works in both the commercial and fine arts fields. Commercially, he owns and operates his own studio, specializing in industrial, illustrative, editorial and portrait services. He has contributed to annual reports, magazines, menus and catalogs for organizations as diverse as GTE, Bucknell University, hospitals, shops and restaurants. In his personal work he uses both color and black-and-white film to depict stable, rooted people and environments in a relatively "straight" manner. He has taught photography at Lycoming College and was Chairman of the Photography Department at Bucknell University.

WILLIAMES, SHEDRICH (Portraiture, Nature)

2910 S. E. Lambert St., Portland, OR 97202
(503) 775-4952

Born: 1934 *Subject Matter:* Nudes, Flowers *Situations:* Studio, Outdoor *Education:* Portland State U.

Working within the West Coast tradition of Edward Weston and Ansel Adams, he opened up a new landscape in photography, that of the male nude. He is one of the pioneers in "fine art" male nudes and he has produced over 200 one-man shows. He also shoots female nudes. Shooting with one light in his studio, he directs the light in a way that creates a luminous skin tone on one side of the body, leaving a wealth of shadowed detail across the muscle and bone structure in the central portion of the image, and a rich black final portion, all seen against a neutral gray or black background. The light is directed to downplay the sexual aspects in order to highlight a fuller range of sensual forms. Many of his images are in the permanent collections of the Metropolitan Museum in New York, the Bibliotheque Nationale in Paris, the Bellevue Museum of Art in Washington state and the Portland Art Museum in Oregon.

WILLIAMS, BARRY (Photojournalism, Advertising)

2802 Walnut Creek Pike, Circleville, OH 43113
(614) 291-9774

Born: 1961 *Subject Matter:* People, Wildlife, Travel *Situations:* U.S. Locations, Studio *Education:* Ohio U.

Animals, fashion, food, nature, people, sports, travel—all have been his subjects during his seven years as a professional photographer. Beginning at Ohio University, he became versed in all aspects of photography and also gained a background in the study of fine art, paving the way for his success with his range of clients. Today, he asserts that there is no job he cannot accomplish. He has published in newspapers and magazines, from small-scale coupon books to full-length texts. He prefers to shoot color, and it accounts for about seventy percent of his work. He spends most of his time in nature, doing scenic and travel series for commercial advertising.

WILLIAMS, DEWAYNE (Photojournalism, Fine Art)

Route 4 W., Riverside, Missoula, MT 59802
(406) 258-6516

Born: 1943 *Subject Matter:* Landscape, Documentary, Composites *Situations:* U.S. Locations *Awards:* Jury Award, Pennsylvania Festival of the Arts; Jury Award; Idaho St. U., Biennial IV *Education:* Florida State U., Oregon State U.

He was an assistant to both Wynn Bullock and Ruth Bernhard upon completing his masters degree. Bullock's concepts of time, space and light influenced Williams' invention of the correlative composite photograph. With masks, he successively prints three 8" x 10" negatives into one print to compress time, to develop relational interaction and to limit spatial separation, while also maintaining each image's individual integrity, tonal range and detail. He has been awarded grants to develop the concept and received numerous awards in national juried exhibitions, and he has been published in newspapers, magazines and books. He is currently trying to develop paper that will print black and white and color on 8" x 10" contact prints. In addition, his large-format portfolios of the history of U.S. presence in Panama and of the existing remains of the historic American West have been exhibited nationwide. He has also taught many workshops in the U.S. and overseas.

WILLIAMS, RON (Advertising, Corporate/Industrial)

105A Space Park Dr., Nashville, TN 37211
(615) 331-2500

Born: 1948 *Subject Matter:* People, Fashion, Products *Situations:* U.S. and Foreign Locations, Studio *Awards:* Diamond Awards; Awards of Merit and Excellence, International Association of Business Communicators *Education:* Brooks Institute of Photography

Bob Tigert of Tigert Communications writes, "Ron Williams is no simple picture taker. Working with him is an exercise in creative photographic communication." After obtaining his undergraduate degree from Brooks Institute he apprenticed in New York and Los Angeles with such photographers as Leffert, Toto, Satterwhite and Bordnick and eventually opened his own studio in Los Angeles. As a commerical advertising photographer, he visualizes the work from beginning to end, spending time with his clients articulating various possibilities until one is chosen. His dedication to quality and his technical precision have brought him numerous awards and national recognition. Today he is based in Nashville, Tennessee, preference, working primarily on product, people and fashion illustration. He also works on corporate image and annual reports.

WILLIAMS, WAYNE (Advertising, Entertainment)

7623 Beverly Blvd., Los Angeles, CA 90036
(213) 937-2882

Born: 1953 *Subject Matter:* Fashion, People *Situations:* Studio *Education:* Art Center College of Design

His style is simple, tough and elegant. Though he is best known for gallery sessions with Hollywood celebrities, his assignments have ranged from advertising, fashion and corporate accounts to creating opening title sequences for television shows. He has been on location for hotel chains, shot cars from helicopters in the Nevada desert and done sessions with Waylon Jennings, Katherine Ross and Jay Leno. His work has appeared in *TV Guide*, *McCall's*, *Motor Trend*, *Fast Lane*, *Ladies Home Journal* and *Redbook*.

WILLIAMS, WOODBRIDGE (Advertising, Photojournalism)

P.O. Box 11, Dickerson, MD 20842 (301) 972-7025

Born: 1917 *Subject Matter:* Animals, Nature *Situations:* Aerial, U.S. Locations *Education:* Scripps Institution of Oceanography

Trained in marine biology, he entered magazine work with Life's *History of the Barnacle*. In 1952 his work appeared in *Life*'s "The World We Live In". The same year he worked in Pakistan, Afghanistan and Ceylon as a staff photographer for the Food and Agriculture Organization of the UN. Later he became a naturalist on the foreign editorial staff of *National Geographic*. He recently directed the mostly aerial photographic documentation of 80 million acres of land for new national parks, wildlife refuges and wild rivers in Alaska. He now contributes regularly to *Photo District News* in New York City and is free to take assignments. After Image in Los Angeles represents him for stock photography.

WILSON, DANIEL R. (Advertising, Corporate/Industrial)

900 Starkey Rd., Zionsville, IN 46077 (317) 873-5871

Born: 1948 *Subject Matter:* People, Products, Food *Situations:* Studio *Education:* U. of Wisconsin; Indiana U.

With extensive experience as a graphic designer, including knowledge of both printing and pre-press operations, he offers complete services as a photographer. His images are "designed," based upon graphic simplicity. Knowing the total reproduction cycle allows him to avoid many errors or delays in production. Involved in general advertising, food and product illustration, he also produces greeting cards, calendars and corporate portraits for annual reports. In addition to his background in design, he credits his master's degree in educational media as having given him the resources to find his own creative solutions.

WILSON, ROBERT VERNON (Editorial, Fine Art)

2460 Park Blvd., Palo Alto, CA 94306 (415) 328-7779

Born: 1938 *Subject Matter:* Fashion, Industrial, Products, Nudes *Situations:* Studio, U.S. Locations

He began his career working as a photojournalist documenting the pilot programs of "Right-2-Read" (later called "Reading Is Fun") for the U.S. Office of Education. This led to editorial photography for general and medical textbooks, magazine publications, advertising and marketing. After seeing an exhibit of Imogene Cunningham's work, however, he switched to fine art black-and-white photography. Inspired by her sensitive treatment of the nude, he has sought to expand and explore the theme of the human form through the use of wide-angle lenses which provide for selective distortion and a greater depth of field. Using such techniques, a new sense of "bodyscape" is created. A contrast to the body's smoothness is achieved through hard and soft printing.

WILSON, WALLACE (Advertising, Fine Art)

604 W. 43rd Terrace, Gainesville, FL 32607
(904) 327-3967

Born: 1947 *Subject Matter:* Fashion, Nature *Situations:* Studio, U.S. & Foreign Locations *Awards:* Florida Artists Fellowship, Swedish Foundation Fellowship *Education:* School of the Art Institute of Chicago

He began his career as a freelance architectural photographer. Influenced by Ralph Eugene Meatyard, he began to make fine art photographs. His early im-

David Y. Watanabe, *Chuck Fratzke, Saddle Bronc Rider*

DeWayne A. Williams, *Transition 1*

ages are bleak black-and-white landscape/topographic photographs, which gave way to intensely colored collage and assemblage work. In 1985 he began using the Polaroid 20" x 24" camera. He returned to straightforward black-and-white photography during a teaching stint at the University of Gothenberg in Sweden. His latest works, measuring 4 x 6 feet and larger, are confrontational and dynamic blow-ups from 35mm negatives. He has published *Light Places* and he teaches at the University of Florida in Gainesville. His images are in the collections of the Museum of Modern Art, the San Francisco Museum of Modern Art and The International Polaroid Collection, Offenbach, West Germany.

WINKLER, ROBERT S. (Photojournalism, Corporate/Industrial)
P.O. Box 2445, Westport, CT 06880 (203) 227-7139

Born: 1953 *Subject Matter:* Travel, Wildlife *Situations:* Studio, U.S. Locations *Education:* Clark U.

In his personal work, he concentrates on black-and-white nature photography, specializing in birds. Commercially, he specializes in advertising and publicity, candid and environmental portraiture, facilities and events documentation and photojournalistic-style photographs. His corporate/industrial clients are Fortune 500 companies in Connecticut's Fairfield County and New York's Westchester County. His articles on photography and other subjects have appeared in the *New York Times* and other publications. He is becoming increasingly involved in filmmaking and video.

WINNELL, SUE (Equine, Advertising)
2122 Enslow Blvd., Huntington, WV 25701
(304) 529-3445

Born: 1949 *Subject Matter:* Animals, People *Situations:* Studio, U.S. Locations *Awards:* Special Merit, Kodak International Newspaper Awards; Honorable Mention, The World Photography Society *Education:* Marshall U.

Although her interest in photography began when she received a Brownie camera at an early age, she didn't pursue its technical aspects until her children were old enough to to attend college. She prefers portraiture, commercial and equine photography as well as photojournalism. She freelances and spends much of her time working for advertising agencies and a national show horse magazine based in Louisville, Kentucky. "I thoroughly enjoy the creative challenges of the dark room with black-and-white medium."

WINNINGHAM, GEOFFREY L. (Editorial)
P.O. Box 2011, Houston, TX 77001

Born: 1943 *Subject Matter:* People, Cities *Situations:* Locations *Awards:* Guggenheim Fellowship; NEA Photography Fellowship *Education:* Rice U.; Illinois Institute of Technology

After studying under Aaron Siskind in Chicago, he returned to Houston where he had spent his undergraduate days studying English, and decided to devote himself to freelance photography. His work has since been included in such magazines as *Life*, *Esquire*, *Time*, *Atlantic Monthly* and *Photo*. His subject matter is Texas, its people and places. He is known for his series depicting unrestrained fans at sporting events, such as *Friday Night at the Coliseum* and *Going Texan: The Days of the Houston Livestock Show & Rodeo*. With the energy of electronic flash, he captures the odd details of individuals at moments of great enthusiasm or emotion.

WISE, KELLY (Fine Art)
22 School St., Andover, MA 01810

Born: 1932 *Subject Matter:* People, Objects *Situations:* Locations *Awards:* Phillips Academy Kenan Grant; Polaroid Corporation Project Director's Grant *Education:* Purdue U.; Columbia U.

An English teacher, he has also been a photographer since he was 36 years old. He concentrates on portraits of family members and friends, and more recently of writers, artists, publishers and editors. Early work was in black and white only, but since 1976 he has also worked in color, using the SX-70 camera, and printing in large and small formats. Wise says there is "a recurrent literary integer in my work. The funny, the absurd, the terrifying, the sensuous, the tender—all merge." Public collections include the Fogg Art Museum and the International Museum of Photography at the George Eastman House.

WISNIEUX, MICHAEL (Advertising, Portraits)
Sound Images, P.O. Box 56411, Chicago, IL 60656
(312) 777-5628

Born: 1963 *Subject Matter:* Fashion, Nudes, Entertainment *Situations:* Studio, U.S. Locations *Education:* Northwestern U.

Since 1977 he has "specialized in diversity" and developed a consistently original, technically sophisticated yet emotive approach. His work has included photojournalism, theatrical, commercial, sports, and architectural photography. He has lately concentrated on entertainment industry work, including music video. In addition to photography, he works in cinematography and video art.

WITHEY, GARY S. (Advertising, Editorial)
938 W. 5th Ave., Unit C, West Fargo, ND 58078
(701) 282-0466

Born: 1947 *Subject Matter:* Nature, Travel *Situations:* U.S. Locations *Education:* Glen Fishback School of Photography

Natural history and tourism were his primary subjects during the thirteen years he lived in South Dakota. Since moving to North Dakota he has begun adding agricultural, small-town and North Dakota scenes to his files. He uses warm and dynamic natural lighting and works primarily in 35mm, though he will also use the 120mm and 4" x 5" formats when needed. In 1981 he joined Bruce Coleman, Inc., and since then his photographs have been used in advertising, tourism, textbooks, encyclopedias, calendars, magazines, coffee-table books, audio-visual presentations and collector prints.

WITKIN, JOEL-PETER (Fine Art)
222 Amherst St., N.E., Albuquerque, New Mexico 87106

Born: 1939 *Subject Matter:* The Grotesque *Situations:* Studio *Awards:* Ford Foundation Photography Grant *Education:* Cooper Union; U. of New Mexico

Witkin's photographs are terrible visions, manifestations of the diabolical, meticulously staged and then manipulated through the use of chemical drips, scratches on the negative and other distortions. Witkin chooses to photograph the monstrous, the deviant, the tortured and the deformed, in order to evoke the "fris-

Ron Williams, *Bernadette*

Michael Wisnieux, *Gloryhounds*

son" that comes from the recognition of simultaneous horror and beauty. "My work reflects the insanity of life," says Witkin. He sees his work as "part of the history of a diverse and desperate time." He relates religious iconography to sado-masochism, fusing desire and death. His photographs shock and puzzle the viewer, who is left to ponder the often great cruelty and suffering depicted.

WITKOWSKI, BOB (Editorial, Corporate/Industrial)

2615 Rutherford Dr., Los Angeles, CA 90068 (213) 467-0572

Born: 1948 *Subject Matter:* People, Sports *Situations:* U.S. Locations *Education:* Yale U.

Trained in both fine art photography and photojournalism, he has spent his career balancing the two. With fourteen years of experience, he has in the past three years developed a clientele that speaks to these two poles, from corporate work for Unocal Oil to album covers for MCA Records to editorials on boxing to special photography for NBC Productions. He has shot feature films in color, but prefers black-and-white location work shot with the available light. He has been featured in *Photographer's Forum* and *Petersen's Photographic*, as well on ESPN television's "Sportslook" for his series of photographs taken behind the scenes of the boxing profession in Watts. For this project he followed one particular boxer for a period of two months. Witkowski was also be featured on the television series "West 57th Street."

WOHL, MARTY (Photojournalism, Portraiture)

40 E. 21st St., New York, NY 10010 (212) 460-9269

Born: 1944 *Subject Matter:* Fashion, People *Situations:* Studio, U.S. Locations *Education:* City College of New York, School of Visual Arts

He bought his first 35mm camera in 1969. Influenced by the style, compositions and subject matter of Henri Cartier-Bresson, he gravitated to street photography and began capturing the nuance and flavor of the counter-culture in the late 1960s and early 1970s. Not having any formal training, he learned photography by studying the work of W. Eugene Smith, Irving Penn, Helmut Newton and others. Today he photographs people in the art and entertainment industry and takes on editorial assignments or special projects that rouse his curiosity. He is a member of ASMP and he lives and works in New York's photo ghetto.

WOLF, HENRY (Editorial, Advertising)

167 E. 73rd St., New York, NY 10021 (212) 472-2500

Born: 1925 *Subject Matter:* Fashion, Food *Situations:* U.S. Locations, Studio *Awards:* Art Director's Hall of Fame; Gold Medal, American Institute of Graphic Arts *Education:* School of Industrial Art; New School for Social Research

Born in Vienna, he arrived in the United States at the age of sixteen and at the age of twenty-seven began as Art Director at *Esquire*. Next he moved to *Harper's Bazaar* and *Show* and was responsible for redesigning *Business Week*, *Look*, *Dial* and *House Beautiful*. Working for Jack Tinker & Partners in 1961, he contributed to Alka Seltzer, Buick, Ciba-Geigy and Gilette campaigns. For a five-year period he was a partner in his own advertising agency, with clients such as Olivetti, Blacklama Mink, Union Carbide, Elizabeth Arden and Hamilton Watch. Leaving his partnership in 1971

to start Henry Wolf Productions, a photography, film and design firm, he has since produced over 500 television commercials and films, won numerous awards and has been listed in *Who's Who in Graphic Arts* and nominated as Art Director of the Year five consecutive times.

WOOD, KEITH S. (Corporate/Industrial, Portraiture)

1308 Conant St., Dallas, TX 75207 (214) 634-7344

Born: 1947 *Subject Matter:* People, Travel, Industry *Situations:* U.S. & Foreign Locations *Education:* Brooks Institute of Photography

An art student prior to his service in Vietnam, he began taking pictures in 1969 while in Southeast Asia. In 1976 he moved to Dallas to start shooting products and fashion for Neiman Marcus Catalogues. Tired of catalog photography's limitations, he began corporate/industrial work in 1979. He now travels worldwide photographing international mining installations and telecommunications subjects for internal communications and annual reports. Using available light, a Nikon 35mm camera and both Kodachrome and Fuji film he works at establishing a rapport with his subjects. "I have become known for having the ability to set executives at ease and always come back with 'the image.'"

WOOD, RICHARD (Corporate/Industrial)

169 Msgr. O'Brien Highway, Cambridge, MA 02141 (617) 661-6856

Born: 1942 *Subject Matter:* People, Still Life, Special Effects *Situations:* Studio, U.S. Locations *Education:* Rochester Institute of Technology

In 1969, after two years in Vietnam as a U.S. Army news photographer, he began his career with an assignment for *Fortune* in New York City. Subsequent New York work included assignments for *Institutional Investor* and other business magazines. In 1973 he moved to Dakar, Senegal where he worked on assignments for the Senegalese Government, Bureau of Tourism. While there, he also did assignments for multi-national corporations such as Texaco and Exxon. In 1976 he opened a studio in Boston and he now caters to a variety of national and multi-national corporations as well as national magazines. His work can often be seen in *Discover*, *Forbes*, *High Technology* and *Us*.

WOODLEY, JAMES EDWARD (Photojournalism, Commercial)

4835 W. 47th St., Chicago, IL 60638 (312) 585-5839

Born: 1945 *Subject Matter:* Human Relationships, Commerical Advertising, Environmental, Travel *Situations:* U.S. & Foreign Locations, Studio *Awards:* Black Creativity, Museum of Science and Industry, Chicago; Grant, Chicago Office of Fine Arts; Juried Art Exhibition *Education:* Chicago Academy of Fine Arts; Columbia College, Chicago

Attending the Chicago Academy of Fine Arts and graduating from Columbia College with a degree in Communications Media, he continues to pursue photography. In 1985 he opened his own studio and photo gallery, Asyia Studio. His photographs are best known for the intimate relationship captured between his subjects and the world around them, whether real or imaginary—in color or black-and-white. He has shot photographs nationally and internationally, many of

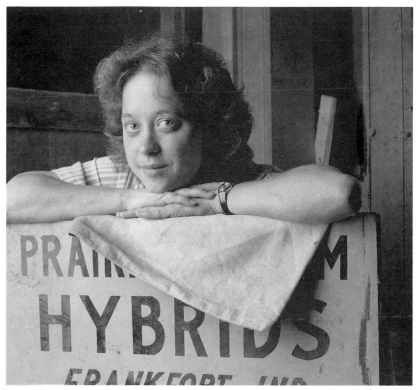

Daniel Wilson, *Prairie Stream.* Client: Tim Wallis, Creative Director, Shepard Poorman Productions

James E. Woodley, *Young Lad*

which have been featured in the media. He has also received a number of grants from the City of Chicago to teach fine art photography to youths. Presently he is concentrating on commercial in-house studio advertising, seeking new accounts and customers. Woodley's work is known for its creativeness, beautiful colors and innovative imagination.

WOODWARD, TRACY A. (Photojournalism)
8904 Camfield Dr., Alexandria, VA 22308
(703) 360-1479

Born: 1954 *Subject Matter:* Sports, Travel *Situations:* U.S. & Foreign Location, Studio

A staff photographer for The Times-Journal Company, he has published world-wide in the Army, Navy and Air Force *Times*, and nationally in such magazines as *Federal Times* and *Military Market*. Assignments for these newspapers have taken him throughout the world, sometimes to hazardous and hostile areas—for instance, covering Drug Enforcement agents and Bolivian soldiers as they raid coca labs in Trinidad and Bolivia. Other assignments have ranged from covering light infantry maneuvers in California and to photographing hearings and press conferences on Capitol Hill and the White House. When not covering the military and political battlefields, he takes time to cover another battle—the annual Army-Notre Dame football game.

WORTH, DON (Fine Art)
38 Morning Sun Ave., Mill Valley, CA 94941

Born: 1924 *Subject Matter:* Plants, People, Urban Landscape *Situations:* U.S. & Foreign Locations, Studio *Awards:* NEA Photography Fellowship; Guggenheim Fellowship *Education:* Juilliard School of Music; Manhattan School of Music

Originally trained as a musician, he turned to photography as an additional medium of expression following an assistantship with Ansel Adams in the late 1950s. He is widely recognized for his vast collection of photographs of plants. He works in black-and-white and color, and his prints range from photographs of plants taken in extreme close-up to panoramic views of hillsides covered with vegetation. His fascination with flora as a subject has taken him around the world. He has also produced several self-portraits over the years, and shots of urban settings and architecture.

WRAUSMANN, GALE (Portraiture, Environment)
2890 California St., San Francisco, CA 93115
(415) 931-0975

Born: 1946 *Subject Matter:* People, Nature *Situations:* U.S. & Foreign Locations *Awards:* Nikon International Photography Contest Winner *Education:* U. of California, Berkeley; U. of Missouri

Using photography to "reveal the fundamental reality of things as spiritual in nature," she specializes in color photography to produce strong, simple, distinct images, be they of people or places. Much of her shooting is done in the Southwest, capturing moments in what are almost surreal images—that of a church as storm clouds gather, the sky a deepening blue-gray, the picture cropped in such a way as to highlight the man-made architecture as well as the architecture of the sky. *American Farm* portrays a collapsing farm house with white cows surrounding it. In this shot a sense of humor joins the surreal elements. "I strive," she says,

"to go beyond realism to a reinterpretation that can tell people something about the world that they would not accept from another art form."

WRISTEN, DONALD F. (Advertising, Corporate/Industrial)
2025 Levee St., Dallas, TX 75207 (214) 748-5317

Born: 1952 *Subject Matter:* Food, Antiques *Situations:* Studio, U.S. Locations *Education:* Austin College; Southern Methodist University

After graduating from college he started working for IBM doing multi-media shows, video tape and still photography. After three years he started D.F.W. photography, a studio specializing in corporate illustration, public relations and architectural interiors and exteriors. He has also freelanced with the *Dallas Morning News Sunday Magazine* Home Section and the weekly deadlines he faced there helped him adjust to the high pressure deadlines and performance demands of commercial work. He is proficient in all formats though he prefers the view camera and other large film sizes. He is best known for his photography of art and antiques and he is currently pursuing an interest in food photography.

YAMADA-LAPIDES, RICK (Advertising, Editorial)
314 Capitola Ave., Capitola, CA 95010
(408) 475-0144

Born: 1951 *Subject Matter:* Fashion, Nature *Situations:* Studio, Foreign & U.S. Locations *Education:* Brooks Institute of Photography

He will go to extraordinary lengths to capture the right image. He hiked an hour into a desert to reach a very rare cactus and three hours through the mountains to visit a crumbling monument to a revered Mexican leader. In the early morning dew he stood on the rim of an ancient volcano overlooking the oldest lake in America. He has had rare encounters with a small family of quizzical pronghorns on the open plains and he has coaxed a reluctant model into draping a ten foot boa constrictor around her body. He works on assignment and has a stock portfolio. "100 feet underwater, 13,000 feet up, and so much in between."

YAMASHITA, MICHAEL S. (Photojournalism, Corporate/Industrial)
Hewn Hollow, Roxiticas Rd., Mendham, NJ 07945
(201) 543-4473

Born: 1949 *Subject Matter:* Travel, Wildlife *Situations:* U.S. & Foreign Locations, Aerial *Education:* Wesleyan U.

His photography assignments have taken him almost literally around the world. After graduating from college, he spent seven years in Asia—four of them in Japan, where he became fluent in Japanese and well-versed in Asian studies and bought his first Nikon. As he became more adept as a photographer, he began to secure work with various Asian accounts, his first being a job with *Far East Travel*, a magazine published in Japan. Assignments for that publication took him from the Soviet Union to Southeast Asia and he was much sought after for his unique combination of cultural and photographic skills. Other accounts included Singapore Airlines, Nikon and Shimizu Construction. In 1975, he returned to the United States. Adventure assignments for the German publications *Stern* and *GEO* included traveling across the Pacific in a 17-foot

David Zahner, *Les Demoiselles Aux Sacs.* Courtesy: Alex Herman Collection

Tom Zmiejko, *Chaco Canyon, New Mexico*

schooner. Two years later he began working as a freelancer with *National Geographic*, for whom he traveled to the Sudan. Today he continues to concentrate on location photography with a photojournalistic approach for both commercial and editorial accounts.

YAPP, CHARLES H. (Advertising, Editorial)

723 W. Randolph, Chicago, IL 60606 (312) 558-9338

Born: 1947 *Subject Matter:* Products, Food, People *Situations:* Studio, U.S. Locations *Education:* Brooks Institute of Photography

His career in photography began in the U.S. Navy in 1966. After an honorable discharge from the service, he worked as a reporter and cameraman for a CBS affiliate. Next he attended Brooks Institute, from which he graduated with honors in photo illustration. Moving to St. Louis, he spent four years shooting for numerous national accounts. Finally he relocated to Chicago, where today he operates his own studio, photographing food, products and people. He works in all formats but prefers 8" x 10" and 2 1/4". His work is characterized by its detail and soft look. Clients include Purina, Quaker Oats and Hyatt, the latter calling for photography featuring architecture and people. He is the Vice President of the Chicago chapter of the Advertising Photographers of America.

YATES, PETER (Photojournalism, Editorial)

515 Spring St., Ann Arbor, MI 48103 (313) 995-0839

Born: 1941 *Subject Matter:* People *Situations:* U.S. Locations *Education:* U. of Liverpool, England

In 1966, he moved from England to New York City and began his photographic career. While in New York he documented the city's jazz clubs and studied with Lisette Model at the New School. In 1969, his landlord destroyed the contents of his apartment, wiping out his entire jazz photography collection. He was traumatized by this event and moved to Michigan. Since the early 1970s he has worked mostly as an editorial photographer. His proximity to Detroit has opened up the automobile market. His photographs have appeared in a wide range of publications including *Time, Newsweek, Business Week, Forbes, Fortune, Der Speigel* and the *New York Times*. He is represented by Picture Group.

ZAHNER, DAVID (Advertising)

145 W. 78th St., New York, NY 10024
(212) 362-9829

Born: 1949 *Subject Matter:* People, Fashion *Awards:* Creativity Certificate of Distinction *Education:* AAS Fashion Institute of Technology

His fashion work is minimalistic and often surreal. There is a certain structural balance which is enhanced by carefully executed lighting, and the elimination of all extraneous elements. The mannequin-like models radiate an aura of mystery, drawing the viewer into a new dimension of reality. Zahner's photography has been published in such magazines as American and British *Vogue, Harper's Bazaar, W* and *Interview*, for clients which include Lisandro Savasda, Gruppo Alma, Louis Feraud and Koos.

ZANZINGER, DAVID (Advertising, Corporate/Industrial)

2411 Main St., Santa Monica, CA 90405
(213) 399-8802

Born: 1944 *Subject Matter:* Interiors, Architecture *Situations:* U.S. Locations

In the late 1960s he began his career as owner of a portrait studio in Philadelphia. After moving to Los Angeles in 1976 he continued to shoot people and portraits until 1981 when he entered the field of architectural and interior design photography. His work has appeared in numerous publications nationwide and abroad. He is known for his ability to enhance the ambiance of a given subject under any lighting situation and also for the way he captures the feeling of space on film.

ZAPPA, TONY (Advertising)

28 E. 29th St., New York, NY 10016

Subject Matter: Products, Still Life *Situations:* Studio *Education:* Columbia U.

After several years at work with a few of advertising's top photographers in still life, fashion and beauty, he opened his own studio. While still producing some of the catalog merchandising photography that supported his early studies, today he concentrates on still life and illustration. Continuing to develop both the technical and creative aspects of his work, he has recently completed a poster, following it through its initial conception to its printing—a process he would perform in all cases if possible. *The Great Mogul Diamond* is his latest piece.

ZAREMBER, SAM (Advertising)

26 Old S. Salem Rd., Ridgefield, CT 06887
(203) 438-4472

Born: 1922 *Subject Matter:* People, Travel *Situations:* Studio, U.S. & Foreign Locations *Awards:* New York Art Directors Gold Medal; San Francisco Art Directors Gold Medal

As the innovator of the soft look, he is best known for his impressionist-influenced romantic mood photography. People are his most frequent subjects, but he has also done pharmaceutical ads, magazine illustrations and other projects. He believes that versatility is important and he enjoys new approaches to photography, adapting his style to each assignment.

ZELLERS, H. GEORGE (Corporate/Industrial)

Carolina Power & Light Co., P.O. Box 1551, Raleigh, NC 27602 (919) 836-6665

Born: 1948 *Subject Matter:* People, Electric Utility *Situations:* Aerial, Hazardous

He is staff photographer for the Photographic Services Unit of Carolina Power & Light Company. He began his career in a portrait studio. After three years he joined a commercial firm where he spent another three years making images for manufacturers of electronic materials. He has been with Carolina Power & Light since the late 1970s and he now supervises the production of photographs and slides for a range of needs including advertising, annual reports, bill inserts, brochures, displays, executive portraiture and technical documentation. He has shot from helicopters and from deep within nuclear power plants. His work has been featured in magazines and textbooks and used by utilities companies in the U.S., Great Britain and Japan.

ZILLIOUX, JOHN (Advertising, Corporate/Industrial)

570 Ridgewood Rd., Key Biscayne, FL 33149
(305) 361-0368

Born: 1949 *Subject Matter:* People, Nature, Wildlife, Fashion *Situations:* Studio, U.S. & Foreign Locations *Education:* U. of Miami

Meeting the challenge of shooting such memorable images as a hawk against water, using long lenses to provide isolation, is one of the hallmarks of this photographer's work. Initially as an excuse to stay in the wilderness for extended periods of time, his career began in the Everglades, where he studied avian species in their natural habitat for twenty years. Continuing his nature photography and augmenting it with occasional commercial assignments, he opened his own studio, eventually concentrating on people and fashion shots for editorial purposes, catalogs and advertisements. His client base again shifted, this time to corporations and an emphasis on location work. Strong in design, his photos are sometimes stark and spontaneous, emphasizing the drama or emotion of the moment without being overly manipulative.

ZMIEJKO, THOMAS B. (Advertising, Corporate/Industrial)

P.O. Box 126, Freeland, PA 18224-0126
(717) 636-2304

Born: 1948 *Subject Matter:* Fashion, Food, Nature *Situations:* Aerial, U.S. & Foreign Locations, Studio *Awards:* Professional Photographers of America; IPSW *Education:* U. of New Mexico

In 1970 he began his career by taking classes and freelancing for corporate accounts in Albuquerque. After ten years he moved to the Pocono Mountains of Pennsylvania where he is now based. He has been influenced by Ansel Adams, Meisel, David Munch and Dean Collins. He prides himself on having "a fine eye for light." He currently focuses on illustration and scenics for contemporary advertising, attempting to influence his clients with powerful themes. Active in video, he shoots weddings for individuals and industrial films for business clients. He is also a painter, specializing in 20" x 24" portraits on canvas.

ZUCKER, GALE (Corporate/Industrial, Photojournalism)

462 Shore Dr., Branford CT 06405

Born: 1957 *Subject Matter:* People, Travel *Situations:* U.S. Locations *Education:* U. of Minnesota

Concentrating on photography that depicts people in their surroundings, she works in both black and white and color. Her work is generally editorial in slant; her work often chronicles events and people in New England and has included offbeat subjects such as the polka dot festival. On the more serious side, she has also worked on a long-term and intimate documentation of Arab-Jewish cooperative projects in Israel. Her corporate and environmental portraits reveal the subject's enthusiasm and caring in a manner similar to her photojournalistic work. Currently, her main projects involve work on feature stories, particularly in overseas locations.

AIRCRAFT & AEROSPACE

CALIFORNIA: *Mill Valley:* Sugar, J; *San Francisco:* Hall, G **NEW JERSEY:** *Rockaway:* Morse, R **RHODE ISLAND:** *Providence:* Swoger, A

ANIMALS

CALIFORNIA: *Davenport:* Balthis, F; *Laguna Beach:* Streano, V **FLORIDA:** *Miami Beach:* Litowitz, D; *Tampa:* Minardi, M **GEORGIA:** *Atlanta:* David, A **ILLINOIS:** *Chicago:* Glenn, E **ILLINOIS:** *Homewood:* Reynolds, L; *River Forest:* Balgemann, L **MARYLAND:** *Dickerson:* Williams, W **MASSACHUSETTS:** *Boston:* Matheny, R; *Cambridge:* Norfleet, B **NEBRASKA:** *Gardnerville:* Lawrence, J **NEW JERSEY:** *Fairfield:* Ayick, P; *Morris Plains:* Degginger, P **NEW YORK:** *Hicksville:* Super, D; *New York:* Dominis, J; Erwitt, E; Funk, M; Green-Armytage, S; Hujar, P; Kahn, R; Mayes, E; Powers, G; *Ossining:* Mejuto, J; *Panama:* Kelly, J; *Sunnyside, Queens:* Bader, K **PENNSYLVANIA:** *Emmaus:* McDonald, J **VIRGINIA:** *Richmond:* Jones, B **WASHINGTON:** *Seattle:* Strathy, D

ARCHITECTURE

FRANCE: *Paris:* Kessel, D **NORWAY:** *Oslo:* Bengston, J **ARIZONA:** *Phoenix:* Gerczynski, T; Much, M; Rippe, R; Schlesinger, T; *Tucson:* Teiwes, H **CALIFORNIA:** *Carmel:* Baer, M; *Inglewood:* Rice, L; *Kensington:* Rokeach, B; *Los Angeles:* Mudford, G; Safron, M; *Nevada City:* Moore, C; *San Diego:* Brun, K; *San Francisco:* Connor, L; Cooper, R; Lidz, J; Perretti, C; *Santa Cruz:* Starr, R; *Santa Monica:* Humble, J; Zanzinger, D; *Ukiah:* Fitch, S **CONNECTICUT:** *Fairfield:* Trager, P **DISTRICT OF COLUMBIA:** Highsmith, C; Mackenzie, M; Olsen, L **FLORIDA:** *Miami Lakes:* O'Connor, M **GEORGIA:** *Atlanta:* McGee, E; Rose, K **ILLINOIS:** *Chicago:* Boschke, L; Francois, R; Maldre, M; Mitzit, B; Palmisano, V; Preis, D; Schwartz, L; *Stickney:* Kezys, A **IOWA:** *Iowa City:* Lutz, R **LOUISIANA:** *New Orleans:* Freeman, T **MAINE:** *Abbot Village:* Abbott, B; *Rockport:* Lyman, D **MARYLAND:** *Baltimore:* Whitman, E; *Rockville:* Landsman, G; *Silver Springs:* Althaus, M **MASSACHUSETTS:** *Boston:* Gorchev, T; Schleipman, R; *Lexington:* Kumler, K; *Longmeadow:* Frankel, F; *Potomac:* Greenhouse, R **MINNESOTA:** *Minneapolis:* Gilmore, S **MISSOURI:** *Kansas City:* Stornello, J **NEW HAMPSHIRE:** *Manchester:* Sanford, G **NEW JERSEY:** *Merchantville:* Pierlott, P; *Morristown:* Russo, R **NEW MEXICO:** *Albuquerque:* Tennies, T; *Santa Fe:* Clift, W **NEW YORK:** *Albany:* Schuyler, J; *Brooklyn:* Bootz, A; Jensen, J; *New York:* Barnett, N; Bellamy, P; Elmore, S; Feiniger, A; Grimaldi, V; Gross, S; Hopp, M; Jenkinson, M; Legrand, M; Leighton, T; Margolies, J; Olman, B; Rivelli, W; Robinson, C; Shapiro, P; Stevenson, M; Thigpen, A; Vlamis, S; *Southampton:* Gaffga, D; Hyde, D; *Woodside:* Geist, W **NORTH CAROLINA:** *Wildington:* Blow, J **OHIO:** *Cincinnati:* Baer, G **OKLAHOMA:** *Tulsa:* Stiller, R **PENNSYLVANIA:** *Bradford:* Tifft, W; *Bryn Mawr:* Crane, T; *Jenkintown:* Carnell, J; *Philadelphia:* Waggaman, J; *Reading:* Plank, D **RHODE ISLAND:** *Pawtucket:* Usher III, A; *Providence:* Siskind, A **TENNESSEE:** *Jonesborough:* Raymond, T **TEXAS:** *Dallas:* Olvera, J; *Houston:* Gomes, G; Howard, M; *San Antonio:* Chavanell, J; *Waco:* Jasek, J **VERMONT:** *Burlington:* Bates, C **VIRGINIA:** *Charlottesville:* Llewellyn, R **WASHINGTON:** *Tacoma:* Penny, M **WISCONSIN:** *Milwaukee:* Oxendorf, E

AUTOMOBILES & BOATS

CALIFORNIA: *Culver City:* Hargrove, T; *Los Angeles:* Trafficanda, G; *Mill Valley:* Holmes, R; *Palm Springs:* Turcotte, J; *W. Studio City:* Riggs, R **FLORIDA:** *Deltona:* Bumpus, K; *St. Petersburg:* Haan, R; *Plantation:* Chesler, K **ILLINOIS:** *Chicago:* Izui, R **KANSAS:** *Merriam:* Mutrux, J **MICHIGAN:** *Birmingham:* Dale, L; *Rochester Hills:* Cleveland, R; *Troy:* Hammarlund, V **MINNESOTA:** *Hopkins:* Marvy, J

FASHION & COSMETICS & BEAUTY

ALABAMA: *Birmingham:* Bondarenko, M **ALASKA:** *Fairbanks:* Rothman, S; *Haines:* Anonymus, E **ARIZONA:** *Phoenix:* Enger, V; *Scottsdale:* Rone, S; *Tucson:* Eglin, T **CALIFORNIA:** *Bakersfield:* Alfter- Fielding, J; *Burlingame:* Degler, C; *Calabasas:* Girardi, C; *Capitola:* Yamada-Lapides, R; *Culver City:* Bernstein, G; *Glendora:* Kakuk, T; *Laguna Beach:* Torrez, B; *Los Angeles:* Bak, S; Bank, K; Booth, R; Graham, D; Harvey, S; Hogg, P; Lennon, ; Ca, Little, B; Narciso, M; Pearson, V; Schiff, D; Swan, M; Volpert, D; Williams, W; *MTB:* Demirdjian, J; *Palo Alto:* Wilson, R; *Sacramento:* Egidi, A; *San Diego:* Kimball, C; *San Francisco:* Hathaway, S; Vera, A; *San Jose:* Scoffone, C; *South San Francisco:* Kaldor, C; *Studio City:* Teke (Matesky), S **COLORADO:** *Aspen:* Marlow, D; *Boulder:* Collector, S; *Durango:* Faustino, ; *Fort Collins:* Clarke, L; *Wheatridge:* Masamori, R **CONNECTICUT:** *Stamford:* Olbrys, A; *Weston:* Seghers II, C **DISTRICT OF COLUMBIA:** Basch, R; Maroon, F **DELAWARE:** *Hockessin:* Graybeal, S **FLORIDA:** *Clearwater:* Riley, R; *Gainesville:* Wilson, W; *Key Biscayne:* Zillioux, J; *Lake Mary:* Bachmann, B; *Lake Park:* Purin, T; *Miami:* Fine, S **GEORGIA:** *Atlanta:* McCannan, T **HAWAII:** *Honolulu:* Noyle, R **ILLINOIS:** *Chicago:* Nielsen, R; Block, S; Candee, M; DeBolt, D; Francois, R; Heil, P; Jones,B;

Leavitt, D; Rashakoor ; Von Dorn, J; Wisnieux, M; *Forest Park*: Konrath, F; *Schaumburg*: Schnaible, G **IN-DIANA**: *Indianapolis*: Ransburg, T **IOWA**: *Des Moines*: Little, S **KANSAS**: *Lenexa*: Pitzner, A; *Merriam*: Mutrux, J **MAINE**: *Portland*: Trueworthy, N **MARYLAND**: *Baltimore*: Norman, H; Whitman, E; *Silver Spring*: Ruggeri, L **MASSACHUSETTS**: *Boston*: Bibikow, W; Curtis, J; Gorchev, P; *Eliot*: Dinn, P; *Hamilton*: Brownell, D **MICHIGAN**: *Berkeley*: Cromwell, P; *Grand Rapids*: Pieroni, F; *Lansing*: Elbinger, D **MINNESOTA**: *Minneapolis*: Arndt, J **MISSOURI**: *St. Charles*: Kodama, K; *St. Louis*: Bartz, C; Meoli, R **NEW JERSEY**: *Fairfield*: Ayick, P; *Hackensack*: Lowe, S; *Jersey City*: Sullivan, S; *Montclair*: Clare, W; *Morristown*: Russo, R **NEW YORK**: *Halesite*: Neville, D; *Long Island*: Frissell, T; *New York*: Abolafia, O; Astor, J; Barboza, A; Bard, R; Bean, J; Bordnick, B; Breskin, M; Bullwinkel, P; Byers, B; Carrino, J; Charles, B; Coupon, W; Cowans, A; Cuington, P; Dantuono, P; Dixon, M; Dubler, D; Eguiguren, C; Foulke, D; Friedman, B; Galante, D; Goldberg, L; Gray, M; Gudnason, T; Halsband, M; Hamsley, D; Handelman, D; Hirsch, B; Hoeltzell, S; Holz, G; Ichikawa, I; Jones, S; Kane, A; Khornak, L; Knapp, C; Larrain, G; Lennard, E; Lulow, W; MacLaren, M; Mellon, T; Miles, I; Morris, B; Nakamura, T; Ney, N; O'Rourke, J; Peck, J; Polsky, H; Rivelli, W; Ryan, W; Salvati, J; SATO ; Shung, K; Silano, S; Stettner, B; Stupakoff, B; Trumbo, K; Volpi, R; Wohl, M; Wolf, H; Zahner, D; *Oceanside*: Halpert, L; *Panama*: Kelly, J; *Peekskill*: Cassaday, B **NORTH CAROLINA**: *Charlotte*: Kearney, M **OHIO**: *Columbus*: Adams, J; Goff, D; *Dayton*: Peterson, S **OREGON**: *Portland*: LaRocca, J **PENNSYLVANIA**: *Philadelphia*: Lynn, J; *Pittsburgh*: Coppola, G **TENNESSEE**: *Chattanooga*: Lowery, R; *Nashville*: Williams, R **TEXAS**: *Beaumont*: Webb, C; *Dallas*: Baker, K; Johnson, M; Kern, G; Whitlock, N; *Houston*: Hart, L **UTAH**: *Salt Lake City*: McManemin, J; Quist, D **VIRGINIA**: *Reston*: Marquez, T **WASHINGTON**: *Seattle*: Burnside, M; Olson, R; Strathy, D; Webber, P

FOOD

ARIZONA: *Tucson*: Eglin, T **CALIFORNIA**: *Los Angeles*: Curran, D; Hogg, P; Montes De Oca, A; Slenzak, R; *MTB*: Demirdjian, J; *San Diego*: Brun, K; *San Francisco*: Vano, T; Vera, A; *South San Francisco*: Kaldor, C **COLORADO**: *Aspen*: Marlow, D; *Denver*: Oswald, J **CONNECTICUT**: *New Canaan*: Swift, D **DISTRICT OF COLUMBIA**: Maroon, F **FLORIDA**: *Clearwater*: Riley, R; *Miami*: Fine, S **HAWAII**: *Honolulu*: Martel, D; Noyle, R **ILLINOIS**: *Chicago*: Block, S; Debold, B; Firak, T; Schabes, C; Yapp, C; *Schaumburg*: Schnaible, G **INDIANA**: *Zionsville*: Wilson, D **IOWA**: *Des Moines*: Little, S **KANSAS**: *Lenexa*: Pitzner, A **MARYLAND**: *Baltimore*: Whitman, E **MASSACHUSETTS**: *Boston*: Curtis, J; Foster, F; Holt, C; Richmond, J; *Eliot*: Dinn, P **MICHIGAN**: *Berkeley*: Cromwell, P; *Grand Rapids*: Pieroni, F; *Saginaw*: Wieck, D **MINNESOTA**: *Golden Valley*: Maki, M; *Hopkins*: Marvy, J; *Minneapolis*: Crofoot, R; McHugh, S; Seaman, W **MISSOURI**: *St. Louis*: Bartz, C; Meoli, R **NEVADA**: *Las Vagas*: DeLespinasse, H **NEW JERSEY**: *Cranford*: Kruper, A **NEW YORK**: *East Greenbush*: Shultis, L; *Halesite*: Neville, D; *New York*: Adams, G; Akis, E; Blosser, R; Breskin, M; Charles, B; Couzens, L; Dominis, J; Fields, B; Galante, D; Galton, B; Grant, R; Laperruque, S; Marcus, H; Obremski, G; Olman, B; Powers, G; Reichman, A; Rudnick, M; SATO; Silano, S; Thomas, M; Wolf, H; *Oceanside*: Halpert, L; *Rochester*: Platteter, G; *Water Mill*: Fotiades, B **OREGON**: *Portland*: LaRocca, J **PENNSYLVANIA**: *Freeland*: Zmiejko, T; *Pittsburg*: Morton, C; *Williamsport*: Wild, T **RHODE ISLAND**: *Providence*: Rockhill, M **TEXAS**: *Dallas*: Baker, K; Kretchmar, P; Olvera, J; Wristen, D; *Houston*: Moot, K; *San Antonio*: Chavanell, J **UTAH**: *Salt Lake City*: McManemin, J **VIRGINIA**: *Annandale*: Colbroth, R; *Arlington*: Neubauer, J **WASHINGTON**: *Seattle*: Burnside, M; Mears, J **WYOMING**: *Laramie*: Alford, J

INDUSTRY

ALABAMA: *Decatur*: Seifried, C **ALASKA**: *Girdwood*: Graham, K **ARIZONA**: *Phoenix*: Much, M **CALIFORNIA**: *Los Angeles*: Aristei, S; *Palo Alto*: Wilson, R; *Santa Monica*: Korody, T; *Sausalito*: Baltz, L **CONNECTICUT**: *New Canaan*: D'Arazien, A; Swift, D **GEORGIA**: *Atlanta*: Sherman, R **ILLINOIS**: *Chicago*: Nielsen, R; Siede, G; *Des Plaines*: Bartholomew, G; *Evanston*: Kelly, T; *Villa Park*: Ellefson, D **MASSACHUSETTS**: *Amherst*: Liebling, J; *Boston*: Dunwell, S; Simmons, E; *Lexington*: Spivak, I **MINNESOTA**: *Minneapolis*: Magoffin, J **MISSOURI**: *St. Louis*: McCowan, R **NEW MEXICO**: *Albuquerque*: Barrow, T **NEW YORK**: *Brooklyn*: Decarava, R; *Cold Springs*: Handler, L; *Kingston*: Dwon, L; *New York*: Barnett, N; Davidson, B; Haling, G; Peacock, C; Steele, K; *North Salem*: Orling, A; *Peekskill*: Cassaday, B; *Rochester*: Rosenberg, L **NORTH CAROLINA**: *Charlotte*: Fritz, G; *Raleigh*: Zellers, H **PENNSYLVANIA**: *Doylestown*: Baker, W; *Philadelphia*: Uzzle, B **TENNESSEE**: *Franklin*: Hood, R; *Memphis*: Walpole, G **TEXAS**: *Dallas*: Wood, K; *Houston*: Green, M **WASHINGTON**: *Kirkland*: Watanabe, D; *Maple Falls*: Devine, B **WISCONSIN**: *Milwaukee*: Oxendorf, E

LANDSCAPE

SCOTLAND: *Glasgow*: Cooper, T **ARIZONA**: *Phoenix*: Gerczynski, T; *Prescott*: Dusard, J; *Tucson*: Jones, H; Teiwes, H; Dykinga, J **CALIFORNIA**: *Albany*: Rowell, G; *Carpenteria*: Merkel, D; *Inglewood*: Rice, L; *Laguna*

Beach: Brown, L; *Los Angeles:* Teske, E; *Mill Valley:* Jones, P; Worth, D; *Mt. View:* Skarsten, M; *Oakland:*Mac-Gregor, G; *Point Richmond:* Wessel, H; *Riverside:* Deal, J; *San Anselmo:* Dater, J; *San Francisco:* Bishop, M; Burchard, J; Cameron, R; Coke, V; Connor, L; Pavloff, N; Welpott, J; *San Jose:* Scoffone, C; *Santa Monica:* Humble, J; *Sausalito:* Baltz, L; *Ukiah:* Fitch, S; *Vallejo:* Minick, R **COLORADO:** *Longmont:* Adams, R **CONNECTICUT:** *Bethlehem:* Vestal, D; *Fairfield:* Trager, P; *W. Suffield:* Cumming, R **DISTRICT OF COLUMBIA:** Cherney, B; Gossage, J **FLORIDA:** *Lutz:* Bailey, O; *Miami Beach:* Litowitz, D; *Winnetka:* Plowden, D **GEORGIA:** *Marietta:* Katz, A **HAWAII:** *Capt Cook:* Vaughn, G **ILLINOIS:** *Chicago:* Woodley, J; *Oak Lawn:* Jachna, J; *Riverside:* Kleinman, J **KANSAS:** *Kansas City:* Vivers, K **LOUISIANA:** *New Orleans:* Freeman, T **MAINE:** *Abbot Village:* Abbott, B **MASSACHUSETTS:***Amherst:* Liebling, J; *Boston:* Littell, D; Nixon, N; Parker, O; Tuckerman, J; MacLean, A; *Holden:* Rosenstock, R; *Lexington:* Kumler, K **MINNESOTA:** *Minneapolis:* Gohlke, F; Shambroom, P; *St. Paul:* Goddard, W **MONTANA:** *Bozeman:* Shore, S; Trolinger, C; *Missoula:* Williams, D **NEW JERSEY:** *Iselin:* Tice, G; *Princeton:* Savage, N **NEW MEXICO:** *Albuquerque:* Barrow, T; *Cerrillos:* Kennedy, D; *Santa Fe:* Chappell, W; Clift, W; Ranney, E **NEW YORK:** *Brooklyn:* Decarava, R; *Long Island City:* Rosenblum, W; *Massapequa Park:* Burnley, J; *New York:* Byers, B; Cowans, A; Davidson, B; Gowin, E; Hallman, G; Hyde, S; Lennard, E; Levitt, H; Namuth, H; Papageorge, T; Pfahl, J; Silano, S; Sommer, F; Sonneman, E; Staller, J; Tress, A; Tweel, R; Wilcox, S; *Rochester:* Margolis, R; Mertin, R; Rosenberg, L **OHIO:** *Cincinnati:* Rexroth, N **OKLAHOMA:** *Tulsa:* Halpern, D **OREGON:** *Portland:* Braasch, G **PENNSYLVANIA:** *Gardenville:* Fell, D; *Ottsville:* Smith, M; *Paradise:* Irwing, J; *Philadelphia:* Uzzle, B; *Tarentum:* Pavlik, P **RHODE ISLAND:** *Providence:* Hanson, D **TENNESSEE:** *Nashville:* Thomas, C **TEXAS:** *Houston:* Schorre, C; Winningham, G **WASHINGTON:** *Seattle:* Reed, S; Westmorland, F

LIVESTOCK
ILLINOIS: *Cary:* Weaver, D **MARYLAND:** *Lutherville:* Jackson, C **WEST VIRGINIA:** *Huntington:* Winnel, S

MEDICAL
CONNECTICUT: *Stratford:* Manning, E **DISTRICT OF COLUMBIA:** Meyer, J **ILLINOIS:** *Mt. Prospect:* Frank, J **KANSAS:** *Kansas City:* Vivers, K **NEW YORK:** *New York:* Menashe, A; Niccolini, D; *Rockville Center:* Chwatsky, A **PENNSYLVANIA:** *Allentown:* Kainz, J **TEXAS:** *Houston:* Howard, M

NATURE & WILDLIFE
ALABAMA: *Birmingham:* Bondarenko, M; *Bessemer:* Falls, R **ALASKA:** *Anchorage:* Johnson, J; *Fairbanks:* Rothman, S; *Girdwood:* Brandon, R; Graham, K; Simmerman, N; *Haines:* Anonymus, E; *Soldotna:* Levy, R **ARIZONA:** *Phoenix:* Dutton, A; Enger, v; *Prescott:* Annerino, J; *Sedona:* Kahl, M; Krasemann, S; *Tucson:* Jones, H **CALIFORNIA:** *Berkeley:* Le Bon, L; Stresinsky, T; *Burlingame:* Degler, C; *Calabasas:* Girardi, C; *Capitola:* Yamada- Lapides, R; *Carmel:* Baer, M; Ross, P; *Cathedral City:* Jacobs, L; *Culver City:* Hargrove, T; *Cupertino:* Fisher, S; *Inglewood:* Johnstone, M; *Inverness:* Blake, T; *Laguna Beach:* Streano, V; *Los Angeles:* Booth, R; Kulkin, N; Scharf, D; *Mill Valley:* Holmes, R; Sugar, J; *Montebello:* Blake, M; *Nevada City:* Moore, C; *Northbrook:* Grover, R; *Oakland:* Elk, J; MacGregor, G; *Pebble Beach:* Alinder, J; *Riverside:* Deal, J; *Romona:* Lawson, G; *San Francisco:* Bernhard, R; Buryn, E; Falk, R; Gagliani, O; Keenan, L; Krutein, W; Mahieu, T; Martin, C; Wrausmann, G; *San Rafael:* Daniel, J; *Santa Barbara:* Roberts, I; Tuttle, T; *Santa Curz:* Lanting, F; *Santa Monica:* Lawton, E; *Solana Beach:* Doyle, R; *Trinidad:* Ulrich, L; *Whittier:* Mendez, R; *Yosemite:* Kemper, L **COLORADO:** *Aurora:* Summers, C; *Boulder:* Roitz, C; *Denver:* Lewis, D; *Fort Collins:* Clarke, L; Weber, J; *Golden:* Milmoe, J; *Weston:* Wachstein, A **CONNECTICUT:** *Westport:* Winkler, R **DISTRICT OF COLUMBIA:** Basch, R; Cherney, B; Gossage, J; Szabo, S **DELAWARE:** *Wilmington:* Eppridge, W **FLORIDA:** *Gainesville:* Wilson, W; *Key Biscayne:* Zillioux, J; *Miami:* Clouse, M; Holland, R; Lucas, S; *Miami Beach:* Litowitz, D; *Sarasota:* Stahl, D **HAWAII:** *Capt Cook:* Vaughn, G **IDAHO:** *Boise:* Mullins, W **ILLINOIS:** *Belleville:* Van Blair, D; *Chicago:* Jones, B; Josephson, K; Koga, M; Maldre, M; Mitzit, B; Morrill, D; Palmisano, V; Villa, A; Woodley, J; *Evanston:* Sheridan, S; *Highland Park:* Valenti, D; *Northbrook:* Sturtevant, P; *Oak Lawn:* Jachna, J; *Ottawa:* Clay, W; *Park Ridge:* Mutter, S; *Stickney:* Kezys, A **INDIANA:** *Brownstone:* Morris, L **IOWA:** *Iowa City:* Lutz, R **KANSAS:** *Kansas City:* Vivers, K; *Lenexa:* Pitzner, A **MAINE:** *Portland:* Trueworthy, N; *Rockport:* Durrance, D **MARYLAND:***Annapolis:* Beigel, D; Warren, M; *Baltimore:* Houston, R; Miller, R; *Bethesda:* Ward, F; *Dickerson:* Williams, W; *Frederick:* IntVeldt, G; *Joppa:* Sacilotto, I; *Rockhill:* Davidson, H **MASSACHUSETTS:** *Boston:* Cosindas, M; Dunwell, S; Jones, L; Littell, D; Matheny, R; Simmons, E; *Cloudcroft:* Davidson, J; *Concord:* Massar, I; *Milton:* Urban, J **MICHIGAN:***Ann Arbor:* Schneider, T; *Battle Creek:* Tarchala, J; *Belleville:* Parkinson, P; *Lansing:* Elbinger, D **MINNESOTA:** *Albert Lea:* Polis, J; *Edina:* Brimccombe, G; *Minneapolis:* Gohlke, F; *St. Paul:* Ahrenholz, D; Smith, H **MISSOURI:** *Columbia:* Bryan, D **NEBRASKA:** *Gardnerville:* Lawrence, J **NEW JERSEY:** *Blairstown:* Rue, L; *Clayton:* Kargman, A; *Fairfield:* Ayick, P; *Mendham:* Yamashita, M; *Merchantville:*

Pierlott, P; *Morris Plains*: Degginger, P; *New Milford*: Atura, F; *Summit*: Cooper, J **NEW MEXICO:** *El Rito*: Eckert, R; *Ruidoso*: Wiggins, W; *Santa Fe*: Capinigro, P; Chappell, W; Fuss, E; Ranney, E; Trimble, S **NEW YORK:** *Bronx*: Rokach, A; *Brooklyn*: Barron, S; *East Greenbush*: Shultis, L; *Forest Hills*: Gotfryd, B; *Kingston*: Dwon, L; *Massapequa Park*: Burnley, J; *New York*: Ashley-White, B; Barnett, N; Beebe, R; Bridges, M; Butler, G; Carroll, J; Cirone, B; Feiniger, A; Funk, M; Heiberg, M; Hyde, S; Izu, K; Kane, D; Kent, K; Kramer, D; Leduc, L; Levy, Y; MacLaren, M; Mayes, E; McCarthy, M; Mroczynski, C; Quat, D; Raskin, L; Rusten, S; Schneider, M; Smith, B; Sommer, F; Sonneman, E; Tucker, T; Waldron, D; Welch, R; Wilcox, S; *Peekskill*: Cassaday, B; *Pelham*: Millard, H; *Poughkeepsie*: Makris, D; *Rochester*: Lent, M; *Somers*: Rauch, B; *Sunnyside, Queens*: Bader, K; *Westfield*: Rossotto, F; *White Plains*: Conte, M **NORTH CAROLINA:** *Horse Shoe*: Nebbia, T; *Raleigh*: Henderson, C; Van de Zande, D **NORTH DAKOTA:** *West Fargo*: Withey, G **OHIO:** *Circleville*: Williams, B; *Wickliffe*: O'Toole, T **OKLAHOMA:** *Tulsa*: Robson, H **OREGON:** *Bend*: Ergenbright, R; *Portland*: Braasch, G **PENNSYLVANIA:** *Drexel Hill*: Kaser, K; *Emmaus*: McDonald, J; *Freeland*: Zmiejko, T; *Gardenville*: Fell, D; *Lancaster*: Dussinger, M; *Merion Station*: Dunoff, R; *Ottsville*: Smith, M; *Paradise*: Irwing, J; *Pittsburgh*: Seng, W; *Pottstown*: Kelly, T; *Tarentum*: Pavlik, P; *York*: Markel, B **RHODE ISLAND:** *Providence*: Swoger, A **SOUTH CAROLINA:** *Myrtle Beach*: Dodson, R **TENNESSEE:** *Jonesborough*: Raymond, T; *Memphis*: Eggleston, W; Riss, M; *Nashville*: Netherton, J **TEXAS:** *El Paso*: Kimak, M; *Houston*: Baldwin, F; Howard, M; Robbins, L; Schorre, C; *Waco*: Jasek, J **UTAH:** *Clarfield*: Jarvis, H; *Moab*: Till, T; *Sandy*: Telford, J **VERMONT:** *Putney*: Kehaya, D **VIRGINIA:** *Alexandria*: Purcell, C; *Charlottesville*: Llewellyn, R **WASHINGTON:** *Bainbridge*: Rabinowitz, N; *Edmonds*: Kirkendall/Spring, ; *Seattle*: Barnes, D; Olson, J; Reed, S; Strathy, D; Webber, P; Westmorland, F; *Spokane*: Boccaccio, A; *Vancouver*: Leeson, T **WEST VIRGINIA:** *Morgantown*: Rittenhouse, R **WISCONSIN:** *Milwaukee*: Miller, B **WYOMING:** *Jackson*: Mangelsen, T; *Laramie*: Alford, J

NUDES

ALASKA: *Fairbanks*: Rothman, S **ARIZONA:** *Phoenix*: Dutton, A; Schlesinger, T; *Los Angeles*: Curran, D; Teske, E; *Palo Alto*: Wilson, R; *San Francisco*: Bernhard, R; Burchard, J **COLORADO:** *Boulder*: Collector, S **FLORIDA:** *Jacksonville Beach*: Hope, C; *Land O' Lakes*: McNeely, B **ILLINOIS:** *Chicago*: Wisnieux, M **MICHIGAN:** *Berkeley*: Cromwell, P **NEW MEXICO:** *Santa Fe*: Chappell, W **NEW YORK:** *Buffalo*: Krims, L; *New York*: Adams, G; Aubry, D; Berk, O; Breskin, M; Carey, E; Grimaldi, V; Holz, G; Hopp, M; Larrain, G; MacAdams, C; Malanga, G; Mellon, T; Morgan, J; Ney, N; Niccolini, D; Silano, S; Tress, A **OHIO:** *Kent*: Pamfilie, A **OREGON:** *Portland*: LaRocca, J; Williames, S **PENNSYLVANIA:** *Philadelphia*: Lynn, J **TEXAS:** *Dallas*: Whitlock, N; *Houston*: Krause, G

PEOPLE & PORTRAITURE

CANADA: *Toronto*: Heath, D **ENGLAND:** *London*: Arnold, E; *Surrey*: Benton-Harris, J **FRANCE:** *Alps Maritime*: Duncan, D; *Paris*: Klein, W **ISRAEL:** *Jerusalem*: Gidal, T **NORWAY:** *Oslo*: Bengston, J **VIRGIN ISLANDS:** *St. Croix*: Henle, F **ALABAMA:** *Birmingham*: Bondarenko, M; *Bessemer*: Falls, R; *Decatur*: Seifried, C **ALASKA:** *Anchorage*: Mishler, C; *Fairbanks*: Rothman, S; *Girdwood*: Simmerman, N; *Soldotna*: Levy, R **ARIZONA:** *Phoenix*: Dutton, A; Enger, V; Gerczynski, T; Much, M; Peterson, B; *Prescott*: Dusard, J; *Scottsdale*: Rone, S; *Sedona*: Krasemann, S; *Tucson*: Eglin, T; Golden, J; Teiwes, H; Dykinga, J **CALIFORNIA:** *Agoura*: Leshnov, M; *Albany*: Rowell, G; *Arcata*: Land-Weber, E; *Bakersfield*: Alfter-Fielding, J; *Balboa Island*: Dunmire, L; *Ben Lomond*: Troxell, P; *Berkeley*: Kriz, V; *Beverly Hill*: Filter, K; *Cameron Park*: Mather, J; *Canoga Park*: Fugate, R; *Carmel*: Ross, P; *Cathedral City*: Jacobs, L; *Culver City*: Bernstein, G; *Cupertino*: Fisher, S; *Glendora*: Kakuk, T; *Greenbrae*: Sultan, L; *Hayward*: Owens, B; *Hollywood*: Gerretsen, C; Noday, S; *Inglewood*: Rice, L; *Kensington*: Rokeach, B; *Laguna Beach*: Torrez, B; *Lawndale*: Gray, C; *Los Angeles*: Aristei, S; Bak, S; Bank, K; Booth, R; Bryant, E; Callis, J; Duhamel, F; Foreman, R; Graham, D; Hammer, W; Harvey, S; Israelson, N; Kulkin, N; Lennon; Lieberman, J; Little, B; Montes De Oca, A; Narciso, M; Paris, M; Pearson, V; Reiss, P; Rudolph, J; Schiff, D; Shea, J; Slenzak, R; Slocum, C; Somma, L; Swan, M; Tepper, R; Teske, E; Trafficanda, G; Volpert, D; White, L; Williams, W; Witkowski, B; *Malibu*: Selig, J; *Merced*: Werner, C; Werner, M; *Mill Valley*: Jones, P; Sugar, J; Worth, D; *Modesto*: Magnus, R; *Montebello*: Blake, M; *Mt. View*: Skarsten, M; *N. Hollywood*: Kennerly, D; *Nevada City*: Moore, C; *Northbrook*: Grover, R; *Oakland*: Brill, L; Downey, M; *Pacific Palisades*: Bartholomew, B; Blumberg, D; *Palm Springs*: Turcotte, J; *Palo Alto*: West, C; Wilson, R; *Panorama City*: Jones, J; *Pasadena*: Mauskopf, N; *Pebble Beach*: Alinder, J; *Point Richmond*: Wessel, H; *Sacramento*: Egidi, A; *San Anselmo*: Dater, J; *San Diego*: Blau, E; Harrington, M; Hicks, M; Kimball, C; *San Francisco*: Atkinson, V; Bernhard, R; Buryn, E; Chester, M; Falk, R; Flesch, V; Hathaway, S; Keenan, L; Krutein, W; Mahieu, T; Martin, C; Mezey, P; Mizono, R; Pavloff, N; Powers, D; Vano, T; Vera, A; Vignes, M; Wagner, C; Welpott, J; Wrausmann, G; *San Jose*: Scoffone, C; *San Mateo*: Rice, M; *San Rafael*: Daniel, J; Fulton, J; *Santa Barbara*: McKiernan, K; Roberts, I; *Santa Cruz*: Thaler, S; *Santa Monica*: Humble, J; Korody, T; Lawton, E; Roundtree, D; *Santa*

Rosa: Cohen, M; *Sepuluedo*: Kalick, C; *Sherman Oaks*: Share, J; *South San Francisco*: Kaldor, C; *Sunnyvale*:Dunn, R; *Vallejo*: Minick, R; *Venice*: Segalove, I; *W. Studio City*: Riggs, R; *Whittier*: Mendez, R; *Woodland Hills*: Colodzin, B; *Yosemite*: Kemper, L **COLORADO:** *Aspen*: Berge, M; Marlow, D; *Boulder*: Collector, S; *Denver*: Dickman, J; Oswald, J; *Durango*: Faustino; *Fort Collins*: Weber, J; *Golden*: Lissy, D; *LaPorte*: Dean, M; *Longmont*: Adams, R; *Vail*: Lokey, D **CONNECTICUT:** *Branford*: Zucker, G; *East Norwalk*: Von Koschembahr,A; *Fairfield*: Trager, P; *Ledyard*: Russell, K; *New Canaan*: Swift, D; *Portland*: Seeley, J; *Ridgefield*: Zarember, S; *Stamford*: Hungaski, A; Olbrys, A; *West Redding,* : Palmer, G; *Weston*: Seghers II, C; Wachstein, A; *Wesport*: Lineon, J; Silk, G; Tenin, B **DISTRICT OF COLUMBIA:** Basch, R; Cherney, B; Evans, M; Fries, J; Grant, J; Keiser, A; Maroon, F; Meyer, J; Olsen, L; Skoff, G; Walker, D; Walters, D; Price, P **DELAWARE:***Hockessin*: Graybeal, S; *Wilmington*: Eppridge, W **FLORIDA:** *Bradenton*: Sweetman, G; *Corn Gables*: Fernandez, J; *Deltona*: Bumpus, K; *Fort Lauderdale*: Slater, E; Trainor, C; *Ft. Lauderdale*: Langone, P; Wiener, R; *Jacksonville Beach*: Hope, C; *Key Biscayne*: Zillioux, J; *Lake Park*: Purin, T; *Land O' Lakes*: McNeely, B; *Miami*: Carlebach, M; Castañeda, L; *Miami*: Clouse, M; Fine, S; Kennedy, W; Walters, D; *Miami Beach*: Litowitz, D; *Sarasota*: Luzier, W; Stahl, D; *St. Petersburg*: Haan, R; *Tallahassee*: O'Lary, B; *Tampa*: Minardi, M; *Winnetka*: Plowden, D **GEORGIA:** *Atlanta*: David, A; McCannan, T; McGee, E; Rose, K; Sherman, R; Taylor, R **HAWAII:** *Capt Cook*: Vaughn, G; *Hilo*: Penisten, J; *Honolulu*: Martel, D; Peterson, R; Shaneff, C **IDAHO:** *Boise*: Poertner, K **ILLINOIS:** *Chicago*: Alderson, J; Battrell, M; Boschke, L; Burris, Z; Candee, M; Cowan, R; Debold, B; DeBolt, D; Francois, R; Frerck, R; Glenn, E; Harney, T; Harris, B; Hauser, M; Heil, P; Izui, R; Jones, B; Josephson, K; Kelly, M; Koga, M; Leavitt, D; Moss, J; Moy, W; Preis, D; Rashakoor, ; Santow, L; Schabes, C; Schrempp, E; Schwartz, L; Siede, G; Villa, A; Il, Von Dorn, J; White, J; Wisnieux, M; Woodley, J; Yapp, C; *Des Plaines*: Bartholomew, G; *Evanston*: Kelly, T; Sheridan, S; *Forest Park*: Konrath, F; *Hinsdale*: Henderson, A; *Homewood*: Reynolds, L; *La Grange*: Mead, R; *Mt. Prospect*: Frank, J; *Northbrook*: Sturtevant, P; *Oak Park*: Gerlach, M; *Park Ridge*: Mutter, S; *River Forest*: Balgemann, L; *Schaumburg*: Schnaible, G; *Springfield*: Farmer, T; *Stickney*: Kezys, A; *Urbana*: Nettles, B; *Villa Park*: Ellefson, D **INDIANA:** *Brownstone*: Morris, L; *Indianapolis*: Carter, M; Ransburg, T; *Zionsville*: Wilson, D **IOWA:** *Des Moines*: Ceolla, G; Little, S **KANSAS:** *Lenexa*: Pitzner, A; *Merriam*: Mutrux, J; *Topeka*: Crowl, G; *Wichita*: Sartore, J **LOUISIANA:** *Baton Rouge*: Bryant, D; Gleason, D; *New Orleans*: Freeman, T; *Shreveport*: Johnson, N **MAINE:** *Abbot Village*: Abbott, B; *Portland*: Trueworthy, N; *Rockport*: Durrance, D **MARYLAND:** *Annapolis*: Warren, M; *Baltimore*: Houston, R; *Bethesda*: Althause, M; Ward, F; *Florissant*: Mosley, K; *Laurel*: Edwards, R; *Rockville*: Landsman, G; *Silver Spring*: Lewis, M; Ruggeri, L; *St. Louis*: Portnoy, L **MASSACHUSETTS:** *Amherst*: Liebling, J; *Andover*: Wise, K; *Boston*: Bindas, J; Cosindas, M; Curtis, J; Dunwell, S; Flowers, M; Foster, F; Gorchev, P; Grossfeld, S; Holt, C; Houch, M; Knott, J; Matheny, R; McQueen, A; Nixon, N; Porcella, P; Richmond, J; Robinson, D; Rowin, S; Simmons, E; Tuckerman, J; *Brookline*: Shook, M; *Cambridge*: Benedict-Jones, L; Berndt, J; Norfleet, B; Wood, R; *Chicopee*: Epstein, A; *E. Bridgewater*: Mercer, R; *Great Barrington*: Aigner, ; *Lexington*: Spivak, I; *Northampton*: Delevingne, L; *Potomac*: Greenhouse, R; *Summerville*: Hilliard, H; *Westwood*: Dreyer, P **MICHIGAN:** *Ann Arbor*: Leonard, J; Yates, P; *B-Hills*: Rodney, A; *Battle Creek*: Tarchala, J; *Belleville*: Parkinson, P; *Berkeley*: Cromwell, P; *Birmingham*: Dale, L; *Detroit*: Salter, T; *Grand Rapids*: Pieroni, F; *Lansing*: Elbinger, D; *Rochester Hills*: Cleveland, R; *Saginaw*: Wieck, D; *Troy*: Hammarlund, V **MINNESOTA:** *Albert Lea*: Polis, J; *Burnsville*: Peterson, B; *Edina*: Brimccombe, G; *Golden Valley*: Maki, M; *Minneapolis*: Arndt, J; Crofoot, R; Hall, A; Magoffin, J; Roepke, L; Seaman, W; *St. Paul*: Stegbauer, J **MISSOURI:** *Columbia*: Bryan, D; *Kansas City*: Stornello, J; *St. Charles*: Kodama, K; *St. Louis*: Bartz, C; Hyman, R; Kincaid, C; McCowan, R **MONTANA:** *Bozeman*: Trolinger, C; *Condon*: Wade, R; *Helena*: Sallaz, W; *Winchester*: Siteman, F **NEBRASKA:** *Gardnerville*: Lawrence, J **NEVADA:** *Las Vagas*: DeLespinasse, H **NEW HAMPSHIRE:** *Exeter*: Lewis, S; *Francestown*: Sweet, O; *Manchester*: Sanford, G **NEW JERSEY:** *Clayton*: Kargman, A; *Collingswood*: Giandomenico, B; *Cranford*: Kruper, A; *Hackensack*: Lowe, S; *Hillside*: Miller, M; *Jersey City*: Sullivan, S; *Merchantville*: Pierlott, P; Thellmann, M; *Montclair*: Diebold, G; *Morris Plains*: Degginger, P; *New Milford*: Atura, F; *Princeton*: Paredes, C; Savage, N; *Summit*: Cooper, J; *Wayne*: Mogerley, J **NEW MEXICO:** *Albuquerque*: Hahn, B; Noggle, A; Tennies, T; Witkin, J; *Cerrillos*: Kennedy, D; *El Rito*: Eckert, R; *Ruidoso*: Wiggins, W; *Santa Fe*: Chappell, W; Nelson, W; Rubenstein, M; Trimble, S **NEW YORK:** *Albany*: Kozlowski, M; Schuyler, J; *Auburn*: Grunfeld, D; *Baldwin*: Marten, B; Philiba, A; Sleet, M; *Brooklyn*: Barron, S; Blackman, J; Bootz, A; Czaplinski, C; Decarava, R; Freedman, J; Fuss, A; Spellings, I; *Buffalo*: Krims, L; *Cold Springs*: Handler, L; *Comack*: Salander, A; *Deer Park*: Neste, A; *Englewood*: Aiello, F; *Floral Park*: Gartel, L; *Halesite*: Neville, D; *Hicksville*: Super, D; *Larchmont New York*: Mydans, C; *Long Island*: Frissell, T; Rosenblum, W; *Mamaroneck*: Millman, L; *New York*: Abolafia, O; Adams, G; Ashley-White, B; Astor, J; Avedon, R; Aubry, D; Barboza, A; Bard, R; Bean, J; Beebe, R; Begleiter, S; Bellack, R; Bellamy, P; Berk, O; Bishop, R; Blosser, R; Bordnick, B; Breskin, M; Butler, G; Cadge, J; Capa, C; Caras, S; Carey, E; Carroll, J; Cirone, B; Clark, L; Clarke, K; Claycomb, E; Clementi, J; Colletti, S; Cotter, M; Coupon, W; Couzens, L; Cowans, A; Cuington, P;

D'Alessandro, R ; Davidson, B; Davidson, D; Diederich , J; Dixon, M; Dominis, J; Dubler, D; Edinger, C;Eguiguren, C; Engel, M; Engel, M; Erwitt, E; Erwitt, M; Falco, R; Feiler, J; Fields, B; Fox, F; Freed, L; Friedman, B; Friedman, B; Gatewood, C; Gibson, R; Goldberg, L; Gowin, E; Grant, R; Graves, T; Green-Armytage, S; Groover, J; Haling, G; Halsband, M; Handelman, D; Harbutt, C; Holbrooke, A; Holz, G; Hopp, M; Hujar, P; Hyde, S; Jann, G; Jones, S; Kahn, R; Kane, A; Kane, D; Kaplan, P; Katzenstein, D; Kent, K; Khornak, L; Knapp, C; Kramer, D; Kroll, E; Kudo, ; Kuehn, K; Laird, R; Lapious, L; Larrain, G; Leduc, L; Legrand, M; Leibovitz, A; Lennard, E; Levitt, H; Logan, F; Lulow, W; Luria, R; MacAdams, C; MacWeeney, A; Malanga, G; Manna, L; Manos, C; Marcus, H; Mark, M; Marx, R; Masunaga, R; Matthews, C; Mayes, E; McCarthy, M; Melillo, N; Mellon, T; Menashe, A; Menschenfreund, J; Meyerowitz, J; Michals, D; Miles, I; Mitchell, J; Morath, I; Morris, B; Murrell, G; Namuth, H; Neleman, H; Nelson, M; Newman, A; Niccolini, D; Noren, C; O'Rourke, J; Olman, B; Papadopolous, P; Papageorge, T; Peacock, C; Peck, J; Peress, G; Polsky, H; Powers, G; Purvis, C; Quat, D; Raskin, L; Reichman, A; Richards, E; Richter, C; Roberts, E; Rody, J; Rohr, R; Rosenthal, M; Rubin, D; Rudolph, N; Rusten, S; Ryan, W; Sacha, B; Sage, L; Sands, M; Satterwhite, A; Schneider, J; Schneider, M; Sclight, G; Seidman, B; Shapiro, P; Shung, K; Silbert, L; Silver, L; Slavin, N; Snider, L; Speliotis, S; Standart, J; Stanton, B; Steele, K; Stettner, L; Stone, E; Stupakoff, B; Suau, A; Szasz, S; Thigpen, A; Traub, C; Tress, A; Trumbo, K; Tucker, T; Twccl, R; Vaeth, P; Viesti, J; Vlamis, S; Volpi, R; Waldron, D; Walsh, B; Warnecke, G; Weinik, S; Welch, R; Werner, P; Wohl, M; Zahner, D; Zappa, T; *North Salem*: Orling, A; *Ossining*: Mejuto, J; *Peekskill*: Cassaday, B; *Pittsford*: Iannazzi, R; *Reno*: Dondero, D; *Rochester*: Kamper, G; Lent, M; McMullen, F; Mertin, R; Platteter, G; Smith, K; Smith, L; *Rockville Center*: Chwatsky, A; *Roslyn HTS.*: Tiernan, A; *Scarsdale*: Morgan,B; *Shushan*: Villet, G; *Smithtown*: Melgar, F; *Somers*: Rauch, B; *Southampton*: Gaffga, D; Hyde, D; *Sunnyside, Queens*: Bader, K; *Syracuse*: Okoniewski, M; *Wantagh*: Kaplan, J; *Water Mill*: Fotlades, B; *West Haverstraw*: Pepis, A; *Woodside*: Geist, W **NORTH CAROLINA:** *Charlotte*: Fritz, G; Kearney, M; *Horse Shoe*: Nebbia, T; *Raleigh*: Henderson, C; Van de Zande, D; Zellers, H; *Winston-Salem*: McIntyre, W **OHIO:** *Cincinnati*: Baer, G; Rack, R; Rexroth, N; *Circleville*: Williams, B; *Cleveland*: Pappas, B; *Columbus*: Lerner, F; *Dayton*: Peterson, S; *Kent*: Pamfilie, A **OREGON:** *Eugene*: Lanker, B; *Portland*: LaRocca, J; Maher, J **PENNSYLVANIA:** *Allentown*: Kainz, J; *Altoona*: McKee, L; *Annville*: Monteith, J; *Bradford*: Tifft, W; *Bryn Mawr*: Crane, T; *Drexel Hill*: Kaser, K; *Elkins Park*: Skoofors, L; *Emmaus*: Heist, S; *Flicksville*: Vitali, J; *Lancaster*: Dussinger, M; *Martins Creek*: Fink, L; *Merion Station*: Dunoff, R; Lconard, B; *Paradise*: Irwing, J; *Phila*: Ward, T; *Philadelphia*: Flanigan, J; Minkkinen, A; Uzzle, B; *Phoenixville*: Falk, S; *Pittsburgh*: Giglio, H; Morton, C; Robinson, M; Seng, W; *Pottstown*: Kelly, T; *Reading*: Plank, D; Weigand, T; *Tarentum*: Pavlik, P; *Wilkes-Barre*: Cohen, M; Musto, T; *Williamsport*: Wild, T; *York*: Markel, B **RHODE ISLAND:** *North Kingstown*: Spratt, J; *Pawtucket*: Ushcr III, A; *Providence*: Rockhill, M; Swoger, A **SOUTH CAROLINA:** *Beauford*: McLaren, L; *Myrtle Beach*: Dodson, R **TENNESSEE:** *Chattanooga*: Lowery, R; *Franklin*: Hood, R; *Jonesborough*: Raymond, T; *Memphis*: Eggleston, W; Riss, M; Walpole, G; *Nashville*: Gwinn, B; Mitchell, M; Thomas, C; Williams, R **TEXAS:** *Beaumont*: Webb, C; *Dallas*: Baker, K; Hagler, E; Johnson, M; Knowles, J; Kuper, II; Olvera, J; Wood, K; Wristen, D; *Ft. Worth-Dallas*: Cabluck, J; *Houston*: Baldwin, F; Connolly, D; Garacci, B; Green, M; Hart, L; Howard, M; Krause, G; Moot, K; Pierson, S; Schorre, C; Vener, E; Watriss, W; Winningham, G; *San Antonio*: Chavanell, J; *Waco*: Jasek, J **UTAH:** *Salt Lake City*: McManemin, J; Miles, K; Quinney, D; Quist, D **VERMONT:** *Burlington*: Sutphen, C **VIRGINIA:** *Arlington*: Godfrey, M; Neubauer, J; *Charlottesville*: Llewellyn, R; *Moneta*: Faber, J; *Reston*: Marquez, T; *Richmond*: Jones, B; *Springfield*: Lubin, J **WASHINGTON:** *Bainbridge*: Rabinowitz, N; *Kirkland*: Watanabe, D; *Longview*: Werth, R; *Maple Falls*: Devine, B; *Seattle*: Barnes, D; Burnside, M; Kuhn, C; Mears, J; Meltzer, S; Olson, J; Olson, R; Ramey, M; Robinson, D; Strathy, D; Thompson, W; Webber, P; *Tacoma*: Penny, M; *Vancouver*: Leeson, T **WEST VIRGINIA:** *Huntington*: Winnel, S; *Wo- Morgantown*: Rittenhouse, R **WISCONSIN:** *Madison*: Kienitz, M; *Milwaukee*: Miller, B; Thien, A **WYOMING:** *Laramie*: Alford, J

PRODUCTS (GENERAL)

ARIZONA: *Tucson*: Eglin, T **CALIFORNIA:** *Bakersfield*: Alfter-Fielding, J; *Canoga Park*: Fugate, R; *Los Angeles*: Lieberman, J; Pearson, V; Shea, J; Swan, M; Trafficanda, G; *Mt. View*: Skarsten, M; *Palo Alto*: Wilson, R; *San Diego*: Harrington, M; *San Francisco*: Hathaway, S; Keenan, L; *San Mateo*: Rice, M; *Santa Monica*: Roundtree, D; *South San Francisco*: Kaldor, C; *Sunnyvale*: Dunn, R **CONNECTICUT:** *East Norwalk*: Von Koschembahr, A; *Ledyard*: Russell, K; *Stamford*: Olbrys, A; *Westport*: Lineon, J **DELAWARE:** *Hockessin*: Graybeal, S **FLORIDA:** *Bradenton*: Sweetman, G; *Fort Lauderdale*: Slater, E; *Lake Park*: Purin, T; *Miami*: Fine, S; *St. Petersburg*: Haan, R **HAWAII:** *Honolulu*: Martel, D; Shaneff, C **ILLINOIS:** *Chicago*: Alderson, J; Burris, Z; Candee, M; Debold, B; DeBolt, D; Izui, R; Moy, W; Schrempp, E; Yapp, C; *Des Plaines*: Bartholomew, G; *La Grange*: Mead, R; *Villa Park*: Ellefson, D **INDIANA:** *Indianapolis*: Ransburg, T; *Zionsville*: Wilson, D **KANSAS:** *Merriam*: Mutrux, J **MARYLAND:** *Rockville*: Landsman, G **MARYLAND:** *Silver Springs*: Althaus, M **MASSACHUSETTS:** *Boston*:

Gorchev, P; Rowin, S; *Chicopee*: Epstein, A; *E. Bridgewater*: Mercer, R; *Lexington*: Spivak, I; *Potomac*: Greenhouse, R; *Westwood*: Dreyer, P **MICHIGAN:** *Battle Creek*: Tarchala, J; *Berkeley*: Cromwell, P; *Detroit*: Salter, T;*Grand Rapids*: Pieroni, F; *Troy*: Hammarlund, V **MINNESOTA:** *Burnsville*: Peterson, B; *Minneapolis*: Crofoot, R **MISSOURI:** *St. Louis*: Kincaid, C; McCowan, R **NEW HAMPSHIRE:** *Manchester*: Sanford, G **NEW JERSEY:** *Collingswood*: Giandomenico, B; *Cranford*: Kruper, A; *Hillside*: Miller, M; *Jersey City*: Sullivan, S; *Merchantville*: Thellmann, M **NEW MEXICO:** *Albuquerque*: Tennies, T; *El Rito*: Eckert, R; *Santa Fe*: Nelson, W **NEW YORK:** *Baldwin*: Marten, B; *Comack*: Salander, A; *Hicksville*: Super, D; *New York*: Blosser, R; Claycomb, E; Clementi, J; Colletti, S; Davidson, D; Fields, B; Grant, R; Haling, G; Holz, G; Kudo, ; Legrand, M; Marx, R; Masunaga, R; Morris, B; Peck, J; Quat, D; Reichman, A; Rubin, D; Sclight, G; Seidman, B; Standart, J; Thigpen, A; Zappa,T; *Rochester*: Kamper, G; Platteter, G; Smith, L; *Smithtown*: Melgar, F; *Water Mill*: Fotiades, B **PENNSYLVANIA:** *Bryn Mawr*: Crane, T; *Philadelphia*: Flanigan, J; *Pittsburgh*: Giglio, H; Robinson, M; *Wilkes-Barre*: Musto, T **RHODE ISLAND:** *Providence*: Rockhill, M **SOUTH CAROLINA:** *Beauford*: McLaren, L **TENNESSEE:** *Chattanooga*: Lowery, R; *Nashville*: Williams, R **TEXAS:** *Dallas*: Wristen, D; *Houston*: Garacci, B **UTAH:** *Salt Lake City*: Quinney, D **VIRGINIA:** *Reston*: Marquez, T **WASHINGTON:** *Seattle*: Burnside, M; Kuhn, C; Mears, J; Olson, J; Ramey, M; Robinson, D; *Tacoma*: Penny, M

SPECIAL EFFECTS

CALIFORNIA: *Burlingame*: Degler, C; *Los Angeles*: Curran, D; Hogg, P; *Merced*: Werner, C; Werner, M; *Mt. View*: Skarsten, M; *San Francisco*: Keenan, L **FLORIDA:** *Fort Lauderdale*: Slater, E **ILLINOIS:** *Chicago*: Alderson, J; Cowan, R; Schrempp, E; Von Dorn, J; *Des Plaines*: Bartholomew, G; *Riverside*: Kleinman, J **MARYLAND:** *Baltimore*: Whitman, E **MASSACHUSETTS:** *Boston*: Gorchev, P; *Cambridge*: Wood, R; *E. Bridgewater*: Mercer, R **MINNESOTA:** *Burnsville*: Peterson, B **NEW JERSEY:** *Merchantville*: Thellmann, M **NEW YORK:** *Floral Park*: Gartel, L; *New York*: Burrell, F; Heiberg, M; Kudo, ; Michals, D; Tcherevkoff, M; *Rochester*: Platteter, G **PENNSYLVANIA:** *Pittsburgh*: Seng, W **TEXAS:** *Houston*: Garacci, B **WASHINGTON:** *Seattle*: Robinson, D

SPORTS

ARIZONA: *Prescott*: Annerino, J **CALIFORNIA:** *Balboa Island*: Dunmire, L; *Beverly Hills*: Friedman, T; *Burlingame*: Degler, C; *Cameron Park*: Mather, J; *Carpenteria*: Merkel, D; *Culver City*: Hargrove, T; *Laguna Beach*: Torrez, B; *Los Angeles*: Graham, D; Witkowski, B; *North Hollywood*: Kent, N; *San Diego*: Harrington, M; *San Francisco*: Atkinson, V; Martin, C; *Solana Beach*: Doyle, R **COLORADO:** *Denver*: Lewis, D; *Golden*: Lissy, D; *Vail*: Lokey, D; *Wheatridge*: Masamori, R **CONNECTICUT:** *Stamford*: Olbrys, A; *Weston*: Seghers II, C; *Westport*: Silk, G; Tenin, B **DELAWARE:** *Hockessin*: Graybeal, S; *Wilmington*: Eppridge, W **FLORIDA:** *Land O' Lakes*: McNeely, B; *Orlando*: King, T; Runion, B; *Sarasota*: Luzier, W; *Tallahassee*: O'Lary, B; *West Palm Beach*: Arruza, T **GEORGIA:** *Atlanta*: Sherman, R **IDAHO:** *Ketchum*: Stoelklein, D **ILLINOIS:** *Northbrook*: Sturtevant, P; *River Forest*: Balgemann, L **INDIANA:** *Brownstone*: Morris, L; *Indianapolis*: Carter, M **MAINE:** *Rockport*: Lyman, D **MARYLAND:** *Monkton*: Sweeney, E; *St. Louis*: Portnoy, L **MASSACHUSETTS:** *Hamilton*: Brownell, D **MINNESOTA:** *Edina*: Brimccombe, G; *Minneapolis*: Seaman, W; *St. Paul*: Smith, H; Stegbauer, J **MONTANA:** *Helena*: Sallaz, W **NEVADA:** *Las Vagas*: DeLespinasse, H **NEW JERSEY:** *Cranford*: Kruper, A; *Montclair*: Clare, W **NEW YORK:** *Accord*: Massie, K; *Brooklyn*: Blackman, J; Iceberg, K; *Deer Park*: Neste, A; *New York*: Beebe, R; Globus, R; Green- Armytage, S; Gross, S; Matthews, C; McGrail, J; Welch, R; Wilcox, S; *Reno*: Dondero, D; *Roslyn HTS.*: Tiernan, A; *Syracuse*: Dowling, J; Okoniewski, M **OHIO:** *Dayton*: Peterson, S **OKLAHOMA:** *Tulsa*: Robson, H **PENNSYLVANIA:** *Jenkintown*: Carnell, J; *Phoenixville*: Falk, S; *Pittsburgh*: Coppola, G; *Williamsport*: Wild, T **TEXAS:** *Ft. Worth-Dallas*: Cabluck, J **UTAH:** *Salt Lake City*: Call, R **VIRGINIA:** *Alexandria*: Woodward, T; *Norfolk*: Fitzgerald, R; *Richmond*: Jones, B **WASHINGTON:** *Bainbridge*: Rabinowitz, N; *Edmonds*: Kirkendall/Spring, **WEST VIRGINIA:** *Wo-Morgantown*: Rittenhouse, R **WISCONSIN:** *Milwaukee*: Biever, J; Miller, B

STILL LIFE

ARIZONA: *Phoenix*: Enger, V **CALIFORNIA:** *Hollywood*: Noday, S; *Laguna Beach*: Ranson, J; *Nevada City*: Moore, C; *Pasadena*: Mauskopf, N; *San Francisco*: Bernhard, R; Connor, L; Mizono, R; *San Jose*: Scoffone, C; *Santa Barbara*: Roberts, I; *Santa Cruz*: Starr, R; *Whittier*: Terrell, T **COLORADO:** *Denver*: Oswald, J **CONNECTICUT:** *Portland*: Seeley, J; *Stamford*: Hungaski, A **FLORIDA:** *Ft. Lauderdale*: Wiener, R; *Gainsvill*: Uelsmann, J; *Tallahassee*: Fichter, R **GEORGIA:** *Atlanta*: Barreras, A **HAWAII:** *Honolulu*: Martel, D **ILLINOIS:** *Belleville*: Van Blair, D; *Chicago*: Palmisano, V; Preis, D; Schabes, C; Von Dorn, J; *Park Ridge*: Mutter, S; *Urbana*: Nettles, B **MARYLAND:** *Laurel*: Edwards, R **MASSACHUSETTS:** *Andover*: Wise, K; *Boston*: Bindas, J; Cosindas, M; Filipe, T; Flowers, M; Jones, L; Parker, O; *Cambridge*: Wood, R; *E. Bridgewater*: Mercer, R; *Longmeadow*: Frankel, F **MICHIGAN:** *B-Hills*: Rodney, A **MINNESOTA:** *Minneapolis*: Crofoot, R **MONTANA:** *Missoula*: Williams, D **NEW JERSEY:** *Princeton*: Savage, N; *Summit*: Cooper, J **NEW YORK:** *Brooklyn*: Fuss, A; Spellings,

PHOTOGRAPHERS CROSS-REFERENCED BY SUBJECTS

I; *New York*: Burrell, F; Coleman, G; Cutler, C; Dantuono, P; Dole, J; Fellman, S; Galton, B; Groover, J; Gudnason, T; Heiberg, M; Hoeltzell, S; Izu, K; Katzenstein, D; Masunaga, R; Meier, R; Morgan, J; Nakamura,T; Neleman, H; O'Neal, C; Purvis, C; Raskin, L; Raymond, L; Richter, C; Rudnick, M; Sclight, G; Silver, L; Smith, B; Sommer, F; Sonneman, E; Staller, J; Stevenson, M; Tcherevkoff, M; Thomas, M; Tress, A; Trumbo, K; Weiss, M; Zappa, T; *Rochester*: Kamper, G; *Water Mill*: Fotiades, B **PENNSYLVANIA:** *Bradford*: Tifft, W; *Flicksville*: Vitali, J; *Wilkes-Barre*: Cohen, M; *Wyncote*: Larson, W **RHODE ISLAND:** *Providence*: Prince, D **TEXAS:** *Dallas*: Kern, G; Olvera, J

TRAVEL

ALABAMA: *Birmingham*: Bondarenko, M; *Decatur*: Seifried, C **ALASKA:** *Anchorage*: Mishler, C; *Girdwood*: Brandon, R; *Soldotna*: Levy, R **ARIZONA:** *Phoenix*: Dutton, A; *Scottsdale*: Rone, S; *Sedona*: Krasemann, S **CALIFORNIA:** *Albany*: Rowell, G; *Arcata*: Land-Weber, E; *Berkeley*: Le Bon, L; Stresinsky, T; *Canoga Park*: Fugate, R; *Carpenteria*: Merkel, D; *Cupertino*: Fisher, S; *Davenport*: Balthis, F; *Los Angeles*: Foreman, R; Graham, D; Somma, L; Volpert, D; *Malibu*: Selig, J; *Mill Valley*: Holmes, R; Sugar, J; *Mountain View*: Boyer, D; *Oakland*: Downey, M; Elk, J; *Romona*: Lawson, G; *San Carlos*: Stoy, W; *San Diego*: Blau, E; *San Francisco*: Atkinson, V; Buryn, E; Cameron, R; Chester, M; Connor, L; Martin, C; Vera, A; *San Rafael*: Fulton, J; *Santa Barbara*: Tuttle, T; *Santa Cruz*: Thaler, S; *Santa Monica*: Lawton, E; *Sepuluedo*: Kalick, C; *Trinidad*: Ulrich, L **COLORADO:** *Aspen*: Berge, M; *Durango*: Faustino **CONNECTICUT:** *Branford*: Zucker, G; *Ledyard*: Russell, K; *Ridgefield*: Zarember, S; *Weston*: Seghers II, C; *Westport*: Tenin, B; Winkler, R **DISTRICT OF COLUMBIA:** Keiser, A; Maroon, F; Price, P; Skoff, G **FLORIDA:** *Lake Mary*: Bachmann, B; *Lake Park*: Purin, T; *Land O' Lakes*: McNeely, B; *Miami*: Castañeda, L; Holland, R; Kennedy, W; Lucas, S; *Miami Lakes*: O'Connor, M; *Orlando*: King, T; Runion, B; *Sarasota*: Luzier, W; *Tallahassee*: O'Lary, B; *West Palm Beach*: Arruza, T **GEORGIA:** *Atlanta*: McCannan, T; Taylor, R **HAWAII:** *Hilo*: Penisten, J; *Honolulu*: Peterson, R; Shaneff, C **IDAHO:** *Boise*: Poertner, K **ILLINOIS:** *Belleville*: Van Blair, D; *Chicago*: Nielsen, R; Frerck, R; Morrill, D; Moy, W; Schabes, C; Woodley, J; *Highland Park*: Valenti, D; *Hinsdale*: Henderson, A; *Homewood*: Reynolds, L; *River Forest*: Balgemann, L; *Springfield*: Farmer, T **KANSAS:** *Kansas City*: Vivers, K **LOUISIANA:** *Baton Rouge*: Gleason, D; *Shreveport*: Johnson, N **MAINE:** *Portland*: Trueworthy, N **MARYLAND:** *Annapolis*: Beigel, D; *Baltimore*: Miller, R; *Frederick*: IntVeldt, G **MASSACHUSETTS:** *Boston*: Bibikow, W; Houch, M; Littell, D; Matheny, R; Robinson, D; Tuckerman, J; *Concord*: Massar, I; *Hamilton*: Brownell, D; *Northampton*: Delevingne, L; *Summerville*: Hilliard, H; *Westwood*: Dreyer, P **MICHIGAN:** *Ann Arbor*: Schneider, T; *Belleville*: Parkinson, P; *Dearborn*: Cox, D **MINNESOTA:** *Edina*: Brimccombe, G; *St. Paul*: Goddard, W; Stegbauer, J **MONTANA:** *Condon*: Wade, R; *Winchester*: Siteman, F **NEBRASKA:** *Gardnerville*: Lawrence, J **NEW HAMPSHIRE:** *Francestown*: Sweet, O **NEW JERSEY:** *Mendham*: Yamashita, M; *Morris Plains*: Degginger, P; *Princeton Jct.*: Paredes, C **NEW MEXICO:** *Santa Fe*: Fuss, E; Nelson, W; Trimble, S **NEW YORK:** *Accord*: Massie, K; *Baldwin*: Philiba, A; *Brooklyn*: Blackman, J; Iceberg, K; *Forest Hills*: Gotfryd, B; *New York*: Ashley-White, B; Aubry, D; Beebe, R; Bellack, R; Bishop, R; Bridges, M; Cotter, M; Cowans, A; Dominis, J; Elmore, S; Falco, R; Feiler, J; Holbrooke, A; Hopp, M; Jann, G; Kent, K; Kroll, E; Kuehn, K; Laird, R; MacLaren, M; MacWeeney, A; Marcus, H; Mayes, E; McCarthy, M; McGrail, J; Menschenfreund, J; Morath, I; Mroczynski, C; Murrell, G; Noren, C; Olman, B; Peress, G; Richards, E; Rohr, R; Rudolph, N; Sacha, B; Sands, M; Satterwhite, A; Snider, L; Standart, J; Stanton, B; Stettner, B; Vaeth, P; Viesti, J; Waldron, D; *Pelham*: Millard, H; *Poughkeepsie*: Makris, D; *Rochester*: Rosenberg, L; *Sunnyside, Queens*: Bader, K; *Syracuse*: Dowling, J; *West Haverstraw*: Pepis, A; *Westfield*: Rossotto, F; *White Plains*: Conte, M **NORTH CAROLINA:** *Raleigh*: Van de Zande, D; *Winston-Salem*: McIntyre, W **NORTH DAKOTA:** *West Fargo*: Withey, G **OHIO:** *Circleville*: Williams, B; *Columbus*: Adams, J; *Wickliffe*: O'Toole, J; O'Toole, T **OREGON:** *Corvallis*: Orans, A; *Portland*: Braasch, G **PENNSYLVANIA:** *Altoona*: McKee, L; *Emmaus*: McDonald, J; *Jenkintown*: Carnell, J; *Lancaster*: Dussinger, M; *Philadelphia*: Davidson, A; *Phoenixville*: Falk, S **SOUTH CAROLINA:** *Beauford*: McLaren, L **TENNESSEE:** *Memphis*: Walpole, G **TEXAS:** *Dallas*: Knowles, J; Kuper, H; Wood, K; *El Paso*: Kimak, M; *Houston*: Hart, L; Pierson, S; Robbins, L **UTAH:** *Salt Lake City*: Call, R; *Sandy*: Telford, J **VIRGINIA:** *Alexandria*: Purcell, C; *Alexandria*: Woodward, T; *Annandale*: Colbroth, R; *Arlington*: Neubauer, J **WASHINGTON:** *Bainbridge*: Rabinowitz, N; *Edmonds*: Kirkendall/Spring, ; *Seattle*: Meltzer, S; Thompson, W; Webber, P; *Spokane*: Boccaccio, A; *Vancouver*: Leeson, T **WISCONSIN:** *Milwaukee*: Thien, A **WYOMING:** *Jackson*: Mangelsen, T; *Laramie*: Alford, J

AERIAL & CELESTIAL

ALASKA: *Anchorage*: Mishler, C; *Fairbanks*: Rothman, S **ARIZONA:** *Sedona*: Krasemann, S; *Tucson*: Eglin, T **CALIFORNIA:** *Carpenteria*: Merkel, D; *Inverness*: Blake, T; *Kensington*: Rokeach, B; *Los Angeles*: Duhamel, F; Foreman, R; Hammer, W; Paris, M; Somma, L; Tepper, R; *Mill Valley*: Sugar, J; *North Hollywood*: Kent, N; *Northbrook*; Grover, R; *San Francisco*: Cameron, R; Hall, G; Perretti, c; *Santa Barbara*: Tuttle, T; *South San Francisco*: Kaldor, C **CONNECTICUT:** *Ledyard*: Russell, K; *Stamford*: Olbrys, A; *Weston*: Seghers II, C; *Westport*: Tenin, B **DISTRICT OF COLUMBIA:** *Washington*: Olsen, L **FLORIDA:** *Ft. Lauderdale*: Wiener, R; *Lake Park*: Purin, T; *Land O' Lakes*: McNeely, B; *Plantation*: Chesler, K; *Sarasota*: Luzier, W; Stahl, D **ILLINOIS:** *Chicago*: Palmisano, V **MARYLAND:** *Dickerson*: Williams, W; *Rockville*: Landsman, G; *Silver Spring*: Ruggeri, L **MAINE:** *Boston*: Holt, C; MacLean, A; *Summerville*: Hilliard, H **MICHIGAN:** *Grand Rapids*: Pieroni, F **MINNESOTA:** *St. Paul*: Smith, H **NEVADA:** *Reno*: Dondero, D **NEW JERSEY:** *Summit*: Cooper, J **NEW YORK:** *Accord*: Massie, K; *Halesite*: Neville, D; *Mamaroneck*: Millman, L; *New York*: Bridges, M; Byers, B; Elmore, S; Funk, M; Gross, S; McGrail, J; Sacha, B; Thigpen, A; Viesti, J; Kuehn, K **NORTH DAKOTA:** *Raleigh*: Zellers, H **OHIO:** *Cincinnati*: Baer, G **OKLAHOMA:** *Tulsa*: Halpern, D **OREGON:** *Portland*: Braasch, G **PENNSYLVANIA:** *Doylestown*: Baker, W; *Freeland*: Zmiejko, T; *Lancaster*: Dussinger, M **RHODE ISLAND:** *Providence*: Hanson, D **TENNESSEE:** *Chattanooga*: Lowery, R; *Memphis*: Walpole, G **TEXAS:** *Houston*: Green, M **UTAH:** *Moab*: Till, T **VIRGINA:** *Arlington*: Godfrey, M; *Charlottesville*: Llewellyn, R **WASHINGTON:** *Seattle*: Olson, J; *Seattle*: Westmorland, F; *Spokane*: Boccaccio, A; *Alps Maritime, France*: Duncan, D

HAZARDS

ALABAMA: *Birmingham*: Bondarenko, M **ALASKA:** *Girdwood*: Graham, K; *Haines*: Anonymus, E; *Soldotna*: Levy, R **ARIZONA:** *Prescott*: Annerino, J **CALIFORNIA:** *Laguna Beach*: Streano, V; *Los Angeles*: Lieberman, J; Montes De Oca, A; *Mill Valley*: Sugar, J; *Oakland*: Downey, M; *San Francisco*: Hall, G; Keenan, L; Perretti, C; *Santa Barbara*: McKiernan, K; *Sepuluedo*: Kalick, C; *Solana Beach*: Doyle, R; *South San Francisco*: Kaldor, C **COLORADO:** *Denver*: Lewis, D; *Vail*: Lokey, D **CONNECTICUT:** *Westport*: Tenin, B **DISTRICT OF COLUMBIA:** Walters, D; Price, P **FLORIDA:** *Miami*: Holland, R; *Miami*: Walters, D; *Sarasota*: Luzier, W; Stahl, D; *Tampa*: Minardi, M; *West Palm Beach*: Arruza, T **ILLINOIS:** *Chicago*: Kelly, M; *Palmisano, V*; *River Forest*: Balgemann, L; *Springfield*: Farmer, T **MAINE:** *Portland*: Trueworthy, N **MARYLAND:** *Annapolis*: Harper, D; *Lutherville*: Jackson, C **MAINE:** *Boston*: Bindas, J; *Cambridge*: Berndt, J **MICHIGAN:** *Birmingham*: Dale, L **MINNESOTA:** *Minneapolis*: Magoffin, J; *St. Paul*: Stegbauer, J **NEW JERSEY:** *Montclair*: Clare, W **NEW YORK:** *Brooklyn*: Iceberg, K; *New York*: Falco, R; Jenkinson, M; Peress, G; Sacha, B; Schneider, M; Vlamis, S; Waldron, D; Walsh, B; *Panama*: Kelly, J; *Peekskill*: Cassaday, B **NORTH CAROLINA:** *Raleigh*: Henderson, C; *Raleigh*: Zellers, H **OREGON:** *Corvallis*: Orans, A; *Portland*: Braasch, G **PENNSYLVANIA:** *Allentown*: Kainz, J **PENNSYLVANIA:** *Lancaster*: Dussinger, M; *Paradise*: Irwing, J; *Reading*: Plank, D; *Wilkes-Barre*: Musto, T **TENNESSEE:** *Jonesborough*: Raymond, T **TEXAS:** *Dallas*: Knowles, J; *Houston*: Howard, M; Vener, E **WASHINGTON:** *Seattle*: Olson, J **WEST VIRGINIA:** *Morgantown*: Rittenhouse, R **WISCONSIN:** *Madison*: Kienitz, M

UNDERWATER

ALASKA: *Girdwood*: Graham, K **CALIFORNIA:** *Burlingame*: Degler, C; *Carpenteria*: Merkel, D **CONNECTICUT:** *Stamford*: Olbrys, A; *Westport*: Tenin, B **FLORIDA:** *Jacksonville Beach*: Hope, C; *Lake Park*: Purin, T; *Land O' Lakes*: McNeely, B; *Miami*: Holland, R; Lucas, S; *Sarasota*: Stahl, D **ILLINOIS:** *Chicago*: Palmisano, V; *Northbrook*: Sturtevant, P **MARYLAND:** *Bethesda*: Ward, F **MAINE:** *Boston*: Bindas, J; Holt, C **NEW YORK:** *New York*: Funk, M **OHIO:** *Columbus*: Adams, J **PENNSYLVANIA:** *Drexel Hill*: Kaser, K **TENNESSEE:** *Chattanooga*: Lowery, R **TEXAS:** *Houston*: Howard, M **WASHINGTON:** *Seattle*: Westmorland, F

A TO Z IMAGES
213 W Institute Pl
Chicago IL 60610

A-STOCK PHOTO FINDER
1030 N State St 30f
Chicago IL 60610

ADVENTURE PHOTO INC
3750 W Pacific Coast Hwy
Ventura CA 93001

AFTER IMAGE INC
3807 Wilshire Blvd 250
Los Angeles CA 90010

ALASKA PICTORIAL SERVICE
Po Box 109144
Anchorage AK 99519

ALASKAPHOTO
1530 N Westlake
Seattle WA 98134

ALL-SPORT PHOTOGRAPHY USA
23335 Lake Manor Dr
Chatsworth CA 91311

AMERICAN STOCK PHOTO
6842 Sunset Blvd
Los Angeles CA 90028

AMWEST PICTURE AGENCY
1595 S University
Denver CO 80210

ANIMALS ANIMALS/EARTH SCENES
17 Railroad Ave
Chatam NY 12037

ANTHRO-PHOTO FILE
33 Hurlbut St
Cambridge MA 02138

APERTURE COMPANIES
1530 Westlake Ave
NorthSeattle WA 98109

ARCHIVE PICTURES INC
111 Wooster St
New York NY 10012

ARIZONA PHOTOGRAPHIC ASSOCIATES
2344 W Holly St
Phoenix AZ 85009

ART COLOR SLIDES INC
235 E 50th St
New York NY 10022

ART RESOURCE INC
65 Bleecker St 9th Fl
New York NY 10012

AUTHENTICATED NEWS INTL
29 Katonah Ave
Katonah NY 10536

BERG & ASSOCIATES
8334 Clairemont Mesa Blvd 203
San Diego CA 92111

BETHEL AGENCY
513 W 54th St 1
New York NY 10019

BETTMANN ARCHIVES INC
136 E 57th St
New York NY 10022

BETTMANN NEWSPHOTOS
48 E 21st St
New York NY 10010

BIOLOGICAL EDUCATIONAL EXPEDITIONS
2838 Garrison St
San Diego CA 92106

BIOLOGICAL PHOTO SERVICE
2830 Highway 1
Half Moon Bay CA 94019

BIRD PHOTOGRAPHS INC
254 Sapsucker Woods Rd
Ithaca NY 14850

BLACK BOX STUDIOS
126 Fifth Ave
New York NY 10011

BLACK STAR PUBLISHING CO
450 Park Ave S.
New York NY 10022

BROOKS & VANKIRK
1230 W Washington
Chicago IL 60607

CACTUS CLYDE PRODUCTIONS
3623 Perkins Rd
Baton Rouge LA 70808

CAMERA
56 W 20th St
New York NY 10011

CAMERA CLIX
275 Seventh Ave
New York NY 10001

CAMERA HAWAII
875 Waimanu St
Honolulu HI 96813

CAMERA MD STUDIOS LIBRARY
8290 Nw 26th Pl
Fort Lauderdale FL 33322

CAMERAMANN INTERNATIONAL LTD
Po Box 413
Evanston IL 60204

CAMERIQUE STOCK PHOTOGRAPHY
1701 Skippack Pike Po Box 175
Blue Bell PA 19422

CANDEE PRODUCTIONS INC
1212 W Jackson
Chicago IL 60607

CAPE SCAPES
542 Higgins Crowell Rd
Cape Cod MA 02673

CASWELL MARINE PHOTOGRAPHY
2732 Tucker Ln.
Los Alamitos CA 90720

CHARLTON PHOTOS
11518 N Pt Washington Rd
Mequon WI 53092

CHICAGO FOOD STOCK
758 W Willow Ave
Chicago IL 60614

CITY NEWS BUREAU
1033 30th St Nw
Washington DC 20007

CLICK/CHICAGO
213 W Institute Pl 503
Chicago IL 60610

CLOUD SHOOTERS STOCK LIBRARY
4620 N Winchester
Chicago IL 60740

COLLECTORS SERIES
161 W Harrison St
Chicago IL 60605

COLOUR LIBRARY INTERNATIONAL LTD
145 E 32nd St
New York NY 10016

COMSTOCK
32 E 31st St
New York NY 10016

CONSOLIDATED NEWS PICTURES
209 Pennsylvania Ave SE
Washington DC 20003

CONTACT PRESS IMAGES INC
116 E 27th St 8th Floor
New York NY 10016

CREATIVE PHOTO
World Image Bank
Rr 1 Bx 124
Le Suer MN 56058

CULVER PICTURES INC
150 W 22nd St 3rd Fl
New York NY 10011

CUSTOM CAMERA INC
416 W Main St
Tomball TX 77375

CYR COLOR PHOTO AGENCY
73 Benedict St
Norwalk CT 06852

DAE FLIGHTS
41271 Via Anita
Temecula CA 92390

DANDELET INTERLINKS
126 Redwood Rd
San Anselmo CA 94960

DCS ENTERPRISES
12806 Gaffney Rd
Silver Springs MD 20904

DESIGN CONCEPTIONS
112 Fourth Ave.
New York NY 10003

DESIGN PHOTOGRAPHERS INTL INC
521 Madison Ave
New York NY 10022

DEVANEY STOCK PHOTOS
755 New York Ave 306
Huntington NY 11743

DMI
1238 River Rd
Edgewater NJ 07020

DOT PICTURES AGENCY
50 W 29th St 10w
New York NY 10001

DPI
521 Madison Ave.
New York NY 10022

DPI INC
19 W 21st St 901
New York NY 10010

DRK PHOTO
265 Valley School Rd
Sedona AZ 86336

DUOMO PHOTOGRAPHY INC
133 W 19th St
New York NY 10011

EARTH IMAGES
682 Winslow Way E
Po Bx 10352
Bainbridge Island WA 98110

EASTERN PHOTO SERVICE
1170 Broadway
New York NY 10001

ECLIPSE & SUNS
Po Box 689
Haines AK 99827

EDUCATIONAL DIMENSIONS STOCK PHOTO
792 Pacific St
Po Bx 126
Stamford CT 06904

ESPN
355 Lexington Ave
New York NY 10017

ESTO PHOTOGRAPHICS
222 Valley Pl
Mamaroneck NY 10543

F/STOP PICTURES INC
Po Box 359
Springfield VT 05156

FIRST PHOTOBANK
17952 Sky Park Circle B
Irvine CA 92714

FLYING CAMERA INC
114 Fulton St
New York NY 10038

FOCUS ON SPORTS INC
222 E 46 St
New York NY 10017

FOCUS WEST
4112 Adams Ave
San Diego CA 92116

FOCUS/VIRGINIA
300 E Main St
Richmond VA 23219

FOTOGRAF/HEADHUNTERS
2619 Lovegrove
Baltimore MD 21211

FOTOS INTERNATIONAL
130 W 42nd St
New York NY 10036

FOUR BY FIVE
485 Madison Ave 21st Fl
New York NY 10022

FOUR BY FIVE PHOTOGRAPHY INC
417 St Pierre
Montreal Quebec CANADA

FPG INTERNATIONAL
251 Park Ave South
New York NY 10010

FRANK MERRILL COLOR LTD
2939 W Touhy Ave
Chicago IL 60645

FROZEN IMAGES INC
400 1st Ave North
Minneapolis MN 55401

FUNDAMENTAL PHOTOGRAPHS
210 Forsyth St
New York NY 10002

GAMMA-LIAISON AGENCY INC
150 E 58th St
New York NY 10155

GLOBUSCOPE INC
44 W 24th St
New York NY 10010

GOTTSCHO-SCHLEISNER INC
150- 35 86th Ave
Jamaica NY 11432

GRANGER COLLECTION
1841 Broadway
New York NY 10023

GREAT AMERICAN STOCK FOOD PHOTOGRAPHY
3955 Pacific Hwy
San Diego CA 92110

HEADHUNTERS
2619 Lovegrove St
Baltimore MD 21218

HEDRICH-BLESSING
11 W Illinois St
Chicago IL 60610

HISTORICAL PICTURES SERVICE INC
921 W Van Buren St 201
Chicago IL 60607

HOLLYWOOD PHOTOGRAPHERS ARCHIVES
820 N La Brea Ave
Los Angeles CA 90038

HOT SHOTS STOCK SHOTS INC
309 Lesmill Rd
Don Mills, Ontario CANADA

HOUCK/HOLT STUDIOS
535 Albany St
Boston MA 02118

IBID INC
727 N Hudson St
Chicago IL 60610

ILLUSTRATORS STOCK PHOTOS & PSI PHOTO-FILE
2991 Glenora Lane
Rockville MD 20850

IMAGE BANK
111 5th Ave 12th Fl
New York NY 10003

IMAGE RESOURCES INC
134 W 29th St
New York NY 10001

IMAGE WORKS
Po Box 443
Woodstock NY 12498

IMAGERY UNLIMITED
Jordan Conrad Po Box 2878
Alameda CA 94501

IMAGES PRESS SERVICE
22 E 17th St 225
New York NY 10003

IMAGES UNLIMITED
13510 Floyd Rd
Dallas TX 75243

INDEX/STOCK INTERNATIONAL INC
126 5th Ave
New York NY 10011

INTERNATIONAL STOCK PHOTOGRAPHY LTD
113 E 31st St
New York NY 10016

IO INC THE IMAGE AGENCY
2651 Connecticut Ave Nw 3rd Fl
Washington DC 20008

J C ALLEN & SON AGRICULTURAL PHOTOGRAPHERS
1341 Northwestern Av Po Bx2061
West Lafayette IN 47906

JEROBOAM INC
120 27th St
San Francisco CA 94110

JOAN KRAMER & ASSOCIATES INC
720 5th Ave
New York NY 10019

KEYSTONE PRESS AGENCY INC
202 E 42nd St
New York NY 10017

LAVENSTEIN STUDIOS
4605 Pembroke Lake Cir
Virginia Beach VA 23455

LEE GROSS ASSOCIATES INC
366 Madison Ave
New York NY 10017

LESTER V BERGMAN & ASSOCIATES INC
East Mountain Rd South
Cold Spring NY 10516

LEVITON-ATLANTA INC
1271 Roxboro Dr Ne
Atlanta GA 30324

LGI
241 W 36th St
New York NY 10018

LIFE PICTURE SERVICE ROCKEFELLER CTR
Time Life Bldg 28-58
New York NY 10020

LIGHTWAVE
1430 Mass Ave
Cambridge MA 02138

LUMIERE
512 Adams St
Centerport NY 11721

MAGNUM PHOTOS INC
251 Park Ave S
New York NY 10010

MAIN IMAGE PHOTOGRAPHICS
801 S Race
Denver CO 80209

MANHATTAN VIEWS
41 Union Square W #1027
New York NY 10003

MEDICAL STOCK PHOTOGRAPHY
271 Madison Ave
New York NY 10016

MEDICHROME
232 Madison Ave
New York NY 10016

MEGA PRODUCTIONS INC
1714 N Wilton Pl
Hollywood CA 90028

MEMORY SHOP
109 E 12th St
New York NY 10003

MILLER SERVICES LTD
180 Bloor St West
Toronto Ontario, CANADA

MONKMEYER PRESS PHOTO SERVICE INC
118 E 28th St
New York NY 10016

NATIONAL CATHOLIC NEWS SERVICE
1312 Massachusetts Ave
Washington DC 20005

NATIONAL STOCK NETWORK
8960 Sw 114 St
Miami FL 33176

NAWROCKI STOCK PHOTO
332 S Michigan Ave #1630
Chicago IL 60604

NEW YORK DAILY NEWS PHOTO SALES
220 E 42nd St
New York NY 10017

NORTH COUNTRY IMAGES
1496 N Albert St
St Paul MN 55108

NYT PICTURES
Ny Times News Serv
229 W 43 St
New York NY 10036

OLD SLAVE MART LIBRARY
Po Box 446 Station 14 1/2
Sullivans Island SC 29482

OMNI PHOTO COMMUNICATIONS
5 E 22nd St
New York NY 10010

ONYX ENTERPRISES INC
8230 Beverly Blvd
Los Angeles CA 90048

OUTLINE PRESS SYNDICATE INC
1068 2nd Ave
New York NY 10022

PACH BROTHERS
16 E 53rd St
New York NY 10022

PACIFIC LIGHT VIEWS
Po Box 625
Soquel CA 95073

PEREGRINE PHOTO ART
8453 176th Lane Nw
Anoka MN 55303

PHOTO AGENTS LTD
113 E 31st St
New York NY 10016

PHOTO ASSOCIATES NEWS SERVICE
PoBox 306 Station A
40-43 172 St
Flushing NY 11358

PHOTO BANK
313 E Thomas Rd #102
Phoenix AZ 85012

PHOTO FILE
550 15th St
San Francisco CA 94103

PHOTO FINDERS INTERNATIONAL
8624 E San Bruno Dr
Scottsdale AZ 85258

PHOTO MEDIAD
Univ Media 3 Forest Glen
New Paltz NY 12561

PHOTO NETWORK
1541-J Parkway Loop
Tustin CA 92680

PHOTO OPTIONS
1432 Linda Vista Dr
Birmingham AL 35226

PHOTO QUEST INTERNATIONAL
175 5th Ave #1101
New York NY 10010

PHOTO RESEARCHERS
60 E 56th St
New York NY 10022

PHOTO SOURCE
145 E 32nd St 6th Flr
New York NY 10016

PHOTO UNIQUE
1328 Broadway
New York NY 10001

PHOTOBANK INC
17905 Sky Park Cir.
Irvine CA 92714

PHOTOGRAPHERS ASPEN
1280 Ute Ave
Aspen CO 81611

PHOTOGRAPHIC EYE INC
4255 Stadium Dr
Ft Worth TX 76107

PHOTOGRAPHSANSTUFF
730 Clementina
San Francisco CA 94103

PHOTOGRAPHY FOR INDUSTRY
1697 Broadway
New York NY 10019

PHOTONET
254 W 54th St
New York NY 10019
PHOTOPHILE
2311 Kettner Blvd
San Diego CA 92101
PHOTOREPORTERS INC
875 Ave Of Americas #1003
New York NY 10001
PHOTOTEQUE
156 5th Ave #415
New York NY 10010
PHOTOVAULT
1045 17th St
San Francisco CA 94107
PHOTRI-PHOTO RESEARCH
505 W Windsor Av
PoBox 26428
Alexandria VA 22313
PICTORIAL PARADE
130 W 42nd St
New York NY 10036
PICTURE CUBE INC
89 Broad St
Boston MA 02110
PICTURE GROUP INC
5 Steeple St
Providence RI 02903
PLESSNER INTERNATIONAL
95 Madison Ave
New York NY 10016
POSITIVE IMAGES
12 Main St
Natick MA 01760
PREFERRED STOCK
706 W Pico Blvd 4th Flr
Los Angeles CA 90015
RAINBOW
PoBox 573
1079 Main St
Housatonic MA 01236
RANGEFINDERS
200 Mercer St
New York NY 10012
RDR PRODUCTIONS INC
351 W 54th St
New York NY 10019
REFERENCE PICTURES
119 5th Ave
New York NY 10010
RELIGIOUS NEWS SERVICE
104 W 56th St
New York NY 10019
RETNA LTD
36 W 56th St
New York NY 10019
SCENIC PHOTO IMAGERY
9208 32nd Ave North
New Hope MN 55427
**SCIENCE PHOTO LIBRARY
INTERNATIONAL INC**
118 E 28th St
New York NY 10016
SCIENCE SOURCE
6 Carpenter St
Salem MA 01970
SHARP SHOOTERS
7210 Red Rd. Ste. 216
Miami FL 33143
**SHERMAN GRINBERG FILM
LIBRARIES**
1040 N Mccadden Pl
Hollywood CA 90038
**SHOOTING STAR
INTERNATIONAL PHOTO AGENCY
INC**
1636 N Fairfax Ave
Hollywood CA 90046
SHOSTAL ASSOCIATES INC
145 E 32nd St
New York NY 10016
SINGER COMMUNICATIONS INC
3164 W Tyler Ave
Anaheim CA 92801

SIPA PRESS INC
8170 Beverly Blvd #104
Los Angeles CA 90048
SITEMAN STUDIOS
136 Pond St
Winchester MA 01890
SOURCE INC
1709 S 29th Pl
Tucson AZ 85710
SOUTHERN STOCK PHOTOS
3601 W Commercial Blvd Ste 33
Ft Lauderdale FL 33309
SOVFOTO EASTFOTO AGENCY
225 W 34th St #1505
New York NY 10122
SPECTRA-ACTION INC
5 Carole Lane
St Louis MO 63131
SPORTS CHROME INC
270 Sylvan Ave Rt 9w
Englewood Cliffs NJ 07632
**SPORTS ILLUSTRATED PICTURE
SALES**
Time Life Bldg #19-19
New York NY 10020
SPORTS PHOTO FILE
24 W 46th St
New York NY 10036
STAR FILE PHOTO AGENCY
1501 Broadway #1512
New York NY 10036
STILLS INC
3210 Peachtree Rd Ne
Atlanta GA 30305
STOCK BOSTON INC
36 Glouster St
Boston MA 02115
STOCK BROKER
450 Lincoln St #110
Denver CO 80203
STOCK CHICAGO
111 E Chestnut
Chicago IL 60611
STOCK IMAGERY
711 Kalamath St
Denver CO 80204
STOCK MARKET
93 Parliament St #228
Toronto Ontario, CANADA
STOCK MARKET PHOTO AGENCY
1181 Broadway
New York NY 10001
STOCK PILE INC
2404 N Charles St
Baltimore MD 21218
STOCK SHOP
271 Madison Ave
New York NY 10016
STOCK SHOP INC
232 Madison Ave
New York NY 10016
STOCKFILE
2107 Park Ave
POBOX 4902
Richmond VA 23220
STOCKHOUSE INC
9261 Kirby
Houston TX 77054
STOCKPHOTOS INC
373 Park Ave S
New York NY 10022
STREANO/HAVENS
Po Box 662
Laguna Beach CA 92652
SYGMA
8633 Sunset Blvd #407
Los Angeles CA 90069
SYGMA PHOTO NEWS
225 W 57th St
New York NY 10019
TAKE STOCK
756 Neilson St
Berkeley CA 94707

TAURUS PHOTOS INC
118 E 28th St
New York NY 10016
TENN EAST STOCK
401 W Superior
Chicago IL 60601
THIRD COAST STOCK SOURCE
205 W Highway Ave
Milwaukee WI 53203
THREE LIONS
145 E 32nd St
New York NY 10016
TIME PIX SYNDICATION
Time Life Bldg #2505
New York NY 10020
TOM STACK & ASSOCIATES
3645 Jeannine Dr #212
Colorado Springs CO 80907
TRAVEL VUES
6342 Beeman Ave.
Hollywood CA 90028
**UNDERWOOD & UNDERWOOD
NEWS PHOTOS**
136 E 57th St
New York NY 10022
UNIPHOTO PICTURE AGENCY
1071 Wisconsin Ave. Nw
Washington DC 20007
**UNITED PRESS INTL
NEWSPICTURES**
220 E 42nd St
New York NY 10017
VIESTI ASSOCIATES
PoBox 20424 Cherokee Station
New York NY 10028
VIESTI ASSOCIATES
6800 Westgate Blvd 139b
Austin TX 78745
VIEW FINDER
818 Liberty Ave
Pittsburgh PA 15222
**VIEW FINDER STOCK
PHOTOGRAPHY**
2310 Penn Ave
Pittsburgh PA 15222
VISIONS PHOTO AGENCY INC
105 5th Ave #9d
New York NY 10003
VISUAL IMAGES WEST
600 E Baseline #B6
Tempe AZ 85283
VISUAL MEDIA INC
2661 Vassar St
Reno NV 89502
WEST LIGHT
1526 Pontius Ave #A
Los Angeles CA 90025
WEST STOCK INC
83 S King St #520
Seattle WA 98104
WHEELER PICTURES
50 W 29th St #11w
New York NY 10001
WIDE WORLD PHOTOS INC
50 Rockefeller Plaza
New York NY 10020
WILCOX COLLECTION
521 Madison Ave
New York NY 10022
WILDLIFE PHOTOBANK
1530 Westlake Ave N
Seattle WA 98134
**WOODFIN CAMP & ASSOCIATES
INC**
116 E 27th St 8th Flr
New York NY 10016
**WTN NEWSFILM & VIDEOTAPE
LIBRARY**
321 W 44th St
New York NY 10036
ZEPHYR PICTURE AGENCY
2120 Jimmy Durante Blvd #U
Del Mar CA 92014

INDEX OF ILLUSTRATIONS